*La Nature c'est le modèle variable et infini qui
contient tous les styles. Elle nous entoure
mais nous ne la voyons pas.*—RODIN.

THE CURVES OF LIFE

BEING

AN ACCOUNT OF SPIRAL FORMATIONS
AND THEIR APPLICATION TO GROWTH
IN NATURE, TO SCIENCE AND TO ART;

WITH SPECIAL REFERENCE TO

THE MANUSCRIPTS OF LEONARDO DA VINCI

BY

THEODORE ANDREA COOK M.A. F.S.A.

Author of "Old Touraine," "Rouen," etc., etc.

*WITH ELEVEN PLATES
AND 415 ILLUSTRATIONS*

DOVER PUBLICATIONS, INC., NEW YORK

Published in Canada by General Publishing Company,
Ltd., 30 Lesmill Road, Don Mills, Toronto, Ontario.
Published in the United Kingdom by Constable and
Company, Ltd., 10 Orange Street, London WC2H 7EG.

This Dover edition, first published in 1979, is an
unabridged republication of the work originally publish-
ed by Constable and Company, London, in 1914.

International Standard Book Number: 0-486-23701-X
Library of Congress Catalog Card Number: 78-14678

Manufactured in the United States of America
Dover Publications, Inc.
180 Varick Street
New York, N.Y. 10014

PREFACE

Considerate la vostra semenza ;
Fatti non foste a viver come bruti,
Ma per seguir virtute e conoscenza.—DANTE.

WHEN my attention was first turned to the subject of spiral formations, more than twenty years ago, it was in connection with an artistic problem, rather than with a biological question, that I investigated them. As was inevitable, I found myself obliged to examine the forms of natural life ; and I learnt that this extraordinary and beautiful formation is to be seen throughout organic nature, from the microscopical foraminifera and from life forms even smaller still. In shells, in plants, in the bodily structures of men and animals, the spiral formation is certainly a common factor in a multitude of phenomena apparently widely different. As my investigations broadened I had to secure the assistance of expert authorities in separate divisions of research, to whom I cannot be sufficiently grateful, and I mention this in order to answer the obvious criticism that no one man would in these days be considered competent to deal with the separate branches of knowledge which my inquiry has gradually necessitated. This is one reason why anyone who is interested in the rough programme sketched in my first chapter may choose his own path to the last one, which sums up the whole. He may read of shells in Chapters III. and IV. and X. ; of plants and flowers in Chapters V. to IX. and in XI. ; of horns in Chapter XII. ; of anatomy and lefthandedness in the two next ; of the growth of patterns in the fifteenth ; of architecture in XVI. and XVII. ; of the attribution of a building to Leonardo da Vinci in XVIII. ; or of Albert Dürer's mathematics in the nineteenth.

The mere recitation of so varied a list of necessary subjects leads me here to lay immediate stress upon the value of human curiosity about the world around us, upon that thirst for a rational explanation of phenomena which Comte so loftily despised, which Aristotle and Spinoza so clearly acknowledged. Such writers as Mach and Kirchhoff seem to me to have gone back to Comte's most vulnerable position when they limit the use of science to description. For we do not want mere catalogues. If every generation of great thinkers had not thirsted for explanations also, we should never have evolved the complexity and beauty of modern science at all. Only by some such discovery of relationships can we ever try to deal rationally with that " perpetual flux " which (as is more and more clearly recognised) the

phenomena of life and nature present. There is a deep-seated instinct which attracts our minds towards those " desperate feats of thinking " which have achieved the greater victories of humanity ; and it is by them that we must surely stand the ultimate test of our survival.

Modern research is gradually becoming free both from accidental prejudices and from meretricious standards. There is a new spirit at work upon constructive philosophy which has never been so urgent, so creative, or so strong ; and knowledge has become much more accessible at the very time when its transmission over the whole world has been enormously facilitated by new methods of communication. This means that thought is becoming clearer and more critical, and that a breadth of outlook and a freedom of imagination have resulted which must impel alike the laziest to look about him, and the busiest to linger and inquire. Some ripple of that widespread impulse has produced this book ; but the very process just described has created its own difficulty ; for specialisation is in these days so sternly necessitated by the obvious benefits of the division of labour, that it becomes an increasingly complicated task to put the various results of separate investigations in their true relation with each other. Analysis, therefore, has been my first aim. Not till my last two chapters have I ventured to elaborate the synthesis which completes and justifies my catalogue of details ; and for this I have ventured to propose a convenient instrument which may be usefully employed in dealing with the varied multiplicity of natural phenomena.

It may be said that with very few exceptions the spiral formation is intimately connected with the phenomena of life and growth. When it is found in inorganic phenomena the logarithmic spiral is again connected with those forms of energy which are most closely comparable with the energy we describe as life and growth, such, for instance, as the mathematical definition of electrical phenomena, or the spiral nebulæ of the astronomer. Newton arrived at his theory of the movements of the celestial bodies in our own solar system by postulating *perfect movement* and by calculating from that the apparently erratic orbits of the planets. In just the same way may it not be possible to postulate *perfect growth* and from that to calculate and define the apparently erratic growths and forms of living things ? In each case the Higher Mathematics will very properly be the instrument of philosophic inquiry, for the science of mathematics, useless as an end in itself, is, in the right hands, the most supple and perfect instrument for defining the relations of things, and classifying phenomena in the manner so eagerly desired by every intelligent

mind. It was Sir John Leslie who first drew attention to the
" organic aspect " of the logarithmic spiral (see p. 58). Canon
Moseley then applied it to the examination of certain turbine shells.
Professor Goodsir sought in it the basis of some physiological law
which should rule the form and growth of organism as gravitation
prevails in the physical world. Mr. A. H. Church, of Oxford, has
founded on it, in quite recent years, the whole theory of modern
phyllotaxis ; and if the symbol illustrated on the cover of this
book is correctly interpreted in its Appendix, it would appear that
Chinese philosophy had adopted the logarithmic spiral as a
symbol of growth as long ago as the twelfth century. But the
exact form of logarithmic spiral most suitable to the fundamental
conceptions involved had never yet been satisfactorily discovered.
The Formula for Growth now suggested in this book is here called
the ϕ spiral, or Spiral of Pheidias, a new mathematical conception
worked out from an ancient principle by Mr. Mark Barr and
Mr. William Schooling ; and Mr. Schooling's exposition of some
of its possibilities will be found in my twentieth chapter and the
pages which immediately follow it.

There is a very significant characteristic of the application of
the spiral to organic forms ; that application invariably results
in the discovery that nothing which is alive is ever simply
mathematical. In other words, there is in every organic object
a factor which baffles mathematics, as we have hitherto developed
them—a factor which we can only describe as Life. The nautilus is
perhaps the natural object which most closely approximates to a
logarithmic spiral ; but it is only an approximation ; the nautilus
is alive and, therefore, it cannot be exactly expressed by any
simple mathematical conception ; we may in the future be able
to define a given nautilus in the terms of its differences from a
given logarithmic spiral ; and it is these differences which are
one characteristic of life. It will be observed that from another
point of view Darwin had long ago stated almost the same
proposition when he showed that the origin of species and the
survival of the fittest were largely due to those differences from
type, those minute adaptations to environment, which enabled
one living creature to pass on its bodily improvements to an
improved descendant.

One link between these theories of life and growth and a
similar theory of beauty—or, if you wish, of art—is contained
in this same observation of minute variations and subtle differen-
tiations. Nothing that is simply mathematically correct can
ever exhibit either the characteristics of life or the attractiveness
of beauty. It is by the subtle variations, which express his own
characteristic personality, that the artist gives his individual

charm to everything which he creates ; and the creations of art are just as rebellious against the simple formulæ of mathematics as are the phenomena of organic life. It is for this reason that I have used the spiral formation (and especially the ϕ spiral, or Ratio of Pheidias) as a kind of key, not merely to natural phenomena, but to artistic and architectural phenomena as well, and I have therefore thought it right to add examples of art and architecture to the hundreds of specimens of natural growth which are published in these pages.

It may appear that the attempts of scientific analysts to formulate the laws of beauty follow too much the line of objective qualities. Some artists may see a champion of their view in Kant when he says that beauty has no quality in things in themselves, but that it exists only in the mind which contemplates them ; or in Mr. Arthur Balfour, when he analyses the qualities we call "sublime," "beautiful," "pathetic," "humorous," "melodious," and denies them any kind of existence apart from feeling. "Are they to be measured," he asks, "except by the emotions they produce ? Are they indeed anything but these very emotions illegitimately ' objectified ' ? . . . We cannot describe the higher beauties of beautiful objects except in terms of æsthetic feeling, and *ex vi termini* such descriptions are subjective." But it is no escape from the inevitability of Nature and her ways (which are called objective) to talk about mental operations. What happens in the mind (though the word subjective may be dragged in, as it too often is) has just as much of Nature's inexorable quality as the formation of a mountain or the rusting of iron. Both may be subject to laws—namely, to sequences of events—though we may not easily find or ever find the laws.

Stated in terms as subjective as possible, beauty is a question of "Fit to us." If the overpowering evidence of continuity is good for anything (and for some men it has given more majesty to life than any religious tenet), it gives us the hint of a transcendental "fitting" among all things. If I am pleased by a vase from King-te-Chen, qualities of me and qualities of the vase make up some fragment of a transcendental equation. This is true, too, if I dislike the vase. A man of science, seeing a phenomenon—the attraction of gravity, the bloom of a rose, the melting of metal, or even the rise of an emotion—wishes to express it. That is not spoiling it. He would have more, not less of it.

Mr. Mark Barr, to whose luminous suggestions this book has owed so much, imagines that the first man of science was he who found that Echo was no sprite. He asked for more of Echo, not less. And when he learned how much more there was than another creature's voice, he found more enthralling mystery (if that is

what is wanted), not less. It is not the hope of science to dispel real mystery. Mystery is widened every day.

Struck by the evidence of continuity and ordered causation, the man of Science may sometimes become obsessed by the idea of formulation. Reaction against that prejudice is natural enough ; but an opposite extreme is reached when men of artistic temperament resist too bitterly what they are pleased to call the " mechanistic theory." The æsthetically moved man looks with too much intolerance upon the claims of science, and his intolerance is quite intelligible, because artistic creation, no matter how arduous it be, tends to encourage lazy habits of mind. Since analyses of things as they are play a less necessary part in his work, the artist is impatient of analysis. But there is another important fact. Appreciation of art depends largely on free gifts which we all possess in some measure. Artistic creations, therefore, make an immediate appeal to the many. Music soothes even the untutored savage ; and hence the artistic worker lives in a ready-made world of admiration, and very naturally resents any disturbance of the creative atmosphere or the receptive attitude. With the young Edgar Allan Poe, he cries out to Science :—

> "Hast thou not dragged Diana from her car,
> And driven the Hamadryad from the wood
> To seek a shelter in some happier star ? "

No, would Mr. Barr reply, that has never been either the aim or the result of scientific analysis. Yet for many years, it is but too true, the formulation of beauty has been the centre of a hot-headed wrangle, due, chiefly, to the diverse use of words. And even if antagonists may agree as to the meaning of certain words, impatience and prejudice too often cloud the issue. In this book I am bold enough to take it for granted that there is a desire to agree. If so, the man of science will drive general principles less violently, while the man of æsthetic temperament will take the argument of science slowly in steps, over which intuitive people wish to bound impatiently.

For my modest purposes, standpoint is everything ; and I feel sure we can reach some guiding principles. The attempt to do so has been far from limited to the scientific analyst. Dante, Dürer, Goethe are fore-runners on the enchanted track. This same combination of the scientific study of Nature with the principles of art is the keynote of the manuscripts from which we can still strive to estimate the many-sided intellect of Leonardo da Vinci. I have reproduced a very large number of drawings from this source, because they illustrate my main theme and provide innumerable suggestions for the theory set forth in my

twentieth chapter, a theory which is not, I dare to believe, without its interest for both the professional artist and the general public. It suggests the application of the φ spiral (essentially a formula for natural growth) to the proportions of a great picture, or, if you prefer it, to the principles which underlie the instinctive " good taste " of a great artist. In " Criticism and Beauty " (1910) Mr. Arthur Balfour, speaking of the two great divisions of the emotions, said : " Of highest value in the contemplative division is the feeling of beauty ; of highest value in the active division is the feeling of love. . . . Love is governed by no abstract principles ; it obeys no universal rules. It knows no objective standard. It is obstinately recalcitrant to logic. Why should we be impatient because we can give no account of the characteristics common to all that is beautiful, when we can give no account of the characteristics common to all that is lovable ? . . . For us, here and now, it must suffice that, however clearly we may recognise the failure of critical theory to establish the ' objective ' reality of beauty, the failure finds a parallel in other regions of speculation, and that nevertheless, with or without theoretical support, admiration and love are the best and greatest possessions which we have it in our power to enjoy."

The words " *here and now* " in the above passage refer to the Romanes Lecture delivered at Oxford in 1909. But, even for " the home of lost causes," it must be too depressing to seek consolation for failure in one direction by recognising failure in another. A mercilessly logical analysis of the foundations of art criticism had produced the conviction in Mr. Balfour's mind that it was " absolutely hopeless to find a scale [in matters æsthetic] which shall represent, even in the roughest approximation, the experiences of mankind." Now I shall not, of course, attempt the arrogance of announcing that so difficult a problem has here been solved. I suggest only that it has been mitigated, and mitigated by a formula which does " represent the experiences," not of " mankind " only, but of all life as we know it, by that new conception, called the φ Progression, which explains not only the phenomena of vital growth, but also the principles which underlie both the artist's expression of the beautiful and our own appreciation of it. This Ratio of Pheidias does not, of course, provide a recipe by which any modern mathematician can produce a rival to the masterpieces of Hellenic sculpture or to the paintings of a Turner or a Botticelli. For φ is no royal road to Beauty ; nor does it in any way diminish the charm and wonder of the artist's achievement ; but it does imply that, if we realise the variations and divergences observable both in Beauty and in Life, we may discover that each

is visibly expressed to us in terms of the same fundamental principle. Art interprets that Nature of which she is herself a part ; and it is therefore only logical that the syllables of her interpretation should be recognisably an echo of the language by which they were inspired.

Those who care to pursue my subject a little further will find it possible to apply the processes I have ventured to suggest to the philosophy of human knowledge, as well as to the theories of growth and art, which are the main subject of this book ; for what we describe as a " rule " in science or a " law " in Nature, is in reality the mere expression, in shorthand, of our knowledge at the moment concerning certain phenomena which we have been able to observe. To carp at a Law because it does not explain everything, would be a grave error in outlook and understanding ; for Laws do not explain ; they describe what happens, and their description should be both helpful and suggestive. But they are the instruments of Science, not its aim. The really important thing is not the " rule " or " law " itself which merely records the investigations of the past. It is the exception ; for this brings the sudden appreciation of facts hitherto unknown, and of their relation to ourselves, which leads us to the discovery of the future, to higher worlds of life and thought than we had ever realised before.

It was, no doubt, the observation of discrepancies in Laplace's famous theory and its developments, which led Henri Poincaré to say that it could only be a special case of a more general hypothesis ; and though all astronomical arguments must at present be conditioned by the fact that the stars whose movements we have observed are only a fraction of the total even of those our telescopes and cameras reveal, yet we have discovered certain differences in their movements and related these differences to the varying ages of various stars. The new " theory of origins " suggested by Professor H. H. Turner (*Bedrock*, January, 1914) has not only explained such new and apparently disconnected facts, but has also stated the nebular hypothesis in a novel form which gives every promise of more exact progress in the future ; and it was the observation of apparent " exceptions " which enabled him to do so.

Nature has no watertight compartments. Every phenomenon affects and is affected by every other phenomenon. Any phenomenon which we choose to examine is *to us* conditioned by what we see and know. We exclude deliberately all other conditions. But Nature does not exclude them. A Nautilus growing in the Pacific is affected by every one of the million stars we see—or do not see—in the universe. But we examine it only by the

light of what we know. Leibnitz and Newton enabled us to know a great deal more than was ever imagined possible before their time. But they could not exhaust the universe. In this book I have been often obliged to use a short phrase to indicate a process that is really long and complex. One of these phrases, in the light of the considerations just developed, I must at once explain and justify. I put the case shortly by saying, " Nature abhors mathematics." What I really mean is that simple mathematics, as we have hitherto developed them, can never express the whole complex truth of natural phenomena. In other words, we must use such instruments as we have, such formulæ as are convenient, such mathematical conventions as suit our human minds, such hypotheses as Newton's, Darwin's, or another's. But Nature, *elle ne s'y mêle pas*, as the Frenchman said. She knows. We try to know. We cannot find her formula however hard we try. But we shall play the game out with her to the end, and go on trying all the time ; only so shall we get nearer and nearer every day ; for only in that stern chase is any life worth living : " *to follow after valour and understanding.*"

Spirality (if the word may be allowed) is a generalisation of far-reaching importance. The logarithmic spiral is an expression of growth. Such complex things as life and beauty cannot be expected to conform with any one simple law, and it is largely by noting approximations to spirality, to the ϕ Progression, as I suggest, or any other suitable principle, and then investigating the deviations, that " knowledge grows from more to more." Discrepancies lead to Discovery.

Just as the human organism is more complex than that of the lower organisms, just as English life in the twentieth century is more complex than that of a primitive tribe, just as organisms are more complex than inorganic objects, so the highest thought and the greatest art are more complex than primitive knowledge or early ornamentation. The more highly developed phenomena are the result of more complex forces, and are therefore the more difficult to explain.

Considerations of this kind at least afford reasons for the existence of greater and more numerous deviations from one simple law in the higher phenomena than in the lower ; they support my contention that Nature exhibits Diversity rather than Unity, and that living things and the highest forms of art cannot be expected to show conformity with any one or a few simple laws of Nature to which it is at present possble to give mathematical definition. They justify also the opinions I have expressed that deviations are one cause of beauty and one manifestation of life ; and this is why the study of exceptions is the road to progress.

I have to thank the proprietors of the *Field* for permission to make use of the articles which originally appeared in the pages of that newspaper. For the complete form of this volume, not only in the matter of correcting proofs, but also in the arrangement of the Index and Appendix, I have to thank my friend, Mr. William Schooling, who undertook this laborious task at a time when illness prevented me from attempting the difficult but inevitable work involved. A great deal has been done to improve and develope the first statement of the case.

I have included a selection from the very large number of letters and illustrations forwarded to the *Field* by numerous correspondents whiie my original series of articles was appearing in that paper. These letters have been arranged at the end of the various chapters to which they refer, and will be found to contribute a number of very interesting illustrations and comments from all parts of the world.

<div align="right">T. A. C.</div>

CHELSEA,
 March 28th, 1914

LIST OF ILLUSTRATIONS

(CLASSIFIED)

I.—ANATOMY (HUMAN)

	FIG. NO.	PAGE
Umbilical Cord, Left-hand Spiral of Human . . .	10	9
Humerus, Spiral Formation of	11	9
Ear, Laminæ of Cochlea of Internal	39	29
Thighbone, Internal Structure of Human . . .	252	222
Femur, Bone Lamellæ in	253	222
Ear, Cochlea of Human	254	223
Umbilical Cord, Spiral Arteries in	255	224
Gall Bladder, Spiral Valve in Duct of . . .	256	225
Sweat Gland, Spiral Arrangement of Duct of . .	257	225
Skin Papillæ, Spiral Pattern of	258	226
Heart, Dissection of the Apex of	260	228
Heart, Diagram of the Fœtal	262	229
Clavicle, Human. Pelvic Bone, Left . . .	264	230
Rib, Seventh on the Right Side	266	231
Anatomical Study by Leonardo da Vinci . . .	282	259

II.—ANATOMY (ANIMAL)

	FIG. NO.	PAGE
Heart, Left Ventricle of Sheep's	3	4
Spirillum Rubrum, The Bacillus	6	6
Polyzoan, Spiral Form of	7	6
Devonian Lampshell, Dorsal Valve and Arms . .	8	7
Glass-Sponge, The	9	8
Caddis-fly, Case made by Larva of	12	10
Narwhal's Tusk, Part of	186	156
Elephant's Tusk	187	156
Elephant's Tusk	188	157
Bower-bird, Nest of	210	169
Frog, Capillary or Arteriole in Web of . . .	259	227
Beaver, Heel of a	263	229
Elephant, Bones of the Left Fore Leg . . .	265	231
Feathers and Wings, Spiral Twist of . . .	267	232
Stanley's Chevrotain, Colic Helicene of . . .	268	233
Musk Ox, Colic Helicene of	269	233
Dogfish, Colon of	270	234
Shark's Egg, Capsule of	271	234
Spirochæte giganteum	272	235
Bacillus from Putrefying Flesh-infusion . . .	273	236
Ciliate Protozoa	274	237
Shark, Jaw of the Port Jackson . . .	403	452
Shark, Dental Plates of the Cochliodus . . .	404	453
Cochliodus, Section of Dental Plate of . . .	405	453
Ray Rhinobatus, Upper Dentition of the . . .	406	454

III.—ARCHITECTURE

	FIG. NO.	PAGE
Parthenon. Painted Frieze from Old	291	276
Volute from Temple of Diana at Ephesus	293	278
Volutes from the Erechtheum	294	279
Mycenæan Lamp, Marble Shaft of a	313	296
" Prentice's Pillar " at Rosslyn	314	297
Chartres Cathedral, Spiral Colonnettes in	315	298
Ferro-concrete, Spiral Staircase of	316	300
Autun Cathedral, Spiral Staircase in	317	301
Primitive Spiral Staircase	318	304
Colchester Castle, Staircase in	319	305
Westminster, Staircase in Painted Chamber	320	306
Lincoln Cathedral, Spiral Stair in	321	307
St. Wolfgang's, Rothenburg, Oak Staircase in	322	309
Fyvie Castle, The Great Staircase of	323	310
Elaborate Spiral Staircase	324	311
Tamworth Church Tower, Double Staircase in	325	313
Palazzo Contarini, Venice, Spiral Staircase.	326	317
Palazzo Contarini, Venice, Scala del Bovolo	329	320
Pisa, The Leaning Tower of	330	320
Chartres, Queen Bertha's Staircase	332	322
Blois, Staircase in the Castle of	333	323
Blois, Spiral Staircase in Château of	334	325
Blois, Balustrades of Open Staircase at	336	326
Parthenon, The	338	334
Design for Church, by Leonardo da Vinci	339	344
Design for Church, by Leonardo da Vinci	340	345
St. Paul's, Spiral Staircase from Crypt of	341	347
St. Paul's, Wren's " Geometrical Staircase " in	342	348
Blois, Inside of the Open Staircase at	343	350
Blois, Exterior of the Open Staircase at	344	352
Blois, The Open Staircase at	345	355
Blois, The Open Staircase at	346	356
French Renaissance Château, Staircase from	347	357
Sketch for Staircases, by Leonardo da Vinci	357	367
Sketch for Staircases, by Leonardo da Vinci	358	368
Design for Spiral Staircase, by Leonardo da Vinci	359	369
Clos Lucé, Door of the Château of	360	370
Amboise, drawn by Leonardo da Vinci	361	371
Sketch for a Castle, by Leonardo da Vinci	362	372
Chambord, Plan of	363	374
St. Peter's at Rome, Plan of	364	375
Dürer's Design for an Ionic Volute	373	389

IV.—ART

Rouen, Carving from Palais de Justice at	24	20
Lincoln Cathedral, Misericorde in	25	20
Allegoria. La Maldicenza, by Bellini	26	21
" Leda," Leonardo da Vinci's Study for	104	64
Scipio Africanus, Bust by Leonardo of	105	64
Japanese Design of Chrysanthemums	131	78
Minoan Temple in Crete, Marine Subjects from	197	161

	FIG. NO.	PAGE
Minoan Clay Seal, Triton Shells from	198	162
Leonardo da Vinci, Portrait of	275	240
Leonardo da Vinci, Sketch by	276	241
Arab Horse, Sketch by Leonardo da Vinci. . . .	280	247
Leonardo da Vinci, Drawing by	281	257
Horse's Head, Carved by Aurignacian Men . . .	283	268
Reindeer's Antler, Carved Fragment of	284	269
New Grange, Spirals carved on a Stone at . . .	285	272
New Grange, Neolithic Boundary Stone at. . . .	286	272
Island of Gavr'inis, Carved Stone in the . . .	287	273
Minoan Vase of Faïence from Cnossos	288	273
Bronze Celt of the Danish Palstave Type	289	274
Etruscan Vase, Two large Spirals on	290	275
Vase, Spiral Pattern on Greek	292	277
Armlet of Bronze	295	280
Violin, Head of Eighteenth Century	296	282
Gold Disc of Gaulish Workmanship	297	283
Bronze Double Spiral Brooch	298	284
Bronze Brooch showing Four Spirals	299	284
Maori War Canoe, Wooden Figurehead on . . .	300	285
Door Lintel from New Zealand	301	286
Neck Ornament from New Zealand	302	286
House Board from Borneo	303	287
Brooch worn by West Tibetan Women	304	287
Hinge from Notre Dame	305	288
Spirals in Stonework	306	289
Violin, Head of, by Mathius Albani	307	290
Violin, Front View, by Mathius Albani	308	291
Torque, Five-coiled Gold	309	292
Torque, Gaulish Bronze	310	293
Torque, Bronze	311	293
" Cavallo," Study for, by Leonardo da Vinci . . .	365	381
Francesco Sforza, Study for Statue of	366	382
" The Knight, Death, and the Devil," by Dürer . .	367	383
Dürer's Invention for Perspective Drawing . . .	368	384

V.—BOTANY

Polygonum baldschuanicum, Left-hand	13	10
Alstrœmeria, Spiral Leaves in	14	12
Apios tuberosa, Right-hand	15	13
Lilium auratum, Young Plant from above	19	15
Fern, Frond of growing	37	29
Chestnut Tree, Twisted Trunk of	43	31
Melon, Spiral Vessels of	58	37
Tecoma, Right-hand Spiral of	59	37
Honeysuckle, Left-hand Spiral of	60	37
Fern, Unrolling its Spiral	61	39
Tradescantia virginica, Portions of Leaf of . . .	92	54
Cyclamen europæum, Fruit Stalks of	124	75
Cyclamen. The Upright Spiral	121	73
Cyclamen, showing Flat Spiral (from above) . . .	122	74
Cyclamen, showing Flat Spiral (from beneath) . .	123	74
Lilium auratum, Spiral Formation of Leaves . .	128, 129	77

	FIG. NO.	PAGE
Chrysanthemum, showing Spiral folding	130	77
Araucaria, Leafy Shoot Spiral System	132	82
Stangeria, Male Cone of	133	83
Cereus, Spiral Spines in	134	84
Houseleek. Spiral Rosette	135	85
Sempervivum. Spiral Rosette	136	86
Echinocactus. Spiral Tufts or Spines	137	87
Gasteria, showing Maximum Superposition	138	88
Gasteria nigricans	139	89
Gasteria, Young Plants of, showing Torsion	140	90
Pinus austriaca (Dry Cone)	141	91
Helianthus annuus	144	98
Araucaria excelsa, Diagram of	146	101
Echeveria arachnoideum	147	102
Amaranthus (" Love Lies Bleeding ")	148	103
Rochea falcata	149	104
Echeveria agavoides	150	105
Anthurium scherzerianum	151	106
Lilium auratum, Young Plant	152	107
Pinus ponderosa	153	108
Pinus excelsa	154	108
Pinus excelsa	155	108
Pinus maritima, Two Views of Cone	156	109
Pinus maritima, Abnormal Growth of Cone	157	110
Pinus radiata, showing Unsymmetrical Form	158	111
Pinus muricata, Two Views of the Cone	159	112
Nymphæa gladstoni (Water Lily)	160	113
Lilium longiflorum	161	113
Lilium pyrenaicum	162	114
Pinus pinea	164	119
Pinus pinea	165	120
Wax Palm and Date Palm	166	121
Fuchsia	167	122
Pandanus millore from the Nicobar Islands	168	123
Pandanus utilis	169	124
Cyperus alternifolius	170	125
Helicteres ixora, Seed-pod of	171	125
Neottia spiralis (" Lady's Tresses ")	172	126
Ranunculus, Spirally-folded Petals of	173	129
Giant Vine in Madagascar	174	130
Cape Silver Tree, " Parachute " Fruit of	175	136
Pinus austriaca, Seeds from Cone of	176	137
Bignonia, " Aeroplane " Seed of	177	139
Helicodiceros, Ladder-leaves of	178	147
Begonia, Spiral Leaves of Hybrid	179	149
Beech, Twisted Stem of (Right-hand)	180	152
Chestnuts, showing Right- and Left-hand Twist	181	153
Lapageria rosea, Left-hand	211	171
Lardizabala biternata, Right-hand	212	171
Muehlenbeckia chilensis, Left-hand	213	172
Wistaria involuta, Right-hand	214	172
Bryonia dioica	215	173
Hops, Left-hand Spiral in	216	174

	FIG. NO.	PAGE
Schubertia physianthus, Right-hand	217	176
Convolvulus arvensis, Right-hand	218	176
Gourd, Spiral Tendrils of	219	177
Smilax	220	178
Passion Flower	221	179
Virginia Creeper	222	181
Vine	223	182
Ampelopsis	224	183
Black Bryony	225	184
Climbing Plant, Diagram of Movements . . .	226	185
Marsh Marigold and Wood Anemone . . .	277	242
Growth of Flowers, Study of the	348	360
Job's Tears	379	396
A Leaf from Leonardo's Note Books . . .	380	397
Sunflower, Head of Giant	386	416
Begonia (Colman)	395	436

VI.—HORNS

Marco Polo's Argali (*Ovis ammon poli*) . . .	20	16
Senegambian Eland (*Taurotragus derbianus*) . .	21	17
Greater Kudu	22	18
Alaskan Bighorn	48	34
Diagram to show Angle of Axis in Horns . .	227	190
Suleman Markhor (*Capra falconeri jerdoni*) . .	228	191
Gilgit Markhor (*Capra falconeri*) . . .	229	192
Pallas's Tur (*Capra cylindricornis*) . . .	230	193
Wild Sheep of the Gobi Desert . . .	231	193
Merino Ram	232	194
Tibetan Argali (*Ovis ammon hodgsoni*) . .	233	194
Nyala (*Tragelaphus angasi*)	234	196
Lesser Kudu	235	197
Situtunga (*Tragelaphus spekei*)	236	200
Ordinary Mouflon	237	201
Senegambian Eland (*Taurotragus derbianus*) . .	238	202
Tibetan Shawl Goat (tame)	239	203
Ancient Egyptian Drawings	240	206
Arui or Barbary Sheep (*Ammotragus lervia*) . .	241	209
Cyprian Red Sheep (*Ovis orientalis*) . . .	242	210
Bharal (*Pseudois nahura*)	243	210
Ibex or Sind Wild Goat	244	211
Asiatic Ibex (*Capra sibirica dauvergnei*) . . .	245	211
Indian Jamnapuri Goat (tame) . . .	246	212
Common Domesticated Goat . . .	247	213
Cabul Markhor (*Capra falconeri megaceros*) . .	248	214
Circassian Domesticated Goat . . .	249	215
Wallachian Sheep (*Ovis aries strepsiceros*) . .	250	216
Ram from Wei-Hai-Wei, Four-horned . .	251	217
Albanian Sheep (showing both Curve and Twist) . .	A	**219**
Albanian Sheep (*Perversion* in Twist) . . .	B	219
Ram's Horns, Study of Spirals by Leonardo . .	352	363

VII.—MATHEMATICS

Flat Spiral, Right-hand	29	25
Flat Spiral, Left-hand	30	25

	FIG. NO.	PAGE
Logarithmic Spiral	31	26
Conical Helix	49	34
Conical Helix, How to construct a	50	35
Cylindrical Helix, Construction of	54	36
Cylindrical Helix, Construction of	55	36
Cylindrical Helix, Construction of	56	36
Cylindrical Helix, Construction of	57	36
Logarithmic or Equiangular Spiral	97	58
Logarithmic Spiral, Theoretical Diagram of	145	100
Theoretical Construction of a (3 + 5) System	163	117
Conical Helix from Flat Spiral, Dürer	369	385
Spiral Crozier and " Line of the Leaf," Dürer	370	386
Dürer's " Line of the Shell "	371	387
Dürer's Plan for a Cylindrical Helix	372	388
Dürer's Logarithmic Spiral	374	390
Logarithmic Spiral with Radii	385	414
Diagram for a Regular Curve System of 5 + 8	387	418
Diagram for Eccentric Curve System of 5 + 8	388	419
Pheidias Spiral	389	421
Swastika in Phi Proportions	391	423

VIII.—SHELLS AND FORAMINIFERA

Orbiculina admea	2	4
Eocene Tertiary Foraminifer	4	5
Polystomella crispa	5	5
Siliquaria striata	16	13
Pleurotomaria conoidea	17	14
Pleurotoma elegans	18	14
Ammonite from Lyme Regis	32	27
Ammonite, Section of	33	28
Solarium perspectivum	34	28
Lamprostoma maculata	35	28
Solarium maximum	36	29
Turbinella pyrum	41	30
Harpa conoidalis	42	30
Turbo marmoratus, Operculum of	45	32
Choristes elegans (showing Operculum)	46	33
Turbo cornutus, Operculum of	47	33
Pleurotoma monterosatoi	53	36
Awl-shell (*Terebra*)	62	41
Truncatulina tenera	63	42
Rotalia calcar	64	42
Peneroplis aricetinus, Section of	65	43
Globigerina linnæana	66	43
Globigerina cretacea (Fossil)	67	43
Globigerina æquilateralis	68	44
Bulimina contraria	69	44
Pteroceras oceani	70	44
Malaptera ponti	71	44
Oyster Shell, Growth of	72	45
Telescopium telescopium	73	46
Amberleya goniata	74	46
Fulgurofusus quercollis, Protoconch of	75	46

	FIG. NO.	PAGE
Clavellofusus spiratus, Protoconch of	76	46
Cirrus nodosus	77	48
Voluta vespertilio, Dexiotropic	78	48
Fasciolaria filamentaria	79	49
Terebra maculata	80	49
Mitra papalis	81	50
Mitra papalis	82	50
Voluta bicorona	83	51
Voluta scalaris	84	51
Scalaria scalaris	85	51
Turritella lentiginosa	86	51
Auricula auris-midæ	87	51
Ceritheum giganteum	88	52
Turritella duplicata	89	52
Voluta vespertilio, Section of	90	53
Voluta musica	91	53
Turbinella pyrum	93	54
Voluta pacifica	94	55
Turbinella fusus	95	55
Nautilus pompilius, Section of	96	57
Ammonite from Lyme Regis (Fossil)	98	58
Burtoa nilotica	99	59
Vasum turbinellus	100	60
Haliotis splendens	101	61
Argonauta argo	102	62
Spirula peronii	103	63
Haplophragmium scitulum, Section of	106	65
Cornuspira foliacea	107	65
Cyclammina cancellata	108	66
Cristellaria tricarinella	109	67
Cristellaria siddalliana	110	67
Melo ethiopicus (showing Upright Spiral)	111	68
Melo ethiopicus (showing Flat Spiral)	112	68
Trophon geversianus	113	69
Acanthina imbricata	114	69
Conus tesselatus	115	70
Pyrula ficoides	116	70
Eburna spirata	117	71
Dolium maculatum	118	71
Dolium perdix	119	72
Harpa ventricosa	120	73
Voluta vespertilio	125	76
Murex saxatilis	126	76
Sycotypus canaliculatus	127	76
Coralliophila deburghiæ	142	92
Planispirina contraria, Section of	143	92
Whelk, Common Living	182	154
Whelk, *Fusus antiquus* (Red Crag) Fossil	183	154
Achatina hamillei	184	155
Lanistes ovum	185	155
Voluta vespertilio, Section of	189	158
Voluta vespertilio, Leiotropic	190	158
Neptunea antiqua	191	159

	FIG. NO.	PAGE
Neptunea contraria	192	159
Helix lapicida (from beneath)	193	160
Helix lapicida (from above)	194	160
Turbinella rapa	195	160
Voluta solandri	196	160
Shells worn by Magdalenians	199	163
Nonionina stelligera	201	164
Polystomella macella	202	164
Discorbina opercularis	203	165
Cristellaria cultrata	204	165
Cristellaria calcar	205	165
Discorbina globularis	206	165
Neritopsis compressa	207	166
Neritopsis compressa	208	166
Nautilus orbiculus	261	228
Land Snail (*Acavus phœnix*) from Ceylon .	312	294
Terebra dimidiata	327	318
Terebra consobrina	328	318
Ammonite, Study of Flat Spiral by Leonardo .	353	364
Cymbium diadema	375	391
Dolium galea	376	392
Rembrandt's Etching of the Shell . . .	377	393
Conus striatus	378	394
Gradual Increase of Spaces in a Shell . .	390	422
Trochus maximus	393	434
Trochus, Under-side of	394	435
Dolium perdix	396	437
Facelaria	397	438
Haliotis corrugata	398	440
Fusus in Eocene Rock, Fossilised Section of .	399	448
Nautilus pompilius, Section of . . .	400	449
Isocardia vulgaris, Front View of . .	407	455
Congeria subglobosa, Front View of . .	408	455
Diceras arietinum, Front View of . .	409	455
Purpura planispira, Terminal Aspect of .	410	455
Nautilus pompilius, Shell and Animal of .	411	457

MISCELLANEOUS

	FIG. NO.	PAGE
Spiral Nebula in Canes Venatici . . .	1	2
The " Unit of Direction " Illusion . . .	23	19
Flat Spiral of Watch Spring . . .	27	25
Clock-face	28	25
Sulphur, Crystals of	38	29
Prochlorite, Spiral Crystals of . . .	40	29
Ionic Volute from Shell	44	32
Common Screw	51	36
Screw with large Thread	52	36
Postage Stamp from Travancore . . .	200	163
Swastika, The Lucky	209	167
Leonardo da Vinci, Signature of . . .	278	243
Leonardo da Vinci, A Page of his Handwriting .	279	245
Wood-turning, Examples of	331	321

	FIG. NO.	PAGE
Spirals formed in Water, Study of	349	361
Spiral Eddies, Study of	350	361
Spirals formed by Smoke and Dust, Study of	351	362
Screw, Drawing of a Left-hand	354	365
Screws, Drawings of Left-hand	355	365
Twist, Drawing of a Left-hand	356	365
Nebula in Andromeda	382	410
Spiral Nebula in Ursa Major	383	411
Spiral Nebula in Cygnus	384	412
Spirals in Clouds and Water, Study of	392	429
Korean National Badge	401	451
Prehistoric Altar from Central America	402	451
Pendulum-drawings with Spiral Formations	412	459
Pendulum-drawings with Spiral Formations	413	460
Pendulum-drawings with Spiral Formations	414	460
Pendulum-drawings with Spiral Formations	415	460

PLATES

I.	Right and Left Spirals in Plants	134
II.	Right and Left Spirals in Plants	144
III.	Homonymous and Heteronymous Horns	199
IV.	Diagrams of Twists and Curves in Horns	204
V.	Diagram of the Inverted Cone	208
VI.	Symbols derived from the Nautilus Shell	450
VII.	The Laughing Cavalier, by Franz Hals	465
VIII.	Venus, by Sandro Botticelli	466
IX.	An Artist's Model	467
X.	Ulysses Deriding Polyphemus, by J. M. W. Turner	468
XI.	A Scale of Phi Proportions	469

TABLE OF CONTENTS

CHAPTER I

INTRODUCTORY—THE SPIRAL

Growth and Beauty and Spiral Formations—Letters from Sir E.
Ray Lankester and Dr. A. R. Wallace—Measurement of
Bones—Nature not mathematically exact—Gravity and
Perfect Motion: Spirals and Perfect Growth—Spirals in
Shells, Whirlwinds, Human Organs, Nebulæ, etc.—Classifica-
tion, Utility, and Antiquity of Spirals—Need of Theory

pp. 1—22

CHAPTER II

MATHEMATICAL DEFINITIONS

Spiral Appearances subjective—Flat Spirals—Left Hand and
Right Hand—Conical and Cylindrical—Ionic Volute drawn
by means of a Shell—Ways of making Spirals—Curious
Nomenclature used by Botanists *pp.* 23—40

CHAPTER III

UPRIGHT SPIRALS IN SHELLS

Formation of Spirals in Shells—Tube coiled round Axis—Life
History of a Series in One Shell—Acceleration and Retarda-
tion—Natural Selection—Adjustment to Environment—
Survival and Spiral Variation—Right-hand and Left-hand
Shells—Ammonite and Nautilus—External and Internal
Spirals—Supporting the Central Column—Comparison with
Insects and Plants—Multiple Spirals . . . *pp.* 41—56

CHAPTER IV

FLAT SPIRALS IN SHELLS

Nautilus and Logarithmic Spiral—Equiangular Spiral a Manifesta-
tion of Energy—Deviation from Curve of Perfect Growth—
Leonardo da Vinci as Student of Shells—Work of Professor
Goodsir—Varying Inversely as the Cube and the Square—
Significance of the Position of the Siphuncle—Vertical and
Horizontal Views of Shells and Plants . . . *pp.* 57—80

CHAPTER V

BOTANY—THE MEANING OF SPIRAL LEAF ARRANGEMENTS

Provision for Air and Sunlight—Overlapping of Old Leaves by
Young—Advantages of Overlapping in Intense Glare—Spiral
Plan for Minimum Overlap—The Ideal Angle—Fibonacci
Series—Mr. A. H. Church on Logarithmic Spirals in
Phyllotaxis *pp.* 81—93

CHAPTER VI

SPECIAL PHENOMENA IN CONNECTION WITH SPIRAL PHYLLOTAXIS

The Spiral Theory of Schimper—Growing Systems in place of
Adult Construction—A Logarithmic Spiral on a Plane
Surface—The Fibonacci Series again—Radial Growth and
Spiral Patterns—A Standard for Comparison—Examples of
Different Systems *pp.* 94—114

CHAPTER VII

RIGHT-HAND AND LEFT-HAND SPIRAL GROWTH EFFECTS IN PLANTS

Twist Effects : (i.) Spiral Leaf Arrangements ; (ii.) Overlapping
Effects ; (iii.) Unequal Growth in Main Axis ; (iv.) Spiral
Movement of Growing Ends ; (v.) Spiral Growth of Twining
Plants ; (vi.) Spiral Effects after Death—Nomenclature of
Spirals—Numerical Proportions of Right and Left Hand
pp. 115—131

CHAPTER VIII

RIGHT-HAND AND LEFT-HAND SPIRAL GROWTH EFFECTS IN PLANTS
(*continued*)
DEAD TISSUES AND SPINNING SEEDS

Spiral Twisting of Dead Tissues—Coiling when Drying : Straighten-
ing when Wet—Predominance of Right-hand Fibres—Seed
Spinning in Flight—The Mechanism of Winged Fruits
pp. 132—141

CHAPTER IX

RIGHT-HAND AND LEFT-HAND SPIRAL GROWTH EFFECTS IN PLANTS
(*continued*)
SOME SPECIAL CASES

Anomalous Variation producing Spirals—" Spiral Staircase " Con-
struction—Peculiarities of Spiral Spermatozoids—Male Cells
of Cycads and Chinese Maidenhair Tree—Spirals and Loco-
motion—Prevalence of Right-hand and Left-hand Spirals
pp. 142—150

CHAPTER X

RIGHT-HAND AND LEFT-HAND SPIRALS IN SHELLS

Contrast of Trees with Shells—Spiral Fossils in Nebraska—Deter-
mination of Hand in Shells—Different Hand in Fossils and
Survivors of same Species—Left-hand Spirals of Tusks—
Sinistral Shell, but Dextral Animal—Shells among Primitive
Peoples—Following the Sun—The Swastika—Spiral Forma-
tion and the Principle of Life *pp.* 151—169

CHAPTER XI

CLIMBING PLANTS

The Purpose of Climbing—With and Without Tendrils—Hand
and Species—Mr. G. A. B. Dewar on Climbers—" Feeling "
for Supports—Inheritance and Memory—Circumnutating—
" Sense Organs " for Gravity and Light—The Statolith Theory
—Influence of Light and Moisture—Effects of Climate—
Reversal of Spirals *pp.* 170—189

CHAPTER XII
THE SPIRALS OF HORNS

Pairs of Horns—Odd-toed and Even-toed Hoofed Animals—The Angle of the Axis in Horns—Suggested Geometrical Classification—Distinctions between Horns of Wild Animals and Tame —Homonymous Horns—" Perversion " and Heteronymous Horns—Comparison with other Spiral Growths, as of Plants and Shells—Exceptions to Dr.Wherry's Rule—Tame Animals showing Twists of their Wild Ancestors—Development or Degeneration?—The Problem stated . . . *pp.* 190—219

CHAPTER XIII
SPIRAL FORMATIONS IN THE HUMAN BODY

Natural Objects do not consciously produce Spirals—Deviation from Mechanical Accuracy—Spiral Formations of Upper End of Thigh Bone—Growth and Change—Corresponding Structures in Birds and Mammals—Conical Spiral of Cochlea— Spiral Formations : Umbilical Cord, Skin, Muscular Fibres of Heart, Tendo Achillis, The Humerus (Torsion), Ribs, Joints, Wings and Feathers, Eggs, Animalculæ . . *pp.* 220—238

CHAPTER XIV
RIGHT AND LEFT-HANDED MEN

Right and Left-handedness—Legs and Arms of Babies—Leonardo da Vinci—Preference of Orientals for Left-hand Spirals— Prehistoric Man generally Right-handed—Skill of Left-handed Men : Examples from the Bible—The Hand of Torques— The Rule of the Road—Left-handed Sportsmen : Anglers, Archers, etc.—Left-handed Artists—More about Leonardo— Letter from Mr. A. E. Crawley *pp.* 239—265

CHAPTER XV
ARTIFICIAL AND CONVENTIONAL SPIRALS

Spiral Decoration in Prehistoric Times—The Successive Races of Man—Artistic Skill of Aurignacians—Magdalenian Civilisation—The Spiral as a Link between Aurignacians and Greeks —The Mycenæan and Minoan Age—Late Neolithic Ornamentation—Distribution of Spirals in United Kingdom—Scandinavia and Ireland—Egyptian Spiral in Danish Celts—Neolithic Stones and Etruscan Vases—The Sacred Lotus—The " Unlucky " Swastika—Spirals in Greek Art—Origin of the Volute—Theory and Experiment—The Iron Age—Uncivilised Communities of the Present Day—Mediæval Gothic —Violin Heads—Cylindrical Spirals : Torques, Armlets, " Collars " *pp.* 266—295

CHAPTER XVI
THE DEVELOPMENT OF THE SPIRAL STAIRCASE

Spiral Columns—Rarity of Left-hand Spirals—Right-handed Architects and Workmen—Accidental Cause of a Twisted

Spire—Efficiency and Beauty—Practical Origin of Spiral
Staircases—Gradual Evolution—Central Support—The Hand
Rail—Defence against Attack—Double Spiral Staircases
pp. 296—314

CHAPTER XVII
SPIRALS IN NATURE AND ART

Shells and Spiral Staircases—Practical Problems and Beauty of
Design—Efficiency and Beauty—Leaning Campaniles Inten-
tionally Designed—Charm of Irregularity—The Parthenon—
Architecture and Life—Quality of Variation in Greek Archi-
tecture—Expression of Emotions—Artistic Selection from
Nature *pp.* 315—340

CHAPTER XVIII
THE OPEN STAIRCASE OF BLOIS

The Staircase designed by Leonardo da Vinci—Voluta Vesper-
tilio—The King's Architect—A Left-handed Man—Work of
Italians in France—Leonardo's Manuscripts—His Theories
of Art *pp.* 341—379

CHAPTER XIX
SOME PRINCIPLES OF GROWTH AND BEAUTY

Dürer and the "Cavallo"—Dürer's Mathematical Studies—
Dante, Leonardo, Goethe—The Experimental Method—
Beauty is "Fitness Expressed"—The Value of Delicate
Variations — "Good Taste" — Processes of Scientific
Thought *pp.* 380—406

CHAPTER XX
FINAL RESULTS

The Logarithmic Spiral as an Abstract Conception of Perfect
Growth—Spiral Nebulæ—Dr. Johnstone Stoney's Spiral of
the Elements—Infinite Series and the Rhythmic Beat—
Phyllotaxis—The Ratio of Pheidias—The ϕ Spiral—Space
Proportion— Art and Anatomy—The Theory of Exceptions—
Value of a "Law"—Complexities of the Higher Organism—
"A Flame to Curiosity"—The Methods of Science . *pp.* 407—432

APPENDIX

I. Nature and Mathematics (*illustrated*) . . . *p.* 433

II. The ϕ Progression. By William Schooling . . *p.* 441

III. Infinite Series and the Theory of Grouping . . *p.* 447

IV. Origins of a Symbol (*illustrated*) *p.* 448

V. The Spiral in Pavement-toothed Sharks and Rays
(*illustrated*). By R. Lydekker . . . *p.* 452

VI. The Spiral in Bivalve Shells (*illustrated*). By R. Lydekker
p. 454

VII. The Shell of Travancore *p.* 456

VIII. The Growth of Shells (*illustrated*) . . . *p.* 457

IX. The ϕ Progression in Art and Anatomy (*illustrated*) *p.* 461

THE CURVES OF
LIFE

CHAPTER I

Introductory—The Spiral

"Painting embraces within itself all the forms of Nature . . . you cannot be a good master unless you have a universal power of representing by your art all the varieties of the forms in Nature. . . . Do you not see how many and how varied are the actions performed by men alone—how many kinds of animals there are, of trees and plants and flowers—how many kinds of springs, rivers, buildings and cities, of instruments fitted for man's use, of costumes, ornaments, and arts ? All these things should be rendered with equal facility and grace by anyone deserving the name of a good painter."—LEONARDO DA VINCI (*Bibl. Nat. MSS.*).

GROWTH AND BEAUTY AND SPIRAL FORMATIONS—LETTERS FROM SIR E. RAY LANKESTER AND DR. A. R. WALLACE—MEASUREMENT OF BONES—NATURE NOT MATHEMATICALLY EXACT—GRAVITY AND PERFECT MOTION : SPIRALS AND PERFECT GROWTH—SPIRALS IN SHELLS, WHIRLWINDS, HUMAN ORGANS, NEBULÆ, ETC.—CLASSIFICATION, UTILITY, AND ANTIQUITY OF SPIRALS—NEED OF THEORY.

THE reason for connecting my search for certain principles of growth and beauty with an inquiry into various examples of spiral formation which may be found in art or Nature, can only become clear to my readers at a later stage. That connection arose in my own mind chiefly owing to the lucky accident of meeting a biologist whose vivid imagination recalled the columella of a shell when he was shown the central column of a staircase. His enthusiasm inspired me to study various natural objects with a delight that has been increasing for the last twenty years ; and for the existence of these chapters upon spiral formations no other apology is needed than the interest and beauty of an investigation which has hitherto only been suggested in a few scattered pamphlets and disconnected references. But an excuse should certainly be forthcoming for the fact that the pages dealing with natural history (which are the majority of those appearing in this book) have been prepared for publication by one whose knowledge ot botany and biology was originally as slight as his

skill in mathematics or his erudition in the development of art. A thorough grasp of at least four or more divisions of science seemed indispensable ; yet, since a profound acquaintance with only two of them would be of no avail, I have ventured, perhaps too boldly, to believe that to have specialised in none, and to have the keenest sympathy with each, is as good a qualification as may be attained for the moment. I have the further consolation that every specialist will delightedly correct those errors which occur in ground familiar to him, while he may perhaps be tempted —by their mere proximity—to consider questions which hitherto he has too often set aside as being beyond his special province. This, therefore, is one reason why, in later pages, I shall venture

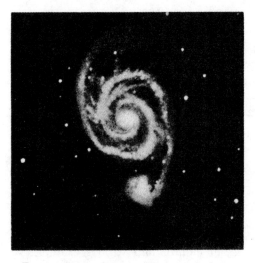

on the hope that the artist or the architect will consider the biologist in a kindlier light, and that the mathematician and the botanist may lie down together. When Captain Scott was in winter quarters near the South Pole, he overheard a biologist of his party offering their geologist a pair of socks for a little sound instruction in geology. So fruitful an attitude of mind need not be limited to the Antarctic region.

FIG. I.—SPIRAL NEBULA, MESSIER 51, CANES VENATICI.

Though I must mention two of the most distinguished helpers who have permitted me to publish their general opinions, I do not give the names of many who have offered me the kindest and most generous assistance in detail during the twenty years or so in which these matters have occupied a large part of my leisure. All of them are conscious of my gratitude. None of them might wish to be held even remotely responsible for suggestions that are unfettered by too keen an appreciation of the technical difficulties involved. When he was aware of my efforts, Sir E. Ray Lankester wrote as follows :—

" I have often thought that if the public knew more of the real beauties of nature our museums would be far more thronged with visitors than is

the case at present. Every effort is made in many of them to display the various specimens to their best advantage, and to explain clearly what they are. But something more is often needed, and the man who knows most about these matters is not always the man who has time to write about them. Moreover, the writings of the specialist are too often necessarily expressed in language that is fully intelligible only to a few. Yet if the energetic worker in other fields will pause a while to consider what he can learn from biology or botany, he will, I think, be rewarded far beyond his expectations. . . .

" . . . I know many of the steps you have taken to arrive at your conclusions, and I think your analysis of the growth of horns (for instance) and your investigation of the growth of plaits upon the columella of a shell might be distinctly useful to the biologist, apart from any connection in which they may be found in your pages.

" The hope that mathematicians may in time produce a system of definitions that will be of use, both to the biological and to the artistic morphologist, is by no means new. But every fresh instance that tends to make it more probable must contribute to the advantage alike of science and of art."

After this, I was still more encouraged to proceed with this publication by receiving, in January, 1912, the following letter from the late Alfred Russell Wallace, which was published during that year with his permission :—

" I was very much interested in your work on ' Spirals ' in Nature, as it is one of the finest illustrations of that extreme ' diversity ' in every part of the material universe from suns and planets to every detail of our earth's surface, and every detail of structure in plants and animals, culminating in an equal diversity in the mental character, as well as the physical structure of man. This final result, as I have suggested in my latest book, ' The World of Life,' is the whole purpose of the material universe, inasmuch as it leads to the development of an infinite diversity of ever-living and progressing spiritual beings. This diversity has been brought about through what we term the ' laws of Nature'—really the ' forces ' of Nature—acting on matter, which itself seems to be an aggregation of more refined forces, acting and reacting for the most part in what appear to be fixed and determinate ways. We are now learning that these forces themselves are never identical, and never act in an identical manner. The atoms, once thought to be absolutely identical, absolutely incompressible, etc. are now perceived to be each a vast complex of forces, probably no two identical. So, the chemical atoms, long thought to be fixed, of definite atomic weights, and combining in definite proportions, are now found to be in all probability diverse, and their atomic weights not commensurable with each other.

" This atomic and sub-atomic diversity is, I believe, the cause, or rather the basic condition of the exquisite forms in Nature, never producing straight lines but an endless variety of curves, and spirals. Absolute uniformity of atoms and of forces would probably have led to the production of straight lines, true circles, or other closed curves. Inequality starts

curves, and when growth is diverted from the direct path it almost neces-
sarily leads to the production of that most beautiful of curves—the spiral.
" *Yours truly,*
" ALFRED R. WALLACE."

I was irresistibly reminded, by this letter, of the last sentence
in " The Origin of Species." " There is grandeur," wrote Mr.
Wallace's great contemporary, " in this view of life, with its
several powers, having been originally breathed by the Creator
into a few forms or into one ; and that, while this planet has
gone cycling on according to the fixed law of gravity, from
so simple a beginning endless forms most beautiful and most
wonderful have been and are being evolved."
It is as a line to a guide our researches among these " endless
forms most beautiful " that I have here chosen the spiral because

FIG. 2.—ORBICULINA ADMEA
(UNGULATUS STAGE) × 30.
(Brady's Foraminifera.
Challenger Reports.)

FIG. 3.—LEFT VENTRICLE OF
SHEEP'S HEART.
(Pettigrew.)

it is prominently connected with so many of them. I do not ask
you to believe that the occurrence of similar curvilinear formations
in various organic and inorganic phenomena is a proof of
" conscious design." I only suggest that it indicates a community
of process imposed by the operation of universal laws. I am,
in fact, not so much concerned with origins or reasons as with
relations or resemblances. It is still more important not to see
in any given natural object that spiral formation which may
merely be a useful convention of the mind. The science of
mathematics has been defined as " the great instrument of exact
statement and mental manipulation," and when it is combined
with the extraordinary power of visual imagination possessed
by such men as Kelvin, Clark Maxwell, Rayleigh, or J. J.
Thomson, we see to what astounding results it may lead the
human intellect. But we must not imagine that " Nature "
is ever " mathematical " or that any natural object " knows what
a spiral means." Yet the neglect of mathematics by the average

biologist is sometimes embarrassing. When I tried to compare the bones of Persimmon with those of his direct ancestor, Eclipse, I found that the world of science had not decided how bones should be measured. They have not decided yet. It was only in 1898 that the first scientific description of the curves of horns was attempted by Dr. Wherry. In several departments of the present inquiry my chief justification for its existence lies in the fact that no answer yet exists to many of the questions obviously involved.

At the end of the fifteenth century, Leonardo da Vinci summed up the knowledge possible to his day in a sentence which has caused a great deal of controversy ever since it was discovered among his long-lost manuscripts. " In this," he wrote, " the eye surpasses Nature, inasmuch as the works of Nature are finite, while the things which can be accomplished by the handiwork,

FIG. 4.—SECTION OF AN EOCENE TERTIARY FORAMINIFER. *Nummulina nummularis.* (Nicholson.)

FIG. 5.—POLYSTOMELLA CRISPA. One of the microscopic Foraminifera figured in Nicholson's *Palæontology.*

at the command of the eye, are infinite." In modern language we might express this by saying that the fact that the logarithmic spiral (for instance) can never be reached in Nature is due to the truth that Nature is finite while the logarithmic spiral is infinite and goes on for ever, as no living organism does. But it is possible to bring the two together mathematically, and so closely, that small variations in the daily growth of an organism would be enough to account for any further discrepancies. For instance, in order to approximate to a finite organism, any infinite curves of growth must be slowed down, and we may thus obtain a retardation spiral by a method something like that applied to Newton's Second Law of Motion. Hyatt and Cope have dis⸗ covered the law of acceleration in the development of such shells as *Fusus,* and Cope has announced the complementary law of retardation. Canon Moseley, making a geometrical examination of certain turbine shells, found that the curve wound round their central axis was logarithmic, and from it he framed a series of

formulæ by which other conditions could be predicted as they were found to exist. In the same way our retardation spiral can be adapted to suit different rates of slowing down as the organism grows older, and slower, till it dies. Conversely, acceleration might be noticeable when the organism was young. But never would the organism exhibit mathematical uniformity, and its growth would not be necessarily centric, indeed, nearly invariably eccentric.

Just as Newton began by postulating Perfect Motion, and thence explained the working of the solar system, so it may be possible to postulate Perfect Growth (by means of a logarithmic spiral) and thence arrive at some law ruling the forms of

FIG. 6.—SPIRILLUM RUBRUM, MAGNIFIED 1,000 DIAMETERS.
(From Kolle and Wassermann, Handbuch der Pathogenen Mikroorganismen, Atlas.)

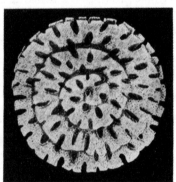

FIG. 7.—SPIRAL FORM OF POLYZOAN. FLUSTRA CRIBRIFORMIS.
(Torres Straits.)

organic objects as gravitation is held to prevail in the physical world. Is the logarithmic spiral the manifestation of the law which is at work in the increase of organic bodies? If so, it may be significant that Newton showed in his *Principia*, that if attraction had generally varied as the inverse cube instead of as the inverse square of the distance, the heavenly bodies would not have revolved in ellipses but would have rushed off into space in logarithmic spirals. Professor Goodsir therefore asked, if the law of the square is the law of attraction, is the law of the cube (that is, of the cell) the law of production? Can we connect this with Goethe's idea that while the straight line was masculine, the spiral was feminine in its essence? As Dr. Wherry has pointed out, many of the problems of spiral growth are deep and difficult. They touch upon the funda-

mental laws which regulate the world, and instinctively direct the art of man.

As an introduction to our search I have selected a few typical instances of the many spiral formations to be found in Nature, from the microscopic foraminifer (Figs. 2, 4, 5), and the even smaller bacilli (Fig. 6) to the enormous nebulæ (Fig. 1) in the firmaments of space. The usual rotation of air currents in our northern hemisphere is from left to right hand, while that in the southern is from right to left. This fact has been offered as an explanation of many phenomena which have not been sufficiently examined ; but it may well be that hurricanes, tornadoes, and whirlwinds are produced by the sudden meeting of strong air currents originally moving in opposite directions. The effect of wind on sand is often to produce the whirling spirals usually seen in sandstorms, which are occasionally reproduced on a small scale even on a dusty road in this country. The waterspout is a more complex instance of the same force, and has been explained as the meeting of a rotating and inverted cone of cloud with a similar but upright cone of water, the two cones having originally started under the same influence of the wind blowing at different levels, and eventually exerting a mutual attraction upon each other. They thus meet at the apex of each cone to form a rapidly rotating column composed of water from beneath, mixed with vapour from above.

FIG. 8.—DORSAL VALVE AND "ARMS" OF DEVONIAN LAMP-SHELL UNCITES GRYPHUS. (Davidson.)

Some of the smaller kinds of spirals observable in crystals will be given in due course. But it is important, even at this early stage of our inquiry, to remember that the spiral (whether flat or upright) is not necessarily connected with vitality, yet it may be perfectly true that when a spiral formation is observable in organic subjects, it may express in them the same results of stress or energy which are observable in such lifeless or inorganic forms as the starry nebulæ, the waterspout, or certain forms of crystals. It may also be noted in this connection that the relation of the direction of the magnetic force, due to an electric current, to the direction of that current itself is the relation involved in a right-hand spiral.

It is, however, mainly with the organic forms of life in animals and plants that I am dealing here ; and when we once begin, in these great divisions of the universe, to look for spirals, it will, I think, be astonishing to find the enormous number and

variety of such formations which can be discovered. In plants, spirals are observable from seeds and seed cases and cells, to stems and flowers, and fruit. In animals, and in man, the spiral may be said to follow the whole course of vital development from the spermatozoön to the muscular structure of the heart ; from the umbilical cord or the cochlea of the ear to the form and framework of the great bones of the body (Figs. 10 and 11). It may be noted that the spiral of the cochlea hidden in the ear is one of the proofs that the bone containing it belongs to a mammal. Hermann von Meyer once accidentally dropped a skull which had previously been considered to be that of a lizard. The breakage revealed the cochlea, proving that the bones were those of a mammal, which was christened *Zeuglodon*.

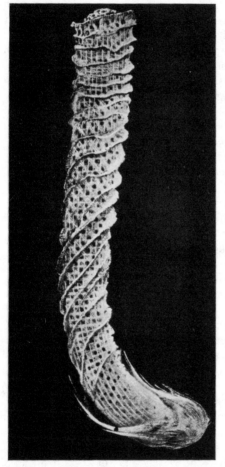

FIG. 9.—THE GLASS-SPONGE (EUPLECTELLA ASPERGILLUM), OR VENUS'S FLOWER BASKET.

Three examples of extraordinarily minute animal life exhibiting a spiral have been drawn in Figs. 4, 5, 6. In the magnificent illustrations of Dr. F. Ritter v. Stein's " Der Organismus der Infusionsthiere " (Leipzig, 1867), a large number of others may be examined, such as *Spirostomum ambiguum*, *Stentor cœruleus*, *Euglena spirogyra*, and many more. The cilia on the top of *Vorticella* are set in a spiral to create a vortex of water that will suck in food. The gills of *Sabella unispira* no doubt produce the same result, and have been beautifully drawn in the atlas to " Le Règne Animal," by G. Cuvier. The egg capsules of certain sharks (*e.g., Cestracion philippi*) show a very beautiful external spiral ; and the case

made by the larvæ of the caddis fly (*Phryganeida*) is formed by a ribbon exquisitely twisted up into a right-hand spiral (Fig. 12).

The whole phenomena of animal locomotion are largely based (as the late Professor Pettigrew so learnedly showed) upon spiral movements, and the same lamented investigator (in the posthumous volumes called "Design in Nature,") has left a series of drawings and observations demonstrating that a bird's wing is twisted on itself structurally and is a screw functionally. He showed that the propeller of a steamship exhibits the same functions as the fin of a fish, the wing of a bird, or the limbs of a quadruped ; and that in the whole range of animal locomotion these functions are most exquisitely displayed in flight. To

FIG. 10.—LEFT-HAND
SPIRAL OF HUMAN
UMBILICAL CORD.
(Pettigrew.)

FIG. 11.—SPIRAL FOR-
MATION OF THE
HUMERUS.
(Pettigrew.)

suggestions in this author's works I owe several of the examples of spirals which have been specially drawn for these pages.

In the interesting book called "The Growth of a Planet," by Mr. Edwin Sharpe Grew, a very convincing explanation of spiral nebulæ is given, which is intelligible to the ordinary layman apart from the technical astronomer. Mr. Grew writes as follows :—

"The discovery of spiral nebulæ was originally made by Lord Rosse. . . . The shape of some nebulæ seems to demand the hypothesis that there was a partial collision between two stars. The heat arising from the impact, or from what in mechanics is called 'arrested momentum,' taken together with the mutual attraction of the two stars, would impart a rotary movement of the highest order to the two systems. In some instances the consequences might be the fusion of the two stars into one giant nebula. Or if there were a partial arrest of the forward motion of one or other, then certain parts of

either star might escape from the main spiral. Such a catastrophe is possibly visible in the nebula in Canes Venatici."

It is this nebula which is reproduced in this chapter (Fig. 1) as an example of the formations described. (Compare Chapter XX.).

There is another theory which is worth transcribing here from the same instructive volume :—

"Sir Robert Ball's variant of the spiral hypothesis sets out by laying down the proposition that a sphere of moving particles has a tendency to spread itself out as a disc. He deduces this from the fact that in any system of moving forces the sum total of the results of the

FIG. 12. — CASE
MADE BY LARVA
OF CADDIS-FLY.
(Enlarged.)

FIG. 13. — LEFT-HAND
POLYGONUM BALDSCHUA-
NICUM. (BOKHARA.)

interactions of the forces (or what is called the ' moment of momentum') will always remain the same ; but that the ' energy ' of the system diminishes with each collision of its particles. The particles after collision would drift towards the centre, and the system tends to that form which combines a minimum of energy with the preservation of its original momentum (or shall we say ' life force ' ?). This form can be shown to be a flat disc widely stretched out." [*This of course would only hold good if the particles were not small enough to be influenced by light pressure to a greater extent than by gravity.*—T. A. C.] " The drift of particles towards the disc's central portion would cause this part to rotate more rapidly than the outer part. Spiral structure would be the result of these differentiated movements. By some process, of which we cannot trace the details, knots or nuclei appeared on the whorls of the spirals, and these formed the embryos of the planets."

In 1904 Professor J. M. Schaeberle announced his discovery of a double spiral structure in the great cluster in Hercules, the more pronounced spiral, formed by outgoing matter, being clockwise (or, as I should say, left hand) the other being counter-clockwise and containing returning matter. There is little doubt that spirality is becoming more and more widely recognised as one of the great cosmic laws, and as being distantly hinted at even by the antipodal disturbances of the sun. This has implied the further recognition that in astronomy, as in every other branch of science, one set of facts dovetails into the next ; none can be properly considered apart from the rest. Though the old imposing façade of exact theory remains erect, as Miss Agnes Clerke happily put it, the building behind is rapidly disintegrating as more and more possibilities come to light in the advancement of our knowledge. In nearly all the apparently fantastic irregularities of the visible nebulæ we observe that spiral conformation which intimates the action of known or discoverable laws in the stupendous enigma of sidereal relationships. The whole history of the heavens, the more clearly it becomes understood, involves more certainly the laws of spirality, from single and comparatively small examples to such vast masses of nebulosity as that which encompasses the Pleiades.

The first eight of the figures illustrating this chapter are all examples of plane or conical spirals. The remainder are more or less cylindrical in form, and I would now direct attention more especially to the leaves in Fig. 14, which are so exactly like a screw-propeller, or the feather of a bird's wing in flight, and then to the climbing plants, from Bokhara and North America, shown in Figs. 13 and 15. I do so because these latter give me another opportunity of showing how much recent inventions have contributed to our knowledge of these things. If the high capacities of modern telescopes have revealed the spiral nebulæ, it is not too much to say that the kinematoscope (with or without the assistance of the microscope) has very notably advanced our appreciation both of the smaller living organisms and of the growth of flowers and plants.

Mrs. Dukinfield H. Scott suggested the use of a kinematograph for showing, at an accelerated speed, those movements (of climbing plants, for instance) which are, in nature, too slow to be clearly appreciated by the most constantly watchful human eye. This is a very interesting development of a mechanism which usually enables us to see those movements (of a galloping horse, for example) which are, in Nature, too quick to be seen by the human eye. The mechanism analyses these

speedy movements in a way which enables us, when we wish, to examine separately one single photograph (out of a long series) which reveals to us a position we may never have realised as actually occurring or even possible ; and a very educational use of such photographs (in rowing or boxing, for instance) might be developed. But Mrs. Dukinfield Scott's suggestion that the process might be reversed has only just, I understand, been practically demonstrated since she first wrote about it in 1904, and you may now see a plant visibly moving, by concentrating into a few minutes a series of photographs which have taken many hours to record from the natural growth. Mrs. Dukinfield

Scott in 1904 produced a simple and cheap machine which registered 350 photographs round a disc 12 inches in diameter, which enabled her in the case of very slowly-moving plants to make a separate exposure every fifteen minutes. She also surmounted the mechanical difficulties of uniform exposure and absolute steadiness, and eventually continued her photographs at night by artificial light.

Fig. 14.—Radiating Whorl of Spiral Leaves in Alstrœmeria.
(Pettigrew.)

Recent developments have solved a good many of the inevitable mechanical problems ; and it has even become possible for the scientific inquirer to carry out his own researches by the new method of photography and to reproduce the results on a screen in his own study. The kinematograph for ordinary field work takes sixteen pictures a second. A high-speed micro-kinematograph camera in France registers 300 pictures a second taken by electric sparks. The reverse process implies a proportionate reduction in speed. Taking sixteen a second, or 960 pictures a minute, as the normal, if we desire to watch the rapid development of a natural growth which, in reality, takes three days, we must spread our 960 pictures equally over the 4,320 minutes of those three days ; in other words, we must take an instantaneous photograph every four

and a half minutes for seventy-two hours successively. By running the film containing these 960 pictures, so taken, through the machine, at the rate of sixteen in every second, we can see the growth of three days as a visible movement of a minute's duration. The whole process should be as valuable to the investigation of spiral growth in botany as is the visible examination of microscopic bacteria upon a screen in other branches of science.

In Figs. 16, 17, 18, will be found three examples of the shells which are among at once the most beautiful and the most easily

FIG. 15. — RIGHT - HAND APIOS TUBEROSA. (N. AMERICA.)

FIG. 16. — SILIQUARIA STRIATA. (Bronn and Simroth.)

examined instances of spirality in organic life. We shall hear more of the wonders of their internal structure later on. Until about 1908 the conchologist who desired to inspect the structure of the columella had to make a section by either sawing through or rubbing down what might be a valuable and beautiful specimen; and sometimes the shell itself was too delicate to admit of such an operation being satisfactory at all. But in that year Mr. George H. Rodman published a number of pictures of molluscal shells in which the use of the X-rays made it possible to show the internal structure without hurting the specimen at all; and these pictures have proved of great interest and value, though

the uninstructed student would need warning that, in the cases mentioned, the pictures printed showed the shells reversed.

I must leave to more scientific pens than mine the task—which I foresee as necessary—of classifying spirals. The broad division into those of inorganic and those of organic origin will at once be obvious ; but it is with the sub-division of the latter that the difficulty really arises. The late James Hinton thought that " growth under resistance is the chief cause of the spiral form assumed by living things." But this generalisation does not cover many of the most remarkable instances. A spiral may exist merely to save space, or to place an organ which has to be long into a situation necessarily restricted. The long intestine of the frog, for instance, is twisted up like a tight watchspring in the tadpole. In most mammals a very considerable length of

FIG. 17.—PLEUROTOMARIA
CONOIDEA.
(Bronn and Simroth.)

FIG. 18.—PLEUROTOMA (AN-
CYTROSYRINX) ELEGANS.
(Bronn and Simroth.)

intestinal tube is folded in spiral coils within the body. In some fishes, like sharks and rays, the tube is provided with an internal spiral, apparently so that every possible nourishment may be extracted from the food while it remains within the animal. Certain sharks also exhibit another use of the spiral in their curiously constructed egg-cases, which would revolve as they floated in the water and therefore travel farther, and the form in *Cestracion philippi* is almost exactly like that of a kind of anchor used for burrowing its way into soft mud or sand and there holding fast. It is shown in Fig. 271 on p. 234.

One of the most extraordinary instances of what I may call the " locomotory " spiral is to be found in the plant called Storksbill (*Erodium*), which is so named from the long " beak " formed in each flower as the seeds ripen. This is described in greater detail later on, but I may say here that this beak

is composed of the long tails (or "awns") sticking out of the top of the seeds, which are also furnished with reflexed bristles. When the seeds ripen they are freed as the awns split off the beak, and each awn begins to show hygroscopic properties of a very marked character. Laid upon water, the awn straightens out into a thin tentacle very slightly curved. When dry, it constricts into a close spiral which is like a cork-screw close to the seed and has a kind of curved arm (the free end of the awn) at the other extremity which must exert a considerable leverage in twisting. As the spiral coils and uncoils according to the presence or absence of moisture in the atmosphere, the seed moves along the ground until its sharp point penetrates a soft bit of earth and bores downwards, the reflexed bristles preventing its retreat. A very similar process is observable in the Russian Feather-grass, which has a much longer awn with an extended feathery tail. This seed penetrates the ground in much the same way already described, and will even get through a sheep's skin, and sometimes cause sufficient irritation to kill the animal, as its remorseless spiral gradually burrows inwards.

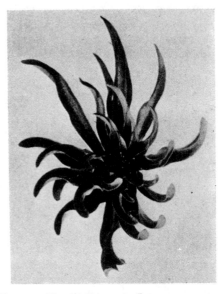

FIG. 19.—YOUNG PLANT OF LILIUM AURATUM

Photographed vertically from above to show spiral growth of the plant and spiral twist in the leaves.

Other seeds show even more delicately beautiful forms of the spiral. The spherical antherozoid of *Cycas revoluta*, for instance, carries a spiral band of minute vibratile hairs (cilia) by which it is propelled. The seeds of certain pines and other trees are provided with wings constructed almost exactly like the leaves drawn in Fig. 13 or the feathers of a bird's wing, and working like a screw-propeller to distribute the life principle of the plant as far as possible through the surrounding air before it falls.

The propelling force given by a screw or spiral is utilised by Nature in a hundred ways. The heart of a man and most other mammals has the formation shown in Fig. 3 for this reason. The

muscular arrangement of the stomach and bladder is very similar ; and their contents are extruded just as the blood is driven from the heart at each alternate beat. There is the combination of protection with economy of space in the cochlea of the internal ear. There is the idea of protection from the results of a fall by the springy resistance of the coiled horns of certain mountain sheep. Some illustrations of horns are given here, but this subject is dealt with more fully in a later chapter. Then there are the spirals produced when some soft, elastic substance, driven forward by its own vital energy, is unable to proceed in a direct line, either because of some slight initial obstacle at the point of emission, or because of the action of such forces as gravity after emission. Recent research also goes to show that the traces of stress on the structure of steel may be found along paths which exhibit spiral formation. In the botanical chapters,

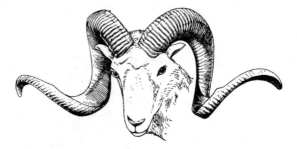

FIG. 20.—MARCO POLO'S ARGALI (OVIS AMMON POLI).

later on, a number of beautiful examples of spirals will be given ; and in Fig. 19 I have shown that by photographing a growing plant (*Lilium auratum*) vertically, you can appreciate the spiral construction of its leaves, and their relations to each other, much better than would be the case in the position in which it is ordinarily observed and drawn. It is, in fact, almost possible to catalogue the forms of the spiral utilised by man, in rifles, in staircases, in tunnels, in corkscrews, or a hundred other ways, and to parallel nearly every one in natural formations. In some cases there have been zealous inquirers so overwhelmed with the significance and ubiquity of this formation that their contributions to knowledge have been seriously weakened by their mystical or spiritual extravagances. As a warning for all who may be thus tempted, I have inserted here (Fig. 23) a picture which gives all the impression of representing a series of spirals originating at a common point, but which in reality is nothing but a cluster of concentric circles, composed of parti-coloured

stripes upon a variegated background. This was first drawn by Dr. James Fraser, but it is used in these pages only to emphasise the fact that this is one of the subjects very apt to carry away the amateur investigator and lead him to assert more than he can prove. There is no need for that. The facts are wonderful enough without addition. But I must admit that I have never been deterred from comparing two natural objects which may be, in essence, entirely different, merely because the only point of similarity was the spiral formation. In my view the mere fact that such a bond may be discovered in objects otherwise so different may have the greatest significance. Few things, at first sight, would seem more different than the action of a magnet upon steel and the passage of a beam of light through the air. Yet in comparing the two, Clark Maxwell showed that the phenomena of light were due to the rhythmic movement of the same stresses in the æther observable in cases of magnetic attraction. "Omnes artes quæ ad humanitatem pertinent" said Cicero, "habent quoddam commune vinculum." With a similar idea of searching for resemblances I have never shrunk from examining any of the artistic or historical traditions of the spiral just as closely as the mechanical aspects of the screw or its artificial uses by mankind. It is certainly curious that spiral shells were used for the adornment of

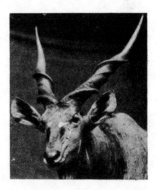

Fig. 21.—The Hon. Walter Rothschild's Senegambian Eland (Taurotragus derbianus).

Length (straight) 36½ inches, from tip to tip 27½ inches. (Photo by Rowland Ward, copyright.)

primitive man in the Magdalenian epoch at least 20,000 years ago ; that they are found among the relics of the earliest Mediterranean civilisation at Knossos ; that in such carvings as those I have reproduced here from Rouen (Fig. 24) or from Lincoln Cathedral (Fig. 25) and in such allegorical pictures as that of Bellini (Fig. 26) the significance of the spiral shell seems certainly recognised. In the chapters on artificial spirals we shall find this strange formation has almost as long a history ; and in fact we shall have traced it, when we reach my closing pages, from the earliest ages of organic life upon the earth to the latest constructions of the modern engineer or architect. Completed in the Ionic capital, arrested at the bending-point of the acanthus-leaf in the Corinthian, it became a primal element of architectural ornament, eloquent with many meanings, representing the power

of waves and winds in Greek building, typifying the old serpent of unending sin in Gothic workmanship.

My next chapter will lay down certain necessary definitions, and give the few essential mathematical conventions that are necessary.

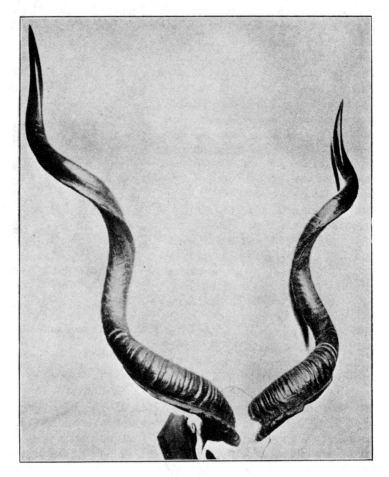

FIG. 22.—GREATER KUDU.
Shot by G. Blaine. (British Central Africa, 1903.

I shall then examine the upright and the flat spirals to be found in shells. Several sections will be devoted to botanical phenomena, including climbing plants, and including also the curious problem of why some spirals are left hand (or clockwise, following the sun) and others right hand. It will then be possible to investigate the growth of horns, and various other anatomical

examples. And not until all these have been as far as may be considered can we approach that portion of our subject which may be considered artistic, philosophical—what you will—at any rate some such conclusion of the whole matter as is inevitable at the close of a search so widespread and so full of interest.

What that conclusion may be, I will not now elaborate ; but I may at least suggest that, however far our study may be prolonged, we shall have to confess that in all efforts to define a natural object in mathematical terms, we come to a point at which

FIG. 23.—THE " UNIT OF DIRECTION " ILLUSION,

discovered by Dr. James Fraser, and first described by him in the *British Journal of Psychology* for January, 1908. In this diagram a series of perfect concentric circles composed of black and white cord have been placed one within the other ; but, owing to the chequered background, they appear in the form of a spiral. I reproduce this curious diagram by courtesy of the *Strand Magazine*.

accurate knowledge of the involved factors ceases. All that can be said is that a logarithmic spiral (for instance) is as near as we can get in mathematics to an accurate definition of the living thing. Nor does the mathematician fare any better when he tries to express beauty in terms of measurement. In other words, the baffling factor in a natural object is its life ; just as the baffling factor in a masterpiece of creative art is its beauty. May it not then be true that beauty, like life and growth, depends not on exact measurement or merely mathematical reproduction, but on those subtle variations to which the scheme of creation,

as we know it, owes those great laws of the Origin of Species
and the Survival of the Fittest ?

FIG. 24. — FIFTEENTH-CENTURY CARVING
FROM PALAIS DE JUSTICE AT ROUEN.

It has been several times stated of late, by Sir George Darwin
and others, that however useful the mere accumulation of facts

FIG. 25.—MISERICORDE IN LINCOLN CATHEDRAL (1375).
(From a Drawing by Miss Emma Phipson.)

may be, it rarely leads to one of the great generalisations of
science, unless there has been some definite aim in view, unless

some theory worth investigation is kept in mind, unless some bond of connection holds the mass together. In other words, we can recognise that the laborious collection of details may be powerless if it goes no farther ; and that the exercise of imagina tion, unrestricted, can neither convince nor gratify. But, in

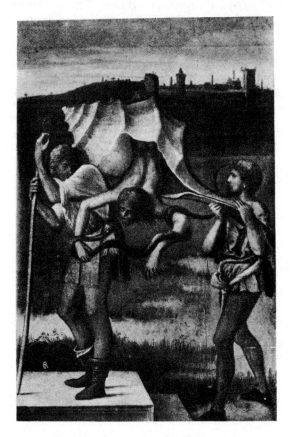

FIG. 26.—ALLEGORIA. LA MALDICENZA.
(By G. Bellini.)

combination, these two can do what, for want of a better word, we call " create."

This must have been Leonardo's meaning when he said that " the works of Nature are finite." They move along those orderly, those vast processes of time and space which can be realised by that human intelligence which is a part of them, if only it will work hard enough to collect the details. This, then, is to " know." But to " create " is greater, for creation takes that further step which must ever be based on knowledge, yet is

beyond knowledge ; for the things which eye and hand and mind can create " are infinite."

Nature must be interrogated in such a manner that the answer is implicit in the question. The observer can fruitfully observe only when his search is guided by the thread of a hypothesis. It is the thread of spiral formations that will guide this essay. It was the manuscripts of Leonardo da Vinci which inspired it.

NOTES.

FIG. 3.—Certain brachiopods contain very beautiful calcareous spiral arm-supports, formed by a ribbon of lime, and attached to the dorsal valve. In *Zygospira modesta* (Hudson River Group), these spiral cones are directed inwards ; in *Spirifer mucronatus* (Devonian) they are directed outward and backward, and formed of many whorls ; in *Koninckina leonhardi* (Trias) the double arm-supports are flat spirals, instead of cones set on their edge, and are each composed of two lamellæ.

SPIRAL NEBULÆ.—These are more fully described in the last chapter.

CHAPTER II

MATHEMATICAL DEFINITIONS

" No investigation can strictly be called scientific unless it admits of mathematical demonstration."—LEONARDO DA VINCI (*Inst. de France*).

SPIRAL APPEARANCES SUBJECTIVE—FLAT SPIRALS—LEFT HAND
AND RIGHT HAND—CONICAL AND CYLINDRICAL—IONIC VOLUTE
DRAWN BY MEANS OF A SHELL—WAYS OF MAKING SPIRALS—
CURIOUS NOMENCLATURE USED BY BOTANISTS.

THERE are no doubt many principles of growth, as there are of beauty ; but for the present I desire to confine myself to those which are intimately connected with the various forms of a spiral, forms which are common to a very large part of the animal and vegetable kingdom. And at the very beginning, I should wish to emphasise a caution which will apply to every section of my inquiry. It is this : Because we can describe a circle by turning a radius round one of its extremities, it does not follow that circles are produced by this method in Nature. Because we can draw a spiral line through a series of developing members, it does not follow that a plant or a shell is attempting to make a spiral, or that a spiral series would be of any advantage to it. All spiral appearances should properly be considered as subjective ; and confirmation of this view that a spiral need not be directly essential to the welfare of a plant is shown by the curious fact that the effect of a spiral becomes secondarily corrected as soon as it becomes a distinct disadvantage to the plant. The same facts are observable in shells and other organic bodies, such as horns. Geometrical constructions do not, in fact, give any clue to the causes which produce them, but only *express* what is seen, and the subjective connection of the leaves of a plant by a spiral curve does not at all imply any *inherent* tendency in the plant to such a construction.

This Mr. A. H. Church fully realises ; and therefore in his treatises on phyllotaxis he specifically bases all his deductions on " a single hypothesis, the mathematical proposition for uniform growth, as that of a mechanical system in which equal distribution of energy follows definite paths which may be studied by means of geometrical constructions." It is in exactly the

same way that I desire my readers both to study the natural phenomena presented in these pages, and to consider the spiral formations here connected with them. Mathematics is an abstract science ; the spiral is an abstract idea in our minds which we can put on paper for the sake of greater clearness ; and we evoke that idea in order to help us to understand a concrete natural object, and even to examine that object's life and growth by means of conclusions originally drawn from mathematics. It is only by some such means that the human mind, which hungers for finality and definite conceptions, can ever intelligibly deal with the constantly changing and bewilderingly varied phenomena of organic life. Definition and description are always difficult. The various forms of spiral offer an admirable means of describing certain natural objects. But for the underlying causes producing the effects observed, we have to go to the biologist, the morphologist, or the botanist ; and I have only entered on this inquiry at all because it suggests so many questions to which the specialist has as yet provided no reply.

In speaking of spiral formations I am faced with the initial difficulty that I must make myself clearly understood by readers who may not at first be interested at all in spirals, and who may never care to consider mere mathematical abstractions. I shall not be more mathematical than I can possibly help. But I am compelled to lay down a few preliminary definitions unless we are to speak of unintelligible and hazy uncertainties, incapable either of examination or of illustration. My object is merely to give my readers a few simple and easily understood formulæ which will enable them to look at growing things and natural objects from a different point of view, and perhaps with a greater interest.

There are many kinds of spirals distinguished by the mathematician. We have need here of only a few of them ; but we must get these few clearly into our minds. I will describe the flat spiral, the conical helix, and the cylindrical helix ; and we may begin with the simplest of all. In the ordinary flat spiral (such as a watch spring) we have a plane curve coiling round a fixed point or centre and continually receding from it, so that, though all points in the curve are in the same plane, no two of these points are at the same distance from the centre. The ratio in which the plane curve recedes from the centre sometimes defines the nature of the spiral. We can examine this for ourselves very simply.

Place the most ordinary form of a flat spiral, a watch spring (Fig. 27), on the table, and next to it a watch, and it would be

convenient if the hands were at twenty minutes to four for the purposes of this argument (Fig. 28).

Draw upon a flat piece of paper two spirals like Fig. 29 (a right-hand spiral), and Fig. 30 (a left-hand spiral). In looking at these figures you have drawn, you will observe that the opening of the left-hand spiral is about at the minute-hand when the

FIG. 27.—FLAT SPIRAL OF WATCH SPRING.

FIG. 28.—CLOCK-FACE.

clock registers twenty minutes to four, and that it is on the left-hand side of the figure. This will be an easy way to remember whether a flat spiral can be called mathematically left-hand or mathematically right-hand. For the opening of Fig. 29, the right-hand spiral, will be where the hour hand is on the clock-face close to the hour of four o'clock, and therefore on the right-hand side. A left-hand (or sinistral) spiral follows the sun, or

FIG. 29.
RIGHT-HAND FLAT SPIRAL.

FIG. 30.
LEFT-HAND FLAT SPIRAL.

the hands of a clock ; a right-hand (or dextral) spiral goes against the sun and contrary to the hands of a clock, in both cases when traced from the outer portions towards the inner, from M to A.

An interesting point about the left-hand spiral, whether it be a flat spiral, or a conical helix, or a cylindrical helix, is this— and it may be verified by the figures of flat spirals in front of you. If an insect walking in at the opening M on Fig. 30 proposes to reach the point A, that insect will have to keep on

turning to the right until it reaches A. It is always obliged
to do this in left-hand spirals. On the other hand, if it starts
from the opening M in Fig. 29, and tries to reach the point A,
it must continually be turning to the left, and this is always neces-
sary in right-hand spirals. This is why, in such upright spiral

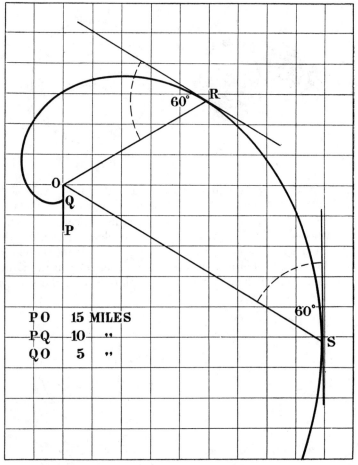

FIG. 31.—LOGARITHMIC SPIRAL FROM THE " FIELD " FOR APRIL 22ND, 1911.

formations as are common in shells, a right hand shell which
has its opening on the right side and which exhibits right-hand
spiral formation is called leiotropic (turning to the left), whereas
a shell exhibiting left hand characteristics is called dexiotropic
(turning to the right), by the conchologist.

Returning to our flat spirals, I may quote, as a good mathe-
matical example, the logarithmic spiral (Fig. 31, published in the

Field for April 22nd, 1911) which afforded its yachting readers the solution to a pretty problem in navigation ; and this spiral is, to my mind, an admirable expression (see the curve AC in Fig. 50), in visible form, of the expansion of energy and growth. But I must not go too fast, and it is now my more immediate business to make it clear that the phrases " right-hand flat spiral " or " left-hand flat spiral " are used merely as mathematical definitions ; they are not used as the names of actual objects. As a matter of fact, it is not always possible to say of a natural object that its flat spiral is either definitely right hand or definitely left hand, because in one aspect of that natural object you see a

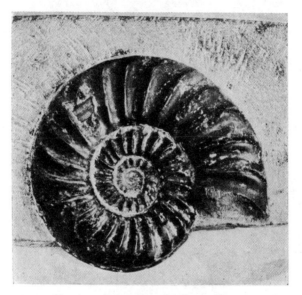

FIG. 32.—AMMONITE FROM LYME REGIS.

left-hand flat spiral and in another aspect of the same object you see a right-hand flat spiral. This difficulty occurs when the object is such a flat symmetrical shell as an ammonite (*e.g.*, Figs. 32 and 33), which is exactly the same on both sides ; and, concerning this ammonite, all you can say in this respect is that in a given position towards the spectator it exhibits a right-hand or a left-hand flat spiral, as the case may be. The same effect may be observed in *Solarium* and *Lamprostoma* in Figs. 34, 35 and 36. Other good examples of the flat spiral are, in plants, the frond of a fern (Fig. 37) and, in inanimate matter, the crystal of sulphur (Fig. 38).

There is, of course, no such difficulty as I have just hinted about either cylindrical or conical helices, for they are always

either right-hand or left-hand, and they retain that characteristic whether they are turned upside down or not ; but one thing can

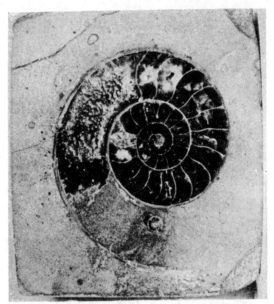

FIG. 33.—SECTION OF AMMONITE.

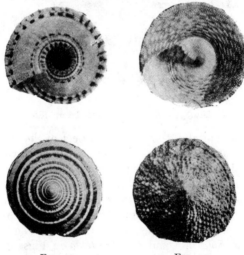

FIG. 34.
SOLARIUM PERSPECTIVUM.

FIG. 35.
LAMPROSTOMA MACULATA.

(Shells seen from above and from beneath.)

be said concerning a flat spiral, and this is that if it is a left-hand flat spiral, and if you may imagine the point A pulled vertically

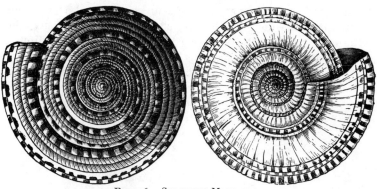

FIG. 36.—SOLARIUM MAXIMUM.

upwards while the point M is fixed to the ground, you would produce a left-hand conical helix from Fig. 30. The cochlea of the human ear in Fig. 39 looks exactly as if it had been produced

FIG. 37.—FROND OF
GROWING FERN.
(See Fig. 61.)

FIG. 38.—CRYSTALS OF
SULPHUR.
(Pettigrew.)

in this way. See also the crystal in Fig. 40. In exactly the same way, if you pulled up the point A in Fig. 29 and held the point M upon the ground, you would produce a right-hand conical

FIG. 39.—LAMINÆ OF COCHLEA
OF INTERNAL EAR.
(Rüdinger.)

FIG. 40.—SPIRAL CRYS-
TALLINE FORMATION OF
PROCHLORITE.
(From D. T. Dana'
"Mineralogy.")

helix. In this connection it should be noticed that in the case of certain shells which exhibit both flat and upright spirals, as, for instance, those in Figs. 41 and 42, when their upright spiral is right hand their flat spiral is also right hand and their

" entrance " on the right, and *vice versâ*. It is also true that
when the plaits on the columella show a right-hand helix, the
external formation of the shell containing them will exhibit a
right-hand spiral. This happens, so far as I am aware, in every
instance of shells which exhibit both kinds of spiral formation.

It is also interesting that in a left-hand spiral, whether it be
flat, or conical, or cylindrical, the movement of a person or insect

FIG. 41. FIG. 42.
TURBINELLA PYRUM. HARPA CONOIDALIS.
(Shells seen from the side and from above.)

supposed to be walking round it, or ascending it, would, as I
have already said, always be in the direction of the hands of a
clock, and this direction seems to have influenced various customs,
either sacred or secular, for we always pass the port in this same
direction round the table, or, as it has sometimes been put,
" through the button hole " ; and it is considered very unlucky
to walk round a church from the western door in any other direc-
tion. It is also, of course, the direction of the apparent movement

of the sun in our northern hemisphere. Some writers (*e.g.*, the Belgian geologist Van den Broeck) say that the twisted trunks of trees are produced by the earth's rotation, and therefore when they exhibit a spiral they should show a right-hand spiral in the northern hemisphere and a left-hand in the southern ; like the turn of the cyclonic storms or the twist in water vortices ; but this is still open to more exact observation. It has also been suggested that, as the winds due to the earth's motion blow fairly steadily just when the trees are growing fast, the young tree may take a permanent twist, from this cause, which it never loses.

FIG. 43.—TRUNK OF CHESTNUT TREE TWISTED
IN RIGHT-HAND SPIRAL.
(From Onslow, Shrewsbury.)

The tree reproduced in Fig. 43 was photographed for me in Onslow Park, Shrewsbury, by Mr. Ralph Wingfield. The late Professor Pettigrew has also described the strongly right-hand spiral he observed on the twisted stem of a huge Spanish chestnut (*Castanea vesca*) on Inchmahome, in the Lake of Menteith. Eighteen inches above ground this tree (which had been felled) was 15 feet in girth, and the spot where it lay has been beautifully described by Dr. John Brown in " Queen Mary's Child Garden."

There are, of course, many examples of such spirals in tree trunks (Figs. 180, 181). I await some instances from Australia. Since I have already shown that a conical helix can be formed

from a flat spiral, it will not be surprising that the process can be reversed, and that a flat spiral can be formed from a conical helix. I shall describe this, because I believe very strongly that if a

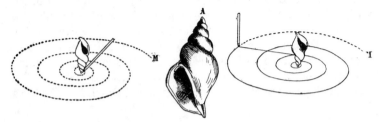

FIG. 44.—RIGHT-HAND SPIRAL OF VOLUTE ON RIGHT SIDE OF IONIC CAPITAL DESCRIBED WITH THE HELP OF THE LEFT-HAND FOSSIL WHELK FUSUS (CHRYSODOMUS) ANTIQUUS.

man can make a thing and see what he has made, he will understand it much better than if he read a score of books about it or studied a hundred diagrams and formulæ. And I have pursued this method here, in defiance of all modern

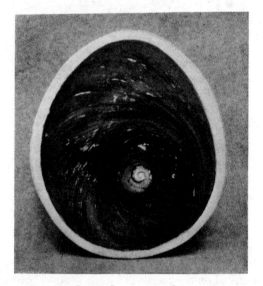

FIG. 45.—INNER SURFACE OF OPERCULUM OF TURBO MARMORATUS. (Life Size.)

mathematical technicalities, because my main object is not mathematics, but the growth of natural objects and the beauty (either in Nature or in art) which is inherent in vitality.

It is obvious that the spiral enters into certain very important architectural decorations, such, for instance, as the volute of an

Ionic capital. In an ancient Greek building this volute is no more mathematically correct than the lines of the Parthenon are mathematically straight, but the Greek volute is beautiful because it exhibits just those differences from mathematical exactness which the shell, or any other natural growth, exhibit also. I can show this, I think, in a somewhat curious manner.

The ordinary method of drawing a " correct " volute with the help of an inverted cone is, of course, well known, and results in a mathematically exact and æsthetically vapid figure. But Mr. Banister F. Fletcher has shown that a shell can be used for the same purpose. Following his instructions (see Fig. 44), I took a sinistral whelk, and wound a piece of tape, 12 inches long, round its spirals from its apex (A) to the top of the opening,

FIG. 46. — CHORISTES
ELEGANS, SHOWING
OPERCULUM.

FIG. 47.—OPERCULUM OF TURBO CORNUTUS
(From the Pacific.)

leaving a little of the tape over to hold the rest in position. A pencil was attached to the end of the tape touching the apex. Reversing the shell so that it stood perpendicularly upon its apex at the centre of the volute, and keeping it fixed on that point, I drew the pencil round and round the shell in the gradually increasing curves permitted me by the gradual unwinding of the string. The volute reproduced in Fig. 44 is the result. The shell used was exactly contained in a rectangular space $4\frac{1}{16}$ inches long by $2\frac{1}{4}$ inches wide. It produced a spiral measuring $10\frac{5}{8}$ inches across from the centre to M. Though both shell and volute are reduced to suit the size of these pages, the relative proportions remain the same. It will be noticed that the *Fusus* (*Chrysodomus*) *antiquus* employed is a specimen of a sinistral or left-hand shell, but that it has produced the right-hand spiral of the volute on the right side of the capital. The volute on the left

side of the capital can be similarly drawn with the left-hand spiral
produced by a common right-hand whelk. This may be one
underlying reason for the fact that every right-hand plane spiral
of an operculum belongs to a left-hand shell, and *vice versâ*
(see Figs. 45, 46, 47). The arrangement of the volutes on an

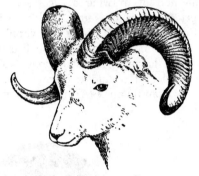

FIG. 48.—ALASKAN BIGHORN.
(*Ovis cañadensis dalli.*)

Ionic capital (viz., a right-hand spiral on its right side, and a
left-hand spiral on its left side), is the same as that of the horns
of the Merino ram and the Alaskan bighorn (Fig. 48), and would
be described by Dr. Wherry as " homonymous."

The method just described, though mechanically performed,

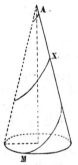

FIG. 49.—CONICAL
HELIX.

actually reproduces those proportions of an
Ionic volute which owe none of their charm
to mathematics ; and whether the ancient
Greeks used a shell or not in making their
designs, it is very significant that the beauty
of their workmanship should exhibit so curious
a harmony with the lines of an organic growth
that are nearly, but not quite, the curves of
a mathematical spiral. It is in this subtle
difference that, I believe, their charm consists.

But I must again return to our definitions.
A conical spiral (more properly called a conical
helix) may be formed, as I have said, by lifting
up the centre of a watch spring and fastening
its longer outside circle to the table. It may be described as
the gradual winding of a spiral line round a cone from its apex
(the centre of the flat spiral) to its base (the outside curve of the
flat spiral).

A cone is formed by the revolution of a right-angled triangle
upon its base as an axis ; and it will be found that no two points

on the spiral line surrounding the cone are at the same distance from that axis (see Fig. 49).

A conical helix can be visibly developed in the manner described in Fig. 50, which was drawn for me by Mr. Mark Barr. Describe a circle with centre at A, and radius AR 13½ inches in length. Draw another radius AQ, and cut away the sector of the circle contained between it and AR. It will then be possible

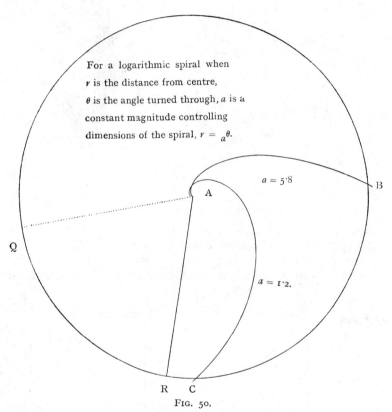

For a logarithmic spiral when

r is the distance from centre,

θ is the angle turned through, a is a

constant magnitude controlling

dimensions of the spiral, $r = {_a}^{\theta}$.

$a = 5 \cdot 8$

$a = 1 \cdot 2.$

FIG. 50.

Cut out the Sector contained by AQ and AR. Twist the paper into a cone with A as centre and AR = 13½ inches.

to fold the original paper circle up into a cone with its apex at A, and the two logarithmic spirals AB and AC (originally drawn on the flat piece of paper containing the circle) will be seen developed each into a conical helix. By twisting your cone up sharper and sharper, you will see each helix making more and more turns round the cone. The paper used should be the transparent linen preferred by architects.

The most usual form of a conical helix is the common screw

used by carpenters and drawn in Fig. 51. In Fig. 52 a screw is shown with a larger thread than usual, and arranged more like a true cylindrical helix, after the fashion of a staircase built

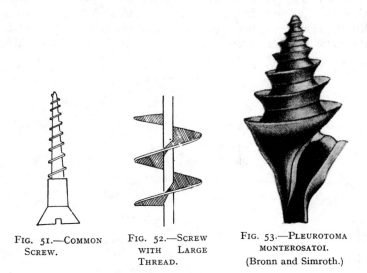

FIG. 51.—COMMON SCREW.

FIG. 52.—SCREW WITH LARGE THREAD.

FIG. 53.—PLEUROTOMA MONTEROSATOI. (Bronn and Simroth.)

with an inclined plane revolving round a central column, instead of steps fitted into that column one above the other.

A cylindrical spiral is more properly called a cylindrical helix, and is defined as the curve assumed by a right line drawn on

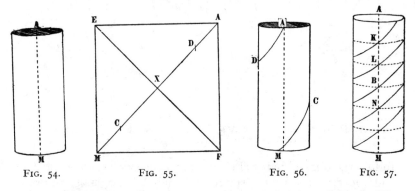

FIG. 54.

FIG. 55.

FIG. 56.

FIG. 57.

a plane when that plane is wrapped round a right cylinder. We can make one for ourselves as follows :—

In Fig. 54 AM is a solid cylinder, with two points marked upon that part of it in front of the spectator. The rectangular figure MEAF is a piece of paper (Fig. 55). Join MA and join EF. X will be the meeting point of these two lines in the centre

of the piece of paper. Fold the paper round the cylinder in such a way that the points EM are in front of the spectator, and so that the point A can be folded round to meet the point E at the top, and M will coincide with F at the bottom.

The cylinder is now wrapped round by the paper (Fig. 56), and shows the portions MC and DA (in Fig. 55) visible of the spiral line now formed by what was once the straight line MXA.

This line MXA was drawn from the left lower corner to the right upper corner of the paper, so that a right-hand spiral has been formed ; the line from F to E would produce a left-hand spiral.

The distance from M to A on the cylinder in Fig. 56 gives the " pitch " of the screw, or spiral, formed by the line MCXDA ;

FIG. 58. — SPIRAL VESSELS OF MELON. (Pettigrew.)

FIG. 59. — RIGHT-HAND SPIRAL OF TECOMA (BIGNONIA).

FIG. 60.—LEFT-HAND SPIRAL OF HONEY-SUCKLE.

but a cylindrical spiral may, of course, exhibit considerably more turns than this ; for instance, the " pitch " of the cylindrical spiral shown in Fig. 57 is the distance from K to L, from L to B, or from B to N. It is interesting to compare the shell of Fig. 53.

As examples of natural spirals which may roughly be defined as cylindrical, I may take the spiral vessels of a melon (Fig. 58). In climbing plants, some grow in one direction and some in the other. Fig. 59 shows a right-hand *Tecoma* and Fig. 60 a left-hand honeysuckle. The human umbilical cord is a beautiful example (Fig. 10) of a left-hand spiral ; and the power of many bones in our body is owing to this shape (p. 9). No doubt all these examples suggest that there is something intimately concerned with strength and growth in the

spiral formation; and it is this question which I propose to examine by considering various other instances to be seen in natural objects. It will be found useful if the preliminary pages here printed are used for reference by those readers who follow me further in our search for natural spirals.

I must add here to our general considerations of spirals that it is possible to make a kind of spiral with a flat piece of paper which it would be difficult to class under any of the heads just mentioned. It is made in the following manner :—

Take a flat piece of paper $\frac{3}{4}$ inch broad and 12 inches long. Fasten one end of it upon the edge of the table with a nail in such a way that the whole length of the paper sticks out beyond the edge of the table. Place your left hand upon the nail to hold the paper steady, and with your right hand twist the other end of the flat strip of paper outwards and away from you. The method used would roughly be that employed in twisting a rope by hand. When you have twisted the paper as far as it will conveniently go, you will find that it exhibits a series of left-hand, ascending lines in a double spiral. This is the way in which the torques were made by ancient workmen out of flat ribbons of soft gold, and this is why nearly all such ancient torques exhibit a left-hand spiral, because they were made by right-handed men. Most ropes made by machinery are made as a right-handed man would twist them, and therefore exhibit a left-hand spiral. If you repeat the experiment with the strip of paper just described, only putting your right hand on the nail and twisting the paper away from you with your left hand, you will find that you have twisted it up into a right-hand spiral; and this is why the ancient torques are so rarely found to exhibit a right-hand spiral. In the twisted piece of paper you have just used there are two edges, and therefore it is a double spiral which goes up to right and left respectively; but the ancient workmen produced the very beautiful effect of a fourfold spiral in precisely the same manner, only in this case they used not a flat ribbon of gold, but a ribbon so arranged that its section was exactly in the form of a cross. This gave four edges, and by the use of exactly the same process just described they produced either a right-hand or a left-hand spiral which was fourfold instead of being double (pp. 292–3.)

This leads me to a question of nomenclature which is appropriate to the opening pages of any discussion like the present. What has just been said concerning the manufacture of torques will fittingly introduce it; for an ordinary rope in English ships exhibits that left-hand twist shown in the honeysuckle in Fig. 60, and explained in the description of the ordinary torque. The rope's twist is of this kind because it was twisted by a right-

handed man. The rope-bridle carved on a prehistoric represen-
tation of a horse some 20,000 years old shows a right-hand twist ;
and this may be either because the drawing was made by a right-
handed man or because the artist was copying a rope twisted by
a left-handed man. I incline to the latter theory, because I
have seen ropes made by Arabs in North Africa which showed
the right-hand twist of the *Tecoma* in Fig. 59, and were no doubt
made by a left-handed man. Now it is obvious that these two
kinds of twists may each be differently described. The left-hand
or sinistral may be called clockwise, as exhibiting the movements
of a clock's hour-hand (for instance) from six o'clock to noon ;
or it may be described as a movement from the south through

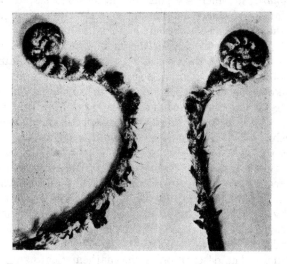

FIG. 61.—THE YOUNG FERN GRADUALLY UNROLLING ITS
SPIRAL.. (Compare Fig. 37.)

west and north to the east, if we take the cardinal points on a
compass ; or it may be defined as " with the sun." In the same
way, the right-hand or dextral spiral may be defined as " against
the sun " or " contrary to the hands of a clock." But against
one form of nomenclature, chiefly favoured, I understand, by
botanists, I must raise a strong and immediate protest. This
method proposes to call the left-hand twist on a rope " right-
hand," because it results from the twist given by a right-handed
man. What reason would be given for calling the honeysuckle
in Fig. 60 " right-hand " ?

Conchologists have certainly agreed to call left-hand shells
dexiotropic, and right-hand shells leiotropic ; but they knew
better than to alter the accepted nomenclature of an abstract

mathematical convention which has no concern either with processes of manufacture or naval customs. Numberless other considerations will occur to invalidate any connection between the origin of a spiral and its name. It is common knowledge, for instance, among art-critics, that in a genuine Leonardo drawing the strokes of the shading slant from left to right. It will be found on trial that such strokes are most easily made from right to left by a right-handed man. Leonardo was left-handed ; and in the spiral shells he drew for the bust of " Scipio " and the sketch for " Leda " both are the right-hand flat spirals he would naturally make (p. 64). Or, again, the famous parry of Kirchhoffer, Mérignac, and other left-handed fencers is the *contre-quarte*, in which the point of the sword describes the right-hand flat spiral shown in Fig. 29, whereas the easiest parry for a right-handed fencer is the left-hand spiral of *contre-sixte* (away from the body, or clockwise) shown in Fig. 30. You will find by experiment that the easiest way to draw the volutes of an Ionic column (in the relative position shown in Figs. 29 and 30) is to take a pencil in each hand, with the left hand on the point M in Fig. 29 and the right hand on the point M in Fig. 30 ; each spiral can then be naturally drawn and both can be done simultaneously. The left hand has drawn the right-hand spiral of Fig. 29, the right hand has drawn the left-hand spiral of Fig. 30. For much the same reasons most skaters find it easier to do the outside edge (a left-hand spiral) on the right foot, and when they skate on the left foot they prefer the right-hand spiral naturally made by the outside edge. In fact, to introduce a method of nomenclature based on manufacture is to make confusion thrice confounded. The way a spiral is made is, for these purposes, immaterial. The description of the mathematical figure is vital, and cannot nowadays be altered from the long-accepted conventions of the mathematician. I should prefer " following the sun " and " against the sun " ; but in these pages for the sake of brevity and clearness I always use the phrase " left hand " and " right hand " respectively, instead of " clockwise " and " anti-clockwise."

NOTE TO CHAPTER II.

YACHTING PROBLEM.—P. 26. A rudderless steamer is moving in an unknown direction straight ahead at ten miles an hour on a calm sea without tides. If a cruiser, moving twenty miles an hour cannot sight her when she has steamed from P to Q, she must inevitably find the lost steamer somewhere on the curve of the logarithmic spiral traced from Q through R to S in Fig. 31.

CHAPTER III

Upright Spirals in Shells

" The shells of oysters and other similar creatures which are born in the mud of the sea testify to us of the changes in the earth . . . for mighty rivers always flow turbid because of the earth stirred up in them through the friction of their waters upon their bed and against the banks ; and this process of destruction uncovers the tops of the ridges formed by the layers of these shells which are embedded in the mud of that sea wherein they were born when the salt waters covered them . . . the shells remained walled up and dead beneath this mud, which then was raised to such a height that the bed of the sea emerged into the air, and so became hills or even lofty mountains ; and later on the rivers have worn away the sides of these mountains and laid bare the strata of the shells."— Leonardo da Vinci (*Inst. de France*).

FORMATION OF SPIRALS IN SHELLS—TUBE COILED ROUND AXIS—LIFE HISTORY OF A SERIES IN ONE SHELL—ACCELERATION AND RETARDATION—NATURAL SELECTION—ADJUSTMENT TO ENVIRONMENT—SURVIVAL AND SPIRAL VARIATION—RIGHT-HAND AND LEFT-HAND SHELLS—AMMONITE AND NAUTILUS—EXTERNAL AND INTERNAL SPIRALS—SUPPORTING THE CENTRAL COLUMN—COMPARISON WITH INSECTS AND PLANTS—MULTIPLE SPIRALS.

I SHOULD exhaust both my reader's patience and the space available if I gave anything like a complete list of spirals in the animal kingdom alone. It will be necessary, therefore, to confine myself to a few typical examples and to those instances

FIG. 62.—AWL-SHELL (TEREBRA) PHOTOGRAPHED BY X RAYS TO SHOW INTERNAL SPIRAL THROUGH THE OUTER WALL.

which may be easily found and intelligently examined by ordinary people in their everyday life.

A " screwstone " is the name sometimes given to one of the joints of the " stem " of an encrinite or " stone lily," a palæozoic crinoid plentifully found in marble, and belonging to a class of animals which are " stalked," or fixed like a plant for a part or all of their life. A " Portland screw " is a similar name bestowed on the fossil cast of the interior of *Cerithium portlandicum*. The

name of auger-shell has, for the same reasons, been given to a long-spired gastropod (Fig. 62) called *Terebra* (*Bullia*) *semi-plicata*, and more especially to *T. maculata*.

It is in shells that may be found the most easily examined examples of beautiful spirality in all Nature, and the formation of spirals by shellfish seems still to be in need of a complete scientific explanation. But we may conceive the process as something of the following kind. When an elastic " bendable " substance is growing above an object and dropping at its free end, it would probably take the form of a plane spiral, under certain conditions. But if, during the growth of the mollusc it lops over at all to one side, it seems usual that it should lop over to the left. What the force is which determines this original direction in the growing shell I cannot say ; but, however slight and subtle this force may be, it is invariably " good evidence " in the case of

FIG. 63.—TRUNCATULINA
TENERA. × 75.
FIG. 64.—ROTALIA CALCAR. × 50.
(Brady's Foraminifera. *Challenger* Reports.)

such " artificial " spirals as the shavings at a carpenter's bench. As Dr. Wherry has pointed out, if these shavings are right-hand screws they are produced by a right-handed carpenter, because a right-handed man invariably drives his plane a little to the left. But I must not yet touch upon the extremely intricate problem of why a spiral is (or should be) either right hand or left hand. That must come later. I only mention the instance of the shavings in order to explain why the elastic substance growing above the young shellfish usually produces a right-hand spiral by lopping over to the left ; and it will be remembered that we have already noted that shells exhibiting a right-hand spiral are called " leiotropic " and those (far rarer) exhibiting a left-hand spiral are called " dexiotropic." We must now return to our theory of the origin of spiral growth in shells.

As an organism of the kind described continues to grow, if the new piece were of accurately rectangular formation, thus : ☐

the result would conceivably be growth in a continued straight

line. But it never is ; for the dorsal surface of a shellfish is thin and ductile, while the ventral surface is harder and contains muscles which continually exercise a certain pull upon the tissues. So the new growth is usually of this form : Since, therefore, the dorsal surface expands more easily than the ventral, while the creature goes on developing, the result is a

continuation of the spiral form thus : It is only necessary to imagine that this spiral is growing vertically at the same time as it grows in length, and you may add the pull of gravity to the other forces at work, while the creature increases in bulk and weight, until the spiral formation of the

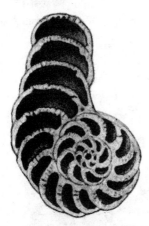

FIG. 67.—FOSSIL GLOBI-
GERINA CRETACEA. × 50.

FIG. 65.—LONGITUDINAL SECTION
OF PENEROPLIS ARICETINUS. × 40.

FIG. 66. — GLOBIGERINA
LINNÆANA, D'ORBIGNY.

(Brady's Foraminifera. *Challenger* Reports.)

shellfish becomes a little more intelligible. It may be roughly reproduced by means of the toy called " Pharaoh's Serpents," a kind of inflammable eggs, one of which may be placed in a small tube slightly dented on the left. As soon as the spiral comes out of the egg from this tube it will exhibit a right-hand helix. If another egg be placed in a tube which has its orifice slightly dented on the right, the spiral will exhibit a left-hand helix.

Perhaps we can illustrate the process just described by some of the beautiful examples of microscopic foraminifera drawn for the *Challenger* Reports. In *Truncatulina* (Fig. 63) for instance, the difference mentioned in length between the " dorsal " and the " ventral " surface of each new growth is very clearly empha-sised from the beginning ; and the same process is observable in *Rotalia* (Fig. 64) and *Globigerina* (Fig. 66), though complicated

in the one case by the spiny projections, and in the other by the
lovely folds of new tissue like the petals of a rose. The form
produced by the addition of irregular formations laterally instead

FIG. 68.—GLOBIGERINA ÆQUI-
LATERALIS. × 50.

FIG. 69.—BULIMINA CON-
TRARIA. × 60.

(Brady's Foraminifera. *Challenger* Reports.)

of longitudinally (as in *Truncatulina*) is prettily shown in *Pene-
roplis*, a tiny model of a nautilus with an extension of two "com-
partments " which were evidently made when the inmate was
growing old just before its death (Fig. 65). But an even more

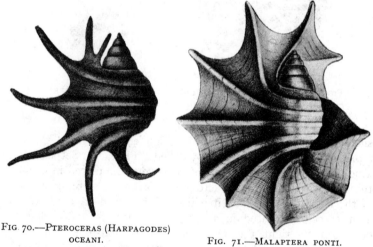

FIG 70.—PTEROCERAS (HARPAGODES)
OCEANI.
(Bronn and Simroth.)

FIG. 71.—MALAPTERA PONTI.
(Bronn and Simroth.)

striking example of the kind of growth we are examining is to be
found in the second *Globigerina* (Fig. 68) here reproduced, in
which the effect of expansion on the left of a series of globes is
very clearly demonstrated as a spiral. In its fossil form (Fig. 67)
the same species shows these globes united. In *Bulimina* (Fig. 69)

the completed shell, though it may seem to suggest a globular origin, is in reality the result of much the same process as in *Peneroplis* (Fig. 65).

Passing from microscopic foraminifera to living shells of larger size, it is tempting to imagine that *Pteroceras oceani* (Fig. 70) with its uneven tentacles sticking out from the main body is the beginning of a development which has reached a more completed stage in *Malaptera ponti* (Fig. 71), and a curious parallel may be found in the growth of a pearl oyster as shown in Fig. 72. The spines of Fig. 70 are, nevertheless, probably protective in their origin and use.

It is, however, with the spiral forms of growth that I am more immediately interested, and from what has been said it will be realised that in most cases (especially in what I have here called

FIG. 72.—GROWTH OF PEARL OYSTER SHELL.
(From Report of Pearl Fisheries at Ceylon. Herdman and Hornell. 1904.)

the " upright spiral," more correctly the *helix*) a shell is essentially a tube coiled round an axis so that the successive coils are in contact. The wall of the tube nearest to the axis forms the columella, that remote from the axis forms the outer surface of the shell. Where the successive whorls are in contact, a double septum is formed running from the columella to the outer surface. In a median longitudinal section through such a shell as *Telescopium* (Fig. 73) the relations of any point on the peripheral spiral of the outside wall to the corresponding point on the columella can be fully determined if we know the measurements of the triangle formed by joining these two points and the apex of the shell ; and we may roughly conceive of the whole growth as the revolution round the columella of this triangle, provided we further imagine that its sides are always growing, in a definite proportion to the base, as the triangle revolves. Or we may conceive that the " entrance " shown in the bottom right-hand

corner of *Telescopium* (Fig. 73) has itself gradually swung round and round the central column, growing a little larger as it goes further and further down.

FIG. 73. — TELESCOPIUM
TELESCOPIUM.

FIG. 74.—AMBERLEYA (EUCYCLUS)
GONIATA.
(Bronn and Simroth.)

I have given several examples of adult shells. Let me now add two illustrations of the *protoconch* from which they grow, taken from Grabau's " Phylogeny of Fusus " (Smithsonian

FIG. 75.—PROTOCONCH OF
FULGUROFUSUS QUER-
COLLIS.

FIG. 76.—PROTOCONCH
OF CLAVELLOFUSUS
SPIRATUS.

(Both from Grabau's " Phylogeny of Fusus." Washington, 1904.)

Institution, 1904). The first shows the Fulguroid protoconch and nepionic stage of *Fulgurofusus quercollis* (Fig. 75) from the Lower Eocene in Alabama, U.S.A. The second is a similar drawing (Fig. 76) of *Clavellofusus spiratus* in which the protoconch

shows two and a half instead of one and a half volutions, a characteristic never found in *Fusus* but typical of *Cyrtulus*. It comes from the Lower Eocene of the Paris basin. In both these protoconchs the " lopping over to the left " producing a right-hand shell will be noticed, as was described in the first few paragraphs of this chapter. The ancestral home of *Fusus* was the British Eocene sea from which it migrated nearly round the world by flotation during the larval period of development.

The shells of gastropoda (in perfect specimens) usually show all the stages from the protoconch to the final development. Their chief changes are noticeable in those portions at the periphery of a whorl which are nearly always exposed even after the addition of new whorls ; and thus nearly the whole life history of a series can be studied in the superficial characters of a single perfect shell. No principles have thrown such light on methods of development as the laws of acceleration and retardation announced by Hyatt and Cope, who thus explained many modifications of the highest importance. A most interesting proof may be added here of the value to research of such details in the special formation of shells.

In his " First Study of Natural Selection in *Clausilia laminata* (Montagu)," which was published in October, 1901, by Professor W. F. R. Weldon in *Biometrika*, he pointed out that the problems presented by certain terrestrial mollusca in Europe are of great interest in connection with the theory of natural selection, and that such specific (though apparently " useless ") characters as the shape of the spire, the number of ridges and furrows on a given whorl, or the size and shape of the aperture, can often be expressed in such a way as " to admit of numerical comparison between individuals." The shell of an adult *Clausilia laminata* is essentially a tube coiled round an axis so that the successive coils are in contact, much as in *Turritella lentiginosa ;* and by carefully determining the pitch and measurements of both the peripheral spiral and the columellar spiral in a number of examples from the beech woods of Gremsmühlen, in Eastern Holstein, Professor Weldon drew various conclusions. The upper whorls of the adult shell, he found, represent the condition of the young shell, from which this adult was formed by the addition of new material, in a practically unaltered form. Specimens taken from a district which the species is known to have inhabited since pre-glacial ages are in such equilibrium with their surroundings that the mean character of the shell spiral is the same from generation to generation, and is not being changed by selection during the growth of a young generation. The life or death of an individual is in fact determined in each case by the value of a

number of correlated characters, among which differences of
structure so slight as that of the measurements of the spirals are
associated with the difference between the survival and the total
extinction of a race in a particular locality.

To this delicate and beautiful example of biological calculations
I may add two instances that can be more readily examined.
Upon the beach at Felixstowe you may pick up hundreds of
living whelks (*Fusus*) any morning, and you will find about 990
out of every 1,000 are right hand (or leiotropic) shells. Within
a few yards the soft soil of the cliffs rises above the same beach,
and out of these cliffs you may pick fossil shells (*Fusus antiquus*)
of the same species. Every one I have found has been left hand.
Does this mean that only the right-hand spirals have survived

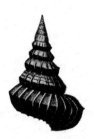

Fig. 77.—Cirrus
nodosus.
(Bronn and Simroth.)

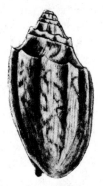

Fig. 78. — Outside of
rare (Dexiotropic)
Voluta vespertilio.

the struggle for existence ? An illustration of these shells
will be given later on, when we come to discuss the propor-
tion between right- and left-hand spirals in shells, and it will
here only be necessary to observe that the proportion of left
hand to right hand is much more than ten in a thousand in
common whelks, and in some few shells (such as an Indian
landshell of the genus *Bulimus*) the proportion is as high as 50
per cent.

Again, no better known fossil perhaps exists than the ammonite
with its tightly coiled flat spiral starting from a very visible and dis-
tinct centre (Fig. 98). The living shell most easily compared with
it is the nautilus, in which the chief difference readily observable is
that the coils of its flat spiral are far looser and seem to give more
room for the expansion of vitality and growth. Is this difference

the reason why the nautilus has survived and the ammonite is but a fossil ? Professor W. R. Dunstan was once kind enough to give me a *Voluta* from the Barton Beds of the Eocene age on the coast of Hampshire, where there are a large number of these

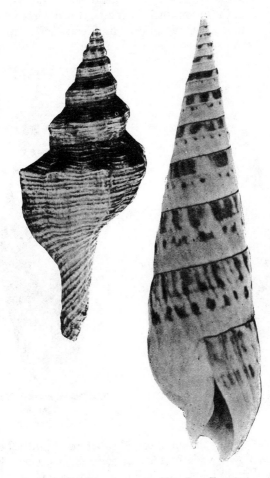

FIG. 79.—FASCIOLARIA FIG. 80.—TEREBRA
FILAMENTARIA. MACULATA.

shells to be found in so remarkable a state of preservation that they seem scarcely fossilised at all. For uncounted centuries *Voluta vespertilio* has vanished, as a living form, from both French and English coasts and from all waters colder than Italian seas. What difference have biologists detected between the fossil *Voluta* and such living forms as that shown in Fig. 90

which may account for the fact that the Italian *Voluta* has
survived and its English sister has become a fossil ?

The *Voluta* shows a remarkably charming spiral formation
on its outside (Fig. 78), but if a section of it is carefully made,
an even more lovely (and far more inexplicable) spiral will be
observed upon the columella, or central pillar round which the
main fabric of the outer shell is built. Before examining this
inner spiral more closely let me first emphasise the smooth
helix of *Terebra maculata* (Fig. 80), the external lines of *Mitra*

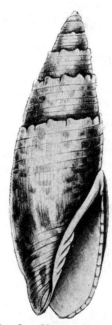

Fig. 81.—Normal Form of
Mitra papalis.

Fig. 82.—Sinistral Mitra
papalis.
(By Hollar.)

papalis (Fig. 81), or the more complicated and beautiful external
structure of *Voluta scalaris* (Fig. 84) or *Scalaria scalaris* (Fig. 85).
These would serve alone as admirable instances of our formation
on the outside of shells, when it is an example of the upright
(whether conical or cylindrical) spiral which we choose to examine.
But some shells exhibit the formation in an even more curious
way internally. Inside the various " compartments " (as I
must call them here) of *Turritella lentiginosa* (Fig. 86) you will
see a spiral of that kind which I was unable to classify in earlier
pages, and which I described as being made by twisting a long
strip of thin paper. Within *Auricula auris-midæ* (Fig. 87) you

may observe that a double twist of the same curious flat spiral
is to be found. But inside *Telescopium telescopium* (Fig. 73)

FIG. 83.—VOLUTA (VOLU-
TILITHES) BICORONA.
(Bronn and Simroth.)

FIG. 84.—VOLUTA
SCALARIS.

FIG. 85.—SCALARIA
SCALARIS.

the columella shows a different formation. Here is exhibited
a slender column going right up the centre of the shell, showing

FIG. 86.—TURRITELLA
LENTIGINOSA.

FIG. 87.—AURICULA
AURIS-MIDÆ.

the firm outline of a single spiral, like the thread of a screw,
ascending from bottom to top of each " compartment." In

Fig. 88 you may see the double thread of Fig. 89, but inside instead of outside. In Fig. 90 the series progresses through *Voluta vespertilio* with its fourfold spiral even as far as the eight-fold formation of *Voluta musica* (Fig. 91). I am not aware that any serious biological investigation has been made as to

FIG. 88.—SECTION OF
CERITHIUM GIGANTEUM.

FIG. 89.—TURRITELLA DUPLI-
CATA.

the growth of these " plaits " upon the columella of certain shells. Let us therefore consider whether any suggestions may be worth making, for it is the first time that any such series of pictures has been published in this form.

If it had ever become " necessary " (I can find no other word) to strengthen the central supporting column or columella, with-

out too much enlarging it or adding to its weight, no better for-
mation than this spiral could be conceived, and an almost exact
parallel to it occurs in the air-tubes or tracheæ of insects and the
water-tubes of plants. Though of totally different origin, these
air-tubes have a spiral thickening of the internal wall, which
strengthens them and keeps them open, rather like a spiral coil
of wire round the outside of a rubber garden hose ; engineers
and mechanicians are, of course, aware of this artful method of
strengthening a cylinder by means of a spiral ; the cannons
made by winding wire round a central core are an obvious
example. In Gegenbaur's " Comparative Anatomy " (Eng.
Trans., published by Macmillan's), there is a good drawing of
this formation in the tracheæ of insects, and I have seen an

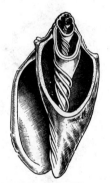

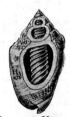

FIG. 90.—SECTION OF
RARE FORM OF VOLUTA
VESPERTILIO (LEFT-
HAND OR DEXIO-
TROPIC).

FIG. 91.—VOLUTA
MUSICA.

example under a microscope in the British Museum of Natural
History. The tube has a delicate outside coating, and after the
death of the insect the spiral (which thickens this coat) can be
pulled out and examined. In just the same way the spiral
band can be unrolled from the water-tube of a plant (compare
also the spiral vessels of the melon shown on p. 37), and this is
very beautifully illustrated in the " Textbook of Botany," by
Julius Sachs (Second Edition. Oxford : Clarendon Press, 1882),
which gives on p. 114 the longitudinal section of a fibro-vascular
bundle of Ricinus.

These spiral filaments are also found in double and triple, as
well as single, threads. The spiral vessels of the Chinese pitcher-
plant (*Nepenthes*) exhibit a quadruple thread, and they have
the further peculiarity of being sinistral, like the rare dexiotropic
Voluta (Fig. 90). These tubes are found in the leaf-stalks ;

they are closed, and their contents only permeate their enclosing membrane, which is so delicate that if the thread on the inner surface is uncoiled, no trace of the thin membrane will be seen except at the conical end of the ruptured vessel. The air-vessels of insects are branched and ramified so as to form a set of continuous tubes, and are framed to resist pressure from without by the elasticity of the fibre spirally coiled within them.

When plants have long continuous tubes, forming ducts for fluid, the internal strengthening is formed by a combination of broken spirals and rings, exactly as in the windpipe of the dugong

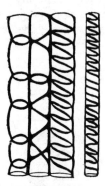

FIG. 92.—PORTIONS OF FOUR
VESSELS FROM A VASCULAR
BUNDLE IN LEAF OF
TRADESCANTIA VIRGINICA.

Showing spiral markings as
seen in a longitudinal section
highly magnified.

(Dendy's " Outlines of Evolu-
tionary Biology." Constable
& Co. 1912.)

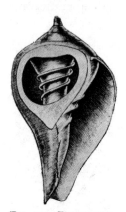

FIG. 93.—TURBINELLA
PYRUM.

we find a spiral cartilage terminating at intervals in rings (see Fig. 92).

Jost's " Physiology," De Bary's " Anatomy," or almost any modern textbook, will give details about these spiral vessels, and to them I must refer my readers, for I have but space here to suggest that the same process observable in these tubes may have gone on in the formation of the spiral round the columella of a shell ; and if so, it would be interesting if it could be further shown that shells with only a single spiral need such strengthening less than those which possess eight, as may be perhaps observed by a comparison of Fig. 73 with Fig. 91.

Charles Darwin noticed that the clasp of a twining plant round its support was definitely strengthened by the spiral twist of its own actual fibre (see the hop drawn later on), and

the plaits on the columella may possibly be the result of a similar set of circumstances. In any case, this additional growth has never yet been satisfactorily explained ; it may certainly be useful, as in some way assisting the animal to keep firm hold of its shell by means of a muscle specially adapted to hold on by it. But there are many large and thick shells in which the columella is perfectly smooth, so that in their case—whatever may be true in other instances—the mode of attachment must be different. The spiral line which I am now considering begins at the topmost and smallest chamber of the shell, and continues growing with the external growth to the largest chamber at the bottom. It is possible, therefore, that this spiral may have some

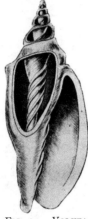

FIG. 94.—VOLUTA
PACIFICA.

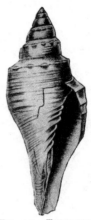

FIG. 95.—TURBINELLA
FUSUS.

intimate relation to the body of the animal in whose dwelling-place it occurs. But this I am inclined to doubt, for the reason that in *Turritella lentiginosa* (Fig. 86), it does not occur at all (though possibly because the " strengthening " process was not yet advisable), while if we take *Telescopium telescopium* (Fig. 73) with its one spiral as the beginning of a series, we shall find *Cerithium giganteum* (Fig. 88), or *Voluta solandri* with two spirals, *Turbinella pyrum* (Fig. 93) with three, *Voluta vespertilio* (Fig. 90) with four, *Voluta pacifica* (Fig. 94) with five, *Turbinella fusus* (Fig. 95) with six, and *Voluta musica* (Fig. 91) with as many as eight, while the number is even greater in *Cymbiola tuberculata* and *Harpula fulminata*. Whatever may be the real explanation of these internal spirals which are reproduced in every chamber of the shell, I do not therefore think that they can be as intimately

connected with the anatomy of the living organism as with the structure of the shelter which it fashions for its home ; for though it may be true that the number of " notches " in the columella-muscle of these shell-fish corresponds with the number of spirals round the columella in each case, and therefore the grasping power of the mollusc itself may be increased and facilitated, producing definite modifications of structure, still, if we consider the details of the formation, the question why these spirals exist remains almost as obscure as their origin in the protoconch.

NOTES TO CHAPTER III.

UPRIGHT SPIRALS IN SHELLS.—For a comparison of these with architectural designs of staircases, see Chapter XVII.

GROWTH OF SHELLS.—See " The Life of the Mollusca," by B. B. Woodward (Methuen, 1913), which I have largely quoted in Appendix VIII.

CHAPTER IV

FLAT SPIRALS IN SHELLS

" The creature that resides within the shells constructs its dwelling with joints and seams, and roofing, and the other various parts, just as a man does in the house which he inhabits ; and this creature expands the house and roof gradually in proportion as its body increases and as it is attached to the sides of these shells."—LEONARDO DA VINCI (*Inst. de France*).

" O Time, thou swift despoiler of created things ! How many kings, how many peoples hast thou brought low ! How many changes of state and circumstance have followed since the wondrous form of this fish died here in this hollow winding recess ! Now, destroyed by time, thou liest patiently within this narrow space, and with thy bones despoiled and bare are become an armour and support to the mountain which is above thee."—LEONARDO DA VINCI (Arundel MSS. in the British Museum).

NAUTILUS AND LOGARITHMIC SPIRAL—EQUIANGULAR SPIRAL A MANIFESTATION OF ENERGY—DEVIATION FROM CURVE OF PERFECT GROWTH—LEONARDO DA VINCI AS STUDENT OF SHELLS—WORK OF PROFESSOR GOODSIR—VARYING INVERSELY AS THE CUBE AND THE SQUARE—SIGNIFICANCE OF THE POSITION OF THE SIPHUNCLE—VERTICAL AND HORIZONTAL VIEWS OF SHELLS AND PLANTS.

AMONG all the flat spirals shown in shells it has long been recognised that *Nautilus pompilius* exhibits the most beautiful

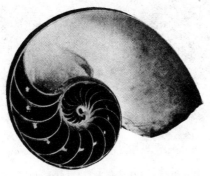

FIG. 96.—SECTION OF NAUTILUS POMPILIUS.

of all, and one so closely akin to mathematical curves that Sir John Leslie, speaking of the logarithmic or equiangular spiral,

and suggesting its "organic" aspect, wrote: "This spiral exactly resembles the general form and elegant septa of the nautilus" ("Geometrical Analysis and Geometry of Curve Lines,"

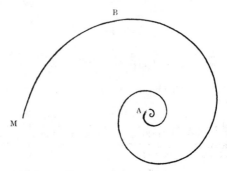

FIG. 97.—LOGARITHMIC OR EQUIANGULAR
SPIRAL.

Edinburgh, 1821, p. 438). But Canon Moseley, of Cambridge, went further. He made an exact geometrical examination of certain turbine shells (*Phil. Trans.*, 1838, p. 351) which exhibited a spiral curve wound round a central axis. This curve was found

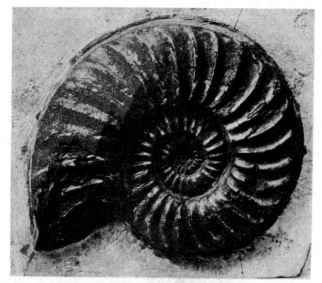

FIG. 98.—AMMONITE FROM LYME REGIS.

to be logarithmic, and from it could be framed a series of formulæ by which the other conditions could be predicted as they were found to exist. The spires of the shell increased in breadth in an exact successive series, each one of which was a multiple, in

a certain ratio, of another. Thus the shell must possess this
form and could possess no other, for its spiral logarithmic curve
reproduced itself. (See Plate VI., in Appendix).

Canon Moseley also noticed that the operculum was remarkable

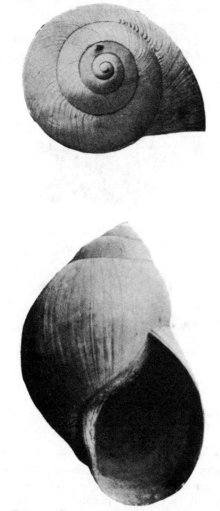

FIG. 99.—BURTOA NILOTICA, SHOWING BOTH
FORMS OF SPIRAL.

for its geometrical symmetry in the shells he examined ; and a
process which no naturalist had yet discovered was thereupon
ascertained by means of a mathematical calculation of the revo-
lution which the operculum of the shell must make round its
axis. By cutting any part of the shell in the direction of the

plane of its axis he found that every section gave a form exactly similar to the form of the operculum ; and so he proved in this way that the form of a turbinated shell is produced by the revolution of the perimeter of the figure formed by the operculum round the axis of the shell. In the nautilus this figure is an ellipse which revolves round its minor axis and increases in geometrical progression without ever changing its form as it revolves. The operculum being of a fixed form, as the shell grew it increased in size proportionately, and thus formed a very

Fig. 100.—Vasum turbinellus, showing
both Forms of Spiral.

convenient measure of the shell itself and all its parts, inasmuch as the curve of the shell possessed the peculiar properties of the logarithmic spiral. Nor was the extension of this animal's dwelling formed by merely pushing the operculum forward, but by the more precise method of depositing additional matter along the lower margin of the shell which formed the tangent of the curve. In Fig. 96 I have photographed the section of a nautilus shell (*N. pompilius*, from New Britain) so as to show the spiral within, and this should be compared with Fig. 97, which was drawn for me by a Senior Wrangler as an academic example of a logarithmic, or equiangular spiral.

It may be noticed here that Mr. A. H. Church's application of the logarithmic spiral, as an ideal formula for "uniform growth" to phyllotaxis, will serve the conchologist equally well in the present instance ; for certainly this nautilus is so nearly a logarithmic spiral that the difference between the two should easily be expressed in a mathematical formula which might give —for the first time—an accurate definition and description of the shell. And the appropriateness of the spiral chosen is prettily apparent from the fact that in two dimensions the logarithmic spiral is the only curve in which one part differs from another in size only, but not in shape. This property naturally follows

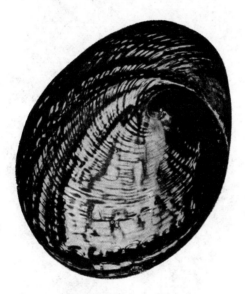

Fig. 101.—Haliotis splendens (California).

from the definition of an equiangular spiral, but it brings out very vividly the essential character of such a curve as a line of growth. Professor Goodsir, and Mr. A. H. Church after him, have considered that the logarithmic spiral is a manifestation of the energy which is at work in the increase of organic bodies : *Spira mirabilis*, as Bernouilli called it (in *Acta Eruditorum*, 1691), and gave it to the motto *Eadem Mutata Resurgo*, because it reproduces itself both in its involute and its evolute. Can we further say that the ammonite, of which I reproduce an example from the Lower Lias of Lyme Regis (Fig. 98), has not survived as a living organism, because the sweep of its curve is not wide enough for truly vital expansion, and does not, in fact, correspond

so nearly to the curve of perfect growth as the living nautilus of Fig. 96? It may be equally significant that the more generous outline of the external spiral on *Haliotis splendens* (Fig. 101) corresponds to the logarithmic spiral in Fig. 31, Chap. II., and only differs from the curve of the nautilus on the side of the increase instead of decrease, and may therefore have had a greater chance of survival. Similar comparisons with the logarithmic spiral

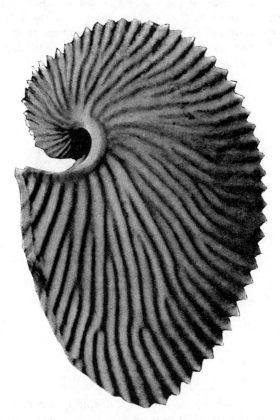

FIG. 102.—ARGONAUTA ARGO.

may be profitably made in the case of the beautiful external spirals clearly marked upon the shells of *H. gigantea* from the Corean Archipelago; of *H. cunninghamii* from Australasia; and of *H. midæ* from the Cape of Good Hope. The first of these three exhibits an especially wide sweep in its outline after the first curves of the spiral have begun to grow and to expand. It may be further noticed that curves closely approaching the logarithmic spiral occur in such minute specimens of life as the *Infusoria*, described by Stein, especially in *Stentor cœruleus;*

so that Sir John Leslie's recognition of the " organic aspect " of this curve was perhaps wiser than he realised. (See Appendix IV.)

Biologists may not see anything very profound in the approximation here illustrated of a logarithmic spiral to a shell; for they know that the spiral curves in the nautilus are due to growth and gravity acting on an elastic substance, and mathematicians tell them that the logarithmic curve merely expresses in a convenient form certain common and usual relations. Still, there is no doubt whatever that the mathematical curve provides an interesting definition of the shell, and I have never yet seen the apparently inevitable corollary to this simple fact, which would be to explain what the component factors are which would produce a logarithmic curve in the nautilus, and how those factors would have to differ in order to produce some other curve.

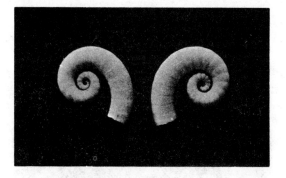

FIG. 103.—SPIRULA PERONII (cf. Figs. 29 and 30).

I would venture to suggest this as an interesting thesis to future examiners.

I have abridged my description of Canon Moseley's investiga- from from Goodsir's " Anatomical Memoirs," edited by Sir William Turner (Edinburgh, 1868, Vol. II., pp. 205 *et seq.*), and I insert it here in order to lay stress upon the fact that if any particular class of natural objects were to be chosen by a student for comparative purposes when considering a mathematical and yet creative art such as architecture, shells would be the most suitable, inasmuch as they suggest with particular appropriateness those structural and mathematical problems which a builder so often has to face. Leonardo da Vinci, who to his other capacities added the practical knowledge of architecture, was certainly a student of shells also, as we shall see later on; but for the present I will only draw your attention to the deliberate copy of an ammonite in his sketch for the " Leda " in the Windsor collection (Fig. 104), and to the obvious copy of

a similar shell in the helmet (Fig. 105) of his " Scipio Africanus."
Among modern artists who have also introduced the lines of

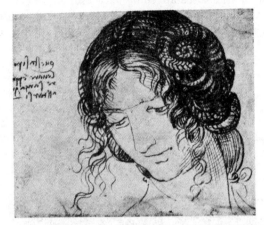

FIG. 104.—LEONARDO DA VINCI'S STUDY FOR THE " LEDA,"
SHOWING HAIR ARRANGED LIKE AN AMMONITE.
(From the Windsor Collection.)

shells very recognisably in the most beautiful of their designs
I may mention Gilbert, the sculptor.

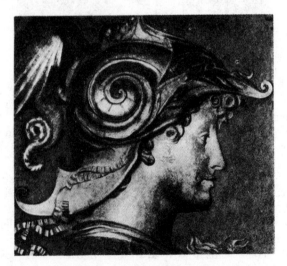

FIG. 105.—BUST OF SCIPIO AFRICANUS.
Bas-relief by Leonardo da Vinci (showing shell ornament on helmet).

Professor Goodsir adopted the logarithmic spiral as a kind of
teleological chart in Nature's beautiful designs. Taking Canon
Moseley's investigations as his text, he tried to illustrate their

logical corollary that the form and law of growth of an organic
body being known, its form at any future time might be made
a matter of mathematical elucidation. Following out with
astonishing fidelity the line of investigation laid down by
Leonardo da Vinci three centuries before, Professor Goodsir
asked when it would be possible, by ascertaining the accurate
shape, form, and proportion between the parts, organs, and whole
body of any animal, to advance anatomical study geometrically.
One of his most enthusiastic disciples, D. R. Hay (" On the
Human Figure," 1849 ; " Natural Principles of Beauty," 1852 ;
" The Science of Beauty," 1856), examined the geometric outline
of the human body, just as Leonardo is said to have done when

FIG. 106. — HORIZONTAL
SECTION OF HAPLO-
PHRAGMIUM SCITULUM.
× 40.

(Brady's Foraminifera.
Challenger Reports.)

FIG. 107.—CORNUSPIRA FOLIACEA. × 15.
(Brady's Foraminifera. *Challenger* Reports.)

the Aphrodite of Praxiteles was discovered, and produced a
certain harmonic proportion, by following which a correct anato-
mical outline could be drawn from a mathematical diagram.
What Goodsir sought for all his life was some physiological law
ruling the form and growth of organism as gravitation is held
to prevail in the physical world. If, said he, from the geometric
curves of the planets' orbits Newton deduced the law of the
force, may we not learn " the law of the force " in natural objects
also when we have got their mathematical forms ? It may be
very long before we do so, because very few biologists seem
to be mathematicians as well. But if ever this does come to
pass, Canon Moseley's paper should be taken as the beginning
of a new epoch in the scientific description of natural forms.

Professor Goodsir considered that biology owed its progress

to the study of final causes, to the study of the remarkable adaptation of structures to particular functions. This is not the most fertile mode of procedure in physical or chemical investigations, owing to the difference between organic and inorganic bodies. For each individual organism forms a system in which the reason why its parts are adapted to each other may be studied. But it is impossible to put the solar system under our eye and examine it in order to explain the sun. I must again emphasise the fact that Newton showed in his " Principia " that if attraction had generally varied as the inverse cube instead of as the inverse square of the distance,

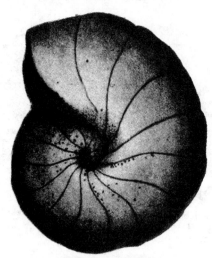

FIG. 108.—CYCLAMMINA CANCELLATA. × 15.
(Brady's Foraminifera. *Challenger* Reports.)

the heavenly bodies would revolve, not in ellipses, but in logarithmic spirals, rapidly diffusing themselves and rushing off into space. If, therefore, asked Goodsir, the law of the square is the law of attraction, is the law of the cube (that is, of the cell, also) the law of production, and is the logarithmic spiral the manifestation of the law which is at work in the increase of organic bodies ? This is one of the questions which this book was written to discuss ; and it should be noted that the growth of systems seems to be expressed in the spiral nebula shown in Fig. 1, as opposed to the circling of completed weights in.the case of perfect planets which follow a fixed orbit, owing to the unvarying law of gravity. (See Chapter XX.)

A careful inspection of Figs. 96 and 411 will reveal the fascinating fact (which is common, I believe, to every nautilus, that

the last chamber or compartment in front of which the creature lived, instead of being the largest of all, is distinctly smaller than the one behind it ; a very pretty instance of Nature's unexpected asymmetry, which may be perhaps explained by the results of increasing age in the inhabitant of the shell. When the animal is not vigorous enough suitably to increase its dwelling it dies for lack of room. This is the only point in which Dr. Oliver Wendell Holmes does not seem quite accurate about his biology in his beautiful lines on the nautilus. (See Appendix VIII.)

In Fig. 45, Chap. II., I reproduced a photograph of the operculum of *Turbo marmoratus*. The operculum of the *Turbinidæ* has been called an " eyestone " and a " sea bean." It is a horny or

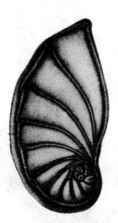

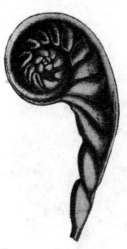

Fig. 109.—Cristellaria
Tricarinella. × 50.
(Brady's Foraminifera.
Challenger Reports.)

Fig. 110.—Cristellaria
Siddalliana. × 35.
(Brady's Foraminifera.
Challenger Reports.)

shelly plate secreted by gastropods and other molluscs, which serves to close the aperture of the shell when the animal is retracted. In *Trochus* the spiral on the inner side is as close as a watch-spring. In *Turbo olearius* it shows a beautiful figure like a logarithmic spiral with septa like the nautilus. In Figs. 106 to 110 I have added a few examples of flat spirals, somewhat like the nautilus, from those microscopic foraminifera which were exquisitely illustrated in the *Challenger* Reports.

In the flat spiral of the *Nautilus pompilius* in Fig. 96, the little projection noticeable in each compartment of the shell is the siphuncle, a membranous tube perforating the septa, which Owen thought was connected with the pericardium, and which may serve to lighten the shell by the passage of some gas into

its various chambers. In the nautilus it very generally projects
backwards, but in the ammonites it nearly always projects for-
wards (Fig. 411). Among ammonites of the family of *Stephano-
ceratidæ, Crioceras bifurcatum* has disconnected whorls, as if the
various coils had not joined together, and it looks something like a
ram's horn, or a rather complicated hook. *Oncyloceras spinigerum*
is a fossil tetrabranchiate cephalopod, in which the whorls are
also disconnected. *Siliquaria striata* has a shell that begins in
a close spiral and ends in irregular separated coils (see Fig. 16,
Chap. I.). *Cylindrella*, the cylinder-snail of the West India islands,

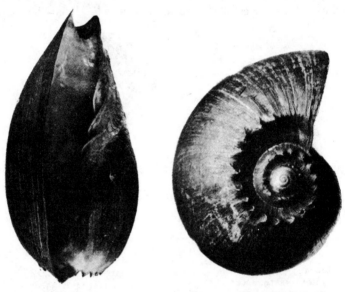

FIG. 111.—MELO ETHIOPICUS, FIG. 112.—MELO ETHIOPICUS,
 SHOWING UPRIGHT SPIRAL. SHOWING FLAT SPIRAL.

a palmonate gastropod of spiral form, has the last whorl detached
from the rest (see Fig. 103), with a circular mouth-opening.

In the British Museum of Natural History there are very
fine examples of *Macroscaphites gigas* and *Macroscaphites ivanii*,
which look like ammonites beginning to unroll themselves ;
and it is possible that the form of *Macroscaphites* may represent
the tendency of a shell contemporaneous with the later forms
of ammonite to expand its coil, and get a larger space for the
life and growth of the animal it shelters.

The position of the siphuncle may also have some connection
with the causes of survival, for while it is on the convex side of
Goniatites, and on the concave side of *Clymenia*, it is placed in
the middle in the nautilus. In " Les Enchainements du Monde

Animal dans les Temps Géologiques " (Paris, 1883), M. Albert Gaudry shows that *Orthoceras* (with its siphuncle in the middle) is in fact, as Barrande thought, " a straight nautilus," and the intermediate steps in development may be traced through *Aploceras*, which shows a slight curvature to the right at the thin end, and *Nautiloceras*, a hook-like formation with disconnected whorls. In the same way M. Gaudry suggests that

FIG. 113.—TROPHON GEVERSIANUS.
(From Southern Patagonia.)

FIG. 114.—ACANTHINA IMBRICATA.

Melia (with its siphuncle on the right side) becomes *Cyrtoceras* when the tip shows a slight curvature, and so may be supposed to pass through such forms as *Gyroceras* and *Ophidioceras* to the ammonite. (See Appendix VIII.)

Another example of the flat spiral is so curious that it may be added here. In the Imperial School of Mines at St. Petersburg is a fossil which has been given the misleading name of *Helicoprion*. A cast of it is placed among the fossils at the British Museum (Natural History) in South Kensington. In general

shape it very much recalls the form of the section of the ammonite shown in Fig. 33, Chap. II., but a closer examination shows that it is really a row of sharp teeth set upon a ribbon which is spirally constricted into that form. On the drawing of the logarithmic spiral in Fig. 97 I have placed letters that will explain the growth of this queer fossil, which has now been proved to be a single transverse row of teeth from the jaw of an elasmobranch fish. The new growth comes from the point M ; the teeth are used

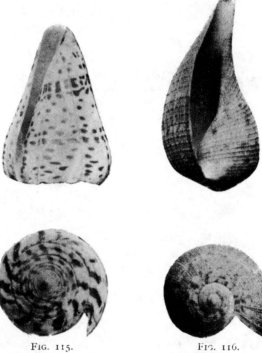

FIG. 115.
CONUS TESSELATUS.

FIG. 116.
PYRULA FICOIDES.

for biting at the point B ; and as they become worn out they move back in a spiral direction, the small teeth of the young fish being naturally in the centre of that spiral at A, and the larger teeth of the growing fish being at M.

An analogous case of this strange folding-up of disused teeth is to be found in *Cochliodus contortus*, a shark-like fish from the carboniferous limestone, with crushing teeth instead of the pointed teeth of *Helicoprion ;* and a very similar arrangement of growth may be observed in the teeth of the skate, which grow at M, are used at B, and, after beginning a spiral curve, fall away

before reaching anywhere near the point A—a much more con-
venient arrangement, it would seem, than that of carrying
disused teeth coiled up somewhere in the head, as must have been
the case with *Helicoprion*. (See Appendix V.)

Some shells, which are usually admired for their upright spiral
only, exhibit a very beautiful and significant plane spiral as
well, from which the actual growth of the mature shell from the
tiny protoconch may be studied. *Melo ethiopicus*, for instance,
is usually looked at in the position represented in Fig. 111, but

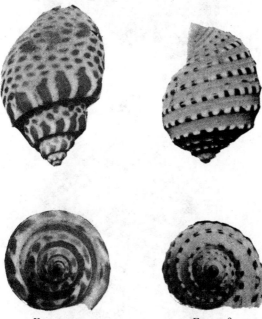

FIG. 117.
EBURNA SPIRATA

FIG. 118.
DOLIUM MACULATUM.

when observed from above, as in Fig. 112, it shows lines of growth
and development which may be compared with the nautilus in
Fig. 96. Exactly the same formations may be studied in the
two positions given for *Trophon geversianus* and *Acanthina
imbricata* in Figs. 113 and 114 ; and in Figs. 115 to 119 five other
examples are added. This suggests that it may be interesting
to consider the growth of a flower from the same two points of
view. The cyclamen is an admirable example of what I mean.
It is usually seen from the point of view photographed in
Fig. 121. But look at it vertically from above, and you
get the beautiful screw-propeller shown in Fig. 122, and in

Fig. 123 the spiral growth of the flower is still more clearly illustrated.

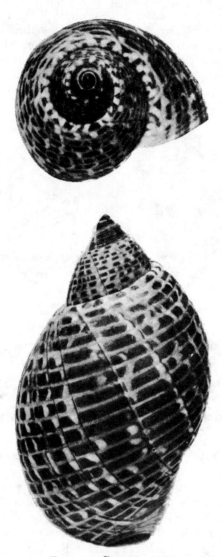

FIG. 119.—DOLIUM PERDIX.

Photographed from the side and from above to show the spiral formation of its growth.

An even closer parallel between the growth of shells and flowers may be quoted, and I give it here because the fact that the same phenomena are observable in such different organisms

may possibly suggest that the same principle of growth, or a similar distribution of vital energy, can be predicated in each

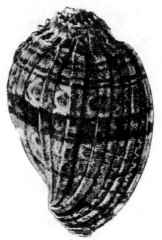

Fig. 120 —Harpa ventricosa. (By Hollar.)

Fig. 121.—Cyclamen. The Upright Spiral.

case. The shells shown in Figs. 125, 126, and 127, though all exhibiting an upright conical spiral of some kind, do not at first sight appear to be very striking instances of this formation. But photograph them from above vertically, and you see at once the principle on which the shell has gradually grown round its central "bud" in slowly widening curves. The *Murex saxatilis* is an especially beautiful instance of this, because it shows reverse curves as well as the main line of spiral growth.

Compare it with the growth of *Lilium auratum* (Fig. 128) when seen from above, and the analogy surely becomes very striking

FIG. 122.—CYCLAMEN, SHOWING FLAT SPIRAL.
(Seen from above.)

between the shell and the plant. The vital energy displayed in the growth of each seems certainly to have been distributed

FIG. 123.—CYCLAMEN, SHOWING FLAT
SPIRAL.
(Seen from beneath.)

along lines which admit of mathematical comparison, whether the "organic" curves of the logarithmic spiral be taken as its basis or not. Neither to the shell nor to the plant can this or any other mathematical formula be made rigidly and accurately

to apply ; yet we have come near enough for the purposes of definition ; and the fact that the organic object (in each case) shows a definite divergence—however delicately expressed—from mathematical exactness, is, as we shall see, the important fact for the later stages of our present inquiry. That subtle divergence is owing in this case to the presence of organic life. When the object displaying such divergences is inorganic, but a work of art, created by a man, we shall find that its beauty is largely owing to similar divergences from exact measurement.

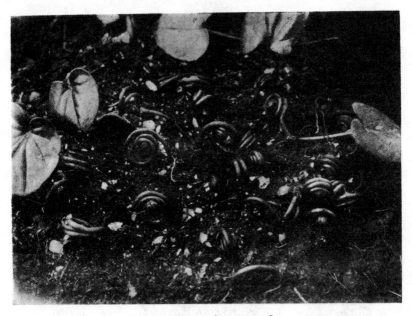

Fig. 124.—Spirally-coiled Fruit Stalks of Cyclamen europæum.

I have added a picture of an unfolding chrysanthemum to this chapter in order to show that the spiral arrangement of growth is far from uncommon when a young plant or flower gradually expands from the closed bud into the fully opened bloom (see Fig. 130). The Japanese in many lovely patterns (see Fig. 131) have made use of this arrangement. Mr. A. H. Church's work on Phyllotaxis provides even more beautiful examples. Some chrysanthemums retain the spiral formation of the petals after maturity, others do not. Dr. Wherry, who has made some most interesting contributions to the study of spirals, points out that in *Selenipedium grande, S. longifolium,* and *S. conchiferum* the twisted petals are so arranged that the direction

of the spiral is right-handed on each side. " They are not heteronymous, *i.e.*, the right petal with a left twist and the left petal with a right twist, as in all antelopes' horns, nor are they arranged homonymously as in most sheep's horns, but the twisted petals have the same direction on each side, and in the cases above mentioned the right-handed spiral is always present." He further found that they only took this formation after they

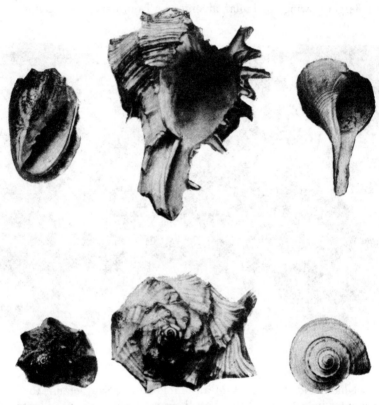

FIG. 125.
VOLUTA VESPERTILIO.

FIG. 126.
MUREX SAXATILIS.

FIG. 127.
SYCOTYPUS
CANALICULATUS.

had grown straight for about 2 inches. He suggests as a reason some " slight force acting continuously during growth, such as would be made by the circulation if there were a difference in the circulation of the sap in the two edges of each petal," a difference which would act alike in each and make each petal twist in the same way. I shall have more to say concerning the horns mentioned by Dr. Wherry in later pages, and I now pass on to a more particular consideration of spiral formations

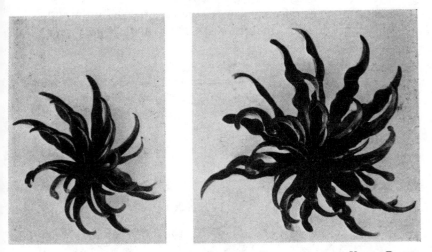

FIGS. 128 AND 129.—SPIRAL FORMATION OF LEAVES IN LILIUM AURATUM, YOUNG PLANTS
PHOTOGRAPHED VERTICALLY.
Compare the growth in the shell *Murex saxatilis* (Fig. 126), and especially in *Murex monodon*.

in plants and to Mr. A. H. Church's development of the logarithmic spiral conventions in phyllotaxis. Their special value is

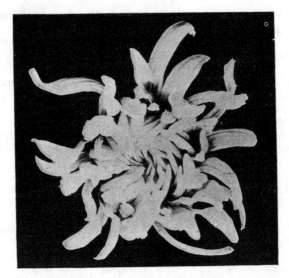

FIG. 130.—FLOWER OF CHRYSANTHEMUM SHOWING SPIRAL
FOLDING OF PETALS.

that they emphasise the fact that *all* curves of growth are spiral derivatives. Obviously this gives us a starting point for the

consideration of leaf-outline and countless other beautiful forms, which are, in fact, the criteria of grace and elegance for all artists.

FIG. 131.—JAPANESE DESIGN, SHOWING SPIRAL PATTERN OF
CHRYSANTHEMUMS.

NOTES TO CHAPTER IV.

LOGARITHMIC SPIRAL.—A general description of the logarithmic or equiangular spiral is given in the Appendix.

FIGS. 102 AND 36 were sent by "M. J." with the following comments :—

" I notice you are allowing several correspondents to enlarge your very charming collection of shells. With reference more particularly to the spirals shown in *Nautilus pompilius* and *Haliotis splendens,* permit me to send you a photograph of my *Argonauta argo* (Fig. 102), a delicately thin shell, which seems to me to show a line of growth midway between the two just mentioned, and as beautiful as either."

FIG. 103.—For this photograph I have to thank Mr. E. du Boulay, who said :—

" I am sending you herewith a photo of two small spiral shells I possess, as you may like to reproduce it in your articles on spiral growths. They are beautifully formed, of a creamy white colour, and are slightly smaller than the photo. No doubt you will recognise them. The spiral of the shells is all in one plane, *i.e.,* they lie quite flat on the table." (See Appendix VIII.)

FIG. 120. HOLLAR'S SHELLS (see Fig. 82, Chap. III.).—As there is always a special interest in Hollar's engravings of shells, I reproduce these from the collection in the Print Room of the British Museum. They are not exact enough to satisfy the modern conchologist, but they show a recognition of beauty in form which deserves wider appreciation than they appear to have obtained. (See Chap. XIX.)

Fig. 124. Spiral Fruit-Stalks of Cyclamen.—This photograph was accompanied by the following interesting letter from " Q " :—

" Many interesting examples of spiral twisting occur in the elongated flower stalks of several widely related plants as these pass on into the fruiting condition. In all cases the directions of the spiral twisting is apparently either R or L, and no observations have been made to determine their numerical relations.

" Thus, according to Conard, as observed in the United States, the stems of the flowers of many water-lilies, growing in deep water 3 feet to 15 feet, become spirally coiled, as the withered blossoms are intentionally pulled beneath the surface, in order that the fruits may be developed under the surface and free from desiccation. In deep water *Nymphœa flava*, *N. odorata*, *N. tuberosa*, the North American forms, as also *N. alba*, the European species growing wild in this country, present a marked coiling of the stem to as many as two or even eight to ten turns of a helix, 1 inch to 4 inches in diameter, so that the fruit develops at a distance of a foot or so from the bottom, and often quite imbedded in the mass of algæ or other vegetative matter on the mud. The object of the movement is usually said to be a means of protection against injurious animals, fish, and also from the mechanical action of currents.

" The classical botanical example of this phenomenon is found in another aquatic, the submerged, grass-like *Vallisneria spiralis*, growing in water a foot or more deep. Here the female flowers are extended to the surface of the water by a long slender stalk, for purposes of pollination by means of remarkable free-floating male flowers. After pollination a very exaggerated spiral looping of the stem draws the developing fruits on a close spiral, so that they mature at the bottom of the pond. A comparable phenomenon occurs in the fruit stalks of *Cyclamen europæum*, of which the photograph I send you affords a particularly charming example (Fig. 124). The relatively long and slender internode of the flower stalk undergoes spiral contraction, and the green capsules are drawn underground in late autumn, and hibernate under the earth, the seeds only attaining maturity in the second summer. Though the primary object may be, again, an attempt to avoid desiccation in the case of the maturing fruit, the story, according to Kerner, becomes much more complicated by the fact that the seeds, though maturing underground, still require to be dispersed. When the seeds are ready, desiccation and severance of the twisted fruit stalk then has the effect of pulling the fruit out of the ground again, the lower portion of the stalk rots, and the part which is left forms a claw surmounting the capsule. The latter, which is full of seeds, lies loose on the ground, and adheres to the foot of any animal that treads on it. This emphasises the fact that the spiral looping is in all cases a means of furthering the protection of the developing seeds, and has no relation to the actual planting of them."

Nautilus Pompilius.—See the paper by Professor Huxley read before the Linnæan Society, on June 3rd, 1858, which was published in the same journal containing the two immortal papers by Darwin and Wallace on the Origin of Species. Owen also has a special " Memoir on the Pearly Nautilus " (1832). (See also Appendix IV. and VIII.)

PROFESSOR GOODSIR.—I am glad of the opportunity of giving further publicity to this letter from " M. D." :—

" In your articles mention is made of Professor Goodsir's work. It is so rarely that modern writers do justice either to him or to Moseley, in this direction, that I think you may be interested to learn that Goodsir was buried in Dean Cemetery, Edinburgh, in 1867, and, following his instructions, his brother directed the mason to carve a logarithmic spiral on the granite obelisk above his grave ; but this was so badly executed that the family set up a bronze medallion in its place, as may still be seen. On p. 205 of Goodsir's ' Anatomical Memoirs ' (Edinburgh : A. and C. Black, 1868), edited by Sir William Turner, will be found a reprint of two lectures delivered in 1849, in which Goodsir expressed his views on the employment of mathematical modes of investigation in the study of organic forms, and directed attention to Moseley's geometrical examination of shells and the importance of the logarithmic spiral in their development. The first number of ' Annals of Anatomy and Physiology,' edited by John Goodsir, appeared in February, 1850, but only three parts were issued. You are doing a service to research by directing attention to work of this kind, and by showing the further developments of which the theory is capable. But you will never, I fear, convince the hidebound specialist !

<div align="right">" M. D."</div>

CHAPTER V

Botany : The Meaning of Spiral Leaf Arrangements

" The leaf always turns its upper side towards the sky so that it may be better able to receive the dew over its whole surface ; and these leaves are arranged on the plants in such a way that one covers another as little as possible. This alternation provides open spaces through which the sun and air may penetrate. The arrangement is such that drops from the first leaf fall on the fourth leaf in some cases and on the sixth in others."—LEONARDO DA VINCI (*Inst. de France*).

PROVISION FOR AIR AND SUNLIGHT—OVERLAPPING OF OLD LEAVES BY YOUNG—ADVANTAGES OF OVERLAPPING IN INTENSE GLARE—SPIRAL PLAN FOR MINIMUM OVERLAP—THE IDEAL ANGLE—FIBONACCI SERIES—MR. A. H. CHURCH ON LOGARITHMIC SPIRALS IN PHYLLOTAXIS.

THE fact that the leaves of a majority of higher plants are arranged in a spiral sequence up the stem, whether on an elongated leafy shoot like a branch of *Pinus*, or an *Araucaria* (Fig. 132), or again in a spiral rosette, as in the case of a houseleek (Fig. 135) or dandelion, is so obvious that it may be taken as a general and fundamental phenomenon of plant-construction. Nor is an intelligible reason for this arrangement far to seek ; a slight consideration of what a leaf really is, and what is its purpose in life, throws an extremely interesting light on this phase of plant form. All land plants may be said to produce leaves as appendages developed from the growing-points of their stems in the form of flat laminæ, which present as great a surface as possible to the external environment of air and sunshine. In this manner the plant produces an enormously increased body surface for a given amount of living material, which comes into direct connection with atmospheric gases and with the incident rays of the sun, from which latter energy is utilised for building up the substance of the plant.

Again, these leaf-members are being continually produced by the growing apex of the plant. They arise behind the actual growing apex in serial succession. That is to say, they go on being produced in rhythmic sequence, and consequently, in the course of time, come to present a definite pattern, unless new and special growth-factors intervene to spoil the appearance of the arrangement. A new problem is at once presented to the plant, in that it is evident that with continued production of

new leaves, some of the younger ones must inevitably overlap
and shade the older ones ; and this must go on indefinitely ;
the older leaves are continually being superseded by younger ones,
and the working capacity of many older ones may be wasted.
Thus, one of the first considerations in the construction of a
leafy shoot will be to find the optimum arrangement, so that
with any number of leaves of the same shape there is the minimum
of overlapping or superposition, and consequently the maximum
exposure to sun and air. Further, it is sufficiently obvious

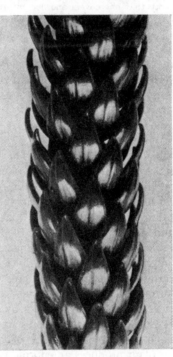

FIG. 132.—ARAUCARIA. LEAFY SHOOT
SPIRAL SYSTEM (5 × 8).

that the effect of any given pattern may be very considerably
modified by making special arrangements at a subsequent
period in the growth of the shoot. Thus, plants by (1) putting
a twist on the main stem ; (2) by making long, slender leaf-
stalks to the leaves ; (3) by dissecting the foliage laminæ to let
diffuse light through to leaves below ; or (4) by elongating the
internodes which space the leaves farther apart, may entirely
alter the effect of the bud-construction laid down at the actual
apex.

The main problem of phyllotaxis is however, concerned

principally with the primary arrangement established at the apex itself, irrespective of any such secondary " compensations." Further, the problem will be seen to be a double one, of two converse propositions. Firstly, if the light be feeble, and all the light that can be obtained be wanted, the problem will be to get the arrangement which mathematically gives the maximum exposure and the minimum of overlapping. Secondly, in the case of exposure to intense sun glare, which may induce excessive desiccation beyond the possibility of life for aqueous protoplasm,

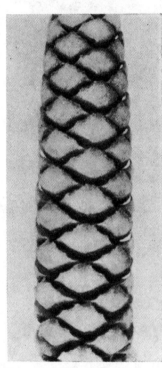

FIG. 133.—MALE CONE OF STAN-
GERIA (A CYCAD).

the ideal may be to obtain a position of minimum illumination for vertical light, and consequently a maximum of overlapping ; the covered leaves still obtaining a weak, shade light sufficient for their metabolism. In conclusion, therefore, the majority of plants may, it is true, aim at maximum exposure ; but there will always be some which, either now or at some past epoch of their history, have been so affected by intense light as to have assumed patterns which promote considerable overlapping. Both conditions are widely distributed in the plant world, and must be carefully distinguished. Either condition may have

been inherited in the past, and may now be compensated for to an extent which renders it sufficiently successful for the modern mode of life of the plant concerned.

The case of maximum overlapping is obviously given by the arrangement of leaves in " whorls " (circles), in which successive or alternate series are accurately superposed. Examples of decussate (four-rowed), and distichous (two vertical rows), are the commonest types of symmetrical leaf-arrangement, especially

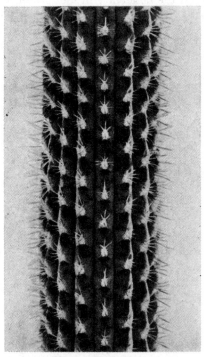

FIG. 134.—CEREUS. SPINES ARRANGED IN
SPIRALS, GIVING VERTICAL ORTHO-
STICHIES IN THE ADULT STEM.

frequent (though by no means invariably so) in so-called xerophytic genera (see Fig. 138). On the other hand, the problem of minimum overlapping is not so easily grasped. The solution was first clearly presented as a mathematical problem by Professor Wiesner in 1875. To secure minimum overlapping leaves must be arranged in a single spiral sequence, each being separated from the succeeding one by an angle of about 137° 30′ 28″, this being the inverse angle of $\dfrac{\sqrt{5}-1}{2}$ of 360°. The angle 137° 30′ 27·951″ may be termed the " ideal angle " for leaf-

distribution ; and we now know how to start building a plant shoot for a definite purpose connected with the way in which a green plant gets its living. In fact, the minimum of super-position will be given when leaves are placed round the stem at a divergence angle of 137° 30' 27·951" ; at this ideal angle, pro-vided the shoot kept perfectly straight, no two leaves would be ever exactly one over the other.

To obtain minimum superposition and maximum exposure, then, it is necessary for the plant-apex to lay down leaves at an angle of about $137\frac{1}{2}°$; to obtain maximum superposition a series

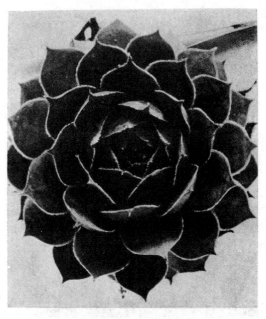

FIG. 135.—HOUSELEEK. SPIRAL ROSETTE.

of vertical rows of the two-rowed distichous type would be the simplest balanced construction (c.f. *Gasteria*). On the other hand, it is important to remember that the apex of a given plant cannot be regarded as discriminating with regard to its external environment, nor can it ever change its nature by direct action of free will, nor is it sufficiently " intelligent " to know that a change of mathematical construction would be beneficial ; and still less what mathematical construction would be the best under the given circumstances. All that a plant can do is to vary, to make blind shots at constructions, or to " mutate " as it is now termed ; and the most suitable of these constructions will in the long run be isolated by the action of natural selection.

Meanwhile, as an alternative for immediate change in the primary apical construction, the plant may continue to make the best of the system handed down to it from ancestral stages, by other variations or mutations in the nature of compensation-adjustments. For example, a spirally constructed houseleek (Fig. 135), on exposure to intense desiccation and xerophytic environment, shuts down its admirably spaced spiral system to a close rosette in which only the leaf tips are exposed. A cactus which has wholly lost its leaves may, nevertheless, retain remarkably beautiful spiral construction, evolved at a time when its ancestors bore leaves, and were not xerophytic succulents.

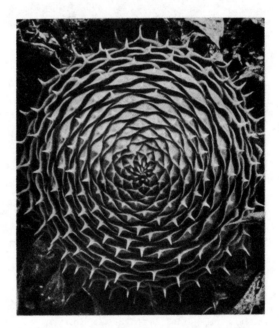

FIG. 136.—SEMPERVIVUM. SPIRAL ROSETTE.

In the same way the ash tree, by producing long-stalked, drooping, compound leaves, entirely eliminates the effect of its original decussate bud-construction. In fact, it soon becomes evident, that the best and clearest phyllotaxis patterns will be observed in cases in which the plant members, since they no longer exercise the function of leaves, may retain an hereditary pattern without any necessity for compensatory disturbances. Thus it follows that the arrangement of flower buds, fruits, and scales may afford the best visible expressions of pattern simply because there has been little necessity for subsequently inter fering with them. The florets and fruits on the disc of a

sunflower or daisy, the scales of a pine cone, and the spines of a leafless cactus thus become the classical, since the most nearly exact, examples of spiral patterns in the plant kingdom.

So far, then, we know what plants should be aiming at in their leaf arrangement ; and the fact remains that the construction traced in a given plant is often a very complex compromise between opposing factors. But, since we are at present interested more particularly in spiral patterns, it remains to discuss what mechanism there may be at the plant's disposal, which may enable it to work out a spiral sequence in the production of young

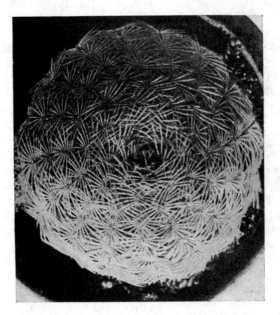

FIG. 137.—ECHINOCACTUS. SPIRAL SERIES OF TUFTS
OF SPINES, REPLACING LEAVES.

leaves at the apex of the shoot, and give in an approximately satisfactory manner an ideal angle of distribution. We should like to know, also, to what extent the ideal angle may be actually attained in the plant, or whether a very rough approximation may prove sufficient. Since angular measurements in terms of anything below a degree are extremely vague in dealing with any actual plant, owing to the difficulty of accurately centring a shoot, the subject has been commonly approached from another standpoint ; and this has, in fact, proved the method by means of which the whole problem has been worked out.

The same ratio $\dfrac{\sqrt{5}-1}{2}$ is the solution of another problem

involving the series of numbers obtained by summation of $1 + 2 = 3, 2 + 3 = 5, 3 + 5 = 8$, and so on. This series of num-· bers, 1, 2, 3, 5, 8, 13, 21, 34, etc., having been apparently first dis- cussed by an Italian mathematician of the thirteenth century, may be conveniently described as the Fibonacci series. The peculiar property of this series lies in the fact that the ratio of any succes- sive pair of these numbers is approximately constant ; while, as we go up the series, this ratio approaches a limit, the limit being,

in fact, $\dfrac{\sqrt{5} - 1}{2}$. This mathema- tical property might have had no bearing on botany in itself ; but the fact remains that these Fibo- nacci numbers are so commonly presented as giving the numbers of the spiral rows of members on plant shoots, that they cannot be wholly meaningless or accidental. Thus, flowers are commonly 3 or 5 parted ; the scales on pine cones run in 5, 8 or 13 curved series ; the curved series on a daisy disc are 21 and 34, while there are almost constantly 13 green in- volucral leaves at the back of the capitulum ; on a sunflower disc the rows of florets may be 34 and 55, and in the finest heads 89 and 144. It is impossible to avoid putting these facts to- gether, and assuming (as has been done in botany) that the occur- rence of such numbers in the

FIG. 138.—GASTERIA, SHOWING MAXIMUM SUPERPOSITION. (No torsion visible.)

case of spirally constructed systems bears a definite relation fo the Fibonacci ratio $\dfrac{\sqrt{5} - 1}{2}$, and that the relation has to do with the Fibonacci or ideal angle of 137° 30′ 28″.

In other words, *the fact that plants express their leaf arrangement in terms of Fibonacci numbers, so frequently that it passes for the normal case, is the proof that they are aiming at the utilisation of the Fibonacci angle which will give minimum superposition and maxi- mum exposure to their assimilating members.* The fact that these Fibonacci numbers dominated leaf-arrangements in the case of higher plants was first established by the German botanists, Schimper and Braun (1830), and the French, Bravais (1837) ;

at this date mathematical constructions based on these numbers were introduced into botany, and these served to tabulate the facts of observation. Thus a spiral sequence in which the leaves were $\frac{2}{5}$ of $360° = 144°$ away from each other was termed a $\frac{2}{5}$ phyllotaxis as early as 1754 by Bonnet and a mathematician, Calandrini. In this system superposition would take place after five leaves had been laid down, and the pattern would ultimately give five vertical rows of leaves with one spiral series winding round the stem. Schimper tabulated other arrangements which follow according to the properties of the Fibonacci

FIG. 139.—GASTERIA NIGRICANS.
(An older shoot showing the effects of torsion.)

series, and they are commonly found on plant shoots. To take four simple examples :—

Fractional divergence.	Angular divergence.	Number of leaves before superposition
$\frac{2}{5}$	$144°$	5
$\frac{3}{8}$	$135°$	8
$\frac{5}{13}$	$138° 27' 41\cdot54''$	13
$\frac{8}{21}$	$137° 8' 34\cdot29''$	21

In such constructions it will be noted that a fairly close approximation to the ideal angle is obtained with a $\frac{5}{13}$ divergence ; and the approximation is closer in higher systems. In a sunflower disc the angle might be as near as $137° 30' 0''$. These mathematical figures, however, only hold for the special case of adult members all of equal size, or equally spaced with regard to one another ; and it was for such adult systems that these generalisa-

tions were drawn up. It is, in fact, quite easy to show in a section
of a bud apex, which is building a so-called $\frac{2}{5}$ system, that the
angle between successive primordia is nothing like the 144°
postulated, but is very approximately 137°. The fact that
these divergences do not hold for the growing-point where the
arrangement is really being made has occupied the attention of
many botanists of the last generation, and has led to great dis-
cussion.

The special point of importance at present, however, is to

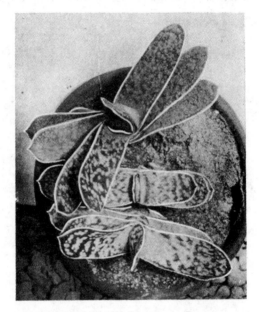

FIG. 140.—YOUNG PLANTS OF GASTERIA.
(One shows torsion of main stem eliminating effects of
superposition ; *i.e.* one has a mutation lucky for
weak light, which might be eliminated in intense sun.)

note that such sets of data merely tabulate the facts observed
on plant shoots ; they afford no insight whatever into the cause
or the mode of operation of the mechanism which may be required
to produce the effects so accurately ; and it still remains to
consider how such patterns may be initiated and maintained
at the apex of a plant shoot. To begin with, at the actual
growing-point the problem is clearly somewhat different, since
the young developing members are of different sizes, and are all
growing together in a correlated system. In such cases it becomes
necessary to call in the hypothesis of a growing spiral, which passes
on with ever-widening coils, of a type quite different from the

coils of a helix or spiral of Archimedes, in which the distance between the coils remains constant.

The ingenious suggestion made by Mr. A. H. Church, of Oxford (in 1901), combines the fact that theories of spiral growth must be founded on a consideration of logarithmic spirals with an admitted generalisation that lateral primordia are arranged in series, which possibly cross at right angles, or arise from primordia which present "orthogonal packing" (Schwendener, 1875). In such cases it appears reasonable to regard a phyllotaxis pattern as mapped out by logarithmic spirals, which intersect orthogonally, if not over their entire course, at any rate at a central

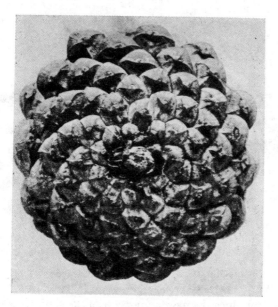

FIG. 141.—PINUS AUSTRIACA (DRY CONE).

region in which the new impulses may be considered to arise. Since such orthogonally intersecting spirals would also indicate the manner in which a growing-point might be sub-divided into regions representing equal distribution of energy, it is possible that the curve appearances may be in some manner correlated with a distribution of energy in some way comparable to equipotential. From such a standpoint the mechanism employed by the plant would thus be provisionally described as a *production of primordia from impulses originated at the points of intersection of two systems of equal growth distribution ; the numbers of these systems being determined, and usually maintained as a constant, by the plant.*

By actual observation of plants, it is seen that the numbers utilised are usually low, so long as the primordia are relatively large ; and one number is never more than twice the other. The ratio of the numbers thus ranges between 1 : 1 and 1 : 2. It now becomes interesting to express the previously tabulated phyllotaxis construction in terms of this postulated apical mechanism, and give the corrected angular divergences, as also the number of leaves laid down before superposition takes place. The results are very striking ; the four sets become :—

Phyllotaxis ratio.	Angular divergence.	Number of members before superposition.
2 : 3	138° 27' 42"	13
3 : 5	137° 38' 50"	34
5 : 8	137° 31' 41"	89
5 : 13	137° 30' 38"	233

It is at once apparent that in such growing systems which

Fig. 142.—Coralliophila
deburghiae.
(Bronn and Simroth.)

Fig. 143.—Horizontal Section
of Planispirina contraria
× 50.
(Brady's Foraminifera. *Challenger* Reports.)

actually reproduce the more important of the conditions obtaining at a plant apex, the approximation to the ideal angle is wonderfully close, being about one minute at (5 : 8) (the construction constant for a pine shoot) ; and even within one degree for such a low system as (2 : 3) (the so-called $\frac{2}{5}$ or quincuncial series). Not only so, but in such a simple spiral system as that expressed by (2 : 3), one cannot avoid being struck by the remarkable relationship of such a construction to the symmetrical systems expressed by (2 : 2) and (3 : 3). These latter would give accurately vertically superposed series of four and six members respectively, but the comparatively slight variation to (2 : 3) yields a perfectly efficient spiral system with almost minimum superposition at once.

The relation of such constructions, as expressed in terms of

these fundamental curves, *indicates the extreme simplicity of the " Mutation " required to change a shoot from the position of effective superposition to one of practical minimum superposition, and vice versâ.* Thus in the flowers of the common barberry, in which the floral construction pattern is inherited from that of the assimilation of shoots, all three of these patterns may occur, and even within the limits of the same inflorescence, *e.g.*, *Berberis*, gives not only whorled dimerous and trimerous flowers, but also spiral ones. In *Mahonia* the same series of constants may be traced in the construction of the inflorescence shoots. On the other hand, the same intimate relations, and the still closer approximation of such constructions to the ideal conditions postulated as the aim of the plant, may be again regarded as confirmatory evidence of the importance of the Fibonacci numbers, and of the value of this presentation of the subject in terms of logarithmic spirals.

The conditions at the growing apex are thus probably far more perfectly adjusted than may appear in the adult structures when final form is attained by a progressive cessation of growth in the members concerned. Finally, the intrinsic interest of the hypothesis of logarithmic spirals (Church) lies in the possibility of the reference of the actual mechanism of the process to molecular phenomena far beyond the present range of visible cell construction as examined in microscopic preparations of the plant apex. And, though such molecular phenomena may be at present far beyond the power of the botanist to follow, there can be little doubt that when physical knowledge is more levelled up, these generalisations will fall into their allotted niche in the general consideration of the molecular manifestations which express the marvellous constructive capacity of living matter.

To the figures of plants here illustrated I have added the shell (Fig. 142) *coralliophila Deburghiæ*, and also one of the microscopic foraminifera (Fig. 143) from Brady's section of the *Challenger* reports to indicate that the growth-mechanism of shells results in very similar structures to that of plants (cf. Figs. 126, 128, Chap. IV.).

NOTE TO CHAPTER V.

The Fibonacci series and angle should be compared with the ϕ series, which is mentioned in Chapter XX., and fully described in the Appendix.

CHAPTER VI

" Although human subtlety makes a variety of inventions answering by different means to the same end, it will never devise an invention more beautiful, more simple, or more direct than does Nature, because in her inventions nothing is lacking and nothing is superfluous."—LEONARDO DA VINCI (Windsor MSS.).

THE SPIRAL THEORY OF SCHIMPER—GROWING SYSTEMS IN PLACE OF ADULT CONSTRUCTION—A LOGARITHMIC SPIRAL ON A PLANE SURFACE—THE FIBONACCI SERIES AGAIN—RADIAL GROWTH AND SPIRAL PATTERNS—A STANDARD FOR COMPARISON—EXAMPLES OF DIFFERENT SYSTEMS.

IT is a curious fact in the history of scientific research that investigations into the system on which leaves on a stem, or the various members of a plant, are arranged, begun by Leonardo da Vinci four centuries ago, should have only just arrived at something approaching to an intelligibly philosophical explanation, as described in the last chapter. For 150 years what is known as the " Spiral Theory " of Schimper formed the foundation of all studies in phyllotaxis ; that is to say, in the consideration of a cylindrical stem bearing leaves as an axis and its appendages. In 1754 botanists were still dominated by the doctrines of Constancy of Species, and as morphology dealt solely with adult structures, it arrived at the very simple ideal of a formal account of the framework of the fully matured stem, leaves, flowers, and fruit ; developmental stages, and buds, being considered unessential. Bonnet therefore took a mature stem, and chose upon it a leaf (A), which came (he said) exactly above another (M). He then showed that the intermediate leaves were arranged as a spiral, exactly as if (M) were the bottom point of the cylinder in Fig. 56, Chap. II., and the intermediate leaves were spirally arranged along the line MCDA until they reached (A) at the topmost point of the cylinder. By the help of the mathematician Calandrini, he formulated a correct geometrical conception of a helix, with parallel screw-thread winding round the cylindrical stem. This mathematical conception was arranged to fit certain definite facts, and, with this as a basis, Schimper and Braun (1830–35) raised an enormous edifice of beautifully precise nomenclature.

But by degrees appeared the results of such ideas as were contained in Goethe's " Theory of the Metamorphosis of Leaves," in Lamarck's " Researches into Development and Heredity," in Von Mohl's " Discovery of the Growing Substance in Plants," in Darwin's great " Hypothesis of Evolution." Gradually the type plant of the new morphologist became the growing body, as seen in the growth of the members, growth of the axes, growth of the whole individual, growth of the race. But while critics exclaimed that Bonnet's mathematical conception had been gratuitously introduced into the plant, and was " merely playing with the properties of numbers," they did not apparently realise what Bonnet himself thoroughly understood, that, being ignorant of protoplasmic growth, he dealt solely with adult structures which had ceased growing.

A few years ago Mr. A. H. Church, a botanist at Oxford, came forward with a new mathematical conception, founded on the fresh mathematical data afforded by the transition of the morphological standpoint from that of adult construction to that of growing systems. As a starting-point for such a conception Mr. Church very properly propounded a certain ideal condition. Just as, in the consideration of the Newtonian laws of motion, the purely abstract and mathematical conception of " uniform motion " precedes that of varying motion, so the growth of a mass of protoplasm may be conceived as a " uniform growth," expansion taking place around a hypothetical central point From this Mr. Church deduces the hypothesis that logarithmic spiral curves (see Fig. 97, Chap. IV.), with the straight line and circle as limiting cases, are the sole curves of uniform growth-expansion. Spiral phyllotáxis must, in future, therefore be based on a logarithmic spiral on a plane surface, and not on Bonnet's old idea of a helix winding on a cylinder, which is merely the expression of the attainment of uniform volume by members in a special series, and which, if carried on to a plane as a spiral with equal screw-thread, would become a spiral of Archimedes.

Of course, when applied to the living and admittedly irregularly growing plant, the conception of a logarithmic spiral would be as difficult to prove by actual measurement as was Bonnet's theoretical helix. But now the standpoint is changed, it becomes possible not only to deal with uniformly growing systems, to deduce mathematically their various properties, to watch them (as it were) grow on paper, but also (as soon as the properties of uniform growth are ascertained) to study the possibility of varying rates of growth, and to state the growth of an irregular body in mathematical terms as precise as those which indicate the erratic orbit of a comet.

Clearly, there can be no objection, as Mr. Church points out, to the application of a mathematical conception in itself either to phyllotaxis and the arrangement of leaves upon a stalk, or to conchology and the growth of the nautilus. Everything in Nature is capable of mathematical expression if the conditions are only sufficiently well known ; the real difficulty is to select a fundamental conception which will admit of modification when new factors are introduced. In other words, if the genetic spiral be regarded mathematically as winding from infinity to infinity, and being engaged in the production of similar members, it can only be represented by the logarithmic spiral which makes equal angles with all *radii vectores*. " Eadem mutata resurgit." These spirals, representing phases of the laws of mathematical growth around a point, constitute in hydro-dynamics the curves of spiral-vortex movement, and their application to magnetism has been fully investigated by Clerk Maxwell. Mr. Church clearly suggests that the distribution of living energy follows lines identical with those of electrical energy, for example, and that a phyllotaxis diagram, or (as I should add) the plan of a nautilus, is comparable with electrical lines of equipotential. The theory, if correct, would be fundamental for all forms of growth, though it could be more easily observed in plant construction than in animals.

But, as we have explained above, the spiral theory worked out so completely by Schimper and Braun cannot be entirely neglected ; for, inasmuch as it first introduced methods of geometrical representation into the interpretation of growth, it deserves a place beside the Linnæan system of classification, and still forms the starting point for our consideration of the relative positions of the members of a plant. Mr. Church, therefore, to this extent makes use of it ; but he goes further both in the way of representing mechanical laws diagrammatically, and in separating the products of known mechanical laws from that part of the problem which cannot be called " mechanical," but is due to some inherent " organising property " in the protoplasm. In fact, even if Mr. Church's diagrams and observations be not accepted by practical botanists, they are of great and immediate interest as what may be termed architectural studies of vegetable life and energy.

Bonnet classified leaf arrangement into five types : (1) alternating, (2) decussate, (3) whorled, (4) quincuncial, (5) multiple spirals. His fourth type includes the " two-fifths spiral " already described, in which a spiral makes two revolutions to insert five members ; he also noticed variations in this system (really due to secondary effects), and described cases of right and left-handed

spirals. His fifth type contains the germ of Braun's *parastichies* and of the multijugate systems of Bravais, and he gave *Pinus* and *Abies* as examples. It was Schimper and Braun who gave the name of *orthostichies* to Bonnet's vertical rows, and *parastichies* to his parallel spirals ; while the number of leaves between two superposed members became a " cycle," tabulated in a series 1, 2, 3, 5, 8, 13, etc., which appears to have been first recognised by Leonardo da Pisa (Fibonacci) in the thirteenth century. The ratios of the numbers of members (being a denominator) to the turns of the spiral (being a numerator) were therefore expressed in a fractional form as follows : $\frac{1}{2}$, $\frac{1}{3}$, $\frac{2}{5}$, $\frac{3}{8}$, $\frac{5}{13}$, $\frac{8}{21}$, etc., and become reduced to angular measurements. The theory of Schimper and Braun, however, must stand or fall with the observation of *orthostichies ;* that is to say, according as a leaf which appears to stand vertically above any given leaf actually does so stand in fact. Unfortunately, the *orthostichies* can no more be proved to be straight than the angles can be measured. Yet the definite notation of the system, and the brevity and apparent simplicity with which it sums up complicated constructions, make it practically impossible to recast a new phraseology nowadays. Sachs disliked the whole thing. The Bravais brothers gallantly attempted to verify the angular measurements, but, after various other efforts, only found themselves involved in mathematical hypotheses which have proved of no practical value. Mr. A. H. Church, abandoning all helical or conical constructions, determined to plot out the construction upon a plane surface, basing all his deductions on a single hypothesis, the mathematical proposition for uniform growth, as that of a mechanical system in which equal distribution of energy follows definite paths which may be studied by means of geometrical constructions.

The most perfect examples of phyllotaxis may be found in the sunflower (*Helianthus annuus*), as near an approximation to the typical Angiosperm as can perhaps be obtained. The head shown in Fig. 144 measured nearly 5 inches across the disc, and the sockets (with or without fruits) form a series of intersecting curves (Braun's *parastichies*) in a horizontal plane, thirty-four of which are long and fifty-five are short. The members still retain, as in the pine-cone, the actual lateral contact they had when they were formed, unmodified by longitudinal extension ; and the whole forms a striking image of a growing-point covered with primordia. As in the case of the pine-cone, so with the sunflower, the structure cannot be defined in terms of the Schimper-Braun theory ; but since no formula can be given for it except that which includes the number of

curved and intersecting *parastichies*, no advantage will be gained by throwing over the Schimper-Braun nomenclature altogether.

The axes bearing the matured structures of sunflower heads have evidently impressed on them, at an early stage of development in the first zone of growth, a certain fixed ratio of curves which possibly follow lines of equal distribution of the growth forces in the semi-fluid protoplasmic cell-mass, the transverse components of which may be represented by the construction

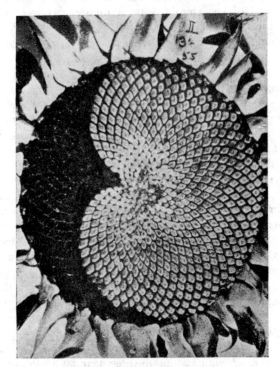

FIG. 144.—HELIANTHUS ANNUUS.
(Fruits partially removed to show the constructional curves of growth.)

of a similar number of orthogonally intersecting logarithmic spirals. The numbers of the curves employed, and their ratio, appear to be an inherent property of the protoplasm of the plant apex, and the phenomena remain constant within the same capitulum. The numbers of the *parastichies* are the only constants which define the system. If, therefore, we draw eight long and thirteen short spirals, a set of *parastichies* may be marked out which will give correct results for the pine-cone (*Pinus pinea*) ; and by inscribing circles within the " square " areas (see Fig. 145) the diagram will fit the case of such spherical

flower primordia as the developing inflorescence of *Scabiosa atropurpurea*, the androecium of *Helleborus niger*, or the bractless spadix of *Anthurium crassinervium*.

In such a plant as *Araucaria excelsa* the remarkably small development of the foliage leaves and the absence of special growth modifications in them allows free scope to the primary system of development. The main axis grows erect in a young plant and produces leaf members in a well-defined (8 + 13) system. In Fig. 146 is shown the transverse section of the growing-point of a lateral branch, and the beautiful spiral arrangement of its growth is very clearly shown. It will be noticed that this drawing from the living plant corresponds extraordinarily closely with the mathematical system drawn in Fig. 145 to represent what the phyllotaxis of such a plant might be expected to be if it followed those mathematical laws of orthogonal logarithmic spiral construction by which Mr. Church desires to express the distribution of growth energy. His conception must therefore be of the utmost importance in determining the primary space form of the whole of the plant body ; and since he has shown that the arrangement of the lateral members of the plant body exhibits remarkable phenomena of rhythm, it is evidently permissible that he should give expression to the observed facts in a mathematical form, while he has further demonstrated that the system of primary construction can only be usefully observed either at the apex of a shoot or on shoots which exhibit no secondary elongation. These data he has reduced to the enumeration of a certain number of equally distributed spiral curves which intersect in either direction ; and when there are five curves in one direction and eight in another he expresses it by the notation (5 + 8) ; where there are eight curves in one direction and thirteen in another the notation would be (8 + 13). In these two cases the two integers which express the spiral curves in either direction are divisible by unity alone, and thus it will follow that one spiral will pass through all the members, this effect becoming extremely general because the Fibonacci ratios commonly utilised agree with this rule.

The data afforded by the plant are (1) a growing, expanding system, containing moving particles ; (2) growth energy introduced from a central " growing-point " ; (3) a construction which implies the geometrical properties of orthogonal trajectories.

Though we still know little of " growth energy " or the energy of life, though we are still ignorant how far it is precisely comparable (for example) with electrical energy, we can at least admit that the actual mechanical energy accompanying life

obeys physical laws just as surely as its material substance obeys chemical laws. But it may be again insisted that no spiral growth movement either exists in the plant or is implied by Mr. Church's logarithmic spiral theory. Though the pattern seen may be expressed in spirals, the growth movements may be, and as a matter of fact *are, absolutely radial.* As a purely psychical phenomenon it is interesting to note how the spiral pattern of a moving mass insensibly leads many observers to the interpretation of a spiral motion. A very curious example of the subjective spiral which is real to the observer's mind

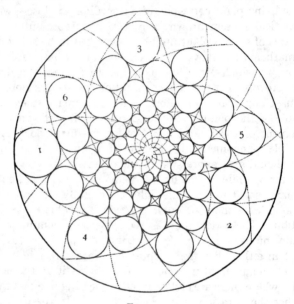

FIG. 145.

Theoretical diagram of logarithmic spiral construction for system (8 + 13) with inscribed circles as representatives of the primordia.
(A. H. Church.)

even when it does not actually exist in the thing observed was printed in my first chapter, where a series of concentric circles give the impression of spiral formation owing to their colouring and the colouring of their background (see Fig. 23).

The fact that we are still unable to suggest any prime cause for the arrangements with which phyllotaxis is concerned need not diminish the value of our considerations, for the observation and tabulation of these arrangements are relatively simple ; and the general facts concerning crystallisation are much more remarkable, even if we accept the latest explanatory theories so ably set forth in Dr. Alfred Tutton's Cantor Lectures, and

published in *Nature* for December 21st, 1911, p. 261. And it must further be admitted that Mr. Church's theory gives no adequate explanation, from the botanical standpoint, of (1) how the system is initiated at the apex of a seedling, or (2) how it was ever evolved phylogenetically. While other more fascinating and productive problems are at hand, botanists are inclined to put on one side these ultimate tests of any perfect system of phyllo-

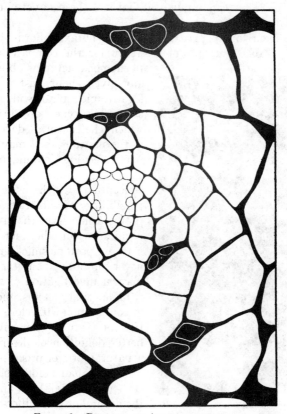

FIG. 146.—DIAGRAM OF ARAUCARIA EXCELSA.
Tranverse section of growing point of a lateral branch, system (8 + 13), camera lucida drawing. (A. H. Church.)

taxis. But avoidance of a difficulty need not imply oblivion of the circumstances which give rise to it.

Possibly more nonsense has been written in the past about these spiral constructions than in any other branch of botany. Hence anyone who starts a new way of looking at them is usually regarded as a crank by scientific botanists. The reason for this is not far to seek. At the growing point of a plant, where the new members are being formed, there is simply *nothing to see.*

The primordia are wholly invisible until they *arise*, and when they arise they are exactly in their appointed places; so exactly that it is difficult to believe they could ever appear in any other spot. Hence scientific botany, which is based on observation and experiment, has little to say, and *speculations* are regarded with suspicion. The proof of the logarithmic spiral hypothesis, as put forward by Mr. Church as the only one possible, is extremely involved, but it is the best yet obtained so far as it goes.

The logarithmic spiral theory of phyllotaxis affords, however, an admirable standard of reference for the comparison of the phenomena actually observed on any given shoot, just as a given logarithmic spiral will afford an admirable type of curve with which the natural development of the nautilus shell may be compared (see Figs. 96 and 97, Chap. IV.). The same mathematical conception which assumes the possibility of abstract uniform protoplasmic growth also takes cognisance of the fact that in Nature protoplasmic growth is never uniform; but the mathematical investigation of the logarithmic spiral systems, undertaken in conjunction with close observation of Nature, can give us a better definition or description of a natural form or process than we have ever had before, because it can show in detail how, and where, the natural growth differs from the mathematical system.

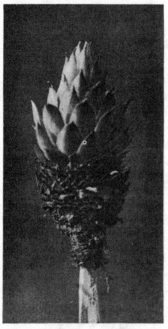

FIG. 147.—ECHEVERIA ARACHNOI-
DEUM. (FLOWERING-STAGE.)

With these general principles in view, we may now examine a few particular instances of pretty curve effects and spirals in living plants.

In the flowering stage of *Echeveria arachnoideum* (Fig. 147) the main axis elongates and bears large succulent leaves, as opposed to the smaller members of the rosette; and although the essential apical construction remains the same, the general appearance of the shoot now affords examples of fewer spiral parastichies, since individual members subtend a larger angle than in the case of the smaller basal leaves. This external

change in appearance was noted by early writers on phyllotaxis, and puzzled them considerably. It is due to *secondary effects* in shoot construction which have no relation to the original plan of the leaf members at the growing point. Similar changes would be noted in the difference between the *scaly bud* leaves of the white lily and the leafy stem which elongates in early spring.

The long, pendulous inflorescence of *Amaranthus* (Fig. 148) is constructed on a spiral phyllotaxis plan, *the first* branches of the

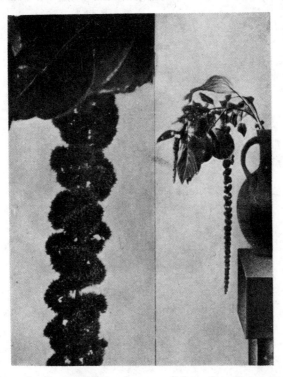

FIG. 148.—SPIRAL FLOWER SPIKE OF " LOVE LIES BLEEDING " (AMARANTHUS), FROM CHERITON BISHOP.

lateral system following the " $\frac{2}{5}$ " arrangement of the foliage leaves. These are, however, widely spaced from each other, and the subtending bracts remain small. Each lateral system ramifies considerably and produces a *close tuft* of flowering branches, each based on a purely dichasial system, and ramifying to the fifth and sixth degree. The main axis is sufficiently elongated to give these tuft-like lateral systems full room, or just enough to make contact with their neighbours, with the result that the " genetic spiral " of the original leaf members is empha-

sised by the spiral sequence of the lateral inflorescence tufts which arise from their axes. The point of interest is that the internodes of the main system are elongated just enough to give room to the lateral clusters and no more ; this is responsible for the neatness of the final effect.

Rochea falcata (Fig. 149) is a remarkable succulent plant adapted for living under conditions of intense light and extreme desiccation. The phyllotaxis system is of an ordinary crossed (2 + 2) or *decussate construction*, this being particularly well

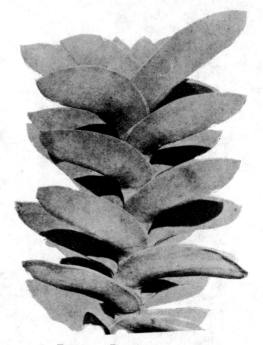

Fig. 149.—Rochea falcata.

seen in the flowering shoots, which have fairly normal foliage leaves. In the vegetative shoots, however, each leaf is thick, succulent, and anisophyllous, being bent with a strong curvature until the leaves of successive crossed pairs are really twisted almost into two rows (instead of four), all the leaves having one edge turned upwards to the light. So strong are these secondary tendencies that even a section of the bud apex shows little proof of what has happened, and the shoot of the plant has been long regarded as a puzzle (*Goebel,* " Organography," Part I., p. 117). The point of interest is that we have here a plant with four rows of leaves, in opposite pairs, trying to change to two rows

of leaves with their edges up to the light. Instead of striking out a wholly new line, and doing what is wanted, extreme measures are taken to tinker up the whole system and make the best of it. This is what plants are always doing ; they have not gigantic intellects, and they have to make the best of the old construction until a new " mutation," as a " lucky shot," just does what would solve the problem.

Echeveria agavoides (Fig. 150) as viewed from above shows a well-marked spiral phyllotaxis. Five curves in one direction are fairly prominent on the specimen as it stands ; eight steeper curves in the opposite sense are traced with a little difficulty. The construction illustrates the use of the familiar Fibonacci

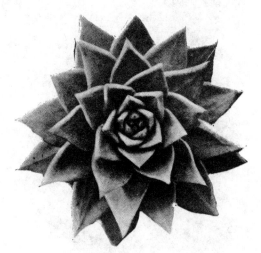

FIG. 150.—ECHEVERIA AGAVOIDES.

series of numbers, but 5 and 8 as seen do not necessarily imply that the leaves at the actual growing point are in this relation, the effect seen in the case of the adult plant being complicated by secondary conditions of the relative shape and condition of the leaves with regard to the main stem.

Anthurium (Fig. 151) is an aroid like the common arum lily, only the spathe does not constitute a trumpet, and is coloured scarlet, while the spadix, covered wholly with sessile florets, is protruded and more or less twisted in a worm-like coil. The general phyllotaxis plan of the plant is a simple spiral form of Fibonacci system, and the red spathe is the uppermost leaf carried up on a long internode, which is the apparent flower stalk. On the yellow spadix, small closely packed florets are borne in a simple *spiral series*. These are not usually in a Fibonacci system, but the

number of curves is very variable, and equal or nearly so in the two directions, with fewer at the apex than at the base. The individual flowers are dimerous, with (2 + 2) perianth members fitted together to make a lozenge-shaped area, so that the crossing lines accurately indicate the boundaries of rhomboidal florets. The spiral twist of the whole spadix is a secondary peculiarity,

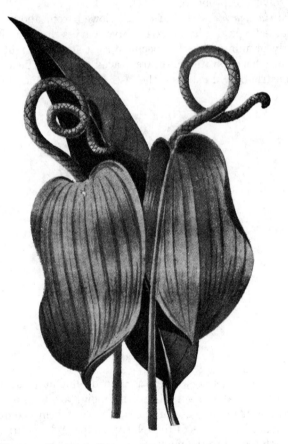

FIG. 151.—FLAMINGO FLOWER (ANTHURIUM SCHERZERIANUM).
Standard crimson, tail yellow. Native of Guatemala.
Spathe crimson, spadix yellow.

due to irregular growth extension, and is usually wanting in most species of *Anthurium*. This species is cultivated because the whole has become gaily coloured and attractive to insects, which pollinate the flowers, just as the arum lily shows a clean contrast of white and yellow, also to attract insects, flies probably rather than bees. In Fig. 152 I have added another example of *Lilium auratum* (shown in Figs. 19, Chap. I., and 128, Chap. IV.)

to suggest the beautiful spiral arrangement of the growing leaves, photographed vertically.

In the closed cone of *Pinus ponderosa* (Fig. 153) the scales retain their original arrangement. The number of the construction curves can only be seen on rotating the specimen. When the scales are small, as at the base of the cone which does not produce seeds, the contact parastichies can be counted as thirteen in one direction and eight in the other. Higher up in the cone the larger fertile scales show more obvious curves of 5 and 8. One system glides imperceptibly into the other, this being the special property

FIG. 152.—YOUNG PLANT OF LILIUM AURATUM.
Photographed vertically from above to show spiral
growth of leaves.)

of a Fibonacci series of ratios, 5 : 8 : 13. On a fine well-developed cone the 8 and 13 curve lines may probably be traced almost to the top of the cone.

The cones of *Pinus excelsa* (Himalayan pine), with comparatively thin leaf-like scales (Fig. 154), are closely pressed in the unripe condition, the exposed facets of the scales forming a pattern which shows as five steep rows of scales in one direction round the cone, and three less steep ones in the opposite sense. These are counted in revolving an actual specimen. The figure illustrates very clearly the steep rows on one side of a cone, of which five complete the construction all round the cone. When the cone is quite dry (Fig. 155), the scales diverge widely, owing to the

FIG. 153.—PINUS PONDEROSA.

FIG. 155.—PINUS EXCELSA.

FIG. 154.—PINUS EXCELSA.

strong contraction of the tissues on the lower side of the scales,
but the leaf-like form of the scales still enables the members
to maintain their lateral contact with each other, and the " 5 "

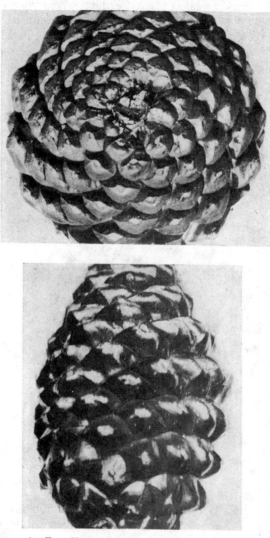

FIG. 156.—TWO VIEWS OF THE CONE OF PINUS MARITIMA.

curves and the " 3 " curves remain quite well emphasised, as a
spiral twist of members passing round the main axis.

In Fig. 156 I show two views of the cone of *Pinus maritima*,
and in the middle of the cone, where the scales are at their
maximum, the type 5 : 8 is fairly regular. But in the lower part

the " 8 " lines continue quite regularly on the left, while the
" 5 " lines become stepped and obscured, until at the base of the
cone the arrangement of 8 : 13 becomes clearer. In the apical
region, the converse takes place, for the " 5 " curves go up quite
normally on the left, but the curves become confused until the
" 3 " curves grow more obvious, and at the apex itself the con-
struction becomes 3 : 5. This means that the "optinium"
region shows 5 : 8, but at the base, owing to the failure of the

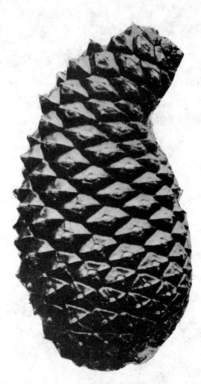

FIG. 157.—ABNORMAL GROWTH OF CONE IN
PINUS MARITIMA. (Bournemouth.)

scales to reach their normal size, each one subtends a smaller
angle, and the appearance of 8 : 13 is given, while the apex
suggests the approach to a lower construction as it tapers off.
A good uniform construction could only be observed either at
a growing apex or on a cylindrical structure. Fig. 157 shows
an abnormal growth from the same tree, due to a spot bruised
during the flowering stage, and scales in this region have not grown
while adjacent scales have grown excessively. The construction
curves show 8 : 13 at the base and 3 : 5 at the apex, but owing to

anomalous extension the system is not accurate in the middle
region ; for though the " 8 " curves run clean edged, it would be
difficult to say whether 5 or 13 should be taken as the other
constant. As examples of other pines, I have added a cone from
the Monterey pine (Fig. 158), and two views of a cone from the

FIG. 158.—CONE OF MONTEREY PINE, OR PINUS
RADIATA (BOURNEMOUTH), SHOWING UNSYM-
METRICAL OVOID FORM PRODUCED BY PROJECTION
OF SCALES ON THE EXPOSED SIDE.

somewhat rarer *Pinus muricata* (Fig. 159). All were collected
at Bournemouth.

NOTES TO CHAPTER VI.

GROWTH AND ADULT STRUCTURE (p. 95).—The most important
thing in the study of phyllotaxis, subsequent to the writings of Schimper
and Braun, was the attempt made by *Schwendener* to adjust their data
for the plant apex by the assumption of peculiar *contact pressures*. For

years botanists debated whether these existed or not. It is now agreed they do not (cf. *Jost. Physiology, Eng. Trans.*).

FIBONACCI SERIES.—Attention may be called to the comparison with the ϕ series given in Chapter XX. and in the Appendix.

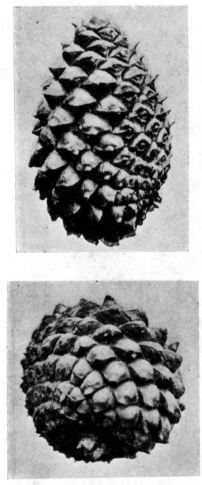

FIG. 159.—TWO VIEWS OF THE CONE OF THE CALIFORNIAN PINUS MURICATA (BOURNEMOUTH), SHOWING THE STRONG PRICKLE SET AT THE END OF THE HARD SCALES.

FIGS. 160, 161 AND 162.— For these illustrations I have to thank a friend, who, when sending them said :—

" The flowers of water lilies (*Nymphæa*) present a general appearance (Fig. 160) of being beautifully formed along a spiral phyllotaxis. But more exact observation shows that this is not the case, and many irregularities occur in the system. For example, it is clear that the four first members (green sepals) have no part in the spiral sequence although it appears evident that the stamens follow on in the same series with the petals. The arrangement can be only checked satisfactorily in a section of the whole of the flower in the state of a young bud, about ¼ inch in diameter. A drawing of such a section shows intersecting curves fairly regular in places, and often suggestively approximating such Fibonacci numbers as 13 and 21, but the irregularities in construction are always numerous, and it is not possible to put one genetic spiral through them all ; although it is quite probable that the ancestral form presented a much more regular construction sequence, comparable to that of the vegetative shoot, which in strong plants is represented by the formula 5 : 8, as in the case of the scales of the commoner pine-cones.

" The flowers of the beautiful *Lilium longiflorum* (Fig. 161) are trumpet-shaped and constructed of the same double set of three members as in the case of the lily, tulip, hyacinth, etc., the perianth taking on the familiar 3 + 3 star pattern of Solomon's seal of

inter-lacing triangles. In the case of this lily the tips of the perianth members are gracefully arched inwards, leaving a wider entrance to the 6-inch trumpet, and allowing the stamens and style slightly to protrude. The flower is pollinated by Sphinx moths, which hover in

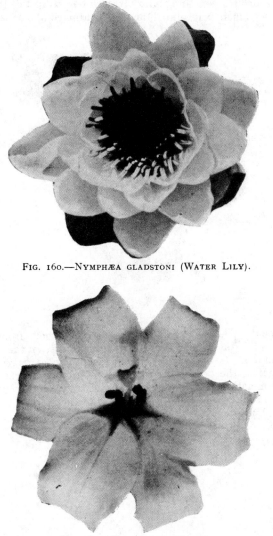

FIG. 160.—NYMPHÆA GLADSTONI (WATER LILY).

FIG. 161.—LILIUM LONGIFLORUM.

front of the horizontally projected trumpet and probe the nectary *at the base* of the tube, this nectary being indicated as greenish grooves secreting honey at the base of each perianth-segment. The graceful recurvature is thus sufficient to present a white conspicuous star effect,

as seen in front view, and at the same time just uncover the essential organs. In more specialised lily flowers, such as *Lilium pyrenaicum* (Fig. 162), especially those visited by diurnal lepidoptera, the flowers hang vertically downwards, and the petals arch boldly, almost to a perfect circle (cf. *Lilium tigrinum*), thus bending up out of the way of the protruded stamens and style. In such reflexed petals the nectary grooves are much exaggerated, and are continued about half way up

FIG. 162.—LILIUM PYRENAICUM.

the segment. The *reflexed surface* is now conspicuous from a lateral position, while the nectary aperture is exposed just on the outer turn of the curve. The insect visitor, in probing these apertures, beats its wings against the protruded stamens and stigmatic surface, and so effects pollination. Note that the exaggeration of the curvature is correlated with increased specialisation of the mechanism, but the original phyllotaxis plan of the flower remains unchanged.''

CHAPTER VII

RIGHT-HAND AND LEFT-HAND SPIRAL GROWTH-EFFECTS IN PLANTS

" Leaves in their earliest growth turn themselves round towards the branch in such a way that the first leaf above grows over the sixth leaf below ; and the manner of their turning is that one turns towards its fellow on the right, the other to the left."—LEONARDO DA VINCI (*Inst. de France*).

TWIST EFFECTS : (i.) SPIRAL LEAF ARRANGEMENTS ; (ii.) OVER-LAPPING EFFECTS ; (iii.) UNEQUAL GROWTH IN MAIN AXIS ; (iv.) SPIRAL MOVEMENT OF GROWING ENDS ; (v.) SPIRAL GROWTH OF TWINING PLANTS ; (vi.) SPIRAL EFFECTS AFTER DEATH—NOMENCLATURE OF SPIRALS—NUMERICAL PROPORTIONS OF RIGHT AND LEFT HAND.

THE effects of asymmetrical construction in plant shoots commonly end in the production of spiral effects, just as in the case of spiral shells and spiral horns. The effect may be that of a *twist*, and either right hand or left hand in direction ; there are, indeed, only these two possibilities, but the *cause* is not necessarily the same in all cases. In fact, any asymmetrical growth-factor will induce a spiral appearance, if continued long enough, and the appearance of " twists " in a plant is always a subjective one ; the cause is always unequal growth of some sort ; but it is so usual to obtain a similar effect by twisting that we have no other word for a structure which grows in this manner. The familiar example of " Pharaoh's serpents " has much in common with the growth of a plant stem, the burning-point being representative of the apex of the shoot. The spiral effects commonly observed in plants may be distinguished under several headings, and it is well to separate them. Among the more usual may be reckoned the following phenomena, omitting many beautiful spiral manifestations in the growth of lower plants.

I. *The spiral leaf-arrangement* at a plant apex has been already included as spiral phyllotaxis, and regarded as the expression of an inequality in the parastichy ratio of the construction system. Given such inequality, all the serial lines traced subjectively through adjacent members are spirals. (We need not include the case of perfectly regular alternating whorls of members in which the diagonal lines of the pattern give spiral series *equal* in

both directions, like the curves seen on an engine-turned watch-case, since these diagonal lines are obviously complementary to a system of circles and vertical rows.) Examples of these spiral effects have been given in preceding chapters.

II. *Overlapping* effects in the corolla of flower-buds (cf. *Fuchsia*) give frequently an effect distinguished as the contortion or convolution of the corolla, and the petals apparently expand with a twist, either right hand or left hand.

III. *Unequal growth in the main axis* gives torsion or twisted effects, examples of which have been seen in *Gasteria* leaf-system. Such twists are common in climbing stems, also in flower stalks, and even in ovaries and fruits.

IV. *The spiral movement* of the growing end of a shoot, or the circumnutation spiral, is seen most obviously in climbers ; this straightens out in the adult stem and is no longer seen, but is intimately associated with

V. *The spiral growth of a twining plant ;* this, as also that of a tendril, becomes fixed in the adult stage, and is then obviously right or left hand.

VI. *Spiral effects may be produced after death,* owing to peculiar histological construction of special cells. Such appearances are presented after desiccation in the case of hygrometric awns and portions of fruits (cf. stork's-bill and pea-pods), and the tissues when wetted again return to their original position.

Such spiral phenomena are characteristic of the higher plants ; among lower types the entire organism may present spiral growth-form, as in the case of spiral bacteria, the spiral antherozoids of ferns (and the beautifully spiral ciliated coils of the antherozoids of Cycads), as also Algæ in which the thallus appears as a spiral ribbon (cf. *Vidalia*) and the similar spiral wing of the liverwort *Riella*. In Plankton there may be spiral chains of diatoms, while in *Spirogyra* the chloroplasts are spiral. In all cases the spiral appears as an asymmetrical growth-expression representing a stage intermediate between a straight line and a circle.

In all these cases the direction of the spiral seen may be given in terms of right or left hand, according to some established convention. It does not matter much what the convention is, since there are only two possibilities, and so far clockwise, or winding with the clock sunwise or following the sun left hand, affords a good working generalisation, which is common to all the various departments of this inquiry, though I am aware that botanical writers in their technical descriptions reverse this nomenclature, and call sunwise or clockwise a " right hand " twist. To this, in these pages at any rate, I cannot agree, and I propose to go on as I began, the *" clockwise " direction being*

called left hand. With such a working generalisation it may be interesting to see to what extent such right and left effects may be constant or variable; and if the latter, do they follow in equal proportions, or does one direction predominate? On general principles they should be: (1) *constant;* or, since it might be purely a matter of chance which occurred, (2) *half*

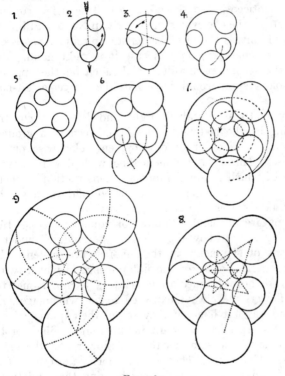

FIG. 163.

Theoretical construction of a (3 + 5) system by uniform rate of growth. The asymmetrical addition of one new member at a time produces a subjective appearance of spirals. In this figure the addition of the second member (number 2, above) is shown on the right side of the first. A similar construction could be worked out if it had appeared on the left. (A. H. Church.)

and half, or 50 per cent. of each; otherwise, if there is a tendency for one form rather than the other, there would be (3) *a bias.*

These conditions may be borne in mind in examining the spirals of plant shoots; usually it is assumed that the chances are equal in either direction, but several interesting cases arise. For example, we may take a normal Fibonacci construction, in which new members follow in sequence at an angle of approximately $137\frac{1}{2}°$ from each other. The figure (163) illustrates a

scheme in which a new member is added in every successive stage, the whole system continuing to grow at an equal rate throughout. The direction in which the new members are added is shown by the arrow in Nos. 2 and 3, and this is counter-clockwise or right hand. In No. 7 the series thus becomes a spiral sequence, and a single curve, the ": genetic spiral," is drawn through all the members. This is, however, quite a subjective appearance ; it is not noticed in No. 8, and, as a matter of fact, other sets of spirals strike the eye even more clearly in No. 9. Still, if we take one spiral only as the test, the genetic spiral of No. 7 is certainly the one to consider ; in this case it is right hand. But if in No. 2 the second primordium had fallen on the opposite side, the whole system would have had the converse left-hand formation.

We may thus talk about right and left-hand constructions according as the members, when thus seen in a ground plan, are arranged in order of development, clockwise or counterclockwise. This is useful in dealing with flowers, a vast proportion of which retain a Fibonacci construction in their *quincuncial calyx*. It is generally assumed that on a given plant the numbers of the two constructions will be equal, if sufficient specimens are at hand to allow for equal chances. But it is interesting to note how the rule may be modified under special conditions of symmetry in the inflorescence system. Thus in a symmetrical *Dichasium*, an inflorescence in which two lateral flowers are borne immediately below a terminal one, the two lateral flowers are always expected to be twin images, *i.e.*, one right and one left hand, if they retain their quincuncial calyx ; while rules are fairly constant in different families for the one which remains the same as the end flower and the one which changes. The inflorescence of the spring-flowering *Helleborus fœtidus* is an admirable type for checking these relations. On the other hand, in the case of a *Scorpioid cyme*, a peculiar two-ranked inflorescence of two rows of flowers zigzagging down the apparent main axis, all the flowers on one side are right hand, and all those on the other left hand, symmetry being arranged for along an imaginary line between the two rows. The inflorescence of a stork's-bill (*Erodium*), or that of *Geranium phœum*, affords a simple illustration.

Although it may be assumed that equality in these respects would be found to obtain if sufficient numbers were taken, rather curious results have been obtained in dealing with comparatively small numbers of specimens. Thus Bonnet long ago counted seventy-three chicory plants, and found forty-three right, or 58·90 per cent., and thirty left. But numbers below

100 may be useless. Further observations on this subject, which is here considered from the standpoint of the direction of the primary spiral of the main axis of the plant, may be readily carried out by anyone interested in the matter ; it is only neces- sary to raise a batch of seedlings, and place them in two sets as soon as the direction of the first leaves becomes apparent, taking, preferably, some common plant in which Fibonacci phyllotaxis obtains, and the seedling tends to distribute its first leaves in a flat rosette.

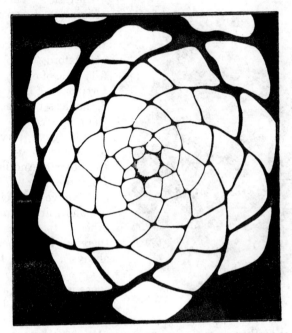

FIG. 164.—PINUS PINEA (SYSTEM 5 + 8).

Transverse section of the apex of young seedling, 6 inches high.
(A. H. Church.)

Genetic spiral, counter-clockwise = R.

On the other hand, the so-called genetic spiral may be a myth ; it is only traced with difficulty in such a diagram as Fig. 145, Chap. VI., and on the adult shoot it owes its appearance to the fact that secondary elongation of the shoots has so far pulled the system apart that the series is at last only expressed as a single curve. In the case of close construction in which no secondary extension takes place, and the members retain the close-set pattern in which they were formed (cf. pine-cones, Fig. 141, Chap. V., and Fig. 156, Chap. VI.), other curved series (para- stichies) are much more readily observed (see Fig. 164), and

these constitute oblique series of members, often conspicuous even when a certain amount of extension obtains. The relation of these right and left curves to the genetic spiral is not the same in all patterns, but they may be readily checked by reference to geometrical constructions of the same numerical value, and for practical purposes these curves may be quite as readily utilised for comparing the numbers of the twin constructions. Thus, on taking cones of *Pinus austriaca* (Fig. 141), the curves on the circular base are eight and thirteen, of which the set of the

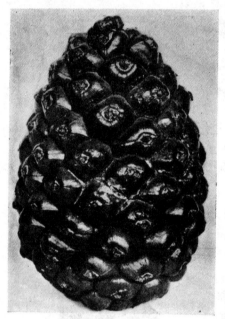

" thirteen " curves is strikingly conspicuous ; a set of 100 cones from the same tree (counted at Oxford, 1900) gave fifty-nine of one type and forty-one of the other. A similar set of 100 cones from a tree of *Pinus pumilio* gave fifty-three of one and forty-seven of the other. Another set from one tree of *Pinus laricio* gave sixty-eight of one and thirty-two of the other. In these cases, therefore, either there was always a bias in favour of one pattern, or 100 cones is too small a number to deal with. To test

FIG. 165.—PINUS PINEA.

this 1,000 cones of the same tree of *Pinus austriaca* were counted during the next season. Successive batches of 100 each gave :—

$$
\left.
\begin{array}{l}
54 : 46 \\
56 : 44 \\
51 : 49 \\
49 : 51 \\
54 : 46 \\
57 : 43 \\
54 : 46 \\
56 : 44 \\
51 : 49 \\
54 : 46
\end{array}
\right\} \quad \text{Average } 53\cdot6 : 46\cdot4.
$$

The same tree was examined again during the third year, with a closely identical result ; while the same tree of *Pinus laricio*

was equally constant at a ratio of about 71 : 29. It would appear possible to say that it was in these cases a matter of mere chance ; yet the reason for the bias remains a puzzle. It is, however, quite possible that the dominant pattern was that set by the apex of the tree as a seedling, and the bias of pine-cones merely expresses the fact that homodromy is more usual than heterodromy. But these problems still require to be investigated.

I. The fact that in many of these close-set spiral patterns, one set of curves is more prominent than the other (Fig. 141, *P. austriaca ;* Fig. 164, *P. pinea ;* Fig. 156, etc.) is due to the progressive flattening of the leaf-member in a horizontal plane, as it becomes more leaf-like. In such cases the members of the lower number of curves become more conspicuous to the eye (*Araucaria* (8 : 13), in Fig. 146) ; if, on the other hand, the members

FIG. 166.—WAX PALM AND DATE PALM.

become radially deeper, the higher number of curves is more prominent. (Sunflower (34 : 55), in Fig. 144.) In special cases, on old stems, the relics of the phyllotaxis spirals stand out as a very marked system which expresses the uniformity of the extension of the adult plant. (See the Wax Palm in Fig. 166.)

II. The *Fuchsia* corolla (Fig. 167) affords a good example of what is technically termed *contortion* or *convolution*, each petal being rolled over an adjacent one, and under the other. In the case of the *Fuchsia* this is absolutely constant (except in occa-sional malformations) and is always in the same sense. Botanically, this is known as " *right convolute* " (Eichler, 1878), because the right-hand edge seen from the outside is external. This is not a very satisfactory reason, but is easy to remember, and some simple convention is necessary. This form of symme-trical prefloration is met with in other families ; cf. *Malva* (holly-hock), *Vinca* (periwinkle), *Erica* (heath), as the highest expression

of symmetrical corolla-arrangement. It has no apparent *use* to the plant, since no insect ever notices or cares if the petals beautifully overlap or not. Its *cause* is to be traced in the asymmetry of each individual petal-primordium, from its first development (a slight anisophylly), so that the young members slip in the bud quite easily, and take up these positions. Why the *Fuchsia* should be right convolute rather than left convolute, or why half the flowers should not be one and half the other, remains a mystery. In the case of *Malvaceæ* and *Hypericaceæ* some are one and some the other. In *Helianthemum* (rock rose) the two cases regularly alternate in successive flowers of

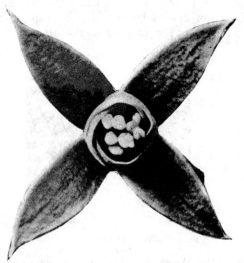

FIG. 167.—FUCHSIA.

the same cyme ; also in the inflorescence of the cotton (*Gossypium*) *Vinca* is constant for one direction (left convolute). The oleander (*Nerium*) is equally constant as a generic type in the opposite sense (right convolute).

III. Spiral, so-called *torsion effects* are particularly common in plants, and may be quite useless and accidental so far as is known, or they may subserve an important function. In any case it would appear that they must have originated as accidental growth irregularities, *mutations*, in fact, and may remain as factors in the plant-mechanism, because being quite useless, natural selection has no effect on them ; or the converse has happened : having proved of use, they have been gradually perfected into a new and striking specialisation. Slight useless twisting effects

are very general, and may escape observation ; a good example
is seen in the twist on the stalk of a *Vinca* flower ; in this case
also the direction appears to be constantly a left-hand twist ;
and it is clearly dissociated from the prefloration twist of the
petals. A singularly beautiful example of exactness in such a
twist is presented in the phenomena of " resupination," seen in
the case of the flowers of *Lobelia* and *Orchis*. In the former
the flowerstalk, and in the latter the green inferior ovary, initiates

FIG. 168.—PANDANUS MILLORE FROM THE NICOBAR ISLANDS.

a twist exactly restricted to 180°, so that the floral mechanism
is turned upside down to face the visiting insect. In such cases,
the torsion effect has been utilised and rendered very precise
for an intelligible purpose. Similar twists are again utilised
as compensation effects in phyllotaxis systems ; the case of
Gasteria has been already instanced as an example in which
the maximum superposition of a distichous leaf-arrangement
has been admirably counterbalanced by a slight growth-twist
of the entire axis, just enough to uncover the leaves from their
adjacent members (Fig. 140). The same type of growth is respon-
sible for the wonderful three-rayed screw of *Pandanus* (Figs.

168 and 169), the screw pine, also seen to a lesser extent in the common umbrella sedge (*Cyperus alternifolius*). In these plants the phyllotaxis is expressed by the ratio 1 : 2, and this would result in the adult plant in three main series of leaves, which should if they attained equal depth, and were exactly equally spaced, become three vertical rows of exactly superposed members. It is true that any deviation from these last conditions would result in the leaves forming three slightly spiral series ; but the

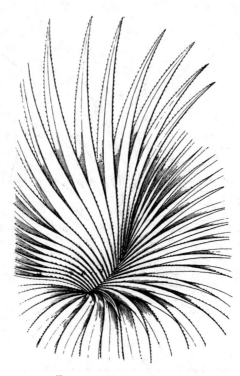

FIG. 169.—PANDANUS UTILIS.

exactitude with which the entire system is built in the case of a fine specimen probably illustrates a perfectly controlled system of " twisted " growth as well. How considerable the growth-wrench may be is illustrated by a plant of *Cyperus alternifolius*, in which the axillary inflorescence shoots are pushing in graded lengths according to their positions behind the apex (Fig. 170). Quite as elegant examples of such secondary twisting effecting " compensation " may be observed in the case of decussate leaf-arrangements. One of the neatest is the case of the foliage shoots of the Rose of Sharon (*Hypericum calycinum*). The

foliage-leaves of the short shoots of this plant when growing in the open apparently lie in two rows, all with their upper side to the light, and yet they are made at the apex in four vertical rows of a decussate system. The final effect is attained by an accurate twist of 90° in a different sense in each alternating

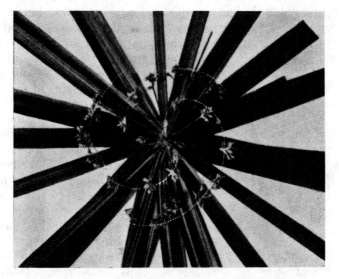

FIG. 170.—CYPERUS ALTERNIFOLIUS.

internode, *i.e.*, one internode twists right and the next left, and so on. A similar phenomenon may be traced in the blue gum (*Eucalyptus*), particularly in the case of lateral shoots with the blue primary leaves. Later in the life of this plant a new compensation has been effected by the invention of pendulous leaves of a new form; but the apical construction may retain the ancestral decussate pattern. The case of *Gasteria* and *Pandanus* may be termed a "winding-up" effect; that of *Hypericum calycinum* an "alternating" mechanism; an increased twist may even produce what may be termed an "unwinding" effect. For example, if in a decussate system, a twist of 90° was put in at every internode in the same sense, the leaves would all come to lie above each other in two ranks. *Hypericum* might have done this, if it had not so ingeniously solved the problem with far less display of twisting power. But such effects have been noticed in plants, more particularly in the case of some freak twisted teazles (*Dipsacus fullonum*), described by De Vries. An ordinary

FIG. 171.—SEED-POD OF HELICTERES IXORA.

teazle has its leaves in opposite pairs, but not quite decussate (really a 2 : 4 system), but if it were twisted far enough all the leaves might be brought into two crested series. This is more or less approximated in these monstrous forms. A similar good example of " unwinding " is seen in the flower spike of the common orchid, *Spiranthes autumnalis* or lady's-tresses ; here the flowers are arranged in the bud in ordinary close spiral series ; but as the inflorescence axis elongates, and the flowers resupine, an extensive twisting tends to unroll the spiral system until the genetic spiral is left almost, but not quite straight. The object of this

curvature is obviously to obtain the benefit of a unilateral spike of flowers, as in the case of the foxglove. The foxglove similarly constructed to begin with, swings each flowerstalk to the front independently ; the mechanism adopted by *Spiranthes* is even more ingenious ; but it is clear that it may have originated in a perfectly accidental tendency to unequal growth in the main axis. So far it is only important to note that in all these cases, so far as is known, the direction of the twist may be either right or left so long as only one twist is concerned. Thus, in whichever direction the genetic spiral of *Spiranthes* may run, a twist in either sense will tend to straighten it out, while the twist of the resupining flowers may also be in either sense in the same inflorescence. Still, quite simple observations on these examples giving statistical information are requisite before it is safe to speak too dogmatically on the point.

FIG. 172.—LADY'S TRESSES. SPIRANTHES AUTUMNALIS.

IV. and V.—With reference to the direction of the spiral of circumnutation, and the correlated direction of twining in the case of climbing plants, much interesting information is available, the general rule being that the direction may be variable in an incipient climber, but becomes very definitely constant, one way or the other, as the climbing habit becomes definitely fixed in the œcology of the plant.

Out of a collection of living specimens of twenty-three climbing plants most kindly sent to me at various times for examination from Kew and elsewhere, only six showed the lefthand formation, " following the sun " or " clockwise." They were :—

> *Polygonum baldschuanicum* (Bokhara).
> *Kadsura chinensis* (China).
> *Humulus lupulus* (English hop).
> *Honeysuckle.*
> *Mühlenbeckia chilensis* (Chili).
> *Lapageria rosea* (Chili).

In Charles Darwin's "Movements and Habits of Climbing Plants" (p. 24, ed. 1905, John Murray) a table is given of several climbing plants, showing the direction of their growth. In all, forty-two are described. Out of these only eleven "follow the sun" and show a left-hand formation, "clockwise." They are :—

> *Tamus communis* (Dioscoreaceæ).
> *Sphærostemma marmoratum* (Shizandraceæ).
> *Polygonum dumetorum.*
> *Plumbago rosea.*
> *Clerodendron thomsonæ* (Verbenaceæ).
> *Adhadota cydonæfolia* (Acanthaceæ).
> *Loasa aurantiaca* (one plant).
> *Scyphanthus elegans* (Loasaceæ).
> *Siphomeris* or *Lecontea* (Cinchonaceæ).
> *Manettia bicolor* (Cinchonaceæ).
> *Lonicera brachypoda* (Caprifoliaceæ).

In the figures given above I have omitted two plants from Darwin's list which happened to occur in those I had previously examined. This omission does not affect the result that seventeen out of a total of sixty-five—or about a quarter—show the left-handed formation. In the case of one plant (*Hibbertia dentata*), Darwin observed the movement reversed frequently from one direction to another, making a whole, or half, or quarter circle in one way and then turning in the opposite way. He decided that the more potent or persistent revolution was against the sun (or right-hand), and observed that the plant was adapted both to ascend by twining and to ramble laterally through the thick Australian scrub. He noted a similar reversal of movement in *Ipomœa jucunda*, but only for a short space, and these instances of adaptation are of interest because they are rarer in twining plants than in the more highly organised tendril bearers. It is rare to find either plants of the same order or two species of the same genus twining in opposite directions ; but such a case as one species of *Mikania scandens* moving against the sun and another (in south Brazil) following the sun is a perfectly intelligible occurrence, for different individuals of the same species (for instance, *Solanum dulcamara*) revolve and twine in two directions, and *Loasa aurantiaca* offers an even more curious example. Darwin raised seventeen plants of this kind, of which eight

revolved against the sun, five followed the sun, and four reversed their course from one direction to the other, "the petioles of the opposite leaves affording a *point d'appui* for the reversal of the spire. One of these four plants made seven spiral turns from right to left and five turns from left to right." *Scyphanthus elegans* behaved in the same strange manner, taking two or three turns in one way and then one or two in the other after a short intervening space of straight growth, the reversal of the curvature occurring at any point in the stem, even in the middle of an internode. Out of nine plants of the hybrid *Loasa herbertii*, which he also cultivated, six reversed their spire in ascending a support.

It is noticeable that of the four plants which revolved most quickly, each taking under two hours for a single revolution, the fastest of all was *Scyphanthus elegans*, which made its left-hand circle in seventy-seven minutes; and even this pace is beaten by the tendril-bearing *Passiflora gracilis*, which revolved in the same left-hand direction, following the sun, and was observed to make three revolutions at an average rate of sixty-four minutes each, and in hot weather of even fifty-eight minutes. But any arguments tending to suggest that movements following the sun imply greater pace will be somewhat weakened by the fact that *Adhadota cydonœfolia*, which is an efficient twiner, took from twenty-six to as long as forty-eight hours to complete a circle in the case of two different shoots; and this plant also grows left-hand, following the sun. The rate of movement, in fact, does not seem to be related to the direction of the growth. And I can only conclude, from observations made up to the present, that though a larger proportion of right-hand than of left-hand spirals has been hitherto noticeable in twining plants, it is possible that if sufficient specimens were examined there would be as many visible of one kind as of the other. The reason for the diversity is not yet apparent.

I postpone to the next chapter the consideration of the sixth division mentioned above, namely, spiral effects produced after death.

NOTES TO CHAPTER VII.

NOMENCLATURE, RIGHT OR LEFT.—On this subject Shrapnel sent me the following letter :—

"In the *Times* for November 18th, 1912, an interesting article appeared, which you may be able to reproduce below. I should like to say a word about it after having read the articles on the subject of spirals, and may I venture to express the hope that their writer will have done something towards making scientific nomenclature on this matter somewhat more clear and homogeneous than it is at present. It will be convenient to take the homely corkscrew which the writer in the *Times* mentions as the type for my

remarks, and I may say that both conchologists and those biologists who describe the spirals of horns would unite in calling this spiral a right-hand spiral. The writer in the *Times* seems to be misled with regard to conchologists. They certainly call a shell with a right-hand spiral ' leiotropic,' but this name is not given to the shell because the spiral is turned to the left. It is given to the shell because the conchologist has considered it as a staircase up which some small insect may be supposed to be mounting from the orifice at the bottom to the tiny apex at the top, and any insect which makes this journey will invariably be turning to the left on the way up this right-hand spiral. For exactly the same reason, conchologists call a shell with a left-hand spiral (the rare form) ' dexiotropic,' and this word again does not refer to the shell, but to the fact that the insect aforesaid must always be turning to the right in going up a left-hand spiral. I need hardly remind you that it makes no difference whatever either to the formation

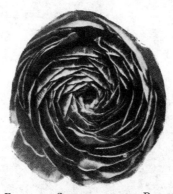

FIG. 173.—SPIRALLY-FOLDED PETALS
OF RANUNCULUS.

of the corkscrew or to our definition of its spiral whether the corkscrew is standing on its point or whether it is standing upside down upon its handle. There may be other sources of error, but the botanists are responsible for the worst error of all. It will hardly be believed that botanists would describe an ordinary corkscrew as a left-hand spiral, apparently for the reason that if a right-hand man is twisting the strands of a rope together with a right-hand twist he invariably produces what the rest of the world would call a left-hand spiral, and for this reason apparently botanists insist on calling ' left hand ' what everybody else calls ' right hand.' This leads to an enormous amount of confusion, because the left-hand spiral in nature is really as rare, if not rarer, than the left-handed man in human experience, and unless we are all to agree to call the same things by the same names we shall never get on at all. It really does not matter what name is given to these various forms of spirals, but it seems obvious that the right-hand spiral for a corkscrew is the one which should persist in every branch of science, and I trust that there will be no further confusion such as seems suggested by the writer in the *Times*, whose article is as follows :—

" ' A Corkscrew Snail.

" ' *Another very odd little exhibit has been placed in the Insect House.
The shell of the common garden snail* (Helix aspersa) *is spirally arranged,
and when a section is cut through it the appearance presented is that of a
rapidly narrowing spiral chamber twisting round a central axis. Mr.*

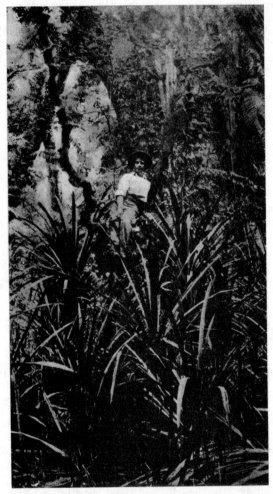

Fig. 174.—A Giant Vine in Madagascar.

*Y. H. Mills has sent a rare monstrosity, which he obtained recently in
Pembrokeshire. The spiral chamber, instead of being compact, is pulled
out into the form and shape of a corkscrew. The twist is of the same kind
as that in a common corkscrew, and raises a point of nomenclature which
is debated indefinitely by those who have to do with horns and shells and
other spiral forms. Is such a twist to be called right handed or left handed ?*

Opinions and practice differ, and it is clear that, as the line curves round the axis, the person following must move now to the right and now to the left, while, if it be sought to fix the designation according to whether the right or left hand is towards the central axis, as in a spiral staircase, one must also decide whether this is to be taken in ascending or in descending. The obvious, and probably historically, correct distinction is that a right-handed spiral is the twist seen on a screw which a normal right-handed person finds it easier to use with his right hand, and a left-handed spiral that which he would naturally insert with his left hand. In this sense, the corkscrew snail at the Gardens is plainly of the right-handed type, although perhaps most conchologists would call it left handed.'

" I do not think ' most conchologists ' would agree with this."

" The spirally-twisted seed pods of *Helicteres ixora* have been put to strange use by certain races who assumed, by the ' doctrine of signatures ' that their peculiar shape (Fig. 171) would make them an admirable medicine for ' twisted bowels ' or colic. It was similarly believed that the plant called ' Jew's ear ' was a good remedy for earache."

Fig. 173 is a beautiful example of the spirally-folded leaves of the ranunculus.

FIG. 174.—" The accompanying photograph of a giant vine in Madagascar," wrote D., " will perhaps add another to the many interesting spirals in Nature that you have published. It exhibits alternations of right and left-hand spirals in a way that, so far as I am aware, is unusual." There is little doubt that the plant is the sea bean (*Entada scandens*), a common giant woody climber in the tropics, sometimes known to develop spirally-twisted stems. There are examples in the museum at Kew. It has bipinnate leaves, small yellow flowers, and enormous bean-like pods, a yard long and 4 inches wide, containing large, flat, dark brown seeds, 2 inches wide. These seeds are sometimes carried long distances by ocean currents ; they have been picked up on our coasts.

CHAPTER VIII

RIGHT-HAND AND LEFT-HAND SPIRAL GROWTH EFFECTS IN PLANTS (*continued*)

DEAD TISSUES AND SPINNING SEEDS.

" The spirally Upward of rapture, the Downward of pain."—G. MEREDITH.

SPIRAL TWISTING OF DEAD TISSUES—COILING WHEN DRYING : STRAIGHTENING WHEN WET—PREDOMINANCE OF RIGHT-HAND FIBRES—SEEDS SPINNING IN FLIGHT—THE MECHANISM OF WINGED FRUITS.

IN my last chapter I mentioned that certain beautiful spiral formations may be produced after death owing to a peculiar histological construction of special cells, and I promised such instances as are observable in hygrometric awns and portions of fruits. To these, therefore, we will now return, for it will be found that they deserve separate treatment and illustration.

Extremely elegant examples of *spiral twisting* are afforded by the *wholly dead tissues* of parts of certain plants which are utilised in the mechanism of fruit and seed dispersal. In such case the tendency to the assumption of spiral form is always the expression of a fundamental irregularity in the detailed histological construction of cell-walls which have been thickened and lignified. In all thickened cell-walls the thickening layers are built up in strands which cross each other obliquely, and it thus follows that in all greatly elongated cell-derivatives these layers are spirally disposed ; hence in spiral vessels, as well as in pitted vessels and sclerenchymatous fibres, the walls of the cells present indications, often very marked, of spiral construction. Thus it may be said that all elongated, thick-walled cells exhibit spiral markings, or spirally arranged pits. Such thick sclerosed fibrous cells constitute the material used in the formation of the hard parts of many fruits which present movements of dehiscence, and from the fundamental spiral nature of these units, spiral appearances may result when the tissues are entirely dead and dried up. The essential point of interest centres in the fact that mere accidental results, consequent on such fundamental histological details of construction, may become ultimately advantageous in the œcology of the plant, and may then be increased by the action of natural selection, until

extremely neat and even complex mechanisms may result. As examples of such phenomena may be instanced the twisting of the valves of pea-pods, the spirally twisted awns on the fruits of some grasses (oats and feather grass, *Stipa*) ; while the neatest example of extreme efficiency in this respect is presented by the contractile strips on the fruits of stork's-bill. (See Plate I., Figs. 15, 19).

Pea-pods, and the pods of many vetches which show still more marked spiral twisting, are lined by a sheet of woody fibres which phylogenetically are identical with the horny sheets of tissue lining the cavities of the core of an apple. The fibres are arranged obliquely across the wall of the pod, and the innermost layers contract the most on desiccation, with the result that on complete desiccation the valves spring apart, and coil up in opposite directions, ejecting the seeds with considerable force. The more specialised the mechanism, the greater the number of coils produced ; less specialised pods only give half a turn or so of a spiral, while the best pods may give half a dozen coils. In this way a mechanism which may be said to have originated as a structural accident (since the oblique fibres are inherited from a long ancestry, and differentiation in contractile quality is secondary), becomes, in the course of time, a characteristic dispersal-mechanism for a wide range of plants. For our present purposes it is important to note *that since the more contractile walls are on the inner surfaces of the two valves of the pod, the valves coil in opposite senses*, one right and the other left, with the outer wall of the fruit on the outside of the coil, so that the seeds are swept off, and the whole construction is symmetrical (cf. Plate II., Fig. 13).

In other cases the direction of the spiral may be more definitely accidental, since associated with the structure of the wall of the fibrous cells themselves. Thus the single awn of *Stipa*, the feather grass, makes a right-hand twist (see Plate I., Fig. 16). In the case of the *oat*, in which two awns are characteristically present belonging to the two fruits of a single spikelet which is the portion shed from the plant, the direction of twisting is similarly constant and *right hand* in both flowers (Plate I., Fig. 13). Possibly the most remarkable spiral construction is that of the fruit of the stork's-bill (*Erodium*, also *Pelargonium*), since the awn-like strip which coils, has no morphological identity, but is merely a strip of tissue cut out from the characteristic " beak " which gives to these plants the old names of crane's-bills (*Geranium*), heron's-bills (*Erodium*), and stork's-bills (*Pelargonium*). The ancestral fruits of these plants were apparently covered with short, stiff bristles, which, as they all pointed the

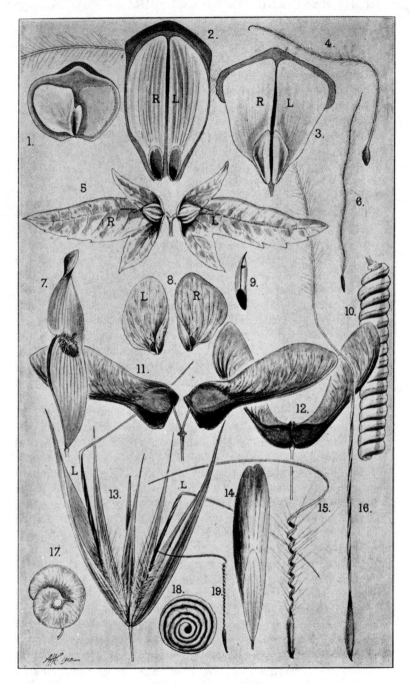

PLATE I.—RIGHT AND LEFT SPIRALS IN PLANTS.

DESCRIPTION OF PLATE I.

1. Cone-scale of Kauri Pine (*Dammara australis*), with one median winged seed.
2. Cone-scale of Pinus (*P. insignis*), with two winged seeds.
3. Cone-scale of Silver Fir (*Abies pectinata*) with winged seeds.
4. Tailed fruit of Clematis (*C. lanuginosa*), with spiral twist.
5. Symmetrical pair of fruits of Hornbeam (*Carpinus*), with three-lobed involucre.
6. Tailed achene of *Geum triflora*, with slight spiral twist.
7. Winged mericarp of *Ailanthus glandulosa*, with right-hand twist.
8. Pair of fruits from a scale of the Hop-cone (*Humulus lupulus*).
9. Winged fruit of *Casuarina*.
10. Spiral pod of Screwbean (*Prosopis strombulifera*), right-hand spiral.
11. Winged mericarps of Maple (*Acer campestre*).
12. Winged mericarps of Sycamore.
13. Fruiting spikelet of *Avena sterilis*, with hygrometric awns.
14. Winged fruit of Ash (*Fraxinus*), with slight spiral twist.
15. Mericarp of Stork's bill, the largest form (*Erodium botrys*).
16. Fruit of Feather-grass (*Stipa pennata*), with hygrometric and feathered awn.
17. Fruit of *Medicago arborea*.
18. Fruit of *Medicago scutellata*.
19. Mericarp of *Erodium laciniata*.

N.B.—All the above were originally drawn to uniform scale of twice the size of nature.

same way, would induce a " creeping " movement, as they slipped
one way, under the action of slight external mechanical agencies
such as wind, and never went back. The addition of a long
strip from a sterile region of the ovary-wall would increase the
ability to creep, just as in the familiar example of the awn of the
barley ; and this would appear to have been the original use of
the " beak-strip," as we may call it. But owing to its construc-
tion with strands of fibrous cells, the strips under desiccation
would tend to coil up in the same sense as would the individual
spirally constructed fibres, if these were left to themselves.
At first the coiling was but slight, a mere turn or so, as persists
to the present day in many geraniums, a good example being
seen in the cultivated dusky geranium (*G. phœum*). The coiled
beak-strip, twisting up under desicca-
tion, and straightening out again when
wetted (in about five minutes), then
becomes a hygrometric driving organ
which pushes the creeping fruit along
with every change of condition, and
a new factor has been introduced into
the working capacity of the plant.
Clearly the longer the strip, the stouter
its hygrometric tissues, and the
greater the number of coils, the more
efficient the driving power behind the
fruit ; and while some species of

FIG.175.—" PARACHUTE " FRUIT
OF THE CAPE SILVER TREE
(LEUCADENDRON ARGENTEUM)
(Natural size.)

Erodium have strips 3 inches long or
more, in others the coils when com-
plete may be seventeen to eighteen in
number (see Plate I., Figs. 15, 19).
Two special points call for notice. All the strips coil in the same
sense, since the histological differentiation is identical in all
the loculi of the same fruit ; and not only so but the tissue-
units are made the same way in all erodiums, and the resultant
spiral is *constantly* right hand. Further, the right-hand direction
is not so simply attained as would appear at first sight, since the
direction assumed on coiling is the accidental product of the
fact, that in different layers of the fibres laid down in the strip
itself, some are left and others right in construction, and the
resultant right spiral is merely due to the fact that in this case
right-hand fibres preponderate over left hand (Steinbrinck,
1895). The fruit of *Erodium* is thus not only a marvellous
example of the fact that a succession of lucky shots (mutations),
many of which may have been purely accidental and meaning-
less, may, in the course of time, produce a beautifully adjusted

mechanism of spiral nature ; but in that it has been derived
from a simple " beak-strip " of the *Geranium phœum* type, it
is equally interesting to note, how by completely eliminating
the spiral tendency, the beak strip might be made to curve to
an exact circular coil. When this happened an entirely different
type of dispersal mechanism became possible, and the final
elaboration of the " sling " mechanism of *Geranium* fruits should
be further analysed from this standpoint.

From this significance of the utilisation of a spiral hygro-
metric driving-mechanism, behind a creeping and boring point,
we may, perhaps, pass on to include the production in dead
tissues of an arrangement which will give a spiral movement
to fruits and seeds as they fall through the air, or are carried
laterally by the agency of the wind. So striking and apparently
purposeful are these *spinning* movements of dry seeds and fruits
that they become extremely useful, as affording examples of the
wonderful results that may follow from a comparatively simple
variation. The development of any seed or fruit, or appendage

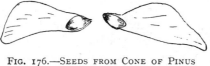

FIG. 176.—SEEDS FROM CONE OF PINUS
AUSTRIACA.
(Natural size.)

to such fruit as a laminar extension of the nature of a plane,
will give a capacity for aerial flotation which, in that it in the
long run delays the rate of falling, must add to the efficiency of
lateral distribution according to the strength of the wind. In
such cases the problem of continued flotation is largely one of
balancing, more particularly of placing the centre of gravity
exactly in the centre of the plane (or below it). In any case of
asymmetrical construction, the movement under flotation will
become spiral in nature, until the case of a seed with a broad wing
attached at one end gives a spinning mechanism of wonderful
efficiency. It is only necessary to refer to the common examples
of the *seeds* of pines, with membranous slip wing, of a perfectly
different nature from that of the wing of the sycamore fruit,
which is again quite distinct in construction and homology from
that of the lime tree. The spirals of the flight of fruits and seeds,
however, have a suggestive value from the standpoint of the
spirals formed in the flight of birds. Thus in the case of a pine-
cone two seeds are borne on the upper surface of each cone-scale,
and these are each associated with a slip of tissue which is readily
detached in the dry cone from the scale, and ultimately from the

seed. In large cones this wing may be an inch in length (*P. insignis*), and by itself has no special motion ; but attached to the seed it gives the falling body a spin, the beauty of which is only understood on throwing a seed into the air and watching it fall. The two seeds on one scale have an opposite asymmetrical shape, and are so far twins. It is easy to see also, on taking the two seeds from one scale of a dry cone, that they fall in opposite directions ; one spins right and the other left. It is difficult to say which may be the right and which the left side of a scale, but on looking down on a scale, as drawn upright on Plate I., Figs. 2, 3, the left-hand seed will spin downwards, falling in a clockwise direction. The fact that these two seeds of *Pinus* spin in opposite directions is, however, the expression of the fact that the slip wing is cut off from a curved cone-scale surface, which curves as it dries ; in the more usual case of *winged fruits*, the wing is an outgrowth or extension of the ovary-wall, which is radially symmetrical in all cases, and the winged mericarps being of identical structure, all spin in the same sense.

Thus the two mericarps (*samaræ*) of the sycamore both spin either way, both are exactly alike, the number two does not, in this case, indicate twin construction ; the ancestral number of carpels for the sycamore being evidently five, and three-winged fruits are still quite common (see Plate I., Fig. 12).

The study of such spinning fruits is so fascinating that we may extend our account to the consideration of a few cases of special interest.

Wing extensions subserving dispersal by the agency of atmospheric currents are extremely frequent in the case of fruits and seeds of genera belonging to most diverse families of flowering plants. The mechanism thus produced may be classed as that of (1) the dart, either simple or barbed, (2) the glider, (3) the flutterer, (4) the spinner, and (5) the parachute.

Parachutes and *spinners* fall vertically when left to themselves, their rate of fall being merely delayed by the wing extensions ; in such case lateral dispersal will be effected solely by the lateral velocity of the wind. On the other hand, darts and gliders move laterally at a rate greater than that of the wind, and may be effective in almost still air, while spinners are the more useful for purposes of dispersal the greater the rate of the wind. For present purposes the parachute type is practically eliminated ; but it is clear that dart and glider types, although quite independent of spiral motion, may take on a spiral path if there is any marked tendency to asymmetrical construction. Thus the fruit of the common ash is a good example of a simple dart

(Plate I., Fig. 14). The long fruits simply shoot forwards and fall with the pointed seed-end downwards ; yet any twist on the plane-extension will tend to cause a rotation in the opposite sense, and ash fruits on some trees have been observed to present a slight left-hand twist, which will cause them to shoot in a right-hand spiral. With this may be compared the samaras of *Ailanthus glandulosa*, five of which are produced from each flower, each with a seed in the middle of the lamina, and a constant right-hand twist at the apex. Such fruits thus grade from mere flutterers into spiral spinners (Plate I., Fig. 7).

Glider types are extremely frequent, since the uniform exten-sion of an ovary wall, or the seed coat—fairly equally in all direc-tions to constitute a flat lamina, more or less circular, with the seed in the centre—would represent the simplest method of

FIG. 177.—" AEROPLANE " SEED OF BIGNONIA.
(Natural size.)

construction. The large disc-like fruits of *Pterocarpus* (*Legu-minosæ*) come under this heading, as also the samaras of the elm and the flat spiral disc of *Medicago arborea* (Plate I., Fig. 17). The finest example of a glider is probably the seed of the East Indian *Oroxylum indicum*, the great papery discs of which, about 3 inches by 2 inches, drift like snowflakes and describe immense spirals.

True spinners depend for their spiral movement on the presence of an unilateral wing-extension, which may be morphologically of most diverse origin. Thus *Pinus* seeds spin in virtue of a slip-membrane detached from the cone-scale ; the sycamore fruits by an extension of the ovary wall. The hornbeam nuts possess a peculiar leaf-like, three-lobed structure evolved from inflorescence-bracteoles ; while one large bracteole is utilised in the case of the lime to spin a cluster of fruits, and a loose

subtending bract is utilised in the case of the hop (Plate I., Figs. 5, 8, 11).

In *Pinus* the spinning effect is associated with the presence of a wing with one stiff, straight edge, which is anterior in flight, and the two seeds from one scale spin in different senses with the concave side of the wing downwards. Many other conifers (*Abies, Picea, Larix*) agree with this type of construction. In the case of genera in which only a single seed or several are borne on the scale two lateral wings to each may occur, and these give the seed a slight glider action, and thus the seed of *Sequoia gigantea* much resembles in appearance the fruit of *Betula*. A critical interest attaches to the seed of the New Zealand Kauri pine (*Dammara*) (Plate I., Fig. 1), since in this case, with one seed only on each scale, a wing is developed on one side of the seed and not on the other, either right or left, on different scales ; that is to say, it would appear that an original glider effect has been replaced by a definite spinning action. The seeds spin well, but the wing is flat, and the movement may be either right or left hand. Similar complementary cases of spinning may be observed in the peculiar fruits of the hornbeam, the two flowers of the symmetrical dichasial inflorescence being images, and the fruits spin right and left respectively, with the concave side of the main lobe downwards and the fruit up, though the wing has no clearly defined front margin (Plate I., Fig. 5). Two fruits similarly resulting from a dichasial pair are found in the case of the common hop, and these again spin in converse directions, right and left, with the concave side up or down, the wing being comparatively ill-defined (Plate I., Fig. 8).

More exact spinning seeds and fruits of the sycamore type are met with in most diverse alliances, and the samara of the sycamore may be taken as typical of the spinning wing at its best development. It closely resembles the wing of some dragon-flies, and spins either right or left, with the stiff edge in front. In many cases a distinct bias will be observed in one direction rather than the other, but this is merely the expression of a slight deviation from the flat plane.

NOTES TO CHAPTER VIII.

FIG. 175 was sent to me by " South African " with the following remarks :—

" I send you a life-size drawing of the ' parachute ' fruit of the Cape ' silver tree,' which I thought you might like to add to your other interesting examples (Fig. 175).

" This common South African tree is a member of the *Proteaceæ.* Its fruits are produced in large cones, not unlike those of a large pine cone, while the peculiar silvery foliage leaves are well known. Each

bract of the ripe cone subtends a fruit in the form of a hard nut, and the withered style and the four perianth segments of the flower persist into the fruiting stage, and are utilised to form the parachute. The perianth members close over the developing fruit as a membranous investment, and become united above it, around the slender style, while their long tips develop prominent hairy crests. When the nut is ripe it is loosened from the cone, together with these other parts The four perianth segments detach below, but, as they are united around the style, they remain connected with the fruit, only they now slip up the wiry style, until they are stopped by the stigma head. As the nut falls away, it has the appearance of a heavy bob attached by a thin wire to four membranous lobes, surmounted by four beautifully crested pieces. The whole fruit looks as if most admirably adapted to act as a parachute ; but on throwing it in the air, it will be noticed that the heavy nut falls about as rapidly without the parachute attachment as with it, so that the arrangement, though so striking in appearance, cannot be regarded as any great success from the standpoint of the flotation of the fruit in the air (nor does it produce any spiral effect). The nut would thus appear merely to retain by accident the hairy perianth lobes, which close over it and protect it externally during the maturation of the seed and the swelling of the style head alone prevents it from slipping off the end of the slender style when detached below. To what extent the parachute effect may be a direct advantage to the plant remains rather doubtful ; but there is no doubt as to the beauty of the fruit as we find it."

FIGS. 176, 177.—" M. L." wrote :—

" From your interesting table of ' Flying Seeds,' you omit two which I happen to have seen and sketched, and I therefore send them in the hope you will let me add to your collection. Fig. 176 shows the seeds from a cone of *Pinus austriaca*, and their likeness to a bird's wings will be at once observable. Fig. 177 shows a perfect example of the aeroplane, the seed of a bignonia, which flutters for some distance through the air before it falls lightly to earth. Both are the size of Nature."

CHAPTER IX

RIGHT-HAND AND LEFT-HAND SPIRAL GROWTH EFFECTS IN PLANTS (*continued*)

SOME SPECIAL CASES.

"Schau' alle Wirkenskraft und Samen
Und thu nicht mehr in Worten Kramen."—GOETHE.

ANOMALOUS VARIATION PRODUCING SPIRALS—"SPIRAL STAIR-CASE" CONSTRUCTION—PECULIARITIES OF SPIRAL SPERMA-TOZOIDS—MALE CELLS OF CYCADS AND CHINESE MAIDENHAIR TREE—SPIRALS AND LOCOMOTION—PREVALENCE OF RIGHT-HAND AND LEFT-HAND SPIRALS.

WE may conclude the consideration of spiral effects in plants by the description of some cases of particular interest which do not come under the preceding headings, but occur as individual or specific sports, the spiral character of which is immediately recognised.

On rare occasions a normally whorled phyllotaxis may vary anomalously to a special case of asymmetry which is most clearly defined as produced by the *loss* of one construction-curve in one sense only ; for example, a plant bearing leaves in whorls of ten (construction system, 10 : 10) may change suddenly to, say, (10 : 9) or (10 : 11). The instant effect would be the substitution of a *winding*, corkscrew-like, genetic spiral all round the axis ; and this would be retained until the system again achieves regularity and symmetrical construction. Such phenomena occurring in typically whorled plants as *Hippuris* and *Casuarina* would be regarded as freaks ; the most beautiful case occurs in *Equisetum*, and a fine specimen of spiral *Equisetum telmatœi* is a thing to marvel at.

Somewhat similar in the production of a spiral wing effect are the remarkable plants *Vidalia* and *Riella*, which occur as somewhat isolated genera in their respective classes. Thus among the red seaweeds, a plant known as *Vidalia volubilis*, growing in the Mediterranean district, shows a spiral twist like a shaving. The upright branches of the thallus attain a length of 60 mm. or more, and with age the spiral becomes more

attenuated. In specimens figured and so far observed the direction of the twist was left hand (Plate II., Fig. 2).

Again, among mosses and liveworts, in which spiral construction is commonly indicated by the spiral succession of segments cut off from the apical cell, which apparently determine the arrangement of the leaves, a single genus alone produces a wing growth which coils in a similar spiral staircase-like frill. The best examples of this construction occur in a rare form *Riella helicophylla*, growing in Algiers. The plants grow submerged, and the erect shoots attain a height of 30 to 35 mm. Several plants figured in the " Exploration Scientifique de l'Algérie " (1848) agree in presenting a constant right-hand spiral (Plate II., Fig. 1).

The construction of these preceding cases affords so strong a suggestion of what may be termed " spiral-staircase " construction that it may not be amiss to point out that suggestions of a similar formation are to be found even among higher plants. Two examples call for special notice.

The formation is comparatively rare, but it appears in some aroids as a normal construction, *e.g.*, in *Helicophyllum* and *Helicodiceros*. In the case of *Helicodiceros muscivorus* it would seem at first sight as if two leafy shoots were springing from the base of the leaf. In reality the lamina has two sagittate basal lobes, as in many other aroids. But these branch *sympodially*, and the ramifications do not spread out, but are twisted into a ladder-like spiral, so that the leaf lobes appear as if they were arranged around a central axis ; the two systems of leaf lobes make spirals in opposite senses, and each foliage leaf thus really produces the effect of a double branch system of leaf laminæ (Goebel, " Organography," Vol. II., p. 324).

From the consideration of organisms which are more or less completely spiral in their whole organisation we may now pass on to the case of *spiral spermatozoids*. The sperm cells of lower algæ are characteristically minute ovoid or pear-shaped bodies with a motile mechanism in the form of two long cilia or flagellæ. With increasing specialisation of the mechanism of sexual fertilisation, further specialisation is observed in the bodies of the sperms themselves. These become much elongated, and the driving power is increased by further elongation of the cilia, or by an increased number. Owing to the development of the spermatozoid, in a fairly isodiametric mother cell, this elongation of the body can be only attained by a coiling up of the nucleus as it becomes converted into the body of the spermatozoid, and, if the elongation be continued to a distance greater than the circumference of the cell, the sperm will take on a spiral form and continue to wind, possibly into many coils. The direction

PLATE II.—RIGHT AND LEFT SPIRALS IN PLANTS.

DESCRIPTION OF PLATE II.

1. *Riella helicophylla*, whole plant, 35 mm. high. (*Flore d'Algerie*, 1848.)
2. *Vidalia volubilis*, whole plant, 60 mm. high, from nature.
3. Antherozoid of *Chara*.
4. Antherozoid of Moss, *Funaria*.
5. Antherozoid of Fern, *Aspidium*
6. Antherozoids of *Cycas revoluta* in pollen-tube. (Miyake, 1906.)
7. Antherozoids of *Dioon edule*, end view and profile. (Chamberlain, 1910.)
8. Male nuclei of *Fritillaria tenella*, with coiled loops; fertilisation phases. (Nawaschin, 1909.)
9. Male nuclei of *Helianthus annuus* (Sunflower), with spirally coiled loops; fertilisation phases. (Nawaschin, 1900.)
10. Antherozoids of *Zamia*, end view. (Webber, 1901.)
11. Side view of the same
12. Spirally twisted fruits of *Helicteres isora*, from nature, R., L., and a case of reversed spiral twist.
13. Fruit of Spanish Broom (*Spartium*), with symmetrically coiled valves (70 mm.).
14. Fruit of *Martynia formosa*, with spirally arched symmetrical horns (4 inches by 4½ inches).

of the spiral coil, right or left, would apparently be determined by chance, according as the tip of the coiling nucleus passes one side or the other of the other extremity, and the spermatozoids of many plant forms thus present simple corkscrew coils, which may be indifferently right or left. Thus the green alga *Chara* possesses a spiral two-ciliated sperm, constructed as two to three coils in a discoid mother cell (Plate II., Fig. 3), and it swims with the pointed end in advance. Such spermatozoids do not wholly straighten out when set free, and the spiral construction apparently gives a rotating movement, which enables motion to continue in a much straighter course than in the case of simple ovoid flagellated cells. In this way a spiral form which was originally induced by the necessities of the construction mechanism may become an advantage to the organism, and the spiral form is henceforward characteristic of male cells. Simple spiral sperms of this character obtain throughout the entire group of the mosses (cf. Plate II., Fig. 4). When discharged the spiral coils are obvious, but when actively swimming, and especially when penetrating the narrow neck of the archegonium, they straighten out very considerably. A more complicated form occurs among ferns (Plate II., Fig. 5). In the common type the number of coils is three to four; the vestiges of the mother cell may be seen dragged at the posterior end, while the front coil is beset with a crown of fine cilia. The record sperm of this type is found in the rhizocarp *Marsilia ;* here the corkscrew-like body forms a particularly beautiful spiral of twelve to thirteen, or in extreme cases seventeen, coils; this remarkable development being possibly associated with the fact that the sperm has to bore its way through a dense mass of mucilage to reach the archegonium.

All these spermatozoids are extremely minute ; that is to say, they can only be observed satisfactorily under the highest powers of the microscope, requiring a magnification of 500 diameters to make them as clear as seen in text-book figures. The remarkable and relatively gigantic male cells of cycads and the Chinese maidenhair tree (*Ginkgo*), which have only been described in recent years, are of a very different character. These sperms are formed *two together* at the apex of the pollen tube, as large rounded nuclei, which do not change their form so much as *take on a spiral band of cilia at one end*. They are so large that they may be just seen with the naked eye, the best cycad sperms being even one-third of a millimetre in diameter, and the effect of the spiral band is to give them a rolling movement ; the distance they have to travel to meet the female cell is not great, and this rolling motion appears to be sufficient for

the purpose and to take them as far as the narrow neck of the archegonium, through which they have to squeeze.

That large motile male sperms should occur in the pollen tube of a large and quite ordinary-looking modern tree, and should be discharged to swim freely to the female cells, is one of the most remarkable facts in modern botany, as confirming the long-established views as to the origin of higher land plants from cryptogamic ancestors, whose fertilisation processes took place in open water. The discovery of such motile sperms in the case of *Ginkgo* by the Japanese botanist Hirasé in 1896 has thus marked an epoch in the study of early seed-plants, and this was

FIG. 178.—THE LADDER-LEAVES OF HELICODICEROS.

soon followed by descriptions of almost identical phenomena in three or four genera of modern cycads. In the case of the cycads the sperms are even larger and clearer than in *Ginkgo*. In *Cycas* they are ·18 to ·21 mm. in diameter. According to Miyake (1906), the spiral band makes five and a half to six turns, and constantly, or with few exceptions, so far as known, in a left-hand spiral, winding in clockwise on looking down on it (Plate II., Fig. 6). In *Zamia*, an American form, according to Webber (1901), there are also five to six complete turns, and in a constant left-hand direction, the sperm being the largest yet seen, ·222 to ·332 mm. in diameter (Plate II., Figs. 10—11). Finally, in the Mexican cycad *Dioon*, described by Chamberlain

(1909), the sperm, up to ·300 mm. in diameter, also shows five
to six turns, "almost without exception," a right-hand spire
as seen from above (Plate II., Fig. 7). What causes the direction
of the spiral is still unknown ; but it is interesting to note that
in these cases the sperms are always formed in a pair from sister-
cells, and are differentiated in these "*back to back.*" Being in
this sense *twin-cells*, with their nuclei derived from an initial
nuclear spindle, it might have been expected that the coils
would have wound in opposite sense ; but the evidence is
distinctly to the contrary and the constant would appear to be
a specific character, although enough work has not been done
on these types to make the matter an absolute certainty.

Even in higher plants indications of spiral movement and
consequent spiral form have been traced in the male cells at
the time of fertilisation. The two male nuclei which leave the
pollen tube of flowering plants have to travel a certain distance
to reach the female cell, as also the nucleus involved in endosperm
formation, and it would appear that such movement must be
performed on their own initiative. Beautiful figures have been
given by Nawaschin for *Fritillaria tenella* (1909) (Plate II.,
Fig. 8), in which the two sperm nuclei present a distinct coiled
worm-like appearance. A still more striking case is illustrated
for the fertilisation of the common sunflower (*Helianthus*)
(Plate II., Fig. 9) (Nawaschin, 1900), the elongated sperms
showing distinct spiral coiling, and even a *kink in the middle
and coiling in opposite directions at the two free ends*. To what
extent this assists the movement, or is merely the expression
of aimless wriggling, is not clear ; but it is interesting to note
the retention of spiral characters in these cells, which are not
spiral by any construction processes, as in the case of the snail-
like cycad sperms, which apparently put on the spiral band
for purposes of locomotion, just as they slip it off again as they
enter the ovum.

Interesting examples of the sporadic origin of the spiral con-
dition are again afforded by many remarkably constructed fruits,
the torsion effect being restricted to single species among a genus,
and very rarely a generic character. Very beautiful spiral
patterns are commonly observed in the case of fruits derived
from one or more carpels which are themselves quite straight
in the flowering condition, but take on a secondary spiral growth
during early stages of fruit development. Here also the spiral
twists may be constant in direction or a matter of chance in
different cases.

Rarely a group of several carpels is twisted together as in
Helicteres isora (Plate II., Fig. 12), in which five carpels twist

together to a close spiral of ten to fifteen coils. In this plant
the spiral may be right or left. Examination of seventy-five
fruits gave forty-five right and thirty left, suggesting a bias in
favour of the former condition. One fruit was found which was
left spiral below, and then changed to a right spiral in the upper
region. The case of the fruit head of many large forms of
clematis (*C. lanuginosa*) affords a less perfect example of a left-
hand constant spiral drift on all the tails of the achenes. Some
of these feathered fruits fall in wormlike sinuous right-hand
spirals, resembling those of the *Stipa* fruit.

Very charming spiral effects are characteristic of certain
genera of the *Leguminosæ*, in which only a single carpel is involved
to constitute the pod fruit. A large number of species of

FIG. 179.—SPIRAL LEAVES OF HYBRID BEGONIA.

Medicago are constantly left hand, *e.g.*, M. *arborea* (Plate I.,
Fig. 17), with one coil only to the flat fruit, which becomes a
wind-distributed glider, or with five to six complete coils in the
rolled-up ball of *M. scutellata* (Plate I., Fig. 18). Right-hand
species of *Medicago* have been described. On the other hand,
the screw beans (*Prosopis*) give very perfect spiral screws of
as many as fifteen coils, constantly right hand ; these screws
2 to 3 inches long, so closely imitate the effect of an ordinary
" right-hand screw " that it is difficult to realise that they are
not artificial productions (*P. pubescens*, *P. strombulifera*). Other
species of the genus may have perfectly straight pods (Plate I.
Fig. 10).

While the direction of coiling in the preceding examples is
clearly quite immaterial to the plant itself, and can be only

regarded as a mere specific or generic " accident," a more elegant example of complementary twisting is seen in the two-carpelled fruits of species of *Martynia ;* in these large capsules two long, stiff horn-like processes curve and inarch like the horns of an antelope. This symmetrical position is said to be utilised in the œcology of the plant, as these long, stiff processes catch in the fetlocks of animals running over the prostrate shoots (Plate II., Fig. 14).

NOTES TO CHAPTER IX.

THE IRISH COURT YEW.—In reference to the second paragraph of this chapter it may be added that the first two specimens of what is now called the Irish or Florence Court yew (*Taxus baccata*, var. *fastigiata*), in which the leaves are sub-spirally arranged round their axis and spreading from all sides of it, were found about 120 years ago by a farmer of Aghenteroark (co. Fermanagh) on his steading among the mountains, and he took one of them to Florence Court. The Earl of Enniskillen afterwards gave the first cuttings to Messrs. Lee and Kennedy, and they then spread all over the world.

FIGS. 178 AND 179.—" F. R." in sending these wrote as follows :—

" You speak of the ladder-like spiral noticeable in *Helicodiceros muscivorus.* I enclose a drawing of it, after Goebel (Fig. 178).

" Somewhat comparable spiral staircase effects have also been noticed in certain begonias (Goebel, 1911), two ' foliage-hybrids ' of the Rex-hybrid, known as Comtesse Louise Erdödy and *B. ricinifolia f. wehleana.* The former is said to be a cross between ' Alexander von Humboldt ' begonia and *B. argentea ;* the latter between *B. heracleifolia* and *B. peponifolia.* The peculiar characters noticed in these cases do not obtain in the parent strains at all ; and the essential point noted is that the basal lobes of the leaf-lamina keep on growing for a considerable time, instead of passing on into adult tissue, as in the case of other begonias. The most perfect development of this spiral effect is seen when a young leaf is used for a cutting, and all adventitious buds are removed as they appear. In such case the *basal lobes* continue to grow, apparently at the expense of food material in the rest of the leaf, and these growths continue from the base of the lamina as two spiral staircase laminæ, winding symmetrically in converse senses. In the case of the plant figured by Goebel, the new growths show five coils, though a few weeks previously they had only two. It is not likely that these spirals will go on growing indefinitely, but they will evidently do so for some months, the limit to the proceeding being set by the available food supply. The spiral effect is clearly due to the fact that the outer edge of the lobes grows more strongly than the inner edge, which resembles a thick vein. (See Fig. 179.) It is evident that here we have to do with a very remarkable and beautiful *mutation*, which may or may not have been produced by hybridisation ; but the utility of the construction is very questionable, and the remarkable leaf would remain classed as an accidental and aimless monstrosity ; it is curious that it should appear in two hybrid strains."

RIGHT-HAND AND LEFT-HAND SPIRALS IN SHELLS

" It has been thought that the shells which are visible at the present time within the borders of Italy, far away from the sea, and at comparatively great heights, are due to the Flood having deposited them there ; and it has been argued that the nature of these shells is to keep near the edge of the sea, and that as the sea rose in height (during the Flood) the shells followed the rising waters to their highest level. But the cockle (for example) is even slower than the snail out of water, and could not possibly have travelled from the Adriatic Sea as far as Monferrati in Lombardy (about two hundred and fifty miles) in the forty days which is given as the duration of the Flood . . . As a matter of fact, in the cutting of Colle Gonzoli, which has been made precipitory by the action of the Arno wearing away its base, you can see the shells in layers in the blue clay, which also contains other relics from the sea."—LEONARDO DA VINCI (Leicester MSS.).

CONTRAST OF TREES WITH SHELLS—SPIRAL FOSSILS IN NEBRASKA —DETERMINATION OF HAND IN SHELLS—DIFFERENT HAND IN FOSSILS AND SURVIVORS OF SOME SPECIES—LEFT-HAND SPIRALS OF TUSKS—SINISTRAL SHELL, BUT DEXTRAL ANIMAL —SHELLS AMONG PRIMITIVE PEOPLES—FOLLOWING THE SUN —THE SWASTIKA—SPIRAL FORMATION AND THE PRINCIPLE OF LIFE.

In that botanical portion of our subject which has just been concluded, it will be observed that the spiral formations of plants have been examined from a different point of view from that illustrated, for instance, in our examination of the spirals of shells shown in the third section of this series. And no possible botanical authority can be given to the suggestion made in my first chapter, that a twist can be imparted to the trunks of trees either by the rotation of the earth or by the action of continuously prevailing winds. In Fig. 43, Chap. II., I gave an example of a right-hand twist in a chestnut tree from Shrewsbury, and added that I awaited examples of the reverse formation from Australia. But the delay is now hardly necessary. In Fig. 180 will be seen a beech at Kew showing a very pronounced right-hand twist. And if this, taken with Fig. 43, and with the right-hand twist of the sweet chestnut on the left of Fig. 181, be taken as a proof that right-hand formations of this kind are more usual in the northern hemisphere, we have an instant contradiction in the second sweet chestnut shown in Fig. 181, which exhibits the reverse twist in spite of being the same kind of tree growing in the same locality. It is clear, therefore, that we cannot predict in botany that all specimens of the same family will show a

similar formation, as we can in most cases of shells ; and our uncertainty will be still further increased, I think, when we proceed to investigate twining plants. But before attempting a closer examination of shells, I must give an instance of a very curious

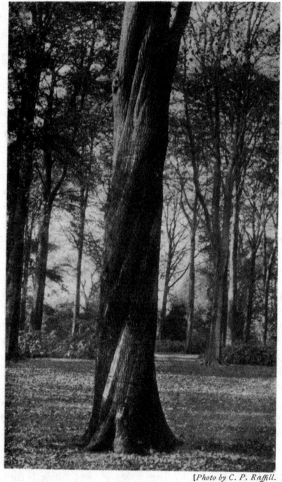

[*Photo by C. P. Raffill.*

FIG. 180.—TWISTED STEM OF BEECH (RIGHT HAND).
(See Fig. 43.)

structure concerning which scientific controversy has not yet absolutely decided whether it is of animal or vegetable origin— a decision which has baffled more than one celebrated investigator in other cases where somewhat similar difficulties have arisen, such as the so-called *Eozoon canadense*, for example.

Some very extraordinary spiral fossils, found in the Bad

Lands of Nebraska, first attracted the attention of the scientific world some years ago ; and by the kindness of Dr. W. H. Drummond, of Montreal, a specimen will, it is hoped, soon be placed in the British Museum of Natural History. Their exact origin and nature are still the subject of discussion, but as the balance of expert opinion inclines to the belief that they are not only organic, but also plants, I have inserted what is known about them here.

Professor Erwin Hinckley Barbour has published an illustrated description of many examples of these " devil's cork-screws " or " fossil twisters," called in more scientific terminology *Dæmonelix*, which he found in large quantities at Eagle

[*Photo by C. P. Raffill.*

FIG. 181.—TWO SWEET CHESTNUTS SHOWING RIGHT AND LEFT HAND TWIST.

Crag, on Pine Ridge, near Harrison, in Sioux County, Nebraska. These peculiar structures, as anomalous as they are unique, are found over an area of some 400 square miles, between the White River and the Niobrara River, and to a depth of about 200 feet. They are corkscrew-shaped columns of quartz, sometimes embedded in sandstone, sometimes " weathered out " quite clear of the original matrix. The spiral varies in length, but sometimes is as much as 20 feet long, and perfectly regular throughout. At the lower end is a large transverse attachment, not spiral but smooth, and roughly cylindrical in shape, as large round as a hogshead, and longer than the spiral growth above it. The surface of these spiral fossils is a tangle of ramifying, intertwining tubules, about an eighth of an inch in diameter, which thicken inside into a solid compact wall, showing (under the

microscope) plant tissue arranged in fibres. Every microscopic section, without exception, shows unmistakable plant structure.

An immense lake of fresh water, in long distant periods of time, once covered the great basin east of the Rocky Mountains, of which the sand rock of the modern district, all sedimentary and of aqueous origin, is a relic. In the course of ages, this lake became filled up by *detritus* poured in from the rivers, and its water plants were buried in sand. By degrees these plants decayed, and, particle by particle, were replaced by silica, the material of quartz ; and in this manner the huge corkscrews of quartz, now found on Pine Ridge, have preserved the shape,

 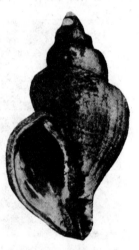

FIG. 182.—LIVING RED WHELK, FUSES ANTIQUUS (RIGHT HAND). (From the beach at Felixstowe.)

FIG. 183.—FOSSIL RED WHELK, FUSUS ANTIQUUS (RED CRAG) (LEFT HAND). (From the cliffs along the shore at Felixstowe.)

the spiral growth, and the huge roots of the vast water weeds which flourished long ago at the bottom of the lake, and persisted in growing at various levels, one above the other, as the filling up process went on, until at last the lake became dry land, and its weeds vanished—to reappear as *Dæmonelix*. The spirals are both right hand and left hand, and their symmetrical arrangement round a vertical axis is alone sufficient proof that they are not the remains of any animal or of any animal's abode ; for though the skeletons of animals have, in two cases, been found in connection with them, I cannot believe that *Dæmonelix* was ever a rabbit burrow. It is almost equally difficult to believe that such huge weeds could have grown in a lake and not in a

sea ; or that any *algæ* had tissues strong enough to resist rotting within a few weeks of death.

Other hypotheses have been put forward to explain these odd formations, one of the most likely being that two plants are involved, one of which coiled tightly round the other ; but this is not the place to enlarge upon them. It is clear that our knowledge is not yet sufficient to produce a theory that will satisfactorily explain all the facts. We are on firmer ground when

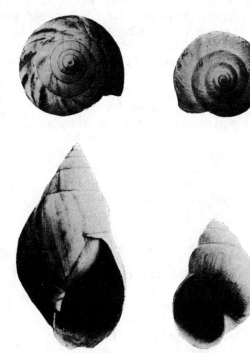

FIG. 184.—ACHATINA HAMILLEI (RIGHT HAND).

FIG. 185.—LANISTES OVUM FROM TANGANYIKA (ALWAYS LEFT HAND).

we turn to the examination of shells, whether the living or the fossil specimens.

Some writers seem to be of the opinion that the " choice " between a right-hand or a left-hand spiral in the formation of living things is largely due to chance. If so, it must be one of those vital " chances " which seriously affect the future both of the individual organism and of the race ; for we have already observed cases where all the fossil shells of a certain species were left hand, and all the surviving specimens of the same species were right hand (see Figs. 182, 183). Are we to argue from this that all early individual creatures of this kind which did

not adapt themselves to changing environment by changing their spiral were not fit to survive ? Or should we merely say that in the age when the fossil shells flourished some continuous influence like the set of the tide gave all the young shells an " inclination " to become left hand, whereas in more modern centuries the set of the tide has altered and the young shells merely show that alteration ? Near Lake Tanganyika there lives an amphibious mollusc with a rather large shell called *Lanistes* (see Fig. 185) which, in that locality, always exhibits a spiral of left-hand formation. The same shell, when it is found at Lake Nyassa or the Victoria Nyanza, exhibits a dextral helix. It was suggested by Mr. J. E. S. Moore that Lake Tanganyika had had some past connection with the tides of the ocean, whereas the others are freshwater lakes. But this is now found to have no justification.

I have mentioned the slight causes which may give an apparently accidental origin to a spiral. The follicle of hair is a good example of this. In Western peoples it is generally straight, but in the negroid races the follicle is bent, and the result is the spiral shown in curly hair. The socket of a tusk or the base of a horn has much the same effect on growth. The examples of narwhal's tusk (really his front tooth), which may be seen in the Museum of the Royal College of Surgeons, show excellently the rare sinistral spiral, and the varia-

FIG. 186. —PART OF NARWHAL'S TUSK (ALWAYS A LEFT-HAND SPIRAL).

FIG. 187.—ELE-PHANT'S TUSK IN ROYAL COL-LEGE OF SUR-GEONS, SHOW-ING ABNORMAL SPIRAL TWIST.

tion shown by the additional curves in one of them is, no doubt, due to a slight variation in the socket. Every narwhal tusk I have ever seen (and there have been six quite lately in one naturalist's shop in London) has a left-hand spiral (Fig. 186), including a sixteenth century carved specimen, now in the Sala dei Stucchi of the Doges' Palace, and another still older tusk, preserved in St. Mark's Treasure, in Venice. But they exhibit an even more extraordinary partiality to this formation. There are seven examples known of narwhals with a double tusk. One of these

is in the British Museum of Natural History at South Kensington. Instead of following the examples of the horns I mention later and showing different spirals, this pair of tusks exhibits two spirals of the same kind, and each of them is sinistral ; and, though I only speak of what I have myself examined, the statement has been made that whenever a narwhal has two such teeth their spirals are identical, instead of exhibiting symmetrically different spirals about the middle plane of the body, as might have been expected. Dr. Wherry thinks that as an unerupted tusk exhibits a perfectly straight fibre, the direction of the spiral is formed after it leaves the bone and becomes opposed to the waves during growth, owing to the fact that the creature " plays " to one side as it ploughs through the water ; and when by a rare chance two tusks are developed, the creature preserves the habit of carrying its head on one side and so gives both tusks the sinistral twist it gives to one. This may be compared with the right-hand spiral observable on each side of the petals of *Selenipedium conchiferum*, which I quoted before from the same writer's observations.

FIG. 188.—ELEPHANT'S TUSK IN ROYAL COLLEGE OF SURGEONS, SHOWING ABNORMAL SPIRAL CURVE.

In the Museum of the Royal College of Surgeons there is also an elephant's tusk which exhibits a very abnormal form indeed, for, instead of being the usual segment of a circle, the tusk has grown into a sinistral spiral, so much accentuated by causes latent in the socket that the whole thing has taken a complete corkscrew formation (Fig. 187). Frank Buckland had certain rabbits' teeth in his collection which had grown into a spiral form owing to an injury at their base from a stray shot or some other accident (compare Fig. 188). That an alteration in the socket is quite sufficient to control the formation of a growing spiral may be proved, as I have suggested already, by placing one of the eggs called " Pharaoh's serpents " in a small tube. As soon as the spiral begins to come out of the egg it will exhibit a dextral helix if the tube is dented slightly on the left, and a sinistral helix when the orifice of the tube has a dent upon the right.

In considering the reasons why a shell should be sinistral rather than dextral, I must distinguish between those sinistral shells which are " sports," or rare exceptions to the dextral rule common in their species, and those shells which are sinistral as a rule of their species. There is yet a third distinction, which must be made later.

Turrilites catenulatus always exhibits a conical sinistral helix. *Turrilites costatus*, a fossil gastropod, commonly called the " screw shell," is found in the Portland formation as a rule. Other left-handed species are *Columna flammea*, from Prince's Island in the Gulf of Guinea ; *Miratesta*, a freshwater shell from Celebes ; *Amphidromus perversus* from Java ; the pond snails *Physa fontinalis* in Europe ; and *P. heterostropha* of America.

The sinistral form of *Voluta vespertilio* (Figs. 78 and 90) is, however, the exception to the rule of the species, which is found on the Italian coasts of the Mediterranean, and an Italian collector would be more likely to have the sinistral form of a common shell than its ordinary growth. This ordinary form is shown in Figs. 189, 190. At the present day, Mr. Fulton

FIG. 189.—SECTION OF COMMON FORM OF VOLUTA VESPERTILIO.

FIG. 190.—COMMON OR LEIOTROPIC VOLUTA VESPERTILIO.

(Compare Figs 78 and 90.)

informed me, specimens of the sinistral *Buccinum undatum*, though not common, can be bought for a few shillings. A Billingsgate porter thinks he has a rare prize when he finds it, and is greatly disappointed when he discovers it is not worth gold. *Fusus antiquus* (Figs. 182 and 183), a fossil sinistral whelk, of which Mr. Morton Loder, of Woodbridge, sent me an excellent specimen, is too common to be bought by dealers at all. The genus *Amphidromus* is about equally divided into dextral and sinistral species. But in cases where a shell only exhibits the sinistral specimens in its fossil form, and is dextral in all living examples, I know no reason for the survival. It may be significant, however, that *Tornatina, Odostomia Turbonilla*, and others, though sinistral in their embryonic form, become dextral as adults, which may suggest the argument that (for some reason

hitherto unknown) no sinistral specimens can survive. The
right-hand form of *Neptunea antiqua* (see Fig. 191) was classed
by Fischer with *Fusus antiquus* (Fig. 183) and in 1898 Harmer
analysed both recent and fossil distributions of the shell. He
found the left-hand living variety south of the Bay of Vigo
along the Portuguese coast, but further north there are more
right-hand than left-hand formations, and var. *Carinata* was
chiefly arctic. But the most interesting point is that the fossil
forms were usually right hand in the English Red Crag, and this
formation, therefore, preceded the living specimens in Portugal,
of which no left-hand fossils are found. The left-hand fossil
form *Neptunea contraria* (Fig. 192), is of the Pleiocene age (see

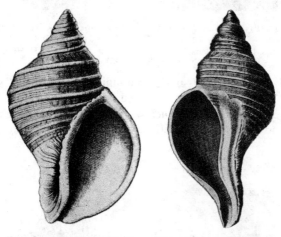

FIG. 191. — NEPTUNEA 'AN- FIG. 192. — NEPTUNEA
TIQUA, CARINATA. CONTRARIA, SINISTRORSA.
(Crag, Little Oakley.) (Pleiocene.)

Simroth's " Mollusca " in Bronn's " Klassen des Tier-Reichs,"
p. 907).
The third distinction to be made in this matter is in such cases
as *Spirialis, Limacina, Meladromus,* and *Lanistes,* in which the
shell is sinistral but the animal is dextral. Here Simroth, von
Ihering, and Pelseneer, explain that the shell is really *ultra-
dextral ;* that is to say, the whorls have been, as it were, flattened,
as in *Planorbis,* then the spire has been still further pushed down-
wards, until the whole is turned inside out, becoming sinistral
with its original dextral animal. The proof that this queer
process has in some way occurred, is arguable from the fact
that every dextral shell has a sinistral twist to the operculum, with
nucleus near the columella, and *vice versa* (see Figs. 46 and 47),
but in " ultra-dextral " shells the operculum is sinistral, in spite

of occurring in what looks like a sinistral shell. There are also instances of " ultra-sinistral " shells, which appear to be dextral though their orifices are sinistral, as in the freshwater *Pompholyx* from North America, and *Choanomphalus* from Lake Baikal.

Among the organisms illustrated here are included several speci-

FIG. 193.—HELIX LAPICIDA. FIG. 194.—THE SAME FROM ABOVE.

(Photos. by J. C. Blackshaw from specimen found by J. B. Higham, Wolverhampton.)

mens of right- and left-hand foraminifera from the *Challenger* reports. The larger shells illustrated include the Central African snails in Figs. 184, 185, in which we find *Achatina* with right-hand curves and *Lanistes ovum* with left ; *Helix lapicida*, an English

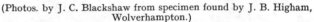

FIG. 196.—RIGHT-HAND VOLUTA SOLANDRI.

FIG. 195.—LEFT-HAND TUR-BINELLA RAPA.

(The sacred Chank Shell held in the hand of Vishnu.)

snail, with the rare left-hand spiral (Figs. 193, 194) ; the common form of right-hand *Voluta vespertilio* (Fig. 189), which may be compared with her extremely rare sister shown in Fig. 90 ; and, finally, the left-hand *Turbinella rapa* (Fig. 195). It is this last example which I would particularly emphasise, because

FIG. 197.—MARINE SUBJECTS IN FAÏENCE FROM THE EARLY MINOAN
TEMPLE REPOSITORY (ABOUT 1600 B.C.) AT KNOSSOS IN CRETE.
(Sir Arthur Evans.)
By permission of the Committee of the British School at Athens.

it is a good instance of the very curious and general fact that when objects which usually display a dextral helix are found to show a sinistral helix, some peculiar value, and often some supernatural signification, is attached to them by the primitive races who make the first discovery. The practice is akin to the delight of an ancient people in such marine treasures as the *echinus* or sea urchin which Schliemann found in the decoration of the prehistoric shields of Troy ; the half-uncoiled arms of cuttlefish on the painted cups of Knossos may be mentioned in the same connection. From " The Palace of Knossos " (1903), by Sir Arthur Evans, I am able to reproduce, by the kindness of Mr. George A. Macmillan, the striking collection of objects in faïence (Fig. 197), dating from about 1600 B.C., and showing prominently the lovely spirals of *Argonauta argo* at each corner. The same

FIG. 198.—TWO TRITON SHELLS
FROM A MINOAN CLAY SEAL
IMPRESSION FOUND AT
KNOSSOS.

(Sir Arthur Evans.)
By permission of the Committee
of the British School at Athens.

volume gives the Triton shells in Fig. 198, carved on a Minoan seal ; and these, like the shells shown in Figs. 24, 25, and 26, all show the spiral formation. Many more examples might be added ; but perhaps the most interesting is that given in Déchelette's famous " Manual," from which Fig. 199 was redrawn for me. It shows part of a collection of 200 seashells (*Nassa*) arranged as a necklace and all tinged with red, which was found in the Grotto of Cavaillon near Mentone. In the Grotte des Enfants two skeletons showed ornaments of *Nassa neritea*. Another

skeleton was found on a bed of shells, *Trochus*. At Laugerie Basse a skeleton showed *Cypræa* (from the Mediterranean) on forehead, arms, knees, and ankles. At Cro-Magnon Lastel found 300 perforated specimens of *Littorina littorea*. At Cavaillon about 8,000 little seashells were found altogether, nearly 1,000 perforated, and almost all painted after the fashion which lasted as long as the specimens found at Knossos.

A curious use of the echinus, which may be compared with that mentioned above as found in prehistoric Troy, was discovered by Mr. Worthington G. Smith. In a round barrow on Dunstable Downs he excavated some 200 fossil echinoderms which surrounded the skeletons of a mother and her child (see " Man the Primeval Savage "). The fossils were of two kinds, known by the folk-names of " heart-urchin " and " fairy loaf " or " shepherd's helmet." Another common chalk fossil, *Porosphœra*

globularis, was a special favourite with the men of the Barrow burials, and was often strung by them into necklaces. Canon Greenwell found an ammonite beside a skeleton in a Yorkshire mound, and it appears that black ammonites are sometimes associated with the religious ceremonies of the Brahmans. In a limestone burial-cave in Belgium, M. Dupont found a collection

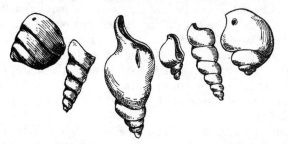

FIG. 199.—PERFORATED SHELLS USED AS NECKLACES BY MAGDALENIAN CHILDREN ABOUT 20,000 YEARS AGO.
Discovered in the caves at Cavaillon (Alpes Maritimes) by Rivière, Lartet, Christy, and others. (Déchelette, p. 208.)

of shells, including *Cerithium*, which must have been brought from nearly fifty miles away for the purpose. Saxon graves in Kent have revealed cowries which can only have come from the Far East ; and necklaces of " elephant's tusk " shells (*Dentalium*) have been found in British barrows. In Mr. Walter Johnson's " Byways in British Archæology," it is also recorded that the Laplanders, who afford another in-stance of the use of sea-urchins in burials, have always treasured fossils and queerly shaped stones as fetishes. They thought snailshells were " dog-souls " (*Hundsjael*), and in the old days seem to have substituted them, in burials, for the more valuable living quadrupeds.

FIG. 200.—POSTAGE STAMP FROM TRA-VANCORE.

The inhabitants of Travancore believe that the sacred shell called " Sankho " is a mani-festation of the god Vishnu, some of whose attributes are indicated in the carved footprints of Buddha. In this shell the internal spiral does not turn to the right (with its " entrance " therefore also to the right), as in the case of the shell *Turbinella pyrum* (Fig. 93), and in many other examples, but turns to the left (with its " entrance " also to the left) as in *Turbinella rapa* (see Fig. 195) with the rare sinistral helix ; and this belief survives in the drawing, conventionalised though it be, of this sacred shell (with its opening to the left) which is to be seen upon the postage stamps now used in Travancore (Fig. 200). This " chank shell," is represented in Hindu religious

art as held in the hand of Vishnu. It is fished for at Tuticorin,
on the Gulf of Manaar, from October to May, and in 1887 a
good sinistral specimen found at Jaffna was sold for Rs.700.
Nearly all the common shells brought up are sent to Dacca
to be sliced into bangles and anklets for Hindu women ; and
this use of shells as ornaments among savage inland races, and
more civilised dwellers by the sea, may be paralleled in every
quarter of the globe and in the earliest periods of history. In
the Indian Ocean *Cypræa moneta* (the " money cowry ") has for
ages been employed as a medium of exchange, as is *Cypræa
annulus* in the Pacific. In Bengal in 1854 the value of 5,120
cowries came to one rupee. In Egypt the same shell is
still used as a preservative against the " evil eye." (See
Appendix VII.)

A pretty parallel with this may be found in a delightful legend
from the folklore of Eastern Europe, related by Mr. George

FIG. 202.—YOUNG
SPECIMEN OF
POLYSTOMELLA
MACELLA. × 60.
(Brady's Foramini-
fera. *Challenger*
Reports.)

FIG. 201.—NONIONINA STEL-
LIGERA. × 60.
(Brady's Foraminifera. *Chal-
lenger* Reports.)

Calderon. It appears, that at the baptism of a Lithuanian infant,
the parents bury one of its little curls at the bottom of a hop pole,
so that the child may " twine out of danger " in its lifetime,
just as the left-hand spirals of the plant twine upwards to the
sun. It is possible that the left-hand spiral may have had a deep
signification as a symbol, in older centuries and in various
climes. The four great columns set up behind the high altar
in St. Mark's at Venice are all carved in left-hand spirals ; and
some special value connected with that formation may be sug-
gested by the tradition that they originally came from the
Temple of Solomon in Jerusalem. The same spiral was also
carved on the pillar of St. Bernwand at Hildesheim in 1022.

Oriental races seem to prefer left-hand spirals, where choice is
possible, whenever they carve a walking stick or make a screw ;
and certainly the majority of the walking sticks sold by Zulus
in South Africa show a left-hand spiral, though whether this is
the preference of the workman, or the mere copy of some left-

hand spiral plant or of the left-hand twist in a rope made by a right-handed man, I cannot say.

In small customs common to our daily life we are aware of a distinct choice, consecrated by tradition, between right-hand

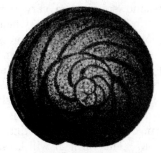

FIG. 203.—DISCORBINA OPERCU-
LARIS. × 100.
(Brady's Foraminifera.
Challenger Reports.)

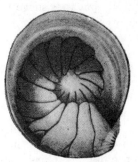

FIG. 204.—CRISTELLARIA
CULTRATA. × 15.
(Brady's Foraminifera.
Challenger Reports.)

and left-hand forms of movement. Port decanters, for instance, must follow the sun ; and the horror of our forefathers in seeing the wine go round from left to right could only be equalled by the amazement of a modern bridge player who beheld his partner

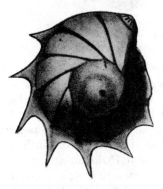

FIG. 205.—CRISTELLARIA
CALCAR. × 25.
(Brady's Foraminifera.
Challenger Reports.)

FIG. 206.—DISCORBINA GLOBU-
LARIS. × 75.
(Brady's Foraminif a.
Challenger Reports.)

dealing the first card to the right instead of to the left. In 1690 there was a slang word (preserved in the " Dictionary of the Canting Crew ") which is worth recalling. " Catharpin-fashion " is defined as follows : " When People in Company Drink cross and not round about from Right to the Left, or according to the sun's motion." The word " widdershins " also conveys a sug-

gestion of misfortune, and has been derived from the same origin as " wiederschein," to reflect after the manner of Virgil's rainbow : " Mille trahit varios *adverso sole* colores." What the origin of these customs was, it would now be almost impossible to guess ; but they suggest, at any rate, that some special significance was attached to the left-hand spiral from very remote times. We still waltz " with the sun," and " reverse " when we turn in the contrary direction. Many of the oldest dances of Mexico, Chili, and Spain were " sun dances," with movements arranged in the same way. The poet Hood must have alluded to the tradition when he describes how Queen Mab " waves a wand from right to left " over the head of a good child asleep.

One of the most ancient and widespread of all symbols is that shown in Fig. 209, the lucky form of the Indian Swastika, the Saxon fylfot, the Greek gammadion. This form, it will be seen, is like a left-hand spiral, and the direction of the arms (or legs, perhaps—for the crest of the Isle of Man is really the same)

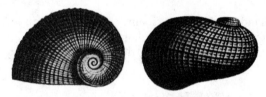

FIGS. 207 and 208.—NERITOPSIS COMPRESSA VAR.
TRANSVERSA.
(Bronn and Simroth.)

follows the sun, while the reverse form indicates movement contrary to the sun (with the topmost limb pointing to the left instead of to the right), and therefore suggests misfortune. Schliemann dug up this symbol from the ruins of Mycenæ and of the Troy of Priam. It is found on the archaic pottery of Cyprus, Rhodes, and Athens ; on the coins of Corinth, Sicily, and Magna Græcia ; on Samnite and Etruscan ornaments. It does not appear in Rome until the fourth century of our era ; but it spread from the Danube provinces to Great Britain throughout the Roman Empire (" The Migration of Symbols," D'Alviella, 1894). Its Indian name signifies propitiousness or prosperity, and it appears on the oldest Indian coins and on the footprints of Buddha carved at Amravati. It was found on bronzes brought from Coomassie by the last Ashanti Expedition, in prehistoric mounds in Ohio, among the ruins of Yucatan ; it is still printed on blankets made by modern Navajo Indians, in Hindu account books, on the skirts of Tibetan women. There is little doubt that it symbolises the apparent movement of the sun through

the seasons. The red eastern arm (for the earth) represents Spring and the morning ; the southern is the gold of Summer noon ; the blue arm of the west is Autumn sunset on the sea ; Winter and white midnight are seen in the northern limb. Thus it symbolises the life-giving sun, the origin of all things, and therefore its left-hand spiral is the auspicious form.

I must conclude with one more example of the connection so often observable between the spiral formation and the principle of life. For purposes of comparison, it is right to mention the remarkable phenomena observable in crystallisation. A theoretical diagram has been drawn by Barlow (reprinted in *Nature* for December 21, 1911), to show the arrangement of the silicon and oxygen atoms in the right-hand and left-hand crystals of quartz. The white spheres of silicon are shown in a

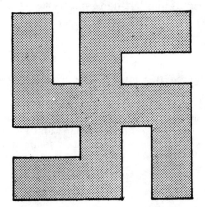

FIG. 209.—THE LUCKY SWASTIKA.
(Following the sun.)

right-hand helix in one case, and in a left-hand helix in the other. But more important and convincing evidence of the right- and left-hand screw structure of quartz is afforded by the optical properties of the mineral, when studied with a polariscope.

If a plate of right-hand quartz 3·75 mm. thick be placed over another of left-hand quartz and examined in the polariscope arranged for convergent light, the remarkable figures known as the " Spirals of Airy " are produced ; and all such phenomena are due to the fact that when a beam of light is sent along the axis of a quartz crystal (see Dr. Alfred Tutton in *Nature, loc. cit.*) the right- or left-hand arrangement of the molecules of silica causes the plane of vibration of the polarised light to be rotated in the same direction. In his laboratory a chemist can prepare a compound, such as tartaric acid, which will be " optically neutral," that is to say, it will exhibit a symmetric grouping of

right-hand and left-hand spirals. Nevertheless, the one kind can be separated from the other by the introduction of an organism which feeds on one and rejects the other. Or the chemist himself, by crystallising the compound, can pick out those salt crystals with their hemi-hedral face to the right from others which exhibit a left-hand formation. But in either case the intervention of "life," in the form of the organism selecting its food, or of the chemist choosing his crystals, has been necessary before the symmetric grouping of the artificial compound could be disturbed. In fact, though recent investigations seem to indicate that Pasteur was incorrect in stating that compounds exhibiting optical activity (and therefore molecular asymmetry) were invariably organic, yet it remains true that the only way in which a difference of property can actually be distinguished, or defined, between such right- and left-hand spirals is when they are brought in contact with the vital principle.

NOTES TO CHAPTER X.

THE SWASTIKA.—" In your discourse on spirals you mentioned the Swastika, that token of good luck which represents the sun on his journeyings, the origin of all things, the march of the seasons, the points of the compass, and many other matters. In accordance with these ideas its arms bear different colours, and I venture to send you some lines upon an ancient sundial which commemorate these multifarious properties:

ON A SUNDIAL.

1. *East, Spring, Morn, Red.*
> Rosy footprints in the sky,
>> Rosy footprints on the sod,
> Spring on earth and dawn on high,
>> Give the opening hour to Godde.

2. *South, Summer, Noon, Gold.*
> Summer's culminating power,
>> Noontide's radiancy of gold,
> Day by day and hour by hour,
>> Godde Hys Majesty unfold.

3. *West, Autumn, Sunset, Blue.*
> Sinks the sun in Heaven's blue,
>> Autumn dons her purple haze,
> Naught is changed, the law holds true,
>> To Godde the hour to Godde the praise.

4. *North, Winter, Midnight, White.*
> Midnight robed in moonlight clear,
>> Winter palled in silver white,
> To the watchful but appear
>> Witnesses of Godde Hys might.

Gloria in Excelsis.
 Rosy Spring and Golden Noon,
 Purple Eve, white Winters sleeping,
 To this song thy soul attune,
 " Everie houre's in Godde Hys keepinge."
 "F. B."

For notes on the arithmetical proportions of a Swastika, see Fig. 391 in Chapter XX. ; and for its origin, see Appendix IV.

[Photo : H. François.
FIG. 210.—PLAYGROUND OF A BOWER-BIRD WITH SNAIL SHELLS
AS DECORATION.

PLAYGROUND OF A BOWER-BIRD (Fig 210).—It is interesting to note that spiral shells are chosen for decorative purposes, not only by men of prehistoric and of later times, but even by the Bower-bird of Australia and New Guinea, as this illustration shows. The collection of shells, in this species, is the first process in decorating their playground, after which the miniature avenue made of fine shoots of trees is constructed. Finally, it is embellished with gleaming mother-of-pearl shells and other bright and shining objects. I was sent the photograph here reproduced by the London Electrotype Agency through the courtesy of the *Illustrated London News.*

For TRAVANCORE see Appendix VII.

CHAPTER XI

CLIMBING PLANTS

*" Rally the scattered causes, and that line
Which Nature twists be able to untwine."*

THE PURPOSE OF CLIMBING—WITH AND WITHOUT TENDRILS—
HAND AND SPECIES—MR. G. A. B. DEWAR ON CLIMBERS—
" FEELING " FOR SUPPORTS—INHERITANCE AND MEMORY—
CIRCUMNUTATING—" SENSE ORGANS " FOR GRAVITY AND
LIGHT—THE STATOLITH THEORY—INFLUENCE OF LIGHT AND
MOISTURE—EFFECTS OF CLIMATE—REVERSAL OF SPIRALS.

AMONG the most interesting of all spiral developments in Nature are the phenomena of climbing plants. Charles Darwin presumed that plants became climbers in order to reach the light, to expose their leaf surfaces to as much of the action of light and air as possible, and to do this with the least possible expenditure of organic matter. The divisions containing twining plants, leaf climbers, and tendril bearers graduate to a certain extent into one another, and nearly all have the remarkable power of spontaneously revolving. With those divisions which ascend merely by the aid of hooks, or by means of rootlets, we have little to do here, for they do not exhibit any special spiral movements, and their " mechanism " is by no means so perfect either as those which twine spirally round a support or as those endowed with irritable organs which clasp any object they touch. It is of these latter, therefore, that I shall chiefly speak ; and the development of tendrils or sensitive petioles may easily be imagined from the fact that plants which only twine may be more easily disturbed from their support than those which are assisted by the additional grasp of leaves or tendrils ; and it may be further noted that some twining plants need a stem of about 3 feet in length to ascend 2 feet in height, whereas, those plants which are assisted by clasping petioles or tendrils can ascend in more open spires (that is, with less expenditure in length of stem), and often exhibit a spiral in one direction, then a portion of straight growth, and then a spiral in the other direction, all of which involves a definite saving in tissue. Dr. Wherry also thinks that the majority of climbing plants prefer to coil round upright supports and no longer climb actively if their support

forms a smaller angle with the horizon than 45°. But the English translation of Pfeffer's " Physiology," which contains some useful records as to the thickness of supports, gives an angle for twining as low as 20°. A further distinction is that the twining plants (which are far more numerous than tendril bearers) wind round in a definite direction according to the species of the plant. The hop, for instance, invariably grows upwards in left-hand spirals (see Fig. 216) ; the majority follow the example of the convolvulus and exhibit right-hand twists (see Fig. 218).

FIG. 211.
LEFT-HAND LAPAGERIA
ROSEA (CHILI).

FIG. 212.
RIGHT-HAND LARDIZA-
BALA BITERNATA (CHILI).

The various kinds of movements displayed by climbing plants in relation to their wants make it very difficult to accept the phrase " the power of movement " as a differentiation between plants and animals. The recent discovery of the continuity of the protoplasm through the walls of the vegetable cells by means of connecting canals or threads is another of the most startling facts in connection with plant structure, since it was held twenty years ago that a fundamental distinction between animal and vegetable structure consisted in the encasement of each vegetable cell unit in a case of cellulose, whereas animal cells, not being so imprisoned, could freely communicate with

one another. After this, it is less surprising that something
closely corresponding to sense organs has been discovered on
the roots, stems, and leaves of plants, which, like the otocysts
of some animals, appear to be really " statocytes," and to exert
a varying pressure according to the relations of these parts of
the plant to gravity (" The Kingdom of Man," Ray Lankester).

But before describing more in detail the scientific results

FIG. 213.

LEFT-HAND MUEHLENBECKIA
CHILENSIS (CHILI).

FIG. 214.

RIGHT-HAND WISTARIA
INVOLUTA (AUSTRALIA).

published by Francis Darwin and others concerning the phenomena
of geotropism. I must direct attention to the observations of a well-
known writer (Mr. G. A. B. Dewar) on some of the most curious
phenomena noticeable in climbing plants. We have seen that
advancing knowledge has made it more and more difficult to
define satisfactorily the difference between plants and animals.
The plants which feed on insects, such as the sundew, the hunts-
man's horn, pitcher plant, the butterwort, the Venus' flytrap,
have always been to me a standing instance of this difficulty.

From them to the romances about man-eating orchids it seems
but a slight step in imagination. But in the climbing plants
an even commoner example of the kind of will power we usually
associate with animals is observable. The way a wild hop
strangled the roses in a garden that I knew in Felixstowe presented
an almost daily tragedy which could scarcely be dissociated
from the relentless exercise of "conscious" power. Yet we

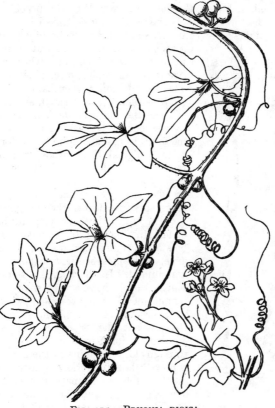

FIG. 215.—BRYONIA DIOICA.
(H. C. Long.)

know that it was not "conscious"; we believe it to be without
individuality, even without freedom; certainly it must be more
regular and enduring than any impulse guiding human conduct.
Though shown in almost every leaf and root in May, this dumb
passion of vitality seems specially developed in the climbing
plants that strive and struggle upwards in the early summer.
I shall paraphrase and shorten what Mr. Dewar says about
them when I cannot quote in full, as I should like to do. He
points out how the "fingers" of these plants feel towards each

other while they are still inches apart, with a sense of weird consciousness of a useful neighbour's presence, which can be neither hearing, sight, nor smell, as we understand those phenomena. The long, wiry-looking apparatus of the bryony points its fine tip at the neighbour it has discovered and wants to grip. Take away that neighbour and return a day or so later, and the feeler will probably be pointing somewhere else.

" The blind, but in the end sure, search of the bryony trailer for support," he continues, " is one of the oddest sights I know. Sopping days and nights followed by hot sun will give the bryony great impetus.

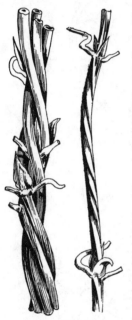

FIG. 216.—LEFT-HAND SPIRAL IN HOPS.

Yards of it will shoot up and writhe and coil about the woodland lane where a fortnight before not an inch showed above the ground. The bryony trailer when bald of leaves is one of those plants that wear an animal look. In some of the climbers one is almost oppressed by the look of half-consciousness, of a mind made up to coil and spire to the fore and top of the hedge at the cost of anything within reach ; even a look of watchfulness. Black bryony and bindweed are climbers that seem to advertise most publicly their fell purpose to grasp and smother their neighbours.

" The tip of the bryony trailer has a kind of fanciful likeness to a snake. It is but a blossom in embryo, yet it might, by its appearance, be the most sentient part of a half-plant, half-animal. Its dark green, sometimes its bluish, lengths have a very snaky coil—they remind me of a viper reared up, wicked, ready to strike and to squirt poison. A most startling thing about the bryony trailer is when it adventures forth from a thin hedge—where, through close trimming in the autumn, there is now little support save grasses and small plants—feels out its path two or three feet over the lane ; and then, finding no cover within reach, turns back ! These adventures are often to be seen where bryony grows along the lanes. It is adventure with risks. Some passer-by may strike at the trailer with a careless stick or thoughtlessly give it a pluck with his hand ; or a cart wheel strike it down and cut it off ; and there is a wound that must take the bryony a week or two to cure. But if no further ill befall the trailer it will return to the hedge whence it came.

" How it knows its search is vain in this direction we cannot tell. But know it must, for it will always return to shelter. Noticing this habit, is it strange we should be struck by a certain animality about this plant ? The bryony trailer might be called a creature of green life. If it has no understanding of its own, what an appearance of understanding is here ! . . ."

Many observers will be inclined to add another instance of 'plant-intelligence" which shows that these curiously "conscious" movements are not limited to one part of the growing organism, for they have been observed in roots as well as in tendrils. There are authenticated examples of a vine's roots having got past (or round) an obstacle like a brick wall in order to reach some special source of nourishment outside the greenhouse in which it originally grew.

" The bryony," writes Mr. Dewar, " if not interfered with, returns to the hedge, I think, always in the same way ; it coils upward and round. It would seem as if it must be a great strain on the trailer to hold thus in the empty air. Every hour the weight upheld increases. But with increasing weight comes growing strength. . . . The ruthless power of these climbers and their mysterious intelligence are worth all the study we can give them. A series of exact trials with the bryonies and bindweeds might be of value. We want to know how far they can feel a neighbour plant ; and whether a plant of large bulk attracts them more than a plant of lesser bulk. It would be curious to try to cheat the bryony trailer ; on its return hedgeward, to fix a support in the ground just behind, so as to lure it back to the lane ; and then, if it turned back, to take away this support, and see if the climber coiled round towards its parent hedge once more.

" ' The mind of a plant '—how our forefathers would have scouted the bare idea of such a thing ! The idea of a plant with any sensitive-ness, or feeling even, would have struck them as wholly absurd—somewhat as if one were to credit a pebble, say, with a desire for motion. Even now—with all our talk and theory about the wonderful devices of plants, their sensitiveness, the knowledge their roots often seem to have as to the best paths to take for food and sure hold—the mind of a green thing is something we can only half imagine."

Let us see if we can " imagine " it a little better to-day. In his lectures on " The Physiology of Movement in Plants " (see " New Phytologist " Reprints, No. 1), Francis Darwin suggests that if, in these questions, we are to reach a point of view which is physiologically valuable, we must reject the barren logic of Descartes and retain the idea of spontaneity in Dutrochet :

" What we do at a particular juncture depends on the nature of our previous experiences and actions. The ' self ' which seems to be spontaneous is the balance which weighs conflicting influences. It is for this reason that even in plant physiology we want the idea of an individuality, of a something on which the past experience of the race is written and in which the influences of the external world are weighed. I do not, of course, imply conscious weighing, nor do I mean that the plant has memory in the sense that we have memory. But a plant has memory in Hering's and S. Butler's sense of the word, according to which memory and inheritance are different aspects of the same quality of living things. Thus in the movements of plants . . . the individual acts by that unconscious memory we call inheritance."

This is not the place in which to introduce those cumbrous forms of scientific nomenclature in which specialists usually delight to communicate their researches to one another. But, looked at in another way, these curious words may be considered as a convenient form of shorthand in which a few syllables— however barbarous they sound—may express a meaning which often needs a lengthy sentence in ordinary language. It will, therefore, not be foreign to our methods if I group all cases in which a plant is stimulated by the force of gravity under the one heading of *geo-perception*. There is also a useful suggestion of the same kind quoted by Francis Darwin from the new edition of Pfeffer's " Physiology." He divides all reactions into two classes : (1) *Autogenic* effects, usually called spontaneous, such

FIG. 217. FIG. 218.
SCHUBERTIA PHYSIANTHUS. CONVOLVULUS ARVENSIS.
Both showing right-hand spirals.

as the jerking of the leaflets of *Desmodium ;* (2) *Ætiogenic* actions, performed at the suggestion of agents such as gravity, light, contact, and the like. But it is evident that, though such a classification is necessary, it is not always possible to distinguish between the two classes, and, in fact, the distinctions between them may often be of less importance than the bond of association which may be found to unite them. It was, for example, the thesis of " The Power of Movement in Plants " (Charles and Francis Darwin, 1880) that the autogenic power of circumnutation is the basis from which the varied ætiogenic curvatures have been evolved ; and obviously this assimilates Pfeffer's classes rather than differentiates them. It also reminds me to add to these " definitions " that of *circumnutation,* introduced in the volume just quoted. This is the most widely prevalent movement in plants. The authors described it as

" essentially of the same nature as that of the stem of a climbing plant, which bends successively to all points of the compass, so that the tip revolves. . . . Apparently every growing part of every plant is continually circumnutating, though often on a small scale . . . in this universally present movement we have the basis or groundwork

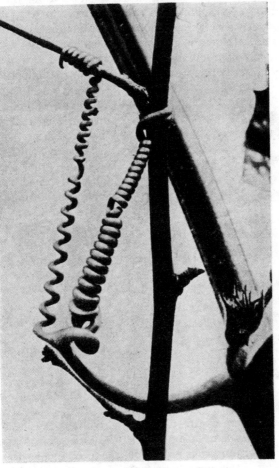

FIG. 219.—SPIRAL TENDRILS OF GOURD.
(Photographed at Wimbledon Park by R. N. Rose.)

for the acquirement (according to the requirements of the plant) of the most diversified movements."

The sentence just quoted was published in 1880, long before the discoveries in vegetable structure to which I alluded earlier in this chapter had been made.

In 1906 Francis Darwin (who assisted Charles Darwin in " The Power of Movement in Plants ") published in the *New*

Phytologist a paper describing the sense-organs for gravity and light with which it is now known that plants are provided ; and it should be pointed out that Francis Darwin is here using the phrase " sense-organs " in the same way as Haberlandt (1901) used " perception-organs," namely, as " all those morphological or anatomical contrivances which serve for the reception of an external stimulus, and exhibit a more or less far-reaching correspondence between structure and function in this respect." L et me now, therefore, give a slight sketch of those organs which in plants are connected with the phenomena of *geotropism*, or the in fluence of gravity, and of *heliotropism*, or the influence of light.

FIG. 220.—SMILAX.

In the case of geotropism our first question is, how the plant is able to " perceive " that it is not vertical. For instance, if a plant, growing vertically from a pot on a table is turned through an angle of 90° until its main axis becomes parallel to the level surface of the table, it is obvious that certain new strains or compressions of tissue will occur which might stimulate geotropism. But these are not its only means of geo perception, because some plants are recognisably geotropic even when supported throughout their whole length. It is necessary, therefore, to find some other workable hypothesis, and the famous *statolith* theory supplies it ; for, by this theory, the stimulus causing the movements of the plant being due to the difference in the specific gravity of certain parts of the cell, the heavy bodies thus implied are, in fact, the specialised form of starch grain described by Haberlandt and Nemec. These grains, or " statoliths," lie freely in the cell and gravitate towards the physically lowest region. " Thus," writes Francis Darwin (*op. cit.*), " in a vertical cell the pressure of the statoliths will be on the basal wall. When the cell is placed horizontally the starch will fall away from the basal wall (which is now vertical) and spread out in the lower lateral wall. In this way it is imagined that the pressure of starch grains on the different parts of the cell walls serves as

signals informing the plant as to its angular position in space."
As the same writer points out, it is important to notice that the
method of orientation thus suggested in plants does undoubtedly
occur in animals, for in the case of the crustacean *Palœmon*
it has been proved that the power of orientation in regard to
the vertical is dependent on the presence of the statoliths (or
otoliths) on the internal surface of the otocyst. And since our
theory suggests a function of the falling starch that occurs in
the endodermis, it is further of importance to notice that the

FIG. 221.—PASSION FLOWER.

starch is only found here as long as the organ is growing ; in
fact, as long as it is susceptible of geotropic curvature. Again,
monocotyledons, in whose leaves starch does not occur, do
possess falling starch in the endodermis, and therefore enjoy
geo-perception ; whereas *Viscum* and other plants which have
lost the power of geo-perception, either entirely or in certain
parts, do not possess falling starch in those parts or in the whole
plant respectively. Recent research has rather strengthened than
invalidated this hypothesis since 1904.

Turning now to *Heliotropism*, we find, from the work of Francis
Darwin and others, that leaves have the power of placing them-

selves at right angles to incident light, and that this is effected by appropriate torsions and curvatures (see Figs. 139 and 140). Probably the act of perception in these cases would be performed by the leaf-blade, while the movement would be confined to the stalk. Haberlandt has discovered the existence (in the epidermis of the leaf blade) of a primitive eye, consisting of a lens and a sensitive protoplasmic membrane, on which the light is focussed. When the leaf is horizontal under a top light (in what may be called a position of equilibrium) a spot of light is thrown on the basal cell wall. When the leaf is subjected to oblique light the direction of this illumination is changed, and in each of the epidermic cells the bright spot on the basal wall will no longer be central. The stimulus thus provided tends to move the leaf until it becomes once more at right angles to the light and a condition of equilibrium has been restored. The various proofs of the existence of this process are too technical for insertion here, but I must at least give one of the most striking, which is that when a leaf, previously orientated by these " eyes," is submerged in water, the refraction of the lens is altered ; the plant, in fact, is " blinded," and unable to orientate itself as before. In those " velvet " leaves, in which the epidermic cells project as papillæ above the general surface, this form of epidermic cell serves to prevent the leaf being " blinded " by the continuous rain of the regions where the plants in question chiefly occur.

One very interesting feature may be noticed which this hypothesis has in common with the statolith theory just previously described. In both cases the directive element in the mechanism depends on the stimulus being applied to certain regions of the protoplasm lining the cell walls. The organ " recognises," as it were, that it is not vertical (in one case) or that it is not at right angles to the light (in the other case) by the fact that a definite change has occurred in the position of the region receiving the stimulus.

In *Science Progress* for January, 1912 (John Murray), Dr. J. B. Farmer, F.R.S., states his opinion that " the mechanisms concerned directly in producing movement all depend upon alterations in the distribution of water " in the moving plant. This is a generalisation which has still to be proved correct for all instances, and while it may explain the mechanical process of a given movement, it does not, I think, explain the cause or stimulus which leads the plant (if I may so put it) to " think " such movement " necessary." Dr. Farmer expresses a very natural surprise that the numerous investigations in regard to the response of living protoplasm to external stimulus have added so little to exact knowledge, and, he adds, " this

is even true of the rhythmic movements frequently met with in growing plants, which are not referable to any stimulating agent that can be detected readily." He mentions some movements due to hygroscopic change such as have been already described in previous pages, namely, those depending on the unequal expansion or contraction which occurs in the cell walls of the different parts of the motile organ, as in the instance of the valves of the gorse-fruit, which suddenly curl up and eject the seeds ; or the curious and somewhat similar action of the

FIG. 222.—VIRGINIA CREEPER.

cruciferous plant *Anastatica*, known as Rose of Jericho ; or the strangely little known phenomena concerned with the warping of timber, which is due to structural conditions involving an unequal capacity for swelling in a given direction possessed by different elements in the tissue. Perhaps his most interesting example is taken from the elaters found mixed up with the spores of most liverworts, structures which may be described as eel-like cells, pointed at each end, and possessing one or more band-like coils of spiral thickening on the inner surface of their otherwise thin membranous walls. When the moist elater gradually dies, these membranous parts of the walls sink

inwards until, quite suddenly, the elater twists up and immedi-
ately straightens itself again with a violent spring-like movement,
jerking the spores out of their capsule. Difficult as it is to explain
movements due to the complex interaction of conditions in the
living protoplasm, it is, as Dr. Farmer points out, no less compli-
cated a problem to discover, even in more purely physical or
mechanical processes, the secret of their *adaptedness* to those
functions which they are so well fitted to discharge. But we
are gradually approaching a solution of a great many of such

Fig. 223.—Vine.

problems, and every year's research is bringing greater know-
ledge.

If we combine these modern theories with Charles Darwin's
earlier " circumnutation," and with the recent discovery of
the continuity of protoplasm through the walls of vegetable
cells, as is the case in animal structure, we shall arrive at a better
understanding not only of those exquisite spiral formations
which result from the movements of the climbing plants illustrated
in these pages, but even perhaps of those questions which
Swinburne asked so beautifully of the sundew : —

" . . . how it grows,
If with its colour it have breath,
If life taste sweet to it, if death
Pain its soft petal, no one knows :
Man has no sight or sense that saith."

All the hedge climbers suggest to Mr. Dewar the idea of
" an intelligence of the body. They suggest it," he concludes,
" as much as the little round-leaved sundew, *Drosera,* which we
found in Blackmoor Forest with yellow asphodel. But their

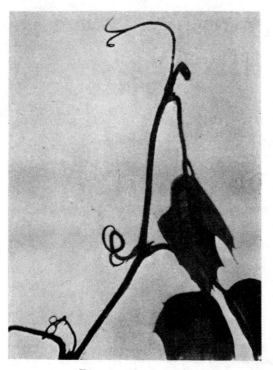

FIG. 224.—AMPELOPSIS.

methods of climbing often differ widely. Black bryony is a python
among plants ; it coils its cruel body round and round the victim.
So does woodbine. The red bryony, as we see, steadies itself
in quite another manner—a fine-pointed, twisting feeler on one
side, a corresponding one on the other side. Clematis economises ;
the little stalk that holds the leaf must here and there twine
about a neighbour to help steady and uphold the whole plant,
though how it is decreed that this stalk or petiole shall twine,
and that one not twine, we do not know. Does chaos or chance
decide it ? If so, it looks as if there must be some effective

ruling principles in chaos, or clematis could never be steadily
reared and held in position at the hedge-top."

In previous pages I have given a description of some of the
twining plants specially investigated by Charles Darwin, and
I specified a certain number of those which twine to the left
instead of to the right, together with the speed of their respective
revolutions. Every part of a revolving shoot in a climbing plant
has its own separate and independent movement, described by
Sachs as " revolving nutation " and by Darwin as " circum-

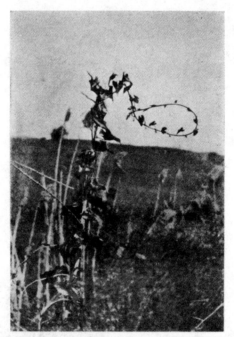

FIG. 225.—BLACK BRYONY NEAR HAMMAM RHIRA, IN THE ATLAS
MOUNTAINS OF N. AFRICA, 2,000 FEET ABOVE THE SEA.
This branch turned completely round upon itself in twenty-four hours.

nutation," a movement which appears to be due to the more
rapid growth of cells on one aspect or edge than on the other,
which makes a curve in the shoot, and rotates it, as the growth
alters and alternates. The result of this is that when a revolving
shoot meets with a support, its motion is arrested at the point
of contact, but the free projecting part goes on revolving. As
this continues, higher and higher points are brought into contact
with the support and there arrested, and thus the shoot winds
round, just as a swinging rope which hits a stick coils round
the stick in the direction of the swing. " Irritability " has nothing,
therefore, to do with these phenomena. The shoot twines round

its support rather more slowly than it would revolve by itself (the difference being about $1\frac{1}{2}$ to 1), owing to the continued disturbance of force by arrestment at various points. But when the shoot has made its first, close, firm spiral, it slips up the support in more open spirals, because it is freed from the pull of gravity.

In the hop it will be noticed not only that the plant coils to the left round the support, but that the very tissue of the plant itself shows a strong left-hand twist, as though there had been continual torsion in the true axis of the growing stem. Charles Darwin showed that the axis is twisted, in all such cases, owing to the roughness of the usual natural support, which is strongly clasped by the rough, glutinous surface of the hop shoot. When some kidney beans were trained up smooth glass rods they showed scarcely any torsion at all. No doubt this twist provides an additional strengthening of the fibre, which enables

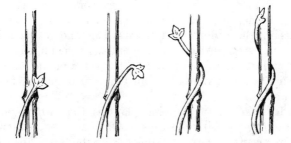

Fig. 226.—Diagram to Show the Movements of a Climbing Plant.

the plant to surmount inequalities. There must be some connection between axial twisting and the capacity for twining, and the stem gains in rigidity by the process much as a well-twisted rope is stiffer than one which is slackly twisted. The spiral twist in the horns of goats and antelopes and on the columella of certain shells may be another instance of the same strengthening process.

In Chapter VII. I gave a list of seventeen climbing plants which twisted clockwise, following the sun, or (as I describe it) in left-hand spirals, out of a total of sixty-five examined ; the remainder twined to the right. Among these I illustrated the right-hand spiral of *Tecoma* and the left-hand spiral of honey-suckle in Chapter II., while the left-hand growth of *Polygonum baldschuanicum* (Bokhara) was contrasted with the right-hand spiral of *Apios tuberosa* in Chapter I. In the present chapter, drawings are given of the left-hand curves of *Lapageria rosea*, with the right-hand growth of *Lardizabala biternata* (both

from Chili) ; also of the right-hand spirals of *Wistaria involuta* (Australia) with the left-hand twist of *Muehlenbeckia chilensis ;* and, lastly, of the typical right-hand growth in *Convolvulus arvensis* or of *Schubertia physianthus* contrasted with the strongly left-hand formation both in growth and fibre of the hop. I need not multiply any further instances, for my readers will now be able to examine many more for themselves. I shall only emphasise again the curiously different rates of speed at which these various plants revolve, and add that in this climate, where twining plants die down every year, they would never have time to reach the sunlight if they climbed up large trees more than 6 inches in diameter, and so they very rarely try to do so, though one has been observed to get round a column of 9 inches in diameter at Kew. In tropical countries, of course, twining plants often ascend very large trees and flourish happily while doing so. *Solanum dulcamara*, on the other hand, can twine round a support only when this is as thin and flexible as a string or thread. It may also be noted that in some cases the lateral branches twine, and not the main stem (*Tamus elephantipes*) ; in others it is the leading shoot which twines, and not the branches (a variety of *Asparagus*). In different cases, again, some shoots revolve and others do not ; and, lastly, some plants never show any inclination to twine at all till they are some distance from the ground.

A different class of climbing plant is that which possesses " irritable " or sensitive organs. Of these the leaf-climbers ascend by means of clasping petioles or by the tips of their leaves, and some few can ascend by twining spirally round a support, showing a strong tendency, in the same shoot, to revolve first in one direction and then in the opposite. But it is the tendril bearers which will be of more direct interest here. Tendrils are filamentary organs sensitive to contact, clasping any object they touch, and used exclusively for climbing. These can grow horizontally, or up and down, in distinction to those twining plants which can only coil themselves round and climb up supports that are almost upright. Whereas these latter always go round a stick in the direction of their own revolving movement of growth (which may be either to the right or the left, as we have seen), tendrils can curl indifferently to either side, according to the position of the supporting stick and the side first touched, the clasping movement of their extremity being undulatory or vermicular. The tendrils of all tendril-bearing plants contract spirally after they have caught an object—with about four exceptions, of which *Smilax aspera* is one ; and this contraction, says Charles Darwin, is quite independent of that power of spon-

taneously revolving which is observable (by " nutation ") in the apex both of the shoot and the tendril ; for *Ampelopsis hederacea* does not revolve at all. The use of the spiral contraction of a tendril is to drag up the shoot by the shortest course towards the object clasped without any waste of growth. This same spiral contraction also makes the tendrils highly elastic, and therefore stronger to resist the wind, so that the bryony, for example, will outride a storm like a ship with two anchors and a long range of cable that serves as a spring.

In the bryony (see Fig. 215) a filiform organ grows out from the plant, as Dr. Wherry observed, and becomes " irritable " in such a fashion that, while revolving at its free end exactly as if groping for a prop, when this free end touches a twig it coils round it at once. The coiling tendril then develops a corkscrew spiral twist in one direction in one part, and in another direction in another part, with a short straight portion between. This reversal of the spirals after fixation sometimes occurs only once, sometimes as much as seven or eight times, but the number of times it appears in one direction is nearly always equal to the number of times in which it appears in another. The reason for this is to be found in the mechanical necessity for preventing excessive torsion. We have seen that a twining plant, as it binds its spiral curve round a support, develops a spiral twist also. This twining involves a twisting of the axis in the same direction which, if persisted in for too long in the same direction, would ultimately burst the tendril. But if nearly as many turns are subsequently taken by the spiral in the opposite direction, the strain involved by the twisting of the axis is removed.

The best example of this double twist I have been able to find is to be seen in the tendrils of the gourd shown in Fig. 219. This curious and symmetrical structure is usually observable only when a tendril has caught and clasped a support. The firm, springy attachment created by the double spiral has only to be seen to be appreciated. I should add that the late Professor Pettigrew recorded a spiral tendril of cucumber showing " a basal coil of three turns, a reversal, a coil of three turns, a second reversal, a coil of five turns, a third reversal, a coil of four turns, a fourth reversal, and an apical coil of five turns. This tendril had clasped a cucumber leaf by its basal and central portion, its apical portion being quite free." This would indicate that, for the production of a reversed spiral, it is not always necessary, as Darwin and Sachs seemed to think, for the tendril to be fixed at each end.

The *Ampelopsis* (Virginia creeper, Fig. 224) shows a sympodial shoot system, and has no true spontaneous circumnutation, but

only a movement of the internodes from light to dark. The tendril will " arrange " its branches so as to press on a given surface, and then the curved tips swell and form on their undersides the little soft discs by which they adhere firmly, and eventually pull forward the growth behind. An attached tendril contracts spirally, and thus becomes so highly elastic that when the main stalk is in any way disturbed the strain is equally distributed among all the discs. The vine has a similar sympodial shoot system, in which the tendrils (as in the passion flowers) are modified flower peduncles, quite thick, and, in vigorous growths, as much as 16 inches long. They are sometimes branched, and their beauty has often attracted the notice of the poet, as when Milton wrote of Eve's hair :—

> " . . . in wanton ringlets waved
> As the vine curls her tendrils."

Taking the tendril bearers, and the most efficient of them, as an example of that " mind " in plants which I ventured to suggest at the beginning of this chapter, we can now realise how high in the scale of organisation such a plant may rightly be placed, and I cannot do better than conclude with Darwin's summary on the subject of the tendril bearing plant, which is as follows :—

" It first places its tendrils ready for action, as a polypus places its tentacula. If the tendril be displaced, it is acted on by the force of gravity and rights itself. It is acted on by the light and bends towards or from it, or disregards it, whichever may be most advantageous. During several days the tendrils, or internodes, or both, spontaneously revolve with a steady motion. The tendril strikes some object, and quickly curls round and firmly grasps it. In the course of some hours it contracts into a spiral, dragging up the stem and forming an excellent spring. All movements now cease. By growth the tissues soon become wonderfully strong and durable. The tendril has done its work, and done it in an admirable manner."

I could have chosen few better examples of the utility of the spiral formation in Nature.

NOTES TO CHAPTER XI.

Fig. 225.—When kindly sending this very interesting picture Mr. C. A. B. Dewar wrote :—

" You were good enough to quote some of my observations on the black bryony.

" I now send you a photograph of a specimen (*Tamus communis*)

which I observed in the Atlas Mountains, where it is very abundant, in March, 1912. This shows (Fig. 225) how the bryony made a sort of expedition towards an asphodel plant, changed its mind, and turned back again. The plant was within a foot of the asphodel when I first saw it, pointing straight at its head. The next day it had evidently concluded the asphodel was useless or unfriendly, for it had turned right round upon itself."

CHAPTER XII

THE SPIRALS OF HORNS

" Judge between the rams and the he-goats."—EZEKIEL.

PAIRS OF HORNS—ODD-TOED AND EVEN-TOED HOOFED ANIMALS—
THE ANGLE OF THE AXIS IN HORNS—SUGGESTED GEOMETRICAL
CLASSIFICATION—DISTINCTIONS BETWEEN HORNS OF WILD
ANIMALS AND OF TAME—HOMONYMOUS HORNS—"PERVER-
SION" AND HETERONYMOUS HORNS—COMPARISON WITH
OTHER SPIRAL GROWTHS, AS OF PLANTS AND SHELLS—
EXCEPTIONS TO DR. WHERRY'S RULE—TAME ANIMALS
SHOWING TWISTS OF THEIR WILD ANCESTORS — DEVELOP
MENT OR DEGENERATION?—THE PROBLEM STATED.

IN most cases where natural objects occur in pairs they may
be described as right hand or left hand respectively; in fact,

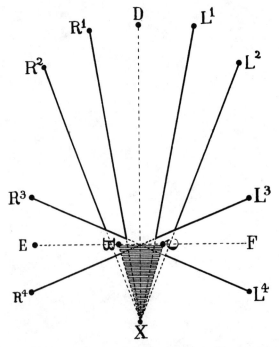

FIG. 227.—DIAGRAM OF THE AXES OF HORNS.

the ordinary use of the word "pair" implies this; for when we
speak of a "pair of gloves" we do not mean two right hand or

two left hand gloves, but two gloves of which one is for the right
hand and the other for the left. So the horns of animals are
as properly " pairs " (except in the case of the rhinoceros) as

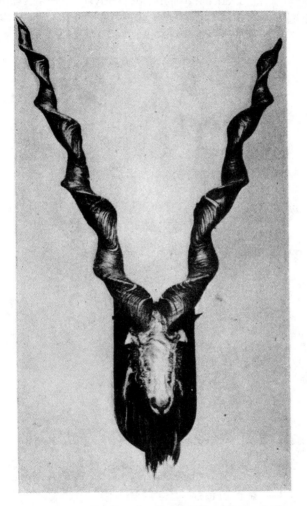

Fig. 228.—Straight Twists. Sir George Roos Keppel's Suleman
Markhor, Capra falconeri jerdoni (R¹ and L¹).
Length (straight) 37 inches, girth 10 inches, tip to tip 32 inches.
(Shot in the Kurram Valley, 1905.) This photograph is repro-
duced by the courtesy of *Country Life* and Mr. C. E. Fagan.

their legs, their ears, or their eyes, and can just as correctly be
divided into right and left. That division (apart from their
position on the animal's head) is usually indicated by the direc-
tion of the spiral curve or spiral twist exhibited by the horn

under examination. I know of no instance in which this rule
would not hold good. But there is the very rare case of the
narwhal with two tusks (not horns), which are not twisted in a
right-hand and a left-hand spiral respectively, for each shows the
same left-hand spiral. They are not, in fact, a natural "pair"
in the sense in which we speak of a pair of boots.

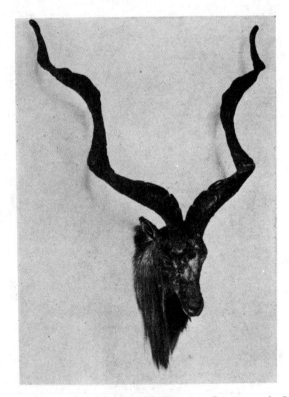

FIG. 229.—CURVED TWISTS. THE MARQUESS OF LANSDOWNE'S GILGIT
MARKHOR, CAPRA FALCONERI TYPICUS (R^2 and L^2).

Length (curve) 57 inches, girth 9¾ inches, tip to tip 38 inches.
(Shot near the Hunza-Nagar Valley about 1891.) This
photograph is reproduced by the courtesy of *Country Life*
and Mr. C. E. Fagan.

The horns of the rhinoceros, which belongs to the odd-toed
series of hoofed animals, have no bony horn-core, and consist
entirely of that fibrous structure of hair-like growths called
"keratin," the same substance composing claws, nails, hoofs, and
hair. The horns and antlers of those even-toed hoofed animals
forming the "Pecora," may be classified in three divisions, and
are essentially a bony outgrowth of the skull. The first division
and the most primitive, are those of the giraffe, they are present

in the unborn young in the frontal region of the skull, and remain covered with skin and hair through life. The okapi's horns, however, grow from the frontal region of the skull as conical

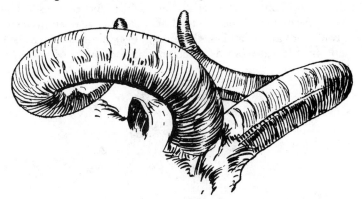

FIG. 230.—TWISTED CURVES (PERVERSION). PALLAS'S TUR (CAPRA
CYLINDRICORNIS PALLASI).

R^3 and L^3 in Fig. 227 showing the axis above the line EF and outside the triangle BCX. This is the geometrical perversion of the curves shown in Fig. 231. (Drawn from p. 385 of Rowland Ward's " Records of Big Game." Sixth edition, 1910.) Shot in the Caucasus by Prince E. Demidoff.

bones, the sharp points projecting slightly from the skin to form better fighting weapons. Secondly, the antlers of deer are bony outgrowths from the frontal region ; they usually become forked

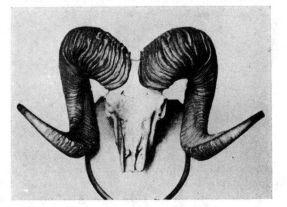

FIG. 231.—TWISTED CURVES. HEAD OF WILD SHEEP OF THE GOBI
DESERT (OVIS AMMON MONGOLICA), THE PROPERTY OF COLONEL
J. H. ABBOT ANDERSON (R^4 AND L^4).

or branched ; the soft, velvety skin which covers them dies off, and every year the old antlers are shed and a new pair are grown. The reindeer is the only instance in this division in which the

females have antlers like the males. The third division, with which we are chiefly concerned here, is that in which a hollow sheath of keratin (which can be removed after death) is formed to cover the bony horn-core in both males and females. This remains permanent, being added to year by year from below as growth advances, and is, therefore, never branched or forked, except in the case of the American prong buck (*Antilocapra*

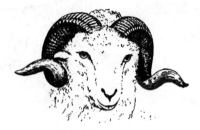

FIG. 232.—MERINO RAM (R⁴ AND L⁴).

americana) which sheds its horn-sheaths every year, and thus forms a remarkable link between the second and third divisions. It is with the sheath-horned group (comprising antelopes, sheep, goats and cattle) that this chapter chiefly deals, and I will begin by suggesting a simple method for classifying the spiral formations they exhibit.

The diagram in Fig. 227 (p. 190) is formed in the following manner: Draw a horizontal line EF. Bisect it with the perpendicu-

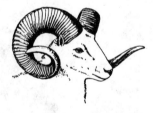

FIG. 233.—TIBETAN ARGALI (OVIS
AMMON HODGSONI).

lar line DX. At equal distances on each side of the point of bisection take the two points B and C, so that the shaded triangle BCX shall roughly represent an animal's face, X being the tip of the nose and BC the top of the skull. From the point X draw the lines R¹ and L¹, which pass inside the triangle, and the lines R² and L², which pass outside the triangle ; these lines will represent the axes of horns which exhibit a twist (Fig. 228) ro a curved twist (Fig. 229). From the point in the base of the triangle where the perpendicular DX bisects the horizontal

EF, draw the lines R^3 and L^3, which pass outside the triangle, and the lines R^4 and L^4, which pass inside the triangle : these lines will represent the axes of horns which exhibit twisted curves, such as those drawn in Fig. 230 (R^3 and L^3) or Fig. 231 (R^4 and L^4).

The order in which the horns are mentioned in this geometrical classification would, of course, only correspond with their development in Nature on a theory of gradual deteriorations. But I shall discuss the theory of improvements first ; and, according to this, it might plausibly be suggested by anyone who had considered the origin and growth of the various spiral formations illustrated in previous chapters, that the type of horns seen in *Ovis ammon hodgsoni*, the Tibetan Argali which is drawn in Fig. 233, or in the merino ram shown in Fig. 232, was the ancestral type of horns, exhibiting both the essential curves we have seen in other organic spiral growths and the twisted surfaces which usually accompany and strengthen such curves, as was noted in the case of the growing hop. We can now carry this hypothesis a little further by supposing that the wild horn-bearing animal found his horns more useful to him when the tips were elevated, and the only way in which the tip of such twisted curves as those shown in Fig. 231 could be elevated is clearly seen in the horns of Pallas's tur (Fig. 230), which exhibit what is called a " perversion " of the usual spiral. This " perversion " I shall explain more fully later on. For the moment I need only point out that it does not exhibit the change expressed by the difference between a right- and left-hand spiral, but shows that a right-hand and a left-hand spiral can each be constructed upon different plans. Continuing this hypothesis of development, I may now suggest that, just as the twisted curves of Fig. 231 (represented in the diagram by R^4 and L^4) have had their points lifted to R^3 and L^3 as shown in Fig. 230, so these latter may be imagined to be still further lifted into the position of R^2 and L^2, and thus to lose their essential character of curves and to become the curved twists of the Gilgit markhor in Fig. 229. Here I must interrupt the argument for a moment to refer to *Tragelaphus angasi* in Fig. 234, which shows that the Gilgit markhor is far from being alone in exhibiting horns which retain the possibility of a spiral curve in spite of being essentially a spiral twist. Take this antelope's left horn at its point of origin, C. The line from C to A might easily have developed into the flat spiral curve CAB, instead of growing into the conical spiral twist CAD. The same possibilities are observable in the Lesser Kudu (Fig. 235) and the Situtunga (Fig. 236). There is fortunately a most interesting corroboration of this theoretical curve (CAB) to be found in the Hume Collection in the British Museum

(Natural History). Number 66 in that collection shows the heteronymous twists of the male Blackbuck's horns (CAD), and number 69 shows the homonymous curves (CAB) in the horns of the female. Mr. Lydekker kindly pointed out these heads to me after my diagram (Fig. 234) had been printed.

But if we follow out the theory that the points of horns have been gradually lifted from those shown in the wild sheep to those of Pallas's tur, and higher again to those of the Gilgit markhor, we eventually reach a position in which all trace of curves disappear. In the upright horns of the Suleman markhor in Fig. 228, we see the effect on growth of axes placed at the angle of the lines R¹ and L¹ in the diagram printed on p. 190. These horns exhibit a

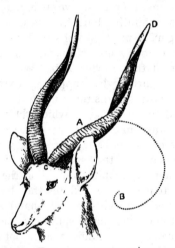

FIG. 234.—NYALA (TRAGELAPHUS ANGASI), SHOWING HORNS BEGINNING IN A FLAT SPIRAL CURVE CAB, AND ENDING IN A CONICAL SPIRAL TWIST CAD.

twist of a remarkably uncompromising nature, and one that is especially adapted for fighting or for pushing through a thick growth of plants. I may add in conclusion that it seems rather more difficult to derive the curves of a merino ram from the corkscrew twists of *Capra falconeri Jerdoni*, whereas, the series I have suggested is at least a mechanical possibility on the lines laid down. I will discuss the reverse order later on.

If the order of development now suggested were correct, several interesting deductions could be made concerning the forms of horns shown in various animals. If, for instance, the twisted curves of *Ovis ammon hodgsoni* were indeed the beginning of such a series as I have described, it would be only likely that this formation would be improved by wild animals which had to fight for their living or their mates, and that it would survive

only in animals whose welfare largely depended on human interference. It may also be significant in this connection that when the change in the elevation of the points is noticed in wild animals which exhibit these curves, that change seems

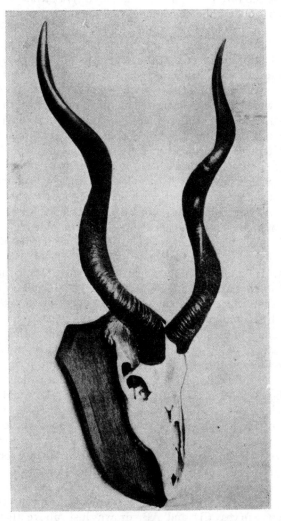

Fig. 235.—Lesser Kudu (Strepsiceros imberbis).
Shot by Mr. G. Blaine. (Somaliland, 1909.)

often to accompany a difference in breed, as in *Capra cylindricornis* compared with the merino ram, or as in the Sind wild goat (Fig. 244) as compared with the Alaskan bighorn, *Ovis canadensis dalli* (Fig. 48, Chap. II.). On the other hand, it

would be difficult to say why *Ovis ammon poli* (Fig. 20, Chap. I.) or *Ovis ammon hodgsoni* (Fig. 233) exhibit the ordinary curves of the merino ram (Fig. 232), whereas, *Ammotragus lervia* (Fig. 241), *Ovis orientalis* (Fig. 242), and *Pseudoïs nahura* (Fig. 243) all exhibit the rare perversion typified in *Capra cylindricornis*. But when we follow the development of the raising of the horn's tip from *Capra cylindricornis* (Fig. 230) to the Gilgit markhor, and even more markedly to the Suleman markhor (Fig. 228), we cannot fail to observe that the raised tips of the *perversus* variety are associated with wilder breeds, and are evidently more useful to animals which fight for their living than such peaceful ornaments as are worn by the domesticated merino ram. In fact, the domestic horned animals would perhaps (on this theory) have died out but for man finding them useful enough to be preserved.

Another very curious fact concerning the development of both curves and twists is that when domestic animals show the twisted horns which have just been associated with wild animals, these domestic varieties exhibit (with one exception) a wholly different form of twist from that worn by wild animals.

Homonymous horns (as defined by Dr. Wherry) are those which exhibit a right-hand spiral on the right side of the head and a left-hand spiral on the left side of the head, as may be seen in the Highland ram shown in I. on Plate III. on the opposite page, or the ordinary Mouflon of Fig. 237. It will be noticed at once that when horns show twisted curves of this kind (which may be compared with Figs. 20, 48, 232, 233, 237), it is physically impossible for them to exhibit any other formation than that described as homonymous. This can be easily proved if you transfer the curve AB (shown in I. on Plate III.) from the right side of the head to the left, as is done above the Mouflon's head in II. on the same Plate. It would obviously grow into the creature's back and be quite useless to it. The only difference possible in these homonymous curved horns is the " perversion " exhibited by the horns of the Red Mouflon (shown in II. on Plate III.), " twisted the wrong way for a ram's," as Billy Priske said when he met the Corsican " Mufro " in Quiller Couch's " Sir John Constantine." As I shall explain later, these " perversion " curves are by no means the heteronymous curves, CD and AB, drawn just above them for the sake of contrast in II. on Plate III. They are examples of the raised tip shown in *Capra cylindricornis* (Fig. 230) and in the similar formations drawn in Figs. 241, 242, 243, 244. These formations are just as " homonymous " as the horns of the Highland ram, but their right and left-hand spirals respectively are of a different character.

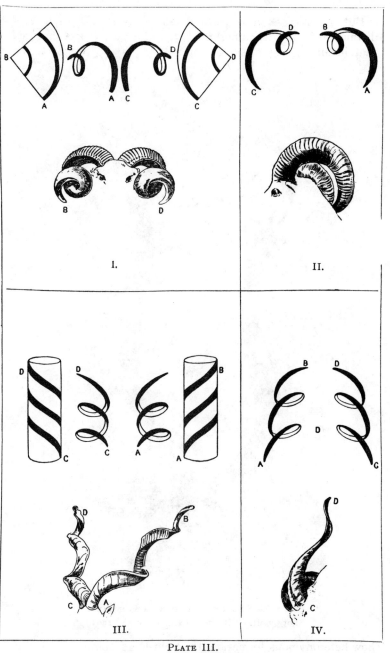

PLATE III.

I. Highland Ram. (Homonymous curves.)
II. Mouflon. (Homonymous *perversion*.)
III. Markhor. (Heteronymous twisted curves.)
IV. Angora Goat. (Homonymous twisted curves.)

But in the case of twists and curved twists, Dr. Wherry's distinction is of vital importance ; for the curious fact emerges that in all existing antelopes and wild goats the twisted horns

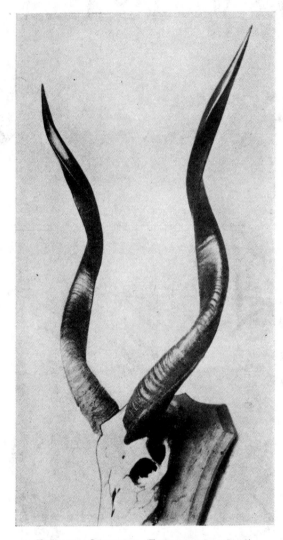

FIG. 236.—SITUTUNGA (TRAGELAPHUS SPEKEI).
Shot by Mr. G. Blaine. (N.E. Rhodesia, 1903.)

show heteronymous formation, the right-hand spiral twist being on the left side of the head and the left-hand spiral twist on the right side of the head, as in Fig. III. of Plate III., or in Figs. 235, 236. And since the direction of a twist on a fairly

upright axis does not possess any structural importance with reference to the rest of the animal's anatomy, we might expect to find the homonymous formation as well, in which the right-hand spiral twist is on the right side of the head and the left-hand spiral twist is on the left side of the head. But this homonymous formation is (with one exception) found in domestic animals only (see Fig. IV. in Plate III.), and I know of no instance of it (in twists) in living wild animals. Though Dr. Wherry does not connect homonymous horns with domesticity except as a distinction between wild antelopes and domestic sheep or goats, the hypothesis, just stated, that the ancestral form of spiral twists was that now shown by domestic animals, involves its natural development from such homonymous curves

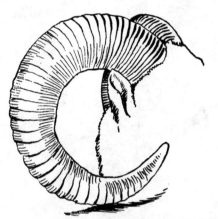

FIG. 237.—SARDINIAN MOUFLON (OVIS MUSIMON) IN THE BRITISH MUSEUM.
Shot by F. G. Barclay. Showing the usual homonymous
curves. (Drawn from page 214 of Rowland Ward's
" Records of Big Game." Sixth edition, 1910.)

as those worn by the Highland Ram ; and if so, we might then conclude that, unless man had intervened, those animals which grew homonymous twists would have died out, whereas, those animals which survived were obliged to develope heteronymous twists, in order to fight better or to throw off thick herbage and undergrowth as they ran through the jungle with their chins forward and their horns flat back upon their shoulders, acting like a wedge and forcing aside the overhanging branches by the screw-like action of the grooves. These strongly marked grooves are particularly noticeable in the Senegambian Eland shown in Fig. 238, and the screw like formation is well exhibited in Figs. 228 and 229. All three, like the Lesser Kudu, and the Situtunga (shown in Figs. 235, 236) are examples of the heteronymous spiral twists characteristic of antelopes

and wild goats. The formation may be admirably studied in the biggest of the Bushbucks, the Bongo (*Boocercus euryceros*),

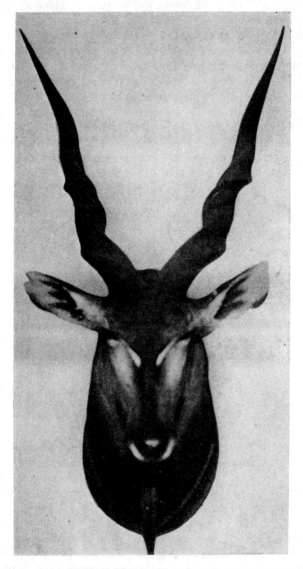

FIG. 238.—SUDAN DERBIAN ELAND (TAUROTRAGUS DERBIANUS GIGAS).
Shot by Mr. G. Blaine. (Bahr-el-Ghazal, 1910.)
Showing the heteronymous twists characteristic of wild animals,
as in Figs. 235, 236, and 248.

the record head of which was shot by G. St. G. Orde Browne, in the Mau Forest of British East Africa. The horns measure

$39\frac{1}{2}$ inches over the curves and $32\frac{5}{8}$ inches in a straight
line along the axis, with a spread of $16\frac{3}{4}$ inches from tip to
tip, and a girth of $11\frac{1}{4}$ inches at the base. The more formid-
able of the hornless animals possess not only tearing claws,
but also those sharp canine teeth which are never found in
horned animals unless (as in the case of the little Indian muntjac)
the horns are quite small and simple. This may indicate that
such weapons as the horns in Fig. 238 are an efficient substitute ;
and I suggest that heteronymous twists would be more advan-
tageous than any other formation. In Fig. IV. of Plate III.
the homonymous twists of the domestic Angora goat are clearly
depicted. You see the same homonymous twists in the Tibetan
shawl-goat (Fig. 239), the common domesticated goat (Fig. 247),

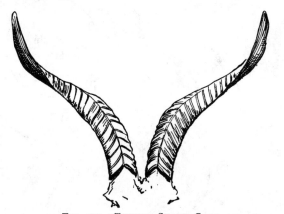

FIG. 239.—TIBETAN SHAWL GOAT.
Showing the homonymous twists characteristic of tame goats.

and the Jamnapuri goat (Fig. 246). All these latter are domestic
varieties, and I can add a pleasing example (by the kindness of
Mr. Lydekker) of the accuracy of the ancient Egyptian artist,
who recognised, some 4,000 years before the birth of Dr. Wherry,
that the domestic, long-legged sheep of Egypt exhibited the
homonymous formation in the twists of their horns (Fig. 240).

The gradual improvement, therefore, suggested by our first
hypothesis may be tabulated as follows :—

I. Open forward curves (Fig. 231), in which the surfaces
are necessarily twisted. Always homonymous.

II. Open curves with points raised higher (Fig. 230) (*perversus*),
in which the surfaces are also twisted. Always homonymous.

III. Open twists, either of the form of Fig. 229, or as shown
in Figs. 235 and 236, which seem the natural transition from
II. to IV. As a rule, homonymous in domestic (Fig. 246) and
heteronymous in wild animals.

IV. Close twists (Fig. 228), as a rule homonymous in domestic (Fig. 250) and heteronymous in wild animals.

It should be understood that this first theory of development applies rather to the form of the horns than to the animals wearing them ; and the reverse theory is possible.

In Plates IV. and V. I have placed a few more diagrams to make a little clearer what has been said concerning the various formations and the suggestion of classifying them. Possibly those of my readers who have been good enough to follow me through the eleven preceding chapters will be much more likely to imagine an explanation for the various forms of horns than

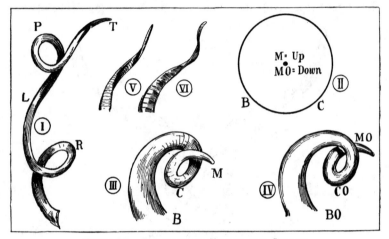

PLATE IV.—DIAGRAMS OF TWISTS AND CURVES.

 I. Tendril of climbing plant changing the direction of its spiral.
 II. The cone, in which M is the apex above, and MO the apex beneath.
 III. Left-hand spiral with apex (M) upwards.
 IV. Left-hand spiral (perversion) with apex (MO) downwards.

will a student whose study of spirals has been limited to what horns alone can show him. Fig. I. on Plate IV. is a diagram of the tendril of a climbing plant such as was described in my last chapter. In its growth up to the point R and beyond it, the tendril finds that a left-hand spiral suits its needs, but from the point L onwards the curve changes to a right-hand spiral, probably because the plant found more light and air in that direction, or possibly from the effects of torsion already described. In any case, we see that the plant can move either to the right or left as it requires. In V. and VI. on the same plate are shown two horns each with the same left-hand twist that is produced in a rope made by a right-handed man. But the horn numbered V. comes from the right side of an antelope's head (compare

Fig. 234), and the horn numbered VI. comes from the left side of the head of an Angora goat. Now, if it were not for the fact stated above, that wild antelopes always show the heteronymous twists, and domestic animals usually show homonymous twists, we might just as well have expected to see the left-hand twist of Fig. V. on the left side of an antelope's head as on the right. But, obviously, the difference in the formation exhibited by the antelope is of advantage to the animal just as the change from left to right at the point R in Fig I. was advantageous to the creeper. Whether the change occurred from older homonymous animals to more recent heteronymous species, as was suggested above, I feel there is not sufficient evidence for proof. To argue that the homonymous animals only survived because they were preserved by man is, no doubt, to take too little account of the enormous periods of time necessary for the production and the permanent duration of such a feature as the heteronymous formation. But two things can be urged in reply to this. The first is that breeding directed by human intelligence has produced such immediate and startling results (in horses and dogs, for instance) in recent decades that many men are now alive who never saw a polo-pony or one of the new terriers until within the last few years. The second consideration is that men who lived more than fifteen thousand years ago are known to have domesticated horses and other animals ; and since the age of man upon the planet has now been thrust back as far as 400,000 years ago, we may reasonably suggest that some animals became domesticated within a few thousand years of the beginning of that remote era. Among such animals it is only likely that such sheep and goats were included as are drawn in Figs. 239, 240, 246, and 247. The suggestion, therefore, is that these animals exhibited the homonymous formation because their horns were never so much used either for fighting their own kind or for penetrating rough brushwood ; whereas, animals less useful and less easily domesticated, such as the antelopes shown in Figs. 234, 235 or 236, and the markhors in Figs. 228 and 229, developed the heteronymous formation which throws brushwood away from the shoulders and leaves the propelling hindquarters free, instead of drawing the boughs inward as homonymous horns would do. If, however, we can prove that domesticated animals show the same spiral formation as that of their wild ancestors, the need of a different theory from that of page 203 will be demonstrated ; and we have to recognise that among male gregarious animals a fight usually occurs, not against carnivora, but between themselves, either for leadership or the possession of the females, and by this means the qualities

of the strongest are transmitted to their young. Living, too, by preference among the mountains and plains instead of forests, they would chiefly depend for safety on sight, scent, or hearing, and on swiftness of pace. Still, it is a fact that sheep and goats (with one exception) which have been domesticated show the homonymous formation, while no heteronymous antelope has ever, to my knowledge, been domesticated.

Passing on to the other diagrams in Plate IV., I will ask you to imagine that Fig. II. is the base of a cone. If you make this base out of a wire ring and fashion your cone out of transparent muslin (after the fashion described in my second chapter), the ring may be placed on a flat table and the apex of the cone (*M*) may be pulled up so as to look like the Fig. BÓK in the top right-hand diagram on Plate V. Now look at Fig. III. in Plate IV., and imagine the diagram to represent a conical helix of such organic substance as horn, the point B in the helix being

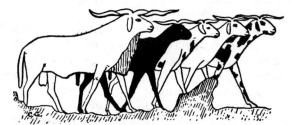

FIG. 240.—ANCIENT EGYPTIAN REPRESENTATION OF TAME LONG-LEGGED RAMS. (LORTET AND GAILLARD.)

supposed to grow from the point B on the base of the cone. The helix will then gradually grow up round the cone until it reaches the apex *M* exactly after the fashion of the left-hand curve of the horn on the left side of the ram's head in Plate III., Fig. I. This is the ordinary form of spiral seen in homonymous curves of Fig. 231.

But another form of spiral is possible, as may be seen by holding up your wire ring (as described in the case of Plate IV., Fig. II.) and letting the transparent muslin fall through the ring until the apex of the cone (MO) is *below* the ring instead of above it, very much like Fig. AOC in the top right-hand diagram on Plate V. Now look at Fig. IV. on Plate IV., and imagine the diagram to represent a conical helix of such organic substance as horn, the point BO in the helix being supposed to grow from the point B on the base of the cone. The helix will then gradually grow down round the cone until it reaches the apex MO, exactly after the fashion of the left-handed curve of the horn on the left side of the head of Pallas's tur in Fig. 230. This is the rare form

of spiral found in the homonymous curves of such animals as those drawn in Figs. 241, 242, 243 and 244. For this rare form I venture to suggest the name " perversion " ; and the addition of some such word as *perversus* to the descriptions of *Capra cylindricornis*, *Ammotragus lervia*, *Pseudoïs nahura*, and the rest, would, I think, be a valuable indication on the labels of museums. The instances just quoted are, I believe, all animals which show this formation only and never use the common formation. But it must carefully be noted that in the mouflon we find the ordinary homonymous formation shown in Fig. 237, where the horns point forwards as in the Alaskan bighorn of Fig. 48, Chap. II. ; but we also know specimens of mouflon which exhibit the rare homonymous formation (*perversus*) shown in Fig. II. of Plate III., in which the horns point backwards as in Pallas's tur, and, therefore, must be so directed as to avoid piercing the animal's back.

I have used the different spirals of the tendril to illustrate the differences in spiral twists. Let me now say that the possibility of *perversus* was suggested to me by the strictly analogous case of certain shells, sometimes styled *perversus* by conchologists. As those will remember who have read my earlier chapters, the operculum always presents a spiral of a contrary direction to that exhibited by the shell itself. Most shells show a right-hand spiral formation, or leiotropic, as the conchologist would say ; and, therefore, the operculum exhibits a left-hand spiral (see Fig. 46, Chap. II.) In these cases, the shell which is usually a right-hand spiral exhibits a few rare exceptions which show a left-hand spiral ; just as shells which, in ordinary cases, may show a left-hand spiral, occasionally produce a few right-hand exceptions. But the operculum in all these instances obeys the rule laid down above. When, therefore, we find a right-hand spiral in the shell, and also a right-hand spiral in the operculum, we at once deduce that a new condition is observable. That condition is indicated by calling this right-hand shell *ultra-dextral* instead of leiotropic ; and the process involved is exactly that by which I illustrated the difference between the ordinary homonymous curves of the Highland ram and the *perverse* homonymous curves of Pallas's tur. The shell, in fact, has gone through just that modification described in the cone of muslin. It began like an upright cone with the base on the table and the apex above. It was gradually flattened out, and the downward pressure continued until the ring or base of the cone was at the top and the apex was beneath it ; in other words, the apex M (in Fig. II. of Plate IV.) had been pushed down until it had gone right through the base and beneath it to MO. This

has occurred in *Spirialis, Limacina, Meladromus,* and *Lanistes,* in which a dextral animal inhabits a shell which appears to be sinistral, but is, in reality, ultra-dextral, as explained by Simroth and Pelseneer. In the same way, *Pompholyx* appears to be dextral, but is in reality ultra-sinistral. No closer parallel to the different growths of horns could be imagined.

That some such distinctive name as *perversus* is required was first borne in upon me by the fact that I found certain eminent biologists describing the left horn of *Ovis ammon hodgsoni* (Fig. 233) as a left-hand spiral, and the left horn of *Capra cylindricornis* (Fig. 230) as a right-hand spiral ; in other words, it was imagined

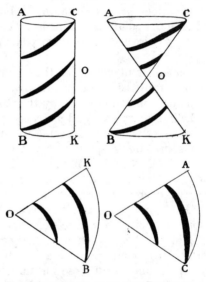

PLATE V.—DIAGRAMS TO SHOW THE PRINCIPLE OF THE INVERTED CONE. (See text.)

that Pallas's tur, the arui, the bharal, etc., exhibited the impossibility of heteronymous curves. There is, of course, a difference between the curves of Pallas's tur and those of the Argali sheep, but it is not a difference that can be expressed by the use of the terms right-hand or left-hand spiral.

In order to show that *perversus* has no effect upon the right or left-handedness of the spiral, I have drawn (in Plate V.) an ordinary cylinder, ACBK, on which the black lines of a cylindrical helix are marked, and you may note that these black lines follow the same direction whether the cylinder is "erect" or "upside down," whether you take AC or BK to be its base. Imagine that at the point O the cylinder is so tightly constricted that two cones are the result, namely, AOC at the top and BOK

at the bottom. You will observe that the black lines of the helix (now conical instead of cylindrical) have not changed their direction in the least. Now take the cone AOC and tilt it on one side so as to balance it on C, with the point O to your left. In the same way take the cone BOK and balance it on B, with the point O also to your left. The black spiral lines point in exactly the same direction in each case yet the cone BOK (at the bottom of the constricted cylinder) represents the normal form, while the cone AOC (at the top of the constricted cylinder) is *perversus*, and is the result of pressing down the apex O until it has come through the base and out the other side, as in an ultra-dextral (or ultra-sinistral) shell, and in the horns of Pallas's Tur.

To the examples of *perversus* already quoted or illustrated I can only at present add the Sind Wild Goat (*Capra hircus blythi*)

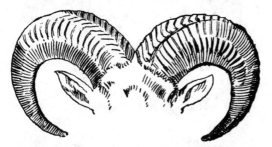

FIG. 241.—(PERVERSION). ARUI OR BARBARY SHEEP
(AMMOTRAGUS LERVIA) FROM N. AFRICA.
(Drawn from p. 389 in Rowland Ward's " Records of Big Game." Sixth edition, 1910.)

and the Ladak Urial (*Ovis vignei typica*). In all these the points of the horns go over the back of the animal's neck and away from a spectator who is looking full in the animal's face. In *Ovis canadensis*, *Ovis ammon*, the Highland ram, and the majority of homonymous curves, the points of the horns come forward towards the spectator. No doubt more examples of *perversus* will reward the careful investigator.

Again, if we are to consider the *perversus* as an improvement developed by wild animals on the ordinary homonymous curves of the domesticated ram, can this process be compared with the fact that in the twisted horns of *Gazella granti* the points come inwards and forwards, whereas a different environment has developed points which go outwards and backwards in the otherwise identical *G. granti robertsi* ? Various suggestions have been made as to the use of different forms of horns. Those of the Sudan Derbian Eland (Fig. 238) or the Suleman markhor (Fig. 228)

are as clearly fighting weapons as those of the common (Fig. 247) or
the Jamnapuri goat (Fig. 246) are peaceful ornaments.　Whether
the horns of the Sind ibex would be useful as scimitars or not
(Fig. 244), they would certainly help to break a fall if the animal
kept his head in and broke the shock upon their massive curves.
Much the same use might be predicted for the firm spirals of
Pallas's Tur (Fig. 230) or the Tibetan Argali sheep (Fig. 233).　But
I cannot agree with the theory (brought forward in the *British
Medical Journal* for September 27th, 1902), that such an open

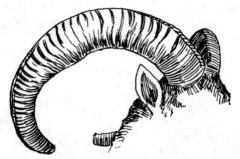

FIG. 242.—(PERVERSION).　CYPRIAN RED SHEEP (OVIS
ORIENTALIS).

(From Biddulph, *Proceedings of the Zoological Society,*
1884.)

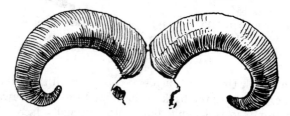

FIG. 243.—(PERVERSION).　BHARAL (PSEUDOIS NAHURA).
(Drawn from figure on p. 387 of Rowland Ward's " Records of
Big Game."　Sixth edition, 1910.)

conical helix as that of a Highland ram's horn could in any way
serve the purposes of a megaphone.

It is only right to quote Dr. Wherry's exact words in mentioning
the theory of horn spirals which he originated.　In the *British
Medical Journal*, of September 27th, 1902, he announced " *that
in the antelopes the right-hand spiral is on the left side of the head
and the left-hand spiral on the right of the head* " (heteronymous),
and " *that in sheep the right-hand spiral is on the right of the head and
the left-hand spiral on the left* " (homonymous).　" *The wild
goats agree with the antelopes in regard to the spiral direction of*

their horns, and the oxen agree with the sheep in cases where the spiral can be noted."

Now it is often by apparent " exceptions " that a " rule," or theory such as this can be corrected or enlarged ; and Mr.

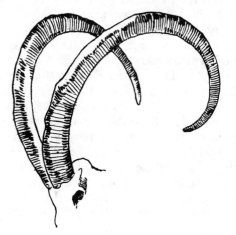

FIG. 244.—(PERVERSION). MR. A. O. HUME'S SIND WILD
GOAT.

Shot by Col. F. Marston. (Drawn from p. 378 of Rowland Ward's
" Records of Big Game." Sixth edition, 1910.)

Lydekker has pointed out two serious exceptions to Dr. Wherry's statement which was evidently based on what he had observed. Did Dr. Wherry refer to the markhor (Figs. 228 and 229) when he used the words " wild goats " above ? If so, how is it that

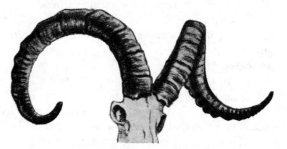

FIG. 245.—DAUVERGNE'S IBEX (CAPRA SIBIRICA
DAUVERGNEI). (Sterndale.)

all tame goats save one are homonymous, whereas the markhor is heteronymous. Is domestication a sufficient reason to assign for the change in spiral arrangement ? Surely an easier explanation may be drawn from the fact that the true ancestor of tame goats is not the markhor but the so-called " Persian ibex " of

sportsmen, *Capra hircus ægagrus*. In Fig. 244 I have shown
the " perversion "-curves of the Sind wild goat, on the head of
Mr. Hume's ibex (Fig. 244). We have seen already that " per-
version" is an accompaniment (though a rare one) of homonymity.
But in the *Field* for December 13th, 1913, Mr. Lydekker pub-
lished Mr. R. A. Sterndale's drawing of an Asiatic ibex (Fig. 245),
which is clearly homonymous, as may be seen by comparison
with the Merino Ram (Fig. 232), or the Tibetan Argali (Fig. 233) ;
and other specimens approaching it (though not so boldly curved)
may be examined in the Natural History Museum. Obviously,
therefore, the homonymous spirals of the ordinary tame goat are
descended from those of the wild goat, which has the same spiral
as the Ibex ; and this is the explanation of the only tame goat
(the Circassian) which exhibits heteronymous spirals (Fig. 249).
For, as Mr. Lydekker says, a comparison of this animal with the
Cabul Markhor (Fig. 248) clearly reveals a similarity which is not
limited to the horn spirals. In each case the tufted chin of the
ordinary tame goat is continued as a thick fringe down the
throat and on into the chest. The tail, too, is of the same

FIG. 246.—INDIAN JAMNAPURI GOAT (TAME).

elongated type in each. There are no doubt other points
of similarity. The specimen photographed in Fig. 249 was
recently sent to the Natural History Museum by Captain Stanley
Flower, director of the Giza Zoological Gardens, as a gift from
the Egyptian Government. The difference in its horn spirals
from those of the ordinary tame goat may be seen at once from a
comparison of Fig. 249 with Figs. 239, 246, or 247, which show
the domesticated breeds.

The suggestion that this Circassian goat is of a different breed
from other tame goats, and owes its derivation to the Markhor
instead of to the Wild Goat, is strongly corroborated by the fact
that the markhor extends to-day as far westward as the Ferghana
province of Turkestan, which makes the possibility of such a
derivation very simple. It also lends considerable probability
to the suggestion of Dr. Trouessart that the markhor should be
separated from other wild goats under the name of *Orthægoceros*.
Certainly nothing could be much more different (in horns) from
the ibex. In 1909 Dr. Otto Keller reproduced from an ancient
cylinder (brought by Sir Henry Layard from Constantinople)
the figures of certain ruminants, which he was evidently mistaken

in describing as argali and markhor. As Mr. Lydekker pointed out, they were in charge of Syrian attendants and obviously domesticated, so they were possibly Circassian goats. It is further noteworthy that Blyth, who was quoted with respect by Darwin, reported that the wild markhor (heteronymous) bred with the domestic goats of the plains ; and it is probably in some such way that the Circassian breed of goats arose. It is also reported by Dr. Wherry that the Egyptian room in the Fitzwilliam Museum at Cambridge contains a portion of the skull with the horns of a domestic animal of about 2,000 B.C., found in the tombs at Beni Hasam. These horns show the markhor type, but are homonymous, and I venture to suggest that they were like those of Fig. 250, and belonged, not to a goat, as has been thought, but to a sheep.

The Wallachian sheep (Fig. 250) has horns which are very like those of a markhor (Fig. 228) though smaller ; but they follow Dr. Wherry's rule and are homonymous, as may be seen by

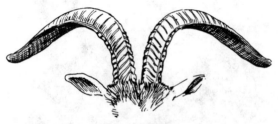

FIG. 247.—COMMON DOMESTICATED GOAT.

comparison, for the right-hand spiral of the markhor's left horn appears on the right side of the head of the Wallachian sheep, an animal to whom I must apologise for my incorrect description in a former book ; for nothing is more difficult than accuracy in these matters unless the student can test the horns by such diagrammatic models of twisted wire as have just recently been placed in the Natural History Museum.

The Circassian goat, therefore, is a very definite exception to the usual rule concerning tame goats, and Mr. Lydekker has satisfactorily explained it. The only exception I have found to Dr. Wherry's rule about antelopes is almost equally signifi-cant ; for the only homonymous horn spirals in this division hitherto discovered are in *Oioceros*, which are known only from tertiary formations, and, if I am right in the theory expressed above, were unable to survive because they were not heterony-mous. They were first named by Charles Gaillard, in 1901, who included among them certain spiral-horned antelopes from the Lower Pliocene of Pikermi, Attica. Dr. Wherry, however,

has shown that the fossil horn cores of antelopes from the Upper Miocene (preserved in the Geological Museum) are heteronymous like those of their living descendants.

From a study of the four-horned Asiatic sheep in the British Museum, Mr. Lydekker has concluded that the upright pair of horns in the Wei-hai-wei ram (Fig. 251) exhibit the normal homonymous spiral, whereas in the horizontal pair he sees that variety which I

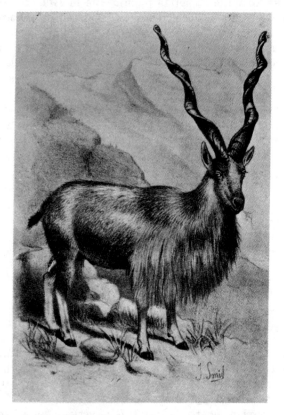

FIG. 248.—THE CABUL MARKHOR (CAPRA FALCONERI MEGACEROS).
(From Lydekker, *Proc. Zool. Soc.*)

have described as *perversus,* " a modification due to a secondary twist in the upper part of the horns, as a result of which the tips curve backwards over the neck, instead of bending forward by the sides of the cheeks."

It would be most interesting if we could show that the *perversus* variation was a link in development connecting the kinds which are at present domesticated with those that are still wild. I think that the curious connection of homonymous twists with domes-

ticity in *goats* is satisfactorily answered by Mr. Lydekker's explanation on p. 212, which has the added advantage of explaining the apparent " exception " as well. But it is still more curious that, although all open curves in the horns of *sheep* must necessarily be either homonymous or *perversus*, when a sheep exhibits the close twists of the Wallachian breed (Fig. 250) these twists are homonymous too. This important fact suggests that

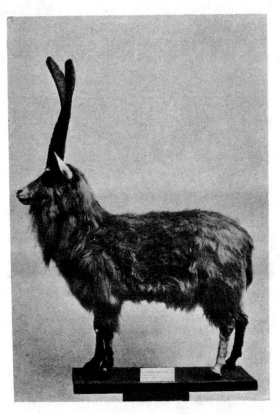

FIG. 249.—CIRCASSIAN DOMESTICATED GOAT.

the order of development given on p. 203 admits, not merely of modification, but of complete reversal ; and since no theory on these subjects has (as far as I am aware) yet been suggested, I feel bound to give my readers a choice ; for " the observer can only observe when his search is guided by the thread of a hypothesis " ; and only continued comparisons will determine which is the more probable. If, therefore, we now imagine that open homonymous curves and close homonymous twists (not upright)

were developed gradually from close heteronymous twists (upright), we shall start with the more scientific consideration that primeval horned animals before the advent of man, being obliged to fight for their living, had such splendid weapons as those of the Suleman Markhor (p. 191), or of the Senegambian Eland (p. 202), animals which have never been domesticated ; but that, in the second stage, animals which were not yet domes- ticated, but were not such fierce fighters, found that the lower twisted curves of the Gilgit Markhor (p. 192), or the Lesser Kudu (p. 197), were sufficient for their purposes. It is then easy to imagine that this process (which is, by hypothesis, a process of slow degeneration) would soften the fibre of the horns and, by

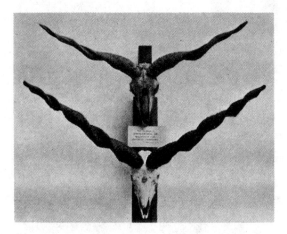

FIG. 250.—WALLACHIAN SHEEP (OVIS ARIES STREPSICEROS).
(From specimens in the Natural History Museum.)

compensation, would thicken them. If so, the next step would be *perversus*, in which the points still remain lifted upwards, as in Pallas's Tur (Fig. 230), but the horns exhibit less twist, more curve, and considerable thickening (p. 193). Lastly, we get the Merino Ram, illustrated on p. 194, which shows the lowered points of the final stage of deterioration, and therefore presented no difficulties to domestication by man, and might possibly, indeed, have died out but for the interference of man, as was the case in *Oioceros*. This hypothesis eliminates the difficulty of the time necessary (p. 205) for the production of a change in the spiral when that change was attributed to processes which can have existed only since man began to tame animals for his own use ; and it explains why antelopes were heteronymous in geological periods (p. 215) long before the advent of man ; but it has not

yet provided a satisfactory explanation for the substitution of the homonymous open curves, or homonymous twists (not upright) in tame animals, for the close heteronymous upright twists of wild animals which had to fight. To supply this gap, I can only suggest that the development may have been analogous to the process described in Fig. 234 on p. 196. There we noted

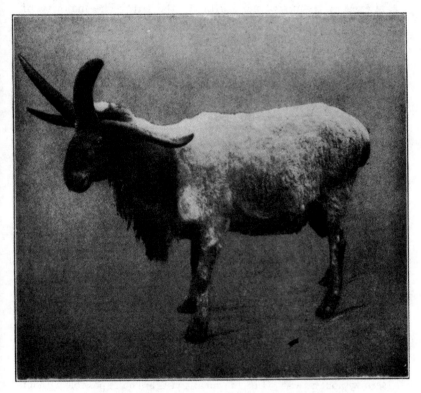

FIG. 251.—FOUR-HORNED RAM FROM WEI-HAI-WEI.
(From photograph by Lieutenant R. H. Lane-Poole, of H.M.S. *Minotaur*.)

that the male blackbuck's horns exhibit heteronymous twists, but that the horns of the female *of the same animal* exhibit homonymous curves, possibly because she had less need to use them as weapons of attack or defence. This, therefore, may be the explanation why fighting wild animals were heteronymously equipped like the Markhor (Fig. 228), while tame animals only needed (1) homonymous curves like those of the female Blackbuck or Merino Ram (Fig. 232), the points of whose horns had dropped much lower than those of Pallas's Tur in Fig. 230 ; or (2) homony-

mous twists like those of the Wallachian sheep (Fig. 250), the points of whose horns had fallen much farther apart than those of the Gilgit Markhor in Fig. 229.

We have seen in earlier pages that a very slight disturbance at the point of origin of a growing spiral will have a permanent effect upon the shape of the completed spiral. Shavings usually exhibit a right-hand spiral because a right-handed carpenter always drives his plane a little to the left. The majority of shells exhibit a right-hand spiral because the material forming the protoconch usually " lops over " slightly to the left at the beginning of its growth. The hair of a negro is curly because in those races of mankind the follicle from which the hair emerges is not straight as in the case of white races. Moisture has also a curious effect on spiral growth. In the museum at Cambridge Dr. Wherry has described a sheep which was shot on damp and boggy soil, in the Falkland Islands. Each portion of its cloven hind hoof had grown to an enormous size and length, exhibiting a spiral twist of about two and a half turns, a right-hand spiral on one side and a left-hand spiral on the other, just as may be observed in the horns of a koodoo. All such details may have a bearing on our present inquiry ; yet I feel that I have made no valuable suggestions as to the reason why the spirals of horns take different shapes, or show different arrangements in various animals. But, at any rate, the problem has been stated rather more fully than has been done before, and the various analogies suggested may even be of some use in determining future classifications.

NOTES TO CHAPTER XII.

ESSENTIAL CURVES AND TWISTED SURFACES (p. 195).—The curve of the horn of the Abyssinian ibex (*Capra walie*) is the only one I have seen without a twist. But, of course, twists are quite possible without curves, as in the case of the Wallachian sheep or the Suleman markhor.

NOMENCLATURE.—THE SPIRAL OF HORNS.

Dr. Wherry sent me the following letter :—

" If in a Rocky Mountain sheep the right horn were sawn off the skull and the tip inserted into the severed horn core on the skull, that horn would, of course, still exhibit a right-handed spiral, and ' homonymous ' is a convenient word for the arrangement on the head and the direction of the spiral in the horn. The *right* horn has a *right* spiral and *left* horn a *left* spiral—' homonymous,' or same name.

" The horn of the Indian antelope (in which, as in all antelopes, the horns go ' heteronymously ') is often made into a toasting fork ; the thick end is capped with silver, and the tip carries the fork.

Knowing that the horn is that of an antelope, you take it up by *either* end, and if it has a right-hand spiral it is the left horn, or if it has a *left*-hand spiral it is the *right* horn—*i.e.*, ' heteronymous.'

" As I first used these words in this connection, I take a paternal interest in them, and venture to think that ' homonymous ' and ' heteronymous ' will be found convenient words and useful aids for observation and memory."

CURIOUS DEVELOPMENT OF HORN-SPIRALS.

Mr. R. Lydekker has very kindly shown me a most remarkable, and apparently unique instance (Fig. A) of the Homonymous (*Perversus*) spiral beginning with a curve and ending with a twist in the same horn, which is even more noteworthy than my example of the two things in the male and female of the same animal (Fig. 234).

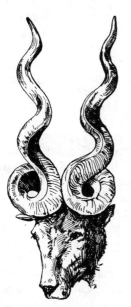

FIG. B.—HEAD-SKIN AND HORNS OF A VARIETY OF THE ALBANIAN SHEEP.

(From a specimen presented to the Natural History Museum by Messrs. Rowland Ward, Ltd.)

FIG. A.—HEAD AND HORNS OF ALBANIAN SHEEP.

(From J. G. Wood's figure.)

Mr. Lydekker thinks this Albanian sheep is a cross between the Parnassian sheep of Macedonia and Greece, represented in the basal curves, and the Wallachian sheep, represented in the terminal twist.

Fig. B shows the horns of another Albanian sheep which point downwards instead of upwards, apparently a rare example of *perversion* in the twist instead of in the curve.

CHAPTER XIII

Spiral Formations in the Human Body

" The earth has a spirit of growth ; its flesh is the soil ; its bones are the successive strata of the rocks ; its muscles are the tufa stone ; its blood the springs of its waters. The lake of blood that lies about the heart is like the tides, for the increase and decrease of blood in its pulses are the ebb and flow of ocean."—Leonardo da Vinci (*Leicester MSS.*).

NATURAL OBJECTS DO NOT CONSCIOUSLY PRODUCE SPIRALS— DEVIATION FROM MECHANICAL ACCURACY—SPIRAL FORMA- TIONS OF UPPER END OF THIGH BONE—GROWTH AND CHANGE —CORRESPONDING STRUCTURES IN BIRDS AND MAMMALS —CONICAL SPIRAL OF COCHLEA—SPIRAL FORMATIONS : UMBILICAL CORD, SKIN, MUSCULAR FIBRES OF HEART, TENDO ACHILLIS, THE HUMERUS (TORSION), RIBS, JOINTS, WINGS AND FEATHERS, EGGS, ANIMALCULÆ.

My readers need not again be cautioned against the idea that any natural object consciously produces a spiral formation ; it grows after a pattern which we describe as " spiral " because that word conveys to our minds a certain conventional mathematical definition which may have no actual existence outside our minds, but permits us to label and classify the pattern shown by the natural object. We have seen, too, that mathematics will enable us to construct a theoretical figure of perfect growth and to compare it with the formations exhibited by such organic objects as plants or shells ; and thereby we may satisfy still more com- pletely the craving of the human mind for orderly explanation by stating that a particular shell differs from a particular loga- rithmic spiral in factors which may conceivably admit of isolation, if not of accurate expression.

But this implies the further power that by the use of mathe- matical formulæ, originally conventional, we can artificially manufacture specific objects which will fulfil certain definite needs, such as a carpenter's screw, a ship's propeller, a spiral staircase, and so forth. Now we have already seen several forms of growth in Nature which can only be distinguished from artificially manufactured spirals by the fact that, since they are the result of organic development through natural processes which are more or less traceable externally, they almost invariably exhibit those subtle variations from mechanical accuracy (those

inexplicable factors, " isolated," as I said above, from the simpler mathematical processes) which are essential to life, and, as I think, to beauty. It has not yet, however, come within our province in previous pages even to inquire whether the artificially manufactured article (such as a spiral staircase or a screw propeller) could have been consciously copied from a natural object. But in the present chapter on spiral formations in the human frame it may at least be possible to suggest that both the object made by man (the only " manufacturer " in the world) and the growing phenomenon in Nature are conditioned by laws, fundamental for them both, which we can only describe to ourselves in terms of mathematics.

A very beautiful instance of what I mean is to be found in one of the most extraordinary structural adaptations in the human body, namely, the architecture of the upper end or neck of the thigh-bone, which has to transfer the weight of the body to the lower extremity. This has been described by Professor A. F. Dixon of Trinity College, Dublin (*Journal of Anatomy and Physiology*, 1910, Vol. XLIV., p. 223). Examined by X-rays, its interior is seen to be made up of a series of lamellæ or needles of bone, arranged on a very definite plan. The cells which form bone (called *osteoblasts*) may be described as the bricklayers of the skeleton, and they lay down these lamellæ within the neck of the bone on the three definite systems shown in the photograph (Fig. 252).

The first of these systems, rising from the dense and compact cylinder which forms the shaft of the femur, produces a series of Gothic arches at the top of this shaft. The second springs from the underside of the neck, and passes upwards to support the weight of the body on the head of the bone. The third passes from the outer side of the cylindrical shaft into the upper part of the neck, bending in such a way as to interlace with the second or supporting series, after the manner of tie-beams, to which these tension lamellæ may be compared.

When examined stereoscopically by X-rays, in order to obtain a true picture, these lamellæ were found by Professor Dixon to be arranged in a spiral formation (Fig. 253) ; in other words, the shaft of the bone becomes a bent cylinder continuing into the neck by means of a left-hand and a right-hand system of spirals, quite comparable with the spiral and cylindrical pillars employed by engineers in bridge-building and other enterprises which obtain the greatest strength, with the least expenditure of material.

A bridge, however, is fairly permanent, or, at any rate, does not visibly vary in size after it has once been built ; whereas the human frame exhibits gradual growth from the infant to the

adult, and constant change through life. The exact adaptation, therefore, of the anatomical architecture just described becomes even more marvellous when its control and development are clearly realised. For when the child learns to walk, the " brick-layers " of its little skeleton have to work out the elaborate design illustrated in Fig. 253, not once only, but many times. In fact, as the femur extends in growth the earlier systems become gradually useless, and are constantly replaced, which suggests that the *osteoblasts* (to give our " bricklayers " their

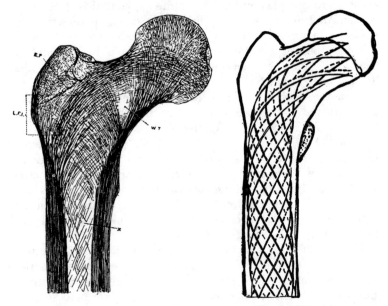

FIG. 252.—X-Ray photograph of the upper part of the right human thigh-bone to show the internal structure.

(Professor A. F. Dixon.)

FIG. 253.—The spiral arrangement of the bone lamellæ seen in the upper extremity of the femur when examined stereoscopically by the X-Rays.

(Professor A. F. Dixon.)

scientific name) are sensitive to the various stresses and strains put upon the limbs, and build up their thighbone with a view to withstanding all those forces applied to the body of which they have any experience.

This involves a form of intelligent workmanship which must remain obscure to us until we discover the conditions controlling their laborious existence ; still less can we understand how they are able to choose, for strengthening the human thigh-bone, just those beautiful applications of the spiral which have resulted from the mathematical researches of highly-trained engineers. Those who have followed me through earlier

pages of this inquiry will, perhaps, be inclined to the supposition
that in this sentence I have done less than justice to our *osteoblasts*,
and have reversed the true terms of the comparison ; for may
we not see in the design of the engineer a fundamental necessity
for the employment of a formation which is at least as old as the
origins of anatomical structure and development ? May we
not find the solution of far more complicated difficulties than his
engineering problems in the bodily framework he has inherited
from vital processes vastly more aged than the humanity he
recognises in himself ?

We may be inclined to take this view even more definitely

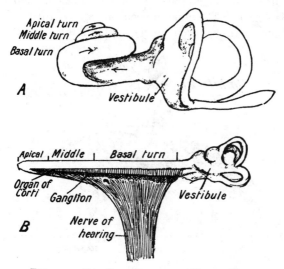

FIG. 254.—THE COCHLEA OF THE. HUMAN EAR.
(A) Viewed from the side. (B) The cochlea unrolled (after Siebenmann).
For Rüdinger's drawing of the laminæ, see Fig. 39, Chap. II.

when we realise that the sensitiveness and aptitude for producing
such spiral architecture as that of the thigh-bone must be handed
on by successive series of *osteoblasts*, not only throughout the life
of the same individual, but through the countless human genera-
tions fitted with similar framework. Even more curious is the
discovery of Professor Dixon that this spiral adaptation is not
confined to human *osteoblasts* : for he has shown that the same
interlacing of right-hand and left-hand spirals in the arrangement
of the bony lamellæ is found in the interior of the shafts of the
long bones in birds and mammals. My readers will remember
somewhat similar instances in substances which are not bone at
all—in plants, in shells, in horns. The process, in fact, may be
carried back to those dim beginnings of organic structure which

can only be referred to the primeval phenomena of energy or
growth.

Another well-known spiral arrangement (but conical this time,
instead of cylindrical) is seen in the inner ear or cochlea of man,
a structure attaining its highest development in mammals and
illustrated in Fig. 39, Chap. II. In Fig. 254 the artist has adapted
the diagrams given by Dr. Siebenmann in Bardeleben's textbook
of anatomy to show the coiling of the tube into a cone. The natural
condition is given in the upper drawing (A), showing the two coils
and a half in the spiral. In the lower drawing (B) the tube is un-
coiled for diagrammatic purposes in order to show the nerve of
hearing, its ganglion, and the organ of Corti spread out along almost
its whole length. The human cochlea is derived from the short,
slightly curved tube (called lagena) found in birds and in an early

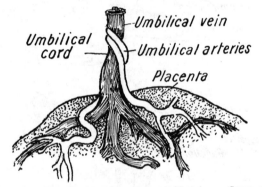

FIG. 255.—THE TERMINATION OF THE UMBILICAL CORD ON
THE PLACENTA, SHOWING THE LEFT-HAND SPIRAL MADE
BY THE TWO ARTERIES.
(After Broman.)

stage of the human and mammalian embryo. It has probably
developed into a spiral not merely owing to the limited space
in the petrous bone containing it, but because of the retardation
of growth of that side of the cochlea at which the cordlike
auditory nerve enters, and the quicker growth of the other side.
The nerve is, therefore, easily distributed along the organ of
Corti by the convenient medium of the columella, or central pillar
of the cochlea ; and this spiral formation does not, so far as we
know, alter the form of the mechanical waves stirred by sound
waves in the fluid contained by the cochlea.

The spiral shown by the human umbilical cord has also been
illustrated in Fig. 10, Chap. I. But in Fig. 255, the termination
of this cord in the placenta is shown. The comparatively straight
vein conveying oxygenated blood back from the placenta has
spirally arranged but somewhat irregular folds in its lining

membrane. The two arteries carrying impure blood encircle the vein in an obvious spiral, which is usually left hand (as in Fig. 10, above). This is produced by the fact that the suspended

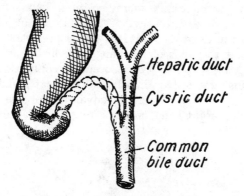

FIG. 256.—DIAGRAM TO SHOW THE SPIRAL VALVE OF THE DUCT OF THE GALL BLADDER.
(After Charpy in Poirier's " Traité d'Anatomie.")

fœtus usually turns to the right ; but why it does so, and what functional advantage there may be in the twisting of the cord (except, perhaps, that of strengthening it), we cannot tell at present. It has been suggested that the right artery may usually

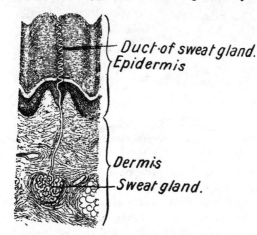

FIG. 257.—THE SPIRAL ARRANGEMENT OF THE DUCT OF A SWEAT GLAND, AS REPRESENTED IN HENLE'S ANATOMY.

predominate ; but as a rule, they are equal in calibre, and even in the absence of the left artery the spiral of the cord persists. It is equally difficult to explain why the spiral in the cystic duct of the gall-bladder (Fig. 256) should always be a right-hand one. It is certainly not produced, in this case, by the twisting

of the gall bladder during development, and its probable reason is to keep the duct open when it is sharply bent within the living body, very much as an internal spiral spring is used to keep a hose-pipe open and without kinks in any position. I should add that it is uncommon to see the spiral of this duct so plainly marked as it is drawn in Fig. 256. But it is always possible by dissection to reveal that the folds of its lining are spirally arranged.

A number of spiral structures occur in connection with the skin, and Fig. 257 shows the duct of a sweat gland as it perforates the epidermis. Here the advantage of the cylindrical spiral (which is right hand) must be to give such storage to the

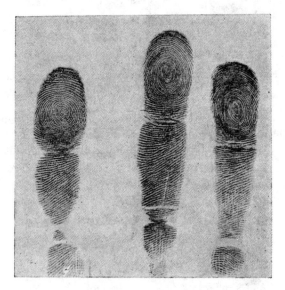

FIG. 258.—IMPRINTS OF THE INDEX, MIDDLE, AND RING
FINGERS OF A MEDICAL STUDENT, SHOWING SPIRAL
PATTERN OF SKIN PAPILLÆ.

sweat that when the skin is grasped or pressed, the sweat exudes ; and the formation may also serve to protect the gland from the invasion of infectious dust. This is another example of a spiral that has to be persistently renewed, for the cells of the epidermis are shed daily. It is well known that on the fleshy pads of the finger tips the papillæ of the skin are arranged in peculiar patterns, which have been classified by Galton, the loop form being the commonest, the flat spiral one of the rarest. The imprint shown in Fig. 258 is taken from one of the two students out of forty-five who possessed this spiral or whorl type. It has been suggested by Hepburn that these papillary patterns give security to the grasp as well as delicacy to the touch. They are found in apes

and monkeys as well as man, and I am inclined to believe that the curious marks in prehistoric carvings (concentric circles, loops, and spirals) may have had their origin in the finger-tips which have provided Bertillon and Galton with subjects for comparative research and modern Scotland Yard with a test for identifying criminals. It appears that no two men exhibit the same markings. I have already mentioned that the papilla from which a negro's hair grows is bent downwards, and thus produces its distinctively " woolly " appearance. His hair-roots, which have been investigated by the late Professor Stewart and Professor Arthur Thomson, have a peculiar kink in them when compared with those of the white races ; and, ultimately, the spiral nature of the hair must be referred to a rhythmical irregularity of growth in the root.

Passing on from the dermal structures, we find a number of

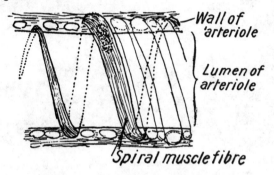

FIG. 259.—DIAGRAM OF A CAPILLARY OR ARTERIOLE IN THE WEB OF THE FROG, SHOWING THE SPIRAL ARRANGEMENT OF MUSCLE FIBRE, DISCOVERED BY LORD LISTER.

spiral patterns occur in the circulatory system. The late Lord Lister (*Trans. Roy. Soc., Edin.*, 1857, Vol. XXI., p. 549) described one of the most beautiful examples (which does not occur in the human system) in the finer vessels of the frog's web. The plain muscle fibres encircle these vessels in a right-hand cylindrical spiral (Fig. 259), which produces a more perfect pressure (or occlusion) than merely circular fibres would do. The arrangement of a conical spiral may be seen in the muscular fibres of the human heart (see Fig. 260, and compare Fig. 3, Chap. I.). As seen on a superficial dissection these fibres form a right-hand spiral, and in their form alone may be compared to the beautiful little *orbiculus*, which has been illustrated in Fig. 261. The fibres begin at the base of the ventricle of the heart and end in the vortex at the apex by becoming continuous with deeper fibres. We do not know the growth mechanism which produces this complicated form, investigated by the late Professor Pettigrew and others,

but we can begin to understand its advantages. The emptying
of the heart was a difficult problem for Nature to solve. In the
lower slow-moving vertebrates she adapted a sponge-work
arrangement ; but such a mechanism was too clumsy for the
fast-moving higher vertebrates, birds and mammals. So a
contractile, thick, and dense-walled pump had to be evolved in
such a manner that the contracting muscular wall could eject
its whole load of blood. This end was beautifully attained by
arranging the fibres in a spiral pattern, so that one twist would
close up the cavity and throw out its contents, and the next
twist (reversed) would open it again ready to be filled. The
functional meaning of the vortex at the apex of the heart has been
described by Dr. Keith in *Journ. Anat. and Physiol.*, 1907,

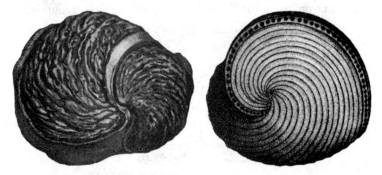

FIG. 260.—DISSECTION OF THE APEX OF
THE HUMAN HEART, TO SHOW THE
SPIRAL ARRANGEMENT OF THE MUS-
CULAR FIBRES. (Pettigrew.)

The fibres enter at a vortex at the apex.

FIG. 261.—A FORAMINIFER.
(From the *Challenger* Reports.)
Greatly enlarged.

Vol. XLII., p. 1. A slighter example of partial torsion may be
seen in the great arterial trunks at the root of the heart. The
pulmonary artery passes from the right ventricle to the lungs ;
the aorta rises from the left ventricle and distributes blood to
the body. In Fig. 262 (A) is illustrated the right-hand spiral
formed by the pulmonary artery on the left side of the aorta.
Why this artery should pass to the left and not to the right of the
aorta is an unsolved question ; but it may be said that the aorta
and the pulmonary artery are parts of a common trunk in the
human embryo, and this condition persists in gill-breathing
animals. They are separated by a septum, which always exhibits
a right-hand spiral except in those rare instances of individuals
in whom all the viscera are transposed as regards right and left,
as shown in Fig. 262 (B).

Among the many peculiar patterns shown by the muscular

system a spiral arrangement is very rare ; but Mr. F. G. Parsons (of St. Thomas's Hospital Medical School) has drawn the attention of anatomists to a beautiful example in the *tendo Achillis*, the tendon of the muscles of the calf of the leg, at its insertion into the

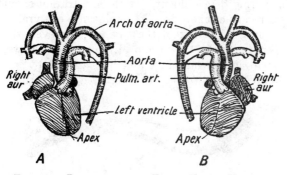

FIG. 262.—DIAGRAM OF THE FŒTAL HUMAN HEART.

Showing (A) the pulmonary artery forming a spiral on the left side of the aorta. In (B) is shown the arrangement in those uncommon cases whose viscera are transposed as regards left and right.

heel. The fibres have a rope-like twist, which is more evident in such animals as the beaver (Fig. 263), and may possibly be related to some inward movement of the sole of the foot when walking.

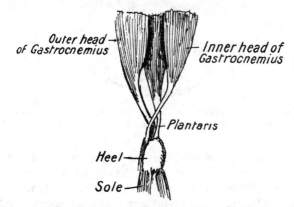

FIG. 263.—TWISTING OF THE TENDONS OF THE MUSCLES OF THE CALF AT THEIR INSERTION INTO THE HEEL OF A BEAVER.

(F. G. Parsons, *Journ. Anat. and Physiol.*, 1894, Vol. xxviii., p. 414.)

Many cases of torsion or spiral arrangement in the bones of the human skeleton are more imaginary than real ; and in the clavicle, which is the upper bone (A) drawn in Fig. 264, the appparent twist, here very much emphasised, is due to the strong line (crossing the undersurface of the bone) made by the insertion

of the *subclavius* muscle. The lower bone (B) in the same figure
is the *os innominatum* or left pelvic bone, which is made up of at
least four functional parts; and though there is no doubt that the
angles and planes in which these parts are set do undergo a certain
rotation during development, yet the illustration should not be
used as a means of analysing the significance of spiral formations
in the body. The shaft of the *humerus*, however, the bone of
the upper arm (Fig. 11, Chap. I.), certainly shows a spiral
arrangement in the markings and lines caused by muscular or
nerve impressions. Torsion has occurred during the evolution

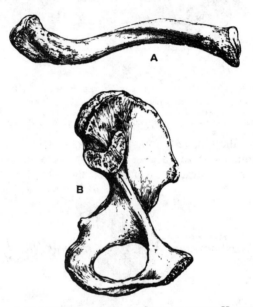

Fig. 264.—A. Represents the Under Surface of the Human Clavicle.
B. Represents the Inner Side of the Left Pelvic Bone.
(Pettigrew.)

of man, and rotation occurs in his upper and lower extremities
during development; so that the upper extremity rotates
outwards and the inner surface becomes anterior, thus forming
a right-hand spiral in the right arm and a left-hand spiral in the
left. The lower extremity rotates in the opposite direction, so
that the original inner surface becomes posterior. It is to this
developmental twist that the spirals apparent on the surfaces of
human bones are largely due. In the *humerus* the axis of the
lower joint is set at right angles to the axis of the upper one, and
the articular surfaces (set on different planes) are so placed as
to allow the bone to move in various directions useful to the body.
A functional twist, due to the same difference in the axis of the

joints at its two ends, may be observed in a bone in the lower extremities. In Fig. 265 is shown the left fore-leg of an elephant seen from the front. In the upper bone the drawing has rather exaggerated the twist and prominence of the ridge caused by the attachment of a muscle. The bones beneath it are permanently fixed in the position known as pronation, the *radius* turning from the outer to the inner side of the limb as it passes towards the foot. The torsion shown on this left fore-leg is seen to be a right-hand spiral, and of course the right fore-leg would show a left-hand spiral. In the case of the ribs there is a very good example of spiral twist (see Fig. 266), which possesses well-recognised functional advantages. The posterior part of the rib (the head, neck, and angle) serve as the axis round which the rib rotates as we breathe ; and the spiral formation of the shaft causes the rib to move outwards as it is rotated upwards, thus enlarging the capacity of the chest and causing air to enter the lungs.

FIG. 265.
BONES OF THE LEFT
FORE-LEG OF AN
ELEPHANT.
(Pettigrew.)

What has been said here by no means exhausts the spiral formations in the human body ; it merely suggests typical instances, and many more might be set forth. The joints provide several interesting examples. The condyles of the lower

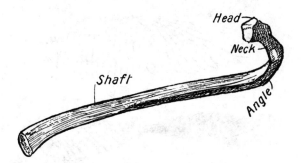

FIG. 266.—DRAWING OF THE SEVENTH RIB ON THE RIGHT
SIDE, TO SHOW THE SPIRAL TWIST WHICH FACILITATES
BREATHING MOVEMENTS.

end of the femur, which enter into the formation of the knee joint, are of a spiral formation, which permits the longest radius of the condyle to come into action when the knee is extended, and thus gives security in various positions of the leg. The movements called supination and pronation in the two bones of the fore-arm are of a spiral nature. The spinal column can

be spirally rotated in either direction. All graceful dancing and human movement is more or less spiral, as may be easily seen in fast swimming, and this makes a definite appeal of its own to

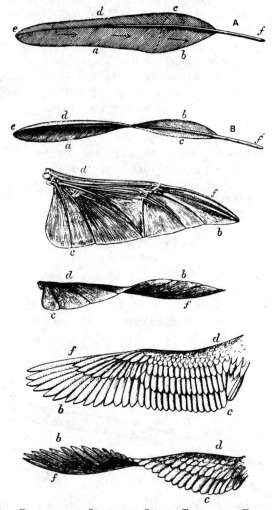

FIG. 267.—DRAWINGS TO SHOW THE SPIRAL TWIST OF A FEATHER, OF THE WINGS IN A BEETLE (GOLIATHUS MICANS) AND OF A KESTREL.

The upper part of each figure shows the forms at rest, and the lower part shows the spiral produced in flight. (Pettigrew.)

the human æsthetic judgment. Our æsthetic approval is no doubt largely due to our appreciation of competence and efficiency combined with balance, and in the case of spirals it is due to our ancestrally-inherited and long-impressed perception of the power and " beauty " of screw-movement.

When we turn to the rest of the animal kingdom many more examples of the same formation can be studied, and again I propose only to choose a few typical instances. Perhaps the most exquisite are to be found in wings and in the feathers of which those wings are composed, and I reproduce drawings of these (Fig. 267) from the posthumous edition of the late Professor Pettigrew's researches, to which reference has already been made.

Instances of what I have previously described as a flat spiral occur in the intestines of many animals as well as man. In an excellent monograph dealing with the intestinal tract of mammals (*Trans. Zool. Soc.*, 1905, Vol. XVII., p. 437), Dr. Chalmers Mitchell has figured many examples of the remarkable spiral arrangement of the upper part of the great bowel in ruminants.

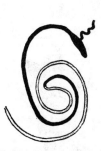

FIG. 268.—SIMPLE COLIC HELICENE OF STANLEY'S CHEVROTAIN. (Beddard.)

FIG. 269.—UPPER PART OF THE COLIC HELICENE OF A MUSK DEER. (Beddard.)

The two illustrations given here are taken from Mr. F. E. Beddard's "Contributions to the Anatomy of Certain Ungulata" (*Proc. Z. S.*, 1909). In Fig. 268 is shown the simple colic helicene of Stanley's chevrotain (*Tragulus stanleyanus*), and in Fig. 269 are drawn the more elaborate curves of the musk-deer (*Moschus moschiferus*). In each case the cæcum is represented in black on the right, and the ingoing limb of the spiral is black, the outgoing limb is lighter ; and the spiral of each is right hand. The forms of these spirals are used by Mr. Beddard to illustrate certain technical developments with which I cannot deal in these pages. But it may be said that a similar arrangement appears in the capybara. In the rabbit and hare the cæcum and appendix form part of an intestinal spiral. All these formations may be considered to be the result of inequality in the rate of growth of the various parts composing the twisted loop. One part of the cæcum of

the rabbit (*Lepus cuniculus*) leads to the vermiform appendix, and is wide in calibre, but diminishes somewhat towards its termination, is thin in its walls, and spirally constructed externally in correspondence with the spiral valve developed internally.

In the colon of the dogfish (*Scyllium canicula*) a different and very beautiful form of upright spiral is found. The lining membrane is developed into a right-hand spiral valve, which greatly increases the absorbing surface of this part of the intestine (Fig. 270). The rotation of a bird's egg while descending the oviduct gives a spiral twist to the envelope as it turns in its progress, and thus the little stringy portion of " white " at each end is strengthened by the spiral formation imparted to it and

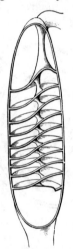

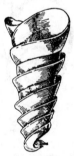

FIG. 270.—COLON OF DOGFISH, SHOWING SPIRALS OF THE INTERNAL VALVE.

FIG. 271. — CAPSULE OF PORT JACKSON SHARK'S EGG, SHOW- ING EXTERNAL SPIRAL.

suspends the egg within the shell. Much the same rotatory process occurs during the birth of mammals. The spiral fold within the oviduct of a shark (*Cestracion philippi*) imprints an unmistakable pattern upon the capsule of its egg (Fig. 271), which is almost precisely the shape of those " ground anchors " which sink themselves into the mud of a harbour and form securing places for mooring chains, lightships, beacons, and the like. The eggs just mentioned provide a typical instance of the generation of a spiral by two movements : (*a*) rotation on the axis, (*b*) longitudinal movement of the rotating mass.

It would be impossible to exhaust this division of the subject in the space at my command ; but I may add that the same formation can be found in the smallest forms of life, in those

organic atoms which seem to partake both of animal and of vegetable characteristics, and particularly in the spirilla, spiro-chætes, and a number of the longer bacilli. A large number of the bacilli which grow into threads tend to take on a spiral form, as may be easily seen in examining unstained specimens through a microscope. One of these, *Spirillum rubrum*, has already been illustrated in Fig. 6, Chap. I. I give here two more photographs

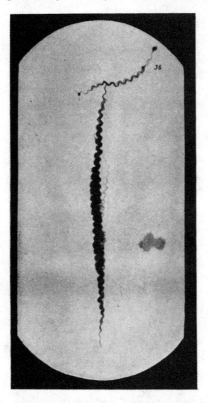

Fig. 272.—Spirochæte Giganteum.
Highly Magnified.
(Kolle and Wassermann.)

reproduced by Kolle and Wassermann. Fig. 272 shows a typical form of motile organism. Fig. 273 represents another well-known bacillus, with its vibratile cilium twisted in a corkscrew spiral. And the spermatozoa of many animals show a spiral flange formed along the cilium, which is used for boring into the egg. Both examples of bacteria given here are of course very highly magnified. Very minute, too, are the ciliate protozoa I reproduce in Fig. 274 from Haeckel's " Künstformen der Natur," in which the better examples are to be found on the side

of the plate to the left of the reader, especially in *Vorticella* (at the bottom corner on the left), *Carchesium* (which looks like a cauliflower growing on a corkscrew), next to it, and *Stentor,* the trumpet shape above them. The spiral cilated forms of the trumpet animalcule, and other similar shapes, have the result of producing a vortex in the water, bringing suspended particles to the apex of the spiral where the mouth is placed.

NOTES TO CHAPTER XIII.

For most of the facts in this chapter I am indebted to Professor Keith, but for the form of statement and for the arguments employed he is no way responsible.

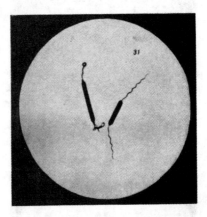

FIG. 273.—A BACILLUS FROM PUTREFYING FLESH-INFUSION, MAGNIFIED 1,500 DIAMETERS.

This and Fig. 272 are taken from Kolle and Wassermann's " Handbuch der Pathogenen Mikroörganismen." Atlas.

TORSION.—" M. B." wrote :—
" Your article on anatomical spirals mentions the effects of torsion. Your readers may therefore be interested to know of a recent addition to the Shell Gallery in the British Museum, in the form of a working model (easily operated by the public), exhibiting the process of torsion in Gastropod Mollusca. The model is diagrammatic and generalised, and does not attempt to suggest a cause for the phenomenon."

EXTRACT FROM THE " LANCET."—I reproduce from the *Lancet* the following very kindly notice, and gladly acknowledge the value of approval expressed by so high an authority on all scientific suggestions.

" The most recent of the series," says this expert newspaper, " is likely to prove of particular interest to readers of the *Lancet,* for it deals with those organs or parts of the human body which manifest a spiral conformation. The list of such structures in the human body is more extensive than is usually believed, several examples given by

the writer in the *Field* being often overlooked. The first example cited is the spiral arrangement of the trabeculæ of long bones, the recent research of Professor A. F. Dixon on the finer structure of the human femur supplying the necessary data. The spiral arrangement

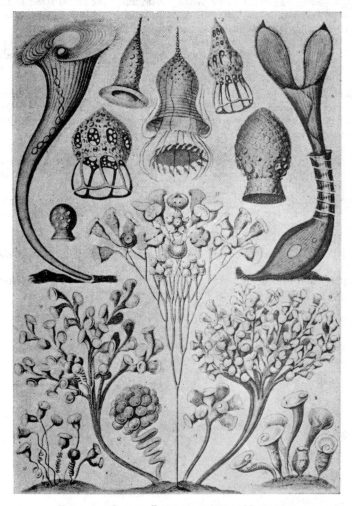

FIG. 274.—CILIATE PROTOZOA, HIGHLY MAGNIFIED.

From Haeckel's " Künstformen der Natur," to show various spiral formations found in Infusoria, especially in Stentor, Vorticella, and Carchesium.

of the vessels of the umbilical cord and of the canals of the cochlea are classical examples ; the ventricles of the heart provide another well-known instance with which the name of the late Professor Pettigrew is naturally associated—as indeed it must be with any inquiry into the significance of spiral formations. The spiral arrangement of the ducts of sweat glands, of the lines in certain types of finger-prints, and of

the muscular fibres in certain of the finer arterioles (a discovery made by Lord Lister while examining the vessels of the frog's web) are less known examples. The spiral arrangement of the great arteries springing from the heart (the form being reversed when the viscera are transposed), the spiral valve of the cystic duct, the spiral twist in the ribs and certain other bones are also dealt with. While in some cases the spiral arrangement gives a manifest mechanical or functional advantage, in other cases its significance is obscure or unknown. The writer in the *Field* has ransacked Nature's treasuries and brought together, from every kind of living things, the most striking examples where growth has developed in a spiral form. So many brilliant minds have fluttered in vain round the dazzling and fascinating problem of spirals that most inquirers, unless they are expert mathematicians, consign them to that lumber room of the mind where time and space and other limitless and unprofitable thoughts are buried. He however, has courage ; he does not pretend to have solved the problem of spirals in Nature. He simply sees in such formations that there is a deep problem, which if it could be solved would throw a light on many of the dark corners relating to our knowledge of the laws of growth and development. He has done biologists a service in bringing together the facts on which all endeavours to solve the biological significance of spiral formations and their relationship to growth and development must be based. We sincerely trust that these articles, which have been submitted in the first place to the readers of the *Field*, may be issued in book form, and be thus more accessible to biologists in particular and to that part of the general public which is interested in one of Nature's most fascinating puzzles."

CHAPTER XIV

RIGHT AND LEFT-HANDED MEN

" Ich stand am Thor ; ihr solltet schlüssel sein
　Zwar euer Bart ist Kraus, doch hebt ihr nicht die Riegel.
　　Geheiminssvoll am lichten Tag
　Lässt sich Natur des Schleiers nicht berauben."

RIGHT AND LEFT HANDEDNESS—LEGS AND ARMS OF BABIES—
LEONARDO DA VINCI—PREFERENCE OF ORIENTALS FOR
LEFT-HAND SPIRALS—PREHISTORIC MAN GENERALLY RIGHT-
HANDED—SKILL OF LEFT-HANDED MEN : EXAMPLES FROM
THE BIBLE—THE HAND OF TORQUES—THE RULE OF THE
ROAD—LEFT-HANDED SPORTSMEN : ANGLERS, ARCHERS, ETC.
—LEFT-HANDED ARTISTS—MORE ABOUT LEONARDO—LETTER
FROM MR. A. E. CRAWLEY.

In the last chapter an illustration was given (Fig. 262) of that arrangement of the heart which is found in rare cases where persons have their viscera transposed from right to left and *vice versâ*. This transposition of the heart has been suggested as one cause for a man being left handed, just as it has been thought that the predominance of one side of the brain accounts for the majority of persons being right handed. But without discussing whether cause and effect may not also be transposed in such arguments, we can make an easy transition from the anatomical spirals discussed in the last chapter to that curious anatomical development which makes us think it odd if we see a left-handed man, and orders all our lives on the theory that the majority of us must always be right handed. That it is a development, and not an innate property, has been fairly conclusively proved ; and it will be of interest to examine the question in order to see whether there be any special quality in right handedness or left handedness which may lead us to value one more highly than the other, or which may suggest a clue in our previous comparisons between right- and left-hand spirals ; and it is noteworthy that the sinistral spiral is proportionately just as rare in other divisions of Nature as left handedness is in human beings.

In the average right-handed man, the right humerus and radius taken together will be from $\frac{1}{3}$ inch to $\frac{3}{4}$ inch longer than the left. This is not so at birth, for, as Dr. Wherry has pointed

out, though a foal is born " leggy," the legs of the human baby
are actually as short as his arms until the former are pulled out
by walking exercise, and our legs are the same length because
we generally use them equally, without preference, in walking
or running ; whereas the induced and educated preference for
the right hand produces different lengths in our arms. Gorillas
and anthropoid apes, which do not enjoy the advantage of

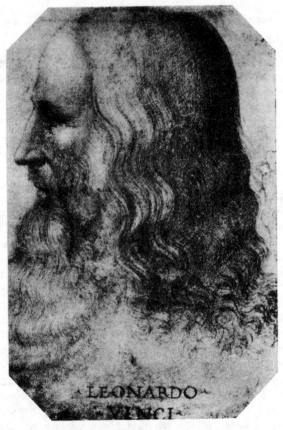

FIG. 275.—PORTRAIT OF THE ARTIST.

education, are naturally ambidextral, and do not develop one
arm at the expense of the other.

At the close of the second chapter we noted that a right-handed
man makes a left-hand flat spiral more easily than he can draw
a right-hand flat spiral ; and that a left-handed artist will put
in his strokes of shading from left to right ; in other words, he
will draw a left-hand cylindrical spiral more easily than he can
draw a right-hand one. It was also pointed out that, for the

same reasons, a left-handed fencer will probably be particularly quick with his *contre-carte* (a right-hand flat spiral), while the average right-handed fencer prefers the motion of *contre-sixte* (a left-hand flat spiral) as being more natural to him. It is worth noticing in this connection that when Londoners had an opportunity, in March, 1902, of seeing eight of the best fencers in the world, of whom four Italians were pitted against four Frenchmen, the pair who did best of all were the two famous French left handers, Louis Mérignac and Kirchhoffer. Indeed, instead of starting at a disadvantage, as is too often assumed, a left-handed artist seems often to have the advantage of his right-handed rivals, for he is usually ambidextrous by education, and probably possesses a high degree of congenital skill in the hand he prefers, as may be seen in the instance of Leonardo da Vinci, with whose drawings (Figs. 276, 277, 279—282) I have illustrated this chapter, or of Hans Holbein.

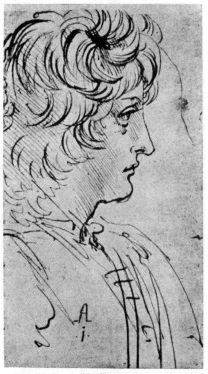

FIG. 276.—A SKETCH BY LEONARDO DA VINCI.

Dr. Wherry has pointed out that right handedness or left handedness sometimes leaves definitely traceable effects in the works of early or unskilled artists. In the archaic bust of an Apollo forty-seven curls out of sixty-one turned the way of the clock hands. In another statue, dating before the Persian war, the curls are arranged in right or left-hand spirals, according to the side of the head on which they grow, not as in Nature.

I have already quoted, from the same author, the instance of shavings. The shape of shavings at a carpenter's bench might furnish another Sherlock Holmes with the proof that his murderous mechanic was left handed ; for this he most probably was if the shavings exhibit a sinistral spiral. The innocent shaving of the right-handed carpenter would be dextral because he invariably drives his plane a little to the left ; and I have

also noted that Japanese and other Orientals seem to prefer a
left-hand spiral, just as they write from right to left, as may be
seen in many instances of their workmanship, such as the screws
of watches made in India, and other matters. In this country
screws are not changed from the usual right-hand spiral of the
penetrating corkscrew unless some special object is in view.
Two examples may be useful. The first is the coffin screw, that
fortunately rare variety, which only penetrates when you turn it
to the left. The other is the rifling in a Lee-Metford, which is
made to turn to the left in order to counteract the pull of the

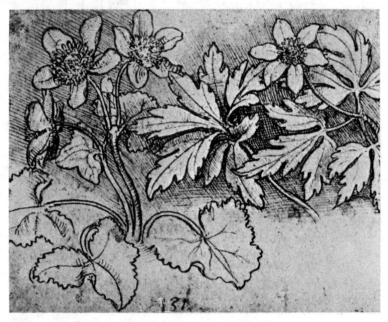

FIG. 277.—MARSH MARIGOLD AND WOOD ANEMONE.
(From a Drawing by Leonardo da Vinci.)

average right-handed soldier. It is curious that all left-hand
spirals look as if they were at almost double the pitch of the
corresponding right-hand spirals ; perhaps because they are less
familiar to the eye.

The investigations of the Anthropological Society in Washington
(May, 1879) go to show that, though left-handed workmen
existed in the Palæolithic Age, prehistoric man was as a rule
right handed, as we shall see when we come to the interesting
question of torques. The buttons of a man's dress, like the hooks
and eyes of our ladies' attire, are now expressly adapted to the
right hand. So are the adze, the plane, the gimlet, the cutting
end of the augur, the scythe, the fittings of a rifle, scissors,

snuffers, shears, and other mechanical tools which must be used by one hand or the other ; or, when used by several men at once, must be used by the same hand in each man. All this, however, will not prevent one who is naturally left handed from continuing his natural practice, though it is attended by great mechanical inconvenience in all the instances mentioned.

A man with only a slight bias towards his left hand will readily become ambidextrous owing to the many right-handed conventions and appliances which occur in everyday life. But the instinctively and strongly left handed will never change, and is usually distinguished for his skill, as Sir Daniel Wilson has pointed out in his interesting monograph on the subject. When Gideon discomfited the hosts of the Amalekites, the 700 Benjamites he selected for their superior skill in slinging were all left handed. Only the best, in fact, of the left-handed men can survive in the struggle against the vast majority of right-handed influences around them, and their skill will go on increasing, as may be seen in the case of left-handed fencers who have far more

FIG. 278.—SIGNATURE OF THE ARTIST, WRITTEN WITH HIS
RIGHT HAND.

opportunity of practising against right-handed men than we have of getting used to them.

The instances of left-handed men quoted in the Bible are worth noticing. In Judges iii. 15, we read how " the Lord raised them up a deliverer, Ehud, the son of Gera, a *Benjamite*, a man lefthanded." The chief value of this, in the incident which has made Ehud immortal, was that he was able to conceal his dagger beneath his raiment " upon his right thigh," where his enemy never suspected its presence, and the fatal stroke was therefore completely a surprise. The passage about the slingers, mentioned above, does not say that the 700 out of the 20,000 children of Benjamin were the only left-handed ones among them, but only emphasises the fact that these were the best slingers ; and no doubt others of them, like Ehud, preferred to use their left hands for their daggers ; and this brings the total up to a percentage which suggests that possibly a certain group of families were congenitally left handed. This theory may perhaps gain consistence from the coincidence that the left-handed men, of whom " every one could sling stones at an hair breadth and not

miss " (Judges xx. 16), " numbered seven hundred chosen men "
and the inhabitants of Gibeah are also described as " seven
hundred chosen men " in another verse. This is strengthened
by the passage in 1. Chronicles xii. 1—7, where it is recorded
that among those who came to help David were " Ahiezer, then
Joash, the sons of Shemaah the *Gibeathite*," of whom it is further
said that " among the mighty men, helpers of the war, they were
armed with bows, and could use both the right hand and the left
in hurling stones and shooting arrows out of a bow, even of
Saul's brethren of *Benjamin*." It is easy to see what an advantage
ambidexterity would be in early warfare, and several instances of
it are recorded in history ; while its benefits to prehistoric man,
in hurling stones or axes, must have been yet more remarkable.
Of course, in our age of " arms of precision " and of carefully-
drilled regiments, it is essential that all the men in line should
carry and manœuvre their rifles on the same side, and therefore,
by general custom, on the right side. For the same reason, all
scabbards were hung on the left side, or confusion would have
resulted when a closely-packed line drew their swords. I was
at first inclined to think that the persistence of the left-hand
twist in prehistoric Irish torques, as may be seen from examples
from Dublin, and in the British Museum, was due either to the
predominance of the usual Celtic left handedness in Ireland,
which is shown by the use of the light left-hand axe mentioned
by Giraldus Cambrensis, or to the fact that the most skilful
artificers were developed from left-handed men. But nothing
is so strange about spiral formations as the results of practical
experience, and I soon found that (as was described in my second
chapter) the flat ribbon of soft gold from which the earliest
torques are made would naturally become a left-hand spiral if
twisted by a right-handed man, for he would hold down one end
with his left hand, and would twist the other end outwards with
his right hand, with the result that the spiral of the twisted gold
would be left hand, as my readers have already proved to
their own satisfaction with a long piece of narrow paper. This
may account for the fact, that from the many torques I have
examined, all the gold examples were left hand, the only
right-hand spiral shown being a silver specimen in the Germania
Museum at Nuremberg, and another silver specimen now in the
Society of Antiquaries. The five-coiled armlet in the British
Museum exhibits the usual left-hand twist, but has the
additional charm of showing four distinct spirals, which has
resulted from the use of four flat ribbons of gold united, the
combined section being cruciform before the process of twisting
had begun. Examples of torques are given in my next chapter.

I have mentioned that in the case of twisting ribbons, or of
fencing, the natural movement of most men's right hand (when

FIG. 279.—A PAGE OF LEONARDO'S USUAL HANDWRITING.
From his Manuscript Note Book on the Flight of Birds.

This manuscript was transcribed by Giovanni Piumati and trans-
lated by Charles Ravaisson Mollien. It can be most easily read when
held before a mirror, as each line is written from right to left.
The first two lines are as follows : " Il predetto ucello sidebbe coll'
aiuto del vento levare ingrande alteza e cquesta sia la sicurta
perche . . " or in English, " The bird above mentioned should,
with the help of the wind, raise itself to a great height, and this
will be its safety because . . . "

it is at rest with the knuckles upwards) is to turn the wrist in
the direction away from the body until the knuckles are

underneath and the flat palm upwards. In driving, this
instinctive movement of the right hand on the reins would turn
a horse to the right when passing an obstacle in its way, and
most nations are content that this should be so, although the
coachman's seat is placed over the right wheel. The English,
however, have preserved the old habits of their riding days, when
all reins were held in the left hand to leave the sword arm free,
and the instinctive movement of the left hand, from the position
at rest with knuckles upwards, is to turn outwards until the
knuckles are beneath. This movement gives a twist to the rider's
reins which must turn his horse to the left, and the English still
drive, as well as ride, to the left ; they like to see where their
right wheel is going. This rule obtains in Portugal, Sweden,
Hungary, most of the cities of Italy, certain cantons of
Switzerland, and certain provinces of Austria ; and it is very
singular that the practice in this matter is so varied that in some
districts of a large country a notice has to be put up warning
strange drivers where the change occurs. There seems little
evidence to guide us in any inquiry as to why one district favours
one style more than the other ; and it will be interesting to see
which side will finally survive in those new rules for the traffic
of the air, which will certainly have to become more fixed and
universal than the old " rules of the road." The custom of
keeping to the right when walking seems already in danger in
London ; yet it is certainly older than any rule for driving past
vehicles in the street ; for it must be a survival of the days when
men carried weapons, and were therefore careful that their own
left arm was next the left arm of a passing stranger, who might
just possibly be an enemy ; and in those times the fighting arm
was the right arm, which held the sword or pistol at full length.
There may also be a further reason, handed down from a remoter
age, for the survival of passing to your right and lifting your hat
with the right hand. It gave the man you met an unobscured
view of your face. I imagine that confusion in this matter may
have arisen from two causes ; the first, that, when boxing
became prevalent and finally ousted duelling altogether, the left
arm became the aggressor ; the second and more pacific, that
when ladies took to walking about the street more than had
previously been their custom, they were generally " given the
wall " by their attendant swains, with the result that the side on
which men walked was largely regulated by reference to their
architectural surroundings. It is also noteworthy that the custom
of giving a lady your right arm arose out of the peaceful promenade
from the withdrawing-room to dinner. It is a custom that would
hardly have been general when a man had to be ready at any

moment to protect a woman in his charge with the strength of his sword-arm. (See Mr. A. E. Crawley's article on " The Rule of the Road " in the *Field* for February 3rd, 1912.) Such changes are very natural, if only as a reaction from the irksome necessities of warfare. Peace, deliberately perhaps, selected their exact opposites, to emphasise security.

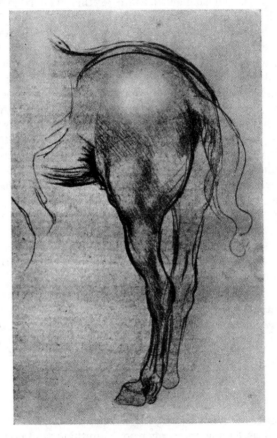

FIG. 280.—HIND QUARTERS OF ARAB HORSE.
(From a Drawing by Leonardo da Vinci.)

It would be a singular question to determine whether driving to the left was developed by ourselves or copied from another nation. In old days, before wheeled vehicles were common, the packhorse and the led horse always passed to the right, so that its leader might be between it and any passing traffic. Even when a waggon-team were led by the carter, the same custom prevailed, and this may have originated the right-hand driving of the United States, a country far more conservative of old

English habits and old English language than we are ourselves. It has been suggested that the change was only made in these islands when coaches became more common in the early seventeenth century. But this is one of the many small details that no writer seems to have chronicled, and we can but guess at possibilities. As a matter of fact, if the rule of the road in driving was indeed changed as late as this (which I doubt, for it must be far older), it was only made law, as we know it now, in 1835, when coaches and teams were driven faster than they had ever been, and when it was essential for a coachman to have his whip hand free if he was to control the leader on the offside. The width of most country roads (then and even to-day) was not much more than enough for two teams to pass each other, and it was therefore also necessary for the coachman to have full view of that side of his vehicle which might be endangered by collision. So he was practically obliged both to sit on the right and to drive to the left. When he had to pass another vehicle from behind, that vehicle, having been first in the position in which it was overtaken, was " given the road " and stayed there, while the overtaking coachman had to steer to the other side.

It may be of interest to consider a few notable examples of left-handed men who have distinguished themselves in various forms of sport. I will take angling, archery, billiards, bowls, cricket, croquet, fives, golf, lawn tennis, polo, and shooting as a fairly typical selection.

ANGLING.

Most capable anglers would be ambidextrous if they could, and George Selwyn Marryat might be quoted as the great instance of perfect mastery with either hand. In tournament work at the present day probably the most finished caster is Mr. David Campbell Muir, whose left hand is very nearly as good as his right.

ARCHERY.

There have been, or are, very few left-handed archers ; only two men, as far as I know, have ever done anything, and none of the ladies have ever shot well. Both of the men began as right-handed shots, and took to the left hand later. W. Butt on one occasion shot in one day one York Round with each hand with the following result :

100 yards.		80 yards.		60 yards.		Total.	
Hits.	Scr.	Hits.	Scr.	Hits.	Scr.	Hits.	Scr.
34	134 ...	28	122 ...	21	105 ...	83	361 right handed.
16	68 ...	23	77 ...	21	95 ...	60	240 left handed.

His best rounds were :—

Feb. 8, 1864	48	216 ...	42	172 ...	23	113 ...	113	501 right handed.	
May 30, 1867	44	206 ...	36	154 ...	24	138 ...	104	498 left handed.	

He never shot anything like so well at any public meeting, his best position at the Grand National having been seventh in 1870, with 152 hits, 726 score (two days). The late G. L. Aston's best score at a public meeting was at the Grand Western in 1864, 190, 838 (two days), right handed. In 1876 he made 176, 740 (two days), left handed. His best place at the Grand National was sixth in 1893, with 155, 669, and he was seventh the next year with 162, 688.

BILLIARDS.

The list of left-handed players who have distinguished themselves at billiards is a remarkably small one. More than half a century ago Mr. Bachelor was generally acknowledged to be about the finest pyramid player of his day, whilst in the seventies, T. Morris and F. Symes were well known professional players, though neither ever attained a position even in the second class. The only really great left-handed player we have ever had was Hugh McNeil. His " touch " was superb, and there is little doubt that it lay with himself to become champion. Unhappily, however, he could never be induced to take the smallest care of himself, and he died November 27th, 1897, at the early age of thirty-two. The only left-handed amateur player of note that I can call to mind in the last forty years is Mr. W. Edgar Thomas, amateur champion of Wales.

BOWLS.

Several of the most accomplished players at the game of bowls are left handed. The following instances are well authenticated :—

1. Andrew H. Hamilton, S.S.C., of Lutton Place B.C., Edinburgh, has represented Scotland in the International matches, has won the championship of his club six times, and was twice champion of Edinburgh and Leith. He is the secretary of the Scottish Bowling Association.

2. C. F. Dunlop, of Wellcroft B.C., Glasgow, played for Scotland in 1910, and has won the famous Moffat Tournament and the championships of the Wellcroft and Stepps Clubs.

3. Andrew Paterson, of Cathcart B.C., Glasgow—now over eighty—is one of the best players Glasgow ever had.

4. James Christie, of Queen's Park B.C. Glasgow, skipped the rink which won the Scottish Championship in 1902.

5. J. W. Clelland, of Larkhall B.C., one of the best players in Lanarkshire, played for Scotland in 1911.

6. James Fleming, of Ardmillan B.C., Edinburgh, has been champion of his club, and skipped the rink which won the Edinburgh Championship.

7. Richard W. Milne, President of Lockerbie B.C., in 1910, was runner-up in the Lochmaben Open Tournament in 1910.

8. E. Lloyd, hon. secretary of the Welsh Bowling Association (of which the Earl of Plymouth is President), of the Cardiff B.C., has played for Wales in several matches (International).

9. Dr. C. Coventry, of Dinas Powis B.C., played for Wales in the International match in 1912.

10. D. Wilkinson, of Dinas Powis B.C., has played for Wales in several Internationals, and was captain of the team in 1911. (Mr. Wilkinson has lost his right arm, and is an example of acquired left handedness).

11. A. Hutchins, of Penhill B.C., played for Wales in the International match of 1911.

12. W. A. Cole, of the Macintosh B.C., Cardiff, has repeatedly played for Wales in the Internationals.

13. T. P. Edmunds, of Cardiff B.C., is a regular skip in his club's matches.

14. John McCann, of Ormeau B.C., Belfast, has played for Ireland in the International matches.

15. Joseph A. McClune, of Ormeau B.C., Belfast, reached the semi-final in the Irish Single-handed Championship in 1909. He and Mr. John McCann (No. 14), when members of the Ormeau United B.C., which won every match it played during the two years of its existence, were respectively third man and skip of the rink that played unchanged through the nine matches.

16. Franc Brown, of Belfast B.C., has played for Ireland in the Internationals, was second in the Belfast quartette that won the Irish Rink Championship in 1909, and is a deadly player on the back hand.

17. John A. McClune, of Ulster B.C., Belfast (brother of No. 15), is a very successful skip of his club, and a winner of several single-handed championships.

18. David E. Henning, of Shaftesbury B.C., Belfast, formerly a fine cricketer, is one of the best skips of his club.

19. Dr. J. W. Taylor, of Belfast B.C., once one of the best rugby forwards in the kingdom and a capital bat, has represented Ireland, though a comparative novice at bowls, in the Internationals.

20. B. D. Godlonton, of Streatham Constitutional and Dulwich Bowling Clubs, has played for England in the Internationals, and was formerly a member of the Sussex county cricket eleven.

21. H. E. Freeland, of the Mansfield B.C., London, was champion of his club in 1909, defeating D. Rice Thomas, hon. secretary of the London and Southern Counties B.A., who had

previously beaten Henry Stubbs, now of Herne Hill B.C., the last two well known single-handed players.

22. W. E. Warran, of the Brownswood B.C., London, president of his club in 1910, and in 1912 its hon. secretary, is an example of ambidexterity. When playing the forehand he employs his right, and when playing the backhand his left hand, using both with equal skill. He is a successful skip in his club, and in 1909 skipped the rink that made the highest score on the winning side in the annual encounter between the London and Southern Counties B.A. and the Midland Counties B.A. His method of play is unique.

CRICKET.

In first-class cricket left-handed bowlers play a conspicuous part. A county eleven is not considered to be well equipped without one. The break-back, which is more easily acquired than the opposite break, is formidable from a left-handed bowler, because it produces catches on the offside. Hence the majority of these bowlers are of slow or medium pace, and are deadly on slow wickets. Occasionally a fast bowler possesses a strong natural break of this kind ; for instance the late Fred Morley and Hirst. Young, the Essex bowler, breaks chiefly in the opposite direction. Recently swim bowling has been cultivated by left- as well as right-hand bowlers ; for instance, Hirst. Dean, of Lancashire, has two styles, the slow break-back and the faster swim. Batsmen are less common than bowlers. Batting is *taught*, and the use of the right hand has been encouraged, perhaps from the idea that left-handed batting is awkward in style, or *gauche*. It is difficult to repress this idea, but to a great extent it is probably illusory and subjective. A right-handed action, *e.g.*, shaving, appears *gauche* when seen in a mirror. Such batsmen as Bardsley and Clement Hill seem graceful in spite of left-handedness, and the addition of Ransford makes the best Australian eleven remarkable for its left-handed talent. Nourse, of South Africa, is another prominent colonial instance. But left-handed bowlers have commonly a delightful freedom of action and appearance of naturalness. Owing to the reason above suggested—that batting is the product of teaching—instances of left-handed bowling combined with right-handed batting are common, especially among amateurs, as in the case of Mr. F. R. Foster. Instances of left-handed batting with right-handed bowling are not very rare. The best example is Mr. C. L. Townsend. It is so advantageous to bowl with the left hand, that it seems strange that a player who is ambidextrous enough to bat left handed and bowl right does not prefer to cultivate the left hand for both purposes. Left-handed batsmen are now much

sought after. It is recognised that they have different strokes from right-handers, and cause trouble to certain bowlers. They can, of course, cope better with the right-handed bowler, who relies on what to right-handed batsmen would be a leg break, and they make them bowl on the unaccustomed side of the wicket —though this change of side (fashionable as it is) is not certainly good policy. Further a left-handed batsman when associated with a right-handed causes frequent changes in the field, and so makes the game slow. This is not only valuable when time has to be killed, but also when it is desirable to stop a " rot." The victorious M.C.C. team in Australia had three left-handed batsmen and four left-handed bowlers. Ambidexterity is not unknown. A well-known club cricketer, Mr. P. Northcote, is said to have made 100 runs batting right, and then another 100 left in an innings. I have some remembrance that a University bowler, E. Bray (*circ.* 1870), bowled alternately with either hand. A schoolmaster at Ewell about 1880 habitually bowled lobs with his left, and for a change fast round right. Ambidextrous throwing in, though extremely valuable, is very seldom cultivated. Edmund Hinkly (Kent) took all ten wickets with his left-handed bowling in an innings against England at Lord's in 1848. Jim Lillywhite (Sussex), Peate and Peel (Yorkshire), Fred Morley and J. C. Shaw (Notts) may also be quoted as famous left-handed bowlers. Kent produced another first-rate left hander in Edgar Willsher, and George Wootton (Notts) may be cited as another instance of first-rate ability in the past. Among examples of the best left-handed batsmen of the old days may be cited Mr. Richard Newland, who captained England against Kent on the Artillery Ground at Finsbury in 1744 ; Mr. N. Felix and Mr. Richard Mills of Kent, ; James Saunders, R. Robinson, John Bowyer, and George Griffith, all of Surrey ; Richard and John Nyren, Tom Sueter, Noah Mann and " Lumpy " Stevens (who bowled left and batted right), all from Hambledon ; Noah Mann also played for Sussex, as did the Mr. Newland mentioned above, John Hammond, Mr. E. Napper, and Mr. W. Napper ; B. Good (Notts) ; W. Searle ; T. Marsden (Sheffield) ; and James Aylward (Hants), the first man to make a hundred after the third stump had been added to the wicket.

A list of modern left-handed players, for the sake of contrast, would contain many well-known names. They may perhaps be classified as follows : Left-handed bowlers may be represented by Mr. F. R. Foster, Dean, Woolley, and Rhodes, all in the English eleven for 1912, Hirst, Blythe, C. P. Mead, and Tarrant. The first and third are also good left-handed batsmen. Rhodes, Hirst, and Tarrant bat right handed. In the Australian eleven

for the same year, Mr. W. J. Whitty and Mr. C. G. Macartney are both left-handed bowlers, but the latter is a first-rate right-handed batsman. In the South African eleven (to complete the " triangular " contrast), G. C. Llewellyn bowls and bats left-handed. Mr. A. D. Nourse is first rate in both bowling and batting left hand, and Mr. Carter bowls left handed. Among famous left-handed batsmen who bowl right handed, Mr. C. L. Townsend, of Gloucestershire, is the best example, and Killick, of Sussex, is another. Other good left-handed batsmen will occur to the memory, such as Mr. H. T. Hewett, Somerset ; Mr. F. G. J. Ford, Middlesex ; Mr. J. Darling, Australia ; Scotton, Notts, and others.

CROQUET.

In croquet there are but few first-class left-handed players, and the only ones I can think of are Mr. R. C. J. Beaton (— 1½) Mr. H. Maxwell Browne (— 1½), who plays his croquet and roll strokes with a left-handed stance. He runs his hoops and shoots in the Corbally style, *i.e.*, with his mallet between his legs, but as his left hand is nearer the head of the mallet, I consider he may be fairly classed as a left-handed player ; Mr. W. H. Fordham (o) ; Mrs. H. M. Weir (1½) ; and Mrs. W. Whitaker (1½). Other left-handed players, whose class is difficult to determine, are Miss M. Gower (4) and Mr. R. P. M. Gower (6), the sister and brother of Mrs. R. C. J. Beaton.

FIVES.

One of the best fives players I ever saw was left-handed : H. R. Bromley Davenport, Keeper of the Fives Courts at Eton in 1888. He thus had a great advantage, as it enabled him to hit harder and much more freely than right-handed players at a ball coming over the buttress, which is on the left side of an Eton fives court.

GOLF.

Few left-handed golfers have achieved real eminence. There has been no professional who, in the words of the old story, has " stood on the wrong side of his ba' " and won competitions nevertheless. Among amateurs Mr. Bruce Pearce, the young Tasmanian who made so favourable an impression on opponents and spectators recently, is as good as any other, with the possible exception of Mr. H. E. Reade, of Portrush. This gentleman ought to have put Mr. Travis out of the 1904 championship. On the fourteenth green from home he stood two up, but allowed his opponent to win all the remaining holes without doing anything extraordinary. Mr. Peter Jannon, another Irishman, has won countless championships on the Continent, and Mr. J. A. Healing,

the old Gloucestershire cricketer is distinctly a good player. When Harry Vardon was engaged at Ganton, his members got rather tired of being beaten by him, though in receipt of extravagant odds. He made a futile attempt to relieve the monotony of the results by playing left-handed from a handicap of scratch. It was soon decided that he ought to owe two as a left hander. There seems here to be some connection between left handedness and Celtic blood, as we have observed before ; for the chief market for left-hand clubs is said to be in the extreme north of Scotland, where right-handed players are reported to be in the minority.

LAWN TENNIS.

An interesting list of left-handed players in lawn tennis may be compiled ; and a few typical instances would be the following : Dwight F. Davis (America)—doubles champion of America (1899–1901) ; his smashing overhead was remarkably severe, probably harder than any player in the world. Beals C. Wright (America)—singles champion of America, 1905 ; doubles champion of America, 1904–1906 ; represented America in Davis Cup matches in America, England, and Australia ; like Dwight Davis severe overhead ; exponent of chop stroke ; eminently sound, low volleyer. Norman E. Brookes (Australia)—singles champion of the world, 1907 ; winner of all comer's singles at Wimbledon, 1905 ; doubles champion (with Wilding), 1907 ; represented Australasia in Davis Cup matches in England and Australia ; the deadly power of his break service is well known ; relatively weak overhead ; plays his back-hand volleys with the finger tips towards the net, *i.e.*, contrary to the usual English custom. The late Herbert Chipp (England) was well known in the eighties as a contemporary of the Renshaws. He had no orthodox back-hand stroke, but would quickly change his racket and drive nearly as hard with his right hand as with his left, as did Miss Maud Shackle, champion of Kent (1891–3) ; a sound base-liner, who could generally pass the most nimble volleyer. Kenneth Powell (England)—a recent captain of Cambridge six ; his promise of some years ago has scarcely been fulfilled ; essentially a volleyer who draws on his powers as a track athlete (he made the hurdles record [15 3-5 seconds] for Cambridge *v.* Oxford, 1907) to secure a winning position at the net. The late F. W. Payn (England)—champion of Scotland, 1903 ; another left hander who was essentially a volleyer. As a rule, left-handed players have developed one or two strokes more than others, and are not remarkable for their all-round capacity. Generally speaking, as in the case of Brookes, Beals Wright and Dwight Davis, they are stronger on the volley than off the ground.

A. E. Beamish (English International) is right handed at lawn tennis, and left handed (handicap 6) at golf. It may be added here that Mr. E. B. Noel won the rackets championship with left-hand play.

POLO.

The following left-handed polo players have been officially registered at Hurlingham, and may therefore be taken as good instances of the particular play for which we are looking : J. S. Bakewell, Lieut. R. C. Bayldon, R.N., H. A. Bellville, T. A. Driscoll, F. J. Grace, A. Grisar, W. P. Gwynne, L. R. S. Holway, L. Larios, G. A. Lockett, J. McConnell, Bradley Martin, jun., Baron Osy de Zegwaart, E. A. Sanderson, H. Scott Robson, Capt. A. Seymour, P. D. Sullivan, R. Wade-Palmer, W. Craig Wadsworth, Watson Webb, and Major F. H. Wise.

SHOOTING.

Mr. Harting tells me that he has known several left-handed shooters, some of them good shots, but only one who could shoot equally well from either shoulder. That was the late Sir Victor Brooke. Shooting one day in 1885, in his own park at Colebrook, co. Fermanagh, he killed 740 rabbits to his own gun. He fired exactly 1,000 cartridges, and shot from his right shoulder for one half of the day and from his left the other half. The last shot, from the left shoulder, killed a woodcock going back.

LEFT-HANDED ARTISTS.

I have mentioned, in the first part of this chapter, the names of two left-handed artists. Sir Edwin Landseer is a well-known example of a man who could not only use either hand equally skilfully, but could also use both at once on different subjects ; and this suggests that by limiting our activities to one hand we really lose a great deal that might profitably be learnt. Whether the use of both hands would also have some kind of reflex result, beneficial to the brain, is a question outside our present inquiry. It is, however, remarkable that the greatest left-handed genius ever known was not merely one of the most skilful artists, but also one of the most extraordinarily gifted intellects the world has ever seen ; and it is for this reason that I have chosen to illustrate this chapter entirely with the drawings of Leonardo da Vinci.

From the technical point of view of our immediate discussion, these drawings show that, evidently from natural preference, the lines of the shading nearly always fall from left to right (see Figs. 276, 277, etc.). The signature from the Windsor manuscripts (Fig. 278) is so uncertainly framed because it has been done with his right hand. The natural handwriting shown in Fig. 279

is not only far more clear and erect, but has the further peculiarity of reading from right to left (like Hebrew) so that it has to be held before a mirror in order to be quickly deciphered.

Though less than a dozen undisputed examples of Leonardo's paintings exist, it is chiefly as a painter that he is known to general fame. The bulk of his sketches and manuscripts in this country exceeds by many times the whole of those possessed by other nations, yet the value and contents of these do not seem to be so well appreciated in England as they are elsewhere. They have been investigated by Venturi, Libri, Govi, Richter, Ravaisson-Mollien, Beltrami, Müntz, Müller-Walde, Uzielli, Sabachnikoff, Piumati, Duval, Séailles, and the editors of the facsimile edition of the Milan manuscripts, to name no more. Apart from the actual drawings and studies they contain, these manuscripts are very much like the notes that might be made by an exceptional professor for a course of very extraordinary lectures. They display a gift of literary expression and construction which lags very far behind the ardour for discovery that inspired them. For this reason their writer remained almost unheard by his contemporaries, and is scarcely yet appreciated by his posterity. His arguments are not presented in that logical form which helps a reader to understand their drift. His discussion of the connection between the scriptural Deluge and the fossil shells found upon a mountain top is one of the few cases in which the literary form of the inquiry is complete. It is therefore only natural that the isolation of his own intellectual life should have been almost reproduced in the comparative neglect of his manuscripts in later years. It was one of his favourite sayings that the strength of the painter was in solitude : " *Se tu sarai solo, tu sarai tutto tuo.*"

Another drawback is the material one of the difficulty in deciphering his writing. Whether it be true or not that it was owing to travels in the East that he took to writing from right to left, it is certain that he largely employed a caligraphy which can best be read in a mirror (see Fig. 279), and which was also an easy accomplishment for a left-handed man. A landscape drawing in the Uffizi—the authenticity of which has never been called in question—is dated " The day of S. Mary of the Snow, the 5th day of August, 1473," when Leonardo was just twenty-one ; and Mr. M'Curdy has pointed out that this inscription shows Leonardo had already adopted the method of writing from right to left ; so that I prefer the theory that this was the natural method of the left-handed man, rather than the acquired result of any possible travels in the East. If the shading of his drawings had not revealed the peculiarity, we should have

known that Leonardo was left handed from the statement of his friend Fra Luca Pacioli, for whose book, " De Divina Proportione," he designed the figures.

These are some of the reasons why the secrets of a man who

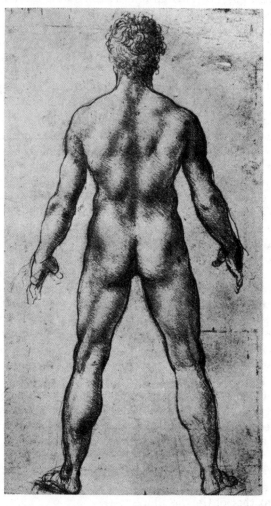

FIG. 281.—DRAWING BY LEONARDO DA VINCI.

spent the last years of his life in exile at the beginning of the sixteenth century remained his own until the last years of the nineteenth. Yet his fame is only strengthened by that long oblivion. For the laws which he established or divined have been independently discovered and proved as advancing knowledge made researches easier ; and the reputation of his

successors remains untarnished, for, though their discoveries must now be antedated by three or four centuries, they made them in their turn while Leonardo's manuscripts were still unknown. A sower of ideas of which he never saw the harvest, he jealously guarded them from intrusion during his lifetime, and they never came to light till long after his death.

Before me as I write are some 500 careful photographs of the originals existing in England, to which it may be hoped that a fuller justice will some day be done than I can now find to be the case. Though it was necessary to examine all of them, only a very small fraction bore upon the special subject of this work, and only a very few examples have been chosen out of these to indicate the kind of material available (see Figs. 280, etc.), and to produce the barest essentials in the progress of our argument. I have also examined the MSS. in Paris, Venice, Vienna, and Milan, where the numbering of the great " Codice Atlantico " has been corrected by the Abbé Ceriani, and the whole is being reproduced at the cost of the State. They embrace drawings of landscape and figures, which are evidently studies for pictures ; anatomical drawings of great beauty and skill (Fig. 282) ; botanical sketches (Fig. 277) ; architectural plans, biological notes, numerous engineering problems, many mathematical inquiries, the whole dashed down without much order in a very fervour of investigation. Though many pages that have survived cannot, under any hypothesis, be considered as prepared for publication, there is some evidence in others that Leonardo not only wrote for a public, but was conscious of his literary short-comings. " Blame me not, O reader," he says, for instance, in one notebook, " for the subjects are numberless, and my memory is weak, and I write at long intervals. . . ."

Carrying as he did, in that brain which bore so many images of beauty, not only all the science known at the beginning of the sixteenth century, but almost half of the attainments that the years since then have brought us, Leonardo lived of necessity a lonely life ; and with advancing years it is known that his thoughts turned more and more from painting to problems of natural science, and to vast collections of natural objects. His quest was that of Goethe's Faust :—

> " Das ich erkenne, was die Welt
> Im innersten zusammenhält.
> Schau' alle Wirkenskraft und Samen
> Und thu nicht mehr in Worten Kramen."

It was characteristic of his genius that the patent phenomena of life did not content him. He insisted on going deeper. " Ma

tu che vivi di sogni," he writes in the " Treatise on Flying "
(Fig. 279), " *ti piace piu le ragion soffistiche e barerie de palari
nelle cose grande e incerte, che delle certe, naturali, e non di tanti
altura."* His intellect was as sincere as it was sagacious. He
penetrated the secret hiding-places of truth with a passionate
industry that never shrank from toil. " Truth," he cries, " is
so excellent that by her praise the very
smallest things attain nobility." His
method was that of Darwin, proceed-
ing by an analysis which does not fear
to be diffuse ; grouping isolated pieces
of evidence, attaining at last a final
law, or at least a hypothesis that
would explain the facts. His anatomi-
cal drawings, apart from their exquisite
draughtsmanship, contain so many keen
parallels and suggestive indications that
the author of the " Origin of Species "
would have perused them with delight.
In the manuscripts at Windsor, for
example, there are careful drawings to
show that the tail in other animals
existed in a modified form in man.
Huxley's manuscript memoranda are,
I am informed, full of delicate drawings,
and in other ways somewhat similar
to those of Leonardo. It is perhaps
a loss both to science and to art that
the majority of Leonardo's manuscripts
do not seem to have been known, as
far as we are aware, either to Darwin
or to Ruskin.

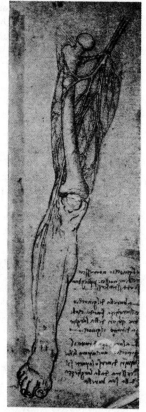

 He understood to the full the defini-
tion of science as " the knowledge of
causes "—Τότε ἐπιστάμεθα ὅταν τὴν αἰτίαν
εἰδωμεν. He realised even more keenly
the necessity that science should be

FIG.282.—ANATOMICAL STUDY
BY LEONARDO DA VINCI.
Note the handwriting in one
corner.

largely occupied with speculations, with hypotheses, with imagina-
tions, with what Müller in 1834 called " Phantasie." Nature
must be interrogated in such a manner that the answer is
implicit in the question. The observer can only observe when
his search is guided by the thread of a hypothesis. I have said
that it was the thread of spiral formations which has guided
these chapters. It was (let me repeat) the manuscripts of
Leonardo which inspired them.

NOTES TO CHAPTER XIV.

RIGHT AND LEFT HAND.—" In chapter five of the fourth book of his ' Enquiries into Vulgar and Common Errors ' (third edition, 1658) Sir Thomas Brown has much to say ' of the right and left hand.' He mentions the remedies of ' the left eye of an hedgehog fried in oyl to procure sleep, and the right foot of a frog in a deer's skin for the gout,' and, further, that ' good things do pass sinistrously upon us, because the left hand of man respected the right hand of the gods which handed their favours unto us.' But his most permanently valuable observation is that the words ' right ' and ' left ' are purely human conventions, which may enable men and women to give intelligible directions to their comrades, but which have no reality in nature, any more than there is any certainty that the right hand of a particular man will be stronger and more skilful than his left. For some men use their left hand as most men use their right.

<div align="right">" B. T."</div>

SURVIVAL OF LEFT-HANDED MEN.—See " Ambidexterity," by John Jackson (1905).

LEFT-HANDED MEN IN THE BIBLE.—" F. M. M." wrote :—

" It is singular, and perhaps not easy to explain, that in the Hebrew of Judges iii. and xx., both Ehud and the 700 slingers are described as ' shut (bound or hindered) of the right hand ' ; but in the Greek version, the Septuagint, both the one and the other are called ' ambidexterous,' a meaning which it seems difficult to get from the original."

LEONARDO'S NOTEBOOK on the " Flight of Birds " was written by Leonardo da Vinci at Florence in March and April, 1505, and left by him in 1519 to Francesco Melzi, who died in 1570. From Melzi's Villa of Vaprio it was stolen by Lelio Gavardi, and finally given by Horace Melzi to Ambrosio Mazzenta of Milan. From him it passed to Pompee Leoni, friend to Philip II. of Spain, and by his heir was sold to Galeazze Arconati, who gave it, on January 21st, 1637, to the Ambrosian Library in Milan, where its existence is recorded by Balthasar Oltrocchi between 1748 and 1797, and by Bonsignori in 1791. All thirteen MSS. of Leonardo were sent to Paris by Napoleon in 1796, the Codex Atlanticus to the Bibliothèque Nationale, the twelve others to the Institut de France. In 1815 the Codex Atlanticus went back to Milan, the rest remaining (by error) at the Institut, where the existence of this treatise on flight is noted by the sub-librarian in 1836. From there it was stolen by Jacques Libri, as Lalannes and Bordier noted in 1848, and was seen in Florence by Count J. Manzoni de Lugo in 1867, who bought it at Libri's death in 1868, and died himself in 1889. In 1892 it was bought by Theodore Sabachnikoff, and published in Paris in 1893.

" DAS ICH ERKENNE."—

> " O for a glance into the earth !
> To see below its dark foundations
> Life's embryo seeds before their birth. . . ."
> <div align="right">(Goethe's " Faustus," trans. by JOHN ANSTER.)</div>

" MA TU CHE VIVI."—" But thou who livest in dreams art more pleased even with the sophistical reasonings and theories of philanderers

when they deal with great and unknown matters, than with researches into things certain, natural, and of a lower interest."

"TRUTH IS SO EXCELLENT."—The passage begins as follows : " Ed è di tanto vilipendio la bugia, che s'ella dicessi be'gran cose di dio, ella to' di grazia a sua deità ; ed è di tanta eccellenzia la verità. . . ."

PHANTASIE.—" Die Phantasie ist ein unentbehrliches Gut ; denn sie ist es, durch welche neue Combinationen zur Veranlassung wichtiger Entdeckungen gemacht werden. Die Kraft der Unterscheidung des isolirenden Verstandes, sowohl als die der erweiternden und zum Allgemeinen strebenden Phantasie sind dem Naturforscher in einem harmonischen Wechselwirken nothwendig. Durch Störung dieses Gleichgewichts wird der Naturforscher von der Phantasie zu Träumereien hingerissen, während diese Gabe den talentvollen Naturforscher von hinreichender Verstandesstärke zu ˙den wichtigsten Entdeckungen führt."—JOH. MÜLLER, *Arch. für Anat.*, 1834.

RIGHT AND LEFT.—A letter from Mr. A. E. Crawley :—

" Of all the simple opposites in the world none seem so simple as right and left. There is no difficulty when the terms apply to mere position or to straight lines. Trouble begins, both for understanding and for language, as soon as they apply to curvilinear or circular motion. This is likely to be the experience of anyone who studies spiral forms in plant or animal structures, or the swerve of balls, or rotation of any object, or even one who has been led to meditate on rules of the road by the recent conclusion of the authorities in Paris that the English ' Keep to the left ' is better than the French ' Keep to the right.' The matter is simple enough when a bowler describes a ball as breaking from the left or off, and the batsman describes the same as from the right or off. But a projectile, whose swerve is in a plane horizontal enough to admit the terms right and left, may start its journey to the left without our knowing from the description whether the curve continues to the left or to the right. ' Curving out to the left and in to the right ' would sufficiently explain the second case. But ambiguity is often experienced, and it is necessary first to define the *terminus a quo* and the *terminus ad quem.* For both Greeks and Romans the right was the lucky quarter for the appearance of omens, but the augurs of the one people faced north, those of the other faced south, the respective lucky quarters being thus diametrically opposite. It is said that the Hebrew ' augur,' if the term may be applied, faced east. But the result was carried farther than by the Greeks and Romans ; for the Hebrew the right-hand side and the south were identical, his front was east, his left-hand side was north, behind him was the west. Sanskrit, Old Irish (in the component of *deasil,* deas), and other Indo-European languages identify right and south. There would already in the days of ' seeing ' have been confusion of tongues and crossing of purposes, when right and left were synonymous with points of the compass.

" The philology of the terms for right and left is curiously interesting, but extraneous to the present subject. Yet it is in point to observe that, as with right handedness itself, so with the terms for this pair of opposites, efficiency and convenience were first regarded long before two sidedness. Carlyle put social solidarity in a right-handed nut-

shell when he invited his readers to consider what would happen if three mowers with the scythe, two being right handed and one left handed, were to try co-operation. It is curious that the name of the Hebrew tribe which supplied a corps of left-handed slingers is Ben-Jamin, ' the son of the *right* hand.' Probably in every language, as in English, ' right ' originally signified merely ' straight,' ' straight-forward,' and thus ' normal.' ' Left ' at first was *no opposite to ' right,'* but meant ' weak,' 'inefficient.' We thus get the invention of the terms prior to the idea of bilaterality. ' Eyes right,' the ' right road,' ' right satin,' and so forth, are relics of the original meaning. ' Left ' gradually acquired its function of an opposite along lines corresponding rather to ' reverse,' ' abnormal,' than to bilaterality, as in the phrase ' over the left,' which in folk custom cancels or reverses the meaning of the spoken word. Putting this in another way, one has only to remember the real meaning of ' right way on,' ' right side up,' and to compare the imaginary case of a left-handed people, who, of course, would apply the word ' left ' and its series of connotations to phenomena which for us are ' right.'

" The only original pair of opposites in ' English,' and the fact is instructive, is *deasil* and *widdershins*, sunwise and counter-sunwise. The industrious folklorist is too apt to explain their origin by superstition. Superstition (as even etymology shows) *supervenes ;* reality and the expression of reality are behind it. It is surprising enough that early thought· and language should have hit upon two terms which still render, better than any others, the bilateral aspects of curvilinear statics and dynamics.

" The reversal of mere right and left is visualised daily in mirror images (in the literal sense). In your remarkable articles on principles of growth and beauty you note and illustrate Leonardo da Vinci's left-hand writing. Children in the pre-pubertal period rarely show a natural predominance of the right hand, and when teaching themselves to write frequently practise both hands, with results equivalent to those shown by Leonardo. A curious central moment between ' left-hand ' languages like Hebrew, written from right to left, and the modern ' right handed,' is the sporadic Greek method, known as βυνστροφηδόν, one line being written from right to left, and the next from left to right, saving the process of transferring the pen to the other side of the paper, but originally necessitating a change of hand, and probably of pen, for pens, like old English nail scissors, when cut sloping, are left handed and right handed.

" In ' Alice through the Looking Glass ' Lewis Carroll denied himself the opportunity (congenial enough to the author of ' right anger,' ' acute and obtuse anger,' and other Euclidean absurdities of reduction) of developing the results of reversal. In his ' Plattner Story ' Mr. H. G. Wells connects the main idea, viz., that the right side of an object is the ' mirror image ' of the left, with atomic disintegration as the means, and the fourth dimension of space as the result. The hero on his return to this, our three-dimensional sphere, was observed to have his heart on the right side and his liver on the left, and to have become not ambidexterous, but left handed.

"A simple experiment showing the simplest result of a twist in space is probably familiar to many of my readers. Take a ribbon of paper

long enough to make, when the ends are joined, a conveniently sized circle. Make one twist in it, and then join the ends with gum. Divide it lengthwise with the help of a pair of scissors. Before division you may trace a pencil line along it, and find that the line ends on the ' side ' opposite to that whence it began. After division you will find one ring with twice the circumferential size of the original, and with a double twist. Split this as before, and two rings interlaced are the result. The experiment is usually the ' first aid ' applied to those who are commencing the study of the fourth dimension. Mr. Wells, by the way, suggests that time, duration, is the fourth dimension of objects ; but inasmuch as the first essential of an additional plane is that it should be at right angles to the other three, why not regard the reflection of an object in a mirror as its fourth dimension ?

" But paradox easily becomes absurdity. An interesting detail is the useful convention by which right and left, in reference to the position of objects on a stage or in a picture, are taken *as from the spectator*. Here we approach the fundamental idea of right and left. In the first place, mutual understanding of their application depends on an agreement as to the *terminus a quo*. My right is your left when we face one another ; when we face the same way it is your right. A second point now comes in, viz., that right and left involve, not merely bilaterality, but *dorsi-ventrality, fore-and-aftness*. They have no meaning unless the objects concerned possess an obverse and a reverse, a front and a rear. We thus come back to the four quarters of the compass. But so far we have not got beyond the horizontal plane ; we are still dealing with objects that might be without height and depth, abstractly flat. We must therefore add a third dimension, and postulate ' length,' with its corollary of top and bottom. It will be seen that polarity is a fundamental principle of our conceptions of reality in general, no less than of our conception of this planet. Sir Thomas Browne had the notion of a dextrality inherent in ' the heavens.' It may be suggested that the tendency to postulate the possibility or necessity of a fourth dimension really depends on the facts of verticality and of bilaterality. For right and left necessitate an ' upright ' standard and a point of view which is perpendicular, at right angles, to it.

" The terminology of spirals, both flat and helical, if the latter term may be used to designate conical and cylindrical and other ' developing ' spirals, is an interesting illustration of the difficulties of right and left. Here the difficulty is increased by the introduction of angular motion ; we have, as it were, to square circles.

" The obvious way of describing a helix is to call it right handed or left handed from the point of view of the spectator, who is perpendicular to its long axis. This axis in a spiral staircase is the newel, and the spectator is not in or on the staircase. His view creates two sides of the spiral, that which is obverse to his view and that which is reverse ; the former alone counts. If the obverse curves rise from his left to his right, the spiral is right hand. Quite correctly common use refuses to apply here the convention as regards pictures. It would also be well if, as you desiderate, spirals produced by a right-handed work-man were never described as right hand for that reason only. Of course, it happens that a right-hand screw is also a spiral which is

best suited to right-handed action. But it is said that the Japanese prefer screws which involve the counter-rotation of the hand.

" The common sense method of describing spiral direction is quite satisfactory, so long as the spiral has a top and bottom. In helical shells, twining plants, and staircases this proviso exists. The door, the root, and the aperture are obvious bases.

" Wiesner censured the Darwins for using the common sense and popular terminology in their studies of twining plants. But modern botany in its desire for precision has only succeeded in establishing confusion. What advantage has *dextrorse*, for instance, over ' left handed ' in the Darwinian and popular sense ? The term itself, with its opposite, *sinistrorse*, could hardly been worse chosen, for the older botanists, Linné and the De Candolles, used them in the very opposite senses. To Linnæus *dextrorse* meant dextral, right-handed, moving from left to right (of the spectator). To the modern botanist (see Strasburger's text-book) it means sinistral, left handed, moving from right to left (*of the plant itself*). The absurdity of the new use is that it assigns dorsi-ventrality, a face and a back, to the hop and the honey-suckle ! This is a fine case of the pathetic fallacy of foisting the spectator's personal equation upon the object he studies. If a rope is coiled round my body from the feet upwards, so that to the spectator's view it twines from his right to his left, of course, the side seen by *me*, the front, twines from my left to my right. But the twining plant has no front. The matter becomes worse when English botanists ' trans-late ' dextrorse and sinistrorse by left handed and right handed respectively. Thus Mr. E. Evans, in his ' Botany for Beginners ' (1907), describes the right-hand *convolvulus* as twining counter-clock-wise, ' *a left-handed spiral* ' ; the hop, he says, makes a '*right-handed spiral.*' Not only is this nomenclature incorrect and confusing, but it seems to imply that a spiral possesses hands.

" It would appear that the conchologists, with their *dexiotropic* and *leiotropic*, have achieved the perfection of terminological exactitude. Starting from the base or aperture, an insect walks up the staircase. If the newel is always on its right hand the staircase is dexiotropic, and *vice versâ*. The botanists might well borrow these terms to replace dextrorse and sinistrorse. One advantage they have is that they are in line with the tropisms of *Entwicklung-mechanik*. A disadvantage is that they have as their components the reverse terms to those of popular description. It might be supposed that the botanical dextrorse and sinistrorse were invested with their modern meaning for the same reasons as suggested dexiotropic and leiotropic to the conchologist. But this does not appear to be the case.

" A flat, indifferent spiral, such as a watch spring, which has no top and bottom, *is neither right hand nor left hand, but both*, and this indifference can be illustrated by making first one side and then the other into the base, by pulling the centre first up and then down. A watch spring, when so manipulated, and viewed first from one base and then from the other, through the coils thus made conical, exhibits first one direction of coiling and then the other. If two such springs, thus coiling differently, were placed base to base round a double cone, the spiral round the whole cone would change its direction at the point of basic junction.

" This is precisely what happens in the case of a tendril, as Darwin showed, which, after finding a hold, presents two cylindrical spirals (the number of the two sets of coils is generally exactly equal), which are joined by a ' half bend.' "

LEFT-HANDED CHILDREN.—At the beginning of this chapter the reader was referred to Fig. 262 (in Chapter XIII., p. 229), which illustrated one of those rare instances of individuals in whom all the viscera are transposed as regards right and left, and the heart is placed on the right side instead of the left.

Since the localisation of the various functions of the brain has been more accurately determined, it seems fairly certain that in the majority of cases the centres which control the movements of the right hand are on the left side of the brain, and in close juxtaposition tc the centres controlling speech. It is, therefore, legitimate to argue the further probability that in the minority of cases (left-handed men and women) the centre controlling the master hand is on the right side of the brain, and, in fact, that as regards the geography of the brain centres, a transposition has occurred somewhat similar to that exhibited in the heart illustrated in Fig. 262. If so, it would be a natural inference that the speech centre would have suffered an analogous change and would have accompanied the leading-hand centre to the right side from the left side. This would involve the possibility of harm being inflicted upon the transposed speech centre, owing to sympathy with its neighbour, if any violence were done to the natural tendencies controlled by the leading-hand centre. I am unable to assert that this is actually the case. But prolonged investigations carried out by Professor Smedley, of Chicago University, a specialist in child-study, have produced the curious result that a large number of naturally left-handed children, who had been laboriously trained to use their right hands, were defective in speech and stammered. This looks as if the deliberate interference with the natural aptitudes of the child had disturbed the delicate balance of the brain centres and had resulted not only in a loss of manual skilfulness, but also in a definite injury to the powers of speech. It may be hoped that further study in this direction will, by degrees, contribute to a greater knowledge of both the advantages and the disabilities of what we call " lefthandedness." Professor F. Ramaley, an American naturalist (December, 1913), is confident that lefthandedness may be attributed to abnormal development of the right cerebral hemisphere.

HUGH MCNEIL (p. 249).—No other left-hander has ever surpassed this beautiful player. But it is worth noting that in the Amateur Billiards Championship for 1914 no less than five left-handers entered, their distinguishing characteristic being a marked freedom and power of cue.

CHAPTER XV

ARTIFICIAL AND CONVENTIONAL SPIRALS

" The Beautiful is a manifestation of secret laws of Nature, which, without its presence, would never have been revealed. When Nature begins to reveal her secret to a man, he feels an irresistible longing for her worthiest interpreter, Art."—GOETHE.

SPIRAL DECORATION IN PREHISTORIC TIMES—THE SUCCESSIVE RACES OF MAN—ARTISTIC SKILL OF AURIGNACIANS—MAGDALENIAN CIVILISATION—THE SPIRAL AS A LINK BETWEEN AURIGNACIANS AND GREEKS—THE MYCENÆAN AND MINOAN AGE—LATE NEOLITHIC ORNAMENTATION—DISTRIBUTION OF SPIRALS IN UNITED KINGDOM—SCANDINAVIA AND IRELAND— EGYPTIAN SPIRAL IN DANISH CELTS—NEOLITHIC STONES AND ETRUSCAN VASES—THE SACRED LOTUS—THE " UNLUCKY " SWASTIKA—SPIRALS IN GREEK ART—ORIGIN ÓF THE VOLUTE— THEORY AND EXPERIMENT—THE IRON AGE—UNCIVILISED COMMUNITIES OF THE PRESENT DAY—MEDIÆVAL GOTHIC— VIOLIN HEADS—CYLINDRICAL SPIRALS, TORQUES, ARMLETS, " COLLARS."

IN later pages we shall see that Leonardo da Vinci, whose wide intellect I tried to sketch in my last chapter, was especially attracted by problems in which the spiral formation was a main factor, as indeed he could hardly fail to be, when we consider that he was both a skilled artist and a patient and indefatigable student of Nature. But the multifarious occurrences and the profound significance of spirals in many natural objects must evidently have been impressed upon thoughtful minds long before his day, and in the present chapter I propose to show that they had impressed themselves upon man in the earliest epochs of which artistic history preserves any distinctive record of him ; and, after all, it is scarcely strange that prehistoric men, although unable to appreciate those functional values which alone give the spiral its unique place in Nature, in engineering, or in architecture, should have dimly perceived not only its importance, but also that element of beauty in it which must inevitably be associated with fitness and with power. I, therefore, have chosen here a few typical instances of the use of the spiral (chiefly the flat spiral) in conventional patterns which in modern centuries are evidently the successors of an ornament originally used with

a mystical (or possibly magical) meaning, and they may have preserved that significance long after we can trace its presence.

Curiously enough, all these patterns show the flat spiral, with very rare exceptions ; so I have been able to arrange them in the order of their historic development. The exceptions may be referred to the class of cylindrical spirals, whether they are torques, the ancient necklaces mentioned in my chapter on left-handed men, or whether they are sceptres. When this cylindrical form of spiral, used conventionally, takes on larger dimensions, in a column for instance, it will be more conveniently treated in my forthcoming division upon architecture.

It will first be necessary to our inquiry to have a clear, if brief, idea of the succession of the various races of mankind ; and I have, therefore, taken the classification of the more ancient epochs from the latest pronouncements of Sir E. Ray Lankester ; and for more recent periods, such as the Bronze and Iron Ages (as they are called), I have consulted the official publications of the British Museum.

The " Quaternary " epoch is so called to distinguish it from those geological eras of vast remoteness known as tertiary, secondary, and primary. Another name for it is the " Pleistocene " epoch, and it is distinguished by the evidences of the life of man discovered in its river gravels, its cave deposits, and its glacier *débris* : rough flint implements skilfully chipped into shape but never polished. From these is derived yet a third name for this same period, which has been called " Palæolithic " to distinguish it from the " Neolithic " age of polished stone implements, of cromlechs, of stone circles, and of lake dwellings.

During the early Palæolithic epoch Britain was continuous with the Continent, and so abundant are the relics left of the human tribes who fed on the roasted flesh of animals and usually lived in caves, that there must have been over a very considerable area a human population which developed through hundreds of thousands of years. During the Glacial Period or Ice Age of the Palæolithic epoch lived the race called the Neander men, chinless, low-browed, short, bandy legged, and long armed, who disputed the possession of their caves with bears, lions, and hyenas, who hunted the mammoth on the edge of the glaciers, who have left no relics save their cleverly-worked flints, and a few of their own bones. It was once thought that these represented the earliest type of humanity, and that before the Ice Age man did not exist, or at any rate had left no traces. But in a præ-glacial deposit at Heidelberg a chinless jaw that must be older than that of the Neander men has been dug up ; and the recent discoveries of worked flints, striated by glacier action, in Kent

seem to demonstrate that man existed in the warm præ-glacial times in the British Islands long before the sands and clays and river gravels of the post-glacial Pleistocene received their traces of primitive humanity.

It is with the post-glacial men of the Later Pleistocene that we have now to deal. When the reindeer was abundant, and the numerous herds of wild horses were used for food, the first sub-division of existing mankind were those now called " Aurignacians," from Aurignac in the Haute Garonne. From the very first it is their artistic skill that is the most extraordinary thing about them. The earliest generations of them of which we have any record produced the marvellously executed horse's head which is reproduced in Fig. 283 of this chapter, a complete piece of " all-round sculpture," the size of which is determined

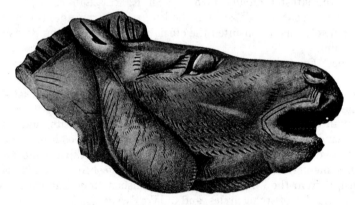

FIG. 283.—HORSE'S HEAD CARVED BY EARLY AURIGNACIAN MEN ABOUT 20,000 YEARS AGO. (Piette.)

by the bone from which it has been carved. Their later generations produced the first conventional flat spiral, used decoratively, of which I can find any authentic record (Fig. 284) ; but before saying more about this spiral I had better complete my short description of Palæolithic man. The Aurignacian age was followed by the Solutrian, so-called from Solutré, near Macon ; and to this in turn succeeded that Magdalenian civilisation from which I reproduced a shell necklace in Chapter X. (Fig. 199) ; and from which came that astounding picture (incised on a cylinder) of " The Three Red Deer " which Sir E. Ray Lankester described in the *Field* for May 13th, 1911. By this time the gradual rise in temperature had sent the reindeer further north, and in southern France the red deer was beginning largely to replace it. In the north of Spain men hunted the bison. On the walls and roofs of their caves many beautiful coloured drawings still

survive of the hunters and the hunted. Yet a fourth sub-division,
the link between the Magdalenians and the Neolithic men, has
been called the Azilian, from Mas d'Azil in the Arriège ; and
though at first sight the local names by which it has been agreed
to distinguish these sub-divisions may appear inadequate, yet it
has been found that the distinctive characteristics of different
forms of pre-historic art revealed in each of these four main
excavations from the ancient French deposits are equally
recognisable in contemporary deposits found in Great Britain,
Belgium, Germany, and Austria ; so the main titles here given
have, hitherto, been universally accepted as correctly scientific
labels.

It must be remembered that the skeleton of the Neander man
of the Glacial period, mentioned above, differed much more from
the well-grown Cromagnard type of the Magdalenian man than
the Australian bush-fellow of to-day differs from the modern

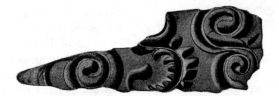

FIG. 284.—FRAGMENT OF REINDEER'S ANTLER.
Found in the Upper Pleistocene deposits of Les Espélunges
d'Arudy, Hautes Pyrénées, carved by late Aurignacian men
of the Third Palæolithic period, about 20,000 years ago.
(Piette.)

Englishman ; and when we consider that it may now be taken
as proved that man worked flint implements even before the Ice
Age, the enormous period of time necessary for development
becomes a little more realisable, and it is perhaps easier to appre-
ciate that the Aurignacian who carved the horse's head of Fig. 283
or the spirals of Fig. 284, was not so " primitive " as might be
imagined ; while the artist of the Magdalenian cylinder was less
" primitive " still.

The late Aurignacian civilisation which produced the spirals
of Fig. 284 was evolved by men of a " negroid " character (as is
shown by skeletons found at Mentone), who were probably a
branch of the race from which those bushmen of South Africa
are descended whose paintings of the chase on rocks and caverns
are singularly like those of their prehistoric forebears. Beneath
a limestone cliff at Laussel, in the Dordogne, Aurignacian carvings
in high relief have recently been discovered by Dr. Lalanne,
representing a woman with strong " bushman " characteristics,

holding a bison's horn ; and a man apparently in the act of shooting an arrow from a bow. I emphasise these resemblances to the external characters of bushmen because nothing could be less like the æsthetic development of the modern savage than Aurignacian art was. In fact, this is a case where the modern representative has notably fallen off from the standard attained many thousands of years ago by men of the same race ; and it is not necessary to go so far as the modern savage to see that falling off just as clearly. For though the Neolithic period is only separated from the Aurignacian by the Azilian, the Magdalenian and the Solutrian eras (all later Pleistocene, or Palæolithic), yet not a trace of Aurignacian art survives in Neolithic times except the use of the conventional flat spiral. In fact, nothing to touch the horse's head in Fig. 283 is found until the Greeks of 500 B.C. The spiral is the only link that passed down consecutive generations from the Aurignacians to Attica, from Les Espélunges d'Arudy to the Acropolis of Pericles.

Some diffidence is necessary in making any definite pronouncement on these far-off matters ; for since the publication of Déchelette's " Manuel d'Archéologie," and of Piette's " Age du Renne," discoveries have been continuous and important, and almost at any moment we may hear of some typical excavation which necessitates a rearrangement of our present classification. In calculating time, too, we are even more liable to error. One fact which is fairly certain is that the Neolithic period lasted on at least to the Swiss lake-dwellings of 7000 B.C. ; and behind them is a gap which nothing has yet bridged. Therefore we may take the latest division (the Azilian) of the later Pleistocene (or Palæolithic) as being before that ; and if we say that the Aurignacians lived 20,000 years ago we shall be well within the mark ; and they may possibly represent a span of 50,000 years, if we consider the enormous time necessary for their development from men of the middle and early Pleistocene, and from that dawn of humanity which left its rostro-carinate flint implements beneath the Red Crag, deposited before the oldest Pleistocene of all. We have, in fact, no exact " chronometer," for even a calculation of the extension and retraction of the Alpine glaciers must be merely relative. If we cannot describe Aurignacian civilisation, in the words of the poet, as " prolem sine matre creatam," we seem compelled, as M. Salomon Reinach says, to recognise it as " Mater sine prole defuncta," so far as its chief artistic manifestations are concerned. My point now is that its conventional spiral alone seems to have passed on ; and therefore the origin of this emblem must be put much further back than many writers have hitherto thought ; for the carved reindeer's

antler shown in our Fig. 284 proves that the spiral was used in western Europe long before the Egyptians and the men of the Ægean used it as a fundamental motive of their decoration. The simple spiral and the double recurrent spiral of Celtic art are to be found clearly and deeply cut in Aurignacian workmanship. It may be true that the spontaneous discovery of the flat spiral as a conventional decoration may have occurred in different places and at different times. But in the Mycenæan epoch (the Bronze Age of the Ægean) we find the spiral in the eastern Mediterranean, in southern Europe, and in Scandinavia ; and it is difficult to deny to such similarity both in time and style an identity of origin which is scarcely obscured by the wide area involved. It is therefore possible that the Bronze Age inherited the spiral from the Palæolithic Aurignacians by way of the Neolithic carvings of Gavr'inis and New Grange, which I shall have to mention next.

But I cannot conclude this portion of our subject without reminding you that the fondness of the Mycenæan and Minoan age for natural objects as models for their artistic work has been already emphasised in my tenth chapter. In many cases it was shells and cuttlefish which supplied a spiral motive that gradually became conventional. But convention in pattern is always a slow growth. It comes long after the naturalistic treatment of some living object ; and this is why the obviously conventional and artificial spirals of the Aurignacian artist of Les Espélunges d'Arudy (Fig. 284) are so extraordinary. They seem to prove the existence of an abstract idea in a civilisation hitherto imagined to be incapable of anything of the kind. We need not go so far as to say that here is the dawn of a mathematical conception, for a snail shell sawn in two or ground down horizontally would produce a flat spiral so nearly mathematical (as we saw in Chapter IV.) that the artist who copied it need have had no idea but fidelity to nature in his curves. Still, in Fig. 284, those curves are conventionalised. The beauty of the abstract figure so produced is evidently realised. The spiral, in fact, has roused that æsthetic sense of which I spoke in my thirteenth chapter, the sense which appreciates the strength and power and fitness of a certain formation, and therefore takes it as a type of life and beauty. The spiral was an integral part of Mycenæan decoration, and so many examples of it are illustrated in Schliemann's " Mycenæ " that it was unnecessary to reproduce them here, but I have collected a few remarks upon them in a Note to this chapter.

The tumulus of New Grange, in county Meath, has been described in a careful monograph by Mr. George Coffey (1912).

It represents the next link in that story of the spiral in art which I am trying to relate, and it is quoted by Déchelette as an example of late Neolithic ornamentation in a form not found in Scandinavia until the Bronze Age had begun there. The united spirals, in double and even triple conjunction, are very clearly

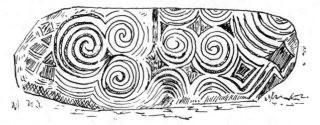

FIG. 285.—SPIRALS CARVED ON A STONE FOUND IN THE NEW GRANGE TUMULUS (CO. MEATH). (Déchelette.)

carved upon the stone illustrated in Figs. 285 and 286; and considering that similar patterns only occur on two stones in Brittany (of which Fig. 287 gives one example), I cannot believe that the symbol reached Ireland by way of the Morbihan. The map (made by Mr. Coffey) showing the distribution of these spirals in what is now the United Kingdom shows a distinct line from the

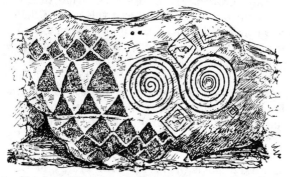

FIG. 286.—LATE NEOLITHIC BOUNDARY STONE AT NEW GRANGE, ON THE BANKS OF THE BOYNE.

Carved by men of the Bronze Age, showing two large spirals united between two lozenges, like the pattern on Melian vases of 600 B.C. (From "New Grange," by George Coffey.)

extreme north of Scotland to a point just west of Dublin. The furthest point south is in north Wales. This seems to indicate that the Irish spirals are more likely to have come from the Baltic than from Brittany; and if this makes it difficult to believe that they were the true successors of the Aurignacian symbol in Fig. 284 we must remember that sea travel was easier than land travel among the earlier civilisations, and that seafarers along the

western coasts of France were more likely to sail north by east, and keep the coasts in sight than to sail either west or north by west towards unknown latitudes. So it is quite possible that before the tin mines of Cornwall had been discovered by the southern traders, the first commercial voyagers descended on these islands from the north-east, and worked along a slant towards the south-west. Nor is it difficult to understand, under this theory, why spirals found on stone in Ireland are first found in

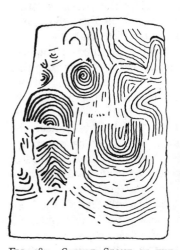

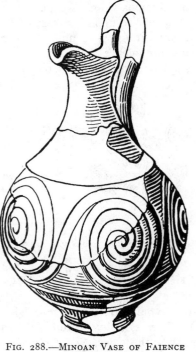

FIG. 287.—CARVED STONE IN THE COVERED ALLEY OF THE ISLAND OF GAVR'INIS (MORBIHAN), SHOWING FINGER PRINTS (?) AND A SPIRAL AT THE TOP.
(Déchelette.)

FIG. 288.—MINOAN VASE OF FAIENCE FROM CNOSSOS.
(Sir Arthur Evans.)
By permission of the Committee of the British School at Athens.

Scandinavia on bronze only. The record of bronze-work in Ireland is extraordinarily defective, and many early examples may yet remain to be discovered ; and it seems also clear that skill in bronze-working was developed much sooner in Scandinavia than in Ireland, where the easy method of engraving curves on stone by a number of blows struck perpendicularly lasted far longer than has been sometimes realised.

I incline to the belief that the spirals of Gavr'inis in Fig. 287 are older than those of New Grange, partly because these carv-

ings, almost the only ones found on a megalithic monument in France, are of ruder workmanship than the Irish examples, and partly because they recall the " fingerprint " patterns common in Palæolithic caves. It may well be that the New Grange carvings are as recent as that Præ-Mycenæan epoch in the Ægean, which lasted until about 2,000 B.C., when the Mycenæan or Bronze Age began. At this period we can trace the spiral from scarabs of the twelfth dynasty in Egypt to Crete in 3,000 B.C., from which it spread northwards along the " amber route " to Jutland and Scandinavia ; and we find the favourite double spiral of the Minoan Age upon the vase of Faience discovered by Sir Arthur Evans at Cnossos, and illustrated in Fig. 288. From this to the prominence of the spiral in Mycenæan patterns is but a slight step in ordinary development. The spiral decorations on the bronze celt of the Danish palstave type, shown in Fig. 289, are of great interest in that they prove the survival in the north of the Egyptian spiral motive, together with the loop in the interstices, which is a reminiscence of the lotus ornament used in ceiling patterns. Déchelette connects the Minoan and Mycenæan spirals above mentioned with those of Gavr'inis and New Grange by the simple argument that the latter were made at the end of the Neo-lithic period, and the former are

FIG. 289.—DETAILS FROM BRONZ: CELT OF THE DANISH PALSTAVE TYPE, SHOWING SURVIVAL IN THE NORTH OF THE EGYPTIAN SPIRAL MOTIVE.

(From " New Grange," by George Coffey.)

the favourite pattern of the beginning of the Bronze Age. But, as has been said, I venture to support the view that though Gavr'inis may be the older, New Grange got its spirals from the north and east, rather than from the south and west ; and Mr. George Coffey points out, in support of this, that certain peculiarities in the spiral patterns of Scandinavian bronze work are without a parallel in the Bronze Age of the rest of Europe, but are exactly the same as those found at New Grange. In fact, the same influence moulded both. In one case it survives in bronze alone ; in the Irish examples only in stone. In the Stockholm Museum is preserved a fine example of a bronze plaque, showing the connected spirals of Fig. 298 continued all round the circle (see M. Salomon Reinach's " Apollo ").

The stone illustrated in Fig. 286 is a boundary stone found on the north of the circle of the tumulus at New Grange, and clearly shows the same use of the united spirals which survived

in such Etruscan vases as that chosen by M. Pottier from the
Louvre collection (Fig. 290), a form of pattern which certainly
lasted until the sixth century B.C., and a piece of evidence which
suggests that the work at New Grange is very much more recent
than the megaliths at Gavr'inis. It has been considered by some
authorities as an indication of the sun worship, which was
probably the most widely spread cult in modern Europe.

Patterns grow ; they are not made. They are evolved from
pictures, and from those pictures which most often occur, and
are most easily repeated. Among such pictures, those which
represented the lotus would be as significant and as sacred as
any known to the earliest periods of Egyptian art. The earliest
pictures were not done for their own sake, as " works of art."

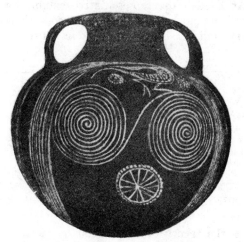

Fig. 290.—Two Large Spirals United on an Etruscan Vase.
(From Pottier's " Vases Antiques du Louvre.")

They were meant to convey an idea ; they were even supposed
to retain some of the powers and qualities of the original. So
the lotus, as the emblem not of one god but of all, not of one
sacred animal but of all, embodied an enormous amount of
ancient and popular symbolism, and no doubt the widespread
value attached to the spiral formation as a decorative pattern
is largely due to its association with the lotus, the symbol of
creative power or energy, of the strength and divinity of the sun, of
the sun's birth from moisture, and of the many sacred phenomena
of life. The lotus was used for the first time in the decoration
of the English throne in Westminster Abbey in 1902 ; and it
will be seen that modern research has largely justified a symbolism
which was based rather on faith than knowledge. Professor
Lethaby has pointed out that the triangular opening over the

door of the " Treasury " at Mycenæ was originally filled with
slabs of dark red marble incised with spiral ornament, one of
which is in the British Museum. There are also flat spirals
carved between the chevrons on the column and capitals of the
same building. Schliemann gives drawings of an elaborate
pattern of double spirals from the Mural frescoes of the palace
of Tirhyns, which are very similar to the " spectacle brooch "
shown in Fig. 298.

Spiral scrolls have been found on pottery in Schliemann's
" First Tomb " at Mycenæ; on scarabs of an Egyptian
dynasty which existed 3,900 years before Christ; on bronze
axe-heads from pre-historic Sweden. Mr. Henry Balfour
possesses many examples in the Pitt Rivers Museum at
Oxford. At Leyden the representative exhibit for the Malay
Archipelago is unique. The ethnographic collections in Washing-
ton, in Rome, and Amsterdam, are also full of similar specimens.

FIG. 291.—PAINTED FRIEZE FROM THE OLD PARTHENON
DESTROYED IN 480 B.C.

Throughout, the theory of spontaneous generation falls to the
ground. The rule of historic development and tradition shows
no exception; and Professor W. H. Goodyear has very carefully
investigated the whole subject as suggested to him first by the
geometric lotuses upon the Cypriot vases. He showed that all
the Arab and Mohammedan spirals came from the Byzantine
Greeks; that they are not found at all in barbaric Africa, and
that, on the other hand, they are the foundation of Malay orna-
ment; they reached Alaska, however, by means of Buddhist
influence, along the Amory valley, through the Yakoots to the
Aleutian islands. When it is realised that five-sixths of the orna-
mental patterns of ancient Egyptian art were based upon the
lotus and its spiral derivatives, the number of spiral traditions
which spread from the Nile valley all over the world will be better
understood. The oldest forms of the spiral associated with the
lotus are found in Egyptian tomb ceilings. The Greeks and
Assyrians, who found the flower already conventionalised almost

out of knowledge, took the spiral accompaniments and developed them in turn to their highest pitch. The Assyrian idea of the organic connection of repeated units of design by linked curves, ending in spiral volutes, was immeasurably improved by the genius of the Greeks, which seized on elements of beauty that had hitherto remained unproductive, and gave them not merely new life, but measureless scope. The descent of the Greek palmette (*anthemion*) from the Egyptian lotus has never been authoritatively contradicted. The painted frieze shown in Fig. 291 is a fragment from the old Parthenon on the Acropolis, which was destroyed by the Persians under Xerxes in 480 B.C., and it shows the drooping palmette alternating with the developed form of the lotus bud. Fig. 292 (a palmette from a Greek vase at Nola) shows the debased form of the design during the period

FIG. 292.—SPIRAL PATTERN ON A GREEK VASE OF ABOUT
330 B.C. FROM NOLA.

of Greek decline after 330 B.C., and I have chosen it because the design includes two examples of the Swastika, or fylfot, that ancient and widespread symbol of the sun's movements which I described at the end of Chapter X. (see also note to Chapter XX.), and both of them are " unlucky "—that is to say, the arms of the cross do not follow the sun in a left-handed spiral after the manner in which we pass the port or deal the cards, but go " contrariwise," against the sun, in the way that has for many centuries been deemed unlucky. The " lucky " form is most usual, and is found alike on bronze Scandinavian scabbards, on the stone spindle whorls of ancient Troy, on the footprints of Buddha, and on the blankets of American Indians ; but for fuller details about it I must refer the interested reader to Mr. Thomas Wilson's monograph, issued by the Smithsonian Institute of Washington D.C. And I will merely add here that the

" unlucky " form shown in the design in Fig. 292 has also been found in some pottery-marks from Asia Minor, on the head of an Armenian bronze pin, on a stone ball found by Dr. Schliemann beneath the site of pre-historic Troy, on an ancient iron spearhead from Brandenburg, on the base of a ruined Roman column in Algeria. Why it should also be found on a Greek vase from Nola, I am quite unable to explain. A suggestion as to its origin will be found in the Appendix.

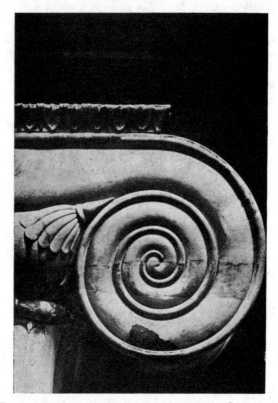

FIG. 293.—VOLUTE OF ABOUT 560 B.C. FROM THE CAPITAL OF AN IONIC COLUMN (BRITISH MUSEUM) FROM THE ARCHAIC TEMPLE OF DIANA AT EPHESUS.

The conventional spiral reaches an even higher point at the best period of Greek art than it did in that brilliant but apparently short-lived age of Aurignacian civilisation ; and in the volutes of the Ionic capital we have it at its best. In Fig. 293 I have reproduced the photograph of a volute from the capital of an Ionic column from the ancient Temple of Diana at Ephesus, now in the British Museum. Obviously the spiral is used here not as a structural or functional necessity, but as a conventional

ornament, descended from a most ancient symbol. It has been
exquisitely adapted to its new position ; and this particular use of
it reminds us of the thesis propounded by Dr. W. H. R. Rivers
before the meeting of the British Association (in 1912) that for
the special directions taken by the process of conventionalisation
one must look to factors arising out of such a blending of various
cultures as is probably observable in the civilisation which pro-
duced the best Hellenic art. Certainly the " conventionalisation "
which produced the Ionic volute cannot be described as a mere
change (from the lines of the original model in Nature) due to
the usual causes of labour-saving, or of inexactitude in copying,
or to the difficulties of surface or material. For nothing more

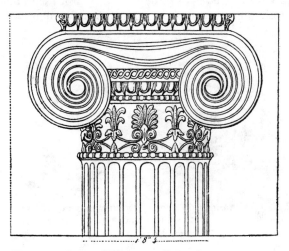

FIG. 294.—SPIRAL VOLUTES OF IONIC CAPITAL IN THE
EASTERN PORTICO OF THE ERECHTHEUM.
(From Stuart and Revett's " Antiquities of Athens.")

tastefully rendered than the volutes I reproduce in Figs. 293
and 294 could well be conceived in ancient architecture.

In Chapter II. I reproduced a diagram (Fig. 44), first drawn
by Mr. Banister Fletcher, to show the possibility of describing
an Ionic volute by means of the fossil shell *Fusus antiquus*
which is used as the pivot round which a gradually lengthening
string is unwound from the apex of the shell (at the centre of the
spiral) upwards ; and I pointed out then that the beauty of the
Greek volute exhibits just those differences from mathematical
exactness which are exhibited by the organic life of any natural
object. After Mr. Fletcher made his diagram, a paper (*R.I.B.A.
Journal*, 1903, p. 21) was published by the late Mr. Penrose,
which once more attacked the old problem of the mathematical

definition of the Greek volute ; and the point on which the learned author seemed chiefly to congratulate himself was that his new formula was so nearly exact that its practical application to various concrete instances of the volute revealed "very few errors," and only a very small "margin of error" on the whole. It happens that the two volutes selected for Figs. 293 and 294 in this paper were among those chosen for the mathematical anti-quary's demonstration. But in that demonstration it is not the small "margin of error" which is to my mind significant. It is the fact that no mathematical formula can express the volute with any greater accuracy than it can express the growth of a shell. It seems obvious to me that the Greek architect had in his mind the same natural curves (whether taken from a living landsnail, from a fossil ammonite, or from a Mediterranean nautilus) which

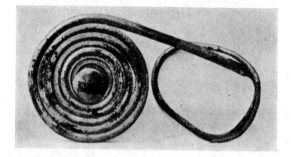

FIG. 295.—ARMLET OF BRONZE TERMINATING IN A SPIRAL,
FOUND IN HUNGARY.
(From the British Museum.)

had appealed to the Aurignacian artist 18,000 years before him. It is certainly true that the volute was known as a "limace" or "snail shell" as late as the middle of the sixteenth century ; for Mr. Reginald Blomfield quotes a "Notice to Readers" at the end of Jean Martin's edition of Vitruvius, in which Jean Goujon writes that the "spiral of the volute, otherwise called snail shell, is not clearly enough explained," and goes on to say that no one has thoroughly understood the true theory of this volute. "except Albert Durer, the painter." On this I need only say here that it seems to me far more likely that the real origin of the volute should occur to such artists as Durer or as Leonardo than that it should be mathematically solved by any antiquarian architect, whose careful measurements of such Greek master-pieces as the Parthenon have proved that the most delicate manifestations of their beauty consist rather in the divergences of their design from mathematical regularity than in the exact

accuracy of their lines and angles. I mention Dürer's work in this direction in a later chapter. Mr. Penrose's investigations irresistibly reminded me of the researches of Mr. Gilbert Walker (a celebrated Wrangler) into the mathematical construction of the boomerangs made by Australian natives. He reached such accurate conclusions that by a given formula he could construct a boomerang which would exhibit given movements in the air when properly thrown. The native had reached similar results after generations of his ancestors had made experiments which may be compared with the various steps in the evolution of organic forms that result in the survival of the fittest. None of his lines or angles were exact, and he naturally could give no reason for them. They had " grown," as it were ; and Mr. Walker's interesting mathematics could only produce a rough definition of the real thing, though they enabled him to manufacture other boomerangs after the formula which was latent in the native workmanship. In just the same way I have suggested that the logarithmic spiral " latent " in a nautilus can be used as the basis of an Ionic volute.

In the earlier volute of 560 B.C. (Fig. 293) it will be noticed that the spiral consists of the single line of one outstanding curve winding inwards to its centre from the line immediately beneath the " egg and dart " moulding at the top of the capital. The technical carving of this spiral curve by the artist is precisely similar to that shown by the Aurignacian artist in Fig. 284. Speaking mathematically, it would be more correct, of course, to say that the spiral originates from a selected point rather to the left of the centre of the volute, and winds outwards until it reaches the straight line at the summit, and in connection with what was said above, it will be noticed that in this Asiatic example the lotus forms a definite portion of the ornamental scheme of the volute itself. In the later column from the Erechtheum, however, the volute is formed by a triple spiral, and the curves composing it start not only from the straight line immediately beneath the " egg and dart " moulding, but also from two curvilinear figures cut beneath it. This has the result not only of covering the space of stone available more completely than was the case with the volute from Ephesus, but also of giving each spiral a wider and more gracious development. The difficulty of indicating the three central points from which these three spirals originated is beautifully met by the application of a separately carved disc just at that part of the volute where the tightening coils of the spirals would become too small to carve and too insignificant to see from any distance, and the place and proportion of the disc itself in the whole decorative scheme is quite distinct.

The same central disc may be observed in the spirals of Fig. 295 and Fig. 296. The lotus, though changed in form, is still preserved in the palmettes which encircle the neck of the column, just beneath the volutes, with a band of jewelled carving. There is no doubt that as a whole this makes up the most delicate and beautiful application of the conventional spiral to architectural ornament which has ever been conceived, and I would once more point out that the chief factor in its charm consists in its neglecting

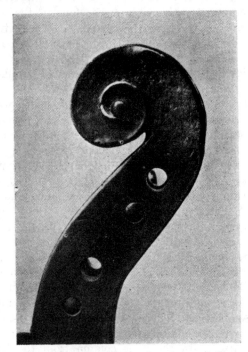

FIG. 296.—HEAD OF EIGHTEENTH CENTURY VIOLIN
(EARLY GERMAN).
(Reproduced by courtesy of Messrs. Hill, of New Bond Street.)

mathematical exactitude after the same fashion as it is neglected by the snailshell which appealed to Aurignacian artists long before Attica had developed any art at all. Professor W. R. Lethaby discusses the question in "Greek Buildings" (B. T. Batsford, 1908), p. 204, and makes some very interesting suggestions. See also his pp. 59, 61, 170 and 180.

Although the mathematical attainments of the Greeks were undoubtedly very high, I do not venture to attribute to them such skill as the demonstration, given by Canon Moseley, of the logarithmic character of the spiral shown in certain shells,

especially the nautilus. But the science of the Chinese, in remote periods of historic antiquity, turns out to be more and more astonishing the more we find out about it, and the use to which their early artists put the logarithmic spiral of the nautilus, as a foundation for symbolism and patterns, is so extraordinary that I have given it special treatment in Appendix IV.

So far, then, we have traced the spiral from Palæolithic to Neolithic workmen, and through the Bronze Age of Ægean civilisation to the highest point of true Hellenic culture. Something must now be said of that Iron Age, which followed the age of copper and of bronze, and may roughly be taken as succeeding the Homeric epoch in historical chronology. It is chiefly named (as we saw was the case in the Palæolithic epoch) after the localities where typical discoveries have been made, and, therefore, its sub-divisions are called after Hallstatt in the Austrian Tyrol,

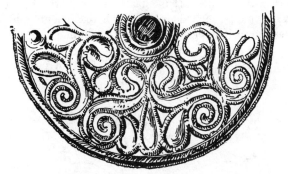

FIG. 297.—SPIRAL PATTERN ON A GOLD DISC OF GAULISH
WORKMANSHIP.

and La Tène, a pile-village on shallows at the north end of the lake of Neufchâtel. The Hallstatt period may be said to begin in 850 B.C. and end in 400 B.C., and is called " early " or " late " by reference to the year 600 B.C. Three periods are predicated of the La Tène culture, namely, the " early " from 400 B.C. ; the " middle," from 250 B.C., and the " late," which includes the first Roman occupation of Great Britain, from about 150 B.C. to the beginning of the Christian era. I shall only say so much of them as may be necessary to explain the examples of spiral decoration illustrated in this chapter.

The embossed gold disc shown in Fig. 297 comes from Auvers, in the department of Seine-et-Oise ; the survival in it of the Greek palmette pattern is sufficiently evident to need no further emphasis, and the derivation thus implied is easily intelligible at a time when classical motives were becoming common property even to the goldsmiths of early Gaul, and when Celtic transforma-

tions of Hellenic designs had become fashionable in the workman-
ship of widely separated areas. In exactly the same way, some
time before this gold disc was manufactured, we find almost
identical elements of design on painted pottery all over France
(except in Armorica and the south-east), on the Rhine, and in

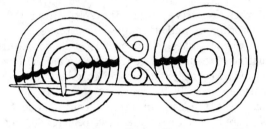

FIG. 298.—BRONZE DOUBLE SPIRAL BROOCH FROM HALSTATT.

Western Switzerland. It is characteristic of the La Tène art of
about 450 B.C., which deliberately chose Hellenic and Etruscan
motives ; and it is curious that where similar patterns occur in
the pottery or wood of Brittany or England, about the first
century B.C., they are always incised and not painted.

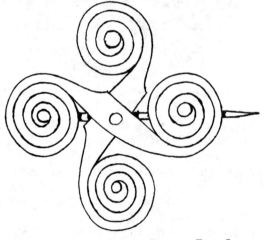

FIG. 299.—BRONZE BROOCH SHOWING FOUR SPIRALS
FROM HALSTATT.

The brooches drawn in Figs. 298 and 299 are examples of the
Hallstatt civilisation. The earlier brooch (Fig. 298) is called
the " spectacle type " formed of two spiral coils of bronze (or
sometimes iron) wire which are united exactly like those carved
on the Aurignacian fragment (Fig. 284), the New Grange stone
(Fig. 286), and the Minoan vase (Fig. 288). The same pattern

was found on earthenware vessels in Bosnia (*Hœrner*) and on a double earthenware vessel of the Hallstatt period at Langenle-bron. Reichhold gives it on a similar vessel as far afield as Central America. They are also found in the south of Italy, in the area of Magna Græcia. The brooch of Fig. 299 is a double variation of the same pattern, and has some similarity to the Swastika, the " unlucky " variety described in this chapter.

As will be seen in the Appendix, one very possible and interest-ing origin of the curved Swastika here suggested, is to be found in a similar union of two curves based on the logarithmic spirals used by early Chinese philosophers to typify infinity and to convey other profound, symbolic meanings.

It very often happens (as the Pitt Rivers Museum at Oxford so beautifully illustrates) that the arts and crafts of savages or

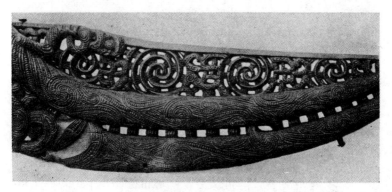

FIG. 300.—WOODEN FIGUREHEAD ON PROW OF MAORI WAR CANOE, THE PRO-PERTY OF MR. W. B. WOODGATE, CARVED WITH TOOLS OF JADE ABOUT THE MIDDLE OF THE SEVENTEENTH CENTURY.

of comparatively rude civilisations at the present day may give us interesting parallels with the prehistoric art of vanished peoples. I have, therefore, added a few examples of what may be called the modern use of the conventional spiral from decorations made by savage or comparatively uncivilised communities. It is a well-known fact that some mediæval monks used to say their prayers within a maze, in order to escape the pursuit of the Evil One ; and the spirals tattooed upon a Maori's face may have the same object of confusing the Devil, though it may quite as pos-sibly be a result of his inborn sense of the adaptation of ornament to form ; for his spirals admirably *express* the feature decorated, and seem to do so in a way which concentric circles never can. Spirals are found in the decorative art of such different peoples as the natives of New Guinea (especially where Melanesian influence occurs), of Borneo, of ancient Peru, of Central Africa.

Sometimes the form is connected with the manufacture of pottery or basketwork, and it is then definitely suggested by the structural lines of the object. Often the spiral seems the genuine expression of artistic feeling or fanciful imagination. But in no case do we

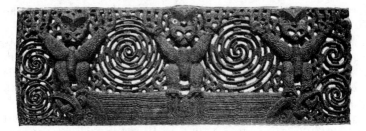

FIG. 301.—CARVED DOOR LINTEL FROM NEW ZEALAND.
(British Museum.)

find a savage making an abstract pattern that does not go back to Nature by a series of conventional variations. All forms of the spiral in Polynesia, for instance, can be traced to a Malay centre, and that centre took its ornaments from Hindoo or Phœnician sources. But it

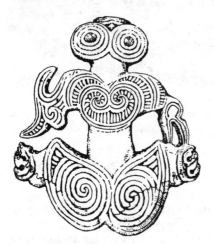

FIG. 302.—NEW ZEALAND NECK ORNAMENT CARVED FROM A HUMAN SKULL.
(British Museum.)

must carefully be remembered that, as Dr. W. H. R. Rivers has pointed out, the directions of conventionalisation cannot always be explained by purely psychological or technological factors. In many cases the motive must be sought in the attraction of peoples possessing different forms of artistic expression, and in factors arising out of the blend of cultures.

The finest example illustrated here is the New Zealand rostrum drawn in Fig. 300. It is really composed of two boards, one to affix on either side of the prow ; but the accuracy of the duplication conceals, in the photograph, the fact that a ditto board (save that it is cut and carved for port side, while the one in view is starboard) lies face to face with the one seen. The tattooing, and, in fact, all the carving, supposed to represent the jawbones of some marine animal, is reported to have

been executed with jade, for there was no metal known among the Maoris at the date ascribed to the manufacture of this figurehead. It was captured in the storming of a wall about 1860 by the 50th Foot, and passed into the hands of Lieut. Allnutt, of the commis-

FIG. 303.—CARVED HOUSE BOARD FROM BORNEO.
(British Museum.)

sariat department, and thence to Mr. W. B. Woodgate. The curves and carving on what might represent the nasal ridge of the marine monster are said to be tribal, and to be translatable as giving a date about *temp.* Charles II. of Britain (so Lieut. Allnutt

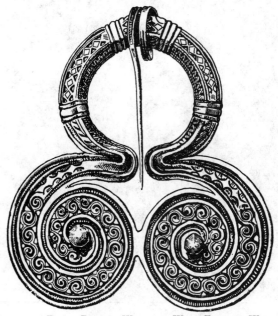

FIG. 304.—BRASS BROOCH WORN BY WEST TIBETAN WOMEN.
(British Museum.)

averred). These figureheads are said to have been cherished as tribal trophies or badges, and were religiously removed from war canoes when not on war duty afloat, and were carefully tended inland or wherever the tribe were for the moment located. Hence, apparently, the discovery of this curiosity at an inland " pah," to which the tribe had retreated for defence.

In the Fisheries Exhibition, 1882, there were some figureheads of this class on exhibition; the most conspicuous of which belonged to the then Duke of Edinburgh. But the Duke's appeared to be more modern than the one given here, for it showed

FIG. 305.—SPIRALS IN IRONWORK (FRENCH GOTHIC). HINGE FROM THE PORTE STE. ANNE, NOTRE DAME, PARIS. (THIRTEENTH CENTURY.)

evidences of having been cut out with metal tools; if so, that fact of itself would correlate it with a comparatively recent era in Maori history. The essentially spiral feature of the pattern is common in New Zealand art, and I have given two more examples: of a door-lintel in Fig. 301, and a neck ornament carved out of a human skull in Fig. 302. They seem to me to indicate that the

pattern is very old, and has persisted into modern times with very little variation. The same motive is shown in the carved houseboard from Borneo, reproduced in Fig. 303, and in the brass brooch from Tibet in Fig. 304. Paintings with a similar pattern are reproduced by Racinet from an Australian canoe.

The Gothic workmen of the thirteenth century welcomed the spiral as a decorative motive almost more warmly than their Greek predecessors had admired it before them ; and in the hinges

FIG. 306.—SPIRALS IN STONEWORK (FRENCH GOTHIC). CARVING FROM THE CLOISTER (THIRTEENTH CENTURY) OF ST. GUILHEM LE DÉSERT (HÉRAULT).

of the great western door of Notre Dame I give one of the best examples possible (Fig. 305) of the ironwork thus inspired. Their exquisite adaptation of the spiral line of growth in stone carving may also be appreciated from the carving here reproduced from the old cloister of St. Guilhem le Désert in the Hérault (Fig. 306). My readers may remember the beautiful little flat spiral of a fern frond gradually uncurling (Fig. 61, Chap. II.) as it grew to maturity, and from this same motive no doubt were designed such crosiers as that preserved at New College, and made in 1400 for William of Wykeham, or the still more naturalistic model of early thir-

teenth century work made by Brother Hugo, and reproduced in the *Architectural Review* for August, 1912 (p. 72).

I could not conclude this slight sketch of the artistic use of the conventional flat spiral without giving one of its loveliest instances, the head of a violin. By the courtesy of Messrs. Hill, I reproduce (in Figs. 307 and 308) two views of the famous workmanship of Mathius Albani in 1674. Their similarity of treatment (down to the central " eye ") to that of the Ionic volutes in Figs. 293

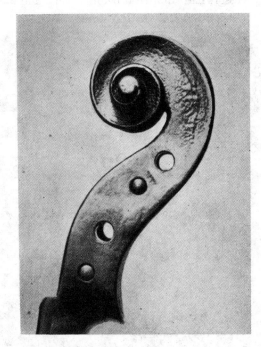

FIG. 307.—HEAD OF VIOLIN BY MATHIUS ALBANI, AN ITALIAN MAKER WHO WORKED IN THE TYROL. PERIOD 1674.
(Reproduced by courtesy of Messrs. Hill, of New Bond Street.)

and 294 will be at once observable. The same " eye " motive in the centre of the spiral volute should be noted in the bronze Hungarian armlet shown in Fig. 295.

From its very nature the cylindrical spiral does not admit of such extended use for a conventional decorative pattern as has been found in all ages for the flat spiral. But we often detect it in the decoration of what might otherwise have been a plain tube or column. The sceptre of the city of London, which is of Anglo-Saxon workmanship, has a firm spiral cut into the gold and crystal of its jewel-studded stem, and the fact that this spiral (which might just as well have been right-hand) is

left-hand may possibly have a significance which has already been suggested and might certainly be further elaborated. But it may, on the other hand, only represent the ordinary twist given to a rope, or to a flat ribbon of soft metal, by a right-handed workman ; and this is the twist seen on most torques, or metal necklaces, which are, after all, only a form of cylindrical spiral. Fig. 309 shows this left-hand twist very clearly in the five-coiled armlet of gold now in the British Museum. Fig. 310 is a bronze torque of Gaulish workmanship, made in a complete circle, fastened by a simple rivet. In a Gaulish burying ground at

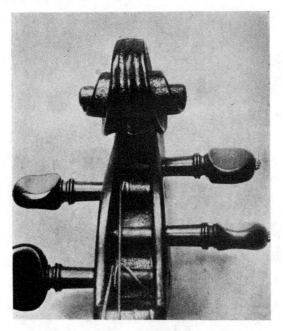

FIG. 308.—FRONT VIEW OF MATHIUS ALBANI'S VIOLIN.

Courtisols (Marne) a similar torque was found in a woman's grave, and, curiously enough, it had been placed not on the neck, but as a diadem on the head.

The use of this spiral formation as an honourable ornament is certainly as old as the golden collar promised by Belshazzar as a reward, the Chaldee name for which was Menéka, transliterated in the Septuagint (Dan. v. 7), as Μανιάκης. From the Chaldæans this form passed to the Persians, and the mosaic pavement from Pompeii, now in the Naples Museum, represents Darius and his officers at the battle of Arbela, wearing torques which end not in the usual cones, but in snakes' heads. The

crest of the Manlius family in Rome had its origin in the prowess of T. Manlius Torquatus, who beat a Gaul in single combat, and took from him the torque which had descended to his nation as an honourable symbol from Chaldæan sources, and which passed on to Druids and Celts in the British Islands in the various forms that are now discovered in their tombs. The collar itself (though not its spiral form) continues to be a mark of honour to the present time, among Knights of the Garter, or the Golden Fleece, and even among provincial mayors. Indeed, the phrase " collar day," as an ordinary concomitant of courtly ceremonial, is to be found in almost any issue of the Lord Chamberlain's instructions

Fig. 309.—Five-coiled Gold Torque (in the British Museum) from the Borders of Glamorganshire.

for " red-letter " days, when there are special Collects, Epistles, and Gospels said in Church, and when the judges wear red in the Courts. The only difference between the modern insignia of rank and the Celtic torque is the loss of the significance involved in the spiral form of the primitive decoration.

The other and larger forms of the conventional cylindrical spiral, in the rising curves often carved round a column, will be dealt with in my next chapter, for they will be a suitable introduction to those developments in architecture which used the spiral as a true and functional element in constructive strength, and not merely as the ornament or symbol which has formed the main theme of this chapter.

Fig. 310.—Gaulish Bronze Torque from the Morel
Collection in the British Museum.

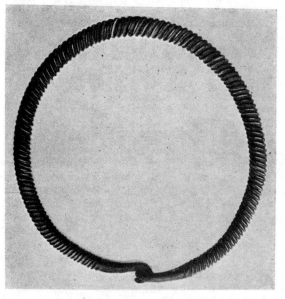

Fig. 311.—Bronze Torque from the Thames near
Westminster. Late Bronze Period.
(In the British Museum.)

NOTES TO CHAPTER XV.

CONVENTIONAL SPIRAL OF AURIGNACIANS.—The following letter was received from " B. R."

" You say that the Aurignacians probably got their conventional spiral from a land snail. Your readers may therefore like to see the lines of Acavus Phœnix from Ceylon (Fig. 312), which suggests the prehistoric spiral : can it also be the *limace*, of which old French architectural writers speak in referring to the volute of the Ionic Column ? "

ALBERT DURER AND THE VOLUTE.—Jean Goujon's original passage runs as follows : " Toutes les quantitez et mesures des chapiteaux Ioniques sont bien comprises dedans le texte et n'y ay trouvé aucune erreur ; mais bien me semble que le circumvolution ou tournoyement

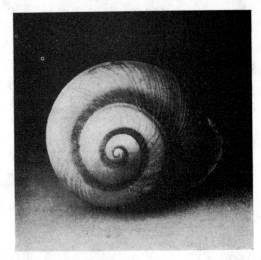

FIG. 312.—A LAND SNAIL (ACAVUS PHŒNIX) FROM CEYLON.

de la Volute *autrement Limace*, n'est assez clairement expliqué à l'occasion de quoy j'en ai faict une figure mesurée de poinct en poinct, par laquelle pourrez cognoistre que noz modernes ont toujours failly à la faire jusques à present, veu qu'ilz ne la tournoient *en rondeur de limace*, ains escale, et afin de ne frauder personne de sa deue louange, je confesse qu'homme ne l'a point faicte selon l'entente de Vitruve fors Albert Durer paintre qui l'a tournée perfectement bien, et ce que Monsieur Philander en a faict en ses annotations Latines a esté pris sur icelluy Albert mesures." For further information concerning Dürer's Volute, see Chapter XIX.

SPIRALS AND THE LOTUS.—See " The Grammar of the Lotus," by Professor W. H. Goodyear (Sampson Low, London), and the *Architectural Record*, Vol. II., No. 2, December 31st, 1892. For another good reference to the same subject, see " Gli Ornamenti Spiraliformi in Italia," by Angelo Angelucci (Turin, 1876). Its press-mark in the British Museum is 7704, g, 17 (5).

MYCENÆAN SPIRALS.—In Schliemann's " Mycenæ" (John Murray, 1878), a very large number of these are illustrated. On p. 82 is a sepulchral stele carved with twenty-four spirals united with each other, and representing a band in relief, which covers the whole field of the upper compartment with a network almost exactly comparable (in its rectilinear form) with the well-known key-pattern. These stelæ are unique of their kind and often exhibit the filling up with manifold beautiful spiral ornaments the space not covered by the forms of men and animals, much after the manner (says Schliemann) " of the painting on the so-called orientalising vases," but without that ornamentation derived from plants which seems characteristic of the same class of Greek work.

AGE OF MAN ON THE EARTH (p. 270).—The famous Piltdown skull was found by Mr. Charles Dawson in 1912. Its two molar teeth are indistinguishable from those of man. But Dr. Smith-Woodward's reconstruction of the brain-pan gave a capacity of only 1,100 cubic centimetres, and much controversy was aroused by Dr. Keith's reconstruction, which gave 1,600 cubic centimetres, or rather above the average of the normal modern brain. Then, in the summer of 1913, Mr. Charles Dawson and a French anatomist, hunting over the original gravel at Piltdown, came upon one of the canine teeth missing from the lower jaw of the skull. It was an extraordinary confirmation of Dr. Smith-Woodward's views (already strengthened by Professor Elliot Smith's opinion) that the skull showed a brain capacity no larger than that of the smallest modern brain, though it was twice as large as that of the biggest ape. The skull has been christened *Eoanthropus Dawsoni*, and is evidently from one of the races which were not a direct ancestor even of the Neandermen, still less of modern man, but died out in early Pleistocene ages, owing to their comparatively primitive brain development, which was reflected in certain ape-like characteristics of the jaws and teeth. Another race which died out is represented by the Java skull, *Pithecanthropus erectus*. Still later came *Homo neanderthalensis*, who was equally unable to survive. No doubt many more races disappeared before *Homo sapiens* was developed and our true ancestors came on the scene—not men-like beings, but real men at last. And how long did it take again before they developed Aurignacian art (p. 268) ?

THE IONIC VOLUTE.—See " The Geometry and Optics of Ancient Architecture, Illustrated by Examples from Thebes, Athens, and Rome," by John Pennethorne. Published by Williams & Norgate, 1878.

CHAPTER XVI

The Development of the Spiral Staircase

"The best sign of Originality lies in taking up a subject and then developing it so fully as to make everyone confess that he would hardly have found so much in it."—GOETHE.

SPIRAL COLUMNS—RARITY OF LEFT-HAND SPIRALS—RIGHT-HANDED ARCHITECTS AND WORKMEN—ACCIDENTAL CAUSE OF A TWISTED SPIRE—EFFICIENCY AND BEAUTY—PRACTICAL ORIGIN OF SPIRAL STAIRCASES—GRADUAL EVOLUTION—CENTRAL SUPPORT—THE HAND RAIL—DEFENCE AGAINST ATTACK —DOUBLE SPIRAL STAIRCASES.

IN the last chapter we have seen how the classical Greek masters developed the conventional flat spiral into the Ionic volute, the most beautiful adaptation possible to architectural decoration. It is curious that they seem scarcely ever to have used the cylindrical spiral in the same way, and to find this use we must come much nearer to the modern builders. The only instance I have been able to discover of cylindrical spirals used conventionally before the Christian era as the decoration of a column is a fragment from Enkomi, in Cyprus, a cast of which in now in the Early Vase-room of the British Museum. It was illustrated by Professor Lethaby in his "Greek Buildings" (Batsford, 1908), and has been redrawn for these pages (Fig. 313). It seems to be a portion of a marble shaft of a Mycenæan lamp, and another lamp at Palaicastro shows a very similar pattern, which may possibly be a conventional derivation of the papyrus blossom. The pillar has an important place in Mycenæan art, for the noble design of the well-known Lion Gate represents a sacred pillar guarded by two lions, "the pillar of the house,". the pillar of Mycenæ.

FIG. 313.—MARBLE SHAFT OF A MYCENÆAN LAMP IN THE BRITISH MUSEUM. (Lethaby.)

I have spoken already, in dealing with the flat spiral, of such smaller objects as torques or sceptres, and I need not add here

any instances of a similar employment of the cylindrical spiral in balustrades, bedposts, or articles of furniture. For its most attractive manifestation we have to look at such larger and more integral portions of an architectural scheme as columns, and the most beautiful instance easily discoverable is what is called the "Prentice's Pillar" in Rosslyn Chapel (see Fig. 314). Here the chief charm of the work is due to the fact that its separate right-hand spirals, proceeding from their separate points at the base, envelop with their long and slender ascending curves a pillar which is artfully grooved in perpendicular lines, so that full value may be given to the encircling decoration.

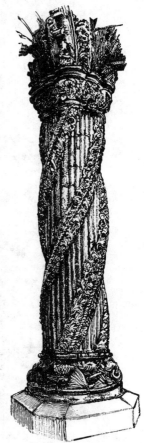

The notable point about the Saxon sceptre I mentioned in previous pages was that its rising spirals were left hand. The same sinistral formation was carved on the pillar of St. Bernwand, at Hildesheim, in 1022. The four great columns, also, which are set up behind the high altar of St. Mark's in Venice are all carved with left-hand spirals. If two had been carved in one way and two in the other for the sake of symmetry, there would have been nothing remarkable about them. But they are all sinistral; and some special value connected with this rarer twist is suggested by the tradition that they originally came from the Temple of Solomon in Jerusalem. Dr. Greenwell in his lecture on Durham Cathedral (1886), observed that the spirals on the piers of the choir and transepts were " contrary to the ordinary direction of those on a screw"; that is to say, they were sinistral. I know of

FIG. 314.—THE "PRENTICE'S PILLAR" AT ROSSLYN.

no other instance of so many in one building.

We have observed already that the more usual curves of the spiral of a natural object, such as a plant, growing upwards from the ground, are right hand, as in the Rosslyn pillar; and it is a fair deduction that left-hand spirals are used as rarely in architecture as they are found in Nature. Even if we refuse at present to consider the possibility of any mystical meaning

having been attached to the left-hand spiral as such, we must acknowledge that since man must build upwards, and since there are more right-handed builders and architects than left-handed, we should expect right-hand spirals to occur more often in building, because left-hand curves would be a conscious effort to a right-handed man, and would therefore be only explicable

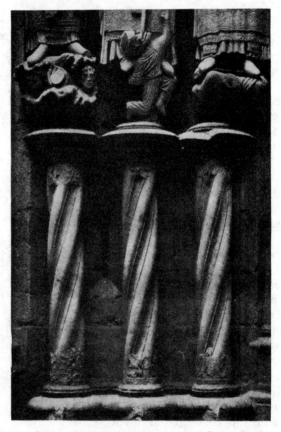

FIG. 315.—SPIRAL COLONNETTES FORMING THE BASES OF STATUES
IN THE NORTH PORCH OF CHARTRES CATHEDRAL.

either by definite constructional necessities or by some acknowledged symbolism in a rarer form ; and such explanations would only be superfluous if we knew the builder or designer was a left-handed man.

In the Chapel of the Holy Innocents in the crypt of Canterbury Cathedral (beneath St. Andrew's Chapel) there is a short column, with a shaft 4 feet in height, showing spiral bands running upwards to the right with very fine effect ; and it is curious that the same

crypt provides an interesting example (in St. Gabriel's Chapel, beneath St. Anselm's Tower) of a column with a shaft 5 feet in height, which begins with a left-hand spiral in its grooved decorations, but halfway up these grooves are changed to a right-hand spiral, with a band of irregular incised diamonds to mark the transition, as if the workman had felt that the design had been begun wrongly, and had therefore corrected its direction. This was built in 1103, and in 1121 a further development in spiral decoration is observable in the same building. If you stand in front of the Lady Chapel in St. Ernulf's Crypt, and look westwards down the central alley, you will see eight pairs of columns, of which the second, fourth, sixth, and last exhibit a spiral arrangement of grooves. In the first two, a right-hand spiral is elaborately decorated throughout. In the next pair the bands of decorations are cut alternately in right-hand and left-hand spirals, and end in straight fluted grooves. The left hand-arrangement is never permitted to stand alone ; from which we may perhaps infer that, if there was one left-handed man among the masons, his right-handed comrades took care that he should never complete a design which did not fall in with their idea of what was appropriate. The colonnettes of the north porch of Chartres Cathedral (Fig. 315) are nearly all right-hand spirals, even where symmetry might have demanded the left-hand.

But the cylindrical spiral itself is not invariably a happy form of mere decoration in every architectural position. Some such idea of growth, of support, of strength, as is shown in the " Prentice's Pillar," or the Chartres Statue-bases, seems as essential to it in art as in Nature. The staircase of the Rundthor at Copenhagen is, for instance, a far more satisfactory example than the twisted copper spire in the same locality ; or than the corkscrew-shaped spire of Gelnhausen, near Frankfort-on-the-Main ; or than the stone spirals in one of the small steeples of the Palais de Justice at Rouen, near the Rue Jeanne d'Arc. I am informed that the twisted spire at Chesterfield, which is made of a timber frame covered with metal, was not originally constructed in this screw-like form, but has been twisted into its present shape by the decay and partial failure of some timbers, an accidental origin for an architectural form which must carefully be distinguished from a structural shape intentionally created from the first. Mere imitation of externals without structural necessity is, in fact, as barren here as it must ever be.

Of course the architect is primarily concerned rather with immediate and technical problems of planning and construction than with any recondite symbolism or even with any æsthetic effect which may be perceived in the lines of his achievement by

sensitive critics, though no doubt he may sometimes pay more attention to these matters than would his friend the engineer. Indeed, the engineer has sometimes been too prone to concern himself with his idea of practical efficiency without any consideration either for beauty or for ugliness ; and it must be remembered that I am dealing now with structural form alone, neither with mere ornament nor with colour. But it is some consolation, in the address read to the British Association (1912) by Professor Archibald Barr (who begins with a quotation from Leonardo da Vinci), to find the highest technical authority for a theory often

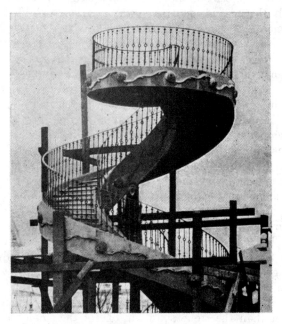

FIG. 316.—SPIRAL STAIRCASE OF FERRO-CONCRETE.
(Built by Messrs. L. G. Mouchel and Partners, Ltd.)

expressed in various forms in these chapters, a theory which amounts to the belief that " ugliness " implies some functional failure both in things made and in the world of Nature, whereas the perfect performance of some necessary function usually implies the accompaniment of " beauty." I need not, therefore, further emphasise the interest of Professor Barr's pronouncement that efficiency in engineering is never incompatible with beauty, except to add its just corollary that the basis of all fine architecture is the recognition of the beauty of pure structure. We have been examining the forms of shells, and we observed that the chief reason why so many of them appeal to our æsthetic

sense of beauty is that we have recognised, after due examination, that the structure we admire is the result not merely of a perfect adaptation of a shell to its inhabitant's chief needs, but of the survival of certain delicate varieties of form which fulfilled their special function more fitly than other varieties which have

died out. In just the same way an engineering feat, whatever be its size, which exactly performs the work it has to do will rouse the same æsthetic sense of fitness and of beauty to which a lovely flower or shell appeals.

We must remember that functions which may be concealed in architecture are usually not merely visible, but prominent in engineering. Only very rarely do we realise their existence without being able to perceive their form, as in the case of the great railways across the American continent, where, as I need hardly perhaps remind the traveller, he would never have got across the Rocky Mountains in a train if the track had not been planned on a feasible gradient by the scheme of spiral tunnels gradually ascending like

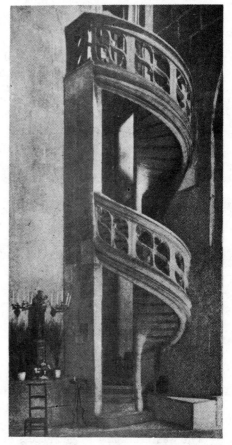

FIG. 317.—SPIRAL STAIRCASE IN THE NORTH TRANSEPT OF AUTUN CATHEDRAL.
(From a photograph by F. H. Evans.)

a corkscrew. But a spiral may be used not merely to assure a gentle gradient ; it may be most useful to secure an easy ascent within a space which is limited either horizontally or vertically. The staircase illustrated in Fig. 316 is an example in which the problem of height presented no difficulty, but the horizontal space available was obviously to be as restricted as possible. The structure is built of Hennebique

ferro-concrete, and its photograph I owe to the courtesy of Mr. Robinson, of Messrs. L. G. Mouchel and Partners, Ltd., the well-known civil engineers in Victoria Street, Westminster. Its lines scarcely suffer by comparison with the beautiful masonry of the somewhat similar structure built so many centuries before in the Cathedral of Autun (Fig. 317), and showing a left-hand spiral. In the north aisle of the choir of Ely Cathedral is a right-hand version of the same design, enclosed within a hexagonal screen of pierced carving.

It is in the form of the staircase that architects have chiefly been concerned with the spiral in its best functional expression, apart from any mere ornament either of volute or of column ; and we must now try briefly to trace the way in which the spiral staircase evolved its very matter-of-fact origins into the thing of beauty it eventually became. Those origins go much farther back than is usually supposed, for in the Babylonian architecture of 6,000 B.C., we find inclined planes winding helically (without steps) round the *outside* of tall towers, as at Tel-lo. Professor Lethaby says of the Greeks, on what authority I do not know, that " the spiral staircase seems to have been their invention." The Romans had certainly advanced sufficiently not only to put steps on their helical planes, but to put their spiral *inside* a tower, as it is found in the column of Trajan. The rough screws they filed out have been found among the ashes of Pompeii, though they seem not to have known enough mechanics to be able to make a nut that would actually correspond, and the silence of Vitruvius on the design of their spiral staircases has somewhat detracted from any ardour of research into a question with which Roman architects were undoubtedly familiar.

When the first great square or circular feudal fortresses or keeps were built the walls were of such enormous thickness that the space for the living rooms was very considerably curtailed, and a staircase after the usual London pattern would have left hardly any room at all either for the owner's family or for his garrison. Yet it was necessary to get access quickly and easily—in some cases secretly—from one floor to another ; and when a lady was living in the same building with a number of soldiers, she might desire, even in those rough times when dignity counted for more than decency, to have a separate staircase to herself, leading perhaps from her boudoir to the dais of the hall, while a different stairway, at the opposite angle of the room, admitted the crowd of men-at-arms who sat below the salt. To manage these separate approaches by means of two " London " staircases would have meant a waste of room even more fatal than our own modern cramped arrangements. The problem was first solved, I imagine,

by providing a shaft in the thickness of the wall from one floor to another, the entrances of which opened in the corner of each room. But it would be impossible to drop a man down this shaft like a parcel, still less to climb up without help ; and a ladder, whether of wood or rope, would necessarily be at a dangerously acute angle. So they began by inserting a brick or slab of stone at the bottom of a shaft, which was just like a long hole in a solid body ; and into this containing circular body a slab of stone large enough to tread upon was placed a foot above the floor and immediately to the right of the entrance. Continuing your natural movement upwards, you must then place another stone in position, a little higher than the other, and further forward—that is to say, further round this internal shaft up which you wish to ascend. Continuing in this way you will gradually fix your slabs of stone to the inside of the shaft in constantly ascending right-hand spiral curves until you reach the top ; and with a little practice you will be able so to adjust the angle of the spiral that the end of it exactly reaches the doorway at the top. The wall will always be on your right as some support, but there is a dismal cavity on the left hand, and a false step would hurl you headlong through the middle of the brick-bristling shaft to the bottom. To avoid this, in your next experiment you take rather longer slabs of stone and diminish the danger ; but a time arrives when you cannot increase their length, owing to the fact that, though one end is firmly inserted in the wall, the other stretches out into emptiness, and a heavy weight might entirely displace it. This would have been a critical moment for the builder whose shaft was of a large diameter, and some modern architects refuse to believe that any workman would pin a step into the outer wall without supporting its other end from beneath. This may be correct of the present day. But it must be remembered that I am confessedly now speaking of the origins of a certain form of stonework, and that the makers of this stonework may quite possibly have gained experience from timber constructions which have no longer survived. We are, indeed, in some cases sure that the hollow cylindrical stone shafts in certain ancient buildings were originally filled with wooden structures which have now disappeared, and which could always be destroyed (or taken out) in case of need by those who originally used them. It must also be remembered that in Wren's famous " geometrical staircase " in the southern tower of St. Paul's (which I shall illustrate in later pages) (see Fig. 342, Chap. XVIII.), the inner ends of the steps, pinned into the wall, were the only means of support, which is entirely in accordance with my hypothesis. A well-known and clever use of the spiral

in a shaft is to be found in three staircases cut in the solid chalk of Dover cliffs, which provide separate approaches for officers, privates, and civilians from the town up to the old Rifle Brigade Barracks behind the inner harbour.

Since the first of the primitive connecting shafts in feudal fortresses was probably quite small, I think the true solution of the whole problem rapidly made its appearance. In the case of a shaft, for instance, of 6 feet in diameter, if all the slabs of stepping stones projected 3 feet 6 inches from the wall they would overlap. The first case of overlapping may have been an accident; but, at any rate, it was soon found that this method entirely covered up that dangerous hole in the middle which I mentioned; and as soon as this was effected the greatest discovery of all came simultaneously to light. For as the stairway rose, a central column was seen to be rising with it on the left hand of any person ascending the dextral helix of the stairs (see Fig. 318); and by degrees the masons learned so to cut their stepping stones that this central column was not only built up by these stones, but also in its turn supported them, for they now overlapped both at their ends and at their edges. And so at last the outer wall on the right-hand side fell into its true position of a mere protective shell, while the essential feature of the whole was the central column round which the fan-like steps revolved.

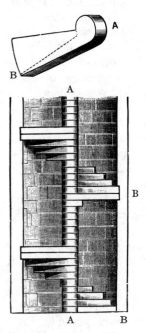

FIG. 318.—PRIMITIVE SPIRAL STAIRCASE, WITH PLAN OF ONE STEP.

To explain this first development of the real spiral staircase (instances of which may be found in most lighthouses and in the Tower of London), I reproduce here a drawing by Viollet-le-Duc, which shows one entire revolution of the steps, and also gives the drawing (Fig. 318) of a single step which contains its own portion of the central pillar. It will be noticed that the architect has not yet reached the idea of a handrail, and is merely producing the simplest necessity for internal communication without any idea of decorative effect. Some kind of handrail for the left hand soon became necessary, and the first was probably a rope which was firmly attached to an iron ring at the top of the stairway and followed its curves down to the bottom, being kept at the

right height by an occasional staple on the way. By degrees
the stone of the central column got worn into a regular groove by
the constant pressure of this rope, and it soon became evident
that the handrail might become not merely an integral part of
the stonework of the staircase, but a very definite addition to
the beauty of its decoration.

When once the essential feature of the central column (or newel)

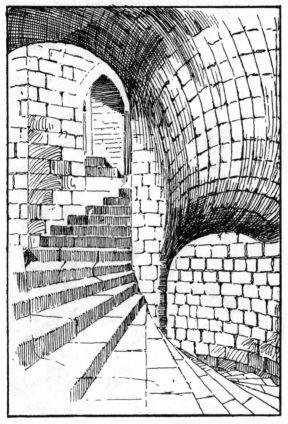

FIG. 319.—STAIRCASE IN COLCHESTER CASTLE.

had been reached further development became more rapid and
a structure hitherto limited to somewhat narrow shafts was seen
to be capable both of improvement and of greater size. A spiral
inclined plane vaulted beneath and flat upon the top was built
from the central column to the walls, and upon this the steps
were placed, so that it was now possible to make them of two or
three slabs each instead of only one. A well-known example of
this, at Colchester Castle, has been drawn for these pages in

Fig. 319. The classical instance of it is, I believe, the Vis de
Saint-Gilles, which I have seen in the north corner of the ruined
sanctuary of the famous church in Provence. You can realise
its structure by imagining that the round arch of the doorway
has been hung by the pillar on your left to the central shaft of

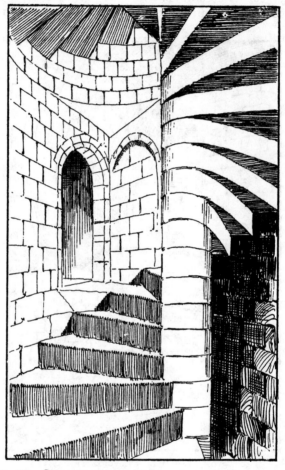

Fig. 320.—Staircase in the Painted Chamber, Westminster.

the staircase, and has revolved round that shaft as it gradually
rose, thus alternately supporting and covering the rising spiral
of the steps. The breakage of the crown of this staircase at the
top reveals the extraordinary delicacy of measurement necessary
in cutting and laying the successive courses of twisted stone.
The stairway at Colchester is of brickwork plastered over, and is
an example of the left-hand spiral, as is that in the Painted

Chamber at Westminster (Fig. 320), which is more like the primitive design drawn by Viollet-le-Duc, and has no support for the centre of each stair. A good instance of Gothic vaulting used in a spiral stair is shown in Fig. 321 from Lincoln Cathedral,

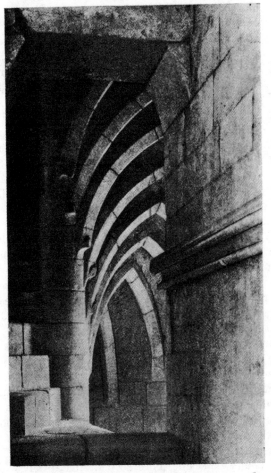

FIG. 321.—SPIRAL STAIR IN THE S.W. TURRET OF LINCOLN CATHEDRAL.
(From a photograph by F. H. Evans.)

which I am privileged to reproduce from one of Mr. Frederick H. Evans's beautiful photographs.

The conditions of mediæval life made spiral staircases peculiarly valuable to the feudal architect, for doors could open into them at any height in their spiral upward course ; they were at first of simple and rapid construction, which could be easily repaired. They could be held by a few men against a hundred foes ; they

joined the very top of the building with the very bottom, and the slope of their ascent could be made gentle or steep at will.

We have, of course, long ago rejected such useful and beautiful possibilities in London houses, which are as narrow and lofty as a feudal keep, perhaps because we could not easily get our furniture and other cumbrous living apparatus up and down a spiral ; yet, with these methods, it would be possible to construct two interior spirals where there is now scarce room for one narrow stairway and a set of useless landings. The danger of fire would certainly be reduced if one of these spirals were constructed of uninflammable materials, or even built outside the main walls of the building. At Hertford College, Oxford, the architect seems to have remembered a sixteenth-century model, but to have been unable to find workmen capable of carrying out a sixteenth century design. At any rate, the result is a somewhat inelegant compromise between old and new.

It is strange that the modern use of this beautiful form of staircase is almost entirely restricted (in the British Islands) to lighthouse keepers ; for it is only found in towers, and dwellers in the Martello towers along the coast are rare. The Border " Peels " were built only for defence, as were probably Dacre Castle, in Cumberland, or Belsay, in Northumberland. In Ireland the form survived much later. In the old part of Blarney Castle the stone used does not contain the full circle shown at A in Fig. 318, but only half a circle, with the result that the columns in the centre of each stair are only semi-cylindrical, and exhibit one flat surface. But a very curious fact I observed there is that throughout this old part of Blarney every staircase without exception is sinistral in form, which shows that Cormack M'Carthy, the Strong, fully appreciated the advantages involved in having his own right hand free to attack an ascending foe, who would only be able to use his left hand in defence. There is a spiral staircase in the stronghold of the Red Douglas, Tantallon Castle, near North Berwick, and this also is sinistral, which may be for the same military reason as that suggested at Blarney.

As the country became more settled, the tower, which was first used simply for safety, was gradually built for pleasure too, as was Nunney Castle, in Somersetshire, or Friston Tower, near Ipswich, or Middleton Tower, near Lynn, in Norfolk, which is of brick, and still (I believe) inhabited. But by far the most interesting structure of the kind, also of brick, which I have heard of in this country is Tattershall Castle, in Lincolnshire, which was designed by no less a person than William of Waynflete, Bishop of Winchester, for Ralph, Lord Cromwell, Lord Treasurer of England from 1433 to 1443, who built a stately house for him-

self in his own country, just as Chenonceaux or Azay le Rideau were built by Financier-Generals of France. Apparently his family had no connection with the ancestors of Thomas, *malleus monachorum*, or of the still more famous Oliver, both of the same name. Many of the fireplaces in the present House of Commons were modelled after the magnificent specimens at Tattershall,

FIG. 322.—OAK STAIRCASE IN ST. WOLFGANG'S, ROTHENBURG.

but the feature of the place which I now wish to emphasise is the grand staircase of 175 steps, which is in the south-east turret and gives communication to forty-eight separate apartments, four of which are very large. Its stone handrail, sunk into the brickwork, and beautifully moulded to afford a firm hand grasp, is original in conception and probably unique in design. This is the only staircase in a building 87 feet long, 69 feet wide, and 112 feet high, which is almost entirely constructed of small and

brilliantly coloured bricks from Flanders, or, as some think, from Holland. The curve of this splendid staircase is of the rare sinistral formation, and is contained within a shaft 22 feet in diameter built of enormously thick walls. The same stone handrail sunk in brickwork is to be found in the spiral staircases of Eastbury Manor House, Barking, built in 1572.

In Fig. 322 I have given an example of a wooden spiral staircase from the church of St. Wolfgang in Rothenburg. At

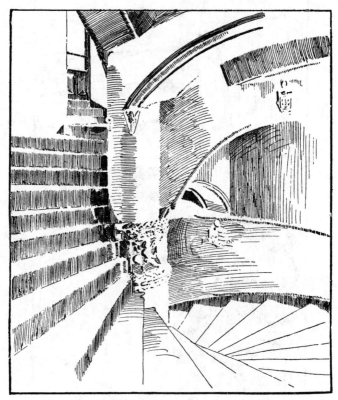

FIG. 323.—THE GREAT STAIRCASE OF FYVIE CASTLE.

Shoreham, Sussex, and at Whitchurch, Hampshire, church staircases of wood in the same form may also be examined. But it is, of course, with stonework that we are now chiefly concerned.

One of the largest stone newel staircases in the United Kingdom is that in Lord Leith's castle of Fyvie, which is another example of the left-hand formation (Fig. 323). Billings, the author of " Baronial Antiquities of Scotland," thought it showed the same French influence observable in that built for Falkland Palace sixty years before. But neither in detail nor in general character

can Fyvie be described as French. Each stair is of two great slabs, and where they join the newel their straight outline is varied by two semi-circular mouldings of somewhat rough design and workmanship. They are supported upon arches moving upward at every quarter turn round the central pillar, which is adorned with a band of carving at every full turn, and never stands out, as it does in the best French examples, owing to the somewhat clumsy method of vaulting. The date " 1603," carved at the head of the. stairway, probably indicates the year of its completion. A better example of ribbed vaulting, which does suggest French work, is at Linlithgow Palace.

A distinct advance was made when French architects first realised that spiral staircases, instead of being englobed within the thickness of interior masonry, might be carried in a turret clinging to a wall, or might form an independent feature (cf. Fig. 317) which would not merely be useful, but highly decorative as an addition to the main structure. One of the earliest of such stairways was that built in the Louvre (since destroyed) for Charles V. Raymond du Temple found that the Paris quarries of 1365 could not furnish big enough slabs in time, for over 6 feet in length was what he needed. So a selection of tombstones from the Churchyard of the Innocents was made ; and I can conceive no

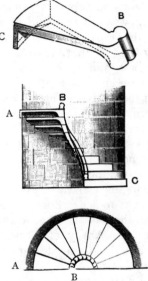

FIG. 324.—ELABORATE SPIRAL STAIRCASE, WITH PLAN OF IMPROVED STONEWORK.

stranger material than this " derangement of epitaphs." Surely the devil on Notre Dame must have chuckled ; for of what else are made the steps which lead to hell, even if the paving stones are—on good authority—of a different substance ?

It was soon found that there was a distinct gain both in freedom of access and in methods of lighting when the whole staircase was placed outside the walls, as in the famous case of the " Escalier à jour " at Blois. By the time that this idea was realised, the architect had made a very distinct advance, and the mason who built for him had attained a skill which seems completely lost in his profession nowadays. The delicacy of measurement implied, for instance, in the single stone and in the completed

spiral of the next stairway I reproduce from Viollet-le-Duc (see Fig. 324), can scarcely be appreciated by anyone who has not endeavoured to do what is here accomplished. For it will be observed that each step is light yet strong, and carries with it not only the central spiral, but a handrail as well, while the construction is so artfully managed that the solid central column becomes lighter and stronger as a hollow cylinder, and, though every step is firmly balanced in its place, yet a stone dropped from the top of this staircase would fall to the bottom without touching anything.

The beautiful possibilities of this method of construction were in fact soon discovered, and, as is so often the case in other matters, men went to extremes of geometrical enthusiasm which would be the despair of modern workmen. This may partly be explained by the fact that life in a feudal castle must have been very dull at best, and a tricky staircase like the one just mentioned may have been a godsend. Not enough of them are still in existence for me to give as many examples as I should like ; but at Chambord, in Touraine, there is still a *tour de force* in the way of spiral staircases which would be very difficult to beat. It contains two spirals, one within the other, so arranged that a man may ascend from the bottom, while the lady is tripping downwards from the top ; yet they will never meet or see each other, though their steps and voices are perfectly audible. The thing is a delight to generations and armies of tourists at the present day, and the pleasure it gave the courtiers of Francis I. in that Gargantuan Abbey of Thelema, in which he combined fortress, hunting seat and pleasure palace, after the dark days of Madrid, may better be described in the pleasant tales of a Brantôme or the picturesque exaggerations of a Rabelais.

An earlier example of this geometrical conundrum in construction was solved in a simpler way in the Church of the Bernadines in Paris, which was begun by Pope Benedict XII. in 1336. According to Sauval, who published his " Antiquities of Paris " in 1724, this contained a dual spiral staircase arranged in an oval, combining a dextral with a sinistral helix, but using two newels for the purpose instead of the single central column built at Chambord. Somewhat similar double stairways are to be found at Pierrefonds, in Beverley Minster, and (among modern buildings) in the new Courts of Justice in the Strand. A simple and good example in England is the double spiral in the tower of Tamworth Church, where two left-hand curves are cleverly juxtaposed, so that one man can ascend 101 steps and another can descend 106 steps without seeing each other, the same newel serving for both (Fig. 325). It is not my present purpose to go

more into detail concerning such *jeux d'esprit*, for I am in search rather of the beautiful in construction than of the merely *bizarre ;* but they serve to show some of the possibilities of a spiral, and of the attractions which it exerted upon a constructively imagi- native mind ; and it may be of interest to observe that all the staircases I have chosen to illustrate exhibit left-hand spiral curves.

It will be appropriate to end this section of our inquiry with a quotation from that address by Professor Barr to which reference has already been made. " Some at least " (said the President

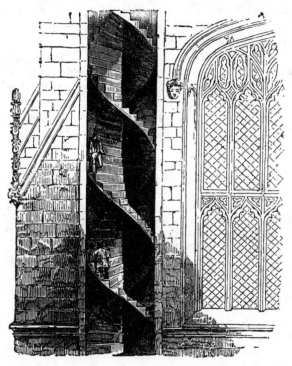

FIG. 325.—DOUBLE SPIRAL STAIRCASE IN TAMWORTH CHURCH TOWER.

of the Engineering Section of the British Association in 1912) " of those to whom we owe the greatest advances in the fine arts were eminent also in the arts of construction. We may claim such men as Michelangelo, Raphael, and Leonardo da Vinci as masters in the art of construction as well as in those with which their names are usually associated. . . . A structure of any kind that is intended to serve a useful end should have the beauty of appropriateness for the purpose it is to serve. It should tell the truth and nothing but the truth. . . . Our works, like the highest creations in Nature, should be beautiful and not beautified. . . .

From the racing yacht the designer has been forced, by the demand for efficiency, to cast off every weight and the adornments that so beset the craft of earlier times, with the result that there is left only a beautifully modelled hull, plain masts, and broad sweeps of canvas, and we can hardly imagine any more beautiful or graceful product of the constructive arts. These examples will serve to illustrate the contention that the attainment of the highest efficiency brings with it the greatest artistic merit." A good modern example of this may be found in Brunel's famous railway bridge at Maidenhead, in which the quality of the bricks and the subtilty of the curve were chosen to secure the most absolute efficiency. They have resulted, as anyone may see, in " the greatest artistic merit."

It is almost exactly in accordance with these ideas that I propose, in my next chapter, to indicate how much more finely spiral staircases have been built when a great designer had the task of planning them, and to suggest a few parallels between the lines of architectural construction and the lines of Nature's handiwork.

NOTES TO CHAPTER XVI.

SPIRAL STAIRCASES.—See "Staircases and Garden Steps," by G. C. Rothery (T. Werner Laurie), also "The English Staircase," by Walter H. Godfrey (Batsford), in which the most beautiful spiral formation shown is that in the hall of Sheen House, Richmond, a typical example of the best Georgian style developed by the Adam brothers, making every part subservient to the upward gliding plane of the ascent. Illustrations are also given of the stone spirals in Castle Hedingham, Essex, and Linlithgow Palace. They are all somewhat clumsy, compared with French work. The staircase drawn in the famous " Philosopher Meditating," by Rembrandt, is another indication that neither in England nor in the rest of Europe, before the 18th century, had the Spiral Staircase been so beautifully developed as in France.

CHAPTER XVII

Spirals in Nature and Art

Nosse fidem rerum dubiasque exquirere causas.

SHELLS AND SPIRAL STAIRCASES—PRACTICAL PROBLEMS AND
BEAUTY OF DESIGN—EFFICIENCY AND BEAUTY—LEANING
CAMPANILES INTENTIONALLY DESIGNED—CHARM OF IRREGU-
LARITY — THE PARTHENON — ARCHITECTURE AND LIFE —
QUALITY OF VARIATION IN GREEK ARCHITECTURE —
EXPRESSION OF EMOTIONS — ARTISTIC SELECTION FROM
NATURE

A CONNECTION between shells and spiral staircases, in the
minds of those who were responsible for the scientific terms of
conchology, as now accepted, has been already indicated. A
shell exhibiting the usual right-hand spiral is called *leiotropic*
because an insect ascending from the mouth
or entrance to the apex would constantly *turn
to the left*, the columella (or central shaft)
being always on its left hand and the outside
wall on its right. In the same way, the rare
dexiotropic shell, exhibiting a left-hand spiral,
necessitates a constant turning to the *right* in
going up its curves from the largest to the
smallest. The parallel was carried further by
these same scientific writers in giving such
names as *Solarium maximum* (Fig. 36, Chap. II.)
or *Scalaria scalaris* (Fig. 85, Chap. III.) to
shells which suggested various forms of staircase, and I have set
Voluta scalaris (Fig. 84) at the head of this page with an intention
which will become more evident in my next chapter.

Fig. 84.

Voluta scalaris.

It is curious that though, as I have tried to show in the last
chapter, the origin and development of spiral staircases are
purely practical, and though the problems they solve are always
practical problems, yet as the beauty of the perfected spiral
staircase grew under the hands of capable designers, so it
approached more and more nearly to the forms of those natural
objects which have not only grown into the lines most adaptable
to their survival, but also have developed extraordinary beauty
in the process. A comparison will therefore be quite possible

between the two divisions, without for a moment hinting, at present, that an architect has deliberately taken any natural object as his special model for a particular staircase. And if shells have certainly suggested staircases to the scientific mind, it is equally certain that staircases have suggested shells to the popular imagination, as may be proved by the nomenclature of certain well-known architectural treasures in Italy and elsewhere.

At Fiesole, for example, in the convent of San Domenico, there is a flight of eight steps (leading down to the cloister) which is so exquisitely arranged in the form of a shell that the little building is called the "Scala della Conchiglia." At Venice a more famous example may be found in the Palazzo Contarini (Fig. 326), near the "Congregazione di Carita" (No. 4,299), which is reached through the Calle della Vida out of the Campo Manin. Its shape has earned it the name of the "Scala del Bovolo," and I have been tempted to wonder whether the architect of this dextral helix, with its exquisite rising spiral of light archways, could have seen the shell so aptly called *Scalaria scalaris* (Fig. 85, Chap. III.), which exhibits exactly the same formation. In this shell the mouth or entrance has gradually grown round and round with the growth of the inhabitant, leaving a little colonnette behind it as it moved, until it reached the place which is equivalent to the door in the staircase to which I compare the shell.

No one, as a matter of fact, appreciates better than I do the improbability of the architect of the Palazzo Contarini having either seen *Scalaria scalaris* or adapted its lines in making his design. Yet it is evident that in each case the problem involved has produced a thing of beauty, because the practical questions are answered by the architect in the best and fittest terms, and because the shell developed for *Scalaria scalaris* is the best and fittest formation for its survival. I think those who have followed me so far will at any rate be ready to accept this next step in our inquiry, whether they be conchologists or architects or merely intelligently interested in the work of both. And, if so, they will perhaps be gratified by a further slight coincidence which possibly suggests that the owners of the staircase were not unfamiliar with the beauty and the legends of the shell. At least Bellini may have thought so, for one of the "Allegories" which he painted for the Contarini family is now in the Gallery of Venice, and it represents the shell I reproduced in Fig. 26, Chap. I.

Even when in its right place, in a staircase, the spiral in architecture needs clever handling if it is to be effective, as may be seen in the clumsiness of the brickwork in the house of Tristan l'Hermite at Tours, and the ambitious failure of the clustered

sinistral spiral in the stone stairway of the cloisters in the same town. In each case the steps, too, are straight and inartistic. But the " Bovolo " is well done. The massive column of its newel, in which the steps are engaged, rises from base to roof, from the horizontal colonnade at the bottom to the horizontal colonnade at the top, with its five complete spiral turns between, and its carved handrail resting on a circular balustrade which describes its even curves throughout behind the outer columns. You may see a similar effect of a continuous balustrade with colonnettes in *Terebra dimidiata* (Fig. 327), while *Terebra consobrina*, in its lower coils, suggests white arches curving upwards against a dark background. It is the outer columns of the Scala del Bovolo, supporting light arches on their slender

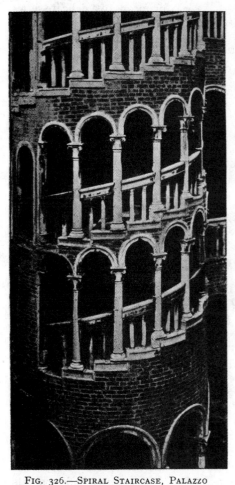

FIG. 326.—SPIRAL STAIRCASE, PALAZZO
CONTARINI, VENICE.

FIG. 85.—SCALARIA
SCALARIS.

capitals, which are the chief beauty of the whole construction, for they rest on stepped stone bases which form an exquisitely contrasted broken line beneath and outside of the continuous balustrade ; and how infinitely finer is the formation of these ascending curves than a mere system of superimposed circles (even when the same colonnettes and arches are employed) may

be seen from a comparison of the whole height of the " Scala del Bovolo " (Fig. 329) with the leaning tower of Pisa (Fig. 330).

This astonishing Campanile is 179 feet in height and no less than 13 feet out of the perpendicular. Its lean is more accentuated in the three lowest stories, and above the third story there is a deliberate effort to return towards the perpendicular

by means of a delicate series of changes in the pitch of the columns on the lower side, and by a slight rise in height of the galleries on the same side. The reasons for this have been somewhat too hastily and generally taken from Vasari's explanation in the " Lives," who attributes it to inexperience of the peculiar soil of Pisa on the part of the architects Guglielmo and Bonanno. They endeavoured, he asserts, to rectify the settlement of the foundations (which occurred, on this theory, just when the third story had been completed) by endeavouring to build back again to the perpendicular in 1174.

I cannot accept Vasari's explanation now that Professor Goodyear's researches into what may be called " symmetrophobia " have been published. Vasari wrote some 400 years after the Campanile had been

Fig. 327. Fig. 328.
Terebra dimidiata. Terebra consobrina.

built, some time after the Italian Renaissance had cast its scorn on what was " only Gothic," and in days when the marriage of a daughter of the Duke of Tuscany was celebrated by whitewashing the Gothic frescoes of the Duomo at Florence. Even if we accept Vasari's theory as to the Campanile alone, it will not explain why similar divergences occur in contemporary buildings. The Baptistery of the Cathedral, begun in 1173, also leans 17 inches out of the perpendicular, and the

plinth-blocks of its foundations tilt down evenly and gradually for exactly 9 inches in the direction of this lean. The Campanile of S. Nicolò (built by Nicolò Pisano) leans forward in the same way, and also curves back again towards the perpendicular. The façades of the cathedral of Pisa, and of its choir, both show a similar forward lean in their original construction, curving back again to the perpendicular. These things Professor Goodyear has proved in the teeth of technical opposition.

Its Campanile, in fact, is not the result of accident. It was originally built as it may now be seen, the most remarkable combination of Greco-Byzantine subtlety with mediæval exaltation in the age which enjoyed such *tours de force* as the bent column of Arezzo, or the Torre del Pubblico of Ravenna or the Garisenda Tower at Bologna, which is 163 feet high and 10 feet out of the perpendicular. This furnished Dante with one of his finest similes

> " Qual pare a riguardar la Carisenda
> Sotto 'l chinato, quand un nuvol vada
> Sovr' essa si ched ella incontro penda :
> Tal parv' Anteo a me. . . ."

Goethe, whose essay on Strassburg Cathedral (about 1773) was a veritable rediscovery of mediæval principles of beauty, explained this leaning tower of Pisa as intentionally so built as to attract the spectator's attention from the numerous ordinary straight shafts ; which may well be true, if we are to believe Benjamin of Tudela's statement to the effect that there were 10,000 towers in Pisa alone.

It must, I think, be now taken as proved that the leaning was intentional, whatever motives may be assigned to the builders. Above the third floor there is a change in the lengths of various colonnades, which is even more noticeable in the topmost and smallest storey. This might have been taken for the rectification of an accidental lean caused by sinking foundations, and for the return to a vertical arrangement which had been originally intended. But that could only be the case if the lower part of the tower were built as a vertical structure would require. It is not. Careful measurement has proved that where the line of greater slope exists the soffit of the staircase has been deliberately increased in height, while the downward dip was so arranged that it threw the weight of the tower off the overhanging side. This would have been quite unnecessary if the architect had meant the tower to rise up straight from its foundations ; and above the critical point none of the precautions just described are taken : If there had been an accident, no precautions would have been

visible beneath, and very careful adjustments would have been necessary above. The exact reverse is the case ; and it is worth observing that if the exterior colonnades had been arranged in a spiral the mathematical problems involved in the leaning construction would have been extremely difficult. This may, there-

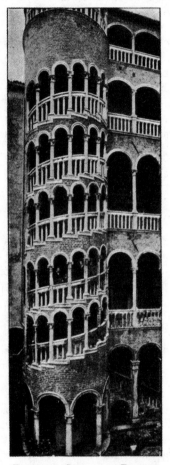

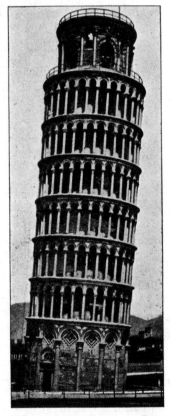

FIG. 329.—SCALA DEL BOVOLO, PALAZZO CONTARINI, VENICE.

FIG. 330.—THE TOWER OF PISA.

fore, be one reason why the architect deliberately built tiers of circles outside, in spite of having a spiral staircase inside. He must have sacrificed the beauty of an external spiral to the oddities of his design.

I cannot here commend the Campanile of Pisa for its eccentric leaning construction any more than for its superimposed circles. but I quote it as the most intelligible instance I know of the

deliberate avoidance of accuracy in construction for deliberate reasons. It is exaggerated, and therefore fails where the more delicate effects of the Parthenon succeed ; but its very conspicuous qualities give a very clear example of that intentional mystification by which the old builders strove to get a look of life ; of that elemental energy which is never limited by rule ; of those principles of growth which have brought *Nautilus pom-*

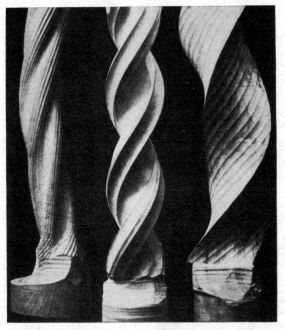

FIG. 331.—EXAMPLES OF WOOD-TURNING.
THE SPIRALS ON THE RIGHT AND LEFT ARE ECCENTRIC.
THE CENTRE ONE IS REGULAR.

pilius so near to the logarithmic spiral without ever exactly reproducing the mathematical curve.

In Fig. 331 I have reproduced three specimens of wood-turning by Mr. H. C. Robinson. The centre spiral, though beautifully executed, is exactly symmetrical. I believe Mr. Robinson was the inventor of the modification in machinery which produced the far more attractive irregular spirals on the left, and the curious concave variety on the right. The smaller model on the left is peculiarly like a living, climbing plant, and its chief charm is that it is almost as irregular in its make as the plant is in its growth. Another example of the same delicate irregularity is observable in the workmanship of the best medals, which nearly always show an uneven floor beneath the design, as may easily be seen

by the unequal thicknesses observable along the rim. This method was well known to the classical Greek medallists and to the best of the Italians ; and in such modern work as Bertram Mackennal's medals for the Olympic Games of 1908, or in the magnificent head of the French Republic by George Dupuis, you see it still. The exigencies of modern coinage may perhaps make it difficult to use the system when money has to be capable of being stacked in regular piles of similar denominations, but this necessity does not exist in

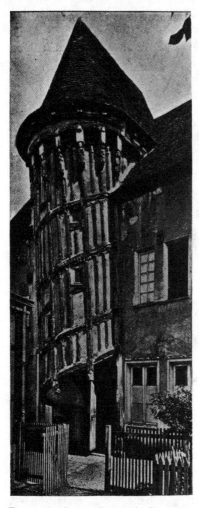

FIG. 332.—QUEEN BERTHA'S STAIRCASE AT CHARTRES.

FIG. 81.
MITRA PAPALIS.

modern medals. Yet if we take such a recent example of the official coronation medal of Edward VII., the " floor " of the design seems so flat that the whole thing looks very like a postage stamp stuck on a thin disc, and has as little light and shade. But I am wandering from our immediate subject, and must return to it at once.

An even more delightful example of the close connection between a good architect's plans and the exquisite lines of Nature is to be found in the stairway called " Escalier de la Reine Berthe " at Chartres (Fig. 332). It exhibits the delicate exterior ascending dextral helix, and even the top of *Mitra papalis* (Fig. 81, Chap. III.)

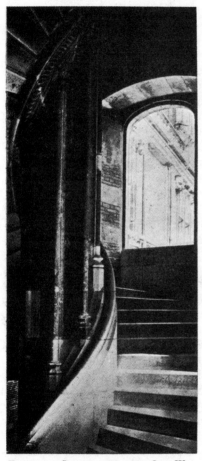

with extraordinary faithfulness, and the parallel becomes even more complete when the position of the darkened doorway is compared to that of the shadowy orifice of the shell. The staircase is contained in an external turret, and the internal spiral is expressed externally by curved timbers and the outer side of the string-course. The surface is also divided by numerous vertical beams, most of which rest on the string timbers, but the three main beams go from top to

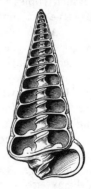

FIG. 333.—STAIRCASE IN THE OLD WING OF THE CASTLE OF BLOIS.

FIG. 73.—TELESCOPIUM TELESCOPIUM.

bottom of the thirty-six steps which swing round the central newel.

In *Mitra papalis* at this orifice you will observe the beginnings of three internal spiral lines, which suggest that the internal arrangements of a shell have as much to teach as its exterior forms ; and a very beautiful spiral may be seen by the aid of the X-rays continuing throughout the whole length of the long

pointed shells so common in the south (see Fig. 62, Chap. III. of
the *Terebra* photographed by X-rays). The clue has been followed
up, and in Chapter III. I showed that a section cut through such
a shell as *Telescopium telescopium* (Fig. 73, Chap. III.) actually
reveals an exquisitely firm and elegant single spiral (a dextral
helix) rising round the columella, that pillar which supports the
whole ; and this at once reminds me of the spiral in a staircase
(Fig. 333) built in the old part of the chateau at Blois many years
before the more famous wing of François I. But I do not for a
moment suggest that there was any conscious comparison in
the mind of the fifteenth century architect, and this for the very
good reason that the curve of his stairway and the beautiful
spiral rail (on which the left hand would rest as one ascended)
are both susceptible of a simple architectural explanation ; so
that all I should be inclined to say of this comparison at present
is that, as the lines of the architecture are right, and fulfil their
purpose exactly, with an economy of space and strength and a
sufficiency of support, they were therefore very likely to be in
harmony with those lines which Nature, the best of all artificers,
has developed in her shell. I should need more resemblances
than this to be satisfied that one might have been taken from
the other ; but, on the other hand, I shall by no means reject
such a possibility, at the outset, as absurd ; for architecture is
full of such copies from Nature, as every organically beautiful,
constructive art must be, and it is full of equally suggestive
relics of the simpler forms of shelter from which the palace
slowly grew. If the Egyptian pillar is a copy of the lotus plant,
so the peculiar shape of the Moorish and Saracen arch is a survival
of that wind-blown tent, with conical top and bagging sides
pegged closely in, which was the habitation of the Bedouin.

There are far more resemblances of the kind for which we are
looking in the open staircase built at Blois between 1517 and 1519
in the wing of François I., the inside of which (Fig. 334) is here
compared with the section of *Voluta vespertilio* (Fig. 335) and
the outside (Fig. 336) with the rising lines and " colonnettes "
upon the exterior of the same shell (Fig. 337). Now I am dealing
with this instance in greater detail in my next chapter, and it
is only inserted here to complete my little quartet of typical
comparisons between the unstudied loveliness of Nature and the
masterpieces of the best creative art. But it happens that this
open staircase (Fig. 334) was built during the last years of
Leonardo's life, when he dwelt at Amboise, where the inclined
plane of the spiral stairway in its tower was one of the chief
features of the castle. It is only a few miles down the Loire from
Blois where the single, strong curve of the staircase in Fig. 333

was one of the most beautiful details in the older portion of the chateau. It also happens that the Scala del Bovolo in Venice and Scala della Conchiglia in Fiesole are of such a date that if

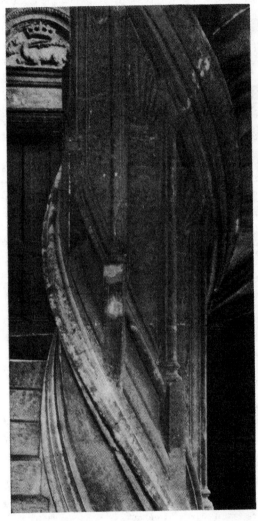

these names had been already popular, they may well have stimulated his imagination at a time when his note-books were already filled with studies of the structural forms of natural objects. And it is certainly true that no one who looks with a seeing eye at the finest of the buildings which Leonardo da Vinci might have known can fail to detect an intense percep-tion of that differ-ence in detail and

FIG. 335.
THE COMMON FORM OF
VOLUTA VESPERTILIO.
(Section.)

FIG. 334.—CENTRAL SHAFT OF SPIRAL STAIRCASE IN
THE WING OF FRANCOIS I., CHATEAU OF BLOIS.
(Photo by courtesy of *Country Life*.)

harmony in mass of which Nature is the great exemplar.

The " straight lines " of the Parthenon (Fig. 338) are in reality subtle curves, and recent investigations (by Professor Goodyear) have detected a similar delicacy of constructive measurement in

the great Gothic cathedrals. The influence of the study of flowers and leaves is especially marked when the positions and proportions of the best Byzantine arches are examined in the light of the laws which govern growth. How slight and exquisite were the details

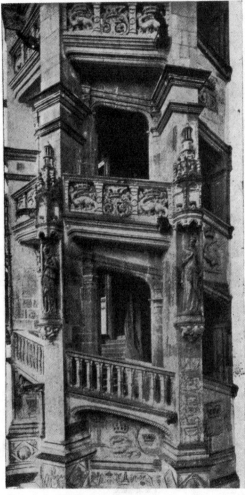

on which such laws depended no one could realise better than the painter who had studied the rendering of expression on a human countenance by lines so delicate that the reason for the effect produced was only visible to the few who knew. The eye is even more influenced by things which are usually " unseen " than by things which are " obvious " ; and it

FIG. 337.
THE COMMON FORM OF
VOLUTA VESPERTILIO.
(Exterior.)

FIG. 336.—BALUSTRADES OF THE OPEN STAIRCASE
AT BLOIS.

is of the essence of Beauty that her origins and causes are hidden from those unworthy to appreciate her.

Some of these origins and causes it may be well to state here, for though the first suggestion of their existence was made many years ago, they have never been properly appreciated by a public which must, after all, be the ultimate arbiter of architectural

taste, and they are closely connected with those methods of Leonardo with which we are now chiefly interested.

The history of architectural theory has seen a renaissance of the ideals called classical, and a revival of the school known as " Gothic," of which the former was incomparably the more valuable, because the conditions of society which made " the pointed style " possible in England, and gave birth to the " Gothic " school in the Ile de France, could never reappear, and were an essential concomitant of the architecture which expressed them. Yet an omission of equal importance was made by the revivalists of both schools. The real " Gothic " preserved certain delicate principles of constructive asymmetry, in the curves and irregularities in the masonry of the old Greek builders ; but the " Renaissance," which pretended to go back to ancient Greek and Roman ideals, did not appreciate, even if it saw, these slight divergences from the rule of thumb which were invisible to any but the trained observer. In the same way, the Gothic revival, which attempted impossibilities by overlooking entirely the radical changes which had occurred in contemporary life, was fated still more fully to destruction by its complete ignorance of the finer subtleties of mediæval art. We have no actual proof of this lack of appreciation in each case, except the proof provided by the buildings which were themselves the products of these separate revivals. For apart from Vitruvius and from the invaluable Notebook of the architect Wilars de Honecourt (1250), we have very few real contemporary records of the growth of architectural principles until these theories concerning slight divergence had been wholly lost. Even the sentence in Vitruvius, which seems directly to refer to them, was never understood until the nineteenth century, and then only by the merest chance on the part of an observer whose real work was never recognised. These constructive refinements, however, died out, not merely because no record existed of them, but for the far more vital reason that the public eye was no longer delicate enough to appreciate them, though, as a matter of fact, they are the real cause of beauty in the finest of our old surviving buildings, which owe their charm not so much to the kindly hand of time, as to the deep-laid skill of their builders. When constructions have arisen which were designed without that skill, even when they are supposed to be exact copies of the old originals, no lapse of time can ever lend them a beauty which is no concern of theirs, as may easily be seen in the " copy " of the *Maison Carrée* at Nîmes which is called the Madeleine in Paris, and in many smoke-begrimed atrocities of modern London.

In these days division of labour has lowered the capacity

of the individual artisan ; and machine-made reduplications, accustoming the eye to an inartistic uniformity of ornamental details, have also destroyed its grasp of delicate structural effects. In the old cathedrals, the mason and the architect, the artist and the artisan, were often one. By the fifteenth century a Florentine, Leon Battista Alberti, had separated the architect from the builder. In England, it was Inigo Jones who first invariably insisted that his wood and stone workers should copy his designs instead of following their own fancies. Each was a great man, yet each was the unconscious origin of a great evil which has befallen the art they loved.

The history of the discovery of curves in ancient Greek, even in Egyptian, architecture is romantic and interesting enough. Every one had read the passage which suggests them in Vitruvius since 1500. Stuart and Revett had measured the Parthenon in 1756. Lord Elgin's workmen noticed nothing. In 1810 Cockerell had established the fact of entasis, and in 1829 Donaldson saw the lean of the columns. But in 1812 the translation of Vitruvius, by Wilkins, only contained a note that " this great refinement . . . does not appear to have entered into the execution of the work of the ancients." Apparently it never occurred to the translator that it was worth while measuring " the work of the ancients " before making general statements about it. At last, in 1833, Mr. John Pennethorne discovered the undoubted existence of convex constructive curves in the architraves of the second court of the Theban temple of Medinet Habou. Four years afterwards he stood before the Parthenon (Fig. 338) with the passage from Vitruvius in his mind, and saw those delicate irregularities which had remained invisible throughout the passage of so many unintelligent years. About the same time two German architects, Hofer and Schaubert, saw them too, and published their discovery in the *Wiener Bauzeitung* of 1838. Save in a private pamphlet, Pennethorne gave nothing to the world till 1878, although in 1851 Francis Cranmer Penrose, helped by the Dilettante Society, published the results of his measurements of the Parthenon in " Principles of Athenian Architecture."

Penrose showed that in this building no two neighbouring capitals correspond in size, diameters of columns are unequal, inter-columnar spaces are irregular, the metope spaces are of varying width, none of the apparently vertical lines are true perpendiculars, the columns all lean towards the centre of the building, as do the side walls, the antæ at the angles lean forward, the architrave and frieze lean backward, the main horizontal lines of construction are in curves which rise in vertical planes

to the centre of each side, and these curves do not form parallels. Professor Goodyear, who completed the investigations of Pennethorne at Medinet Habou, found that similar curves existed in the Maison Carrée, and it is clear that while irregularities which would be easily detected or obtrusively conspicuous were avoided, there was also an unquestionable intention of avoiding exact ratios or mathematical correspondences wherever such an avoidance was calculated to produce a certain effect. That these deviations were not the result of error in the workmen, or of accidents in the lapse of centuries, is also clear from Penrose's calculation that the maximum deviation of the Parthenon in the case of lines intended to correspond (as at the two ends) is as little as the fiftieth part of an inch, while the refinement of jointing in the masonry is so great that the stones composing the great steps have actually grown together beneath the pressure of the columns they support. It is, in fact, impossible, to explain such asymmetries as these, on the theory of faulty work, of the use of varying materials from different sources, or of subsequent accidents, or of successive generations of builders being inaccurate ; and the principle thus found to be practised by the builders of the Parthenon have also been discovered by Professor Goodyear to exist not merely in Egyptian, Greek, and Roman buildings, but in Italo-Byzantine, Byzantine-Romanesque, and Gothic buildings, especially where Byzantine influence has been strong, in obedience to laws which fell into abeyance almost completely when the classical Renaissance fully established itself.

"Much time has been spent," writes Professor Lethaby, " in trying to elucidate Greek proportions, for the most part time wasted. . . . It is quite different with modifications by curvature and other adjustments made by Greek masons ; here we have something tangible, if subtle . . . such adjustments are most natural in a highly refined school of architecture and need no explanation." It is refreshing, in 1913, to read this recognition of the truths brought out by Professor Goodyear's researches. But I cannot agree that the " adjustments " (which I prefer to call refinements) " need no explanation " ; for they constitute to my mind, one of the chief reasons why classical Greek architecture is better than any of its later copies.

Again, in speaking of French Gothic, Professor Lethaby says : " Originality was insight for the essential and the inevitable. Proportion was the result of effort and training, it was the discovered law of structure " (in these pages I suggest that it is the discovered law of growth) " and it may be doubted if there be any other basis for proportion than the vitalising of necessity.

Nothing great or true in building seems to have been invented in the sense of wilfully designed." (What then are his "adjustments" made by Greek masons?) "Beauty seems to be to art as happiness to conduct—it should come by the way, it will not yield itself to direct attacks." Surely this means no more than that the highest genius is born and not made. But when we see such a work of genius as the Parthenon, for example, is it "time wasted" to analyse those qualities in it which are absent in other work? And if we think we can discover some of them, is it "time wasted" to suggest that new work may take account of them instead of belittling or ignoring them?

"Proportion," says Professor Lethaby, "means either the result of building according to dimensions having definite relations to one another, *or it means functional fitness.*" Of course it means "functional fitness" if the theory I am trying here to elaborate is worth anything at all. One of the conditions of organic life is the possibility of slight deviations which will fit the function for its environment. One of the conditions of beauty is the use of subtle variations from exactitude. After Penrose's measurements, it is futile to deny that subtle variations were a large factor in the beauty of the Parthenon. After Goodyear's work on Gothic buildings, it is equally impossible to deny that the great cathedrals owed a large part of their charm to the same principle. And, in both cases, the deviations are deliberate, forecasted, planned ; not the mere result of difficulties in making a complex building join together.

After stating such "obviously desirable qualities" of architecture as "durability, spaciousness, order, masterly construction, and a score of other qualities," Professor Lethaby says that "there is no beauty beyond these except in the expression of mind and of the temperament of the soul." I agree entirely ; but why does he sternly deprecate any analysis of that expression ? Why should we not diligently try to arrive at a few general principles, at some sort of formulation, simply enough stated, which will guide our understanding ? Why does he think that "much aesthetic intention is destructive ? " Unless the public taste is to a certain extent educated, nothing is more certain than that contemporary architecture will reflect its carelessness. Both the greatest Greek art and the greatest Gothic art were produced by a people in the deepest sympathy with every principle expressed by the buildings made for them. Every age has the architecture it deserves.

Like other wonders of the world, the Parthenon makes a different appeal to almost everyone who sees it ; but nearly half of that appeal must always depend upon its setting in the marvel-

lous light and landscape of Attica. There is a genius of place, as there is individual influence in every personality ; and on the Acropolis that genius is more insistent than in any other spot I know. " You may almost hear the beating of his wings." It is not dependent on the landscape, though here, as in similar instances, the surroundings seemed made to fit their central gem ; it is not dependent upon accidents of time or idiosyncrasies of character, for the Parthenon, like all great works of art, makes its essential call on those primeval fibres of our common humanity through which the greatest artists of all ages have made their own appeal to all the populations of the world. But inasmuch as no other architectural composition has had quite this effect upon all beholders—has, in fact, so nobly succeeded in impressing the meaning of its builders upon every successive generation—it is worth while asking why what at first appears to be only an arrangement of straight lines of marble should have been able, in the certain mind of its creator, to express so much. If there is any answer to this, it will also be the answer to the even more insistent question : why so much architecture afterwards has been not only meaningless, but positively offensive, both to its contemporaries and to their posterity.

One general consideration must be at once stated, and then left. If architecture is not a fair reflection of the age and the life that called it into being, it will fail in every other age, and will appeal to no other form of life. Now it is fashionable to be pessimistic about our own times and our own country. But without being that, it is possible to say that both are presented to any thinking man to-day as a far more complex environment than was the case in any country even only two centuries ago. Within that short span of history boundaries have lapsed, races and nationalities have slid into each other or changed their temperament in the melting-pot of war, distances have decreased, the material diffi- culties of time and space have almost disappeared. Politics present themselves under the form of compromise ; patriotisms tend to become vague generalities of colour ; nationalities are but the reflection of wide-reaching ties of blood that constant inter-marriage weakens every day. If it is difficult to appeal to a public which is no longer homogenous, it is still more difficult to express that monstrous shape which shall embody its distinctive personality. So it is not the English architect alone who is to blame for the absence, in this twentieth century, of any archi- tectural style that can express or reflect the age and the life in which he lives.

That marvellous moment in the early sixteenth century when all the knowledge of his time could be garnered in a Leonardo's

single brain has gone ; its parallel can never more return. Knowledge has now perforce become a divided kingdom in which the specialist, in his own ring fence, explores his own few acres with very little reference to any other's work. So there is little of that unity in modern life or thought which architectural conceptions can best reflect. In Greece, the unity and harmony of their common life was the one essential characteristic which the citizens of Pericles desired to see embodied in the Parthenon. " The Hellenic temple " (writes Compton Leith) " soothes and delights the mind, persuading it of a power in man strong to achieve all things ; in every part and in the whole it is instinct with a supreme grace and continence. The columns spring like living stems ; and as, in the tree, the risen sap flows easily along the branches, so all upward effort is diffused along these entablatures and ebbs in a harmony of receding lines. The roof, with its broad gable, confines and embraces the whole ; its calm length, its quiet overshadowing, are symbols of a world summed, contained, pacified."

The western portico of the Propylæa on the Acropolis of Athens is built with fluted Doric columns ; and three huge steps of Pentelic marble, with one dark blue Eleusinian stone, lead to the top. There is a slope of scarred soil, strewn with marble fragments and with limestone, stretching upwards for a short way beyond it. On the summit, and a little to the right, stands the Parthenon, not identical in orientation with the gateway of the Propylæa, as you notice when you stand beneath the enormous blocks of marble, over 22 feet long, which span that gateway from one pillar to another, but so placed that the play of light and shade may be varied in each building ; and the Erechtheum is set at a different angle too, its graceful outlines forming a perfect contrast to the majestic solemnity of the larger structure.

This subtle quality of variation persists throughout the best Greek architecture. Besides those which I have already mentioned, there are many more interesting instances of deliberate and delicate divergence from mathematical accuracy, and it is this divergence which gives the Parthenon its living beauty. For the essential principle of life and growth is constant variation from the rigid type. No tree grows all its branches at the same angles to the trunk, no flower springs from the earth to meet the sun in the straight lines of geometry ; and so Ictinus and Callicrates built, between 447 and 438 B.C., a temple for the Athenians which should enshrine, in lines of imperishable marble, subtly wrought, the evanescent and essential beauty which they loved.

Though bereft of well-nigh every ornament, and mutilated

even in the skeleton of its structural anatomy, the Parthenon retains the unfaded glamour of its first conception. Like a broken statue which suggests the marvels of the perfect master-piece, it preserves the spell which first inspired its wondrous lines, and leaves to every understanding heart the happy task of filling up the gaps at pleasure. This is the more remarkable because it is not the pathetic fragment of what was once the tenderness and grace of woman, or the resource and strength of man, or the complicated emotion of a group of human figures, or the self-sufficient majesty of serene divinities. It is a building only, erected for man's purposes after patterns man alone has made.

Nor does its charm essentially depend either upon the natural surroundings which add so much to the sympathy and pleasure of the visitor who travels to that storied shrine, or upon those gifts of mellowing time which make the shadows in its fluted pillars deepen into sunset gold instead of the more frigid blues and greys that fringe the bosoming snow on mountain pastures. There is in it something of the " stuff incorporeal that baulks the grave," something of that impalpable essence which informs all living things.

Who shall say, in these days when science is knocking so close upon the doors of life and death, that inorganic matter as we have understood it hitherto is in its highest forms incapable of receiving some impress of what we still must call organic energies ? At the last's last we are as incapable of defining one as we are unable to describe the other. The only thing about our own personality of the existence of which we can speak with greater certainty than of anything else connected with our being is our will, our power of choice, " the satisfaction," as it has been called, " of a passion in us of which we can give no rational explanation whatever." This is the element which assures us of a future and relieves us of that despotism of the past to which the clod of shapeless mud and the iron-bound mathematical conclusion must alike be fettered. This is that life which is the baffling factor in all organic beings ; and in the greatest master-pieces of creative art their beauty is as baffling and intangible as life. This, too, is the one link through which our brains can realise and our eyes can see as Pheidias, Ictinus, or Callicrates could see and realise the Parthenon. It is, indeed, the only clue by which we may arrive at any the least success in understanding what they meant.

Art, at its highest, is the expression of its maker's emotion through channels which the rest of his world may understand. And it is only that artist who gives you his own inspiration

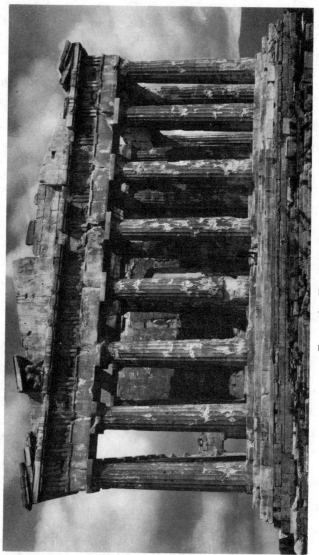

FIG. 338.—THE PARTHENON.

of the things and men he sees around him who will be intelligible
not to his own time and his own friends alone, but to all time
and to all generations of the world's posterity. For the methods
by which he has expressed the emotions roused in him by his
environment are precisely similar to the methods by which we
shall recognise the expression of similar emotions until man shall
cease to be. We recognise it because the elements that are com-
mon to the artist and the spectator are inherent in humanity
itself ; in the organic character which has been shared by every
man since we inhabited this planet.

Art, though it may be found in any human handiwork, exists
in nothing else, and is discoverable only through those common
channels of perception which are most efficient in the strongest
and the most healthy organisms. So that art has as little to do
with insanity, or decadence, or deterioration, as with morals.
In a madman those channels through which his mind should
direct its communications to his comrades have become clogged ;
the balance between the receptive and responsive body and the
creative mind has been destroyed, and so the possibility of his
art's appeal is wrecked. The greatest artists have almost
invariably possessed the most essential attributes of physical
perfection ; they were the healthiest workers.

The true artist, we may imagine, is the man whose eyes can
freely see, whose ears can freely understand, as the dull senses
of his fellows never will, and who transmits the emotions which
his senses have conveyed to him through instruments akin to
ours, but tuned to a finer melody, and harmonised to deeper
chords. For him the little hills rejoice on every side, the valleys
also standing thick with corn do laugh and sing. Fire and hail,
snow and vapours, the heavens that are a tabernacle for the sun,
" which goeth forth as a bridgeroom out of his chamber and
rejoiceth as a giant to run his course "—these things appeal
to him with a keener sympathy than ours, with a quicker percep-
tion of that intimate, far-off progression of the race throughout
the ages, with a deeper knowledge of what Nature means to
man. And so, discovering the laws by which this Nature works,
he frames some kindred principle on which to fashion new creations
of his own. He does not merely reproduce the beauty he has
seen ; he adds to the stock of beauty in the universe of his own
skill and handiwork.

This, then, is one reason why the greatest creations of art
are not for one age, but for all time ; not for one man, or even
for one class of men, but for humanity. This, too, is one reason
why such buildings as the Parthenon possess something of that
undying, ever-changing, elemental charm which we perceive in

hills and forests, in the rivers and the ocean, in the glow of dawning or in the splendour of the evening clouds ; something of that vital property of Nature which

> " Gives to seas and sunset skies
> The unspent beauty of surprise."

There is no other building in the world which has achieved so certain, so age-long, and so perfect a result.

In many of the best of the old buildings still surviving you may see some of the delicacies of divergence I have just described. Oblique plans are common in old churches. In Tamworth Church the chancel inclines so much to the north that a straight line drawn up the nave would hardly touch the altar. The same peculiarity can be seen in St. Ouen at Rouen, in Lichfield Cathedral, or the choir arch in the parish church of Wantage, where the deflection of the building has been said to represent the position of Christ's head upon the cross. Such instances, however, are of a grosser nature than the curves in constructional line, which I wish chiefly to emphasise, and which may be seen in the walls of the nave of Westminster Abbey. These are bent inwards at about the height of the keystones of the arches, and outwards above and below this point, as Mr. Julian Moore has shown. They are not only structurally sound to this day, but have retained a greater beauty than exists in any of the numerous ruler-made copies in different modern churches of the country. In Evelyn's " Diary," there is a most interesting indication of similar divergences in Old St. Paul's. " Finding," he writes on July 27th, 1665, " the main building to recede outwards, it was the opinion of Mr. Chichly and Mr. Prat that it had been so built *ab origine* for an effect in perspective, in regard of the height, but I was, with Dr. Wren [Sir Christopher], quite of another judgment, and so we entered it ; we plumbed the uprights in several places."

This implies that two English architects of the seventeenth century asserted a constructive existence and an optical purpose for an outward divergence from the perpendicular in the vertical lines of the nave of a Gothic cathedral, and favoured the preservation of the Gothic building as far as possible. To Evelyn and Wren, however, the champions of the Renaissance, the old church was " only Gothic." Keen as they were, they had lost something which two lesser men remembered, though we shall see, later on, that Wren was not above putting a distinctively " Gothic " feature into his Renaissance plans for the new St. Paul's. Similar divergences from accurate measurement in St. Mark's at Venice have been equally overlooked by almost every visitor. The piers

and upper walls of the nave lean outward to an extent of 18 inches out of the perpendicular on each side, a deviation which, had it been accidental, or later than the original construction, would have disintegrated the arches supporting the dome, ruined the mosaics, and destroyed the building. Again, in the choir of Sant' Ambrogio at Milan the main piers on the right and left lean out nearly 6 inches from the perpendicular on each side ; and a similar lean may be observed in S. Maria della Pieve at Arezzo, where the queer bent column in the choir gallery is a conspicuous instance of the capricious and eccentric forms occasionally developed by the hatred of mathematical exactness.

" Only Gothic ! " The phrase, in this twentieth century, strikes like a blow. What better name than " Gothic " were it possible to bestow on that indomitable wildness of aboriginal strength which so differentiates French architecture in the thirteenth century from the suave and silent calmness of the Parthenon ? For here, indeed, are the outspoken chords of " frozen music " Goethe loved so well ; here is the divine unrest of passionate endeavour. The high vaults bear down, in an imposing fierce expansion, upon the walls of the clerestory which themselves are balanced above the arches of the nave. Other arches again are built to counterbalance that resistance, with flying buttresses in tiers downweighted by their carven pinnacles. Arch fights the expanding bow of arch, till eight together balance on one slender pier and cross like jets from some colossal fountain of stupendous energy. All seems to be pitted and opposed. Force visibly meets force as in some monstrous organism. Almost you hear the laboured breath of wrestlers, the sigh of the living creature, tense and struggling to be free, without pause and without rest ; and every stone seems surging towards ascent, until the spires above them lose their vanes among the clouds. This was the architecture " Only Gothic," an architecture of endeavouring life, full of the differences and divergences of life.

The principles which guided the Greek builders seem to have lasted just as long as building was done from the freehand drawings of the artist-mastermason. No painter, even of to-day, would draw in a door in one of his pictures with a rule and compasses ; he knows that there is a quality in the natural work of hand and eye which no artificial aids can give him. The old Egyptians and the Greeks knew that, and the tradition of it lasted on in a few cases of stone construction even when the designs were ruler-made, and when the irregularities of handiwork had become the conventions of a few skilled masons. As we have seen, two English architects in the seventeenth century

recognised the existence of deliberate constructional inequalities. As late as the eighteenth century these principles prevailed, as may be seen in the "humped" pediment of the Mansion House in London. Even to-day the thatcher builds his cottage roof not in straight lines, but in curves, which absorb less rain water, and he achieves a beauty which is denied to mathematics.

The old streets were full of beautiful curves which cannot be explained only on the theory that twisting thoroughfares were more easy to defend, or by the suggestion that the houses grew up at haphazard. Neither of these reasons can explain the beauty of the High at Oxford, or the angle at which Magdalen Tower is set to its own quad, or the superiority of Regent Street and Piccadilly to Victoria Street or the Edgware Road. The "whiff of grapeshot" has Haussmannised modern Paris into a city of straight lines, and the next step is the chessboard of the American city, in which every thoroughfare leads to nowhere in particular. When the divergences in building and in the laying out of streets were almost forgotten, the principle that underlay them still survived in that more intimate form of architecture which is furniture and domestic decoration. In the best periods of Chippendale, or Hepplewhite, or Sheraton, you find each step in a staircase gently bowed outwards, or given a waving outline ; you find, too, that the walls of the best rooms are given slight curves horizontally as well as vertically ; you find the subtle inequalities of feeling handiwork in settee, and chair, and screen. But the modern " decorator " seems so fond of Euclid that the joys of the rectangle and the parallelogram have swamped the charms of Nature. He forgets that even so common an object of his daily life as the human face has two sides which are quite different the one from the other.

Fortunately, for us, Leonardo, that mighty master of the human face, lived when these principles were not so utterly forgotten as they are now. He was, indeed, a painter of the Renaissance and the Renaissance influenced all his life and art. But he was a man whose personality broke a way through the limitations of every style. He realised to the full what Whistler said long after him, that " Nature contains the elements in colour and form of all pictures . . . but the artist is born to pick and choose, and group with science, these elements, that the result may be beautiful." He was a student of Nature who had observed that her divergences were even more important than her reproductions, and who did not even shrink from saying that the creative imagination of the understanding man was infinite in comparison with her. We shall see more of the designs of which he was capable in the next chapter.

NOTES TO CHAPTER XVII.

SHELLS AND STAIRCASES.—The following letter is from " P. E." :—

" You speak of ' a connection between shells and spiral staircases in the minds ' of both conchologists and ordinary people. Do you remember what Leoni says about them ? I quote the translated passage :

" ' As for winding stairs, which are also called *Cockle-stairs*, some are round, some oval, some with a newel in the middle, some open, especially when room is wanting. . . .' (' The Architecture of Palladio,' 1742). The Italian for ' cockle ' is *Vinca*. This is odd.

" Staircases (of any form) must always appeal to the imaginative mind. They always recall to me that vision of Piranesi's, in which a man is shown mounting a stair which is broken at the top. But another figure (the same man) appears beyond the chasm on a higher stair. And yet again above a third break a third figure mounts towards the sky. All good staircases give one that ' aspiring ' sensation, as if to walk upwards were an easy thing."

THE TOWER OF PISA.—The problem of this leaning tower was discussed by Professor Goodyear in the *Architectural Record*, Vol. VII., No. 3, March 31st, 1898. The illustrated catalogue of the exhibition of " architectural refinements " held by Professor Goodyear in 1905 at the National Portrait Gallery in Edinburgh gives a most interesting series of examples of vertical curves, of curves in plan, of asymmetric plans, of bends in elevation, and many more matters treated of in the chapter just concluded.

ORGANIC AND INORGANIC MATTER.—See " The Fitness of the Environment," by L. J. Henderson (Macmillan, 1913).

NO TREE GROWS ALL ITS BRANCHES AT THE SAME ANGLE.—It has, I believe, been demonstrated that variety in this angle predicates a high level of perfection in development.

GREEK ARCHITECTURE.—" We have heard too many hot-headed statements about deviations and inflections in Greek architecture. For some people the subject is wrapped in a sacred mystery, and their attitude seems to prevent their arriving at any sort of helpful statement. Is no statement necessary ? Are we never to understand nor to do anything in our own age ? Are we for ever to talk sentimentally about the one Renaissance, and even in our tables and chairs despair (delightedly) of our joinery and our inspirations ? Well, there are some who do not believe in synthetic æstheticism ! There are some who wish to believe that a sacred, delicate flower will be killed by the least amount of conscious sane attention. Such people will not even try to find seeds. The beliefs have gone wrong ; not the springs of inspiration, nor the skill of eye and hand. Those who foolishly champion art against the analysis of science, and who shout to us about the exceptions, tell us very little about the deviations or inflections.

" In Greek architecture, as in every other work of man, there are three kinds of inflections. Centrally, on the average, I do believe that regular forms, based on simple rules of proportion, make the chief factor. Then there are the cleverly measured-out deviations to correct the eye, which is too far subjected by the perspective, by images of

irradiation and by contrasts. Then come the little errors in human touch, never conscious, that show skill, which so nearly made no error. Without these errors we should miss the sense of labour in the work. But there can be no forgery of such errors. If beauty is ' fitness expressed,' charming errors in workmanship are the residuum of difficulties conquered to the point where they just cease to interfere with fitness. In pure decoration the fitness is the clarity of the central law of regular form. The hand of the good workman expresses the central law of a regular form to a point where it is clear and obvious, but he does not accentuate the expression. After these inflections come the irregularities of form and colour due to age. These stir in us a different set of emotions, but the mixture of our feelings is so fine that many of us think it amorphous. Some of us, overpowered by our emotions, become hysterical, if not fanatical, worshippers. Such worshippers are seldom helpful, and they are never good workers.—M. B."

CHAPTER XVIII

The Open Staircase of Blois

Majestati Naturæ Par Ingenium.

THE STAIRCASE DESIGNED BY LEONARDO DA VINCI—VOLUTA
VESPERTILIO—THE KING'S ARCHITECT—A LEFT-HANDED MAN
—WORK OF ITALIANS IN FRANCE—LEONARDO'S MANUSCRIPTS
—HIS THEORIES OF ART.

THE Open Staircase in the courtyard of the Château of Blois has long been celebrated, and to my mind it is one of the most beautiful designs of its kind in the world. All direct proof as to its origin or construction has disappeared. It was built between 1516 and 1519 and all documents concerning the work at Blois during that period have been lost. This chapter collects the evidence in favour of attributing the design to Leonardo da Vinci, and the steps in the argument to be developed may be summarised as follows :

1. When he lived in Italy Leonardo worked (Figs. 339, 340) at architecture as a pupil and collaborator of Bramante.

2. The argument that a spiral staircase is impossible, either as a design by a Renaissance architect or as a feature in Renaissance building, is met by examples of a spiral staircase by Bramante for the Vatican, and by Wren for St. Paul's (Figs. 341, 342).

3. The Open Staircase at Blois, though perhaps developed from the ordinary *Vis de St. Gilles* (as shown in Chapter XVI.), has many of the characteristics shown in Chapter XVII. and a few distinctive variations peculiar to itself.

4. The inside spiral shaft (Fig. 343) compared with the inside of *Voluta vespertilio* (Fig. 90).

5. The balustrades outside (Fig. 344) compared with the outside of *Voluta vespertilio* (Fig. 78).

6. *Voluta vespertilio* comes from the north-west coast of Italy. A section made of it.

7. The staircase exhibits a left-hand spiral. Was this taken from the rare (dexiotropic or sinistral) *Voluta*, or was it drawn by a left-handed man ?

8. A shell is carved upon the central shaft (Fig. 345).

9. The steps are cut in a double curve like the outline of a leaf

(Fig. 346), not in a straight line as at Châteaudun (Fig. 347) and other places.

10. To recapitulate. On the hypothesis that a shell suggested the staircase, we must find an Italian who had studied shells and leaves, who was left-handed, who was Architect to the King, and who lived at or near Blois between 1516 and 1519.

11. Leonardo da Vinci studied the curves of leaves and plants (Fig. 348), the spiral formations of water (Figs. 349, 350), dust (Fig. 351), horns (Fig. 352), and shells (Figs. 104, 105, 353). He came from north-western Italy. He was left-handed, and always drew left-hand spirals (Figs. 354, 355, 356).

12. He was architect to the King of France.

13. He designed square staircases (Figs. 357, 358).

14. He designed a spiral staircase in a tower (Fig. 359).

15. He lived and died, between 1516 and 1519, within a few miles of Blois, at Amboise (Figs. 360, 361).

16. He is recorded to have done work (connected with the fountains) at Blois.

17. Other Italians are known to have worked in France.

18. The suggestion, by French writers, that Leonardo built Chambord is unfounded, but shows their readiness to accept the possibility of his architecture (Fig. 362) in France.

19. General reasons, deduced from Leonardo's manuscripts to show that, alone of architects living at that time, he could have used a shell as the suggestion for his design of the staircase. The illustrations will, of course, carry much more conviction than this bare summary of the facts.

From 1519 onwards it is known that Jacques Sourdeau was Master of the Works on the wing of François I. at Blois, in which this Open Staircase is the most prominent feature. It is also known that the only previous record existing was preserved in the archives of the Baron du Joursanvault, and consists of a receipt, signed by Raymon Phelippeaux, master builder, of Blois, on July 5th, 1516, for 3,000 livres tournois to him paid over by Jacques Viart, official treasurer of the county, towards the expense of certain repairs being carried out by the orders of François I. These two years, therefore (1516–1519), measure the interval during which it is most probable that the designs were made for a staircase of which neither the architect nor the exact date has ever been fixed, for from 1516 to 1519 no records exist. The façade on this side of the courtyard of the château is very simple, with its three rows of pilasters superimposed one above the other,

marking a distinct advance in that new movement which had already produced Chenonceaux and Langeais. It shows a restrained gravity, a fine instinct of proportion, which have produced exactly the right background for the crowning master-piece of the Open Staircase in its midst. At first that staircase seems to stand free, breaking up the ordered descent of perpendicular columns with its boldly projecting lines ; yet its summit is clasped by the broad cornice of the main wall, which gathers every varying angle into harmony with the main building.

But I only draw attention to this point because it explains certain problems in the detail of the staircase itself, and renders more probable the hypothesis that, after the original architect had planned the mass of the building and the place of the stairs, the design of the detached staircase itself came from another hand, and many of its details of carved ornament were added at a still later date. Indeed, they seem to have taken so long in completion that many of the stones remain uncarved to this day, and have evidently not been touched since they were set in their places ready for the carver's chisel. Examples of this later work may be found, on the inside, in those somewhat vapid and meaningless panels of light-relief Renaissance scrollwork set between the colonnettes encircling the main central shaft. On the outside the most conspicuous additions are the canopied statues set on the columns above the first sloping balustrade. Jean Goujon was born in 1520, a year later than the interval suggested above for the design of this staircase, and the beginning of its actual building. But its completion (in such details) may well have been postponed for five-and-twenty years ; and any one who knows the Fontaine des Innocents or the Diane Chasseresse will find it difficult to believe that these statues were not from Goujon's chisel, or, at any rate, from the hand of one who was strongly influenced by his individual style.

Mr. Reginald Blomfield has shown that for the designs attributed to Lescot for the Louvre Jean Goujon should have the credit, and Martin (in his edition of Vitruvius already quoted) calls Goujon " architecte." He was, in fact, just that combination of architect and sculptor in France which the designer of the lost " Cavallo " evidently was in Italy ; and he died in Bologna about 1567, as far from his home as was the great artist who was buried at Amboise so long before him.

The genius of Leonardo was of so universal a quality that I feel no real necessity for proving over again that in Italy he had

turned his attention, among many other studies, to those of archi-
tecture. Though no building has come down to us which has yet
been recognised and agreed to be by him, alone, the researches
of J. P. Richter produce more than sufficient evidence of his skill.
In 1490, at any rate, Leonardo was able to write to the Duke of
Milan that : " In time of peace I shall be of as much service to you
as any one in whatever concerns the construction of buildings" ;
about the same time the Vice-General of the Carmelites writes to
Isabella d'Este, concerning Leonardo, that " his mathematical
studies have so drawn his tastes away from painting that he will

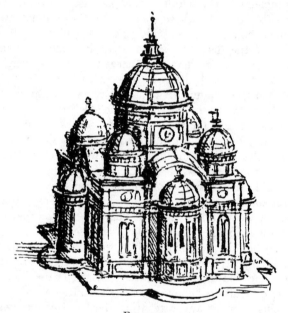

Fig. 339.
Sketch for a church by Leonardo.

scarcely hold a brush," and Sabba da Castiglione says also that
" when he should have wholly consecrated himself to painting,
in which he would, no doubt, have become another Apelles, he
entirely surrendered himself to the study of geometry, archi-
tecture, and anatomy " ; and it is significant that between 1472
and 1499 we find many important buildings in Lombardy by
unknown architects, which are so good that the tradition of
collaboration between Leonardo and other architects may well
be true. At Pavia Cathedral, and in the church of Santa Maria
delle Grazie at Milan, this tradition was so strong that the
corroboration of it lately found in Leonardo's manuscripts,
preserved in Milan, was only to be expected.

From the manuscripts in the Institut de France I reproduce
two sketches for a church by Leonardo (Figs. 339, 340). These
might certainly be attributed (apart from other evidence) to an
admirer of Bramante ; and the idea of collaboration has so
strongly influenced MM. Marcel-Reymond and Charles Marcel-
Reymond (*Gazette des Beaux Arts*, June, 1913) that, as I shall
show later, they use the similarity between the plan of Chambord
and the plan of St. Peter's at Rome as an argument in favour
of Leonardo having built Chambord. But I stand in no need of
improbabilities to strengthen my position ; and for the present

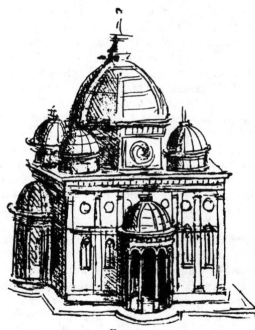

Fig. 340.
Sketch for a church by Leonardo.

I am concerned chiefly with Leonardo's architectural work in
Italy.

Already the best minds of his day had tried to grasp the
problems of a proportion in architecture which should reflect the
laws of construction and growth exemplified throughout organic
life in Nature. Leonardo took up that inquiry in his usual
original and thorough manner, and the investigations embodied
in my former chapters were in many cases suggested by materials
in his manuscripts. He has left sketches of columns with
archivolts shaped like twisted cords, copied from interlacing
branches. He has left drawings of flowers, such as eglantine,

or cyclamen, of a delicate tenderness, that is only surpassed by the loving accuracy with which he analyses and depicts the growth and structure of trees or of mountains ; accumulating this infinity of observation not for its own sake merely, but in order to combine and to create afresh ; to invent with knowledge, and to design without disorder.

He studied deeply the strength and resisting-power of various materials, and was the first to produce an exhaustive theory of the fissures in walls. In Fig. 351 I reproduce a careful study of the spiral forms of smoke and dust caused by the ruin of a building. He wrote much upon the nature of the arch, and the results of pressure upon it. There was no problem of construction that came within his ken which he did not grapple and attempt to solve. The traffic in a crowded city was a difficulty in Italy long before London had become overgrown. He proposed to solve it with a system of high and low level streets, such as may be seen to-day at Chester, and as has been suggested in these last years for the new streets near the Strand.

But it is his collaboration with Bramante, that master of the high Renaissance, which seems to prevent mòdern architects from accepting Leonardo as the author of a design so Gothic in feeling as a spiral staircase. Well, Bramante himself felt no such difficulty. In about 1444 he built a spiral staircase connected with the Belvedere at the Vatican. It is in an isolated tower, with steps so broad and easy that a man on horseback might ride up them, and it was done some seventy years before the Blois staircase was ever thought of. Wren found no difficulty either. In St. Paul's, far more than seventy years after the Blois buildings, he placed a beautiful spiral staircase, of the true Gothic type, from the crypt up to the Dean's library (see Figs. 341, 342). From some assertions that have been made concerning the influence of Italian architecture, it might almost be imagined that such structures as the Scala del Bovolo (described in my last chapter) or the Scala della Conchiglia never existed in Italy at all. And if it be argued that spiral staircases only occur in Italy in Gothic buildings, I may add to the instance by Bramante, already quoted, the large oval spiral staircase designed by Borronini (though probably built by Bernini) in the Palazzo Barberini in Rome, for which plans were made by Carlo Moderna for Pope Urban VII. The persistence of custom would alone be almost sufficient reason for the survival of staircases in this form till the end of the sixteenth century in France, even if there were no other explanation ; and there are a great many examples of such staircases to show how steady was the development of French architecture, and how slowly it cast away the older

forms of detail in progressing towards new methods of design. It must be remembered, too, that nothing corresponding to the modern "architect" (the designer of the whole, who supervises

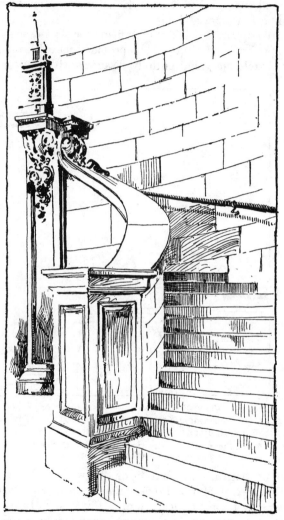

FIG. 341.—THE LOWER PART OF THE SPIRAL STAIRCASE FROM THE CRYPT TO THE LIBRARY AND SOUTH GALLERY OF ST. PAUL'S.

(Designed by Sir Christopher Wren, of Wadham.)

plan and detail) existed before Philibert de l'Orme took over Fontainebleau from Serlio in 1548; and this north wing at Blois, built between 1515 and 1520, was actually the first of all

the many buildings François I. began, and therefore it is only natural to find in it such structural " irregularities " as the addition of the Open Staircase to the façade. The spiral design, in fact, persisted for centuries after Leonardo's death, and we may dismiss all such difficulties of schools or styles in searching for the unknown master at Blois.

My friend, Mr. Reginald Blomfield, for whose scholarship I have a profound admiration, has provided me with many of my most valuable facts, but entirely disagrees with my conclusions.

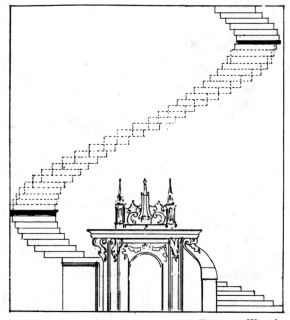

FIG. 342.—THE FIRST TWENTY-SEVEN FEET OF WREN'S "GEOMETRICAL STAIRCASE" IN THE SOUTHERN TOWER OF ST. PAUL'S CATHEDRAL.

(After the measured drawings by Theo. G. Scott in the *Architectural Review* for July, 1910, p. 26.)

or, rather, with my attribution of this work to Leonardo. His deep knowledge of the French Renaissance, and especially of its later developments, leads him, I think, slightly to underrate those Gothic elements in its early period before the professional architect had appeared, which are to me so fascinating a proof of independence and originality. In the Open Staircase of Blois, for instance, he seems to see little more than the " Vis de Saint Gilles, the mediæval newel staircase of immemorial antiquity, set out in this case with a succession of openings between the angle piers instead of a solid outer wall." My readers will remem-

ber what he means if they refer back to my earlier pages on the development of spiral staircases, in the sixteenth chapter, where they can look at the drawing from Colchester Castle (Fig. 319), or from the Painted Chamber, Westminster (page 306). If they do not see the extraordinary development between such work as this and the Open Staircase at Blois, then all appeal to individual taste is vain. It is quite true that the central newel, the running vault, the wreathed handrail are to be found elsewhere, even in the same castle, in the older staircase in the wing of Louis XII., reproduced in Fig. 333 in my last chapter. But how infinitely finer is their treatment by the master of the Open Staircase! And where else will you find that delicate treatment of the handrail so similar to the spirals on Voluta's columella? Where else are the steps cut in this curious double curve? The actual masonry of the Vis de St. Gilles is, I have already said, most remarkably skilful; but the stone-cutting in this Open Staircase is nothing short of miraculous; it could only have been done by that experienced school of handiwork which the best French builders had developed, and it could only have been designed by a first-rate artist. There is a nobility of invention, an originality and vitality, about it which has developed new motives out of the old ideals, and added the delicate treasures of an inexhaustible fancy to the structural models that were common knowledge of the past. There is a beauty of proportion and restraint just as there is a beauty of independence and individuality. But if we want to see how the ordered scholarship of Jean Bullant's art could degenerate into lifeless correctitude, we need only turn from this Open Staircase to the cold lines of Mansard's wing a little further on.

More than twenty years ago I was dining at Oxford in company with some distinguished biologists. Each seemed to have something of value either to relate or to display, and the unlearned guest was feeling a little at a loss for any topic of discourse in a conversation which ranged so far beyond his own experience and knowledge. At length he ventured to produce for general inspection a photograph of a certain staircase (see Fig. 343) built by an architect whose name had been hitherto unknown in the early sixteenth century at Blois. I had but just returned to Oxford after a long visit to the banks of the Loire. The little picture was indulgently received; and the joy of its humble possessor may be imagined when Charles Stewart loudly proclaimed his recognition of the spiral curves therein depicted. No

sympathy was suggested with any architectural problem ; but
the critic who now held the picture of the spiral staircase in his

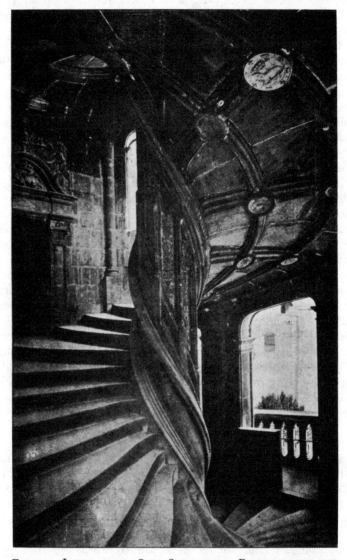

FIG. 343.—INSIDE OF THE OPEN STAIRCASE AT BLOIS, SHOWING THE
 SPIRAL LINES CARVED ON THE CENTRAL COLUMN AND THE
 VAULTING.

hand announced to his comrades that the curves upon its central
column were identical with those of *Voluta vespertilio*.

Abashed, befogged, but keenly interested, I hinted at my

ignorance of what *Voluta* might be. The shell was fetched (page 353). Still I remained unmoved and unilluminated. Finally our learned host had pity upon me. A longitudinal incision was made, and the four-fold spiral stood revealed within upon the columella (see Fig. 90, on this page).

Everyone was soon talking of other subjects, but I could think of nothing else. In spite of many other conflicting interests and duties, I have thought of that chance discovery ever since. If a biologist could recognise the lines that are hidden within a certain shell as soon as he saw them reproduced in a French staircase, there was also the possibility that the staircase had been originally suggested by the shell. In any case, a staircase whose form and construction so vividly recalled a natural growth would, it appeared to me, be more probably the work of a man to whom biology and architecture were equally familiar than that of a builder of less wide attainments. It would, in fact, be likely that the design had come from some great artist and architect who had studied Nature for the sake of his art, and had deeply investigated the secrets of the one in order to employ them as the principles of the other.

It is, of course, a somewhat trite commonplace that art is one thing, and Nature is another, and that mere unintelligent copying of natural phenomena will never be artistic. however faithfully performed. Structural forms in architecture—it is as great a

FIG. 90.—RARE FORM OF VOLUTA VESPERTILIO.

(Section showing spirals on columella within.)

platitude as the other—are usually the result of direct problems in building. Yet I do not hesitate to say that the philosophy of architecture must finally be based on general principles which will appeal to other intelligences than those of the strictly professional architect. The architects apparently assert that they only design their staircases to fulfil a practical necessity, and the penalty for failure would be their client's refusal of payment. Well, the shell has developed into a shape we all admire, because its builder had to face certain practical necessities of existence. The only difference is that in this latter case the penalty for failure was death. On the other hand, though natural forms, unmodified and unrestrained, can never become architectural elements, yet it is not necessary to lose all the charms of natural beauty by exaggerated convention, or by too rigid application of the T square and the ruler. Indeed, it is only by appreciating the irregularities of Nature that beauty can ever be artificially attained.

Language is not literature ; nor is mere verse poetry. Style is
not attained by over-elaborated exactness, nor is industrious

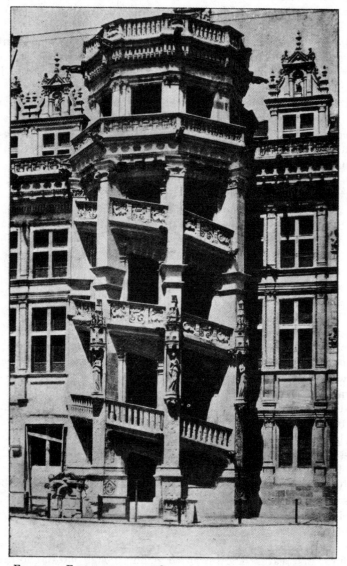

Fig. 344.—Exterior of the Open Staircase at the Château of
Blois, on the Loire, built between 1517 and 1519.

reproduction an attribute of genius. Architecture should take
her right place at the head of all the arts, because she can most
clearly manifest that divine attribute in man which is connoted

in creation ; and the creative imagination is no more concerned with facts alone than it is with fancies only ; it deals with the material of scientific knowledge, and with the causes that underlie phenomena, in order to evolve new combinations of its own.

My last chapter suggested the likeness between this staircase and *Voluta vespertilio*, the similarity first pointed out to me (as I have just described) by the late Charles Stewart, president of the Linnæan Society. Now, those of my readers who compared Fig. 335 carefully with Fig. 334 will have noticed that the shell (being one of the ordinary variety) exhibited a right-hand spiral, while the staircase was undoubtedly an instance of a left-hand spiral. But take Fig. 90, one of the very rare dexiotropic Volutas, and you see at once that its sinistral curves are the same as those so magnificently dis- played in the central shaft of Fig. 343. An examination of the plan of the building will convince any impartial critic that this stair- case would have been just as convenient to its inhabitants, and possibly easier to build by average workmen, if its curves had been right hand. But as a matter of fact both inside and outside the lines of the staircase are strongly left hand. It will therefore be a fair deduction that if the staircase had been copied from a shell it would probably be the rare sinistral form of *Voluta vespertilio* which furnished the model ; while, on the other hand, if the resemblance is merely that

FIG. 78.

RARE FORM OF VOLUTA VESPERTILIO.

(Exterior.)

between the workmanship of genius and the harmonious lines of Nature, it would probably be a left-handed artist who drew the first design. Let us take the shell first.

If this shell was consciously used as the model for the design, it is not likely to have been a Frenchman who took it, for *Voluta vespertilio* has been unknown for many thousand years in French seas, and the nearest waters in which it is common are on the north-western curve of Italy, along the Bay of Genoa, and south- wards. If, then, the man who collected natural objects on that coast were to add *Voluta vespertilio* to his cabinet, he would hardly be likely to choose the ordinary variety, which any child could pick up on the seashore. He would naturally prefer the rare exception, that sinistral form which exhibits precisely the same lines as those of the staircase as we know it. And if he used the shell as a model at all, he would obviously consider what the outside had to suggest, as well as the inside which we have already admitted.

Now consider the outside of the shell (Fig. 78) and compare the
rising row of light columns on its surface, and the shadowed lines
they seem to support, with the columns outside the staircase on
page 352 and the balustrades which cross them. Note, too, that
these transverse balustrades are by no means at the same angle ;
one is obviously flatter than the other two, and no two of them
are exactly parallel. The transverse lines outside the shell show
the same peculiarity.

Then compare Fig. 344 with Fig. 343, and tell me, if you can,
what there is in the outside of the staircase which leads you to
anticipate the marvellous construction shown (at various heights)
in Figs. 345, 346, or 334. Are not these revelations as great a
surprise to you as the spirals shown on page 351 which lie hidden
behind the very different exterior of the shell on page 353 ? Most
certainly, if the artist used the shell at all, he was as well aware
of what lay within as of the visible structure evident outside.
But it was not everyone in the early sixteenth century (and not
many even in the nineteenth) who cared sufficiently for natural
structure to saw in half or rub down a shell and reveal the secret
of its hidden growth. So, if the shell was used at all, it was used
by someone who was a careful student of Nature, accustomed to
dissections, and fond of a particular line of research in which the
spiral formation was an important factor.

If, as I believe, this staircase at Blois was inspired by a shell,
the man who owned the shell, and used it so, must have been not
merely an architect, but a master of construction, for the groin-
work and vaulting of the stairs (Fig. 343) are not the least astound-
ing part of the whole building ; and he must have been a decora-
tive artist, too, of the very highest order. Confining your
attention for a moment to the inside of the staircase only, you
will see ample evidence of this in various directions.

Though I am more concerned with constructive lines than with
mere decorative detail, it is impossible to overlook the set of
these colonnettes that move upwards with the rising shaft, and
the splendidly sculptural treatment of the shells which are set
between the twisted capitals of each (Fig. 345). I would draw
particular attention to these, because if they were placed here by
the man who was inspired to take his original model from a shell
they would be treated very differently from any ornament,
subsequently affixed by a lesser artist with a lesser inspiration.
And this is, as a matter of fact, exactly what is to be found here.
These shells are broadly carved, with light and shadow ; not with
a mere imitation of exact form, but with a fine feeling for their
effect in this precise position.

Then consider the outline of each step (Fig. 346). The stairs

wind upwards, folding round that exquisite central shaft as the
petals of a flower fold one within the other ; and in the very lines
of each step itself a strange and beautiful look of life and growth
is produced by the double curve on which it is so subtly planned ;
for these steps are not straight, as in the older staircase of Blois

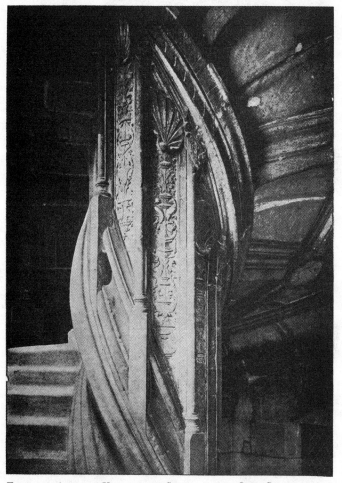

FIG, 345.—ANOTHER VIEW OF THE SHAFT OF THE OPEN STAIRCASE AT
BLOIS, SHOWING THE SHELLS CARVED BETWEEN THE COLONNETTES.

(page 323), and in most of such ordinary instances as were shown
in my last two chapters, or in the example from another château
given here for comparison (Fig. 347) ; they are carved into a
sudden little wave of outline just where each one springs out from
the supporting pillar—from the supporting stalk, as it were, of
these delicately encircling leaves.

Such curves can only have been designed by one who had carefully studied the forms of leaves and the arrangement of leaves upon a central stalk ; by one who knew that Nature has no straight lines, and that nearly all natural curves exhibit just

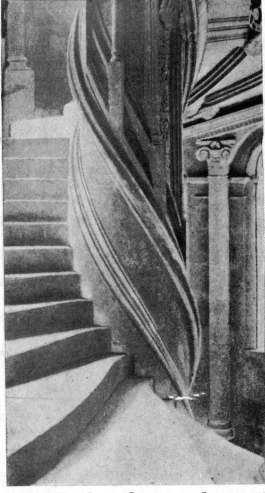

FIG. 346.—THE CURVED LINE OF THE STEPS IN THE OPEN STAIRCASE AT BLOIS.
(Photo by courtesy of *Country Life*.)

this delicate mingling of the convex with the concave. There used to be an old canon of art that the curves of the human body were wholly convex ; and it may well have been in protest against this error that Hogarth drew the double curve of his Line of Beauty beneath his own portrait. But the design of these steps

is far more subtle ; and I cannot but express my conviction
that they were planned by an architect who was familiar with
such botanical principles of morphology as those which Leonardo

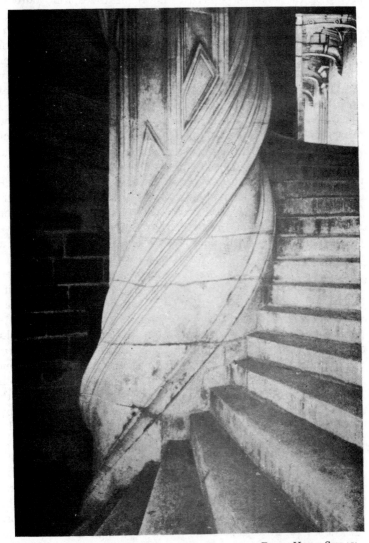

FIG. 347.—THE STRAIGHT STEPS OF AN ORDINARY RIGHT-HAND SPIRAL
STAIRCASE IN A FRENCH RENAISSANCE CHÂTEAU.
(Photo by courtesy of *Country Life*.)

undoubtedly investigated and described in several of his
manuscripts.

You should observe that the designer of the Blois staircase

does not take such a natural object as a shell or a leaf merely to make an exact copy of it. He uses it to study the reason of its form, the spirit of its anatomy. In the old Hotel de Bourgogne in Paris, the mouldings on the newel of the spiral staircase (fourteenth century) represented the trunk of an oak, from which branches spread over the soffit all the way up ; and in a fifteenth-century spiral staircase of oak from Morlaix (now in the South Kensington Museum), the diamond notches carved on the lower part of the outer newel change, as they rise higher, into neatly overlapping layers of naturalistic leaves. This was not the way of the Blois Master, or of Leonardo da Vinci. He would have used the shell to study the secret of its beauty, and to reproduce new forms based on such principles. The shell itself he would neglect save for such special treatment as I have just described in the spaces between the colonnettes upon the newel. When he desired to do so, he drew wreaths of fruit, flowers, and leaves with the exquisitely minute skill shown in the decorations above his greatest masterpiece " The Last Supper," just revealed by Signor Luigi Cavenaghi's skilful restorations. But we may well suppose that, even to such marvellous fidelity to nature, he preferred a more profound analysis of Nature's charms.

" *Voluta scalaris* " (Fig. 84, on page 315) was, of course, given its name some centuries after Blois was finished. But the " staircase shell " chosen by the designer of this staircase was the far more subtly-fashioned " *Voluta vespertilio*," because he saw its possibilities both from within and from without. If its four-fold spiral had alone attracted him, he might have chosen *Cymbium* as his model. But in *Voluta vespertilio* he recognised that an even more graceful internal spiral was enshrined in an exterior which suggested sloping balconies held up by columns ; and he used both suggestions in his design for the Blois staircase. An article by L. March Phillips (to which I shall have to refer again) in the *Architectural Review* for October, 1912, puts the point we have just been considering with great clearness. In all rational architecture form should embody function, and if this is true of mere decoration, it is even more certain concerning the main structural lines of any good building, such lines, for example, as may be embodied in a column. The columns of Egyptian architecture (at Thebes, for instance) are an evident copy of a bunch of papyrus stems with a lotus bud on the top. But the architect has had no desire (and probably no idea) of expressing the function of the column in its form. So he has merely achieved " an imitation of a Nilotic vegetable." Its " base " is contracted ; its " capital " is narrower than its shaft. Nothing less suggestive of a column's strength and fitness could well have been constructed. Yet

" somewhere concealed within the imitation of the lotus lie the proportions which correspond with the column's function of support." The Egyptian architect never troubled to look for them, probably never thought of looking for them. Consider, for a moment, those columns of the Parthenon reproduced in my last chapter. In the difference between them and the Egyptian column lies the whole principle of perfect architectural design as the architect of the Blois staircase understood it ; for whereas a natural object can only be what finite Nature made it, the form which is given to a natural object by man is the expression of that human creativeness which, in art, is infinite. It is the chiefest sign and symbol of the master craftsman that he is not content with merely copying Nature. He studies her in order to discover those essential elements from which to fashion new beauty for himself.

Can such lines as are developed in this masterpiece at Blois be the result of a merely architectural solution of the problem ? Can they be merely one more example of what we have seen already of the fortuitous correspondence between perfect workmanship and the lines of Nature ? Surely they must have been intimately inspired by the natural object they so closely imitate, by the shell so rarely shaped by some left-handed Angel of the Ocean. And if so, this is no ordinary imitation ; it is a copy with the very striking and logical and persistent differences necessitated by architectural considerations.

This, in fact, must be an example of that greatest art which imitates the greatest models with a difference that reveals the strength and personality of the designer ; which discards the trivial and preserves the essential ; which loves knowledge much, and is therefore unafraid of novelty ; which realises the existence and the value of a studied exception here and there among all ordered things ; which can unite design with fact, and originality with truthfulness ; which has, in fact, discovered that the beauty of Nature is to be found not in agreement, but in difference.

To recapitulate the position ; we have stated the hypothesis that the Blois staircase was definitely suggested by a certain shell ; this involves that the architect was an Italian ; we find further that he must have closely studied shells and leaves in order to try and discover the secret of their growth and beauty ; that he was left-handed ; that he must have been appointed architect to the King of France ; and that he must have lived at or near Blois between 1516 and 1519.

These are the necessary corollaries, so far, of my position ; we have now to see how far they coincide with facts.

In the Windsor collection of the manuscripts of Leonardo da Vinci and in several other collections in the great capitals

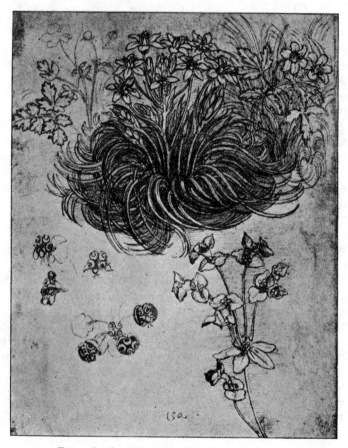

FIG. 348.—STUDY OF THE GROWTH OF FLOWERS.
(By Leonardo da Vinci. From the Windsor Collection.)

of Europe, we find many evidences of the great artist's passionate studies of natural objects. In Fig. 348 is a drawing of the growth of flowers which contains several instances of the same double curve noticeable in the steps of the Blois staircase.

Water, and the forms of water, always attracted him ver

strongly, as is suggested in the blue hills and streams which form the background to "La Gioconda." The Windsor Collection is full of extraordinary studies of waves for his representation of

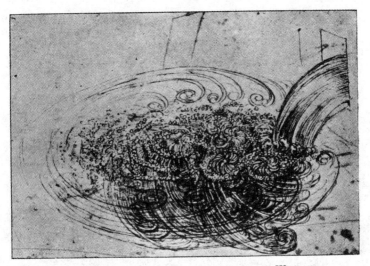

FIG. 349.—STUDY OF THE SPIRALS FORMED IN WATER.
(By Leonardo da Vinci. From the Windsor Collection.)

the Deluge. The great struggle of one element against another did not appeal to him merely as a Biblical dream. He examined currents, whirlpools, and ripples, until he had a host of actual

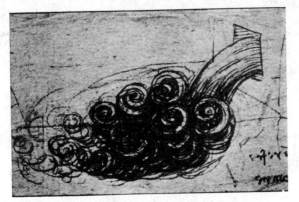

FIG. 350.—STUDY OF SPIRAL EDDIES BY LEONARDO.

facts with which to work ; of true observations from which to create his vision ; of laws and principles by which to guide his imagination. In Figs. 349 and 350 I have reproduced an example

of the careful way in which he studied the spiral formations of water. Among his drawings are studies of the curves of waves, and of the effects of currents upon the banks of the mainland and of islands. In these studies he foresaw the scientific advance which he had no instruments delicate enough to prove, for he wrote that : " *Le onde sonore e luminose sono governate delle stesse leggi che governano le onde delle acque.*" He frequently expresses his admiration of Archimedes, and of that great inventor's

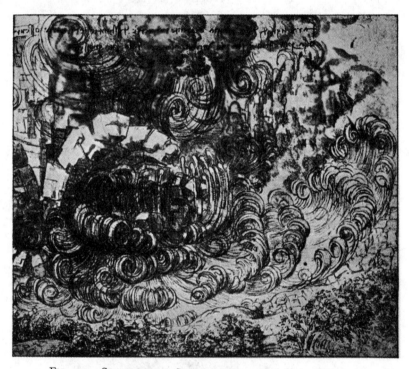

Fig. 351.—Study of the Spirals formed by Smoke and Dust.
(By Leonardo da Vinci. From the Windsor Collection.)

famous screw, which raised up water by the revolution of a pipe twisted in a dextral helix round a rod.

In Fig. 351 I give the sketch already mentioned in which Leonardo studies the spirals of dust and smoke rising from a falling edifice, a sketch which forms part of his careful study of cracks and fissures in building.

In Fig. 352 he draws the spirals of horns (investigated in my twelfth chapter) with the evident purpose of weaving them into a conventional pattern for decoration.

FIG. 352.—STUDY OF THE SPIRALS OF RAM'S
HORNS BY LEONARDO.

I have already mentioned his particular interest in shells, and
in the study for the head of his " Leda " ; it is impossible to avoid
the parallel between the twisted coils of the ammonite he knew

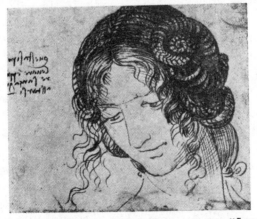

FIG. 104.—LEONARDO DA VINCI'S STUDY FOR THE " LEDA,"
SHOWING HAIR ARRANGED LIKE AN AMMONITE.
(From the Windsor Collection.)

FIG. 105.— BUST OF SCIPIO AFRICANUS.
(Bas-relief by Leonardo da Vinci, showing shell ornament on helmet.)

(compare Figs.' 104 and 105, which I take again for these pages from an earlier chapter) and the ornament for a helmet or the spiral tresses into which a woman's beautiful and abundant hair is plaited. In another manuscript he compares a woman's curls to the circling of a whirlpool. In Fig. 353 he draws the spiral of the shell itself. Among all his scattered, multitudinous notes, it is his explanation of the presence of fossil shells upon Italian mountains far from the sea which has most literary form and completeness, as may be seen in the admirable translations of Mr. E. McCurdy, who has done more than anyone to put the real Leonardo before modern readers by giving actual extracts from the

FIG. 353.—STUDY OF THE FLAT SPIRAL OF AN AMMONITE BY LEONARDO.

MSS. I shall be saying more of this, and of Dürer's work in the same direction, in my next chapter.

I have already stated that Leonardo was left-handed. But in Figs. 354, 355 and 356 (chosen from his manuscripts) I give an interesting example of one result of this. He shaded from left to right, as we know, and wrote from right to left, so that his manuscripts must be read in a mirror. But whenever he drew a cylindrical spiral (such as a rope or a screw) he always made it a left-hand spiral, the spiral

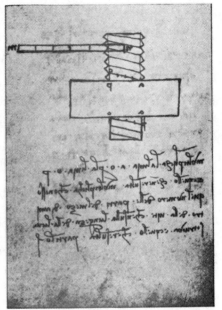

FIG. 354.—DRAWING OF A LEFT-HAND SCREW BY LEONARDO.

(In the South Kensington Museum.)

of Fig. 356, the spiral of the staircase shaft of Blois in Fig. 343.

It was in 1516, the year when the first payment is recorded at Blois for the wing containing this staircase, that Leonardo da

FIG. 355.—DRAWINGS OF LEFT-HAND SCREWS.

(From Leonardo's MSS. at S. Kensington.)

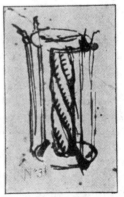

FIG. 356.—DRAWING OF A LEFT-HAND TWIST BY LEONARDO.

(From the Windsor MSS.)

Vinci crossed the Alps from north-western Italy at the request of François I., who gave him the manor of Clos Lucé (or Cloux) to live in. He was born in 1452, the natural son of Ser Piero da Vinci and Caterina, and he died at Amboise on May 2nd, 1519, the date after which we know that Jacques Sourdeau was Master Mason at Blois. Is it not probable that the gap in existing records at Blois between 1516 and 1519 can be to some extent filled up by the work of the engineer whose studies for the waterworks at Blois still exist, of this same Leonardo, who is described in his burial certificate (at the Church of the Royal Chapter of S. Florentin at Amboise) as " premier peintre et ingénieur *et archi-tecte du Roy*, mechanischien d'estat " ? I should like to emphasise these various titles. Goujon's combination of sculpture with architecture has been already mentioned. The Italian pre-decessor of Philibert de l'Orme at Fontainebleau is described as " Bastiannet Serlio, *peintre et architecteur*, du pays de Bologne." Evidently the combination of the title " architect " with that awarded for other qualities was quite usual in the years (before 1550) when the specialised type of architect had not yet been developed.

From 1516, then, to 1519, Leonardo da Vinci was official architect to the King of France who built the north wing of the château of Blois. But as long before this as 1506 his talents were known to Louis XII., and a letter from Charles d'Amboise, the French King's Governor of Milan, suggests that even in that year he had been officially employed by Louis. This was written on December 16th, 1506, to the Gonfalonier Soderini, requesting that Leonardo should remain at Milan in the French King's service. Charles says :—

" *Depuis que nous l'avons pratiqué et que nous avons reconnu par notre propre expérience ses talents si variés, nous voyons véri-tablement que son nom, célèbre en peinture, est relativement obscur, eu égard aux louanges qu'il mérite pour tous les autres branches dans lesquelles il s'est élevé si haut. Et nous nous plaisons à reconnaitre que, dans les essais faits par lui pour répondre à n'importe laquelle de nos demandes, dessins d'architecture et autres choses appartenant à notre Etat, il nous a satisfait de telle manière que nous avons conçu pour lui une grande admiration.*" If Leonardo had been employed by the French King ten years ago in Milan, it was only likely that his " architectural designs " should have been appreciated by that King's successor when the artist was in France.

I have already said that Leonardo was a good enough archi-tectural scholar in Italy to have collaborated with Bramante. It remains for me to show that he had specially studied the particular

kind of work which I venture to attribute to him at Blois, apart
from the general consideration, arguable from hundreds of his
manuscripts, that the spiral formation was one which appealed
to him so strongly that his drawings and notes have furnished
suggestions for the contents of nearly every one of my preceding
chapters. It was his way to study diffusely. Indeed he has
left so few completed works just because his study often

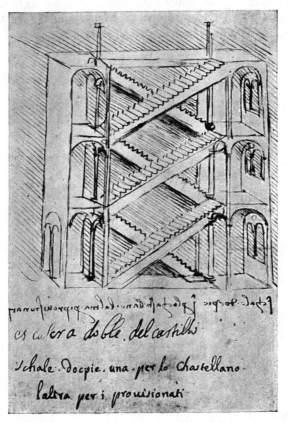

FIG. 357.—SKETCH FOR STAIRCASES BY LEONARDO.

outran his achievement. But in this case I think we can show
both.

Professional critics who reject all possibility of Leonardo
having been an architect, either in France or Italy, are
evidently unacquainted with the enormous mass of his manu-
scripts which have been discovered and preserved. Most of them
have been perused for the purposes of this book; and I can
therefore give an appropriate reply to the suggestion usually
put forward that " the only staircase " known to have been drawn

by Leonardo's hand occurs in the background of a sketch for his
" Adoration of the Magi " in the Uffizzi Gallery ; and it is always
pointed out that this shows very little architectural feeling and
no spiral curves at all. As a matter of record, this is not his
only sketch for a staircase, and it would be curious if it had
been, when we consider the enormous amount of preparatory
work Leonardo put into every question which attracted him.
The sketches I now reproduce from folio 69 recto, folio 68
verso, and folio 47 recto of manuscript B in the Institut de
France are very important evidence for the argument I wish to

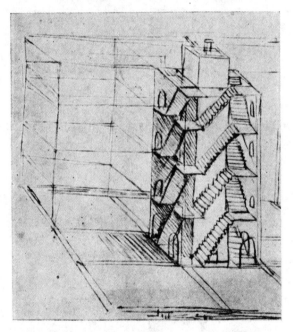

FIG. 358.—SKETCH FOR STAIRCASES BY LEONARDO.

develope. They were mentioned in the *Gazette des Beaux Arts*
for June, 1913, but as far as I am aware they have never been
published before in England.

The first two (Figs. 357 and 358) are of the " squared " type,
though the second (Fig. 358) suggests the spiral idea by the
revolution of the various flights round the central mass of the
building.

But what we have to find is a spiral staircase in a tower. No
one who looks at Fig. 359 can deny, I think, that the man who
drew it was familiar with the kind of work required by the design
at Blois. This " Renaissance pupil of Bramante " has here

shown a style far more " Gothic " than anything in the north
wing of Blois ; he is almost feudal ; and not content with a
single spiral, he designs two in the same shaft so as to admit of
servants and masters, or native soldiers and mercenaries, descend-
ing or ascending without meeting one another. These sketches
seem to me to prove conclusively not only that Leonardo had
studied the complex possibilities of straight staircases, but that
he had developed the far more simple and beautiful charm of
spiral staircases. Indeed, in the absence of all other direct

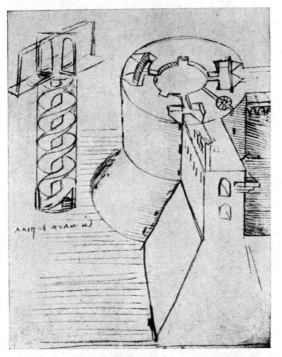

FIG. 359.—DESIGN BY LEONARDO FOR A SPIRAL STAIRCASE
IN A TOWER.

evidence, I must claim for the sketch shown in Fig. 359 the only
possible proof that such a staircase as that at Blois would have
been as familiar a problem to Leonardo architecturally as it
certainly was æsthetically.

I have still to show that he might have been at Blois in the
years when this staircase was built.

The manor of Clos Lucé, or Cloux, which Francis I. gave him
as his residence, is near Amboise, less than twenty miles down the
river Loire from Blois ; and he must have been there in 1517,
though the first letter of his from Amboise, as far as I have been

able to discover, is dated June, 1518. The doorway through which he must have so often passed is shown in Fig. 360. The curious and charming sketch of Amboise, done during his residence there at this period, I have reproduced in Fig. 361 ; and those who have seen the place from across the Loire will only recognise this drawing if they look at it in a mirror ; for it is done by the

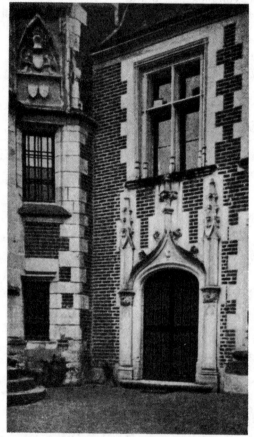

FIG. 360.—DOOR OF THE CHÂTEAU OF CLOS LUCÉ, NEAR
AMBOISE, ON THE LOIRE, WHERE LEONARDO LIVED
FROM 1517 UNTIL HIS DEATH ON MAY 2, 1519.
(Photograph by Frederick Evans.)

left-handed Leonardo, from right to left, just like his handwriting, so that what he saw on his left appears in his drawing on our right.

It was probably here, unless exaggerated reports of weakness be true, that he painted the " St. John the Baptist " of the Louvre. But what is more to our purpose is that here he certainly

made plans for a canal, with locks, at the confluence of the
Sauldre and the Morantin, and drew up a scheme for connecting
the Loire by an immense canal with the Saône at Macon, in order
to open up a new route for commerce between the north and south
of Europe. His hydrographic map of the Loire and its affluents
is now in the Codice Atlantico of the Ambrosian Library at Milan.
In fact, he thoroughly worked out the whole water-system of
the Cher and Loire, and his map shows the relative position of
Tours, Amboise, Blois, Montrichard and other places. Baron
Henry de Geymüller has also published Leonardo's plan for
draining " Romolontino " (Romorantin) for Francis I., and his
sketches for a new royal residence at Amboise " with a moat

FIG. 361.—AMBOISE.
From the drawing by Leonardo da Vinci.

40 braccia wide, and to the right of the castle a large basin for
jousting in boats."
 Among all the studies of this kind made at this time perhaps
the most interesting proof of Leonardo's direct connection with
Blois is the record among his manuscripts of his plans and sketches
of further improvements to the conduit, with its syphon dis-
charging into the Loire, which had been built there in 1505 by
Fra Giocondo; the Veronese architect.
 Fra Giocondo (Frère Jehan Jucundus) came to France with
Charles VIII. in 1497. He had designed bridges and waterworks
in Italy, and one of the few Italian designs known to have been
built in France between 1500 and 1512 is the Pont Notre Dame in
Paris, for which he was responsible. He died in Leonardo's life-
time. One of his companions, with Charles VIII., was Paganino,
that " Master Pageny " who gave a design for Henry VII.'s

monument at Westminster. He had left France by 1516. But the third Italian in this " first invasion " is of more importance to our argument. He was Domenico Barnabi di Cortona, called Il Boccador, never a " deviseur de bastiments," never an "archi- tecte," but described by Charles VIII.'s officials as " menuisier de tous suvrages et faiseur de chasteaulx " ; and in 1523 he is further entitled " maistre des œuvres de menuiserie du Roy et valet de chambre de la Reine." The meaning of " faiseur de chasteaulx " is that he made wooden models of such places as Tournay, Ardres, and Chambord ; and the record of his payment for these (900 livres) is the only mention of any Italian master employed by the King in Touraine before 1531, with the exception of Leonardo. It was probably Il Boccador's model of Chambord which is described in Félibien's " *Memoires.*" No work besides

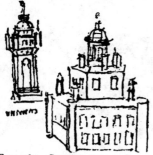

these models (made from the designs of other people) is recorded of Il Boccador before 1531, though he is known to have had a house at Blois since 1512. After 1531 he was put in charge of the new Hôtel de Ville in Paris, for which he is thought to have made designs as well as models. But this differed entirely in style from anything in the north wing at Blois ; and what was left of the original was com- pleted in 1628 by Marin de la Vallée and finally destroyed by the Commune. If he was employed on any work at all at Blois it would only have been on such decorative details as befitted a " *maistre des œuvres de menuiserie,*" and we know no more of him. In his Hôtel de Ville and in Fra Giocondo's Pont Notre Dame we exhaust the buildings known to have been designed by Italians in Paris before 1535.

Fig. 362.—Sketch for a Castle by Leonardo da Vinci.
(From the MSS. of the Institut de France.)

The idea of connecting the name of Leonardo da Vinci with any French architecture has been so loudly decried in England that I have always wondered at Professor Lethaby's courage in the suggestion that he built Chambord. But there is evidently a tendency to consider such attributions among the French them- selves, and M.M. Marcel-Reymond and Charles Marcel-Reymond in the *Gazette des Beaux Arts* for June, 1913, elaborate the argu- ment that Leonardo did design Chambord, with very considerable skill. I mention this not because I believe it probable or even possible, but because it is interesting to observe the readiness

of such eminent authorities to consider such an hypothesis. I only ask an equal indulgence for my own.

M.M. Marcel-Reymond published a sketch (Fig. 362) from the manuscripts of the Institut made by Leonardo for a castle, to which he assigns dimensions which are almost exactly those of Chambord ; and they further suggest that since Leonardo was a pupil of Bramante it was only natural that considerable affinities should be discoverable between the plan of Chambord (Fig. 363) and the plan of St. Peter's in Rome (Fig. 364). My untrained eye sees very little agreement. But the value of their theory does not depend on mere analogies. Unluckily there are far more facts with which to confront it than is the case with the Blois staircase. For instance, Chambord was not even begun in Leonardo's lifetime. On September 6th, 1519, just four months after Leonardo's death, François I. wrote to Pontbriand, his maître d'hôtel, to " *construire bastir et édifier un bel et somptueux édifice, au lieu et place de Chambord, en notre comté de Blois, selon l'ordonnance et devis que en avons faits,*" a phrase which certainly suggests the hand of the royal amateur in any professional designs that were to change the old hunting-seat of 1519 into the " palace of Gargantua " of 1539. Its exaggerated eccentricities could never be connected with the genius of Leonardo's ordered and laborious methods. Even its double spiral staircase only seems to show that no single curve (even when sinistral) could compete with the older masterpiece at Blois. Except for the details of its Italian ornament Chambord is entirely French in design, and Pierre Nepveu (or Trinqueau), its reputed architect, only appears in 1538 as " *commis au conterolle desdits edifices.*" Nor could anyone who had seen the curious pentagonal castle of Caprarola for one instant imagine that its designer (in spite of its spiral staircase) had anything to do with Chambord, apart from the fact that Giacomo Barazzi (called Il Vignola) only came to France in 1540. As a matter of record the only " design " we know for Chambord is the wooden model for which (in addition to models of Tournay and Ardres) François I. paid Il Boccador 900 livres. It has also been established by Mr. Reginald Blomfield that before 1525 at any rate there was no one corresponding to a modern " architect " in any of the great buildings of France. French families of master-masons (says the same authority), like the Chambiges,' the Le Bretons, the Bacheliers, the Grappins, did the actual work of building and masonry, and left the *travaux de choix*, the ornaments, modelling, painting, and carving, to such Italians as Fra Giocondo, Paganino, or Il Boccador, who had been brought over by Charles VIII., and who were chiefly used to add Italian detail to French masonry and to haphazard

plans. Careful specifications for contracts were indeed drawn up for such buildings as Blois, Chaumont, or Chenonceaux ; but the plans were necessarily irregular, because they were based on older structures, and because such " amateurs " as the King continuously interfered with what was going on. Even when François brought over such greater masters as Il Rosso or Primaticcio, and paid them all royally, it was not till Philibert de l'Orme took over Fontainebleau from Serlio in 1548 that the serious detailed designing began which was to become the trained architectural skill of such true architects as Jean Bullant.

There is no trace of Leonardo's grave in the cloister of S. Florentin, at Amboise, which was destroyed in 1808, though M. Arsène Houssaye has found at Clos Lucé two stones with the letters LEO INC . . still visible. His will, made in April, 1519 (though the written date is 1518), left his pupil and faithful comrade, Francesco Melzi, his sole executor and heir to all those priceless manuscripts and memoranda of which so many examples have been given in these pages. Only after a careful study of the manuscripts themselves can you become convinced that the growing estimate of the man

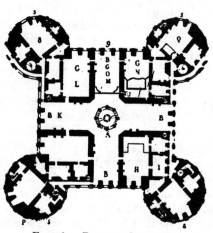

FIG. 363.—PLAN OF CHAMBORD.

has never been exaggerated ; for they are compact of observation, of prophecy, of achievement. His drawings of anatomy are amazing, and William Hunter had no praise too high for them. The downward stroke of a bird's wing, which is supposed to be so new a revelation of the instantaneous camera, was noted independently by Leonardo, as it had been drawn by the quick-sighted Japanese of his own time. The prophecy he made that man would learn to fly was based on studies of his own from which I have already reproduced one striking illustration, and he did much to render its fulfilment possible. *Pigliera il primo volo*, he cried, *il grande ucello sopra del dosso del suo magno Cecero, empiendo l'universo del stupore, empiendo di sua fama tutte le scritture, e gloria eterna al nido dove nacque.* The main impression produced by the Open Staircase is its

spiral formation. It is therefore likely that its builder would have given particular attention to spiral formations in Nature, with the object of discovering the principles involved in them, and applying these principles to the actual designs (for staircases and other things) which we find in his manuscripts. I think we may take it as proved that this was one of the many problems to which Leonardo turned his extraordinarily original and acquisitive intellect ; and in the various instances of natural spirals which I have collected I would repeat that the original indication was given me, in very many cases, in his manuscript notes.

In considering the possibility of such studies in parallelism of structure having occupied the leisure of a great designer, it will be only natural to look for the evidences of any practical result towards the end of a life in which busy activity would for the most part postpone such delicate imaginations until increasing years had brought more oppor- tunities of investigation and research. When Leonardo reached Touraine he was near- ing the end of a life that had been crowded with creative action. The full fruit of one of the most strenuous and imagi- native careers ever known was in the autumn of its ripeness. Many of the problems which that fertile brain attacked have never yet been solved, and if I

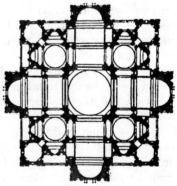

FIG. 364.—PLAN OF ST. PETER'S AT ROME.

finally trace to its marvellous inventiveness a creation that no recorded architect has yet been found worthy to claim, it is chiefly because the beauty of that creation of man's handiwork remains unparalleled outside the realm of Nature.

For it is the irresistible, spontaneous, uplifting movement of the whole that remains, after all, the main impression of this marvellous piece of work at Blois. To walk up those steps is to be borne along upon a breath of beauty, and not to feel the clogging feet of human clay at all. Those waving lines rush upwards like a flame blown strongly from beneath ; for there is in them a touch of that spell which is elemental ; of that same Nature's mystery which curves the tall shaft of the iris upwards from the pool in which it grows, or flings the wave in curving lines of foam upon the rocks the rising tide will cover.

He who made all this, and who owned the shell which first

suggested it, must have been an architect of powerful originality, and an artist of extraordinary imagination, with a sense of harmonious proportion rarely equalled in the world, a sense which he had trained in many various arts and many branches of science, for he must have been a student of biology who collected natural objects with a determination to penetrate the secret of their beauty, just as one of the greatest of our modern sculptors, Gilbert, has studied the bony forms of fishes, and from them designed the most exquisitely curved armour and the most fantastically beautiful ornaments. Learning and taste so universal as this seems to indicate have been rare at any period of the world's history : between 1500 and 1519 there was certainly but one man who possessed them, and that was Leonardo, the artist, architect, and biologist, who devoted so much of his life to the study of the intercommunication between art and Nature ; who, in fact, did even more in this direction in the fifteenth century than Gilbert or any other artist did in the nineteenth ; who gave this final manifestation of his constructive genius to France's ungrateful monarch just before he died ; who came from those Mediterranean shores where *Voluta vespertilio* was to be found.

For him science was the handmaid of the imitative and creative arts, the tool by which he gave reality to his imaginations. His work was the healthy manifestation of a strong and subtle intellect ; the mixture, and the equipose, of all that is best in the faculties of man ; and this is why his creations show that elusive quality of naturalism mingled with the ideal, of analysis with emotion, of soul with body. In him the artist and the scientist dwelt harmoniously together, worked harmoniously. No one of his time had observed so keenly ; no one could express his observations with a greater realism. But his art was no mere servile form of imitation. He could both imagine and create, because he had an inexhaustible material from which to mould fresh forms. " Non e creatore se non Iddio ed il poeta " (" God and the poet are the only creators "), said Tasso. But only an intellect so comprehensive as was Leonardo's could have justified the greater saying : " Natural Things are finite, but the works which the Eye can order of the Hand are infinite." One such " work " of his creative imagination did he reserve for the close of his life, and for its expression he chose that " mistress-art," architecture, to which all the other arts he knew are handmaids.

Not for such a soul as Leonardo's was that curve of calm ease which flows to the full circle of content. He chose that growing curve of vital endeavour which can sway from the very principle of Being to the outer spaces of Infinity ; for, as the striving Michelangelo wrote in his greatest sonnet, " from the stars of the

uttermost height comes down that Splendour, and to these it draws the heart's desire." From such high places of adventure genius brings back some echoes which may abide among men for a witness, and is thereby repaid for half its suffering. " Yet even the creative life " (as Compton Leith has finely said) " is haunted by the Imagined Better Thing, which, in more vivid shape than any seen by dull minds, will ever arise behind the thing achieved."

Such a creation as this staircase might well have been one of the few practical results of a philosophy which was not likely to have been expounded by one who could have permitted many such works to survive him. For this man had realised that in the perfection of Nature there is an end attained, unchanging, because perfect in its kind ; but that we are " something better than the birds or bees," and in our best building, as in our best art, the confession of that superiority must always be found. Hence comes that nobler love of change which is the divine unrest of genius, which often leaves so little done behind it, because there is always so much still to do. Some faint suggestion of this feeling is to be found in the expression on the face of his much-travelled " Mona Lisa." Not of any mortal handiwork were the words written, " Behold, it was very good " ; for labouring humanity is driven forward through the ages by the constant search for something higher that is ever hidden, yet ever to be revealed.

NOTES TO CHAPTER XVIII.

LEONARDO'S ADORATION OF THE MAGI.—The value of this picture, in the argument just stated, is not owing to any single detail, but to the fact that it was the masterpiece in painting of Leonardo's creative youth in Florence, before he attacked so many other problems, after 1482, in Milan and elsewhere. The studies for it, especially the perspective drawing, show the earliest contribution to architecture we possess from Leonardo's own hand ; and, in this case, at any rate, neither Leon Battista Alberti nor Paolo Uccello could have executed the technical work more scientifically, whatever may be said of the design. From 1473, when he was twenty-one, onwards, it is known that Leonardo wrote with his left hand from the right side of the page to the left. Sabba Castiglione and Raffaele del Montelupo, the sculptor, did the same, among his contemporaries ; and both Sabba and Luca Pacioli call him " left-handed." His manuscripts (as distinguished from his sketch-books for paintings) begin in 1483, and a good list of the publications concerned with them is given in " Leonardo da Vinci," by Dr. Jens Thiis (1913). Taking them all together they build up a great harmonious humanity which is without a parallel in the history of art.

LEONARDO'S BIRTH AND FAMILY.—Uzielli has shown that the Vinci family can be traced as far back as 1339, and still exists. A still better indication of the virile stock from which the love-child Leonardo sprang is given in the fact that his father married four times and had eleven children in lawful wedlock. Piero da Vinci was a Florentine notary, like his father before him, and had his country house in the village of Vinci, which is in the Arno Valley where the Florentine district approaches the plain of Pisa. Here he met and wooed, when he was twenty-five, one Cattarina, who became, in 1452, the mother of Leonardo, and subsequently married a certain Acchattabrigo di Piero del Vaccha of the same village. She disappears from history after having contributed one of the greatest minds that ever overtopped humanity to the life of her generation. The young Leonardo was brought up with his father's first and second wives who were both childless. In 1469 Piero moved permanently to Florence, having become a flourishing notary, and even legal adviser to the great house of Medici. But, most fortunately for the world, he did not insist upon the law for Cattarina's son, who left his house on the arrival of a third wife, for in 1469 he took the handsome lad of seventeen to the studio of his good friend Verrochio, and three years later the boy's name was inscribed in the " Red Book " of the worshipful company of painters. Supple, good-looking, witty, a well-known horsebreaker, with beautiful strong hands, Leonardo must have had hosts of friends, not one of whom (we may surmise) began to realise what vast potentialities were latent in that complex personality.

Dr, Thiis, in his volume on Leonardo mentioned in the previous Note, has a short way with the casual attribution, and works veritable havoc even with things fairly generally accepted. But he rightly points out, though he reduces the authentic drawings in the Uffizi from forty-two to seven, Leonardo's real reputation only gains in the process of separating the gold from the dross. The manuscripts and notes have indeed expanded our conceptions of Leonardo's knowledge almost beyond the credible. But the criticisms of Dr. Thiis have still further reduced the number of the accepted paintings, which was already very small.

In my opinion an even more valuable result arises from the attitude of the writer. Every judge of art, he insists, ought to be a connoisseur ; every lover of art ought to become a critic of art ; and the study of Leonardo's work is most beneficial to this end, because it is art of the highest quality. I am heartily tired of the cant about " Art for Artists." Great art should be for all the world. And it is books like this which open to us all its magic casements.

USE OF THE WORD "ARCHITECT."—This word was evidently very loosely employed in England, even in 1746, for in Eversley Church the epitaph of John James, clerk of the works to Sir Christopher Wren, records that " the said John James built the house called Warbrook in this parish, anno 1724, was the son of y^e Rev. Mr. John James, rector of Stratfield Turgis in this county, and *was Architect* to the churches of St. Paul, London, St. Peter, Westminster, y^e fifty new Churches, and y^e Royal Hospital for Seamen at Greenwich. He died y^e 15th of May, 1746, ætat. 74." This inscription was

recorded in the *Architectural Review* for May, 1902, by the Rev. P. H. Ditchfield. Pierre Trinqueau, at Chambord, has evidently won his title on evidence of much the same value.

No DOCUMENTARY EVIDENCE (p. 341).—The fact that no records of building at Blois exist, either of French or Italian sources, is no proof that domestic jealousy of the foreigner was the reason for this unexplained and unfortunate hiatus. It is probable, in the case of Leonardo, that as he was paid by salary, and not by piecework, there would be even less trace of his personal presence in the accounts than there might have been in the case of native artists; but as a matter of fact our best authority in these matters, the " Comptes des Bâtiments du Roi," only began in 1528, some ten years too late for our purpose, though it extends to 1571. It was published in 1880, and the best copy of Félibien's notes on it is preserved at Cheverny, on the way from Blois to Chambord.

VOLUTA VESPERTILIO —" No architect will believe that a shell was deliberately used as a model for your staircase, even if a few admit the possibility of Leonardo having designed it. But I see no reason why you should not compare the beauty of a good architectural design with the beauty of a ' natural object,' provided you do not press such pretty analogies into sterner service as proofs of attribution or of origin. They suggest, at any rate, that certain fundamental principles may provide a common form of expression both to a beautiful shell and to a fine staircase, and that each may exhibit those delicate variations from simple mathematics on which you lay such stress. If beauty is not different when we perceive it in different things, why should it not be due to the same causes in an artistic design as in a natural object? I ask; but there is apparently no answer—except the statement that beauty, having no real or separate existence *per se*, is only the supposed cause of certain emotions which it rouses in us; and that we cannot explain *why* we feel any such emotions; we can only say we *do* feel them; they are one proof of our individual existence. This is somewhat vague Have you a better answer in your final chapter?"

F. R. B. A.

CHAPTER XIX

Some Principles of Growth and Beauty

"Nature, that universal and publick Manuscript that lies expanded unto the Eyes of all."—Sir Thomas Browne.

DÜRER AND THE " CAVALLO "—DÜRER'S MATHEMATICAL STUDIES—
 DANTE, LEONARDO, GOETHE—THE EXPERIMENTAL METHOD
 — BEAUTY IS " FITNESS EXPRESSED "—THE VALUE OF
 DELICATE VARIATIONS—" GOOD TASTE "—PROCESSES OF
 SCIENTIFIC THOUGHT.

Jean Goujon, the famous French sculptor and architect, in a remarkable passage quoted by Mr. Reginald Blomfield, wrote that : " No one has thoroughly understood the true theory of this volute (*rondeur de limace*) except Albert Dürer " ; and some of my readers may be surprised to find the painter's name in connection with architecture. But if there is one thing that characterises the greater men of the centuries before the nineteenth it is their broad view of science and art, their eager interest in all the world had to show them, their bold knocking at every door of knowledge. I have taken Goethe and Leonardo as examples of an avoidance of specialism which has inevitably grown less and less as the advance of time has more and more necessitated a division of labour in the vast fields of research opening before us. But Albert Dürer might almost be taken as a third instance, though he cannot be placed in the same rank as the other two. He died some ten years after Leonardo, and it is almost certain that he took the Italian master's lost " Cavallo" as the model for the horse in " The Knight and Death." It was M. Salomon Reinach who first drew my attention to Woefflin's very interesting theory. But I have only space here to compare two sketches made by Leonardo for the lost statue of Francesco Sforza, with Dürer's well-known engraving. The more finished of the two sketches is that given in Fig. 365 ; but a very curious coincidence appears in the second (Fig. 366) ; for here the Italian has evidently had some difficulty with the near hind leg of his horse. Dürer's engraving shows a similar uncertainty, for he seems to have changed the position of this same leg in his horse even on the plate itself, and his correction is still visible in the

finished picture. In his own original study for the Knight made before 1512, the horse's legs are quite different from those shown in the engraving published in 1513. A note at the end of this chapter gives a few details about this very attractive comparison ; but here it is my business to show that in other ways Dürer followed up Leonardo's studies.

In one book, Dürer goes very closely into the spiral theory, as connected with the Ionic volute and the shapes of leaves. One of the subjects on which he wrote was the proportions of the horse, anticipating the work of Vial de St. Bel ; he also studied music, civil architecture, fortifications, fencing, landscape, and

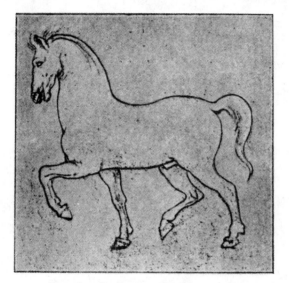

FIG. 365.—STUDY FOR THE "CAVALLO."
(From the MSS. of Leonardo da Vinci.)

colours ; and his " Banquet for Young Painters " is full of valuable maxims. In 1525 he printed a book on optics and perspective, and in 1528 appeared his four books on "Human Proportions." Ten years after his death were published his " Instructions for Mathematical Measurements," with figures " done by him so that any craftsman can recognise them," and finally " put in print for the benefit of all lovers of art." I reproduce several of the illustrations from the copy in the Print Room of the British Museum, among them the picture (drawn in 1525) of his invention for mechanically drawing an object in perspective (Fig. 368). But by far the most interesting things for us in this volume are the more mathematical figures, which follow the lines of Leonardo's work so closely that many of the

details taken from the Italian's notebooks for these pages will be found in Dürer's calculations. For instance, in my second chapter I showed how to construct a conical helix out of a flat spiral. Dürer does the same by another method in Fig. 369.

Again in Chapter XV., I suggested that the bishop's crozier had been taken from " the beautiful little flat spiral of a fernfrond gradually uncurling " (Fig. 61, p. 39). In the diagram which he numbers " thirteen," Dürer has the mathematical drawing for a crozier developed from gradually increasing curvilinear triangles set upon a spiral. Beneath it he shows that double curve of a leaf which Leonardo so exquisitely adapted to the steps of his open

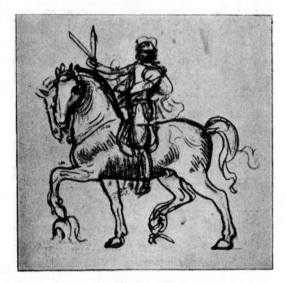

FIG. 366.—STUDY FOR THE STATUE OF FRANCESCO SFORZA.
(From the MSS. of Leonardo da Vinci.)

spiral staircase at Blois. Both these drawings are given here in Fig. 370.

In describing that staircase I laid some emphasis on the fact that its designer must have studied many natural objects and particularly shells. In Fig. 371 I reproduce the exquisite curve which Dürer calls his " *muschellini* " or " shell-line." More wonderful still here (Fig. 372) is his " schneckenlini," in which he develops a cylindrical helix from a circle, and thereby produces a measured drawing for a spiral staircase plotted out from the circle at the bottom of its containing tower. His curve in this case is not, of course, structural ; it only follows the ends of such steps as were drawn in Fig. 318. It shows a helical curve in silhouette, as it were, which forms the sine curve that is the wave

of harmonic motion, and is used in designing the side-elevations of screws. After this, it scarcely needed the " rondeur de limace," to which Goujon so enthusiastically refers in connection with Ionic volutes (Fig. 373), to prove that Dürer had indeed studied architectural details. Almost as interesting, for the main purpose of this book, is Dürer's freehand study of a logarithmic spiral, evidently drawn from some natural object, shown in Fig. 374. And yet, in spite of Leonardo's manuscripts, and in

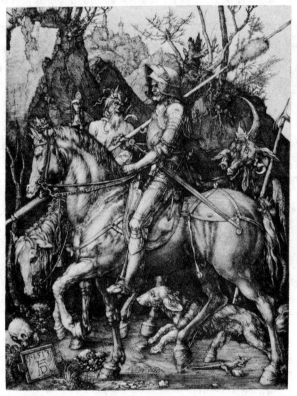

FIG. 367.—"THE KNIGHT, DEATH, AND THE DEVIL." By Albert Dürer.

spite of Dürer's studies, there are still some modern architectural critics left who deny the probability of a painter being an architect, or of either concerning himself with natural forms. It were impossible to convince such pedants though Leonardo and all the sixteenth century prophets rose from the dead. One thing, however, the rest of us may at least believe : that in the years from 1500 to 1550 the greatest men were not content to get their knowledge secondhand. They worked out their own salvation, calculated their own perspective, laboured at their own anatomy,

studied the treasure-house of Nature with their own eyes ; and obviously the method of work which I have described in the last chapter as that preferred by Leonardo was not unfamiliar to Dürer, whose words on the subject are as follows :—

" It is ordained that never shall any man be able, out of his own thoughts, to make a beautiful figure, unless, by much study, he hath well stored his mind. That, then, is no longer to be called his own ; it is art acquired and learnt, which soweth, waxeth, and beareth fruit after its kind. Thence the gathered secret treasure of the heart is manifested openly in the work,

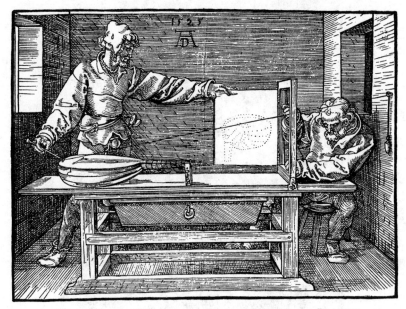

FIG. 368.—DÜRER'S ENGRAVING OF HIS INVENTION FOR DRAWING
IN PERSPECTIVE.

and the new creature which a man createth in his heart, appeareth in the form of a thing."

This may be accepted as a rough suggestion of what is meant by the Experimental Method, and for Leonardo I claim the honour of having founded that method before Bacon or any other philosopher, just as he announced that " the sun did not move " before Copernicus, and suggested the circulation of the blood before Harvey. And you should remember (in order to realise what this means) that the year when Leonardo finished his " Last Supper " was the year when Savonarola was burnt. In that same year Leonardo wrote : " My arguments are derived solely from *experiment, which is the source of all evidence, the one and only mother of true science.* . . . It is useless to conduct an argument by mere quotation from authorities ; that does not

prove cleverness ; it only suggests a good memory." There is more living sap (as Peladan has said) in one such sentence than in all the faggots of the Inquisition ; and it is difficult to say which was the more admirable, the independence of such an intellect

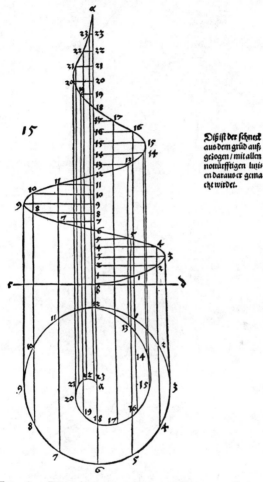

Diß ist der schneck
aus dem grüd auf;
gezogen / mit allen
notürfftigen luni;
en daraus er gema
cht wirdet.

FIG. 369.—DÜRER'S CALCULATION FOR MAKING A CONICAL
HÉLIX FROM A FLAT SPIRAL.

or the secrecy with which it worked ; for the value of such doctrines can only now be understood if we recall the time at which they were uttered. They closed the doors of dusty libraries ; they bade defiance both to classic texts and theological dogmas ; they sounded a trumpet-call of liberation from the fetters of scholasticism ; they summoned man to prove his intellectual

supremacy before the face of Nature. Nothing more contrary to the whole spirit of his day can easily be imagined ; and though I have suggested certain reasonable causes for the neglect of Leonardo's manuscripts during his lifetime and their loss for so

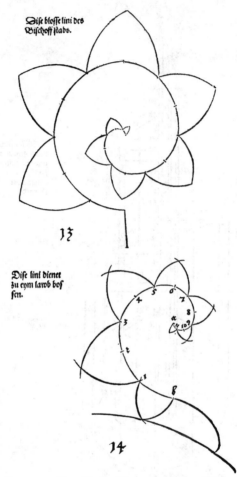

Fig. 370.—The Upper Drawing shows Dürer's Design for a Spiral Crozier, the Lower he calls the "Line of the Leaf."

long after his death, just as Dürer's " Bilderbucher " had been lost for 200 years till Baron von Derschau bought it, I have never emphasised the even more significant fact that, had they been publicly known to his contemporaries, Leonardo's writings would have sufficed to send their author to the stake.

Before Leonardo came Dante ; after him came Goethe. Of

no other poet, as of Dante, can it be said that he was the greatest
political thinker of his age ; of no other philosopher or theologian,
that he was its greatest poet, and in the front rank of its scholar-
ship and science. And this was the age of Louis IX. and Thomas
Aquinas, of Cimabue and Giotto, of Amiens and Westminster, of
the Old Palace of Florence, and the Holy Field of Pisa. Within the
limits of his time Dante knew all literature accessible, all science
hitherto attained. His writings lead the student into almost as
many branches of investigation as do the manuscripts of Leonardo,

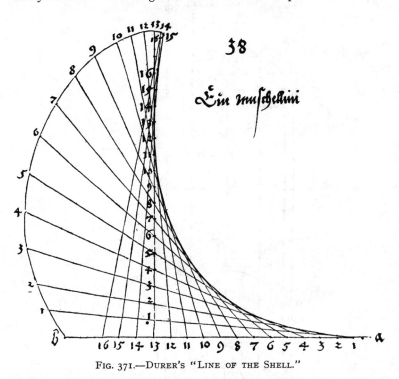

FIG. 371.—DURER'S "LINE OF THE SHELL."

and they have waited almost as long for fitting exposition of that
mass of accumulated detail which underlay the magic creativeness
of the poems so beautifully elucidated by the scholarship of the
late Arthur Butler.

Michelet described Leonardo, in a thoroughly characteristic
phrase, as " the Italian brother of Faust " ; but there is an even
closer parallel between the Italian and Faust's great creator,
Goethe, " Europe's sagest head." For the genius of the German
shone not merely in the poetry and prose of which he is the
acknowledged master, but in osteology, in botany, in morphology,
in anatomy, in optics, in the theory of architecture. His name

will indeed be connected with some of these as long as it is honoured in the language he immortalised. Like Leonardo, Goethe projected a mind that was primarily artistic into all those scientific

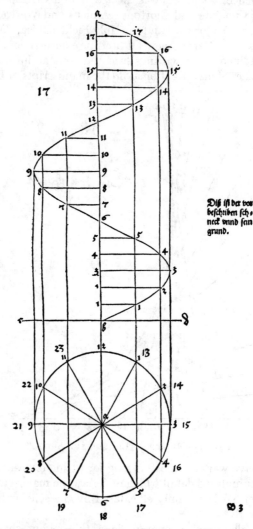

Diß iſt der von beſchriben ſchneck vnnd ſein grund.

FIG. 372.—DÜRER'S PLAN FOR THE CYLINDRICAL HELIX OF A STAIRCASE.

problems which the errors or inadequacy of his time had left incomplete. Such prophetic insight as was theirs is never understood in the age of which it is a part. But when their day has itself become a portion of the past, then their own value emerges clear, in its true perspective, above the many-headed ignorance

that once shrouded them ; for " it is not the intelligent man, but intelligence, that rules." In the words of Matthew Arnold :

> " The one or two immortal lights
> Rise slowly up into the sky
> To shine there everlastingly,
> Like stars over the bounding hill.
> The epoch ends, the world is still."

Leonardo possessed to an extraordinary degree that masterful quality of the human mind which Goethe called " das Dämonische," that power which makes and transforms ideas, that living and constructive energy which flings itself into the future while it assimilates the present.

> " Ich, mehr als Cherub, dessen freie Kraft
> Schon durch die Adern der Natur zu fliessen. . . ."

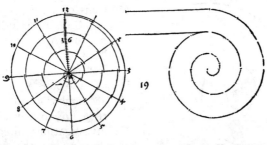

FIG. 373.—DÜRER'S DESIGN FOR AN IONIC VOLUTE.

It must be remembered, too, that Leonardo lived and laboured in an age when what we may call " the scientific sense " was far less developed than it is now, and when the multitudinous possibilities of the printing press, the camera, and the telegraph were either unknown or unappreciated. In his library, biology was represented by Pliny, John de Manderville, and " a lapidarium." Yet he suggested the theory of the eye, which was slowly elaborated from Leonardo to Kepler, from Kepler to Helmholtz.

" *Il Moto*," he wrote, " *è causa d'ogni vita*." " Activity," said Professor Clifford 400 years afterwards, " is the first condition of development." Leonardo was the first to propose a division of animals into vertebrates and invertebrates. He guessed that the blood circulated, but could not explain the mechanism. " The heart," he wrote, " is a muscle of great strength . . . the blood which returns when the heart opens again is not the same as that which closes the valve."

Long before Bernard Palissy he studied the fossil shells on mountain tops, and showed that " the Deluge had nothing to do

with them," and that they were remains of living organisms, left there by water, " Nature's charioteer," in the course of prolonged changes in the surface of the earth, and revealing in their fossil state the circumstances of their far-off existence.

I have placed in this chapter two shells which appealed to Hollar, though I fear the sterner conchologist might not accept them as correct (Figs. 375 and 376), and the famous etching by Rembrandt reproduced for these pages (Fig. 377) from a beautiful example which was last year in the galleries of Messrs. Colnaghi and Obach. It has been reversed in printing off the design, so I give a photograph of an original shell to compare with it (Fig. 378).

Leonardo thought (to continue my brief analysis) that " the sandy desert beyond Mount Atlas " had formerly been " covered with water," and anticipated Cuvier by showing that the level of the sea's bottom is continually rising, sometimes rapidly, some-

FIG. 374.—DÜRER'S LOGARITHMIC SPIRAL (FREEHAND).

times by lengthy accumulations of *débris*, and pointed out the strata in the stone of the Apennines revealed by the cutting of the river Lamona. He gave as long as 200,000 years for the accumulations formed by the river Po ; and in geology his investigations directly foreshadow in other ways the work of Lyell, who established geology as a science by showing that the causes which had produced the past were still at work producing the future, just as Darwin not only explained the biology of vanished forms, but gave the reasons for further development, and assigned living things to their right place in the great order of Nature.

Besides founding the science of anatomy Leonardo was the first to investigate the structural classification of plants, and (in the fourth book of the " Trattato ") to study the system on which leaves are disposed and arranged about their stalks, and laid down laws which were re-discovered independently in the seventeenth century. He explained the suspension of bodies in the air, and experimented on the consistency of the atmosphere at various heights, besides going far towards a solution of those problems of flying which still occupy us to-day. " *Il sole non si move*," he wrote, anticipating Copernicus in propounding his theory of the movement of the earth round the sun, and explaining to the dogmatists of his day that " the supreme wisdom of God

guided him to choose those laws of movement which were in closest agreement with abstract and metaphysical reasoning."

He laid the foundations for those laws of the movement and equilibrium of fluids which were completed by Pascal, D'Alembert, Bernouilli, and others. He proved that water in communicating vessels remained at the same height in each, which was the theory of the hydraulic press of 1653. Attracted irresistibly by the practical problems of the Scriptural "Deluge," he covered innumerable sheets with studies of the movement of water under the stress of such a sudden cataclysm. The canals and irrigating works already existing in Lombardy were enormously improved by his hydraulic knowledge, and his contrivances were still employed by the Milanese at the end of the seventeenth century. He experimented on the lines which subsequently produced the "*camera obscura*," and initiated the theory of complementary colours which was carried on by Chevreuil. Of his numberless mechanical inventions, it will be sufficient to say that he designed a breech-loading cannon which pro-

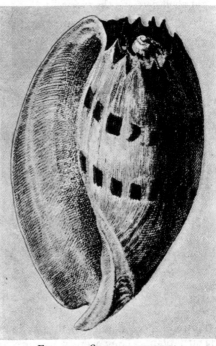

FIG. 375.—CYMBIUM DIADEMA.
(By Hollar.)

pelled its ball by steam, that he invented paddle-wheels for boats, and that he suggested the use of parachutes and of screws turning on a vertical axis as a means of aerial locomotion. I have added to this chapter (Figs. 379, 380 and 381) a few more typical examples of his studies of natural forms ; and it must become more and more clear to the sympathetic reader how natural it would be for such a man to live his life out to the end, as Titian did, and even to produce a masterpiece of architectural design within a few months of his death. It is of those whose joy is in creation that Compton Leith has written in one of the finest passages in his "Sirenica."

" The tree of their life shall not slowly rust to dull hues, but flush
to a swift splendour in the woods of autumn, until at last it is absorbed
into one clear flame, as though it should not die but glow into
annihilation. While the mind performs its office and the wedlock
of body and soul holds undissolved, there shall still be scope for
dreams not unimpassioned, the soul shall yet be quickened with the
unquenchable fire. So long as the eye has light, the heart shall yet
be enamoured of arduous hopes, as in the blazing days of manhood.
And in the distance there shall be surer glimpses of that which youth
but half perceived ; the things which were invisible but not vain
shall seem now to pause for them, the flash shall linger ; a steadfast
sight shall perceive the vision."

Even from so slight a summary as is here given of Leonardo's

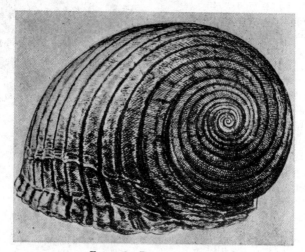

Fig. 376.—Dolium galea.
(By Hollar.)

wide researches it may easily be seen that they were on no hap-
hazard plan. They were a definite attempt to collect material
in order to frame new generalisations and fundamental principles
on which all fresh creation should be based. The attribution of
the design for a certain staircase to Leonardo may interest the
biologist as little as it convinces the architect. But it is not
necessary to be a professional specialist to appreciate and even
enjoy the process by which that attribution has been proved to
be a probability, in a case where no documentary evidence (either
for or against) can be discovered. It must at least be conceded
that Leonardo took up architecture just as Goujon, the sculptor,
and Dürer, the painter, studied it after him, in that first fruitful
half of the sixteenth century. Goujon's contributions to Martin's
edition of Vitruvius are sufficient to show his real knowledge, even

if Mr. Reginald Blomfield's proof of his work on the Louvre did not give him a higher place in practical skill than either of the other two. Bramante studied painting before he became an architect, and was a military engineer as well. He died only five years before Leonardo. Indeed, the men of that time who are now considered famous for one thing had tried many different paths before they reached it. And without doubt each effort contributed to the certainty of that one success which now has overshadowed all the rest.

" In life Beauty perishes," wrote Leonardo, " but not in art " ; and we may certainly assume that he first investigated the principles of life and growth with the main object of discovering those principles of beauty which were to guide him in his art, and the conclusion of our essay must therefore embody something of those theories of which he left such marvellous practical examples.

Let us be careful in our use of words. " Beauty " is almost as humanly conventional and subjective as " spiral formation." Beauty, in fact, connotes humanity, and we call a natural object " beautiful " because *we* see that its form expresses fitness, because we realise the perfect fulfilment of function in the lines of structure ; as the orange and the pomegranate promise sweetness in every coloured curve, or the horse shows strength and courage in every line and muscle, or the woman's graceful body offers the mate who shall be the mother. But we cannot say that any concrete thing or quality, called beauty, resides in any natural object, any more than we can say that shells or plants consciously assume the formation which we classify as spiral. We can only say that such objects rouse in us a pleasurable emotion stimulated by that sense of beauty which is the ancestral heritage of the human race, though it is very variously developed in various individual men. But, being men, we are not content merely to enjoy the stock of beauty already visible to us and existing in the universe. We struggle to create fresh beauty for ourselves. That desire is as old as the Aurignacians, who have left us the first dawn of the artistic impulse, 20,000 years ago. By the time of the classical Hellenic civilisation that same desire culminated in finer work than any later centuries have produced. What was the secret of the greatest artists' skill ? It was not the mere copying of natural objects they thought beautiful. It was the study of natural objects to discover the secret sources of their beauty. And we enjoy their work, not because they consciously aimed at beauty in itself, but because their interpretation of their subject was inspired by that delicate sense of beauty which was keenly developed in their hearts ; because the expression (in

terms of paint or marble) of the emotion which they felt rouses an echo, a reflection, of that same passion in ourselves.

Now, even the chapters of this short essay, have taught us in our turn, something about the world of Nature. " Atomic and subatomic diversity," wrote the late Alfred Russell Wallace to me, " is, I believe, the basic condition of the exquisite forms in Nature, never producing straight lines but an endless variety of curves. Absolute uniformity of atoms and of forces would probably have led to the production of straight lines, true circles, or other closed curves. Inequality starts curves, and when growth is diverted from the direct path it almost necessarily leads to the production of that most beautiful of curves, the

FIG. 377.—REMBRANDT'S ETCHING OF THE SHELL (1650).
Reproduced from the original in the possession of Messrs. Colnaghi and Obach, 168, New Bond Street.
(The shell is reversed by printing, not by nature.)

Spiral." But in all efforts to define a natural object in mathematical terms we have come to a point at which our knowledge of the involved factors ceases. The nautilus is almost a logarithmic spiral, but not quite. Nor can a phyllotaxis diagram ever show that the plant's growth is mathematically correct. It may well be the case that though a logarithmic spiral may serve us admirably as a working definition of a shell's or a plant's growth, it may not actually be the formula most closely approximating to the vital processes involved. All that can be said is that the logarithmic spiral described in my next chapter is as near as we can get in mathematics to an accurate definition of the natural phenomena, and that it provides a standard by which we can approximately define those phenomena in terms of

differences. To this same stopping-place the mathematician is also brought when he tries to express beauty in terms of measurement. In other words, the baffling factor in a natural object is its life, its organic growth. The baffling factor in a masterpiece of creative art is its beauty, a quality as essential and as intangible as life. This means therefore that growth cannot be wholly expressed by simple mathematics, though they may help us to appreciate and catalogue the phenomena we examine. It means also that a thing constructed merely by rule of thumb and mathematics must inevitably fall short of perfect beauty. For perfect beauty, like natural growth, implies irregular and subtle variations.

By this path we may perhaps reach some more intelligible explanation of that vague but most important quality—" good taste." It is born in some men and unknown by others. It

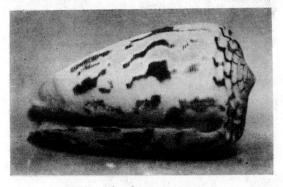

FIG. 378.—CONUS STRIATUS.

can be widely distributed, or the life of ancient Hellas becomes an unintelligible miracle. It can be lost in just as large a measure, or most modern architecture would be a nightmare, from which our waking moments would be free. It has a definite relation to, and a keen sympathy with, the phenomena of life and growth ; so it must to some extent partake of their qualities. A man whose vitality is strong, whether it be physical or intellectual, would therefore be likely to possess it, if he were not only keenly in touch with the proportions of Nature, but if he also were strong and subtle enough to vary them at will. This would explain both its general prevalence in ancient Hellas, and its general absence in an age when machine-made productions have become paramount ; when designers trust to mathematics ; when the public object to anything but repetition. One of the chief manifestations of " good taste," then, is the appreciation of the truth that beauty, like life and growth, largely depends not on

exact copying, but on those subtle variations to which the scheme
of creation, as we know it, owes those great laws of the origin of
species and the survival of the fittest.

The fact that a shell is beautiful may be observable by us, but
it has been no factor in the conscious life of its inhabitant. The
shell is of the shape which has best enabled that inhabitant to
survive. Its " beauty " is the result (or the accompaniment) of
an absolute fitness for its function arrived at by countless delicate
divergencies from mathematical regularity. If, therefore, we
propose to create beauty in our own handiwork, it is a fair con-
clusion that we should not forget those same divergencies from

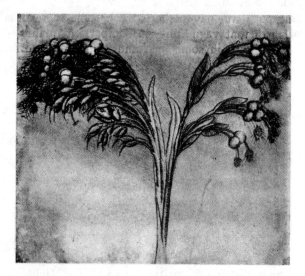

Fig. 379.—Job's Tears.
(From the original drawing by Leonardo da Vinci.)

mathematical exactitude which the Greeks were so careful to
recognise in the lines and columns of the Parthenon ; and we
should realise that one great factor in the beauty both of art
and of Nature consists in those same subtle variations which
have moulded vital forms since life began.

" The art of painting is made for the eyes, for sight is the
noblest sense of man," wrote Albert Dürer ; and because all man's
artistic creations must primarily appeal to other men through the
sense of sight, it has been sometimes wrongly held that the Greeks,
having analysed and formulated the laws of sight, proceeded to
turn them into laws of art ; and that, since the laws of sight are
fixed and unchangeable, therefore Greek art produced a fixed and
unchangeable canon of workmanship. Both the conclusion and

its corollary will not bear examination. You might as well try to explain Beethoven's melodies by saying that his music is founded on the laws of sound. You might as well say that one who knew the laws of sound could create the tunes of Schumann, though you would not be so far wrong in thinking that Sebastian Bach, for instance, thoroughly understood those laws before he wrote his greatest fugues. Even if the Greeks had been capable

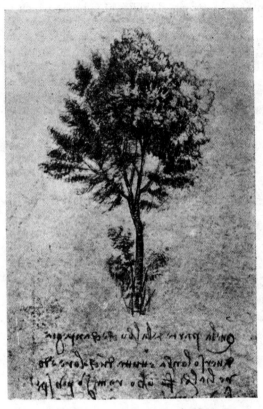

FIG. 380.—A LEAF FROM LEONARDO'S NOTE BOOKS.

of analysing laws of sight which were unknown to the modern world for sixteen centuries after the fall of Athens, they would not have dreamed of such a theory. What they evidently did realise was that all the creations of an artist can only attract the spectator through the ancestral channels of those human senses which are common to them both, through the infinitely various and intimate appeals to the very fibre of our being which have been the same (in varying quality) since man was man at all.

It is in the form of " the thing which he has made " (as Dürer

puts it) that man's relation to that thing is indicated, just as in the form of a natural object is expressed its function, because the more ably it fulfils the function the more beautifully is that form developed. It is clear, therefore, that in architecture a form which rightly expresses function should be beautiful, and I have already pointed out that the Doric columns of the Parthenon are indeed more beautiful than the Egyptian columns of Thebes precisely because the Greek workmanship produces the ultimate expression of that strong stability of support which is the main

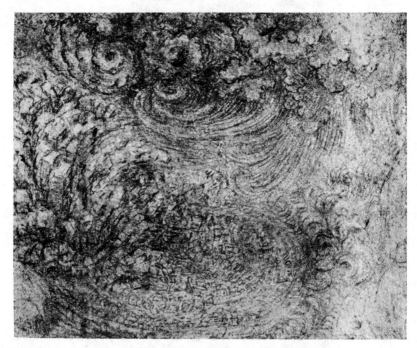

FIG. 381.—STUDY OF CLOUDS.
(From Leonardo's sketches for "The Deluge.")

function of a column. Now from a strictly mathematical point of view straight lines would have literally served this purpose. But the Greek sculptor knew at any rate enough of the " Laws of Sight " to realise that when the eye considers a perfectly straight vertical shaft, the message transmitted to the brain is that of a skinny, shrunken column not strong enough to hold up anything at all; just as a perfectly straight horizontal line conveys the effect of dipping weakly in the middle. As we have already seen, the Greek made the steps of the Parthenon swell upwards in a slight but beautiful curve, and he did this with the sole object of

making them look strong for their purpose and organically beautiful. For precisely the same reason he introduced the subtle curves of entasis (a variation of less than one inch in 360) in the outline of his column ; and the eye was at once satisfied that it was beautiful because it looked strong enough to fulfil its function. In both instances, therefore, we find a deliberate recognition of the fundamental truth that, in any great architectural creation, a member of the scheme must not merely *be* strong enough ; it must *look* strong enough ; it must be " fitness *expressed.*" To attain this end, to make sure of winning that appreciation from the spectator without which their work was vain, the great Greek architects fearlessly sacrificed scientific truth to the higher dictates of their art. They realised, in fact, the difference which has been the subject of so many of our chapters, the difference between living art and frigid exactitude, between organic beauty and simple mathematics.

But such theories of art and beauty as have been just suggested are, after all, only a by-path in that long research into the organic forms of growth and energy which probably absorbed the greater part of Leonardo's life and has monopolised the majority of my previous pages. It must be my final task to try and indicate some of the more scientific results which apparently follow from the facts we have examined ; and, as a preliminary, to offer some suggestions as to the method of that inquiry itself. I shall, therefore, consider, quite briefly, a few examples of those processes of scientific thought which have led in the past to valuable conclusions and which are still producing so many marvellous results. An example was quoted by Professor W. K. Clifford, which is typical of the mental process to which I desire to draw attention. A dot on paper seen through Iceland spar shows as not one, but two dots. Sir William Rowan Hamilton, late Astronomer Royal of Ireland, knowing both this phenomenon and Fresnel's explanation of it, predicted that by looking through certain crystals in a certain direction we should see a continuous circle, and Mr. Lloyd did see this circle.

I have already mentioned Professor Goodsir's deductions (as to the logarithmic spiral) from Canon Moseley's investigations of the forms of shells. I will add another example of the same kind from the history of English racing. M. Vial de Saint-Bel, a famous veterinary surgeon and anatomist of the eighteenth century made very careful examinations and mathematical measurements of the body and skeleton of Eclipse, the famous racehorse which died in 1789. From these a valuable series of standards and proportions was deduced, which has been republished elsewhere (in " A History of the English Turf," Messrs.

H. Virtue & Co.), as a method for comparing the developments of the English thoroughbred in the past 100 years, and as some explanation, from the purely mathematical point of view, of a speed and endurance which were entirely owing to Eclipse's wonderful anatomical construction. The most interesting result of M. de Saint-Bel's investigations has only recently appeared ; for he proved by mathematics that Eclipse must have made certain movements with his legs which nobody could see. Only when instantaneous photography was invented and applied to horse racing did these movements actually make their appearance in the photograph of a galloping horse.

The progress of science largely depends on this power of realising events before they occur. The process by which such results as those shown in the " Principia " must be reached may be described as two steps, the first being the hypothesis (based on the purely abstract conception of perfect motion) that the motion of a planet was like that of a ball swung on the end of a string ; the second step is when science discards the hypothesis, and uses it merely to investigate the properties of a planet's motion. This is the process that has been exemplified in the discovery of the law of light and heat, or in the hypothesis which is based upon the abstract conception of a perfect liquid. It is also the process by which, in our chapters on the growth of shells and plants, we have postulated the logarithmic spiral as an abstract conception of perfect growth, and used it to investigate the properties of organic life and energy. As soon as those properties become more clear by the continuous process of research we shall be in the position to formulate some definite laws for life and energy like those laid down by Newton for the solar system. These investigations of spiral formations are a first step towards that formula.

Clearly it will be unprofitable to emphasise the value of variations unless we also suggest some standard by which those variations can be measured. My last chapter offers such a standard for consideration.

NOTES TO CHAPTER XIX.

Leonardo's Cavallo and Durer's Knight.—There is nothing in the dates to disprove a thesis incapable indeed of actual verification, but none the less attractive for that. Leonardo lived from 1452 to 1519. Dürer was born in 1471, and died in 1528.

There is nothing improbable in the theory that Dürer might have

seen either a model of the " Cavallo " or, at any rate, some of its
artist's many sketches for the statue, and how numerous those sketches
were may be realised from the long catalogue (still possible even of
those that still survive) printed in " Leonardo da Vinci," by Eugene
Müntz (Vol. II., p. 273), and in the magnificent volume by Dr. Thiis,
published in 1913. There must have been many more such
drawings extant before 1500, and it is only after Leonardo had
definitely taken up his abode in France that we are unable to say
with some degree of certainty that those sketches were accessible to
artists. Dürer was in Venice in 1490, and again from 1505 to 1507 ;
even if he happened to have seen none of Leonardo's work on his first
visit, he must have heard something on his second journey of the most
gorgeous pageant held in Milan during the interval, when that city
celebrated the marriage of Bianca Maria Sforza to the Emperor
Maximilian on November 30th, 1493. The most popular and long-
talked-of feature of that festival, we may be sure, was Leonardo's
plaster model of the great equestrian statue of Francesco Sforza,
which stood before the castle at the Porta Giovia under a triumphal
arch. Absolutely nothing of that statue, save its creator's sketches,
now remains to us. Its history has been traced, by Louis Courajod,
by Bannaffé, by Müller-Walde, and others.

The Duke Francesco had died in 1466. In 1472 his successor,
Galeazzo Maria, determined to set up a monument to his memory.
Several artists had tried their hands at it before Ludovico Sforza,
called Il Moro, was able to secure from Leonardo that first triumphant
plaster model set in place in 1493. It is curious not only that this
model should have so wholly disappeared, but that Ludovico himself
should later on have suffered the horrors of subterranean imprisonment
in Loches, not far off the house at Clos-Lucé, where Leonardo died
in the same valley of the Loire. It is said by Sabba di Castiglione
(who wrote before 1546) that the Gascon crossbowmen of Louis XII.
of France shot the model to pieces. In 1501 there was enough left
for the Duke of Ferrara to desire to get possession of it. After this
date there is no trace of it ; and this is the more unfortunate because
in Leonardo's drawings, many of which have been reproduced in these
pages, we can distinctly trace the origins of that epic warhorse so
beloved by Rubens, by Van Dyck, and by Valasquez. Even Dürer,
whose ideals may be taken to be very different, in his unsparing
realism, may not inconceivably have been influenced by the majesty
of imagination in the greater Italian. Is it too fanciful to suggest
that when Dürer became court painter to Maximilian in 1512, the
Emperor may have reminded him of that splendid equestrian statue
which had been the most striking artistic contribution to Bianca's
wedding festival in Milan nineteen years ago ? If so, we can under-
stand why Dürer so radically altered the first study for his knight's
horse made before 1512, and substituted for it the very different
conception published in 1513 and here reproduced. Where did that
altered conception come from ?

The Italian's outline of the horse alone without a rider (Fig. 365)
is perhaps the one which agrees most generally with Dürer's
finished horse, with the single exception that the two legs off the

ground are lifted slightly higher in the Italian sketch than they are in the German engraving, for the Knight's horse is weary. When we consider the second Italian sketch (Fig. 366), which shows a man upon the horse, we see a possible reason for the lifting of these two feet. One original sketch of Leonardo's for the " Cavallo " shows a fallen urn of water beneath the horse's forefoot and a tortoise beneath his hind foot, both objects having a special symbolical meaning in this place. But it was also sound construction to support both these feet in a statue of such great weight, and you will notice that the hind foot in Leonardo's sketch has given him some little trouble, and has been redrawn at least twice. Now it is a curious coincidence that it is just this hind foot lifted from the ground which seems to have given Dürer also a little trouble, for his engraving is one of the few instances I know in which the artist has made a mistake upon the metal and boldly left it there for all the world to see, finishing off his work without being afraid of having revealed his original uncertainty ; and you can still see the lines both of the leg and of the hoof which Dürer originally drew and then deliberately altered. M. Reinach also points out that the wrinkled nostrils and open mouth of the horse, very common in designs inspired by the antique, occur in Leonardo's sketches for the " Cavallo," and in Dürer's finished picture, but not in Dürer's study for the picture. It is quite a common feature in Leonardo's many sketches of horses fighting, which may well have come to Dürer's knowledge before 1512, and after his first study of the knight was finished. It is, of course, quite possible to exaggerate the meaning of what may merely be coincidences, but I am inclined at least to think that the German must have had the sketches of Leonardo in his mind when he drew this patient horse plodding steadily forward towards an unknown fate, and posed in exactly the same position as the Italian's horse, with the exception that its legs are not raised so high off the ground, owing to the fact that it represented a tired steed carrying a heavy burden, instead of a triumphant war horse bearing a conqueror upon its back. The knight is riding, with his spear ready on his shoulder, through the clear light of evening, leaving behind him the pleasant evidences of human habitation and entering resolutely and calmly the dark portals of what may be the valley of the shadow of death. The spectre of Dissolution rides opposite him ; the father of all Evil creeps upon his flank. Both his horse and his faithful hound show that they are aware of these monstrous presences ; but he himself rides forward, unshaken, unappalled.

There is no doubt that the German carried that passionate study of facts, that inveterate and untiring search for detail, even further than did Leonardo, and that in certain of his works (for instance the famous " Melencolia ") he somewhat exaggerated this principle, and overlaid the grand conception with too multitudinous detail. Yet it is no less certain that Dürer well knew how to profit by the work and the ideals of other artists, and it is perhaps significant, in connection with the present inquiry, that in the Barberini collection at Rome there is a picture of the child Jesus disputing with the doctors which has often been considered to have been suggested

to Dürer by Leonardo's most characteristic studies of this same subject.

The small point of influence here raised is not, of course, of any vital importance in the consideration of either of the great artists concerned, but I must admit that after seeing Dürer's original study for his knight's horse, and after comparing his finished engraving, both with that and with several more sketches by Leonardo than the two which are here reproduced, I cannot but agree with the great probability of the interesting suggestion supported by M. Reinach.

GOETHE'S " FAUSTUS."—The translation is :—

> " High above cherubs—above all that serve
> Raised up immeasurably—every nerve
> Of Nature's life seemed animate with mine. . . ."
> (Goethe's " Faustus," trans. by JOHN ANSTER).

FITNESS EXPRESSED.—I think the first writer who used this definition of beauty was Sir Walter Armstrong, director of the National Gallery of Ireland, to whose analytical writings modern art-criticism owes so much.

ENTASIS OF COLUMN.—See the article by L. March Phillipps on " The Origin of Structural Forms," in the *Architectural Review* for October, 1912, which confirms in the most interesting and independent manner certain conclusions already stated in the first form of these pages.

The following letters were received when this chapter was first published in the *Field* :—

SLIGHT DIVERGENCIES AND SUBTLE DEVIATIONS.—" I see you found a theory of art upon the principle that, as Nature is never mathematically correct, so the artist should attain his form of beauty by similarly subtle differences from exactitude. It may be true that these differences are the things which chiefly attract the intelligent observer ; they have even attracted me ; but do I admire them because they miss the perfection of ' exactitude ? ' No ; because they come so close, and because in the minuteness of that failure may be judged the artist's skill. Do you think his compatriots admired Giotto's freehand circle because it was nearly a perfect circle ? I trow not. They admired him because his unaided handicraft had enabled him to draw something that only just missed being a perfect circle, and by the minuteness of his failure they estimated the greatness of his skill. I admit that this is no answer to your theory. It only explains my own feelings about your main thesis." " B. S. M."

SLIGHT ERRORS.—" If your theory of art be true, and if it is to the divergencies of the artist from the rule that his excellences are due, you surely are preaching dangerous doctrine. For what is it save the glorification of error ? I have heard it said that the faculty of making mistakes is one of the chief factors in human progress. The animal makes no mistakes, because he dies if he does ; so does the plant. But men and women would never progress at all unless we took such risks as civilisation may be expected sometimes to cancel. Sometimes I admit, we pay the penalty of the ' survival of the fittest,' a theory

which always seems to me to lay a sinister insistence on the value of death. But sometimes we win through. And I contend that a man who never makes mistakes never does anything. And in so far as his mistakes are unconscious he does not come within the four walls of your theory." "Q. T."

THE ARTIST'S CREATION.—" Though there may be others, I know no living artist who has done more than Professor Edward Lanteri in the direction of education in art principles on the line which, as you have been explaining to us, was familiar to Leonardo da Vinci. For instance, I can quote to you something written by Professor Lanteri which will show how closely he is in touch with the theories you have been developing. ' In order to develop the artist intelligence,' he says, ' you must work from Nature with the greatest sincerity, copy flowers, leaves, or whatsoever it may be, with the most scrupulous analysis of their character and forms, for Nature only reveals herself to him who studies her with a loving eye. In this way the student will find the essentials of the spirit of composition, for there is nothing more harmonious, nothing more symmetrical than a flower, a leaf, and, above all, the human form. Here are found all the laws of beauty in composition, and the student who copies them sincerely assimilates their laws with his temperament and personality, and creates for himself an ideal which later on he applies to his own composition.' " ". A. R. A."

SCIENCE AND ART.—" You have so often emphasised the difference between art and mathematics and so deeply stressed the combination of art and science which was Leonardo's mighty gift, that I fear your readers may lose sight of that difference between quantity and quality, which explains why Leonardo could hand on his scientific attainments, but not enable anyone to reproduce his painting.

" When he struck a bell and heard its note echo in the other bells, or when he touched a lute string and roused the sympathetic concord of another, any of his contemporaries might have done the same ; just as the humblest student in a chemical laboratory to-day starts with a greater knowledge than Lavoisier himself possessed and reproduces all the experiments of his most brilliant predecessors. But none of Leonardo's contemporaries could paint a ' Mona Lisa,' no living man to-day could draw a profile as Leonardo's pencil drew it. In other words, experiments in themselves are quantitative ; they become the inheritance of each succeeding age ; they are the baggage of evolving civilisation ; and therefore science continually progresses. But art is in essence qualitative, personal ; it appears and disappears like some bright meteor in the sky, conditioned neither by time nor space ; and the most industrious pupil in art cannot reproduce a single atom of his master's personality." " A. S. F."

FITNESS EXPRESSED.—" Though I do not believe that anyone will ever enclose anything of natural growth in a mathematically exact figure or formula, such efforts can, at any rate, give us a figure or formula which is rationally comparable with a plant or a shell. In discussions of this kind we are obliged to use figurative or symbolic language, and therefore we may shortly describe a nautilus as

' endeavouring to reach ' a logarithmic spiral in perfecting its shape during growth. What we really mean is that after elaborate examination of a large number of examples of the mature nautilus, we come to the conclusion that a logarithmic spiral is the mathematical convention by which the perfect shell is most clearly and easily labelled and classified in our minds. The biological process has probably been that all examples of the nautilius which were not near enough to this spiral have died out, and that the species has survived owing to the more perfectly developed specimens having become parents ; so that we get the same idea as is inherent in an ' infinite series ' ; each generation gets a little nearer and a little nearer without ever actually attaining to what means perfection for the organism in a certain environment. It is certainly tempting in this connection to suggest that the tighter coils of the ammonite were not adaptable to the environment produced by certain changes in the earth's surface which took place during the life history of this creature ; and therefore it died out ; it is only known to modern investigation as a fossil. We may not have sufficient data to say that a nautilus is now compelled either to approach a logarithmic spiral in form, within certain limits of error, or to die out. We can only assert that a living nautilus never does produce an accurately mathematical spiral, and this may be due to the fact that the mathematical convention of a logarithmic spiral can satisfy our own minds, but may not represent the exact goal at which the living thing is aiming. Indeed, it may be inferred that the nautilus does not ' express itself ' (if I may use the phrase) in accurate mathematics, just for the very reason that it is alive. And so it rouses in us that happy feeling which we call a ' sense of beauty,' because we realise its life just in that aberration, just in that delicate divergence from exactness, which records an effort to attain an ideal, and suggests that the errors made in the course of that effort were not bad enough to prove fatal. We have the same feeling of approval also, because ' beauty ' is ' fitness expressed ' ; that is to say, the nautilus has survived many contemporary weaklings because it was ' fittest.' It has preserved its species from the origin onwards because it has successfully adapted itself, by minute changes of form and structure, to its environment.

" Carry the same thought with you from the realm of Nature to the handiwork (even the art) of man. Consider one of those gate-legged tables of black oak which have survived the simple cottage or the farmstead to decorate the opulent withdrawing-room. They are not satisfactory now merely because they are old. On the contrary, they have survived to be old because they are the fruit of satisfactory handicraft. The carpenter aimed at a circle, or large oval, for his main outline ; and though that line is not mathematically correct, it is near enough, to be perfectly serviceable. He laid his oak boards edge to edge to make the main surface, but that surface is far from being mathematically level ; it is only sufficiently level to hold the cup or platter firmly. There were difficulties to surmount in handiwork on such tough wood. We see the result and sympathise with the workman who surmounted these difficulties within that margin of error beyond which the table would have become ugly, unfit, useless.

As it is, we see ' fitness expressed ' in that handiwork ; we recognise its beauty because it fits in with some ancestral need of our humanity, because we like to feel it is a part of the world we live in. This has nothing to do with mere irregularity. You can make tens of thousands of symmetrical teatrays by machinery, and then get a workman to hammer their outlines into irregularity. That will not produce the happiness inspired by beauty. It is almost as futile as the South Kensington æsthete who said that a crooked line was beautiful *because* it was crooked. Nothing would be further from the truth, except perhaps the thesis that a natural object (or a work of art) would be beautiful if it were strictly mathematical." " K. B. C."

CHAPTER XX

FINAL RESULTS

" From the stars of the uttermost height comes down that splendour, and to these it draws the heart's desire."—MICHELANGELO.

THE LOGARITHMIC SPIRAL AS AN ABSTRACT CONCEPTION OF PERFECT GROWTH—SPIRAL NEBULÆ—DR. JOHNSTONE STONEY'S SPIRAL OF THE ELEMENTS—INFINITE SERIES AND THE RHYTHMIC BEAT —PHYLLOTAXIS—THE RATIO OF PHEIDIAS—THE ϕ SPIRAL— SPACE PROPORTION—ART AND ANATOMY—THE THEORY OF EXCEPTIONS—VALUE OF A " LAW "—COMPLEXITIES OF THE HIGHER ORGANISM—" A FLAME TO CURIOSITY "—THE METHODS OF SCIENCE.

I HAVE brought together in these pages a larger number of instances of the spiral in Nature than have ever been similarly collected and illustrated before. The series of examples of spiral plaits upon the columella of shells, the analysis of the curves of horns, the comparison of anatomical spirals in the human body— these things are, in their modest way, new contributions to the spadework of scientific theory. We have examined spirals which seem merely the contraction of a long organ into a small space ; others which have only assumed the form because one edge grew more slowly (for varying reasons) than the other. We have also found spirals evidently used either for the ejection of contained fluids by a well-known mechanism or for the retention of foreign matter in order to extract from it the last particle of benefit. Others, again, we have seen which make use of the locomotory possibilities of the screw, either in forms of flight or in other varieties of movement upon earth or in the water. We have found the same formation in innumerable examples through Nature from the tiniest foraminifer to the gigantic nebula in the immeasurable heavens ; and we have occasionally been tempted to such general considerations as the suggestion that the growth of systems seems to be expressed in these spiral nebulæ, as opposed to the circling of completed weights in the case of planets which follow a fixed orbit, owing to the unvarying law of gravity. Throughout our investigations this idea of energy and growth under resistance seems consistently to be connected with the spiral, and we have found that idea recognised in the use of a spiral as

a conventional decoration not only by the philosophers of ancient China but even by peoples so old as the Aurignacian civilisation of 20,000 years ago. And a very curious instance of the development of conventional symbols from the logarithmic curves of the Nautilus will be found in Appendix IV. We have also traced in engineering and in architecture the application to art by man of the same principles which are evident in Nature ; and we have found, throughout, the extreme utility of applying abstract mathematical conceptions to such phenomena as the arrangement of leaves or petals and the growth of shells.

It has been often pointed out that the spiral is a conventional term by means of which the human mind can classify and describe certain formations in Nature, or even certain processes in thought ; but it seems necessary again to emphasise the fact that the occurrence of many different natural formations which we can classify as spiral is no proof either of Design (as one school suggests) or of the conscious production of that formation by any plant or animal. The spiral is merely an extremely useful heading or formula under which certain phenomena can be grouped and their common characteristics examined. And as the spiral is pre-eminently a mathematical convention, it appears right to insist here that the use of mathematics is not an object in itself ; indeed, I have shown in many ways on previous pages that Nature abhors exact mathematics (if the phrase may be permitted me), and that no man who puts 2 and 2 together to make 4 will ever achieve art. But no finer instrument than the higher mathematics was ever conceived for enabling the human brain to grasp the unity of apparently complex phenomena. This can be very prettily illustrated in those phyllotaxis diagrams (see Figs. 387, 388) which I have described from Mr. Church's work.

The present position of exact physical science affords no special clue to the deeper meaning of those phenomena of spiral phyllotaxis which have been analysed in earlier chapters, or to such curious problems as the fact that the most sensitive wireless crystal detector, when put in contact with a gold point, is to be found in the spiral grooves produced by a conoidal fracture of iron pyrites. It may only be an accident that a symmetrical growth-construction for plants (see Fig. 387) in terms of logarithmic spirals agrees with the diagram for the distribution of lines of equipotential, and paths of current-flow in a special case of electric conduction, and that the asymmetrical systems (see Fig. 388) are similarly homologous with lines of equal pressure and paths of flow in a vortex in a perfect fluid. The one proposition is certainly static, the other is kinetic. But few facts are more significant than a similarity which may be proved to

occur in things that are apparently quite different ; and they present a curious analogy with the theories of the ultimate constitution of matter ; indeed, it must always strike an unprejudiced observer that there may be underlying all these cases the working of some still more fundamental law which finds expression in a similar mathematical form, in that same spiral which seems naturally assumed both by growth in living organisms and by energy in lifeless things, such as the nebulæ.

Dr. Arthur Edward Fath (of the Mount Wilson Solar Observatory) has just published an admirable summary of the research of the last half century in these marvellous astronomical formations. It was Messier who first catalogued 103 stationary objects in the sky which he was unable to classify, and which were described as nebulæ. With a reflector 4 feet in diameter Sir William Herschel found many more, and he and his son, Sir John, published a catalogue of 5097. In 1845 Lord Rosse, with a 6-foot reflector, discovered that Messier's fifty-one showed a distinctly spiral structure (see Fig. 1, on p. 2 of this book), the most important contribution of that year to astronomical science. In 1864, by the use of the spectroscope, Sir William Huggins proved that a planetary nebula in Draco was a luminous spiral of gas. In 1888, by the employment of the photographic dry plate, Dr. Isaac Roberts showed that the Great Andromeda nebula (Fig. 382) was a gigantic spiral considerably inclined towards the line of sight. In 1899 and 1900 Dr. James E. Keeler, of the Lick Observatory, was able to say that there were 120,000 nebulæ in the sky, and that nearly all of them had a spiral structure. What this structure looks like may be seen from Fig. 383, which gives the well-known spiral nebula in Ursa Major. About the same time Dr. Scheiner, of Potsdam, and Sir William Huggins found out more about the composition of the Andromeda nebula by means of the spectroscope, and since 1907 Dr. Fath has discovered fourteen absorption lines in the same nebula, which corresponded line for line with absorption lines in the solar spectrum, and suggested that its real dimensions must be forty million times larger than those of the sun. In other words, at an unknown distance in which no telescope can separately distinguish them, there must be a vast assemblage of suns so far beyond the stars as to constitute them another universe. And if we can realise a spiral pattern there, it is at least probable that the arrangement of our own universe was originally a spiral also, as is indicated by evidence brought forward by many astronomers. For though mutual attraction and rotation about the main nucleus may have altered the original positions, yet there are still many unequivocal traces of the original spiral formation which is distinctly visible in

Andromeda, a universe in the making. As such a vast spiral rotates condensation is taking place, until we get a large star (or sun) in the centre surrounded by smaller ones, which will cool off into planets and satellites, while the overplus of nebulous material

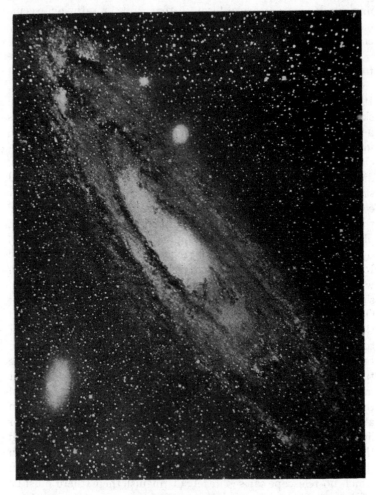

FIG. .382.—PHOTOGRAPH OF THE GREAT NEBULA IN ANDROMEDA BY THE 40-IN. TELESCOPE OF THE YERKES OBSERVATORY (U.S.A.) AFTER FOUR AND A HALF HOURS EXPOSURE.

trails away into meteors and comets or becomes the source of the zodiacal light. I am aware that Professor Schwartzschild, of Potsdam, considers that if we take Neptune to represent the most distant part of our system, the genetic spiral thus predicated as beginning in our sun would be smaller than any other hitherto

discovered, which means that he would find some difficulty in accepting the theory of the birth of our solar system described above. He has even gone so far in the contrary direction as to suggest that spiral nebulæ have perhaps grown into that form, and, therefore, may not represent the origin of any system. The very curious formation shown in Fig. 384 seems to exhibit both a plane spiral and a cylindrical spiral, and certainly stands in need of some special explanation. Still, in the present state of knowledge, it is enough for my purpose that he is forced to

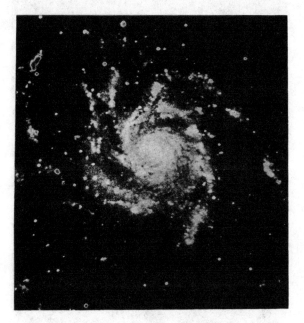

FIG. 383.—SPIRAL NEBULA IN URSA MAJOR (NEW G. C. 545).
(Photographed by the Crossley Reflector at the Lick Observatory.)

admit that the best spirals observable in the sky do approximate in form to logarithmic spirals, and with that I am content.

From this point of view it appears that the story of spirals would be the story of the universe ; and if this be true, it would be only likely that the spiral would admit of application to the elements of which that universe is composed. It was in 1869 that Mendeléeff published a Periodic System which was accepted as the groundwork of classification for the elements. Some years before Mendeléeff's system was known John Newlands had observed (in 1863) that if the elements (omitting hydrogen, the lightest) were arranged in the order of their atomic weights, the first, eighth, fifteenth, indeed every element seven above the

lowest member of a group, was an approximate repetition of the
first, like the eighth note of an octave in music. This is merely

FIG. 384.—SPIRAL NEBULA IN CYGNUS (N. G. C. 6992.)
W. E. Wilson, Daramona, Westmeath, Ireland.
(Silver on glass reflector.)

the spiral in another form. In 1888 Dr. Johnstone Stoney
submitted to the Royal Society a memoir on the " logarithmic
law of atomic weights," which, however, was not published in

full. Lord Rayleigh (*Proceedings of the Royal Society*, Series A, Vol. LXXXV., p. 471, 1911) consulted the original manuscript, and gives some extracts from and remarks upon it. After many fruitless efforts to extract information from the curves obtained by plotting the atomic weights, it happily occurred to Dr. Stoney to employ the volumes proportioned to the atomic weights. When this was done the resulting figure (cf. Fig. 385) at once suggested a well-known logarithmic spiral, and a close scrutiny justified this suspicion. In other words, the relations of all the known elements to each other could almost exactly be expressed by the logarithmic spiral. If this held true of what was known already, it became apparent that it would also hold true of what was to be discovered later on ; and that if new elements were discovered after 1888, they would find their right places in the gaps indicated in Dr. Johnstone Stoney's spiral diagram. This remarkable process had already occurred in Mendeléeff's Periodic System since the year of its publication in 1869 ; and the fact that it has also occurred in the spiral system (which includes the Mendeléeff system and gives it an additional confirmation) is one of the most convincing proofs that the spiral system is not merely a correct hypothesis, but a fundamental law. The total of the elements known in 1912 was about eighty-three. Six elements were missing in 1888 in Dr. Stoney's diagram, between hydrogen and lithium ; Sir William Ramsay discovered helium in 1895, which fills one of the gaps, though the position is not mathematically exact. But on the sixteenth radius an even more remarkable corroboration was effected, in what had hitherto been a gap between the most intensely electro-negative elements (such as fluorine, chlorine, bromine, and iodine) and the most electro-positive elements (such as lithium, sodium, potassium, etc.). This gap was filled, with absolute appropriateness, by the series of inert gases : argon, discovered by Lord Rayleigh, and Sir William Ramsay in 1894, and helium, neon, krypton, and xenon, discovered by Sir William Ramsay between 1895 and 1898, five new elements which occupy places foretold to be necessary to the Mendeléeff series as well.

One of the chief beauties of the spiral as an imaginative conception is that it is always growing, yet never covering the same ground, so that it is not merely an explanation of the past, but is also a prophecy of the future ; and while it defines and illuminates what has already happened, it is also leading constantly to new discoveries. This, therefore, is that " unspent beauty of surprise " which Nature can always offer her best lovers, though she works at the bidding of the majestic harmonies of some universal law we are unable yet to recognise. This is

the mysterious elemental charm which appealed to one of the oldest poets of the world: "Can'st thou bind the sweet influences of Pleiades or loose the bands of Orion? Can'st thou bring forth Mazzaroth in his season? or can'st thou guide Arcturus with his sons?"

In mathematics we have the most supple and beautifully precise instrument by which the human mind can fulfil its need of cataloguing, labelling, defining the multifarious facts of life around us. In this task the visible expression of various results or totals in the form of curves is an invaluable convention; and in problems of growth or increase the logarithmic spiral occupies perhaps the

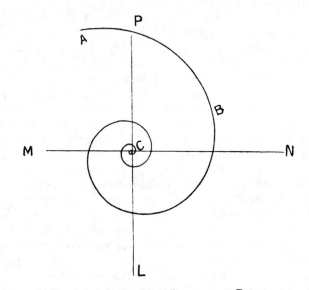

FIG. 385.—LOGARITHMIC SPIRAL WITH RADII.

most important position of all. For it can be used not merely in the sense of the curve of growth and energy which swings from origin to outer space, it can define growth along its radii as well. In Fig. 385, for instance, we have the definite curve which has grown from a centre we will call C to B, and ends (as far as I have drawn it) at A. But we have also the radii which I will call C P, C L, C M, C N, each of which is cut at three points by the curve progressing from C to A, and you will notice that the three points of intersection on the line C P are differently situated (with regard to C) from the points of intersection on C L, which differs again, in this respect, from C M, and C M differs from C N. Now, since the spiral curve C B A extends infinitely in each direction from any point within it, which is easier to imagine at A than it

is at C, and since there can be any number of radii, so this mathematical concept embodies the great truth of infinite gradations, which is explained in the very beautiful and valuable theory of infinite series. The rhythmical beat of the spiral curve upon its radii is in direct relation to this theory, as has been pointed out to me by Mr. Mark Barr.

Infinite series as expressed in mathematics and as graphically represented in mathematics are not spirals ; but where we have any series of terms which grow regularly, the concept of a spiral can be realised if we regard the successive terms as the successive " throws " of a spiral along a radial line. This is by no means an absurd co-relation of different things in a useless way, because I wish to show that the idea which underlies our conception of a spiral is a special form of the idea which underlies a surprisingly large number of our methods of successful analysis.

If we wish to express the idea of such a growth that the rate of its growth shall be measured by the magnitude of the growth, we get the beautiful series of terms embodied in the laws of ϵ :

$$\epsilon^x = 1 + x + \frac{x^2}{2!} + \frac{x^3}{3!} + \frac{x^4}{4!} + \text{ to infinity.}$$

Of course by 4 ! I mean factorial four, which is $4 \times 3 \times 2 \times 1$.

There is no spiral here, but we have illustrated the fact that, in obtaining the value of a fixed—a static—quantity such as ϵ^1 which (equals 2·71828) we are driven to utilise the concept of a gradual and rhythmic growth, up to the ultimate value, by a series of steps or " throws."

But there is another example even better for my purpose. Few things are more certain and fixed than the fact that the circumference of a circle is not exactly three times its diameter (which would have been too satisfactorily simple), but 3·14159265979 . . . times its diameter. This value is known to mathematicians as π ; and Archimedes discovered π by imagining a constantly diminishing series of polygons, which modern mathematicians have embodied in an infinite series, such as $\frac{\pi}{8} = \frac{1}{1·3} + \frac{1}{5·7} + \frac{1}{9·11}$ to infinity. This series gives just as definite a result, but it has the added charm of visibly showing the explanation of that result in terms which reproduce unmistakably what I have called the rhythmical beat of the spiral ; and it is this rhythmical beat or " throw " which solves the whole mystery of π.

But I can hear the lamplit student arguing that " π is NOT a growth." Now, it is important to distinguish between specific and relative forms even in our toil after analysis. When a growth is seen in the process of actual successive accretions, and we

express the facts in the form of a series, we have a specific (or objective) form of analysis. But when we consider static things like the fixed ratio of a circle to its diameter, and find that the only possible way of analysing the facts (so as to determine the fixed value of π) is to express the relation in the form of a series, then we have a relative (or subjective) form of analysis. Now, how comes it that even static facts require those successive "throws" of a series which are like the beating rhythms of a spiral? In the mental phenomenon underlying this there is a fundamental truth discoverable : the truth that in some way or

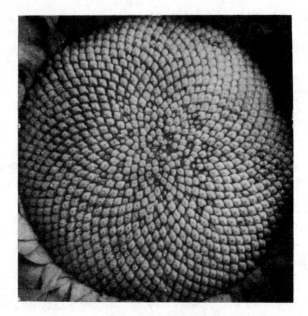

Fig. 386.—Head of Giant Sunflower, showing Spiral Curves on which the Seeds are Planned.
(Photograph by the courtesy of the *Empire Magazine*.)

other all our mental concepts are bound up with rhythmic "throws." To conceive even static things we must realise the sense of flux. The thing that seems dead, inorganic, still, zero, must for our "triumphant analysis" become, as it were, alive, and be imagined in successive rhythmical accretions. As the late William James said, our mind is too often attempting to force the applications of the law of continuity to a stage where we can recognise familiar fixed facts ; so that by a neglectful familiarity we attain to a kind of learning which is not knowledge. "It is not similarities, but 'the Ever-not-Quite' that we should look for," said Mr. James. "It is not for fixed rules, but for the

subtleties of divergence that we should search," would be my
own version of the same truth ; for such divergences will be like
those slight " throws " of progression by which the close spiral
of the engineer's lathe will always miss repetition on its path, yet
always advance a little higher (on the same line) above the point
it passed before. " *L'esprit humain,*" wrote Madame de Staël,
with one of her rare flashes of intuition, " *fait toujours des progrès,
mais ce progrès est spirale.*"

Everything in Nature is capable of mathematical expression if
the conditions are only sufficiently well known and the mathe-
matics are sufficiently complicated. The real difficulty is to
select a fundamental conception which will admit of modification
when new factors are introduced. I have shown that the
logarithmic spiral is such a conception (p. 96). But any mathe-
matician will tell you that an infinite number of logarithmic
spirals are possible between the limitations of the straight line
and the circle ; and it therefore becomes necessary to choose the
one most suitable for our purpose. We must consequently find
out whether any form (and if so, what form) of logarithmic spiral
will suit our larger needs more exactly than that suggested by
Mr. A. H. Church for those theories of spiral growth in plants
which were described in the fifth and sixth chapters of this
book.

To remind you more clearly of their scope, I reproduce here a
photograph (kindly lent me by the managing editor of the
Empire Magazine, in which it was first printed in November,
1912) of the disc of a giant sunflower (Fig. 386), and the curves
on which the seeds are arranged should be very carefully noted.
The nature of this arrangement is of course of the greatest signifi-
cance to my argument, and if you consider how many other
arrangements were possible, it must become clear that a very
special value should be attached to the method of intersecting
curves, so clearly visible in the flower's construction.

In his invaluable " Principles of Phyllotaxis " Mr. A. H. Church
publishes two diagrams, which I reproduce to make the argument
a little clearer.

In Fig. 387 you see the diagram of a floral system in which spiral
curves radiate from a central point in such a manner that five
are turning in one direction and eight in the other, giving the
results of intersection in a uniform sequence. Even a very small
amount of eccentricity produces a very different result, and in
Fig. 388 you see the eccentric condition observed in the floral
construction of *Tropæolum.* This seems to suggest that the only
correct way of interpreting systems of intersecting curves is in
terms of the number of curves radiating in each direction, and

these numbers always occur in the Fibonacci series, 1, 2, 3, 5, 8, 13, 21, etc., which is quite sufficiently accurate for all the purposes for which Mr. Church uses it. On the mathematical nature of the spirals thus traced, or the nature of the intersection, we need not any further enlarge ; but it is clear that there are analogous constructions in the domain of pure physics, and in that analogy I believe will be found the whole problem which the logarithmic spiral will help to elucidate.

It was explained in the earlier chapters to which I have referred that in the Fibonacci series, 1, 2, 3, 5, 8, 13, 21, 34, 55, 89, and so forth, the ratio of any successive pair is approximately constant,

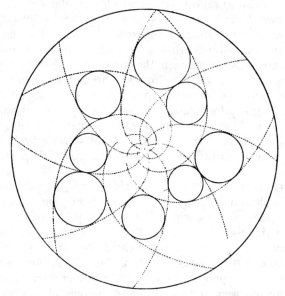

FIG. 387.—DIAGRAM FOR A REGULAR CURVE-SYSTEM OF 5 + 8.

while as we go up the series this ratio approaches a limit, the limit being, in fact, $\dfrac{\sqrt{5}-1}{2}$. The inverse angle of $\dfrac{\sqrt{5}-1}{2}$ of 360 degrees is 137° 30′ 27·95″, and if the leaves of a plant were set round a straight stem at a divergence angle of about 137° 30′ 28″, no two leaves would ever be exactly one over the other, which is generally the ideal condition. From this we deduce the fact that plants which utilise this angle to give the minimum superposition and maximum light exposure to their assimilating members are employing a leaf arrangement which may be expressed in terms of Fibonacci numbers. Finally, it may further be pointed out that the numbers 1, 2, 3, 5, 8, 13, 21, etc., are by no means accidental. The curves on a daisy disc run into two sections, 13 one way and

21 the other. The rows of florets on a sunflower disc may show 34 in one way and 55 the other, or even as high as 89 and 144. It is impossible to avoid the conclusion that the occurrence of such numbers in the case of spirally-constructed plant systems bears a definite relation to the Fibonacci number $\dfrac{\sqrt{5}-1}{2}$. So much of Mr. A. H. Church's theory must be repeated (see pp. 81 to 102).

Now, it was only a few days after these deductions had (with

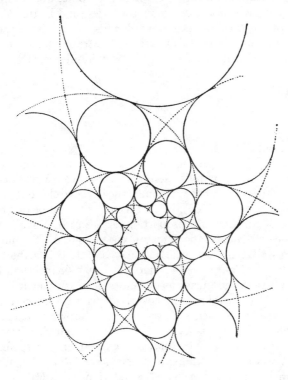

Fig. 388.—Diagram for an Eccentric Curve-System of $5 + 8$.

Mr. Church's kindly supervision) been published in the *Field* that I received a letter from Mr. William Schooling pointing out that if, in a geometrical progression, the sum of any two terms equals the next term, the values of the ratio are $(1 + \sqrt{5}) \div 2 = 1\cdot61803398875$ (nearly) : or $(1 - \sqrt{5}) \div 2 = -0\cdot61803398875$ (nearly).

The sum of these roots is $+1$, their product is -1, and their difference is $+$ or $-$ the $\sqrt{5}$.

This is the only geometrical progression the successive terms

of which can be obtained by addition as well as by multiplication by the common ratio in the ordinary way.

Mr. Mark Barr suggested to Mr. Schooling that this ratio should be called the ϕ proportion for reasons given below. Adopting this symbol for the common ratio the equation becomes :

$$\phi^n = \phi^{n-1} + \phi^{n-2}$$
$$\phi^2 = \phi + 1$$
$$\phi = (1 \pm \sqrt{5}) \div 2.$$

The most significant fact, for our purpose, about the ϕ series is that it gives a *double* Fibonacci series, and in the ϕ series the ratio of any two successive numbers is not merely approximate, but exact, for the constant ratio is $\phi = 1.618034$.

The *double* Fibonacci series in ϕ is exhibited thus :

$$\phi^2 = 1 + \phi$$
$$\phi^3 = 1 + 2\phi$$
$$\phi^4 = 2 + 3\phi$$
$$\phi^5 = 3 + 5\phi$$
$$\phi^6 = 5 + 8\phi$$

and so on.

The symbol ϕ given to this proportion was chosen partly because it has a familiar sound to those who wrestle constantly with π (the ratio of the circumference of a circle to its diameter), and partly because it is the first letter of the name of Pheidias, in whose sculpture this proportion is seen to prevail when the distances between salient points are measured. So much is this the case that the ϕ proportion may be fitly called the " Ratio of Pheidias." Take a well-proportioned man 68 inches in height, or ϕ^4 if we take ten inches as our unit of measurement. From the ground to his navel is 42 inches, or ϕ^3 ; from his navel to the crown of his head is 26 inches, or ϕ^2 ; from the crown of his head to the line of his breasts is 16 inches, ϕ ; and from his breasts to his navel is 10 inches, or the unit of measurement, or 1, which is ϕ^0.

There are many valuable properties in Phi. Mr. Church, for instance, in pointing out the relation of spirally-constructed systems of plant-growth to the Fibonacci ratio, speaks of the " Fibonacci or ideal angle " of 137° 30′ 27.95″. From what has been said above about the ϕ (or Phi) proportion, it may be seen that this ideal angle can be prettily and neatly expressed in circular measurement as $\dfrac{2\pi}{\phi^2}$ (or twice Pi divided by the square of Phi).

I shall leave Mr. Schooling himself to explain many other most interesting facts concerning ϕ in the Appendix. For the present it will be enough to say that it appears likely to give more accurate

results for other forms of natural growth than the Fibonacci series so admirably used for botany by Mr. A. H. Church, and closer calculations in matters of art than the theory published in 1876 by Theodore Fechner in his " Vorschule der Aesthetik." I would further suggest that research into its uses in both directions would probably be well repaid ; for in Mathematics it can be expressed with binomial coefficients, and it can also be used as a base which greatly facilitates the computation of logarithms. In Geometry and Trigonometry its properties are further explained in Appendix II. (pp. 441—447).

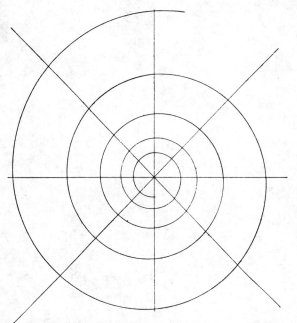

FIG. 389.—THE PHEIDIAS SPIRAL.

One more thing must be added here. If the radii vectores of a logarithmic spiral are in ϕ proportion, the result is not only a spiral of singularly pleasing character, but there is the further feature that on any radius the sum of the distances between two successive curves of the spiral equals the distance along the same radius to the succeeding curve (see Fig. 389). Such a ϕ spiral bears a close resemblance to the spiral shown in my second chapter produced by unwinding a tape from a shell (see Fig. 44, p. 32).

In art, on the other hand, it ought to prove as useful for proportional areas as for simple linear measurements ; for since, as has been shown, the series is essentially spiral in character, and since it gives the ϕ proportion along any radius, it should also

provide a formula for the proportions of successive areas or spaces between the radii. I suggest that such increases of space as are observable in the various " compartments " of the shell shown in section in Fig. 390, will be in ϕ proportion, and bear a direct relation to the external spiral.

The value of the proportion for architectural spaces can be most

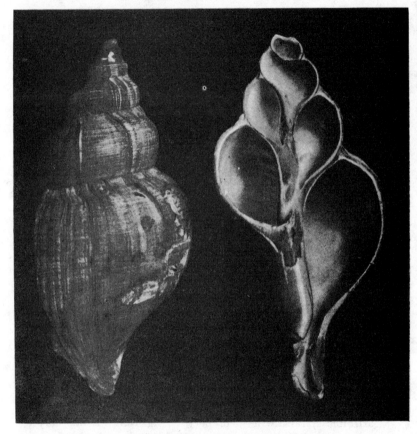

FIG. 390.—THE GRADUAL INCREASE (IN ϕ PROPORTION) OF THE SPACES IN A SHELL.

simply demonstrated by the diagram of the Swastika in Fig. 391 Here the rectangles are all in the same ϕ proportion which we observed in the development of the perfect human body and in the lines of the shell. Not only so, but 8 areas of ϕ^5 and 5 areas of ϕ^4 exactly fill one square, with sides ϕ^5 in length, and therefore having an area of ϕ^{10}. It may be noted that

$$8\phi^5 + 5\phi^4 = 8 \times 11{\cdot}090 + 5 \times 6{\cdot}854$$
$$= 88{\cdot}72 + 34{\cdot}27 = 122{\cdot}99 = \phi^{10}.$$

This seems to imply that it will be possible to produce a formula which should not only explain the spacing of such buildings as the Parthenon or the Arch of Constantine, but might explain them in accordance with those fundamental

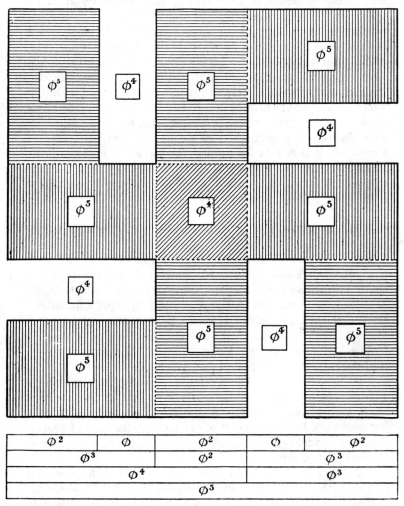

FIG. 391.—THE SWASTIKA DIVIDED INTO RECTANGLES IN ϕ PROPORTION.

principles of growth and energy associated in so many previous pages with the logarithmic spiral in general and here examined by means of the ϕ spiral in particular. And if for architecture this should prove possible, why should we not use the suggestion in examining other forms of art as well, such as the composition and spacing of a great picture? I propose to develop this in

the Appendix, in order to avoid clogging my final chapter with too much detail ; but the only real difficulty may be at once stated : it is the difficulty of connecting the ϕ proportion (which was primarily an explanation of certain properties of growth) with those workings of the artist's brain which result in the spectator observing certain pleasing qualities of space and proportion in the picture. I have given several indications in the course of this book, of my own opinion that such a link exists and may in fact be stated. I have described the artist as a man whose brain or temperament, being of more sensitive fibre than the common, is more closely in touch with that world of Nature which he sees and feels more keenly than his fellows. His artistic work is in the strict sense " creation," for he does not merely copy the natural beauty which he sees around him, he " creates " a fresh stock of beauty for us all. His picture, therefore, (or his statue, his building, or his music), may be fairly compared with the living things in the world of which he is at once a part and an interpreter. These organisms have reached certain forms through the essential processes of life. The creations of his art are, I suggest, equally essential (if more subtle) manifestations of those same processes.

This is not merely owing to the concentrated study of Nature from which such men as Leonardo evolved their masterpieces, to that " invention or discovery in the highest sense " which Goethe described as " suddenly flashing out into fruitful knowledge," or even to the reproduction in their artistic creations of those laws of proportion with which their researches into natural forms have familiarised them ; it goes deeper still into the very personality, the characteristic sensitiveness of the artist himself ; it is, as Goethe elsewhere said, " a revelation working from within ; a synthesis of world and mind " ; for it is profoundly true that " Art does *not* exactly imitate that which can be seen by the eyes, but goes back to that element of reason " (to that law of proportion, as I should put it) " of which Nature consists and *according to which Nature acts.*"

This suggests, I think, that the fundamental element in that joy which the artist's creation gives us may well be the manifestation of those profound laws of Nature which in some cases, he may have deeply studied, and, in many more, he may have so instinctively appreciated that they are the unconscious motives of his style and sense of taste. If ϕ in some way describes the principle of growth, which is one revelation of the spirit of Nature, would not the artist most in touch with Nature tend to employ that proportion in his work even though he were not conscious of its existence?

" In proportion," says Mr. Arthur Balfour, " as criticism has

endeavoured to establish principles of composition, to lay down laws of beauty, to fix criterions of excellence, so it seems to me to have failed. . . . The critic tells you what he likes or dislikes. He may even seem to tell you why. But the ' why ' is rarely more than a statement of personal preferences." I do not here venture to suggest the " why " to any art critic. But I do say to my readers that some reasons for it may be found in the ϕ series. Though for aesthetic beliefs Mr. Balfour may find no such pedigree of organic evolution as he may admit for ethics or for knowledge, I cannot be content with his description of them as " a chance by-product, a happy accident of evolution," or agree with his verdict on the genius who produces works of art as " an equally accidental product." But when he points out that " we need feel no surprise at the feeling of beauty being occasioned in different people by different objects, because the feeling of beauty springs from psychological causes so complex and so subtle," then I am more ready to accept the position. For among such subtle and complex psychological causes I must name the principle embodied in the ϕ progression as one of the most fundamental in its application.

The beauty of a shell or a flower makes an irresistible appeal to us which needs no argument. I have indicated in previous pages some possible reasons both for that appeal and for that beauty. The emotion roused in us by the beauty of a shell or a flower is due both to the unconscious but continuously instinctive efforts made by the growing organism to adapt itself to its environment, and to the fact that those efforts have been sufficiently successful to express that organism's fitness to survive. Had they been insufficient it would have died. The processes of growth explained by the ϕ spiral, and the successive proportions they reveal, have therefore an intimate connection with the source of our pleasure in the beauty of a natural object.

A great painting also makes an irresistible appeal to us which needs no argument ; and I may fairly compare the masterpieces of art with the shells or flowers that have survived, because bad pictures, though they do not " die," are certainly forgotten, and need not be brought into my argument at all. But if the comparison between a masterpiece of painting and a beautiful shell is to be more essentially exact than the many instances of external agreement illustrated in my seventeenth and eighteenth chapters, an analysis of the proportions of the picture ought to reveal the same proportions as have been developed in ϕ to explain the processes of natural growth. I have already shown that the same interesting " variations " from any such simple formula as ϕ are to be found in the best art just as they are to be found in the

surviving organism. It will clearly be of some significance, therefore, if I can also show that there is as great a measure of agreement with ϕ in the one case as in the other. If so, it will not imply that the artist had any preconceived idea of using the ϕ proportions in his composition, any more than the Nautilus had any conscious plan of developing a certain spiral in its shell. But it will suggest the possibility that there exists a very real link between those processes of artistic creation which are vaguely called " instinctive " and those principles of natural growth which are admittedly fundamental. I venture, in fact, to offer ϕ as an underlying reason for what we call Beauty both in a natural object and in a masterpiece of art.

In Plate VII. of the Appendix, I have reproduced the famous picture of the Laughing Cavalier by Franz Hals. An application of the ϕ progression (as explained in Appendix IX.) will emphasise the fact that this perfect artist, in expressing his instinctive taste for spacing, has expressed it in the perfect proportions shown to be intimately connected with the phenomena of life and growth. There are slight divergences from such simple formulæ both in the Nautilus and in the picture. But the measure of agreement shown is the same in each case.

There are so many obvious criticisms of this theory that I do not shrink from offering it for that deeper and more accurate investigation which can alone produce valuable results. But if it be true, it will admit of more extended application.

It has often been pointed out that in Sandro Botticelli's Venus, in the Kaiser Friedrich Museum of Berlin, the line containing the figure from the top of the head to the soles of the feet is divided, at the navel, into the exact proportions given by that ancient formula the " Golden Section," sometimes called the " Extreme and Mean Proportion," which was merely applied to length, and only to two divisions of length. It can be frequently found in various forms of art, and ϕ is definitely based upon it. But, as is explained in Appendix II., this book for the first time makes use of the ϕ proportion as an infinite series in which any one term is the sum of the two terms before it. And though our unit of measurement may of course be anything from a millimetre to the distance between the earth and the sun (for ϕ is a proportion, not a length), yet obviously the ratios between the consecutive powers of ϕ are always the same, whatever power of ϕ we may begin with. It therefore produces a cumulative effect of conviction when we find in such pictures as the Franz Hals not merely one or two terms, but every consecutive term from ϕ^1 to ϕ^5. In exactly the same way, I should see very little importance in emphasising only " Extreme and Mean Proportion " in the Botticelli Venus.

But if I find that here, as in the Franz Hals, we have seven consecutive terms of ϕ in the complete composition, then, I think it is worth careful notice. (See Plate VIII. in the Appendix.)

If this be true of figure-paintings, it should be true of other masterpieces as well. I have therefore chosen Turner's magnificent " Ulysses Deriding Polyphemus " for similar examination (Plate X. in the Appendix), and it shows the working of the same principle. The scale of Phi proportions given at the end of this book will enable anyone to examine the masterpieces he may personally prefer, and to draw his own conclusions.

It is obvious that most men in ordinary life will show slight variations from the perfect proportions given on p. 420, where our unit of measurement was taken to be 10 inches. In Plate IX. of the Appendix I have examined an artist's model, who exhibits a still greater number of slight variations because she is not only alive but beautiful. Mr. Lancelot Speed has examined many specimens of Greek sculpture of the age of Pheidias with equally interesting results. They exhibit the same amount of agreement ; they show the same fascinating variations. (See pp. 461—464.)

We have, therefore, reached a point at which it is possible, and even probable, to conclude, not merely that the ϕ spiral (a new mathematical conception) is the best formula for the hypothesis of Perfect Growth, and a better instrument than has yet been published for kindred forms of scientific research ; but also that it suggests an underlying reason for artistic proportions, and provides an exquisitely delicate standard by which to appreciate divergences and variations of different kinds. We can perhaps progress even a little further under the same guidance.

In the Appendix of this book, Mr. Schooling very beautifully shows that the new ϕ progression is the ideal which all series formed by successive additions tend to approach but never attain, just as the nautilus " strives to reach " (if I may be allowed the phrase) a logarithmic spiral, but never succeeds in doing so exactly. If a nautilus were put before me which exactly reproduced a logarithmic spiral, I should remain unmoved, because a machine can make me such a shape if I desire it. For precisely the same reasons a photograph or a tracing would leave me cold. What I want to see, after comparing a given nautilus with a given logarithmic spiral, is a statement of the difference between the two ; for in that difference lies something which I cannot make, something which has never yet been defined—the mystery of life, in the shell ; the immortal spell of beauty, in the artist's rendering of his masterpiece.

It would only be possible to imagine life or beauty as being " strictly mathematical " if we ourselves were such infinitely

capable mathematicians as to be able to formulate their characteristics in mathematics so extremely complex that we have never yet invented them. So I have emphasised the importance of divergences, or discrepancies, because they set us hunting after sequences of events that have hitherto remained unnoticed or unknown ; and because they are due to the fact that the more highly developed a natural organism becomes (or the more delicately sensitive was the genius which inspired a masterpiece of art) the more difficult is it to explain, and the more complex are the laws to which it must conform.

We sometimes speak of " exceptions " or of things " abnormal " because they are phenomena which manifest their obedience to some special law unknown to us. As Darwin expressed it, " I mean by Nature only the aggregate action and product of many natural laws ; and by Laws the sequence of events as ascertained by us " (" Origin of Species," Chap. IV., sect. 1). In reality nothing is abnormal. We must always be ready, in every scientific investigation, for occurrences which might, in a narrow view, be called " exceptions," but which in reality provide an indication of the presence of some other principles conditioning the whole of our original hypothesis.

It has long ago been recognised that no theory whatever can represent absolute truth. A " law," in the sense in which I use it here, obviously expresses an ideal condition under which certain results occur *in given circumstances*. Such circumstances never occur in real life. As Duhem pointed out, geometry can progress by adding proved and indisputable propositions to propositions already indisputable and proved. But science would never progress unless experiment were constantly revealing disagreement between " laws " and facts. This means that we have only arrived at the formulation of a " law " by so far doing violence to Nature as to isolate the problem we wish to study, by eliminating as many factors as we believe might unduly complicate the question. This is as much as to say that a law only approximates to the facts ; and every time we use it we have to make appropriate additions or corrections. " Laws " had no existence until we formulated them, and they cease to exist when we have merged them in a wider, a more fundamental principle. They neither express reality nor are they real themselves. They are (as I said in the Preface) the instrument of science ; not its aim. They assist us to pursue that rational analysis which is essential to our own minds, but which forms no part of the actual mechanism of Nature. They result in economy of labour, as Mach said, in very much the same way as a Greek letter is used as the symbol of a number with many places of decimals. The mere agree-

ment of various phenomena with a given formula is not an important factor in knowledge ; it only sums up a certain sphere of investigation in a convenient way. The important thing is the exception ; for it is discrepancies which lead to discovery.

Theories about the " tendency to unity " are the merest " phantoms," as Bacon would have said. But they sound plausible ; and they are evidently derived (by specious though faulty reasoning) not only from that " identity " which is the

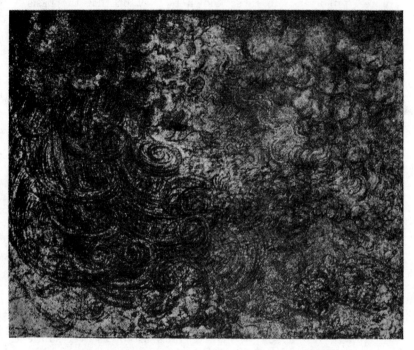

FIG. 392.—STUDY OF SPIRALS IN CLOUDS AND WATER.
From one of Leonardo's sketches for his picture of the Deluge.

basis of causation in the human mind, but also from that apparent " simplification " of knowledge which is the result of " laws."

It is, however, very often observable that what appears to " simplify " phenomena may, in reality, reveal new and entirely unsuspected complications. This is why I suggest that a logarithmic spiral, though it serves us as the best working defini- tion of a shell's growth, may not actually be the formula most closely approximating to the vital processes involved. In just the same way the principle enunciated by Newton may " simplify " the phenomena of our solar system sufficiently to enable us to

talk about the movements of the earth and the celestial bodies. But that simplicity, we may feel sure, is only apparent. Newton himself, as far as I am aware, never ventured even to suggest any " cause " for his great principle. We may well consider that its value as a working hypothesis outweighs the possibilities of its inexactness. But we must be equally prepared to realise that it may not fit all the facts which future science will discover. It is, in H. Poincaré's admirable phrase, " *une règle d'action qui réussit* " ; or, in other words, we have added so few phenomena of real importance to those known by Newton that the basis furnished by his " law " has not yet been disintegrated. But it is easily conceivable that a broader foundation will be needed, even in the present century ; and we need have no fear that men of science will shrink from the endeavour to provide it. The sterile reprobation of such efforts by Auguste Comte (who was obsessed by sociological ideas of " Order ") has long ago become inoperative.

Greater hypotheses even than that of Newton have been attacked. In his lectures at Glasgow, in January, 1914, Mr. Arthur Balfour discussed the idea of regularity which philosophers and scientific men have embodied in the law of universal causa-tion, in the principle that every event has a cause or antecedent, and that the same cause or antecedent always produces the same effect. " Is it so obvious," he asked, " that Nature is regular ? I find myself tormented by its irregularities, by the occurrence of something unexpected. . . . The hope of progress lies in aban-doning methods which require the law of universal causation." Mr. Balfour evidently objects to a law as soon as he discovers an exception to it ; he is " tormented," in fact, by such exceptions, apparently because they are " unexpected." But the whole value, to my mind, of any law is that it enables us to discover exceptions, just as the ϕ spiral enables us to discover subtle variations. It may well be that the law of universal causation, which at present governs all our scientific reasoning, is itself bounded by the world we know, and is therefore liable, like every other law and hypothesis, to exceptions which may eventually enlarge it. But without such a standard we have no instruments of measurement. Without a hypothesis of some kind we have no means of examining or classifying the phenomena we observe. It may be imagined that, even in ultimate areas beyond the worlds we can at present conceive, the law of causation which we have now focussed for ourselves may present exceptions. But those exceptions will only mean that our progress is not over yet. No theory can ever remain logical and perfect to the end. But we shall not give up the sole method by which science can

progress, and we shall use the theory or law chiefly to discover the exception.

It is in such considerations as these that we may perhaps find the reason why the world of Nature so frequently refuses to be contained within the limits of exact and simple mathematical formulæ ; for though we can indeed frame hypotheses which fit the facts we know, and sometimes even fit new facts which swim into our ken, yet we can never frame a rule that will have no exceptions in the natural world until every phenomenon in Nature is embraced within the scope of scientific knowledge. It is an old saying that " we know in part and we prophesy in part. But when that which is perfect is come then that which is part shall be done away." Until then, though we "see through a glass darkly," we can but use the instruments we have. Until then, it is just the missing of exact uniformity and monotonous repetition ; it is just the lack of agreement with the simple expressions of a law, that claims our most diligent examination and acts, in Sir Francis Darwin's phrase, as " a sort of flame to curiosity " ; for the hidden meaning of such deviations will be more significant than any mere conformity to the law itself ; and we shall begin to realise that the " exception," like a spark from the obscure unknown, leaps into light towards some affinity in conscious space, and suddenly illuminates whole tracts that once were pathless and inexplicable.

We can no longer lament the " aberrations " in the orbit of Uranus, since we have joyfully discovered that these previously unintelligible phenomena are really due to the far larger laws which govern the movements not of Uranus only but of Neptune as well. Again, when Mr. E. T. Whitaker announced that it was difficult to reconcile the Law of Gravity with the phenomena of inter-stellar space, some critics might have imagined that an " exception " had been found. But fortunately in only a few years Professor Poynting and others discovered a new law ; for the pressure of light was then calculated (see p. 10) and was found to give a complete and satisfactory explanation of the " abnormal " conditions predicated by Mr. Whitaker. Mr. Arthur Balfour has suggested that if Kepler had possessed more perfect instruments he would never have made his great generalisation about the elliptical character of the orbits round the sun, which was at the root of Newton's immortal discovery ; and Mr. Balfour would apparently even go so far as to believe that " if Kepler could have observed the deviations from elliptical form without having our modern knowledge of the cause of the deviations, he would have discarded his theory." But my reply is that without Kepler's work (and

Newton's additions to it) we should never have had a standard by which to detect these deviations at all ; for the real value of deviations is not that they make it necessary to discard a theory, but that they enlarge our laws and thereby advance our knowledge.

It was the lack of agreement between the weights of oxygen or hydrogen, obtained from the atmosphere and chemically prepared, which led Lord Rayleigh to the discovery of Argon. Minute discrepancies between numerous weighings, each taking many hours, are recognised as implying the most profound significance. The history of the discovery of Radium, from the elder Becquerel to Madame Curie, is a history of the illuminating flashes of such exceptions as are only recognised at their true value by the discriminating investigator. " Fluorescence " has become " Radio-activity."

Once sacrosanct and indivisible, the Atom is now recognised to be a universe of primordial electrons in a constant and terrific motion more stupendous to conceive than any movements of our planets in their orbits. Thus we are progressing further still ; for it has been recognised that no exception is an " accident," and that by the explanation of the apparently " abnormal " we are most likely to advance from those few principles we know towards the making of some golden guess, the " morning star to the full round of Truth."

Many have studied those principles of growth and beauty which inspired so much of the great Italian's deepest researches. But of all his modern successors not one has left such visible monuments of insight and creative power as the Leonardo who saw the same problems both in Nature and in Art so long before them.

Majestati Naturæ Par Ingenium. We have not yet said the last word on that theory of flight he studied from the wings of birds before the fifteenth century was gone. We know very little more than he has written of the mysterious principles which shape the structure of waves, of reeds, of animals, of shells. We are still groping after those fundamental laws he sought, which existed " before the fair flowers were seen, or ever the movable powers were established, before the innumerable multitude of angels were gathered together, or ever the heights of the air were lifted up." We, too, must look beyond, as he looked long ago towards the stars, moving in the sky " to their own natural home, which they enter unannounced as lords that are certainly expected, and yet there is a silent joy at their arrival."

APPENDIX

"You enjoy the studies with your Spiral."—MEREDITH.

 I. NATURE AND MATHEMATICS (Illustrated).
 II. THE φ PROGRESSION. BY WILLIAM SCHOOLING.
 III. INFINITE SERIES AND THE THEORY OF GROUPING.
 IV. ORIGINS OF A SYMBOL (Illustrated).
 V. THE SPIRAL IN PAVEMENT-TOOTHED SHARKS AND RAYS
 (Illustrated). BY R. LYDDEKER.
 VI. THE SPIRAL IN BIVALVE SHELLS (Illustrated). BY R.
 LYDDEKER.
 VII. THE SHELL OF TRAVANCORE.
 VIII. THE GROWTH OF SHELLS (Illustrated).
 IX. THE φ PROGRESSION IN ART AND ANATOMY (Illustrated).

I. NATURE AND MATHEMATICS.

JUST as I was reading the proofs of " The Curves of Life," a book by Samuel Colman, M.A., edited by C. Arthur Coan, LL.B., and published by Messrs. G. P. Putnam's Sons, was sent to me from New York, entitled " Nature's Harmonic Unity : A Treatise on its Relation to Proportional Form." Its preface is dated December 1st, 1911, and it therefore provides a very interesting example of the way in which two minds may be attracted by kindred subjects at the same time, without any knowledge of each other's studies, and arrive at different conclusions from a similar set of data. Readers of the *Field* in 1912 will remember the chapters in that paper in which I tried to expound certain principles which are discoverable in natural growth, and applied them to such artistic creations as the Parthenon and the Open Staircase of Blois, illustrating my theory from a large number of examples chosen from botany, anatomy, conchology, and other branches of natural science. A great many such " illustrations " of his thesis are provided by Mr. Colman in the volume before us, from the nautilus or the sunflower, to the Parthenon or the facade of Rheims Cathedral. Yet the treatment and main result are different. Although Mr. Colman's pages and Mr. Coan's mathematics are of absorbing interest, I venture to uphold the theory set forth in 1912 in the *Field* and developed in " The Curves of Life " as a better working hypothesis, a better " explanation " of the phenomena.

The title of Mr. Colman's book suggests and epitomises the contrast between his attitude and mine. I could almost call my book *Nature's Geometrical Diversity* in contrast with Mr. Colman's *Nature's Harmonic Unity*. There is some confusion also in his use of the word " unity." At one time he seems to suggest that the phenomena of Nature and art exhibit the common characteristic—the one feature—of obedience to the laws of Nature, which is true. Elsewhere, and in the main,

he insists that these varied phenomena exhibit unity by following one—and only one—law so far as proportion of form is concerned. The expression of that law he finds mainly in " extreme and mean proportion." He regards deviations from this law as negligible, and it is even suggested that, since the measurements of the Parthenon do not conform precisely with this law, the measurements are wrong ! I hold, on the contrary, that the deviations from law are of more moment and of greater interest ; that they are better calculated to extend our knowledge than the detection of rigid conformity with the law.

Again, his book is concerned with proportional form, while I think that far greater advantages attach to considering form in connection with growth. He may be said to be dealing with morphology apart from physiology, with form separate from function, whereas, in my judgment, considerations of function and growth are essential to the

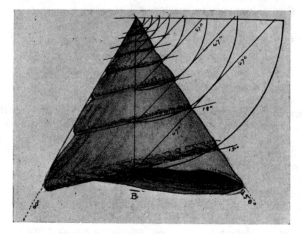

FIG. 393.—TROCHUS MAXIMUS (COLMAN).

right understanding of form and its proportion. He proposes to explain the complicated phenomena of forms in life and of beauty in art by saying that they all agree with one very simple mathematical expression. My position, on the contrary, is that the phenomena of life and beauty are always accompanied by deviations from any simple mathematical expression we can at present formulate.

Mathematics, to my mind, are of the highest value as an instrument ; but, as we have seen in previous pages, it is of the essence of a living thing, as of a beautiful work of art, that it cannot be exactly defined by any simple mathematical formula like that chosen by Mr. Colman. I have pointed out in the last chapter that the agreement of a number of phenomena with a given formula is not an important factor in knowledge ; it merely sums up a certain sphere of investigation in a convenient way. The really important thing is the exception. But I must not be taken as expressing disdain for laws in general or for Mr. Colman's mathematics in particular. Indeed, without the mathematical expression as a guide we should be unable to take note

of the aberration, and to this extent Mr. Colman and Mr. Coan have done very valuable work ; but Mr. Colman makes, as I think, the fundamental error (which runs through his whole argument) of predicating certain mathematical forms in his own mind, and then saying that they exist in the natural object (still more in the artificial or architectural object) which he is examining. Judging it on these lines, the most valuable part of Mr. Colman's book is to be found in Mr. Coan's appendix, which faithfully and accurately sets out the actual differences between living organisms (or architectural creations), and strictly mathematical results. It is these differences which predicate life in the one case and beauty in the other.

The invincible honesty of the mathematical scholar compels Mr. Coan (the editor) to say (if I may choose one out of several instances)

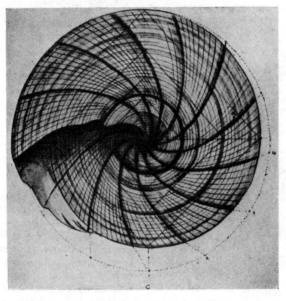

Fig. 394.—Under-side of Trochus (Colman).

that the statements of Mr. Colman (the author) regarding the raking cornice of 14°, in the Parthenon, should, in one case, be 14° 2′ 11″, and in another, 13° 3′ 52″. I have reproduced, to illustrate this portion of my Appendix, several of Mr. Colman's diagrams of such natural objects as shells or plants. As will be seen, he makes them all fit into his formulæ, and neglects (or relegates to the Appendix) just those variations or differences which are to me so valuable and suggestive.

To put it in another way, I emphasise the exception as being more valuable than the law, because a law expresses our knowledge of the past. It is a record of a sequence of events which, if similar conditions prevail, we are justified in thinking will be repeated ; but the exception gives the hope of future progress. A law is the statement of a central set of relations, from which there may be deviations. But while the

central facts do not vary, the deviations will not bear in any one direction. Otherwise they would form part of the formulation. If, and when, we can trace and state the law—the sequence—that prevails among the exceptions, we shall find yet further deviation, the law of which we may be able to trace ; and so on through a long series of interacting forces, which are the more numerous and the more complex the higher the stage of evolution that has been reached. The law of gravity holds good—exactly good—though conformity with it may not be completely manifested by phenomena. The mutual attraction of the earth and a book tend to make the book and the earth come together : the book tends to fall by the action of gravity. For various reasons my will directs my muscles to move my fingers and to set up friction between them and the book ; the book does not fall. Here there is no lack of precise conformity with the law of gravity, but other forces are at work as well, and if we knew as little of gravity as we know of some other natural laws we should, on regarding the book, say that it manifested a deviation from the law of gravity. We begin to investigate the deviation and discover friction between the book and the fingers ; from this and other examples we learn something about the law of friction ; we apply it to other phenomena we have observed, and notice a closer approximation to the laws of gravity and friction combined than to the laws of gravity alone. Still, there are deviations, and —not to be too prolix—we begin to find out something about the muscular action which moves the fingers. We now apply the three laws of gravity, friction, and muscular action to phenomena, and the deviations, though less than before, still remain. In investigating these exceptions we come upon nervous action and human thought, and the stimulating causes of that thought. We finally reach a stage where, for the present at least, our knowledge is insufficient to trace the sequence—to express the law.

FIG. 395.—BEGONIA (COLMAN).

We are confident, however, that here, as elsewhere, order prevails, not chaos, and that the inability to state the law is due to our ignorance and not to the absence of an unvarying chain of identical consequences from similar causes. Antecedents being the same, the sequences will be alike.

If there be—as I think there is—a tendency for a nautilus to acquire the form of a logarithmic spiral, just as there is a tendency for a book to fall under the action of gravity, and yet there is no known example of a nautilus shell being an exact logarithmic spiral, it is reasonable to assume that there are other forces at work, akin to friction or muscular action, which cause this deviation. The deviation stimulates us to further investigation, and to the probable or possible discovery of some other law of nature, from which in turn deviations will be discovered, leading to yet further extension of knowledge.

Nothing is more deceptive than facts, except figures. And it would be complicated enough if Mr. Colman were to limit himself to suggesting that Nature, in the one case, and the architect in the other, were growing or working on a system of geometrical conventions which conditioned the results. Unfortunately, the author goes further. He speaks of "objects expressing divine unity of construction." Mr. Coan speaks of polygons as fundamental elements, "revealing in a large measure the hand of Divinity." They both,

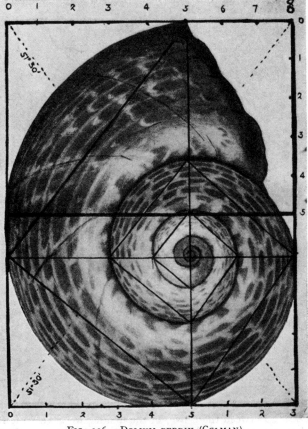

Fig. 396.—DOLIUM PERDIX (COLMAN).

in fact, run grave risks of vitiating their whole argument by that logical fallacy of "Design," which weakened the arguments drawn by the late Professor Pettigrew from so much of his most brilliant original research. Sir Ray Lankester has stated that he regards the utmost possibilities of human science as the contents of such a bracket as is used in algebra, with x placed outside as the factor representing unknown and unknowable possibilities. Within the bracket, elaborated by science, is a true and trustworthy scheme describing a system of relations in time and space, a limited reality with which we

have to be content, an observed order which remains unassailable, whatever be the character of the unknown factor (x) outside the " bracket." In the case of Mr. Colman and Mr. Coan, that factor (x) is apparently " Design." In his lectures at Glasgow, in January, 1914, Mr. Arthur Balfour seems to suggest the same conclusion, though he rightly distinguished between " the argument *from* design " and " the argument *to* design," with which latter he was chiefly concerned. He reached his results by steps which appear perfectly logical. There was a beginning, it is agreed, to the physical universe we know. There will also be an end, a time when the various transformations of energy

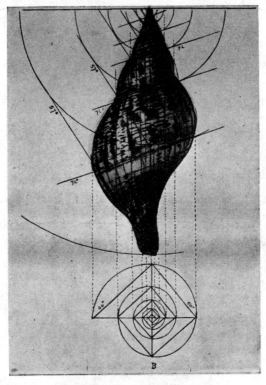

FIG. 397.—FACELARIA (COLMAN).

will cease. Between these two, in the middle, we have " the feelings of feeling beings and the thought of thinking beings " ; and, he argues, " it is reasonable to conclude that, since matter cannot make will and reason, then will and reason must have made matter." He proceeded with further arguments as follows : " The men who are most alive to the higher æsthetic emotions feel that their emotions open up something that contains an intuition greater than knowledge. There is always in a great work of art the sense of communication from its creator. . . . Can we accept this view for works of art and deny it for the manifestations of natural beauty, before which the greatest works of art fade into insignificance ? . . . We must regard the beauties of

Nature as signs, as symbols, as a language, just as we do chords and colours. The entire value of the glories of Nature is lost unless we conceive behind Nature one who has designed it. . . . Unless we are willing to sacrifice the æsthetic emotion in its highest development and in its greatest examples, we must believe in a Great Spirit whose manifestations these things are."

Well, my position in regard to such arguments is that Mr. Balfour predicates too diminutive a content for his " bracket " before placing the " x," which is his " Great Spirit," outside it ; and that Mr. Colman (or Mr. Coan) is scientifically inexact in asking us to condition the known contents of his " bracket " by the influence of an " x " which is *ex hypothesi* unknown. I must take much the same position (in considering the book before me) with regard to the second chapter contributed by Mr. Coan. As a thesis in pure mathematics it is beyond my criticism ; but as an integral part of Mr. Colman's argument it only proves that once you apply mathematics to phenomena you are in grave danger of predicating actual correlations of the phenomena, when the truth is that such correlations only exist in the mathematics. This error, it seems to me, Mr. Colman commits in several of his chapters and in the whole of his conclusions. " Unity," " Proportion " ; these are, indeed, invaluable. But the essence of beauty is not " unity." To say that the " proportions " of a tree are beautiful because of its " unity " is meaningless ; for you are only considering one tree, and all its parts are parts of the same whole. The wonderful thing is that, in spite of its details being utterly rebellious to mathematical expression, they do, as a matter of fact, make up one living and harmonious organism. The inference is irresistible. The beauty of the whole is *not* due to the observance, by the tree, of any mathematical formulæ, but to subtle differences from exact rigidity which are noticeable in the set of every bough, in the fall of every leaf, in the whole growth of flower and fruit.

In just the same way no mathematical formula can ever express that imaginatively creative power in man which we have agreed to call " genius." The circle which Giotto drew with a free sweep of his hand was not marvellous because it was almost mathematically *correct*. The wonder of the performance was typified by that diminutive *divergence* from correct formality, which was the subtlest gift of Giotto's genius, and expressed his delicately sensitive personality. In just the same way, the disc of a sunflower is not a perfect circle, because it is a portion of a living plant.

Mr. Colman shows ordered proportions which may be attributed to certain laws. But he sees too much in laws when he means by this word the narrowest sort of geometrical relations. The law of extreme and mean proportion stands out as a proved principle, and it does govern a pleasant relation for the sweep of the eye across some architectural and natural spacings. It is the old and well-known " Golden Section." It is also Euclid, Book VI., prop. 30. But this principle is not more than a letter in the alphabet of architecture, to say nothing of the other arts. Mr. Colman (guided, I think, too little by his editor) believes not only in a very wide application of the Golden Section, but he wishes to show that most of art is governed either by this or by other laws which are as easily formulated. In

order to prove his contention, he draws a maze of lines over his architecture and his natural objects (as may be seen from those here reproduced), but the lines result merely in presenting one or another aspect of the extreme and mean proportion. And while no one can deny that this relation is important, the author tries to show too much more than Zeising and Fechner showed. Still, it would be unfair to overlook the author's extension of the older observations, and one is surprised to see the increased number of agreements with ordered geometry. But when we analyse the geometry we find that the author's demonstrations could be expressed by a very simple formulation of the wider meanings of the extreme and mean proportion. Such a simplified formulation at once exposes the improbability of a

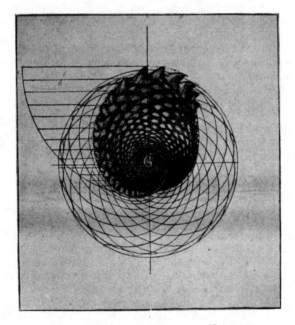

FIG. 398.—HALIOTIS CORRUGATA (COLMAN).

royal road to the arts, though it widens the significance of the Golden Section. This law, as usually stated, relates to the proportion of two magnitudes: "*The first part is to the second part as the second is to the whole or sum of the two parts.*"

Mr. William Schooling has extended the law and enlarged it from a certain proportion concerning two magnitudes into an infinite series; and I will leave it to him to show in detail the wonderful properties of the number 1·61803, which is the heart and soul of the relation. But I may remark, in passing, the curious fact that Nature seems (by acting so closely in accordance with this new ϕ proportion) to prefer to add the last *two* terms together in order to obtain her next term, instead of adding the last three, or four, or more. Why is this?

Mr. Schooling has demonstrated, among other things, that successive

powers of the number 1·61803 (now called ϕ) give a series of steps (numbered from minus to plus infinity), each of which bears to its neighbour the exact golden proportion. But further, the number ϕ is found to be the basis of many relations that are not linear. At all events, all of Mr. Coleman's congruities depend upon the properties of ϕ. The relations can be stated simply, and they have a wide application. But where is the royal road to architecture ? Nowhere, in terms of one single principle. But even one established principle is a gain to us. Small beginnings in these complex studies are important. If we take Mr. Colman's thesis as a rough standard by which we may detect exceptions, it will be much more valuable than if we take it at his own valuation, either as a rule of Nature or a canon of artistic creation.

Mr. Schooling suspects (he does not claim yet to have proved) that the ϕ proportion mentioned in the last chapter is an expression of economy of form, manifested in the packing of the human fœtus, in the shape of shells, and in other ways. That such an economy of form should result in beauty is analogous with the fact that gracefulness is the result of ease or economy of force or effort.

Darwin, describing the wonderful horsemanship in Chile, said : " The Gaucho never appears to exert any muscular force " (" Naturalist's Voyage," Chapter VIII.), and Herbert Spencer wrote : " Grace, as applied to motion, describes motion that is effected with economy of force." In skating, " the graceful way of performing any evolution is the way that costs least effort. . . . The reference to skating suggests that graceful motion might be defined as motion in curved lines . . . a leading trait of grace is continuity, flowingness " (" Essays," Vol. II.).

Mr. Schooling also tells me that he is constructing an instrument for drawing logarithmic spirals automatically, using the ϕ spiral as a standard, and stating the conditions of any other logarithmic spiral in terms of deviation from this standard. Incidentally this instrument will show that it is possible to proceed from a straight line to a circle through an infinite number of logarithmic spirals.

T. A. C.

II. The ϕ Progression.

By William Schooling.

I HAVE been asked to give some further account of the ϕ progression, which was first briefly described in the *Field* on December 14th, 1912.

The chief interest of ϕ in relation to Mr. Cook's inquiry into the principles of growth and beauty is, on the one hand, its connection with the Fibonacci series and phyllotaxis, and, on the other, with the ϕ spiral, an illustration of which was published in the *Field*, and which throws some light on numerous spiral formations in Nature and art (see Fig. 385).

The ϕ ratio has long been known, but it receives an added significance when it is recognised as the common ratio of a geometrical progression, in which the sum of any two consecutive terms equals the next term. The progression is :

$$1, \phi, \phi^2, \phi^3 \ldots \phi^n, \phi^{n+1}, \phi^{n+2}, \text{etc.}$$
$$\text{Then, } \phi^n + \phi^{n+1} = \phi^{n+2}$$

Divide by ϕ^n

$$1 + \phi = \phi^2$$

$$\phi = \frac{1 \pm \sqrt{5}}{2} = 1\cdot 618033988750$$

$$\text{or} - \cdot 618033988750$$

In certain circumstances the signs may be opposite and ϕ may have four values, i.e.,—

$$+ 1\cdot 618, \text{ etc.}$$
$$- 1\cdot 618, \text{ etc.}$$
$$+ \cdot 618, \text{ etc.}$$
$$- \cdot 618, \text{ etc.}$$

Writing in the *Daily Telegraph* for January 21st, 1911, I said there is a " very wonderful number which may be called by the Greek letter phi, of which nobody has heard much as yet, but of which, perhaps, a great deal is likely to be heard in the course of time. Among other things, it may explain to architects and sculptors and painters, and to everybody interested in their work, the true law which underlies beauty of form. This is a number which never could be expressed exactly, however many figures might be used for the purpose."

I will now turn to the famous Fibonacci series and compare it with the ϕ progression, taking the value of ϕ as 1·618, etc. The Fibonacci series is formed only by successive addition. Commencing with 1 as the first term, and 1 as the second term, we obtain the numbers, 1, 1, 2, 3, 5, 8, 13, etc.

We can have a similar additive series, in which the first and second terms are any numbers whatever ; call them a and b. I give below the general form of such a series ; a numerical example, in which the first term is 1 and the second term is 3, and the ϕ series :

Term.	General Form.	$a = 1$ $b = 3$	$a = \phi$ $b = \phi^2$
1	$1a + 0b$	$1 + 0 = 1$	$1\phi + 0\phi^2 = \phi$
2	$0a + 1b$	$0 + 3 = 3$	$0\phi + 1\phi^2 = \phi^2$
3	$1a + 1b$	$1 + 3 = 4$	$1\phi + 1\phi^2 = \phi^3$
4	$1a + 2b$	$1 + 6 = 7$	$1\phi + 2\phi^2 = \phi^4$
5	$2a + 3b$	$2 + 9 = 11$	$2\phi + 3\phi^2 = \phi^5$
6	$3a + 5b$	$3 + 15 = 18$	$3\phi + 5\phi^2 = \phi^6$
7	$5a + 8b$	$5 + 24 = 29$	$5\phi + 8\phi^2 = \phi^7$

The ϕ series can be formed either by addition as above, or by taking successive powers of ϕ as in any other geometrical progression. It is the only series that can be so formed, and it has, in consequence, a number of curious properties.

The numerical values of some terms of ϕ and the presence of the Fibonacci numbers in various forms are exhibited in the next table.

$$\phi^{-5} = 0\cdot 090170 = - 8 + 5\phi = - 3 + 5 \div \phi$$
$$\phi^{-4} = 0\cdot 145898 = + 5 - 3\phi = + 2 - 3 \div \phi$$
$$\phi^{-3} = 0\cdot 236068 = - 3 + 2\phi = - 1 + 2 \div \phi$$
$$\phi^{-2} = 0\cdot 381966 = + 2 - \phi = + 1 - 1 \div \phi$$

$$\phi^{-1} = 0.618034 = -1 + \phi = 0 + 1 \div \phi$$
$$\phi^{0} = 1.000000 = 1 = 1$$
$$\phi = 1.618034 = 0 + \phi = 1 + 1 \div \phi$$
$$\phi^{2} = 2.618034 = 1 + \phi = 2 + 1 \div \phi$$
$$\phi^{3} = 4.236068 = 1 + 2\phi = 3 + 2 \div \phi$$
$$\phi^{4} = 6.854102 = 2 + 3\phi = 5 + 3 \div \phi$$
$$\phi^{5} = 11.090170 = 3 + 5\phi = 8 + 5 \div \phi$$
$$\phi^{6} = 17.944272 = 5 + 8\phi = 13 + 8 \div \phi$$
$$\phi^{7} = 29.034442 = 8 + 13\phi = 21 + 13 \div \phi$$
$$\phi^{8} = 46.978714 = 13 + 21\phi = 34 + 21 \div \phi$$

It may be noted that when the powers of ϕ are odd the difference of the corresponding plus and minus powers is integral. When the powers are even the sum is integral. These integral numbers form the series 1, 3, 4, 7, 11, which result from making the first term of an additive series 1, and the second term 3. Thus:

$$\phi^{5} - \phi^{-5} = 11 \cdot 090 - \cdot 090 = 11$$
$$\phi^{4} + \phi^{-4} = 6 \cdot 854 + \cdot 146 = 7$$

The sum or difference of corresponding plus and minus powers of ϕ are exact multiples of the square root of 5 by Fibonacci numbers. Thus:

$$\phi^{5} + \phi^{-5} = 11 \cdot 180340 = 5\sqrt{5} = 5 \times 2 \cdot 236068$$
$$\phi^{4} - \phi^{-4} = 6 \cdot 708204 = 3\sqrt{5} = 3 \times 2 \cdot 236068$$

There are literally innumerable ways in which any term of the Fibonacci series may be expressed in multiples of other terms of the same series, and this remark is true of other kindred additive series, including the ϕ progression.

These ways are indicated by the method of obtaining the value of any term of the Fibonacci series without calculating all the intermediate terms. If we call the twentieth term of the series F_{20} we may say:

$$F_{20} = (F_6 \times F_{15}) + (F_5 \times F_{14}) = (8 \times 610) + (5 \times 377) = 6765$$
or $$F_{20} = F_{11}^{2} - F_{9}^{2} = 89^{2} - 34^{2} = 7921 - 1156 = 6765$$

Stated generally :

$$F_n = (F_d \times F_{n+1-d}) + (F_{d-1} \times F_{n-d}).$$

Here F_n is the nth term of the Fibonacci series, and we can find its value by using any other term d as above. This d may be any integer whatever, plus or minus, even or odd.

The value of any term in the ϕ progression, or in any additive series of the type a, b, $a + b$, etc., may be found in a kindred way.

The Fibonacci, the ϕ, or any other such series may be expanded with Binomial co-efficients.

$$\text{Thus } F_{10} = F_9 + F_8$$

$$\text{but } F_9 = F_8 + F_7$$
$$F_9 = F_7 + F_6$$
$$\overline{F_{10} = F_8 + 2F_7 \times F_6}$$

$$\text{Again } F_8 = F_7 + F_6$$
$$2F_7 = 2F_6 + 2F_5$$
$$F_6 = F_5 + F_4$$
$$\overline{F_{10} = F_7 + 3F_6 + 3F_5 + F_4}$$

In the same way

$$\phi_{10} = 1\phi^9 + 1\phi^8$$
$$= 1\phi^8 + 2\phi^7 + 1\phi^6$$
$$= 1\phi^7 + 3\phi^6 + 3\phi^5 + 1\phi^4$$
$$= 1\phi^6 + 4\phi^5 + 6\phi^4 + 4\phi^3 + 1\phi^2$$
$$= 1\phi^5 + 5\phi^4 + 10\phi^3 + 10\phi^2 + 5\phi^1 + 1\phi^0$$

and so on indefinitely.

Another point of great interest emerges when we consider the ratios between successive terms of the Fibonacci series. In the ϕ progression the ratio is by definition always ϕ, i.e., 1·618034. The Fibonacci and other such additive series tend to become geometrical progressions, with ϕ as the common ratio, but never become so exactly. Thus we have the following ratios, which are alternately more and less than ϕ, the deviation from which is indicated :

Fibonacci numbers.	Ratios.	Deviations from ϕ.
5 ÷ 3	= 1·666666667	= ϕ + ·048632678
8 ÷ 5	= 1·600000000	= ϕ — ·018033989
89 ÷ 55	= 1·618181818	= ϕ + ·000147829
144 ÷ 89	= 1·617977528	= ϕ — ·000056461
4181 ÷ 2584	= 1·618034056	= ϕ + ·000000067
6765 ÷ 4181	= 1·618033963	= ϕ — ·000000026

An even term of the Fibonacci series divided by the preceding odd term gives a ratio less than ϕ ; and an odd term divided by the previous even term gives a ratio greater than ϕ. For example, 5 is the fifth term, and 8 is the sixth term of the Fibonacci series. Again, 89 is the eleventh term, and 4181 the nineteenth.

We saw above that when n is odd $F_n \sqrt{5} = \phi^n + \phi^{-n}$, and when n is even $F_n\sqrt{5} = \phi^n - \phi^n$. Therefore

$$\frac{F_5}{F_4} = \frac{\phi^5 + \phi^{-5}}{\phi^4 - \phi^{-4}} = \phi + \frac{\phi^{-3} + \phi^{-5}}{F_4(\phi^1 + \phi^{-1})} = \phi + \frac{\phi^{-4}}{F_4}$$

$$= \phi + \frac{·145\ 898\ 034}{3} = \phi + ·048\ 632\ 678$$

as shown when stating the deviations from ϕ.

In general terms when n is odd

$$F_{n+1} \div F_n = \phi - \phi^{-n} \div F_n = \phi - 1 \div F_n \phi^n.$$

When n is even,

$$F_{n+1} \div F_n = \phi + \phi^{-n} \div F_n = \phi + 1 \div F_n \phi^n.$$

The higher numbers of the Fibonacci series, as Mr. Church pointed out, approximate more and more closely to the ratio 1 to 1·618, etc., or ·618, etc., to 1, but never reach it. They are alternately too large and too small.

So far as I am aware it has not been pointed out before that *every additive series of the type* a, b, a + b, *etc., approximates more and more closely to a geometrical progression with* φ *as the common ratio.*

It will be noticed in the above formulæ that, as the higher terms of the series are taken, the numerator in the fraction expressing the deviation from φ is always unity, but the denominator becomes larger. Thus the ratios tend to equality, and if they were equal they would be in φ proportion. $F_{31} \div F_{30} = \phi + \cdot000\ 000\ 000\ 000\ 646$.

The φ progression is, in fact, the ideal which all additive series of the Fibonacci type tend to reach but never attain. It gives exact expression to the spirit of them all.

It is probable that the φ proportion expresses more nearly than the Fibonacci series certain tendencies of growth and pleasing proportions of form. It links many diverse phenomena and *suggests a reason* for that truth of form which we call beauty.

Especially when the φ proportion is used as a logarithmic spiral (previously published in the *Field*) does it become helpful in that study of Nature and art which associates so many phenomena that are apparently unconnected.

It may be interesting to show a geometrical method of dividing a given line into a series of lengths in φ proportion.

In the right angled triangle ABC, the given line is AB taken as unity. The perpendicular BC is ½ AB. With centre C and radius CB

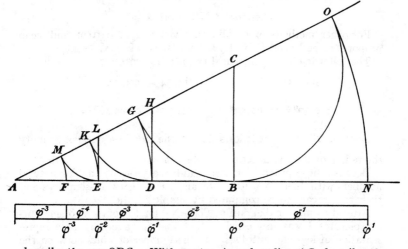

describe the arc OBG. With centre A and radius AG describe the arc GD. Draw DH perpendicular to AB. With centre H and radius HD describe the arc DK. With centre A and radius AK describe the arc KE. Draw EL perpendicular to AB. With centre L and radius LE describe the arc EM. With centre A and radius AM describe the arc MF.

Then the line A B is divided into ϕ proportions at D E and F.

Let $A B = b = 2p$; $B C = p = \dfrac{b}{2}$; $A C = h$.

Then
$$h^2 = b^2 + p^2 = 4p^2 + p^2 = 5p^2$$

and
$$h = p\sqrt{5} = \frac{b\sqrt{5}}{2}$$

but
$$C G = C B = p$$
$$\therefore\ A G = h - p = A D$$

and
$$h = p\sqrt{5}$$
$$\therefore\ h - p = p(\sqrt{5} - 1) = \frac{b(\sqrt{5} - 1)}{2} = b\phi^{-1}$$

Thus $\quad A D = \phi^{-1} A B$

and the given line A B is divided in ϕ proportion at D.

The triangles A C B, A H D, and A L E are similar. Therefore A D is divided in ϕ proportion at E; and A E at F.

$$\begin{aligned}
\text{Since } A B &= \phi^0 &&= 1\\
A D &= \phi^{-1} &&= 0\cdot618\\
A E &= \phi^{-2} &&= 0\cdot382\\
A F &= \phi^{-3} &&= 0\cdot236
\end{aligned}$$

Similarly the line A B may be increased in ϕ proportion.

$$\text{For } A O = A N = h + p.$$

Since $h = p\sqrt{5}$

$$h + p = p(\sqrt{5} + 1) = \frac{b(\sqrt{5} + 1)}{2} = b\phi^1$$

Therefore $A N = A B \times \phi^1$

For other methods of dividing a given line in extreme and mean proportion see Euclid Book II. xi. and Book VI. xxx.

The following Trigonometrical ratios are of interest.

$$\text{Sin } 18^0 = \cos 72^0 = \frac{1}{2\phi}\ ;\ \sin 54^0 = \cos 36^0 = \frac{\phi}{2}$$

$$\text{Sec } 36^0 = \operatorname{cosec} 54^0 = \frac{2}{\phi}\ ;\ \sec 72^0 = \operatorname{cosec} 18^0 = 2\phi$$

Since $\sin 18^0 = \dfrac{1}{2\phi}$ it follows that if the side of a decagon is unity the radius of the circumscribed circle is ϕ.

Because the ϕ progression is an additive series it enables natural numbers with their logarithms to any base, their Gaussian logs and their reciprocals, to be computed by simple addition.

After drawing the diagram of Plate XI. for the purpose of measuring pictures I was interested to find that it gave a graphic representation of logs and anti-logs. If the number of units between the sloping lines ϕ^1 and ϕ^2 are 1 at the left; 1·271 at line T, and 1·618 at the right, the proportions are :—

$$1 : 1\cdot271 : 1\cdot618 : \text{ or } \phi^0 : \phi\cdot4988 : \phi^1$$
$$\text{or } \log{}_\phi\ 0 : \cdot4988 : 1 : \text{ or } \log{}_{10}\ 0 : \cdot1043 : \cdot2090.$$

Since $\log{}_{10}\ \phi = \cdot2090$ we have :—

Between Lines.	Logs to Base 10.			Numbers.		
	On Left.	At T.	On Right.	On Left.	At T.	On Right.
ϕ^1 and ϕ^2	·000	·104	·209	1·000	1·271	1·618
ϕ^2 and ϕ^3	·209	·313	·418	1·618	2·057	2·618
ϕ^3 and ϕ^4	·418	·522	·627	2·618	3·328	4·236
ϕ^4 and ϕ^5	·627	·731	·836	4·236	5·385	6·854

The logs are found by repeated addition of ·2090 ; the natural numbers by successive additions, or by multiplication by ϕ. Thus the vertical and sloping lines give logs and a scale on either side supplies the corresponding natural numbers.

III. INFINITE SERIES AND THE THEORY OF GROUPING.

" THE theory of infinite series enables us to classify and understand not material phonemena merely, but even mental processes as well. There are the further possibilities, in this latter direction, of the theory of grouping, and this theory should certainly enable us to analyse the relations of structure in the amorphous. Let me choose one example. There is a very peculiar and characteristic joy in the grouping of ideas, a pleasure which undoubtedly rises from the rhythmic flow of unknown laws. A single note conveys nothing. But the rhythmical grouping of a number of notes is music. A single word, alone upon a page, might convey an idea to the reader, but it could convey nothing of that ordered assemblage of ideas which constitutes an author's message. Yet the proper (may we assume sanction and borrow the word ?)—the proper grouping of words is literature. The rhythmical and proper grouping of words is poetry. Facts in themselves are useless clay, but when used in building up a hypothesis they become invaluable bricks. As the simplest way of printing a number of words singly and alone, each without relation to any other, I will set down here some words in alphabetical order. Here they are :—

Account	Either	Land	Ore	That
Also	Ere	Lest	Own	Therewith
And	Exact	Light	Patience	They
Ask	Fondly	Lodged	Post	Though
At	Gifts	Maker	Present	To
Bear	God	Man's	Prevent	Useless
Bent	He	Me	Replies	Wait
Bidding	Hide	Mild	Rest	When
But	Him	More	Returning	Which

" In this form these words mean nothing, even if I were to add the other fifty ; yet rhythmically grouped the whole becomes one of Milton's loveliest sonnets :—

" *When I consider how my light is spent*
Ere half my days in this dark world and wide
And that one talent which is death to hide
Lodged with me useless, though my soul more bent

To serve therewith my Maker and present
My true account, lest He, returning, chide ;
' Doth God exact day-labour, light denied ? '
I fondly ask. But Patience, to prevent
That murmur, soon replies, ' God doth not need
Either men's work or his own gifts. Who best
Bear His mild yoke, they serve Him best. His state
Is kingly ; thousands at His bidding speed,
And post o'er land and ocean without rest ;
They also serve who only stand and wait.'

" The evolution of such poetry, out of the list of apparently incongruous words just printed, seems to suggest that just as the mathematician may use the subjective concept of the Spiral in order to explain and define the laws of energy and growth, so we may also conceive of a single subjective gamut of human emotions with an infinity of winds to stir it ; for ' the wind bloweth where it listeth, and thou canst not tell whence it cometh or whither it goeth,' inspiring at one time art, at another music, at another literature, at will ; each related to the other (as was shown in Fig. 391 of the Spiral and its radii) and each a part of that great final rule to which, at last, we shall find no exceptions." M. B.

IV. Origins of a Symbol.

By the courtesy of Sir Ray Lankester I have been shown a slab of Bognor rock, the same Eocene formation as the London clay, which reveals the fossilised cross section of a Fusus or whelk. As will be

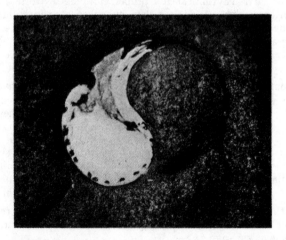

Fig. 399.—Fossilised Section of Fusus in Eocene Rock.

seen by the photograph (Fig. 399) here reproduced, the pattern shown is a circle divided in two by a double curve, by which two comma-like figures of equal size are produced, called by the Japanese Tomoye, and

used by the Chinese philosophers of the twelfth century as a symbol of generation. They developed it by saying that in the beginning was a circle with a spot in the centre, just like the organic cell of modern science. This spot, or nucleus, then divided into two, which were Yin, the feminine, and Yang, the masculine. The visible universe produced by both was represented by the symbol so curiously reproduced in the Eocene clay specimen ; and though you can almost evolve this figure by drawing half circles on each side of the diameter of a larger circle, yet I cannot help thinking that the formation may have been suggested by the section of an actual shell, which can be reproduced any day from a fresh specimen. For the curves in the symbol are not really portions of regular circles ; they are portions of logarithmic curves such as are exhibited in the section of *Nautilus pompilius* (a tropic shell) here reproduced in Fig. 400. Indeed, if you superimpose tracings of each section of this shell, you arrive at a natural and beautiful derivation of the Tomoye symbol which I do not think has been suggested before (see Plate VI., 1, 2, and 3.)

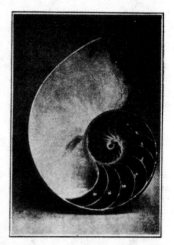

It will be noticed that the cones or commas produced in each half of the Tomoye are very like the so-called " cones " in the patterns of Indian shawls (see Plate VI., 6 and 7). But it is more important to observe that if you take the S-curve of the Tomoye and place another at right angles to it, you get the curved Swastika, which has now become angular from a natural tendency in conventionalised patterns, often observed in other cases (see Plate VI., 8 and 9). If so, the "lucky Swastika" may well have some connection both with the " Tomoye," which means " Triumph," and with the older

FIG. 400.—SECTION OF NAUTILUS POMPILIUS USED IN DRAWING THE DIAGRAMS IN PLATE VI., 1, 2, 3 (Cf. FIGS. 96 & 97, CHAP. IV.).

Chinese symbol, for small representations of the Swastika are found covering almost the whole ground (like diaper work) of the small boxes of red lacquer made in the Kien Lung period, about 1750. In any case, the curious point I wish to emphasise is that a shell is more likely to have suggested the Swastika (if we agree that its origin was a natural object) than the flying stork, with outstretched wings and legs, which Mr. Salomon Reinach prefers (see Plate VI., 11 and 12).

We can extend the question a little further. Mr. Percival Lowell's well-known book says that the Koreans, when they adopted Chinese customs, also studied Chinese philosophy, and they took up with enthusiasm those mystic symbols which play so important a part in most philosophies of the Far East. The Japanese Tomoye, thinks Mr. Lowell, certainly came from the Chinese, though the former sometimes developed the " scroll " within the circle into three, instead of only two. But in Korea there are always two only, representing

light and shade, male and female, called in Korean Yang and Yoeng. This badge forms the centre of the Korean national flag, adopted when they entered the world of modern nations, just as, in earlier years, it had formed the centre of their Red Arrow Gates, the portal

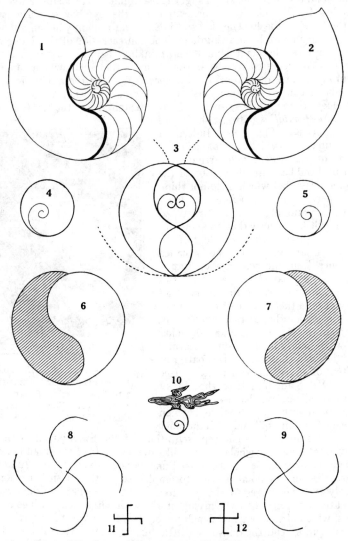

PLATE VI.—Symbols derived from the Nautilus Shell.

leading to all they reverenced. The figure here reproduced shows the conventionalising of one "comma" from the natural form of the shell section in Fig. 400, and the joining of the two "commas" in a circle which is the Korean national badge (Fig. 401.). It has also been adopted as the trade mark (1896) of the Northern Pacific Railway Company.

It is no business of mine, or of this volume, to go into the intricate problem of the origins of symbols. But a curious parallel with the Tomoye has been found by Harvard archæologists in Central America. In Fig. 402 I show a sacrificial altar from Copan. It takes the shape of the old Chinese circle with the nucleus in its centre, and it shows

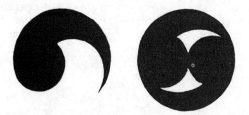

FIG. 401.—THE KOREAN NATIONAL BADGE.

the old Chinese symbol of generation, which thus appears to have travelled from Japan to Central America, and to be as widespread as the Swastika itself. Human victims were sacrificed to the sun god on this prehistoric altar, and the curved grooves carried off their blood. It is only right to add that on Chinese porcelain of 1720 I have

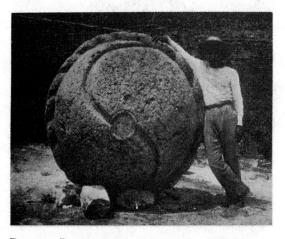

FIG. 402.—PREHISTORIC ALTAR FROM CENTRAL AMERICA
(SMITHSONIAN INSTITUTE).

found a green pattern consisting of a logarithmic spiral within a circle, the circumference of which is crowned by a conventionalised plant (see the cover of this book and Plate VI., 4, 5, and 10). What can this be but a clear recognition of the logarithmic spiral as the principle of growth within a cell? And this symbol also is obtainable by the same superposition of sections of a nautilus, shown in Plate VI. 1, 2, and 3. T. A. C.

V. THE SPIRAL IN PAVEMENT-TOOTHED SHARKS AND RAYS.

By R. LYDEKKER.

The well-known Port Jackson shark (*Cestracion philippi*, p. 234) and its immediate relatives of the Indo-Pacific are the last survivors of a long line of extinct sharks remarkable for the peculiar structure and arrangement of the pavement-like teeth on the inner and palatal surfaces of the sides of the jaws, these teeth forming some of the most

FIG. 403.—JAW OF THE PORT JACKSON SHARK (CESTRACION).

exquisite spirals to be met with in Nature. And yet they do not form complete spirals, the spiral effect being produced by the arrangement of these oblong or brick-shaped teeth in parallel bands running obliquely across the inner sides and margins of the jaws, each band, or series, being perfectly distinct from those on either side, maintaining the same diameter throughout, and ending abruptly at the base of the inner sides and the outer part of the margins of the jaws. As the teeth on the free margins of the jaws become worn out (as the results of crushing the shells of molluscs and other marine animals) they are shed, and their places taken by those on their inner sides, the whole series thus

being gradually pushed across the margins of the jaws, as if by a clock-work movement, and new teeth continually growing at the bases of the different bands on the inner sides of the jaws, and eventually taking the places of those that are shed. In the Port Jackson shark there are four main bands of these teeth (Fig. 403), two of them (dotted in Fig. 403) being larger and more prominent than the others, so that the whole structure has a kind of half-melon shape. In each of the

Fig. 404,—Lateral Dental Plates of the Carboniferous Shark Cochliodus. (From Owen.)

main bands there are usually five or six unused teeth on the inner sides of the jaws.

The spiral of these bands, it will be observed, is of the homonymous type, being right hand on the right side of the jaw, and *vice versâ*, and it is of great interest to note that the same direction obtains in all the extinct members of the group. In *Cochliodus* (see p. 70) the whole series of teeth in each jaw is welded into a single pair of large dental plates (Fig. 404), traversed by oblique ridges and grooves (1 and 2), which serve to mark the lines of the original homonymous spirals. Owing to this fusion, which includes not only the oblique bands, but likewise their constituent teeth, it will be obvious that there can be no shedding of the latter along the free outer border of the margins of the jaws. Consequently, the outer margins of the dental plates, albeit somewhat reduced in thickness by mutual attrition, are gradually pushed round the free margins of the jaws, so as to form on their outer sides an involuted scroll-like spiral (Fig. 405). How the free margin of this scroll was prevented

Fig. 405.—Transverse Section of Dental Plate of Cochliodus, showing Spiral Formed by Involuted Outer Margin.
(From Smith-Woodward.)

from indefinite growth and extension does not appear to be ascertained, but it may perhaps have been kept in check by absorption.

The interest, from our present point of view, of the dentition of the Port Jackson shark is, however, not yet exhausted. For, if we have the complete jaw before us, it will be noticed that as the fore part is approached the individual teeth gradually diminish in size till they eventually become diamond-shaped, instead of oblong, each, when unworn, being crowned with a sharp spine. In consequence of this

the small individual teeth now form a double series of oblique bands, crossing one another at right angles, and producing a chequer-like pattern, in which neither system of spirals predominates over the other.

This is of particular interest from the fact that a precisely similar type of crossing, or decussating, spiral bands occurs throughout the

FIG. 406.—UPPER DENTITION OF A RAY (RHINOBATUS), SHOWING THE DIAMOND-SHAPED TEETH ARRANGED IN A DOUBLE SYSTEM OF SPIRAL BANDS.

entire dentition of the shell-crushing rays of the genera *Rhynchobatus* and *Rhinobatus*, as shown in Fig. 406, one set of these bands—the transverse—corresponding to the homonymous spirals formed by the bands of teeth on the lateral portion of the jaws of the Port Jackson shark, while the second, or longitudinal, set of bands are, of course, arranged on the heteronymous plan.

VI. The Spiral in Bivalve Shells.

By R. Lydekker.

In a large number of bivalve shells—many kinds of scallops, for example—the right and left valves are more or less nearly symmetrical to a line drawn vertically down the middle of the lateral surface from the hinge to the free margin. Consequently, in such "equivalve" shells, the "umbones," or points, of the two valves, forming the middle of the hinge, are likewise symmetrical, and do not form curves or spirals. In other bivalves—known as "inequivalve"—each valve is unsymmetrical to a line drawn vertically from the umbo to the free margin of the lateral surface, and the umbones are consequently curved towards the anterior, or front, border of the shell.

In the great majority of such inequivalve shells this curvature of the umbones is comparatively slight, so that it is difficult or impossible to say whether the incipient spirals thus formed are right hand or left hand. There is, however, a very beautiful little Chinese shell, known as *Isocardia vulgaris* (Fig. 407), in which the umbones form a distinct spiral curve, and an inspection of the diagrammatic figure will at once show that these spirals are of the heteronymous type—that is to say, the spiral of the left valve is right-hand, while that of the right valve is left-hand.

Although there appears to be no other existing bivalve in which the umbones show such well-marked spiral curves, in certain extinct genera the latter are still more pronounced. This is well exemplified in the

outline figure of the front, or anterior, aspect of *Congeria subglobosa* (Fig. 408), a characteristic shell of the upper Miocene strata of the Vienna Basin. Here, too, the heteronymous nature of the spirals is perfectly apparent.

FIG. 407.—FRONT OR ANTERIOR VIEW OF ISOCARDIA VULGARIS.

FIG. 408. FRONT VIEW OF CONGERIA SUBGLOBOSA, FROM THE MIOCENE TERTIARY OF THE VIENNA BASIN. (From Zittel.)

The supreme development of the spirals is, however, displayed by *Diceras arietinum* (Fig. 409), a fossil shell from the Coral Rag of Belgium. In this it will be noticed the umbones are unsymmetrically developed, but the heteronymous type of the spirals is most clearly shown.

As the three genera referred to above belong to as many distinct

 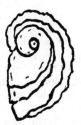

FIG. 410.—TERMINAL ASPECT OF THE SHELL OF A GASTROPOD PURPURA PLANISPIRA.

FIG. 409.—FRONT VIEW OF DICERAS ARIE-TINUM, FROM THE CORAL RAG OF BELGIUM, TWO-THIRDS NATURAL SIZE (From Zittel.)

families, and as there appears to be no evidence of the occurrence of species with spirals of the homonymous type, it seems justifiable to infer that in all inequivalve bivalves the heteronymous plan holds good. In the case of ungulate mammals it has been stated (see p. 198, *supra*) that it would be impossible to have heteronymous horns of the curved type—as opposed to the corkscrew type—because they would

tend to grow into the creature's back, or into one another. In the aforesaid bivalves this difficulty has been avoided by pushing the spiral forward, and at the same time making it of a very close and depressed type.

The interest of the spirals in the inequivalve, heart-shaped bivalves discussed in the preceding paragraphs is, however, by no means yet exhausted. For, if the shell of one of the short-spired members of the *Purpura* group of univalve gastropods be viewed from the spiral aspect (Fig. 410), it will be seen that it corresponds very closely in form, as well as in the right-hand direction of the spiral, with the left valve of *Isocardia* or *Congeria*. The spiral is, indeed, right-hand in the shells of all dextral gastropods, but whether such shells correspond to the left valves of bivalves is a question that must be left for others to answer.

VII. THE SHELL OF TRAVANCORE.

In Fig. 195, on p. 160, the left-hand shell *Turbinella rapa* is illustrated, and in Fig. 200, on p. 163, is given a postage stamp from Travancore, showing the shell used as a national emblem. By the courtesy of an Indian Forestry student from Travancore, now at Oxford, I am enabled to give a few more notes which will materially add to our knowledge of the symbolic use of shells in the East.

This *Turbinella* is used on the Government seal of Travancore as the national crest. The idea underlying its use is that it brings prosperity, and it is also found, with the club, the wheel, and the lotus (see Chapter XV.) among the emblems held in the four hands of Vishnu. As the vicegerent of the god and protector of the State the Maharaja assumes the same symbol.

As is the case with certain European charms, the idea of prosperity involves protection against the " evil eye," and in Travancore a white, polished shell is hung, for this purpose, by a black cord round a cow's neck. And a third stage (in a well-known development) is reached when the same symbol suggests fertility. At weddings a note sounded from a shell indicates the culminating moment of the ceremony. For much the same reasons shells are worn on necklaces as lucky charms, a custom as old as the Magdalenian children of 15,000 years ago, as was illustrated in Fig. 199, on p. 163 ; and the local *Turbinella* may well have been taken as a convenient symbol of ideas descended from far older generations than are recorded in India. An odd habit of the country folk is to give their babies milk (and sometimes castor oil) through the perforated end of a shell. After what has been stated in pp. 162 to 167 of my tenth chapter, it will be of interest to note that sinistral shells, such as *Turbinella rapa*, and the shell on the Travancore postage stamp, are especially valued and kept in the temples as sacred objects. In all parts of the world savages are just as fond of using shells for ornaments as were the prehistoric Magdalenians. Sections of Turbo or Conus are extensively popular as large rings or bracelets ; and, to show that the trade is by no means confined to savage countries, it may be added that shells to the value of £587,115 were imported into the United Kingdom in 1910 (B. B. Woodward). In some quarters of the globe shells are themselves used for money. The " money-cowry "

(*Cypræa moneta*) has still a wide currency in West Africa, and the "wampum," used by the North American Indians on the eastern coast of what is now the United States, was formed of beads made from the common clam (*Venus mercenaria*), while *Saxidomus* and *Haliotis* provided a medium of exchange in California. In New Britain and

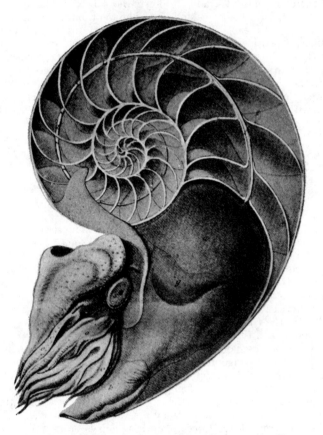

FIG. 411.—THE SHELL (IN SECTION) AND SOFT PARTS OF THE PEARLY
NAUTILUS (*Nautilus pompilius*), FROM OWEN.
(From B. B. Woodward's "Life of the Mollusca" [Methuen].

the Solomon Islands shells and beads made from shells are still used as money.

VIII. THE GROWTH OF SHELLS.

One of the best books of a reasonable size and price for studying the various forms of the Mollusca mentioned in previous pages has just been written by Mr. B. B. Woodward, of the British Museum (Natural History) ; and from this volume I give a reproduction of Owen's well-known figure of the section of *Nautilus pompilius* in Fig. 411. This shows that, when I referred to the last " compartment " being

smaller than the rest, and suggested that the animal had died " for lack of room " (p. 67) because it was no longer strong enough to build the size required, I must not be taken as imagining that the shell's inhabitant actually lived inside each of these " compartments." Their " walls " are only formed because the animal grew bigger by degrees and, therefore, moved gradually down the slowly widening conical tube of shell, closing it up behind him as he went, but preserving communication with each " compartment " by means of the central siphuncle, a continuous pipe which passes from the outermost chamber right through to the apex of the shell. The Nautilus family began in the Cambrian age with seven straight-shelled species representing four genera, and attained its maximum in the 230 species and twenty genera of the Silurian age. A vigorous offshoot started in the Devonian period with a very large number of genera and species, but at the close of the Cretaceous period not one of these was left, though their efforts to survive had produced almost every possible type of shell. The genus *Nautilus* appeared for the first time in the Tertiary epoch. In the existing species the only trace left of its protoconch is a scar on the exterior termination of the first chamber, so we are unable to say whether its life history repeats the history of the species by developing from straight shells, through curves, to the coiled spiral. The chambers are filled with air highly charged with nitrogen, which gives the shell sufficient buoyancy for very rapid swimming (see p. 57).

The shell of *Argonauta argo* (p. 62) is only formed some days after the creature is hatched, and is peculiar to the female, being used chiefly as a vehicle to carry and protect the eggs. It is held in place by the anterior pair of " arms," which are furnished with web-like expansions for the purpose. In *Spirula peronii* (p. 63) the shell is partly internal, and its curves are separated from each other, instead of being closely coiled, as in the *Nautilus*, which, in its turn, shows a more free swing of the spiral than the ammonite.

A shell is composed of about 95 per cent. of carbonate of lime in the form of calcite or arragonite, says Mr. Woodward, with an admixture of conchyolin, a little phosphate of lime, and a trace of carbonate of magnesia. It originates in a shell-gland, or pit, in the embryo, and the successive layers of which it is built up are formed as the animal grows by additions to the margin made by a series of special cells. These additions generally leave ridges, known as " lines of growth " ; and periods of " rest " (when the deposition is no longer continuous) are detected by the presence of a somewhat stronger ridge or mark. In gastropods (such as the whelk and snail) the shell is secreted by the " mantle " covering the visceral lump, and, as it reaches the adult stage, instead of coiling forward over the animal's head, as in the case of the *Nautilus* and of its own protoconch, it is swung round, owing to the torsion of the growing body, and coils backwards, or endogastrically. Beginning as a simple hollow cone, the shell becomes an elongated cone coiled round in whorls, the last of which is the " bodywhorl," and the majority exhibit the coils of a dextral helix (pp. 158—159).

The nucleus, or protoconch, formed in the egg, is also called the " embryonic shell " (p. 46). In the gastropod egg it is interesting to note that a curious obliquity in the cleavage becomes evident, known

as the " spiral cleavage," and this obliquity takes a reverse inclination in sinistral forms to that which obtains in dextral. The junction between the protoconch and the adult shell is usually so marked as to suggest a pause in development while the animal itself was growing. In most embryo gastropods we find an operculum, that horny layer, sometimes strengthened by shelly matter, which differs in structure from the shell itself and forms its " front door," as it were, which can be closed as a protection against enemies. Its inner side is marked, sometimes in beautiful spirals, by the scar of the muscle to which it is attached (see pp. 32 and 33).

It has been a frequent difficulty in biological description that what we classify in our minds as a spiral appearance has, in fact, often resulted from gradual accretions, which are not spiral at all in their

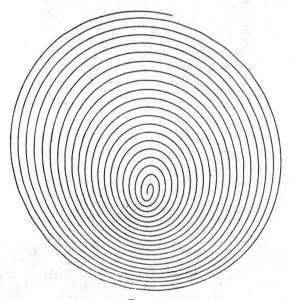

FIG. 412.

essence. In other words, a spiral formation may be produced by the overlapping at certain points of a number of flat curves or other kinds of lines. I imagine that the spiral shown in the operculum of some shells may have been formed in this manner, and that there was no original growth which could itself be classified as spiral. In order to illustrate this I have asked Mr. Wyndham Payne Gallwey to make me a few diagrams by means of the swinging of a pendulum in more or less flattened curves in various directions, the paper being sometimes still and sometimes rotated in a given proportion to the pace of the pendulum. In many cases a spiral almost exactly similar to the spiral of an operculum has been produced by the intersection of these flat curves at a series of points, which produce a shaded curve of a distinctly spiral kind that was never originally contemplated. I do not, of course, refer (in what has just been said) to such deliberate spirals as that in Fig. 412,

though I cannot conceive how such a diagram could have been drawn by any method other than that so cleverly employed by Mr. Payne Gallwey, a method which is, of course, by no means novel, though I believe that the use I now propose for it is new, and it admirably represents the eccentric growth of certain shells.

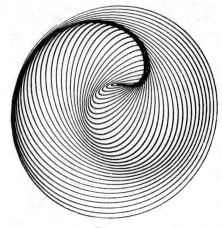

FIG. 413.

What I wish to take the opinion of scientific readers about is to be seen in Fig. 414, and especially in Fig. 415. Here the original arrangement of lines is not spiral, and is analogous to several organic forms of fibrous or muscular growth. Yet the intersection of these lines at various points has evolved a " shading," which is unmistakably spiral

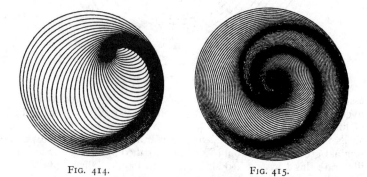

FIG. 414. FIG. 415.

in form, and sometimes suggests a logarithmic character of curve. I venture to think that many of the appearances we call " spiral " in natural objects have come into being in much the same way, the " shading " of Fig. 414 being represented by outstanding tissue, or differently coloured tissue, which emphasises the spiral result, while it obscures the previous process. Fig. 413 produces a very curious " shadow curve," entirely different from the lines which have actually

composed it, and very like the "Tomoye" shown in Plate VI. and Fig. 401. It is, I think, evident that by further investigation some definite mathematical character might be predicated of the intersection of these lines, and very possibly a pretty parallel with biological processes might be revealed. It should also be possible, by means of delicate adjustments in pendulum drawings, to suggest the effects produced on shells by those principles of acceleration (in youth) and retardation (in age) which were discussed on p. 47. The swing of a pendulum can be arranged to die down in gradually diminishing curves, and if the resulting diagram be considered to have been produced by the reverse process, we should see the increasing growth of a spiral formation in a very graphic way. But this is not so interesting as the production of the "shadow spiral" by interwoven lines of a different form ; and I believe the suggestion here made is capable, in the right hands, of valuable development.

IX. THE ϕ PROGRESSION IN ART AND ANATOMY.

It would be inappropriate to reproduce in these pages a large number of masterpieces by the best painters or sculptors in order to reinforce the arguments given on p. 425. It must be permitted me, " by readers of goodwill," to say shortly that a large number have been examined by myself and by those who so kindly and carefully have helped me. Three familiar pictures by great artists are given, not as exceptions to the general rule—if we may speak of any "general" rule in those highest manifestations of the greatest art which must of necessity be few—but as typical examples, selected merely to provide and illustrate a method by which the principle suggested here may be studied by many other people from many other instances. Nor do I desire once more to emphasise that long-proved principle called "Extreme and Mean Proportion" ; for though this ancient "Golden Section" admits of very wide and very simple application, it lays stress on agreements without taking account of deviations, and it merely states, concerning the proportion of two magnitudes, that "the lesser is to the greater as the greater is to their sum." This statement, however, forms the basis of the infinite series now named Phi, in which the wonderful properties of the number 1·61803 are put to their full use and marvellously extended. For whereas the "Golden Section" may be said to deal with form apart from function, with morphology apart from physiology, the Phi progression implies that considerations of function and growth are essential to the right understanding of form and its proportions. It suggests some relationship between the principles of growth and of beauty, which, if followed up, may throw light on both. This is why it will be far more interesting to find manifestations of Phi in art than to analyse specimens of architecture, sculpture or painting by the merely linear relations set forth in the thirtieth proposition of the sixth book of Euclid, relations which are far too rudimentary and simple to provide either a rule of Nature or a canon of artistic workmanship.

In order that my argument may be followed more easily, and also that my readers may be able to make other such comparisons for them-

selves, I give in Plate XI. a scale of ϕ proportions which Mr. William Schooling has drawn and explained. If we look at the lettering on the right-hand side, we see that there are eight separate spaces: the length of the top space is ϕ^1; the length of the second is 1 or ϕ^0; then comes another space ϕ^1, followed by ϕ^2, ϕ^3, and so on up to ϕ^6.

The outside scale shows the distance from the top line, and therefore represents successive additions of the individual spaces. Thus the distance from the top to the bottom of the first space is ϕ^1; adding 1 we get ϕ^2; adding ϕ^1 to ϕ^2 we have ϕ^3, and so on all the way down.

On the left-hand side the same symbols are repeated, but they apply to smaller spaces. This is because ϕ is a proportion, not a length. The length of the top space is ϕ^1 units, of the second space one unit, and of the bottom space ϕ^6 units. By proceeding from left to right along the sloping lines, I obtain increasingly larger units; and thus the diagram is of universal application within the limits of its size.

The lengths that are in ϕ proportion are the distances between the sloping lines measured on any vertical line shown in the diagram, or on any other vertical line (parallel with these) which we may choose to draw or imagine.

It is quite immaterial, except from the point of practical convenience, to what scale we make the diagram. This one was drawn so that my second space 1, or ϕ^0, was $\frac{1}{4}$ inch, and the whole scale about forty-seven quarters, or $11\frac{3}{4}$ inches. This was copied on tracing cloth, which could be placed over any picture I wished to examine, and I could thus see at a glance how nearly the salient points of the picture were in ϕ proportion. A photographic positive on glass would be even more convenient. If I had wanted a scale for measuring human beings, I might have chosen 1 inch as my unit, which would have enabled me to measure men that were 6 feet 4 inches high.

I tabulate below the number of units of length in the individual spaces, and then, by successive additions of these numbers, give the total distance from the top of the diagram.

TABLE OF ϕ SCALE.

Separate spaces.		Successive additions.	
Symbol.	Number of units.	Number of units.	Symbol.
ϕ^1	1·618	1·618	ϕ^1
ϕ^0	1·000	2·618	ϕ^2
ϕ^1	1·618	4·236	ϕ^3
ϕ^2	2·618	6·854	ϕ^4
ϕ^3	4·236	11·090	ϕ^5
ϕ^4	6·854	17·944	ϕ^6
ϕ^5	11·090	29·034	ϕ^7
ϕ^6	17·944	46·979	ϕ^8
ϕ^7	29·034	76·013	ϕ^9

It is to be noted that the top line, which is not sloping, must be our starting point whenever we wish to measure any *series* of lengths that are in ϕ proportion ; the reason for this is interesting.

We may take any distance we please, whether a millimetre or the distance to the farthest star, and define that distance as some power of ϕ ; we can then divide that length into an infinite number of shorter lengths, all in ϕ proportion. Thus in the diagram we have a total length of ϕ^8 ; excluding the next lower term, which is ϕ^7, this total length of ϕ^8 contains seven successively smaller terms, and the remaining little bit is made up by a repetition of ϕ^1. I might, in fact, have divided this final ϕ^1 space into many smaller ϕ proportions ; numerically I could divide it into a very large number indeed, and in theory this process could be carried to infinity.

It may be added that the spiral on p. 421 could be used as a ϕ scale, since on any radius whatever the spiral lines fall in ϕ proportion. Placing a drawing pin through the centre of the ϕ spiral, and then putting it at the top of the cavalier's hat (Plate VII.) and rotating the spiral, we should, on a line drawn vertically downwards from the drawing pin, have the ϕ proportions falling at salient points, as shown in the scale by the side of the picture.

The vertical line H on Plate XI. agrees with the scale on Plate VII. If the lines of the scale are carried horizontally across the Franz Hals picture, it will be seen how nearly they coincide with the salient points. Taking the first obvious bit of spacing in the composition, the width of the big black hat-brim, as the first power of the ϕ series, we find the line of ϕ^2 crosses the pupil of the eye ; ϕ^3 comes at the point of the chin ; ϕ^4 marks the end of the black kerchief which cuts the white space of the ruff ; and the whole composition is contained in ϕ^5.

It is only by chance that the same line (B) is almost exactly the position on the ϕ scale (Plate XI.), which must be used for Botticelli's " Venus " in Plate VIII. Here we use the full length of the line, while for " The Laughing Cavalier " we used only a part (H). For the " Venus " we again take the top line of the composition, and the distance to the pupil of the right eye will give us ϕ, while the edge of the nostril is marked by ϕ^2, and ϕ^3 is the spring of the shoulder from the neck. ϕ^4 indicates the ends of the braided hair that falls upon her bosom ; ϕ^5 is the navel ; ϕ^6 gives the lock of hair on her left thigh ; and ϕ^7 marks the centre line of her feet, corresponding with the lowest line in Plate IX. It will be noticed that these proportions (with the slight deviations to be expected) occur in Botticelli's composition, in spite of the fact that the figure does not stand upright, and a certain elongation of the proportions is observable as compared with the figure of the artist's model who stood upright for the carefully measured drawing of her made for Plate IX. In this, if we again take the first power of ϕ as the distance from the top of the head to the pupils of the eyes, ϕ^3 shows the spring of the shoulders ; ϕ^4 gives the points of the breasts ; ϕ^5 comes just below the navel ; ϕ^6 gives the tips of the outstretched fingers ; and the girl stands firmly on the line of ϕ^7. If there were the deviations of art and beauty in the Botticelli, there are the deviations of life and beauty in this tall, slender Swiss, whose proportions may be compared with those given for a perfectly proportioned man on p. 420.

It may be urged that ϕ proportions are as likely to be found all over

a well-formed human body as they are in other living forms, and therefore that their occurrence in paintings of the human form is only natural and does not carry us much further. But I think that the space proportions in the Franz Hals painting cannot be thus explained ; and there is certainly no such explanation for the approximations to ϕ which occur in countless examples of landscapes or similar pictures. I have, therefore, taken one of the finest compositions in the world as my last example, the magnificent " Ulysses Deriding Polyphemus," by J. M. W. Turner, in the National Gallery. Again seven powers of ϕ are observable, and, without going more into detail, I may point out that ϕ^5 comes on the line of high sunlit rock behind the shadowed archway of the nearer crag, while ϕ^6 gives the centre and balance of the mainmast that is the most conspicuous feature in a composition exactly measured by ϕ^7.

Such a theory as that just developed must not, of course, be pushed too far. I even prefer the phrase " approximations to ϕ " instead of the words " agreements with ϕ " ; and I particularly draw attention to the fact that these " approximations " in art not only exhibit the same measure of " standardisation " as is observable in such natural objects as shells or flowers, but also exhibit the same amount of deviations from the one simple principle we have chosen as our standard in each case, just that amount, in fact, which my previous pages have demonstrated as likely in the highest forms of life or the greatest works of art. It is, indeed, chiefly as a standard by which such deviations can be measured that I offer ϕ in this book ; for it is meaningless to lay any stress whatever upon deviations unless we state from what they deviate. I do not suggest that ϕ is a canon of art; but I venture to believe that ϕ is an *explanation* of what Mr. Arthur Balfour gives up as an insoluble problem in his Romanes Lecture (*rewritten in* 1910) on " Criticism and Beauty," a lecture in which, with his own inimitably suave iconoclasm, he urges us " to reject the idea that a standard of excellence [in art] can either be extracted by critical analysis from the practice of accepted models, or that it can be based on the consensus of experts, or upon universal suffrage." In another passage of the Lecture he argues, " Beyond doubt we cannot regard æsthetic emotion as a homogeneous entity, undifferentiated in quality, simply to be measured as ' more ' or ' less.' This makes it hard enough for a man to determine a scale of values which shall honestly represent his own æsthetic experience. But does it not make it absolutely hopeless to find a scale which shall represent, even in the roughest approximation, the experiences of mankind ? " If that be his main question, I must answer that it is not hopeless. The " scale which shall represent, . . . in the roughest approximation, the experiences of mankind " is, I submit, to be found in the proper use of the ϕ Progression and the due appreciation of its profound significance.

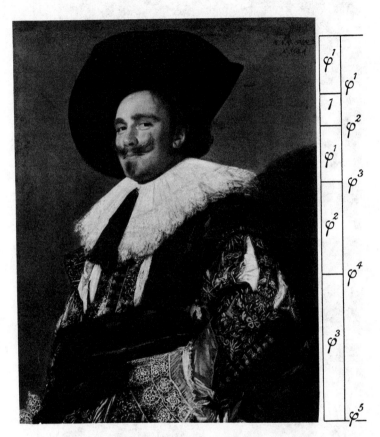

PLATE VII.—THE LAUGHING CAVALIER.
By Franz Hals.
Reproduced by permission of the Trustees, The Wallace Collection, London

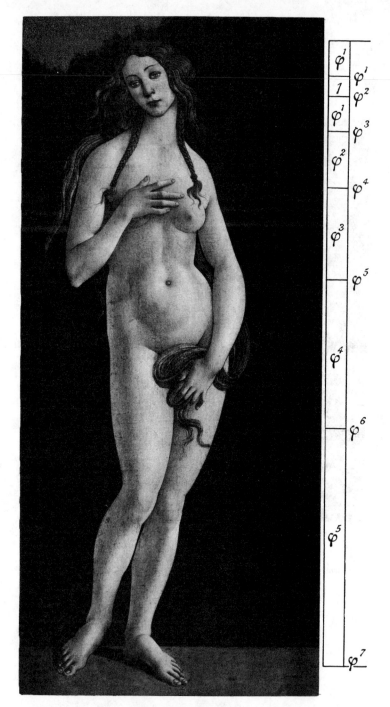

PLATE VIII.—VENUS.
By Sandro Botticelli.
Gemäldegalerie, Bildarchiv Preussischer Kulturbesitz

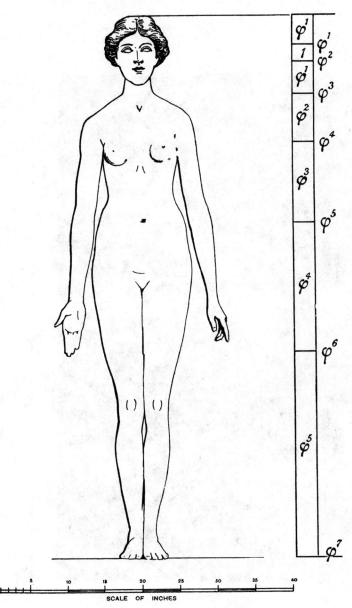

SCALE OF INCHES

PLATE IX.—An Artist's Model.

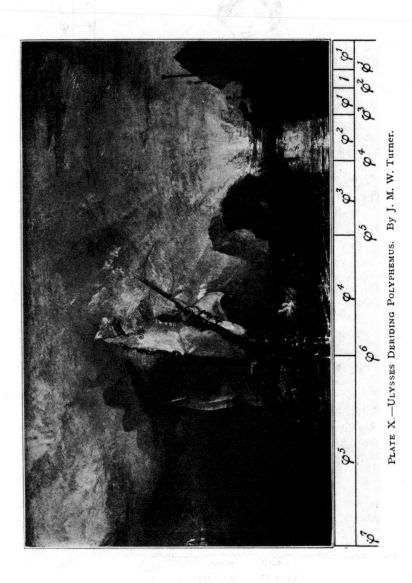

PLATE X.—ULYSSES DERIDING POLYPHEMUS. By J. M. W. Turner.

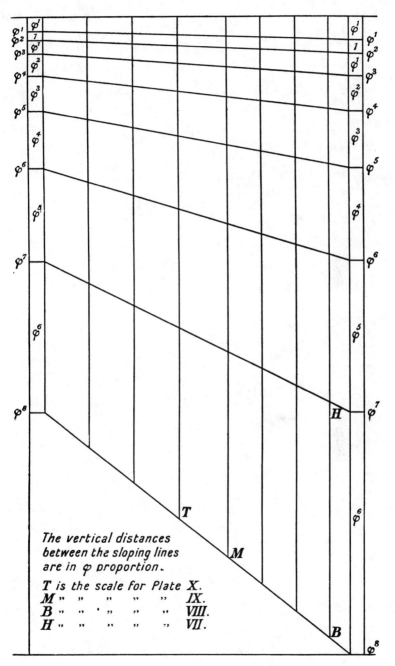

The vertical distances
between the sloping lines
are in φ proportion.

T is the scale for Plate X.
M " " " " " IX.
B " " ' " " " VIII.
H " " " " " VII.

PLATE XI.—A SCALE OF PHI PROPORTIONS.

INDEX

Abies, 97, 135, 140
Abyssinian ibex (*Capra walie*), 218
Acanthina imbricata, 71
Acer campestre (Maple), 135
Achatina, 160
Acropolis, 270, 331, 332
Additive series, 444—445
Adhadota cydonæfolia (Acanthaceæ), 127, 128
Ætiogenic actions, 176
Ailanthus glandulosa, 135, 139
Air-currents, 7
Air-vessels of insects, 54
Alaskan bighorn, 34, 197, 207
Albani, Mathius, 290
Albanian sheep, 219
Alberti, Leon Battista, 328
Alembert, J. d', 391
Amaranthus, 103
Ambidexterity, 240, 243—244
Amboise, 324, 343, 366—374
American prong buck (*Antilocapra americana*), 194
Ammonite, 27, 48, 49, 61, 68, 70, 163, 280, 363
Ammotragus lervia, 198, 207
Ampelopsis hederacea (Virginia creeper), 187
Amphidromus perversus, 158
Anastatica (Rose of Jericho), 181
Angiosperm, 97
Angle, ideal, 87, 92
Angling, 248
Angora goat, 203, 205
Animal locomotion, 9
 structure, 171
Animals, domestic and wild, 198, 201, 205
Antelope, 195, 205, 210, 215
Anthropological Society in Washington, 242
Anthurium, 99, 105, 106
Antlers, 192, 193
Apes, 226, 240
Aphrodite of Praxiteles, 65
Apios tuberosa, 185
Aploceras, 69
Arabs, 39, 276
Araucaria, 81, 99, 121
Archery, 248
Archimedes, 362
Architecture, Gothic, 17, 337
 Greek, 18, 332
 and shells, 1, 349
Arezzo, 327
Argali sheep, 208, 213
Argon, 432

Argonauta argo, 78, 162
Armstrong, Sir Walter, 403
Arnold, Matthew, quotation from, 389
Artery, 228
Arui, 208
Arum lily, 105
Ash tree, 86, 135
Asiatic Ibex, 212, Fig. 245
 sheep, 215
Asparagus, 186
Asphodel, 183, 189
Aspidium (fern), 145
Assyrian, 277
Athens, 166
Atom, 432
Atomic weights, 412
Augur-shell, 42
Auricula auris-midæ, 50
Aurignacians, 268—272, 278—284, 294 —295, 394, 408
Autogenic effects, 176
Autun Cathedral, 302
Avena sterilis, 135
Awns (of seeds), 15
Azilian Age, 269, 270

BABYLONIAN architecture, 302
Bach, J. S., 397
Bacilli, 7, 234
Bacon, Francis, 384, 429
Bacteria, 13, 116
Balfour, Arthur J., 424, 425, 430, 431, 438, 439, 464
Ball, Sir Robert, 10
Barbour, Professor Erwin Hinckley, 153
Barr, Professor Archibald, 300, 313
Barr, Mark, 35, 415, 420
Bean, kidney, 185
Beauty and fitness, 300, 330, 340, 393, 397, 399, 404, 425
Beaver, 229, Fig. 263
Beddard, F. E., 233
Beech, 151
Beethoven, L. van, 397
Bellini, 17, 316
Berberis, 93
Bernadines, Church of the, 312
Bernouilli, 61, 391
Bertillon, A., 226
Betula, 140
Beverley Minster, 312
Bharal, 208
Billiards, 249
Binomial theorem. 421, 443

Biological significance of spiral formations, 238
Bird's egg, 234
 wing, 9, 11, 15, 232
Blackbuck, 196, 217
Blarney Castle, 308
Blois, 311, 324, Chap. XVIII., 433
Blomfield, Reginald, 280, 343, 348, 373, 380, 393
Bologna, 319
Bones, measurement of, 5
Bonnet, Ch., 89, 94, 95, 96, 118
Boomerangs, 281
Botticelli, Sandro, 426, 463
Boulay, E. du, 78
Bower-bird, 169
Bowls, 249
Boxing, 12, 246
Brahmans, religious ceremonies of, 163
Bramante, 341, 345, 346, 366, 368, 373, 393
Braun, A. *See* Schimper.
Bravais, 88, 97
Breeding animals by man, 205
British Medical Journal, 210
Broeck, Van den, 31
Bronze Age, 267—274, 283
Bronze-work, 273
Browne, Sir Thomas, 260, 264
Brunel, I. K., 314
Bryony, 174, 183, 187
Buccinum undatum, 158
Buckland, Frank, 157
Buddha footprints, 166
Bulimina, 44, 48
Bushbuck, the Bongo (*Boocercus euryceros*), 202
Butler, Arthur, 387
Butterwort, 172
Byzantine Greeks, 276

CABUL Markhor, 212, Fig. 248
Cactus, 86, 87
Caddis fly (*Phryganeida*), 9
Calandrini, 89, 94
Calderon, George, 164
Cambrian Age, 458
Campanile of S. Nicolò, 319
Canterbury Cathedral, 298
Cape " Silver tree," 140
Capra cylindricornis, 197, 198, 207, 208
 falconeri Jerdoni, 196
 hircus ægagrus, 212
Carchesium, 236
Carinata, 159
Carlyle, Thomas, 261
Carpinus (Hornbean), 135
Castiglione, Sabba da, 344
Casuarina, 135, 142
" Catharpin-fashion," 165
" Cavallo," 381, 400
Cavenaghi, Luigi, 358
Celtic art, 271
Ceriani, Abbé, 258
Cerithium, 41, 55, 163
Cestracion philippi, 8, 14
Challenger reports, 43, 67, 93, 160

Chambord, 312, 342, 345, 372—373
Chara, 145—146
Chartres, 299, 323
Chenonceaux, 343
Chestnut tree, 31, 151
Chicory plants, 118
Chinese, 283, 285, 408, 449, 451
 maidenhair tree (*Ginkgo*), 146
Choanomphalus, 160
Chrysanthemum, 75
Church, A. H., 23, 61, 76, 78, 91, 93, 95, 96, 97, 99, 100, 102, 408, 417—421
Circassian goat, 212—215
Circulatory system, 227
Circumnutation, 176, 184
Clausilia laminata, 47
Clavellofusus spiratus, 46
Clematis lanuginosa, 135, 149, 183
Clerke, Miss Agnes, 11
Clerodendron thomsonæ (Verbenaceæ), 127
Clifford, Professor W. K., 389, 399
Climbing plants, Chap. XI.
Clockwise, turning, 116, 166, 185
Clos Lucé, 366, 369, 374
Clymenia, 68
Cnossos, 17, 274
Coan, C. Arthur, 433—441
Cochliodus, 70, 453
Cockerell, C. R., 328
Coffey, George, 271, 272, 274
Colchester Castle, 305, 349
Colman, Samuel, 433—441
Columna flammea, 158
Columns, 297
Common goat, 210
Conical helix, 206
Constantine, Arch of, 423
Contortion (plants), 121
Convolution, 121
Convolvulus, 171, 186
Coomassie bronzes, 166
Cope, E. D., 5, 47
Copernicus, 384, 390
Coralliophila deburghiæ, 93
Corinthian capital, 17
Cortona, Domenico Barnabi di, 372
Cotton (*Gossypium*), 122
Courajod, Louis, 401
Crawley, A. E., 247, 261
Cricket, 251
Crioceras bifurcatum, 68
Croquet, 253
Crystals, 7, 27, 100, 167—168
Cube, law of the, 66
Cucumber, 187
Curie, Mdme., 432
Curvature, 180
Cuvier, G., 8
Cycads, 15, 116, 145, 147
Cyclamen, 72, 79
Cylindrella, 68
Cymbiola tuberculata, 55
Cymbium, 358
Cyperus alternifolius, 124, Fig. 170
Cypræa, 162, 164
Cypriot vases, 276
Cyprus, 166

Cyrtoceras, 69
Cyrtulus, 47

Dæmonelix, 153, 154
Dancing, 232
Dandelion, 81
Dante, 319, 386, 387
Darwin, Charles, 4, 54, 80, 95, 127, 170, 176, 182, 184—188, 213, 259, 264, 390, 428, 441
Darwin, Sir Francis, 172, 175—179, 264, 431
Darwin, Sir George, 20
Dawson, Chas., 295
Dead tissues of plants, 132
Deasil, 262
Déchelette, 162, 270, 272, 274
Decussate construction, 104
Deer, antlers of, 193
Descartes, R., 175
Desmodium, 176
Deviation from accuracy, 220, 282
laws, 5, 6, 19, 395, 403, 405, 416, 425—431, 434—440
Devil, confusing the, 285
" Devil's corkscrews," 153
Dewar, G. A. B., 172, 173, 183, 188
Dexiotropic, 39, 42, 129
Diceras arietinum, 455
Dioon, 145, 147
Dipsacus fullonum, 125
Diversity in Art, 34
Nature, 3
Dixon, Professor A. F., 221, 223, 237
Doges' Palace, 156
Dogfish (*Scyllium canicula*), 234
Domesticated goat, 203
and wild animals, 209, 217
Dover cliffs, 304
Driving, 246—247
Drosera (sundew), 183
Duhem, 428
Dürer, Albert, 280, 281, 294, 365, 380—386, 392, 397, 400—403
Durham Cathedral, 297
Dutrochet, R. J. H., 175

EAR, cochlea of, 8, 16, 29, 224
Echeveria agavoides, 105
arachnoideum, 102
Eclipse (racehorse), 5
Economy of form, 441
Egypt, long-legged sheep, 203
Egyptian columns of Thebes, 398
Egyptians, 275, 276, 328, 337, 358
Eland, Senegambian, 201
Elaters, 181, 182
Elephant, 231
Ely Cathedral, 302
Endodermis, 179
Equipotential, 96, 408
Equisetum telmatæi, 142
Erica (heath), 121
Erodium, 135, 136
Etruscan ornaments, 166, 275
Eucalyptus, 125

Euglena spirogyra, 8
Evans, Sir Arthur, 162, 274
Evans, E., 264
Evelyn's diary, 336
" Extreme and Mean Proportion," 426, 434, 461
Eye of leaf, 180
Eyestone (*Turbinidæ*), 67

FAÏENCE, early Minoan, 162, 274
Farmer, Dr. J. B., 180, 182
Fath, Dr. Arthur Edward, 409
Feather-grass, 15, 133, 135
Fechner, Theodore, 421, 440
Femur, 231
Fencing, 40, 241, 245
Ferns, 27, 116, 145, 289
Fibonacci series, 88, 93, 97, 99, 105, 107, 117, 118, 418—421, 441
Fibres of human heart, 227
Fiesole, 316, 325
Finger-prints, 226, 237
Fin of fish, 9
Fives, 253
Fletcher, Banister F., 33, 279
Flight, 9, 137, 260, 432
" Following the sun," 30, 40, 116
" Fossil twisters," 153
Fraser, Dr. James, 17
Fraxinus (Ash), 135
Fresnel, A. J., 399
Fritillaria tenella, 145, 148
Frog's web, 227, 238
Fuchsia, 116, 121, 122
Fulgurofusus quercollis, 46
Funaria (moss), 145
Fusus antiquus, 5, 33, 47, 48, 158, 159, 279
Fylfot, 166, 277
Fyvie, 310

GAILLARD, Charles, 215
Gallwey, Wyndham Payne, 459, 460
Galton, Sir Francis, 226, 227
Gammadion, Greek, 166
Gasteria, 123, 125, Fig. 140
Gastropoda, 47
Gavr'inis, 271—275
Gazella granti robertsi, 209
Gegenbaur, C., 53
Genetic spiral, 118—119
Geo-perception, 176
Geotropism, 178
Geranium, 118, 133, 136, 137
Geum triflora, 135
Geymüller, Baron Henry de, 371
Gilbert, A., 64, 376
Gilgit Markhor, 195, 196, 198, 217—218
Giocondo, Fra, 371—373
Giotto, 387, 403, 439
Giraffe horns, 192
Glider types of seed fruits, 139
Globigerina, 43, 44
Globularis, 163
Goats, 205, 216
Goebel, K., 104, 143

Goethe, 6, 95, 142, 259, 260, 266, 296, 319, 337, 380, 386—389, 403, 424
Golden fleece, 292
" Golden section," 426, 430, 461
Golf, 253
Goniatites, 68
Goodsir, Professor, 6, 61, 63—66, 80, 399
Goodyear, Professor W. H., 276, 294, 318—319, 325, 329, 330, 339
Gorse-fruit, 181
Gothic, 288, 318, 327, 330. 337, 348, 369
Gothic cathedral, 336
Goujon, Jean, 343, 366, 380, 383, 392
Gourd, 187, Fig. 219
Gracefulness, 232, 441
Gravity, 436
Greek architecture, 34, 339
Greeks, 277—278, 288, 296, 302, 322, 327—330, 337, 397—399, 427
Grew, Edwin Sharpe, 9
Grouping, theory of, 447
Growth, energy of plants, 99
Gyroceras, 69

Haberlandt, G., 178, 180
Haeckel, E. H., 235
Hair, 156, 218, 227
Haliotis, 62, 78, 457
Hallstatt period, 283, 284, 285
Hals, Franz, 426—427, 463—464
Hamilton, Sir Wm. Rowan, 399
Hand of spirals, 297, 315
Hare, 233
Harmer, F. W., 159
Harpula fulminata, 55
Harvey, W., 384
Hay, D. R., 65
Heart, 15
Helianthus annuus (sunflower), 87, 97, 98, 145
Helicodiceros, 143, 150
Helicophyllum, 143
Helicoprion, 69, 70, 71
Helicteres, 131, 145, 148
Heliotropism, 178, 179
Helix, 24, 29, 32, 34—36, 167, 208—209
Helix aspersa (snail), 130
 lapicida, 160, Fig. 193, 194
Helleborus, 99, 118
Helmholtz, H. L. F., 389
Herschel, Sir John, 409
Herschel, Sir William, 409
Hertford College, 308
Heteronymous, 198, 200, 201, 204, 208, 210, 217, 219
Hibbertia dentata, 127
Highland ram, 198, 201, 207, 209—210
Hildesheim, St. Bernwand at, 164
Hindu account books, 166
Hinton, James, 14
Hippuris, 142
Hogarth, W., 356
Holbein, Hans, 241
Hollar, W., 79, 390
Homonymous, 198, 201—210, 217, 219

Honecort, Wilars de, 327
Honeysuckle, 37, 38, 39, 127, 185
Hop, 54, 185—186
 wild (bryony), 174, 183
Hornbeam (*Carpinus*), 135
Hornless animals, 203
Horns, 16, Chap. XII.
 classification of, 194
 diagrammatic models, 215
 hand of, 195, 200
Houseleek, 81, 86
Huggins, Sir Wm., 409
Hume collection, 195
Hume's ibex, 212
Humerus, 230
Humulus lupulus (English hop), 127, 135
Hunter, William, 374
" Huntsman's horn," 172
Hurricanes, 7
Huxley, Professor T. H., 80, 259
Hyatt, A., 5, 47
Hydrogen, 432
Hypericaceæ, 122
Hypothesis as guide, 217

Ibex, 213
Ice Age, 267, 269
Ideal angle, 418
Illusion, optical, 16
Indian muntjac, 203
Infusoria, 62
Intestines, 233
Ionic capital, 17
Ionic volute, 32, 33, 34, 40, 279, 290, 296, 381, 383
Ipomœa jucunda, 127
Irish Court yew (*Taxus baccata*), 150
Iron Age, 267, 283
Isle of Man crest, 166
Isocardia vulgaris, 454

James, William, 416
Jamnapuri goat, 203, 210
Japanese, 76, 242, 264, 374, 448
Jones, Inigo, 328

Kadsura chinensis (China), 127
Keith, Dr., 228, 236, 295
Kepler, J., 389, 431
Kinematograph of plant growth, 11, 12
" Knight and Death, The," 380
Knights of the Garter 292
Koninckina leonhardi, 22
Koodoo, 218

Ladak Urial (*Ovis vignei typica*), 209
Ladies' Tresses (*Spiranthes autumnalis*), 126, Fig. 172
Lamarck, J. B. P., 95
Lamprostoma, 27
" Lancet," the, 236
Langeais, 343
Lanistes, 156, 159, 160, 208, Fig. 185
Lankester, Sir E. Ray, 2, 172, 267—268, 437, 448

Lanteri, Professor Edward, 404
Lapageria rosea (Chili), 127, 185
Lardizabala biternata, 185
Larix, 140
Last Supper, the, 378
La Tène, 283, 284, 285
Law of gravity, 431
 of the square, cube and spiral, 6
 sequence of events, 428
Lawn tennis, 254
Laws of Nature, 3
Leaf arrangement, 81, 82, 86—88, 96,
 115, 390
 -climbers, 170, 186
 -distribution, " ideal angle " for, 84
Leaves, air and sunshine, 81, 82
"Leda," 63, 363
Left hand, 128, 165, 260, 342
 handed men, Chap. XIV., 298
Leguminosæ, 149
Leiotropic, 39, 42, 48, 129
Leith, Compton, 332, 377, 391
Leonardo da Vinci, 5, 21, 40, 63, 65, 94,
 241, 255—260, 266, 280, 313,
 324—327, 331, 338, 424, 432,
 Chaps. XVIII., XIX.
 quotations from, 1, 5, 23, 41, 57,
 81, 94, 115, 151, 220
Leslie, Sir John, 57, 63
Lesser, Kudu, 195, 201, 217
Lethaby, Professor W. R., 275, 282,
 296, 302, 329, 372
Lichfield Cathedral, 336
Light, 10, 17
Lilium, 16, 75, 106, 112, 114
Limacina, 159, 208
Lincoln Cathedral, 17, 307
Line of beauty, 356
Linlithgow Palace, 311
Lister, Lord, 227, 238
Lithuanian infant, baptism of, 164
Littorina littorea, 162
Liverworts, 181
Loasa, 127, 128
Lobelia, 123
Logarithms, 447
Logarithmic spirals, 60—63, 413—421
Lonicera brachypoda (*Caprifoliaceæ*),
 127
Lotus, 275—277, 281—282, 294, 324,
 359
Louvre, 311
Lydekker, R., 196, 203, 211—216, 219,
 452, 454

Macroscaphites, 68
Magdalenians, 17, 268—270, 456
Magnet, 17
Magnetic force, 7
Mahonia, 93
Malaptera ponti, 45
Malva (hollyhock), 121
Malvaceæ, 122
Manettia bicolor (Cinchonaceæ), 127
Maple (*Acer campestre*), 135
Markhor, 211, 217, Figs. 228, 229
Marsilia, 146
Martello towers, 308

Martynia, 145, 150
Mathematics, 24, 220
Maxwell, J. Clerk, 4, 17, 96
McCurdy, E., 256, 364
Medals, 321
Medicago, 135, 139, 149
Meladromus, 159, 208
Melia, 69
Melo ethiopicus, 71
Melon, 37
Mendeleeff, D. I., 411, 413
Meredith, G., quotation from, 132
Merino ram, 34, 195—198, 212, 217
Messier, Charles, 409
Meyer, Hermann von, 8
Michelangelo, 313, 376, 407
Mikania scandens, 127
Milan, 337, 344
Milton, John, 188, 447
Minoan Age, 271, 274, 284
 seal, 162
Miratesta, 158
Mitra papalis, 50, 323
Mohammedan spirals, 276
Moisture, 15, 218
Mona Lisa, 377, 404
Money-cowry, 456
Monocotyledons, 179
Moseley, Canon, 5, 58, 59, 63, 64, 65,
 80, 282, 399
Moss (*Funaria*), 145
Moths, Sphinx, 113
Mouflon, 198, 207
Muhlenbeckia chilensis (Chili), 127, 186
Murex saxatilis, 75
Musk-deer (*Moschus moschiferus*), 233
Mycenæ, 166, 276
Mycenæan, 271, 296

Narwhal's tusk, 156, 192, Fig. 186
Nassa neritea, 162
Nature and art, 5
 mathematics, 4, 19, 33, 96,
 433
Nautiloceras, 69
Nautilus, 48, 49, 58, 60, 67, 68, 96, 102,
 280—283, 395, 408, 426—427, 436,
 458
Nautilus pompilius, 57, 67, 78, 80, 321,
 449, 457
Navajo Indians, 166
Neander men, 267, 269, 295
Nebulæ, 7, 9, 11, 66, 409, 411
Nemec, 178
Neolithic Age, 267—274, 283
Nepenthes, 53, 172
Neptunea, 158, 159
New Grange, 271, 273—275, 284
Newton, Sir Isaac, 5, 6, 65, 66, 400, 429
 —431
Notre Dame, 288
" Nutation," 187
Nymphæa, 79

Oats, 133
Odostomia Turbonilla, 158
Ohio prehistoric mounds, 166

Oioceros, 215, 217
Okapi horns, 193
Oleander (*Nerium*), 122
Oncyloceras spinigerum, 68
Ophidioceras, 69
Optical illusion, 100
Orbiculus, 227
Orchids, man-eating, 173
Orchis, 123
Orientals, 242
Oroxylum indicum, 139
Orthægoceros, 213
Orthoceras, 69
Orthogonal packing, 91
Orthostichies, 97, 98
Osteoblasts, 222
Ovis ammon, 198, 209
 canadensis, 209
 orientalis, 198
Owen, Sir R., 80, 487
Oxen, 211
Oxford, 338
Oxygen, 432

PAIRS of horns, 190
Palæmon, 179
Palæolithic Age, 267—270, 274, 283
Palazzo Contarini, 316
Pallas's Tur, 195—196, 207—210, 217
Pandanus, 124, 125
Parachutes, 138, 141
Parastichies, 97, 98, 102, 115
Parnassian sheep, 219
Parsons, F. G., 229
Parthenon, 33, 280, 321, 325, 328—337, 359, 397—398, 423, 433—435
Passion flower, 128, 188
Pasteur, Louis, 168
Pelargonium, 133
Pelseneer, P., 159, 208
Pendulum, 461
Peneroplis (nautilus), 44, 45
Pennethorne, John, 328, 329
Penrose, Francis Cranmer, 279, 281, 328, 330
Persian ibex, 211
Persimmon, 5
" Perversion," 195, 198, 207
Perversus, 207—209, 215, 216, 217
Pettigrew, Professor J. B., 9, 31, 187, 227, 233, 237, 437
" Pharaoh's serpents," 43, 115, 157
Pheidias, 333, 420, 427
Phi progression, 420—428, 430, 440—447
 spiral, 421
Phillips, L. March, 358, 403
Phyllotaxis, 23, 61, 76, 82, 86, 87, 89, 94, 96, 97, 99, 100, 395, 408, 417
Physa, 158
Picea, 140
Piette, E., 270
Pillar, 296
Piltdown skull, 295
Pine cone, 87, 119
Pinus, 81, 97—98, 107, 109, 111, 120—121, 135, 138—141
Pisa, 318, 319, 320, 339

Pitcher plant, 53, 172
Pitt Rivers Museum, 276, 285
Pleistocene Age, 268, 295
Plankton, 116
Planorbis, 159
" Plant intelligence," 175
Plant structure, 171
Plants, climbing, 11, 37, 126, 127, 170, 173, 184, 204
 twining, 54, 170, 186—187
 water-tubes of, 53, 54
Plumbago rosea, 127
Poincaré, H., 430
Polo, 255
Polygonum, 127, 185
Pompholyx, 160, 208
Porosphæra, 162
Port decanters, 165
Poynting, Professor J. H., 431
Præ-Mycenæan epoch, 274
Prehistoric carvings, 226
" Prentice's Pillar," 297, 299
Pressure of light, 431
Primitive tribes and shells, 163
Prosopis, 135, 149
Pseudoïs nahura, 198, 207
Pterocarpus (leguminosæ), 139
Pteroceras oceani, 45

QUATERNARY epoch, 267

RABBIT, 157, 233, 234
Radium, 432
Ranunculus, 131, Fig. 173
Ravenna, 319
Rayleigh, Lord. 4, 413, 432
Rays, 452
Reinach, Salomon, 270, 274, 380, 402, 449
Reindeer, 193
Rembrandt, 314, 390
Renaissance, 327, 338
Reversal of spirals, 127
Revett, Nicholas, 328
Reymond, Charles Marcel-, 345, 372
Reymond, M. Marcel-, 345, 372
Rhinobatus, 454
Rhinoceros, 191—192
Rhodes, 166
Rhynchobatus, 454
Ribs, 231
Richter, J. P., 344
Riding, 246
Riella, 116, 142—143, 145
Rifles, 16
Right hand, 120, 128, 165, 260—261
 and left-handed men, Chap. XIV., 239
Rivers, Dr. W. H. R., 279, 286
Rochea falcata, 104
Rock rose (*Helianthemum*), 122
Rocky Mountain sheep, 218
Rodman, G. H., 13
Rope bridle, 39
Rope's twist, 38
Rose of Sharon (*Hypericum calycinum*), 124, 125
Rosse, Lord, 9, 409

Rotalia, 43
Rothery, G. C., 314, 377
Rouen, 17, 336
Rowing, 12
Rule of the road, 248

Sabella unispira, 8
Sachs, Julius, 53, 97, 184, 187
Saint-Bel, Vial de, 399, 400
Saint-Gilles, 306
St. Mark's at Venice, 164, 296, 336
St. Paul's, 303, 336. See Wren.
Samnite ornaments, 166
Sandstorms, 7
Saxidomus, 457
Scabiosa atropurpurea, 99
Scala del Bovolo, 316, 317, 318, 325, 346
Scalaria scalaris, 50, 315—316
Scarabs, 274, 276
Sceptre, 290, 297
Schaeberle, Professor J. M., 11
Schimper, A. F. W., 88, 94, 96, 97, 98, 111
Schliemann, 162, 166, 271, 276, 278, 295
Schooling, William, 420, 427, 440—447, 462
Schubertia physianthus, 186
Schwartzschild, Professor, 410
Schwendener, S., 91, 111
" Scipio Africanus," 64
Scorpioid cyme, 118
Scott, Mrs. Dukinfield H., 11
Screw, 36
Screwbean (Prosopis strombulifera), 135
Screwstone, 41
Scyphanthus elegans (Loasaceæ), 127, 128
Sea-bean, 67, 131
Sea-urchins, 163
Seeds, spinning, 137
Selenipedium conchiferum, 76, 157
Senegambian eland, 201, 217
Sense organs, 172, 178
Sequoia gigantea, 140
Serpent of sin, 18
Sharks, 8, 14, 234, 452
Shavings, 42, 218, 241
Sheep, 205, 211, 216
Shell spirals, 218
 and staircases, 1, 314, 339, 350
 turbine, 58
Shells, bivalve, 454
 fossil, 256
 hand of, 33, 129, 157, 207
 internal structure of, 13
 sections of, 13, 60
Ship's propeller, 220
Shooting, 255
Siebenmann, Dr., 224
Silicon and oxygen atoms, 167
Siliquaria striata, 68
Silurian Age, 458
Simroth, 159, 208
Sind ibex, 210
 wild goat, 197, 209

Siphomeris or lecontea (Cinchonaceæ), 127
Siphuncle, 68
Situtunga, 195, 201
Skating, 40, 441
Skin, 226
Smilax aspera, 186
Snail shells, 163
Solanum dulcamara, 127, 186
Solarium, 27, 315
Solutrian Age, 268, 270
Sourdeau, Jacques, 342, 366
Spartium (Spanish Broom), 145
Speed, Lancelot, 427
Speed of revolution in plants, 186
Spencer, Herbert, 441
Sphærostemma marmoratum, 127
Spinal column, 231
Spiral appearances subjective, 23
 fossils, 152
 horns, hand of, 192
 leaf arrangement, 115
 nomenclatures, 39, 116, 118, 128, 264
 phyllotaxis. See Phyllotaxis.
 seeds and primitive races, 131
 spermatozoids, 143
 staircases, 220, Chaps. XVI.— XVIII.
 tunnels, 301
 vortex movement, 96
" Spirals of Airy," 167
Spirals, alternating hand, 299
 cause of, 14
 conical, 24, 27, 29, 209, 227
 conventional, 266, 270
 cylindrical, 24, 27, 227, 267, 292, 296
 efficiency of, 14, 37, 53, 54, 221, 226, 228
 flat, 24, 28, 32, 233, 267, 271, 296
 formation of, by shellfish, 42
 fourfold, 38
 hand of, 25—27, 30, 34, 36, 42, 116, 149, 155, 230, 241, 365
 in human body, 221
 " locomotory," 14
 logarithmic, 5, 6, 26, 35, 57, 60—63, 66, 70, 78, 91, 95— 98, 102, 281, 221, 395, 405, 413—414, 417, 421, 429
 Mycenæan, 295
 mystical meaning, 267
 in nature and art, 315
 reversal, 187
 in shells, number of, 55
Spire, 299
Spiralis, 159, 208
Spirifer mucronatus, 22
Spirillum rubrum, 235, Fig. 6
Spirogyra, 116
Spirostomum ambiguum, 8
Spores, 181, 182
Square, law of the, 66
Staël, Mdme. de, 417
Staircase and shells, 1, 314, 339, 350
Staircases, Chaps. XVI.—XVIII.

Stanley's chevrotain (*Tragulus stanleyanus*), 233
Star clusters, 11
Statoliths, 178, 179
Stein, Dr. F. Ritter v., 8, 62
Stentor, 8, 62, 236
Stephanoceratidæ, 68
Stewart, Charles, 227, 349, 353
Stipa, 133, 135, 149
Stoney, Dr. Johnstone, 412—413
Storks-bill (*Erodium*), 14, 118, 133, 135
Storms, cyclonic, 31
Strassburg Cathedral, 319
Stresses in steel, 16
Subjective, spiral, 220, 393
Sudan Derbian eland, 209, Fig. 238
Suleman markhor, 196—198, 209, 217, 218, Fig. 228
" Sun dances," 166
Sundew, 172, 183
Sunflower (*Helianthus annuus*), 87, 97—98, 121, 145, 148, 417
Sunlight on leaves : obtaining and avoiding, 81—83
Survival of species, 47
Swastika, 166—169, 277, 285, 422, 449, 451
Swimming, 232
Swinburne, A., quotation from, 183
Sword arm, 246
Sycamore, 135, 138, 140

Tame goats, 211—212, 215
Tamus communis (Dioscoreaceæ), 127, 188
Tamworth Church, 312, 336
Tattershall Castle, 308, 309
Teazle, 126
Tecoma, 37, 39, 185
Telescopium telescopium, 45, 46, 51, 55, 324
Temple of Solomon, 164, 297
Tendo Achillis, 229
Tendril bearers, 170, 186, 188
Terebra, 42, 50, 324
Tertiary epoch, 458
Theory and observations, 20
Thigh-bone of man, 221
Thiis, Dr. Jens, 377, 378, 379, 401
Tibetan argali (*Ovis ammon hodgsoni*), 195, 196, 198, 208—212
 shawl-goat, 203
 women, 166
Tomoye symbol, 449, 451, 461
Tools, hand of, 243
Tornadoes, 7
Tornatina, 158
Torques, 38, 244, 267, 291—292
Torsion, 122, 148, 180, 185, 187, 204, 228—231, 236
Touraine, 375
Tours, 316
Tracheæ of insects, 53
Tragelaphus angasi (antelope), 195
Travancore, 163, 456, Fig. 200
Tree trunks, twisted, 31
Trees and shells, 151

Trochus, 67, 162
Trophon geversianus, 71
Tropæolum, 417
Troy, 166
Truncatulina, 43
Turbinella, 55, 160, 163, 456
Turbinidæ (" eyestone," " sea bean "), 67
Turbo, 67
Turner, J. M. W., 427, 464
Turrilites, 158
Turritella lentiginosa, 47, 50, 55
Tutton, Dr. Alfred, 100, 167
Twisted paper, 38, 50, 244, 263

Ultra-dextral, 159
Umbilical cord, 8, 37, 224

Vallisneria spiralis, 79
Vegetable structure, 171
Venus' flytrap, 172
Vidalia, 116, 142, 145
Vinca (periwinkle), 121, 122, 123
Vine, 188
Violins, 290
Viollet-le-Duc, 304, 307, 312
Virginia creeper (*Ampelopsis*), 187
Viscum, 179
Voluta, 50, 52—53, 55, 349, 358
 vespertilio, 49, 52, 55, 158, 160, 324, 341, 350, 353, 358
Volute, drawing a, 33
Volutes, Ionic, 32, 33, 34, 40, 279, 290, 296
Vorticella, 8, 236
Vries, De, 125

Walde, Müller, 401
Walker, Gilbert, 281
Walking, 246
Wallace, Alfred Russell, 3, 80, 394
Wallachian sheep, 214—219
Warping of timber, 181
Wassermann, A., 235
Water lilies (*Nymphæa*), 112, Fig. 160
Waterspout, 7
Wax palm, 121, Fig. 166
Wei-hai-wei ram, 215, Fig. 251
Weldon, Professor W. F. R., 47
Westminster, 307, 336, 349, 372
Whelk, 33
Wherry, Dr., 5, 6, 34, 42, 76, 78, 157, 170, 187, 198, 200—203, 210—211, 214—215, 218, 239, 241
Whirlwinds, 7
Whistler, J. M., 338
Whitaker, E. T., 431
Widdershins, 165, 262
Wiesner, Professor J., 84
Wild goat, 210—213
Wilson, Sir Daniel, 243
Winds, 31
Winged fruits, 138
 seeds, 15
Wings, 233, 432

Wistaria involuta, 186
Woodbine, 183
Wood-turning, 321
Woodward, B. B., 56, 456—458
Woodward, Dr. Smith, 295
Wren, Sir Christopher, 303, 336, 341, 346, 379

X-RAYS, 13, 221, 323

YACHTING problem, 40
Yucatan ruins of, 166

Zamia, 145, 147
Zeising, Adolf, 440
Zeuglodon, 8
Zulu walking sticks, 164
Zygospira modesta, 22

A CATALOG OF SELECTED
DOVER BOOKS
IN ALL FIELDS OF INTEREST

A CATALOG OF SELECTED DOVER
BOOKS IN ALL FIELDS OF INTEREST

CONCERNING THE SPIRITUAL IN ART, Wassily Kandinsky. Pioneering work by father of abstract art. Thoughts on color theory, nature of art. Analysis of earlier masters. 12 illustrations. 80pp. of text. 5⅜ × 8½. 23411-8 Pa. $2.95

LEONARDO ON THE HUMAN BODY, Leonardo da Vinci. More than 1200 of Leonardo's anatomical drawings on 215 plates. Leonardo's text, which accompanies the drawings, has been translated into English. 506pp. 8⅜ × 11¼.
24483-0 Pa. $11.95

GOBLIN MARKET, Christina Rossetti. Best-known work by poet comparable to Emily Dickinson, Alfred Tennyson. With 46 delightfully grotesque illustrations by Laurence Housman. 64pp. 4 × 6¾. 24516-0 Pa. $2.50

THE HEART OF THOREAU'S JOURNALS, edited by Odell Shepard. Selections from *Journal*, ranging over full gamut of interests. 228pp. 5⅜ × 8½.
20741-2 Pa. $4.50

MR. LINCOLN'S CAMERA MAN: MATHEW B. BRADY, Roy Meredith. Over 300 Brady photos reproduced directly from original negatives, photos. Lively commentary. 368pp. 8⅜ × 11¼. 23021-X Pa. $14.95

PHOTOGRAPHIC VIEWS OF SHERMAN'S CAMPAIGN, George N. Barnard. Reprint of landmark 1866 volume with 61 plates: battlefield of New Hope Church, the Etawah Bridge, the capture of Atlanta, etc. 80pp. 9 × 12. 23445-2 Pa. $6.00

A SHORT HISTORY OF ANATOMY AND PHYSIOLOGY FROM THE GREEKS TO HARVEY, Dr. Charles Singer. Thoroughly engrossing non-technical survey. 270 illustrations. 211pp. 5⅜ × 8½. 20389-1 Pa. $4.95

REDOUTE ROSES IRON-ON TRANSFER PATTERNS, Barbara Christopher. Redouté was botanical painter to the Empress Josephine; transfer his famous roses onto fabric with these 24 transfer patterns. 80pp. 8¼ × 10⅞. 24292-7 Pa. $3.50

THE FIVE BOOKS OF ARCHITECTURE, Sebastiano Serlio. Architectural milestone, first (1611) English translation of Renaissance classic. Unabridged reproduction of original edition includes over 300 woodcut illustrations. 416pp. 9⅜ × 12¼. 24349-4 Pa. $14.95

CARLSON'S GUIDE TO LANDSCAPE PAINTING, John F. Carlson. Authoritative, comprehensive guide covers, every aspect of landscape painting. 34 reproductions of paintings by author; 58 explanatory diagrams. 144pp. 8⅜ × 11.
22927-0 Pa. $5.95

101 PUZZLES IN THOUGHT AND LOGIC, C.R. Wylie, Jr. Solve murders, robberies, see which fishermen are liars—purely by reasoning! 107pp. 5⅜ × 8½.
20367-0 Pa. $2.00

TEST YOUR LOGIC, George J. Summers. 50 more truly new puzzles with new turns of thought, new subtleties of inference. 100pp. 5⅜ × 8½. 22877-0 Pa. $2.25

THE MURDER BOOK OF J.G. REEDER, Edgar Wallace. Eight suspenseful stories by bestselling mystery writer of 20s and 30s. Features the donnish Mr. J.G. Reeder of Public Prosecutor's Office. 128pp. 5⅜ × 8½. (Available in U.S. only)
24374-5 Pa. $3.95

ANNE ORR'S CHARTED DESIGNS, Anne Orr. Best designs by premier needlework designer, all on charts: flowers, borders, birds, children, alphabets, etc. Over 100 charts, 10 in color. Total of 40pp. 8¼ × 11. 23704-4 Pa. $2.50

BASIC CONSTRUCTION TECHNIQUES FOR HOUSES AND SMALL BUILDINGS SIMPLY EXPLAINED, U.S. Bureau of Naval Personnel. Grading, masonry, woodworking, floor and wall framing, roof framing, plastering, tile setting, much more. Over 675 illustrations. 568pp. 6½ × 9¼. 20242-9 Pa. $8.95

MATISSE LINE DRAWINGS AND PRINTS, Henri Matisse. Representative collection of female nudes, faces, still lifes, experimental works, etc., from 1898 to 1948. 50 illustrations. 48pp. 8⅜ × 11¼. 23877-6 Pa. $3.50

HOW TO PLAY THE CHESS OPENINGS, Eugene Znosko-Borovsky. Clear, profound examinations of just what each opening is intended to do and how opponent can counter. Many sample games. 147pp. 5⅜ × 8½. 22795-2 Pa. $2.95

DUPLICATE BRIDGE, Alfred Sheinwold. Clear, thorough, easily followed account: rules, etiquette, scoring, strategy, bidding; Goren's point-count system, Blackwood and Gerber conventions, etc. 158pp. 5⅜ × 8½. 22741-3 Pa. $3.00

SARGENT PORTRAIT DRAWINGS, J.S. Sargent. Collection of 42 portraits reveals technical skill and intuitive eye of noted American portrait painter, John Singer Sargent. 48pp. 8¼ × 11⅛. 24524-1 Pa. $3.50

ENTERTAINING SCIENCE EXPERIMENTS WITH EVERYDAY OBJECTS, Martin Gardner. Over 100 experiments for youngsters. Will amuse, astonish, teach, and entertain. Over 100 illustrations. 127pp. 5⅜ × 8½. 24201-3 Pa. $2.50

TEDDY BEAR PAPER DOLLS IN FULL COLOR: A Family of Four Bears and Their Costumes, Crystal Collins. A family of four Teddy Bear paper dolls and nearly 60 cut-out costumes. Full color, printed one side only. 32pp. 9¼ × 12¼.
24550-0 Pa. $3.50

NEW CALLIGRAPHIC ORNAMENTS AND FLOURISHES, Arthur Baker. Unusual, multi-useable material: arrows, pointing hands, brackets and frames, ovals, swirls, birds, etc. Nearly 700 illustrations. 80pp. 8⅜ × 11¼.
24095-9 Pa. $3.75

DINOSAUR DIORAMAS TO CUT & ASSEMBLE, M. Kalmenoff. Two complete three-dimensional scenes in full color, with 31 cut-out animals and plants. Excellent educational toy for youngsters. Instructions; 2 assembly diagrams. 32pp. 9¼ × 12¼. 24541-1 Pa. $4.50

SILHOUETTES: A PICTORIAL ARCHIVE OF VARIED ILLUSTRATIONS, edited by Carol Belanger Grafton. Over 600 silhouettes from the 18th to 20th centuries. Profiles and full figures of men, women, children, birds, animals, groups and scenes, nature, ships, an alphabet. 144pp. 8⅜ × 11¼. 23781-8 Pa. $5.95

25 KITES THAT FLY, Leslie Hunt. Full, easy-to-follow instructions for kites made from inexpensive materials. Many novelties. 70 illustrations. 110pp. 5⅜ × 8½.
22550-X Pa. $2.50

PIANO TUNING, J. Cree Fischer. Clearest, best book for beginner, amateur. Simple repairs, raising dropped notes, tuning by easy method of flattened fifths. No previous skills needed. 4 illustrations. 201pp. 5⅜ × 8½. 23267-0 Pa. $3.50

EARLY AMERICAN IRON-ON TRANSFER PATTERNS, edited by Rita Weiss. 75 designs, borders, alphabets, from traditional American sources. 48pp. 8¼ × 11.
23162-3 Pa. $1.95

CROCHETING EDGINGS, edited by Rita Weiss. Over 100 of the best designs for these lovely trims for a host of household items. Complete instructions, illustrations. 48pp. 8¼ × 11. 24031-2 Pa. $2.25

FINGER PLAYS FOR NURSERY AND KINDERGARTEN, Emilie Poulsson. 18 finger plays with music (voice and piano); entertaining, instructive. Counting, nature lore, etc. Victorian classic. 53 illustrations. 80pp. 6½ × 9¼. 22588-7 Pa. $1.95

BOSTON THEN AND NOW, Peter Vanderwarker. Here in 59 side-by-side views are photographic documentations of the city's past and present. 119 photographs. Full captions. 122pp. 8¼ × 11. 24312-5 Pa. $7.95

CROCHETING BEDSPREADS, edited by Rita Weiss. 22 patterns, originally published in three instruction books 1939-41. 39 photos, 8 charts. Instructions. 48pp. 8¼ × 11. 23610-2 Pa. $2.00

HAWTHORNE ON PAINTING, Charles W. Hawthorne. Collected from notes taken by students at famous Cape Cod School; hundreds of direct, personal *apercus*, ideas, suggestions. 91pp. 5⅜ × 8½. 20653-X Pa. $2.95

THERMODYNAMICS, Enrico Fermi. A classic of modern science. Clear, organized treatment of systems, first and second laws, entropy, thermodynamic potentials, etc. Calculus required. 160pp. 5⅜ × 8½. 60361-X Pa. $4.50

TEN BOOKS ON ARCHITECTURE, Vitruvius. The most important book ever written on architecture. Early Roman aesthetics, technology, classical orders, site selection, all other aspects. Morgan translation. 331pp. 5⅜ × 8½. 20645-9 Pa. $5.95

THE CORNELL BREAD BOOK, Clive M. McCay and Jeanette B. McCay. Famed high-protein recipe incorporated into breads, rolls, buns, coffee cakes, pizza, pie crusts, more. Nearly 50 illustrations. 48pp. 8¼ × 11. 23995-0 Pa. $2.00

THE CRAFTSMAN'S HANDBOOK, Cennino Cennini. 15th-century handbook, school of Giotto, explains applying gold, silver leaf; gesso; fresco painting, grinding pigments, etc. 142pp. 6⅛ × 9¼. 20054-X Pa. $3.50

FRANK LLOYD WRIGHT'S FALLINGWATER, Donald Hoffmann. Full story of Wright's masterwork at Bear Run, Pa. 100 photographs of site, construction, and details of completed structure. 112pp. 9¼ × 10. 23671-4 Pa. $7.95

OVAL STAINED GLASS PATTERN BOOK, C. Eaton. 60 new designs framed in shape of an oval. Greater complexity, challenge with sinuous cats, birds, mandalas framed in antique shape. 64pp. 8¼ × 11. 24519-5 Pa. $3.75

THE BOOK OF WOOD CARVING, Charles Marshall Sayers. Still finest book for beginning student. Fundamentals, technique; gives 34 designs, over 34 projects for panels, bookends, mirrors, etc. 33 photos. 118pp. 7¾ × 10⅝. 23654-4 Pa. $3.95

CARVING COUNTRY CHARACTERS, Bill Higginbotham. Expert advice for beginning, advanced carvers on materials, techniques for creating 18 projects—mirthful panorama of American characters. 105 illustrations. 80pp. 8⅝ × 11.
24135-1 Pa. $2.50

300 ART NOUVEAU DESIGNS AND MOTIFS IN FULL COLOR, C.B. Grafton. 44 full-page plates display swirling lines and muted colors typical of Art Nouveau. Borders, frames, panels, cartouches, dingbats, etc. 48pp. 9⅜ × 12¼.
24354-0 Pa. $6.95

SELF-WORKING CARD TRICKS, Karl Fulves. Editor of *Pallbearer* offers 72 tricks that work automatically through nature of card deck. No sleight of hand needed. Often spectacular. 42 illustrations. 113pp. 5⅜ × 8½. 23334-0 Pa. $3.50

CUT AND ASSEMBLE A WESTERN FRONTIER TOWN, Edmund V. Gillon, Jr. Ten authentic full-color buildings on heavy cardboard stock in H-O scale. Sheriff's Office and Jail, Saloon, Wells Fargo, Opera House, others. 48pp. 9¼ × 12¼.
23736-2 Pa. $4.95

CUT AND ASSEMBLE AN EARLY NEW ENGLAND VILLAGE, Edmund V. Gillon, Jr. Printed in full color on heavy cardboard stock. 12 authentic buildings in H-O scale: Adams home in Quincy, Mass., Oliver Wight house in Sturbridge, smithy, store, church, others. 48pp. 9¼ × 12¼. 23536-X Pa. $4.95

THE TALE OF TWO BAD MICE, Beatrix Potter. Tom Thumb and Hunca Munca squeeze out of their hole and go exploring. 27 full-color Potter illustrations. 59pp. 4¼ × 5½. (Available in U.S. only) 23065-1 Pa. $1.75

CARVING FIGURE CARICATURES IN THE OZARK STYLE, Harold L. Enlow. Instructions and illustrations for ten delightful projects, plus general carving instructions. 22 drawings and 47 photographs altogether. 39pp. 8⅜ × 11.
23151-8 Pa. $2.95

A TREASURY OF FLOWER DESIGNS FOR ARTISTS, EMBROIDERERS AND CRAFTSMEN, Susan Gaber. 100 garden favorites lushly rendered by artist for artists, craftsmen, needleworkers. Many form frames, borders. 80pp. 8¼ × 11.
24096-7 Pa. $3.50

CUT & ASSEMBLE A TOY THEATER/THE NUTCRACKER BALLET, Tom Tierney. Model of a complete, full-color production of Tchaikovsky's classic. 6 backdrops, dozens of characters, familiar dance sequences. 32pp. 9⅜ × 12¼.
24194-7 Pa. $4.50

ANIMALS: 1,419 COPYRIGHT-FREE ILLUSTRATIONS OF MAMMALS, BIRDS, FISH, INSECTS, ETC., edited by Jim Harter. Clear wood engravings present, in extremely lifelike poses, over 1,000 species of animals. 284pp. 9 × 12.
23766-4 Pa. $9.95

MORE HAND SHADOWS, Henry Bursill. For those at their 'finger ends," 16 more effects—Shakespeare, a hare, a squirrel, Mr. Punch, and twelve more—each explained by a full-page illustration. Considerable period charm. 30pp. 6½ × 9¼.
21384-6 Pa. $1.95

SURREAL STICKERS AND UNREAL STAMPS, William Rowe. 224 haunting, hilarious stamps on gummed, perforated stock, with images of elephants, geisha girls, George Washington, etc. 16pp. one side. 8¼ × 11. 24371-0 Pa. $3.50

GOURMET KITCHEN LABELS, Ed Sibbett, Jr. 112 full-color labels (4 copies each of 28 designs). Fruit, bread, other culinary motifs. Gummed and perforated. 16pp. 8¼ × 11. 24087-8 Pa. $2.95

PATTERNS AND INSTRUCTIONS FOR CARVING AUTHENTIC BIRDS, H.D. Green. Detailed instructions, 27 diagrams, 85 photographs for carving 15 species of birds so life-like, they'll seem ready to fly! 8¼ × 11. 24222-6 Pa. $2.75

FLATLAND, E.A. Abbott. Science-fiction classic explores life of 2-D being in 3-D world. 16 illustrations. 103pp. 5⅜ × 8. 20001-9 Pa. $2.00

DRIED FLOWERS, Sarah Whitlock and Martha Rankin. Concise, clear, practical guide to dehydration, glycerinizing, pressing plant material, and more. Covers use of silica gel. 12 drawings. 32pp. 5⅜ × 8½. 21802-3 Pa. $1.00

EASY-TO-MAKE CANDLES, Gary V. Guy. Learn how easy it is to make all kinds of decorative candles. Step-by-step instructions. 82 illustrations. 48pp. 8¼ × 11.
23881-4 Pa. $2.95

SUPER STICKERS FOR KIDS, Carolyn Bracken. 128 gummed and perforated full-color stickers: GIRL WANTED, KEEP OUT, BORED OF EDUCATION, X-RATED, COMBAT ZONE, many others. 16pp. 8¼ × 11. 24092-4 Pa. $2.50

CUT AND COLOR PAPER MASKS, Michael Grater. Clowns, animals, funny faces...simply color them in, cut them out, and put them together, and you have 9 paper masks to play with and enjoy. 32pp. 8¼ × 11. 23171-2 Pa. $2.50

A CHRISTMAS CAROL: THE ORIGINAL MANUSCRIPT, Charles Dickens. Clear facsimile of Dickens manuscript, on facing pages with final printed text. 8 illustrations by John Leech, 4 in color on covers. 144pp. 8⅜ × 11¼.
20980-6 Pa. $5.95

CARVING SHOREBIRDS, Harry V. Shourds & Anthony Hillman. 16 full-size patterns (all double-page spreads) for 19 North American shorebirds with step-by-step instructions. 72pp. 9¼ × 12¼. 24287-0 Pa. $4.95

THE GENTLE ART OF MATHEMATICS, Dan Pedoe. Mathematical games, probability, the question of infinity, topology, how the laws of algebra work, problems of irrational numbers, and more. 42 figures. 143pp. 5⅜ × 8½. (EBE)
22949-1 Pa. $3.50

READY-TO-USE DOLLHOUSE WALLPAPER, Katzenbach & Warren, Inc. Stripe, 2 floral stripes, 2 allover florals, polka dot; all in full color. 4 sheets (350 sq. in.) of each, enough for average room. 48pp. 8¼ × 11. 23495-9 Pa. $2.95

MINIATURE IRON-ON TRANSFER PATTERNS FOR DOLLHOUSES, DOLLS, AND SMALL PROJECTS, Rita Weiss and Frank Fontana. Over 100 miniature patterns: rugs, bedspreads, quilts, chair seats, etc. In standard dollhouse size. 48pp. 8¼ × 11. 23741-9 Pa. $1.95

THE DINOSAUR COLORING BOOK, Anthony Rao. 45 renderings of dinosaurs, fossil birds, turtles, other creatures of Mesozoic Era. Scientifically accurate. Captions. 48pp. 8¼ × 11. 24022-3 Pa. $2.50

JAPANESE DESIGN MOTIFS, Matsuya Co. Mon, or heraldic designs. Over 4000 typical, beautiful designs: birds, animals, flowers, swords, fans, geometrics; all beautifully stylized. 213pp. 11⅜ × 8¼. 22874-6 Pa. $7.95

THE TALE OF BENJAMIN BUNNY, Beatrix Potter. Peter Rabbit's cousin coaxes him back into Mr. McGregor's garden for a whole new set of adventures. All 27 full-color illustrations. 59pp. 4¼ × 5½. (Available in U.S. only) 21102-9 Pa. $1.75

THE TALE OF PETER RABBIT AND OTHER FAVORITE STORIES BOXED SET, Beatrix Potter. Seven of Beatrix Potter's best-loved tales including Peter Rabbit in a specially designed, durable boxed set. 4¼ × 5½. Total of 447pp. 158 color illustrations. (Available in U.S. only) 23903-9 Pa. $12.25

PRACTICAL MENTAL MAGIC, Theodore Annemann. Nearly 200 astonishing feats of mental magic revealed in step-by-step detail. Complete advice on staging, patter, etc. Illustrated. 320pp. 5⅜ × 8½. 24426-1 Pa. $5.95

CELEBRATED CASES OF JUDGE DEE (DEE GOONG AN), translated by Robert Van Gulik. Authentic 18th-century Chinese detective novel; Dee and associates solve three interlocked cases. Led to van Gulik's own stories with same characters. Extensive introduction. 9 illustrations. 237pp. 5⅜ × 8½.

23337-5 Pa. $4.95

CUT & FOLD EXTRATERRESTRIAL INVADERS THAT FLY, M. Grater. Stage your own lilliputian space battles.By following the step-by-step instructions and explanatory diagrams you can launch 22 full-color fliers into space. 36pp. 8¼ × 11. 24478-4 Pa. $2.95

CUT & ASSEMBLE VICTORIAN HOUSES, Edmund V. Gillon, Jr. Printed in full color on heavy cardboard stock, 4 authentic Victorian houses in H-O scale: Italian-style Villa, Octagon, Second Empire, Stick Style. 48pp. 9¼ × 12¼.

23849-0 Pa. $4.95

BEST SCIENCE FICTION STORIES OF H.G. WELLS, H.G. Wells. Full novel *The Invisible Man,* plus 17 short stories: "The Crystal Egg," "Aepyornis Island," "The Strange Orchid," etc. 303pp. 5⅜ × 8½. (Available in U.S. only)

21531-8 Pa. $4.95

TRADEMARK DESIGNS OF THE WORLD, Yusaku Kamekura. A lavish collection of nearly 700 trademarks, the work of Wright, Loewy, Klee, Binder, hundreds of others. 160pp. 8¾ × 8. (Available in U.S. only) (EJ) 24191-2 Pa. $5.95

THE ARTIST'S AND CRAFTSMAN'S GUIDE TO REDUCING, ENLARGING AND TRANSFERRING DESIGNS, Rita Weiss. Discover, reduce, enlarge, transfer designs from any objects to any craft project. 12pp. plus 16 sheets special graph paper. 8¼ × 11. 24142-4 Pa. $3.50

TREASURY OF JAPANESE DESIGNS AND MOTIFS FOR ARTISTS AND CRAFTSMEN, edited by Carol Belanger Grafton. Indispensable collection of 360 traditional Japanese designs and motifs redrawn in clean, crisp black-and-white, copyright-free illustrations. 96pp. 8¼ × 11. 24435-0 Pa. $3.95

CHANCERY CURSIVE STROKE BY STROKE, Arthur Baker. Instructions and illustrations for each stroke of each letter (upper and lower case) and numerals. 54 full-page plates. 64pp. 8¼ × 11. 24278-1 Pa. $2.50

THE ENJOYMENT AND USE OF COLOR, Walter Sargent. Color relationships, values, intensities; complementary colors, illumination, similar topics. Color in nature and art. 7 color plates, 29 illustrations. 274pp. 5⅜ × 8½. 20944-X Pa. $4.95

SCULPTURE PRINCIPLES AND PRACTICE, Louis Slobodkin. Step-by-step approach to clay, plaster, metals, stone; classical and modern. 253 drawings, photos. 255pp. 8¼ × 11. 22960-2 Pa. $7.50

VICTORIAN FASHION PAPER DOLLS FROM HARPER'S BAZAR, 1867-1898, Theodore Menten. Four female dolls with 28 elegant high fashion costumes, printed in full color. 32pp. 9¼ × 12¼. (USCO) 23453-3 Pa. $3.95

FLOPSY, MOPSY AND COTTONTAIL: A Little Book of Paper Dolls in Full Color, Susan LaBelle. Three dolls and 21 costumes (7 for each doll) show Peter Rabbit's siblings dressed for holidays, gardening, hiking, etc. Charming borders, captions. 48pp. 4¼ × 5½. 24376-1 Pa. $2.50

NATIONAL LEAGUE BASEBALL CARD CLASSICS, Bert Randolph Sugar. 83 big-leaguers from 1909-69 on facsimile cards. Hubbell, Dean, Spahn, Brock plus advertising, info, no duplications. Perforated, detachable. 16pp. 8¼ × 11.
24308-7 Pa. $2.95

THE LOGICAL APPROACH TO CHESS, Dr. Max Euwe, et al. First-rate text of comprehensive strategy, tactics, theory for the amateur. No gambits to memorize, just a clear, logical approach. 224pp. 5⅜ × 8½. 24353-2 Pa. $4.50

MAGICK IN THEORY AND PRACTICE, Aleister Crowley. The summation of the thought and practice of the century's most famous necromancer, long hard to find. Crowley's best book. 436pp. 5⅜ × 8½. (Available in U.S. only)
23295-6 Pa. $6.50

THE HAUNTED HOTEL, Wilkie Collins. Collins' last great tale; doom and destiny in a Venetian palace. Praised by T.S. Eliot. 127pp. 5⅜ × 8½.
24333-8 Pa. $3.00

ART DECO DISPLAY ALPHABETS, Dan X. Solo. Wide variety of bold yet elegant lettering in handsome Art Deco styles. 100 complete fonts, with numerals, punctuation, more. 104pp. 8¼ × 11. 24372-9 Pa. $4.50

CALLIGRAPHIC ALPHABETS, Arthur Baker. Nearly 150 complete alphabets by outstanding contemporary. Stimulating ideas; useful source for unique effects. 154 plates. 157pp. 8⅜ × 11¼. 21045-6 Pa. $5.95

ARTHUR BAKER'S HISTORIC CALLIGRAPHIC ALPHABETS, Arthur Baker. From monumental capitals of first-century Rome to humanistic cursive of 16th century, 33 alphabets in fresh interpretations. 88 plates. 96pp. 9 × 12.
24054-1 Pa. $4.50

LETTIE LANE PAPER DOLLS, Sheila Young. Genteel turn-of-the-century family very popular then and now. 24 paper dolls. 16 plates in full color. 32pp. 9¼ × 12¼. 24089-4 Pa. $3.50

KEYBOARD WORKS FOR SOLO INSTRUMENTS, G.F. Handel. 35 neglected works from Handel's vast oeuvre, originally jotted down as improvisations. Includes Eight Great Suites, others. New sequence. 174pp. 9⅜ × 12¼.

24338-9 Pa. $7.50

AMERICAN LEAGUE BASEBALL CARD CLASSICS, Bert Randolph Sugar. 82 stars from 1900s to 60s on facsimile cards. Ruth, Cobb, Mantle, Williams, plus advertising, info, no duplications. Perforated, detachable. 16pp. 8¼ × 11.

24286-2 Pa. $2.95

A TREASURY OF CHARTED DESIGNS FOR NEEDLEWORKERS, Georgia Gorham and Jeanne Warth. 141 charted designs: owl, cat with yarn, tulips, piano, spinning wheel, covered bridge, Victorian house and many others. 48pp. 8¼ × 11.

23558-0 Pa. $1.95

DANISH FLORAL CHARTED DESIGNS, Gerda Bengtsson. Exquisite collection of over 40 different florals: anemone, Iceland poppy, wild fruit, pansies, many others. 45 illustrations. 48pp. 8¼ × 11. 23957-8 Pa. $1.95

OLD PHILADELPHIA IN EARLY PHOTOGRAPHS 1839-1914, Robert F. Looney. 215 photographs: panoramas, street scenes, landmarks, President-elect Lincoln's visit, 1876 Centennial Exposition, much more. 230pp. 8⅜ × 11¾.

23345-6 Pa. $9.95

PRELUDE TO MATHEMATICS, W.W. Sawyer. Noted mathematician's lively, stimulating account of non-Euclidean geometry, matrices, determinants, group theory, other topics. Emphasis on novel, striking aspects. 224pp. 5⅜ × 8½.

24401-6 Pa. $4.50

ADVENTURES WITH A MICROSCOPE, Richard Headstrom. 59 adventures with clothing fibers, protozoa, ferns and lichens, roots and leaves, much more. 142 illustrations. 232pp. 5⅜ × 8½. 23471-1 Pa. $3.95

IDENTIFYING ANIMAL TRACKS: MAMMALS, BIRDS, AND OTHER ANIMALS OF THE EASTERN UNITED STATES, Richard Headstrom. For hunters, naturalists, scouts, nature-lovers. Diagrams of tracks, tips on identification. 128pp. 5⅜ × 8. 24442-3 Pa. $3.50

VICTORIAN FASHIONS AND COSTUMES FROM HARPER'S BAZAR, 1867-1898, edited by Stella Blum. Day costumes, evening wear, sports clothes, shoes, hats, other accessories in over 1,000 detailed engravings. 320pp. 9⅜ × 12¼.

22990-4 Pa. $10.95

EVERYDAY FASHIONS OF THE TWENTIES AS PICTURED IN SEARS AND OTHER CATALOGS, edited by Stella Blum. Actual dress of the Roaring Twenties, with text by Stella Blum. Over 750 illustrations, captions. 156pp. 9 × 12.

24134-3 Pa. $8.50

HALL OF FAME BASEBALL CARDS, edited by Bert Randolph Sugar. Cy Young, Ted Williams, Lou Gehrig, and many other Hall of Fame greats on 92 full-color, detachable reprints of early baseball cards. No duplication of cards with *Classic Baseball Cards.* 16pp. 8¼ × 11. 23624-2 Pa. $3.50

THE ART OF HAND LETTERING, Helm Wotzkow. Course in hand lettering, Roman, Gothic, Italic, Block, Script. Tools, proportions, optical aspects, individual variation. Very quality conscious. Hundreds of specimens. 320pp. 5⅜ × 8½.

21797-3 Pa. $4.95

HOW THE OTHER HALF LIVES, Jacob A. Riis. Journalistic record of filth, degradation, upward drive in New York immigrant slums, shops, around 1900. New edition includes 100 original Riis photos, monuments of early photography. 233pp. 10 × 7⅞. 22012-5 Pa. $7.95

CHINA AND ITS PEOPLE IN EARLY PHOTOGRAPHS, John Thomson. In 200 black-and-white photographs of exceptional quality photographic pioneer Thomson captures the mountains, dwellings, monuments and people of 19th-century China. 272pp. 9⅜ × 12¼. 24393-1 Pa. $13.95

GODEY COSTUME PLATES IN COLOR FOR DECOUPAGE AND FRAMING, edited by Eleanor Hasbrouk Rawlings. 24 full-color engravings depicting 19th-century Parisian haute couture. Printed on one side only. 56pp. 8¼ × 11. 23879-2 Pa. $3.95

ART NOUVEAU STAINED GLASS PATTERN BOOK, Ed Sibbett, Jr. 104 projects using well-known themes of Art Nouveau: swirling forms, florals, peacocks, and sensuous women. 60pp. 8¼ × 11. 23577-7 Pa. $3.50

QUICK AND EASY PATCHWORK ON THE SEWING MACHINE: Susan Aylsworth Murwin and Suzzy Payne. Instructions, diagrams show exactly how to machine sew 12 quilts. 48pp. of templates. 50 figures. 80pp. 8¼ × 11. 23770-2 Pa. $3.50

THE STANDARD BOOK OF QUILT MAKING AND COLLECTING, Marguerite Ickis. Full information, full-sized patterns for making 46 traditional quilts, also 150 other patterns. 483 illustrations. 273pp. 6⅞ × 9⅜. 20582-7 Pa. $5.95

LETTERING AND ALPHABETS, J. Albert Cavanagh. 85 complete alphabets lettered in various styles; instructions for spacing, roughs, brushwork. 121pp. 8¾ × 8. 20053-1 Pa. $3.95

LETTER FORMS: 110 COMPLETE ALPHABETS, Frederick Lambert. 110 sets of capital letters; 16 lower case alphabets; 70 sets of numbers and other symbols. 110pp. 8⅛ × 11. 22872-X Pa. $4.50

ORCHIDS AS HOUSE PLANTS, Rebecca Tyson Northen. Grow cattleyas and many other kinds of orchids—in a window, in a case, or under artificial light. 63 illustrations. 148pp. 5⅜ × 8½. 23261-1 Pa. $2.95

THE MUSHROOM HANDBOOK, Louis C.C. Krieger. Still the best popular handbook. Full descriptions of 259 species, extremely thorough text, poisons, folklore, etc. 32 color plates; 126 other illustrations. 560pp. 5⅜ × 8½. 21861-9 Pa. $8.50

THE DORÉ BIBLE ILLUSTRATIONS, Gustave Doré. All wonderful, detailed plates: Adam and Eve, Flood, Babylon, life of Jesus, etc. Brief King James text with each plate. 241 plates. 241pp. 9 × 12. 23004-X Pa. $8.95

THE BOOK OF KELLS: Selected Plates in Full Color, edited by Blanche Cirker. 32 full-page plates from greatest manuscript-icon of early Middle Ages. Fantastic, mysterious. Publisher's Note. Captions. 32pp. 9⅜ × 12¼. 24345-1 Pa. $4.50

THE PERFECT WAGNERITE, George Bernard Shaw. Brilliant criticism of the Ring Cycle, with provocative interpretation of politics, economic theories behind the Ring. 136pp. 5⅜ × 8½. (EUK) 21707-8 Pa. $3.00

THE RIME OF THE ANCIENT MARINER, Gustave Doré, S.T. Coleridge. Doré's finest work, 34 plates capture moods, subtleties of poem. Full text. 77pp. 9¼ × 12. 22305-1 Pa. $4.95

SONGS OF INNOCENCE, William Blake. The first and most popular of Blake's famous "Illuminated Books," in a facsimile edition reproducing all 31 brightly colored plates. Additional printed text of each poem. 64pp. 5¼ × 7.
22764-2 Pa. $3.50

AN INTRODUCTION TO INFORMATION THEORY, J.R. Pierce. Second (1980) edition of most impressive non-technical account available. Encoding, entropy, noisy channel, related areas, etc. 320pp. 5⅜ × 8½. 24061-4 Pa. $4.95

THE DIVINE PROPORTION: A STUDY IN MATHEMATICAL BEAUTY, H.E. Huntley. "Divine proportion" or "golden ratio" in poetry, Pascal's triangle, philosophy, psychology, music, mathematical figures, etc. Excellent bridge between science and art. 58 figures. 185pp. 5⅜ × 8½. 22254-3 Pa. $3.95

THE DOVER NEW YORK WALKING GUIDE: From the Battery to Wall Street, Mary J. Shapiro. Superb inexpensive guide to historic buildings and locales in lower Manhattan: Trinity Church, Bowling Green, more. Complete Text; maps. 36 illustrations. 48pp. 3⅞ × 9¼. 24225-0 Pa. $2.50

NEW YORK THEN AND NOW, Edward B. Watson, Edmund V. Gillon, Jr. 83 important Manhattan sites: on facing pages early photographs (1875-1925) and 1976 photos by Gillon. 172 illustrations. 171pp. 9¼ × 10. 23361-8 Pa. $9.95

HISTORIC COSTUME IN PICTURES, Braun & Schneider. Over 1450 costumed figures from dawn of civilization to end of 19th century. English captions. 125 plates. 256pp. 8⅜ × 11¼. 23150-X Pa. $7.50

VICTORIAN AND EDWARDIAN FASHION: A Photographic Survey, Alison Gernsheim. First fashion history completely illustrated by contemporary photographs. Full text plus 235 photos, 1840-1914, in which many celebrities appear. 240pp. 6½ × 9¼. 24205-6 Pa. $6.00

CHARTED CHRISTMAS DESIGNS FOR COUNTED CROSS-STITCH AND OTHER NEEDLECRAFTS, Lindberg Press. Charted designs for 45 beautiful needlecraft projects with many yuletide and wintertime motifs. 48pp. 8¼ × 11. (EDNS) 24356-7 Pa. $2.50

101 FOLK DESIGNS FOR COUNTED CROSS-STITCH AND OTHER NEEDLE-CRAFTS, Carter Houck. 101 authentic charted folk designs in a wide array of lovely representations with many suggestions for effective use. 48pp. 8¼ × 11.
24369-9 Pa. $2.25

FIVE ACRES AND INDEPENDENCE, Maurice G. Kains. Great back-to-the-land classic explains basics of self-sufficient farming. The one book to get. 95 illustrations. 397pp. 5⅜ × 8½. 20974-1 Pa. $5.95

A MODERN HERBAL, Margaret Grieve. Much the fullest, most exact, most useful compilation of herbal material. Gigantic alphabetical encyclopedia, from aconite to zedoary, gives botanical information, medical properties, folklore, economic uses, and much else. Indispensable to serious reader. 161 illustrations. 888pp. 6½ × 9¼. (Available in U.S. only) 22798-7, 22799-5 Pa., Two-vol. set $16.45

DECORATIVE NAPKIN FOLDING FOR BEGINNERS, Lillian Oppenheimer and Natalie Epstein. 22 different napkin folds in the shape of a heart, clown's hat, love knot, etc. 63 drawings. 48pp. 8¼ × 11. 23797-4 Pa. $1.95

DECORATIVE LABELS FOR HOME CANNING, PRESERVING, AND OTHER HOUSEHOLD AND GIFT USES, Theodore Menten. 128 gummed, perforated labels, beautifully printed in 2 colors. 12 versions. Adhere to metal, glass, wood, ceramics. 24pp. 8¼ × 11. 23219-0 Pa. $3.50

EARLY AMERICAN STENCILS ON WALLS AND FURNITURE, Janet Waring. Thorough coverage of 19th-century folk art: techniques, artifacts, surviving specimens. 166 illustrations, 7 in color. 147pp. of text. 7⅞ × 10¾. 21906-2 Pa. $9.95

AMERICAN ANTIQUE WEATHERVANES, A.B. & W.T. Westervelt. Extensively illustrated 1883 catalog exhibiting over 550 copper weathervanes and finials. Excellent primary source by one of the principal manufacturers. 104pp. 6⅛ × 9¼. 24396-6 Pa. $3.95

ART STUDENTS' ANATOMY, Edmond J. Farris. Long favorite in art schools. Basic elements, common positions, actions. Full text, 158 illustrations. 159pp. 5⅜ × 8½. 20744-7 Pa. $3.95

BRIDGMAN'S LIFE DRAWING, George B. Bridgman. More than 500 drawings and text teach you to abstract the body into its major masses. Also specific areas of anatomy. 192pp. 6½ × 9¼. (EA) 22710-3 Pa. $4.50

COMPLETE PRELUDES AND ETUDES FOR SOLO PIANO, Frederic Chopin. All 26 Preludes, all 27 Etudes by greatest composer of piano music. Authoritative Paderewski edition. 224pp. 9 × 12. (Available in U.S. only) 24052-5 Pa. $7.50

PIANO MUSIC 1888-1905, Claude Debussy. Deux Arabesques, Suite Bergamesque, Masques, 1st series of Images, etc. 9 others, in corrected editions. 175pp. 9⅜ × 12¼. 22771-5 Pa. $5.95

TEDDY BEAR IRON-ON TRANSFER PATTERNS, Ted Menten. 80 iron-on transfer patterns of male and female Teddys in a wide variety of activities, poses, sizes. 48pp. 8¼ × 11. 24596-9 Pa. $2.25

A PICTURE HISTORY OF THE BROOKLYN BRIDGE, M.J. Shapiro. Profusely illustrated account of greatest engineering achievement of 19th century. 167 rare photos & engravings recall construction, human drama. Extensive, detailed text. 122pp. 8¼ × 11. 24403-2 Pa. $7.95

NEW YORK IN THE THIRTIES, Berenice Abbott. Noted photographer's fascinating study shows new buildings that have become famous and old sights that have disappeared forever. 97 photographs. 97pp. 11⅜ × 10. 22967-X Pa. $7.50

MATHEMATICAL TABLES AND FORMULAS, Robert D. Carmichael and Edwin R. Smith. Logarithms, sines, tangents, trig functions, powers, roots, reciprocals, exponential and hyperbolic functions, formulas and theorems. 269pp. 5⅜ × 8½. 60111-0 Pa. $4.95

HANDBOOK OF MATHEMATICAL FUNCTIONS WITH FORMULAS, GRAPHS, AND MATHEMATICAL TABLES, edited by Milton Abramowitz and Irene A. Stegun. Vast compendium: 29 sets of tables, some to as high as 20 places. 1,046pp. 8 × 10½. 61272-4 Pa. $19.95

REASON IN ART, George Santayana. Renowned philosopher's provocative, seminal treatment of basis of art in instinct and experience. Volume Four of *The Life of Reason*. 230pp. 5⅜ × 8. 24358-3 Pa. $4.50

LANGUAGE, TRUTH AND LOGIC, Alfred J. Ayer. Famous, clear introduction to Vienna, Cambridge schools of Logical Positivism. Role of philosophy, elimination of metaphysics, nature of analysis, etc. 160pp. 5⅜ × 8½. (USCO)
20010-8 Pa. $2.95

BASIC ELECTRONICS, U.S. Bureau of Naval Personnel. Electron tubes, circuits, antennas, AM, FM, and CW transmission and receiving, etc. 560 illustrations. 567pp. 6½ × 9¼. 21076-6 Pa. $8.95

THE ART DECO STYLE, edited by Theodore Menten. Furniture, jewelry, metalwork, ceramics, fabrics, lighting fixtures, interior decors, exteriors, graphics from pure French sources. Over 400 photographs. 183pp. 8⅜ × 11¼.
22824-X Pa. $7.95

THE FOUR BOOKS OF ARCHITECTURE, Andrea Palladio. 16th-century classic covers classical architectural remains, Renaissance revivals, classical orders, etc. 1738 Ware English edition. 216 plates. 110pp. of text. 9½ × 12¾.
21308-0 Pa. $11.50

THE WIT AND HUMOR OF OSCAR WILDE, edited by Alvin Redman. More than 1000 ripostes, paradoxes, wisecracks: Work is the curse of the drinking classes, I can resist everything except temptations, etc. 258pp. 5⅜ × 8½.
20602-5 Pa. $3.95

THE DEVIL'S DICTIONARY, Ambrose Bierce. Barbed, bitter, brilliant witticisms in the form of a dictionary. Best, most ferocious satire America has produced. 145pp. 5⅜ × 8½. 20487-1 Pa. $2.75

ERTÉ'S FASHION DESIGNS, Erté. 210 black-and-white inventions from *Harper's Bazar*, 1918-32, plus 8pp. full-color covers. Captions. 88pp. 9 × 12.
24203-X Pa. $6.95

ERTÉ GRAPHICS, Erté. Collection of striking color graphics: *Seasons, Alphabet, Numerals, Aces* and *Precious Stones*. 50 plates, including 4 on covers. 48pp. 9⅜ × 12¼. 23580-7 Pa. $6.95

PAPER FOLDING FOR BEGINNERS, William D. Murray and Francis J. Rigney. Clearest book for making origami sail boats, roosters, frogs that move legs, etc. 40 projects. More than 275 illustrations. 94pp. 5⅜ × 8½. 20713-7 Pa. $2.25

ORIGAMI FOR THE ENTHUSIAST, John Montroll. Fish, ostrich, peacock, squirrel, rhinoceros, Pegasus, 19 other intricate subjects. Instructions. Diagrams. 128pp. 9 × 12. 23799-0 Pa. $4.95

CROCHETING NOVELTY POT HOLDERS, edited by Linda Macho. 64 useful, whimsical pot holders feature kitchen themes, animals, flowers, other novelties. Surprisingly easy to crochet. Complete instructions. 48pp. 8¼ × 11.
24296-X Pa. $1.95

CROCHETING DOILIES, edited by Rita Weiss. Irish Crochet, Jewel, Star Wheel, Vanity Fair and more. Also luncheon and console sets, runners and centerpieces. 51 illustrations. 48pp. 8¼ × 11. 23424-X Pa. $2.50

YUCATAN BEFORE AND AFTER THE CONQUEST, Diego de Landa. Only significant account of Yucatan written in the early post-Conquest era. Translated by William Gates. Over 120 illustrations. 162pp. 5⅜ × 8½. 23622-6 Pa. $3.50

ORNATE PICTORIAL CALLIGRAPHY, E.A. Lupfer. Complete instructions, over 150 examples help you create magnificent "flourishes" from which beautiful animals and objects gracefully emerge. 8⅛ × 11. 21957-7 Pa. $2.95

DOLLY DINGLE PAPER DOLLS, Grace Drayton. Cute chubby children by same artist who did Campbell Kids. Rare plates from 1910s. 30 paper dolls and over 100 outfits reproduced in full color. 32pp. 9¼ × 12¼. 23711-7 Pa. $3.50

CURIOUS GEORGE PAPER DOLLS IN FULL COLOR, H. A. Rey, Kathy Allert. Naughty little monkey-hero of children's books in two doll figures, plus 48 full-color costumes: pirate, Indian chief, fireman, more. 32pp. 9¼ × 12¼. 24386-9 Pa. $3.50

GERMAN: HOW TO SPEAK AND WRITE IT, Joseph Rosenberg. Like *French, How to Speak and Write It.* Very rich modern course, with a wealth of pictorial material. 330 illustrations. 384pp. 5⅜ × 8½. 20271-2 Pa. $4.95

CATS AND KITTENS: 24 Ready-to-Mail Color Photo Postcards, D. Holby. Handsome collection; feline in a variety of adorable poses. Identifications. 12pp. on postcard stock. 8¼ × 11. 24469-5 Pa. $2.95

MARILYN MONROE PAPER DOLLS, Tom Tierney. 31 full-color designs on heavy stock, from *The Asphalt Jungle, Gentlemen Prefer Blondes,* 22 others.1 doll. 16 plates. 32pp. 9⅜ × 12¼. 23769-9 Pa. $3.50

FUNDAMENTALS OF LAYOUT, F.H. Wills. All phases of layout design discussed and illustrated in 121 illustrations. Indispensable as student's text or handbook for professional. 124pp. 8⅜ × 11. 21279-3 Pa. $4.50

FANTASTIC SUPER STICKERS, Ed Sibbett, Jr. 75 colorful pressure-sensitive stickers. Peel off and place for a touch of pizzazz: clowns, penguins, teddy bears, etc. Full color. 16pp. 8¼ × 11. 24471-7 Pa. $3.50

LABELS FOR ALL OCCASIONS, Ed Sibbett, Jr. 6 labels each of 16 different designs—baroque, art nouveau, art deco, Pennsylvania Dutch, etc.—in full color. 24pp. 8¼ × 11. 23688-9 Pa. $2.95

HOW TO CALCULATE QUICKLY: RAPID METHODS IN BASIC MATHE-MATICS, Henry Sticker. Addition, subtraction, multiplication, division, checks, etc. More than 8000 problems, solutions. 185pp. 5 × 7¼. 20295-X Pa. $2.95

THE CAT COLORING BOOK, Karen Baldauski. Handsome, realistic renderings of 40 splendid felines, from American shorthair to exotic types. 44 plates. Captions. 48pp. 8¼ × 11. 24011-8 Pa. $2.50

THE TALE OF PETER RABBIT, Beatrix Potter. The inimitable Peter's terrifying adventure in Mr. McGregor's garden, with all 27 wonderful, full-color Potter illustrations. 55pp. 4¼ × 5½. (Available in U.S. only) 22827-4 Pa. $1.75

BASIC ELECTRICITY, U.S. Bureau of Naval Personnel. Batteries, circuits, conductors, AC and DC, inductance and capacitance, generators, motors, trans-formers, amplifiers, etc. 349 illustrations. 448pp. 6½ × 9¼. 20973-3 Pa. $7.95

SOURCE BOOK OF MEDICAL HISTORY, edited by Logan Clendening, M.D. Original accounts ranging from Ancient Egypt and Greece to discovery of X-rays: Galen, Pasteur, Lavoisier, Harvey, Parkinson, others. 685pp. 5⅜ × 8½.
20621-1 Pa. $10.95

THE ROSE AND THE KEY, J.S. Lefanu. Superb mystery novel from Irish master. Dark doings among an ancient and aristocratic English family. Well-drawn characters; capital suspense. Introduction by N. Donaldson. 448pp. 5⅜ × 8½.
24377-X Pa. $6.95

SOUTH WIND, Norman Douglas. Witty, elegant novel of ideas set on languorous Meditterranean island of Nepenthe. Elegant prose, glittering epigrams, mordant satire. 1917 masterpiece. 416pp. 5⅜ × 8½. (Available in U.S. only)
24361-3 Pa. $5.95

RUSSELL'S CIVIL WAR PHOTOGRAPHS, Capt. A.J. Russell. 116 rare Civil War Photos: Bull Run, Virginia campaigns, bridges, railroads, Richmond, Lincoln's funeral car. Many never seen before. Captions. 128pp. 9⅜ × 12¼.
24283-8 Pa. $7.95

PHOTOGRAPHS BY MAN RAY: 105 Works, 1920-1934. Nudes, still lifes, landscapes, women's faces, celebrity portraits (Dali, Matisse, Picasso, others), rayographs. Reprinted from rare gravure edition. 128pp. 9⅜ × 12¼. (Available in U.S. only)
23842-3 Pa. $7.95

STAR NAMES: THEIR LORE AND MEANING, Richard H. Allen. Star names, the zodiac, constellations: folklore and literature associated with heavens. The basic book of its field, fascinating reading. 563pp. 5⅜ × 8½.
21079-0 Pa. $7.95

BURNHAM'S CELESTIAL HANDBOOK, Robert Burnham, Jr. Thorough guide to the stars beyond our solar system. Exhaustive treatment. Alphabetical by constellation: Andromeda to Cetus in Vol. 1; Chamaeleon to Orion in Vol. 2; and Pavo to Vulpecula in Vol. 3. Hundreds of illustrations. Index in Vol. 3. 2000pp. 6⅛ × 9¼.
23567-X, 23568-8, 23673-0 Pa. Three-vol. set $36.85

THE ART NOUVEAU STYLE BOOK OF ALPHONSE MUCHA, Alphonse Mucha. All 72 plates from *Documents Decoratifs* in original color. Stunning, essential work of Art Nouveau. 80pp. 9⅜ × 12¼.
24044-4 Pa. $7.95

DESIGNS BY ERTE; FASHION DRAWINGS AND ILLUSTRATIONS FROM "HARPER'S BAZAR," Erte. 310 fabulous line drawings and 14 *Harper's Bazar* covers, 8 in full color. Erte's exotic temptresses with tassels, fur muffs, long trains, coifs, more. 129pp. 9⅜ × 12¼.
23397-9 Pa. $6.95

HISTORY OF STRENGTH OF MATERIALS, Stephen P. Timoshenko. Excellent historical survey of the strength of materials with many references to the theories of elasticity and structure. 245 figures. 452pp. 5⅜ × 8½. 61187-6 Pa. $8.95

Prices subject to change without notice.
Available at your book dealer or write for free catalog to Dept. GI, Dover Publications, Inc., 31 East 2nd St. Mineola, N.Y. 11501. Dover publishes more than 175 books each year on science, elementary and advanced mathematics, biology, music, art, literary history, social sciences and other areas.